Manual of Photo-Technique

THE MANUALS OF PHOTO-TECHNIQUE

ARTHUR COX, *M.A., D.Sc., F.Inst.P.*

Photographic Optics

A MODERN APPROACH TO
THE TECHNIQUE OF DEFINITION

FIFTEENTH REVISED EDITION

 Focal Press LONDON & NEW YORK

ISBN 0 240 50844 0

FIRST EDITION: JANUARY 1943
SECOND EDITION: JUNE 1943
THIRD EDITION: JANUARY 1944
FOURTH EDITION: JANUARY 1945
FIFTH EDITION: SEPTEMBER 1945
SIXTH EDITION: SEPTEMBER 1946
SEVENTH EDITION: SEPTEMBER 1947
EIGHTH (US) EDITION: MARCH 1949
NINTH EDITION: MARCH 1951
TENTH EDITION: OCTOBER 1953
ELEVENTH EDITION: MARCH 1956
TWELFTH EDITION: JANUARY 1961
THIRTEENTH EDITION: APRIL 1966
EXPANDED EDITION: AUGUST 1971
FIFTEENTH EDITION: MAY 1974

In Dutch
FOTOGRAFISCHE OPTICK 1949

In Spanish
OPTICA FOTOGRÀFICA 1952

In Italian
OTTICA FOTOGRAFICA 1973

ALL INQUIRIES

relating to this book or to any other photographic problems are readily answered by the Focal Press and its Circle of Photographers without charge if a stamped addressed envelope is closed for reply and the inquiry sent to

FOCAL PRESS, 31 FITZROY SQUARE, LONDON, W.1.

Made and Printed in Great Britain
by A. Wheaton & Co., Exeter

Contents

6

List of Tables

To Vida

Preface

In the preface to the first edition of this book its basic aim was expressed in these terms:

"Of all the components of photographic technique, optics has been linked longest with science proper. At a stage when the chemical aspects of photography still suffered from the comparatively crude means of trial-and-error practice, lenses were already designed, made and tested on a basis reliably provided by the quantitative methods of physics.

"This fact accounts for three effects. First, the development of photographic optics has always been conservative as compared with the frequent leaps of progress of photography in general. Secondly, books on photographic optics—provided that they did not choose to be quite superficial—appeared to be more academic than books on any other chapter of photography. Lastly, the photographer, even if he were thoroughly interested in the different aspects of the techniques at his disposal, resigned himself to scraps of information regarding the performance of his lenses rather than be bothered by the intricacies of what must have appeared to him as higher mathematics.

"Thus, the optical part of the equipment necessarily became a much less flexible instrument of photographic expression in the hands of the practical worker than did negative material, processing or printing. The rise of the 35 mm. or miniature camera, with its wide choice of interchangeable lenses and special viewfinders, made the photographic public more optics-conscious than it was before, but it had little to rely on for reference apart from the somewhat dogmatic claims of manufacturers.

"The man who designs a lens and the man who uses it in a camera, enlarger or projector, are interested in the same thing: Is the lens the right one and best one for the job in hand? But as long as they do not speak the same language the attitude of the 'scientific' man is little understandable to his 'practical' opposite member.

"In this book a modest attempt has been made to get the photographer more interested and to help him to understand how his lens works and why, and what can be expected of it. Step by step, the reader without previous knowledge is led from somewhat loose definitions of terms met with in his daily work to explanations of the designer's difficulties, and sobering qualifications of the manufacturer's claims. These vistas into the best use of lenses and their background are opened without using any but the bare minimum of formulae. Some, however, had to be included as one can no more talk about lenses without referring to the applicable formulae than one can discuss developing without the proper formulae. Their presence in this book may be found to be somewhat counterbalanced by an unusually large number of diagrammatic representations. Pictures, by nature, can never tell the whole truth, but what they tell of it is easier to perceive than the more exact meaning of an equation.

"Particular care has been taken not to devote unduly large space to somewhat dry subjects. The details of coma, astigmatism, chromatic aberrations, etc., are matters for the optical specialist. Still, it is these faults or their absence that make or mar the performance of a lens, and no discussion of the best types of lenses at present available can be introduced without an understanding of the nature of these possible faults."

These are still the aims of the book, but since that preface was written in 1942 there has been nothing short of a revolution in photographic optics.

In 1942, for example, electronic computers still belonged to the future. Now they are an everyday part of the scene, and they permit a volume of calculation that would have been quite impossible in 1942. Ray tracing can now be carried out at a speed which is at least two thousand times faster than the speed of calculation of twenty years ago, and the approach of the optical designer to his problems has been strongly conditioned by this fact.

The past few years have also seen the development of new and more powerful tools for the evaluation of photographic images. The use of resolving power rose to a peak of application, only to be superseded by the newer techniques of Optical Transfer Functions (O.T.F's) and Modulation Transfer Functions (M.T.F's.).

12

In the product field the last ten years have seen a remarkable development of zoom lenses. From being rather expensive and exotic systems they have now become everyday, and comparatively inexpensive, items of photographic commerce.

A serious attempt has been made to take these factors into account, without losing the spirit of the book which gave it an outstanding success in its earlier editions. This has necessitated an almost complete re-writing of the book. In particular a completely new chapter has been added on picture quality, including a full treatment of O.T.F's. and M.T.F's. Every effort has also been made to bring up-to-date the description and listing of modern lenses.

In view of the increasing importance of microfilm and microfiche equipment a new section has been added which deals with the optical aspects of such equipment. The general principles to be applied in microfilm equipment are basically the same as those enunciated in earlier chapters, but the different use of this equipment, as compared to pictorial photography, means that a different emphasis has to be placed on the application of these principles.

My thanks for the illustrations are due to Mr. Rudolph Hartmann for the frontispiece (facing page 15); Dr. Erich Heynacher of the Zeiss Company (page 267); The Polaroid Corporation (page 269, middle and bottom); The American Optical Co. (page 270); Dr. Jumpei Tsujiuchi (page 271); and Drs. Emmett N. Leith and Juris Upatnieks (page 272).

I should like to make a special acknowledgement of my thanks to Mr. G. H. Cook for the work which he did in revising the tenth and later editions of this book. I would also like to record my thanks to Mrs. Alice Geib for her patience in reducing my manuscript to typescript.

ARTHUR COX

13

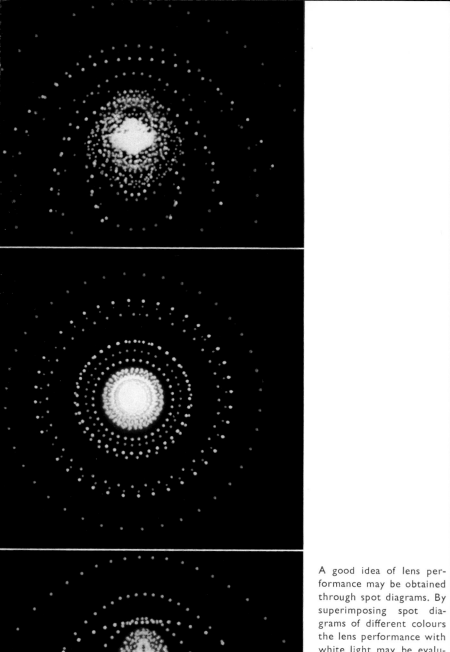

A good idea of lens performance may be obtained through spot diagrams. By superimposing spot diagrams of different colours the lens performance with white light may be evaluated. *See p. 466.*

(Courtesy of R. Hartmann.)

Introduction

The greater part of our knowledge of the world about us is gained through the use of our eyes. The link between our eyes and the objects we see is *light*. This defines what we mean by light without, at the moment, saying anything about its nature. Light is primarily defined as the link between the viewing eye and the object that is viewed.

Light is today recognised as being energy which is sent out by the object being looked at, which travels to the eye at the enormous speed of 186,000 miles per second, and which can stimulate not only the human eye, but also a photographic film.

The first thing to notice is that it travels in straight lines. Except to a very minute extent, light does not curl round the edges of obstacles that it cannot penetrate. Through some objects, those that are *transparent*, light can travel without any appreciable change. Others, those that are *opaque*, block it off completely. If a sheet of opaque material is held between the eye and a luminous point, i.e. a point source which is sending out light, then none of this light reaches the eye.

LIGHT RAYS

This behaviour leads to the idea that every luminous point, whether it is sending out light because it is glowing like the filament of a lamp, or because it is illuminated by daylight or artificial light, sends out light in all directions. Each element of the light, sent out from the luminous source, travels away from it in a straight line, along the so-called *light ray*. Rays of light, strictly speaking, are the straight lines along which fractions of the emitted light are travelling. This is shown in Fig. 1a. Not only does light stimulate the eye when it reaches it, but if it falls on a suitable surface, such as that of white paper, it illuminates this latter, which in turn can send light rays to the eye. (With pedantic accuracy this last statement should read "can send light to

15

the eye along light rays," but the phrasing used expresses the same thing in a more compact and standard form.)

Now suppose that we have a flat surface, such as that of a white card, and in front of it an opaque screen pierced with a fine pin-hole, as shown in Fig. 1b. If this arrangement is pointed towards a scene containing light and dark objects, every bright point in the scene sends light rays to it. Some of these rays get through the pin-hole and produce a small patch of light on the white card. This happens for each bright point in the scene. No rays are sent out by points in the scene that are completely dark. The result of this, as shown in Fig. 1b, is that to every bright point in the scene there corresponds a small patch of light on the white card, and so on the card there is a rather diffuse replica of the original scene. This is the *image* of the scene.

LENS AND FOCI

The rays of light from any bright point are spreading out until they come to the pin-hole, and continue to spread out after they pass it, as already shown in Fig. 1b. Better results are obtained if, by an arrangement of polished pieces of glass, the light rays are bent when they reach the aperture in the opaque screen, so that instead of continuing to spread out they now converge and meet again in a point, as shown in Fig. 1c. A replica is now obtained in which, to every bright point in the original scene, there may correspond a bright point on the white card, and as a result a much crisper and sharper image is obtained. The arrangement of glasses that bends the light rays in such a way is a *lens*.

The point, to which the previously diverging light rays are brought by a lens, is a *focus* or *image point*.

The simplest types of lens are shown in Figs. 2a, 2b. They are made from pieces of glass with polished surfaces, each surface being part of a sphere. The essential thing is that the centres of all these spheres lie on a straight line, as illustrated in the figure, which shows a lens consisting of two glasses cemented together with Canada Balsam, or with one of the new synthetic cements. This straight line of centres, about which the lens is symmetrical, is the *axis* of the lens.

16

IMAGE FORMATION
AND THE SIMPLE LENS

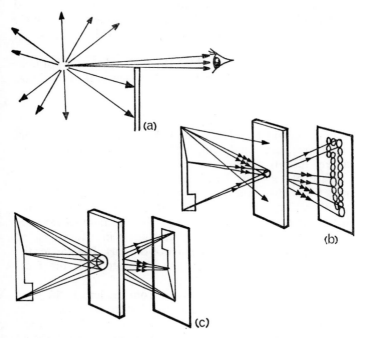

Fig. 1. (a) Light travels in straight lines, along *light rays*, and is obstructed by opaque objects; (b) an *image* is formed by light rays which go through a small hole; (c) a sharper image is produced by a *lens*.

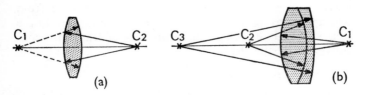

Fig. 2. (a) A simple lens is bounded by two spherical surfaces; (b) in a compound lens the centres of the surfaces lie on a straight line, the *axis* of the lens.

17

Any particular lens can produce only a certain amount of bending of the diverging light rays that come to it. The more the rays are diverging, when they come to the lens, the less they are converging after they pass through it, and as a result the greater the distance away is the focus, namely the point to which the rays converge. This is shown in Fig. 3a.

The greater the power of the lens to bend the rays of light that come to it, the closer to it is the focus, all other things being equal.

FOCAL LENGTH

The extent to which lenses can bend the rays reaching them can be measured and compared in the following way. Take a very distant luminous point, such as one located on the surface of the sun. To all intents and purposes the light rays from this point that reach any lens are parallel to one another. Direct the lens so that its axis points towards the luminous point as shown in Fig. 3b. The parallel rays are bent by the lens so that they meet again in a focus, called in this special case the *focal point* of the lens. The greater the bending power of the lens, the closer to it is the focal point.

The distance of the focal point from the lens is the *focal length* of the lens. The important feature of a lens is its power to bend light, and this is measured by its focal length. The shorter the focal length, the greater the bending power of the lens. (It is possible also to have a lens which causes light rays to diverge rather than converge; this is dealt with in later chapters.)

In the definition just given, there is a certain amount of ambiguity regarding the part of the lens from which the position of the focal point is to be measured. The last glass-to-air surface is not always the proper base from which to measure it. A more exact definition is given in the following chapter, where the properties of lenses are considered in greater detail.

IMAGES AND FOCUSING

Now consider any object point in front of the lens, which is sending rays of light to the lens. The divergence of these rays is fixed once the distance of the point from the lens is settled.

18

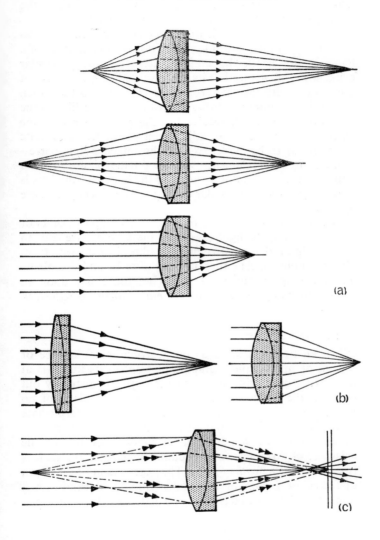

Fig. 3. (a) As the object point moves away from the lens the image point moves in towards the lens; (b) by changing the shape of a lens the focal length is decreased; (c) rays from an object point that is *in focus* meet in the image plane. Rays from other object points meet in front of or behind this plane.

19

As a result the convergence of the rays emerging from the lens is determined uniquely, and so is the position of the focus corresponding to that particular object point.

One result of this fact is that foci or image points, corresponding to all the multitude of luminous points in front of a lens, do not lie in the same plane. Now any particular element in the picture has its sharpest and crispest image at the point where the rays from it are brought to their foci. If then it is required to bring a sensitive plate or film to the position where it will receive the sharpest image of some elements of the scene, an adjustment of the lens and plate position has to be made, so that the image points corresponding to these elements will lie on the plate. Such an adjustment is spoken of as *focusing* the lens, and the lens is *focused upon* those particular elements. The object points are *in focus*.

When the lens is focused on a certain group of points or objects, so that the light rays from these points are bent to meet again on the sensitive plate or film, then the rays from all other points meet either in front of or behind this plane, and form light patches of small but finite size upon it. These other objects or points are *out of focus*, as shown in Fig. 3c.

DEPTH OF FOCUS

When an object is in focus on a ground-glass surface or screen, or upon a photographic plate, then its image is at its sharpest and crispest. When the object is distinctly out of focus the image is very diffuse, and as a rule is of no particular interest. There is, however, an intermediate region where, although the image is not perfectly sharp, it is of an acceptable standard of sharpness. Because of the existence of this region of acceptable image quality, the lens is said to have a *depth of focus*. The exact extent of the depth of focus, or region of acceptable quality, depends on a number of factors, and is discussed in detail in later chapters.

f-NUMBERS

In many instances it is important to have a measure of the amount of light that goes through a lens. For astronomical work the feature which determines the brightness of the image produced is the diameter of the lens. But, for normal

20

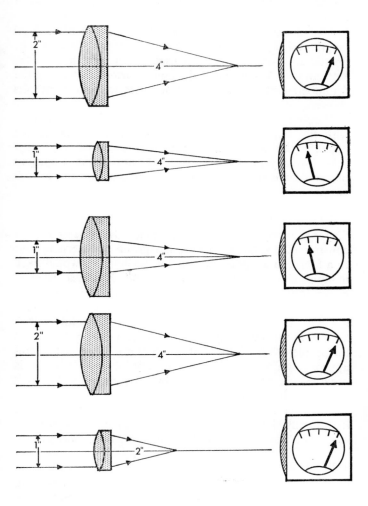

Fig. 4. The brightness of an image depends on the *f-number* of the lens, i.e. the focal length of the lens divided by the beam diameter shown. The top diagram is an *f*2 lens; the second and third are *f*4 lenses while the bottom two are *f*2 lenses. The meter readings represent the image brightness.

everyday photography, the only useful measure of the amount of light going through the lens, of the brightness of the image it produces, is the ratio of the focal length of the lens to its diameter, its *f*-number. Thus if a lens has a focal length of 4 in., and a diameter of 1 in., it is an *f*4 lens. The greater the *f*-number the less useful light goes through the lens, and the less bright is the image formed. Doubling the *f*-number reduces the image brightness to one-quarter, as shown in Fig. 4.

The *f*-number in any actual lens is changed, in accordance with the requirements of the occasion, by changing the diameter of a hole in an opaque diaphragm or stop. As a rule, nowadays, this is effected by the movement of a group of curved metal leaves sliding over one another in an *iris diaphragm*.

ABERRATIONS

So far the assumption has been made that a lens may be constructed so that it will bring a group of diverging rays to a focus, in a sharp image point. Such a lens would have many of the attributes of a perfect lens. However, when it comes to the problem of shaping glass, either practically in the shops, or in the mind of the designer, to give this result, it has to be admitted that the problem is insoluble. It is known on theoretical grounds, from the nature of light, that the problem is insoluble. But this does not mean that a good approximation to a solution cannot be made. What is obtained, in place of a perfectly sharp image point, is a small illuminated light patch.

The defects in the performance of a lens, which result in its bringing rays of light together in a small patch of light, instead of bringing them to a sharp point, are its *aberrations*.

SPECTRUM

Of the aberrations which are present in a lens, an interesting group are related to the fact that the extent to which a ray of light is bent by glass depends on the colour of the light ray. This is shown in Fig. 5. By the arrangement of slits shown there, a narrow pencil or beam of light rays is produced, such as a narrow beam of sunlight. If this beam traverses a prism, it is bent or *refracted* at each glass to air surface. Owing to the varying degrees to which the light making up

22

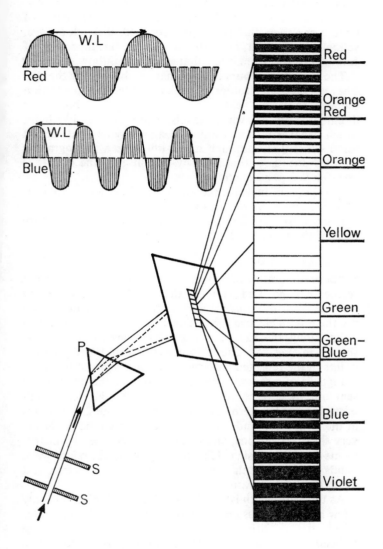

Fig. 5. A beam of light is spread out by a prism to form a *spectrum*. The colours of light in the spectrum are related to the *wavelength* of light. Blue light has a wavelength about half of the wavelength of red light.

23

the original beam is bent, there emerges from the prism, not a single beam of light, but a number of coloured beams. If these fall on white card they produce a coloured patch of light, a *spectrum*, that shades off from red, through orange, yellow, green, and blue to violet. The arrangement of colours in a spectrum is just that seen in a rainbow.

These are the colours of light that can be seen by the eye. They also affect a photographic plate or film. But in addition there is radiation sent out by most glowing bodies or illuminated objects, which travels in straight lines like light, which behaves in practically the same way as light, except for the fact that, although it can influence a photographic plate, it does not stimulate any response by the eye. It is *invisible light*, or *radiation*.

Two kinds of invisible radiation are of particular interest, *infra-red* and *ultra-violet* radiation.

In order to understand what these are, we must take more note of the nature of light.

WAVELENGTH OF LIGHT

Suppose that at some instant we freeze things, prevent further change, and examine the conditions along a ray traversed, for example, by blue light. At any point on the ray there is an electric force. This force varies from point to point along the ray in a regularly repeated pattern, as shown in Fig. 5. The distance between corresponding points in the repeated pattern is the *wavelength* of the light.

Light is of essentially the same nature as the disturbance sent out by a radio transmitter. In radio the wavelength of the repeated pattern of electric force is about 2,000 metres in the long wavebands, down to five or seven metres in the very short wavebands, and can only be recorded by instruments especially designed for the purpose. In the micro-wave bands the wavelength is reduced to a few centimetres, and again special apparatus is needed.

As the wavelength is still further decreased, until it is only a few hundred-thousandths of an inch, the conditions under which the radiation is sent out and perceived change radically. It is now capable of affecting a photographic plate and of producing a feeling of warmth on the skin. It is *infra-red light* or *infra-red radiation*.

With a still further reduced wavelength it is capable of

24

VISIBLE AND INVISIBLE RADIATION

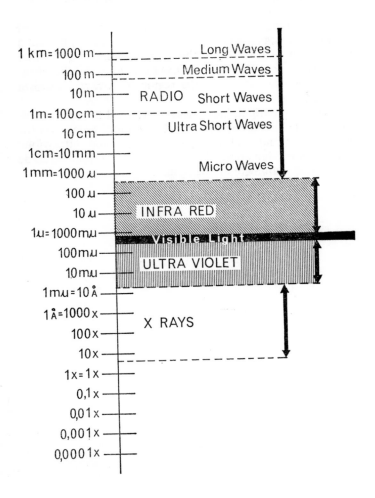

Fig. 6. The extent of the visible spectrum relative to the total range of electro-magnetic radiation is quite small, but it is the area of main interest in photographic optics.

stimulating the human eye and of producing a red colour sensation. It is, in fact, red light. At this stage the wavelength is about ·00003 in.

Further reductions of the wavelength take the colour of the light through the entire range of the spectrum, until at a wavelength of ·000015 in. the light is violet. Any further decrease in wavelength takes the radiation into the ultra-violet, and after that into the region of X-rays, as shown in Fig. 6.

As far as photographic optics is concerned the only region of interest, out of the totality of radiation, comprises the visible spectrum and the near infra-red and ultra-violet regions bordering on it. It is in this region that photographic lenses and equipment are designed to work.

The Ideal Lens

No lens yet made is perfect.

A perfect lens would reproduce every object point of light as an exact point on the properly positioned sensitive material or focusing screen, and reproduce every straight line as a fine straight line.

Any actual lens falls short of this ideal. An object point of light is reproduced as a patch of light of finite size. A straight line is reproduced as a narrow band of light, usually curved instead of being straight. But there are times when there is really no difference between a point and an illuminated area of ·001 in. diameter, when the width of the reproduced band is negligible by ordinary standards, and when its curvature is barely noticeable. By ordinary standards the lens is behaving perfectly, even though it is not perfect by really critical standards.

The best way of discussing the performance of a lens is to assume, first of all, that it is perfect, that it reproduces points as points, and lines as lines.

From this point of view a broad outline of a lens' performance can be given.

The second stage is to set up really critical standards, and to examine how imperfect the lens actually is by these standards. The first step is taken in this chapter. Any lens considered is taken to be near enough to perfection, and an account is given of the way in which it will therefore perform: the finer details of its virtues and vices are dealt with in later chapters.

It will be assumed, throughout this chapter, that a lens reproduces an object point of light (in front of it) as an exact point on a plate or focusing screen, and that it reproduces a straight line in any object as a straight line in the image.

With this in mind, the first thing we have to do is to describe a lens in a useful and compact way. This is done by specifying its *focal length* and *f-number*.

Every lens catalogue refers to lenses as 6 in. $f4 \cdot 5$, or 2 in. $f2$, and so on, and this description is adequate for most purposes. The 6 in. and 2 in. refer of course to the focal length of the lens. But it is not immediately obvious what exactly is meant by the focal length of a lens, what it is the length of, and between what points it is measured.

FOCAL POINTS

It is so absolutely necessary to have a clear idea of what is meant by focal length, and of the points between which it is measured, that it is worth going into the matter fully, and to describe in detail such things as *focal points* and *nodal points*.

When the object in front of the lens is a point of light on the lens axis at an infinite distance, then all the light from it, which goes through the lens, is brought to a focus at the *rear focal point*. This is marked as F2 in Fig. 7a. The light that enters the lens, in this case, is composed of parallel rays: because of the infinite distance that they have to travel, from the object to the lens, they need only diverge from one another by an infinitesimal amount in order to fill the lens aperture.

The plane at right angles to the lens axis, through the rear focal point F2, is the *rear focal plane*. Every object at infinity is reproduced sharply in the rear focal plane. The rear focal plane is also shown in Fig. 7a.

There is another focal point of equal importance, the *forward focal point*, marked as F1 in Fig. 7b, and the plane through this at right angles to the lens axis is the *forward focal plane*. When the object in front of the lens is a point of light at the forward focal point, the rays of light emerging from the lens are all parallel to the lens axis, as shown in Fig. 7b. And when the object is a point of light somewhere in the forward focal plane, the rays of light emerging from the lens are all parallel to one another, making an angle with the lens axis, as also shown in Fig. 7b.

These constitute the two focal points of the lens. The other two points of importance are the two *nodal points*.

NODAL POINTS

Suppose that a ray of light enters the lens, aiming at a point P on the lens axis, as shown in Fig. 8a. After bending

FRONT AND REAR FOCAL PLANES

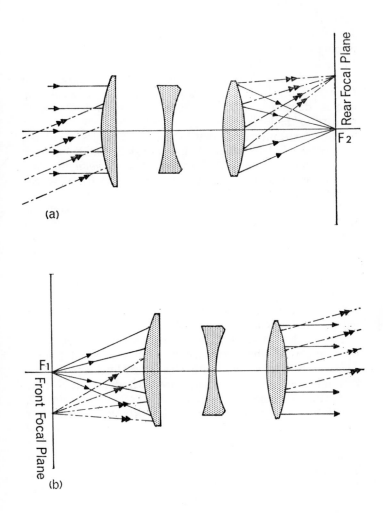

Fig. 7. (a) Parallel rays of light from distant object points are brought to a focus in the *rear focal plane;* (b) rays of light from points in the *front focal plane* emerge from the lens as parallel bundles of rays.

29

at the lens surfaces it finally emerges from the lens, directed away from the point Q. In general, the ray entering the lens makes an angle with the lens axis that differs from the angle made by the emerging ray. For instance the ray aiming at the point P may make an angle of ten degrees with the lens axis, and the emerging ray, directed away from Q, may make an angle of perhaps eight or twelve degrees with the axis. The actual ratio, between the emerging and entering angles, depends on the positions of the points P and Q relative to the lens.

The important case is that in which the angles are equal, no matter what their actual size is in degrees. In this case the entering ray aims at the *forward nodal point*, marked N1 in Fig. 8b, and the emerging ray aims away from the *rear nodal point*, marked N2.

There is one possibility to bear in mind. Although the nodal points are called forward and rear nodal points, it may happen that they are crossed over, and the forward nodal point may lie behind the rear nodal point. This is also shown in Fig. 8c.

The essence of calling them "forward" and "rear" is that a ray coming in from the front of the lens aims at the forward nodal point, and a ray coming out of the lens aims away from the rear nodal point.

To complete this section, we have to consider the planes at right angles to the lens axis, through the nodal points. These are the *principal planes*. The forward principal plane, PP1 in Fig. 8d, goes through the forward nodal point N1; the rear principal plane PP2 goes through the rear nodal point N2.

The principal planes have this important property: if a ray of light goes into the lens aiming at a point X in the forward principal plane, then it comes out of the lens aiming away from a point Y in the rear principal plane, and Y is at the same height above the lens axis as the point X. This is shown in Fig. 8d. When the nodal points are crossed over, the principal planes are crossed over. This makes no difference to their properties as described above.

FOCAL LENGTH

The forward and rear focal points are shown in Fig. 8d for the sake of completeness, and because the relative positions of focal and nodal points are important.

30

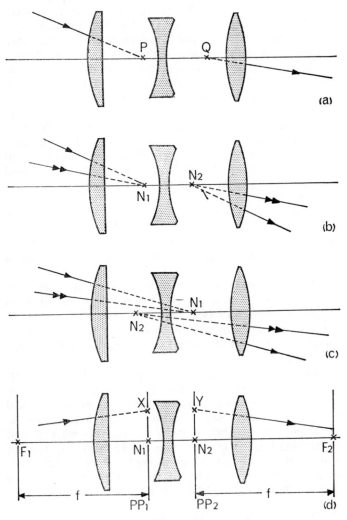

Fig. 8. (a) In general the ingoing ray directed towards a point P is not parallel to the corresponding emerging ray directed away from the point Q; (b) when P and Q become the *nodal points* N1 and N2 the ingoing and emerging rays are parallel; (c) in some lenses the front and rear nodal points are crossed over; (d) the *principal planes* go through the nodal points N1 and N2.

31

Detailed mathematical work shows that the distance from the forward nodal point N1 to the forward focal point F1 is exactly the same as the distance from the rear nodal point N2 to the rear focal point F2. This distance, marked as *f* in Fig. 8d, is the *equivalent focal length* of the lens. When the focal length of a lens is given, without any further qualification, it can be taken for granted that it is the equivalent focal length which is meant, and not the back focal length which is described below.

A normal photographic lens is a converging lens. Rays of light from a distant point come out of the lens so that they all converge to a point, as shown in Fig. 9a. It is possible, however, to have a diverging lens. In this case, rays of light from a distant point emerge from the lens as if they diverged from a point in front of the rear nodal point, as shown in Fig. 9b.

When the lens is converging the focal length is said to be *positive*. When it is diverging the focal length is *negative*, and the lens is often spoken of as being a negative lens. In the same way a converging lens is often called a positive lens.

Negative lenses only enter into photography in very special circumstances, such as when they are used as supplementary lenses (see page 55), or as components in complex lenses. Throughout this book, unless a special mention is made, it can be taken for granted that any lens referred to is a positive or converging lens.

Once the positions of the focal points and nodal points are known (or what comes to the same thing, when the focal length is known, as well as the positions of the nodal points), relative to such features of the lens mount as shoulders and flanges, quite a lot can be worked out. Everything needed in arranging the lens for any type of work can be calculated and worked out on paper, from focusing scale markings to enlarger settings. Some of these topics will be discussed later in this chapter.

MEASURING THE FOCAL LENGTH

As far as focal length is concerned the maker's nominal value, engraved on the lens, can usually be relied upon to within 1 per cent or less. And for that matter any information about the positions of nodal and focal points can

CONVERGING AND DIVERGING LENSES

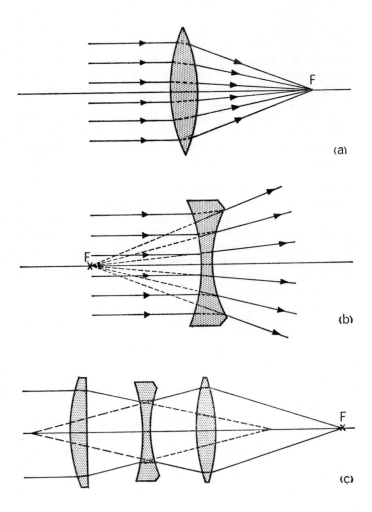

Fig. 9. (a) A converging lens causes light rays to meet in a point; (b) a diverging lens causes incident rays to spread out; (c) a practical lens comprises both converging and diverging lenses with a total converging effect.

33

usually be obtained from the makers. But it is sometimes useful to be independent of the makers, as far as obtaining this information is concerned. What follows is, therefore, a short account of the principles involved in determining focal lengths and so on. Details of improvising apparatus are best left completely to individual cases, and only the general ideas common to all are given in the following pages.

The first thing to do is to find the position of the rear focal point or focal plane.

By its definition this is the plane in which the image of an infinitely distant object is formed. For any lens of the size normally used in cameras the difference between an object at a thousand yards and one at infinity is negligible, as far as finding the position of the rear focal plane is concerned. For a lens of 6 in. focal length the error introduced is only ·001 in. The procedure, then, is to focus some object, at a distance of about a thousand yards or over, on a focusing screen, and to measure the distance of the screen from the lens. This gives the position of the rear focal plane and rear focal point. The distance of the screen, from the centre of the last glass surface of the lens, is the *back focal length* or *back focus* of the lens.

To obtain the position of the forward focal point, the simplest thing to do is to turn the lens round, so that the glass surface which usually faces the distant object now faces the focusing screen. Then find the rear focal point of this turned-round lens in the same way as described above. This point is the forward focal point of the lens in its normal position, relative, of course, to the lens and not in absolute position.

It will probably be found that, in focusing a lens turned round in this way, it will be necessary to stop it down to a small aperture in order to get a reasonable definition, and one which will stand examination with a 10X or 15X magnifier of the kind normally used to examine the image on a focusing screen. If the definition is at all soft, with the lens turned round in this way, it is the proper thing to stop the lens down to improve the definition, and then to find the best focus, rather than try to find the best focus with soft definition on the screen.

In dealing with both rear and forward focal planes another practical point must be borne in mind. In view of

34

the fact that no lens is perfect, it may happen that the field is curved, and objects whose images lie away from the centre of the focusing screen may be in sharp focus, while an image in the centre of the screen is slightly out of focus. In this case the position of the focal point is found by getting the central image as sharp as possible. (See also the notes on focusing on page 315.)

The third and last thing to do is to find the position of a nodal point.

USING A NODAL SLIDE

To do this, some improvised form of *nodal slide* must be used as shown in Fig. 10a. The lens can be mounted in V-grooves cut in uprights which are fastened to a baseboard A, and can be held in position by stops bearing against front and back of the lens mount (not shown in Fig. 10). The depth of the grooves, in relation to the part of the lens mount against which they bear, has to be adjusted so that the lens axis is horizontal. This can be checked, within very close limits, by placing a 90 degree set square against the front or back of the lens mount and against the base-board.

This lens carriage A is carried on a second carriage B, as shown in Fig. 10a, and can slide between ways on B, in a direction parallel to the lens axis. This direction, again, can be checked by means of a 90 degree square placed against the front of the lens mount.

The second carriage B rests on yet a third C. The surfaces of B and C in contact are finished as smoothly as possible, so that they can move over one another with the minimum of friction. The carriage B can swing about a vertical axis carried by C. It is essential that the movement about this pivot be perfectly smooth, and that there be no play between the axis and the hole in B into which it fits. There are various ways of arranging this: one is to cut the hole in B rather larger than is needed, and form a close fitting bearing surface by pouring in Wood's metal or other low melting-point alloy. More elaborate metal fabricating techniques may, of course, be used in order to obtain the same result.

The carriage C can slide backwards and forwards on the base of the whole apparatus, in a direction parallel to the lens axis. This is effected by mounting it between runners,

35

(as shown in Fig. 10a,) which have already been set parallel to the lens axis.

The final requirement is a focusing screen of ground glass which is set at right angles to the lens axis, or, what amounts to the same thing, at right angles to the runners guiding the movement of the carriage C.

The carriage B is brought to its central position, and the lens carriage A is moved backwards or forwards until a distant object is in sharp focus at or near the centre of the focusing screen, i.e., where the lens axis cuts the screen, as nearly as can be judged by eye. The carriage C is not touched at this stage. With an object at infinity, or at a great distance, all the rays of light from it that reach the lens are sensibly parallel.

The carriage B is then pivoted through two or three degrees. What usually happens is that the image on the focusing screen moves to one side or the other.

In Fig. 10b it is shown why this happens. The original position of the lens is shown with the nodal points at N1 and N2 and the pivot at P. The parallel rays of light are brought to a focus on the screen S in the rear focal plane. The lens position is shown next after it has been swung through a few degrees (exaggerated in the diagram). One of the parallel rays entering the lens goes through the forward nodal point N1, as illustrated by the actual ray in question namely X—N1. It emerges from the rear nodal point as the ray N2—Y, parallel to X—N1, as shown. Since all rays from a distant point come together in an image after passing through the lens, the image of the distant point must lie somewhere on the ray N2—Y. This means, as is shown in Fig. 10b, that as a result of the lens movement the image moves sideways. Actually it also moves out of focus slightly, but not enough to matter with a small swing of the lens.

The carriage C is then moved away from or towards the focusing screen, and the image refocused (with the carriage B in its central position) by moving the lens carriage A. This adjustment is carried out until there is no sideways movement of the image on the screen when B is pivoted through a degree or two. It is useful to have fine pencil lines ruled on the ground glass surface, in order to detect most easily the absence of movement.

36

NODAL SLIDE

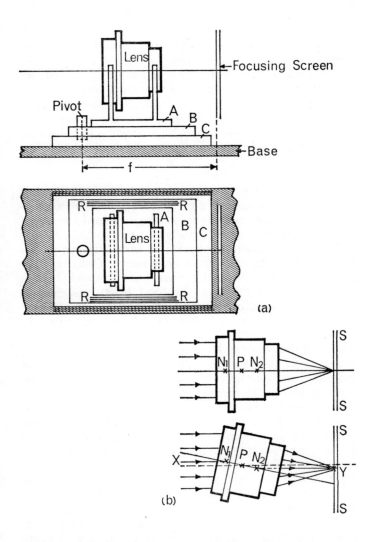

Fig. 10. (a) An important method of measuring the focal length of a lens is with a *nodal slide* of the form shown; (b) the operation of a nodal slide depends on the fact that there is no image movement when the lens pivots about its rear nodal point.

37

When this situation is established the nodal point N2 coincides with the centre of the axis or pivot carried by the carriage C. There is then no movement of N2 as the lens pivots, and no consequent movement of the image.

All that is necessary then is to measure the distance of the centre of the pivot from the focusing screen. This gives the focal length, which has already been defined as the distance from the rear nodal point to the rear focal plane.

The forward nodal point is found by measuring off a distance equal to the focal length, from the forward focal point, which may be located as already described in previous pages.

ALTERNATIVE METHODS

The method of measuring focal lengths just described is only one out of a number of possible ways. The two alternative methods given below are in some ways easier to apply with improvised or readily available apparatus.

The first is adapted for occasions when outdoor photography is possible, and when a street map or Ordnance map is available. The procedure then is as follows: Take a photograph with the lens (the focal length of which is required) mounted in some suitable camera, using a scene in which some prominent objects can be picked out on an Ordnance map. Church steeples or high buildings are useful for this purpose. Note on the map the position of the camera and of three other points, if possible each lying more than a thousand yards away from the camera. In the diagram in Fig. 11 the camera position is marked by P, and the objects on which attention is to be concentrated, when the exposure is made and the negative fixed, are taken to be three steeples at A, B and C. Join PA, PB and PC and continue the lines as shown in the diagram. In the negative measure the distances between the images of the steeples. Suppose that these are 1 inch from A to B, and $1\frac{1}{4}$ inch from B to C, as also shown in Fig. 11. On the map draw one line parallel to PB 1 inch away from it, and on the opposite side of it to the point A, and another $1\frac{1}{4}$ inch away on the other side of PB. These cut the lines already drawn on the map in *a* and *c* respectively. Join *a* and *c* and measure their distance apart: suppose that it is 3 inches. Next draw a line PQ from P at right-angles to *ac,* and

38

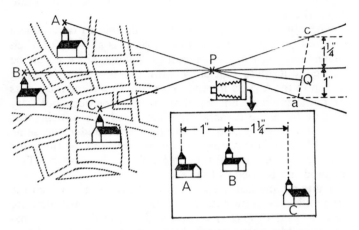

Fig. 11. An alternative method of measuring focal length is to take a picture of objects whose positions can be accurately established.

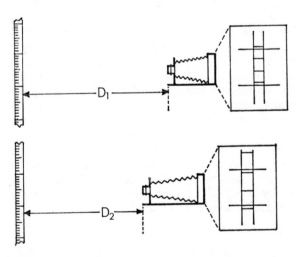

Fig. 12. Yet another method of measuring focal length is to note the camera movement which is needed to change the scale of image formation.

measure its length: suppose that it is 6 inches. Then the focal length of the lens is equal to 6 inches \times $2\frac{1}{4}$ \div 3, i.e., $4\frac{1}{2}$ inches ($2\frac{1}{4}$ inches is the separation of the images of A and C on the negative).

The other method is specially applicable to cases where outdoor photography is not possible. It is also useful when plates and films are not readily available, since it can be carried out quite efficiently with the use of a focusing screen in the camera instead of a plate. In outline it consists of photographing an object from two positions not very distant from the camera, or alternatively of noticing the size of the images on a focusing screen under the same conditions, of measuring the image sizes and, at the same time, the distances of the object from the camera. This method can be used as follows:

Hang a tape-measure in front of the camera in which the lens under test is mounted, and make sure that the focusing screen in the camera is vertical and so parallel to the tape-measure. Move the camera either nearer to, or farther from, the measure until 20 inches of this latter form a sharply focused image that occupies exactly 2 inches on the focusing screen, i.e., the system is working at a reduction of 10 to 1. Then measure the distance of the tape-measure from some definite point on the camera or lens mount, as shown in Fig. 12. Next repeat the procedure, so that a length of 40 inches of the measure now occupies a length of exactly 2 inches on the focusing screen, and so that the system is working at a reduction of 20 to 1. Again measure the distance of the tape-measure from the camera, using the same reference point. Then the difference between the two distances from the camera is equal to 10 times the focal length of the lens.

More generally the formula is: If the distance between the two camera positions is D, and the difference between the two degrees of reduction is M, then the focal length of the lens is given by D \div M. The example given above will make it clear how this formula is to be used.

THE VIEWPOINT OF THE LENS

The camera does not see a scene in exactly the same way that it is seen by any human observer. When one looks at a scene there is more to it than the mere formation of an

image on the retina of the eye; there are, in addition, a series of psychological phenomena to be taken into account. For instance it is a photographic commonplace that, if the camera is taken too near to a subject, the resulting picture shows a very pronounced distortion of the relative proportions of the subject. Those parts near the lens are grossly enlarged. One never encounters this in real life unless it is specially looked for. If one looks at a scene, from the same viewpoint as a lens that is giving a distorted perspective, this distortion is not immediately evident to the eye. The mental processes that are called into play allow for the increase in size of the image formed in the eye.

Because of the more direct and less interpretive recording of a scene given by a lens, and because of the fact that it may differ in important respects from the way in which the same scene is apprehended and automatically interpreted by the combination of brain and eye, it is of importance to consider in detail the way in which a camera views a scene.

The critical fact to be taken into account is that every ray which goes into the lens aiming at the forward nodal point, comes out of the lens aiming away from the rear nodal point, and travelling in a direction parallel to its entering direction.

Suppose, then, that a fan of rays is drawn from the forward nodal point to all points in the objects to be photographed. To these rays there correspond a fan of rays leaving the rear nodal point and proceeding to the photographic plate, as shown in Fig. 13. The rays in this emerging fan are arranged among themselves in exactly the same way as the rays in the first or in-going fan, and make exactly the same angles with one another that are made by the corresponding rays in the first fan. The whole set of rays emerging from the rear nodal point is upside down, relative to the set of rays drawn from the forward nodal point to the object points, but this is of minor importance. What is important is the fact that the angles between the rays are the same for both sets of rays.

If a frame, of the same size as the plate or film being used, is placed in front of the forward nodal point, at the same distance from it that the sensitive surface of the emulsion is located behind the rear nodal point, (not the focal distance except when the objects are at infinity), then

the fan of rays from the forward nodal point traces out, in this frame, exactly the same pattern that the rays from the rear nodal point trace out on the plate or film. The fact that one of these patterns is upside down is of no material importance.

The picture thrown on the film or plate is just that which an eye, placed at the forward nodal point, would see framed by a rectangle having the size of the plate or film, held at a proper distance. That distance is equal to the distance of the sensitive plate from the rear nodal point of the lens.

There is one qualification to make. The eye, viewing such a framed picture, can change its accommodation and focus every element of the picture separately in an almost unconscious fashion. This is out of the question with the camera lens. Elements of the picture included in the frame may be quite a long way out of focus and hardly recognisable. But as far as they are recognisable on the sensitive surface of the emulsion, their positions and relative sizes are given by the considerations outlined above.

IMAGE SIZE AND FOCAL LENGTH

With a given subject to be photographed, the largest image is obtained on the plate when the frame in front of the nodal point (we can call it the *perspective frame*) is near to the subject, or even beyond it, as shown in Fig. 14. When the frame is beyond the subject an enlarged image is obtained, and this may be used for low-power photo-micrography.

When a large image is needed on the plate, as in making close-ups, there are two ways of making the frame move towards the subject. The first is to use a lens of short or moderate focal length, and to move the lens and plate bodily towards the subject. The second is to use a long focus lens, when the increased distance, from the rear nodal point to the plate, correspondingly throws the perspective frame forward.

The first method can only be used easily when the subject to be photographed is flat, or without much depth and relief. Moving the lens forward means that the viewpoint at the forward nodal point also moves forward, and the usual difficulties are then met of exaggerated perspective with outsize noses, outlandish limbs and the like.

The second method is usually the best. With a long focus

THE PERSPECTIVE FRAME

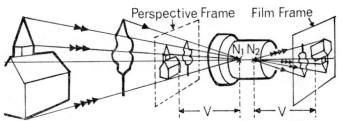

Fig. 13. The composition of an image may be visualised by using the *perspective frame* defined in the text.

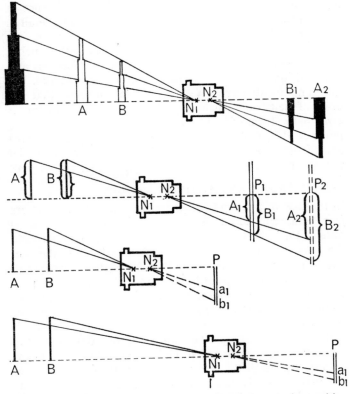

Fig. 14. *Top:* As the focal length of a lens increases, the sensitive film and the perspective frame both move away from the nodal points. *Upper centre:* When lenses of different focal lengths are used from the same viewpoint, the images have the same relative proportions but different scales. *Lower centre and bottom:* when the point of view $N1$ moves away from the scene the images tend to become more nearly the same size.

lens the perspective frame moves forward, but the viewpoint at the forward nodal point remains at a safe distance from the subject and there is not the same danger of exaggerated perspective. This is shown in Fig. 15.

There is one further point worth noting. It has just been explained why it is better to use a long focus lens for close-up work, and the above discussion and argument is applicable even when the close-ups are in the nature of table-top photography. When close-ups are required out of doors a form of lens that is very useful indeed is a telephoto lens (page 272). But if a telephoto lens is used for table-top work special attention must be paid to the position of the forward nodal point, which is usually at a considerable distance in front of the lens. Telephoto lenses are dealt with in detail in another chapter, but the diagram on page 273 will give a general idea of the positions of the nodal points of such a lens. In actual work of this type, of course, the focusing and composition are best done on a ground glass screen, but time and trouble are saved if it is remembered that the point of view from which a telephoto lens sees the picture is away out in front of it. There is no need to make any special point of this, if the long focus lens used is of a standard anastigmat construction, as in this case the forward nodal point is not very far behind the front surface of the lens.

RISING FRONT AND SWINGING BACK

In the case of a rising front the picture seen by the camera lens, and reproduced by it on the sensitised surface, is obtained merely by raising the perspective frame relative to the lens, through exactly the same height that the lens itself has been raised by the movement of the camera front. If the lens moves upwards through a distance of half an inch, then the viewpoint from which the lens sees the picture, namely the forward nodal point, moves upwards through half an inch. The perspective frame moves upwards with the lens through the half inch, but does not stop there. It moves a further half inch, to take into account the amount by which the lens axis is offset from the centre of the plate. This is shown in Fig. 16. Except in close-up work, where actually there is no need of a rising front, the effect of the movement of the nodal point is absolutely negligible compared with the relative shift of the perspective

44

IMAGE SIZE AND PROPORTIONS

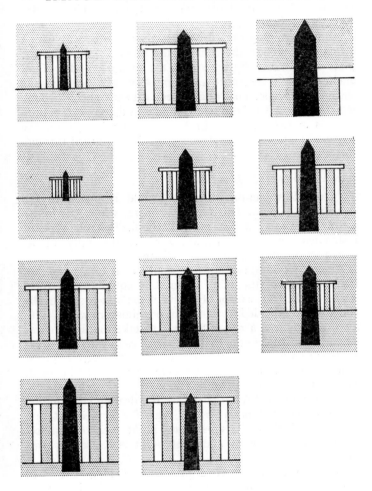

Fig. 15. *Top:* With a fixed camera viewpoint the use of longer focus lenses gives larger images, but their proportions are unchanged. *Second:* As the viewpoint approaches the objects being photographed (without change of focal length) proportions in the image change rapidly. *Third:* The proportions of a scene can be changed at will by properly adjusting the taking distance *and* focal length. *Bottom:* Again by adjusting focal length and distance the proportions may be changed without affecting background size.

frame. It is this relative shift that brings into the picture features which would otherwise be left out. This is also brought out in Fig. 16.

With a swinging back (or in exactly the same way with a swinging front) on the camera, the picture thrown on the plate is that seen by an eye at the forward nodal point, enclosed by a perspective frame that has been swung through an angle. That angle is equal to the angle through which the back has been swung, and is in the same direction. This is shown in detail in Fig. 16. The images on the sensitive material are covered by the frame turned through this angle.

THE PANORAMIC CAMERA

To close this section reference should be made to the panoramic camera. This type of camera, while it is by no means new, and not a particularly fashionable type of instrument, deserves mention for the ingenuity of its construction and method of working.

A good working rule for a normal lens is to assume that the diagonal of the plate covered is equal to the focal length of the lens, except of course if the lens is specifically stated to be intended for cine-film or miniature work. With a wide-angle lens a rough figure is to take the diagonal as twice the focal length. In the special case where a wider angle is required, and especially where the picture required is long and narrow, the *panoramic camera* may be used. The principle of it is as follows:

It was explained fully, in the section dealing with finding the position of a nodal point, that if a lens is rotating about an axis through its rear nodal point, then no displacement of the image of a distant point is caused by this rotation.

Now consider a lens covering a small field, as shown in Fig. 17, which forms an image of an infinitely distant, or comparatively distant, scene. The lens can rotate about an axis through its rear nodal point.

Suppose further that the photographic material is a strip of film wrapped round part of the circumference of a drum, whose centre is at the rear nodal point of the lens. The radius of the drum is equal to the equivalent focal length of the lens. The arrangement is shown in Fig. 17.

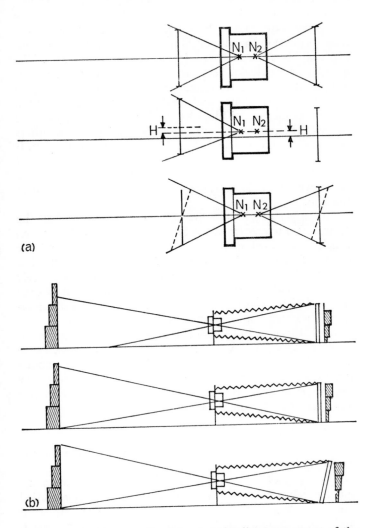

Fig. 16. (a) The use of a *rising front* implies a movement of the perspective frame relative to the lens, and the use of a *swinging back* results in a rotation of the perspective frame. (b) The use of either a rising front or a swinging back means that unwanted foreground gives way to parts of the picture which would otherwise be outside the field of view.

47

Owing to the small area covered by the lens in this special case, there is no appreciable difference between a plane and a small element of the drum locating the film. A sharp image of a small part of the distant field covered by the lens is thus formed on the curved film. As the lens swings round, pivoting about its rear nodal point, there is no shift of the image of a particular element in the scene. For a while, as long as it is in the restricted field of view of the lens, an element of the scene sends light through the lens to a definite point on the film. As the lens swings round some parts of the picture go out of the field of view and others come in, as shown also in Fig. 17. The fact that the film is wrapped round a drum of the proper radius, means that the image stays in focus throughout the course of the movement of the lens. There is, of course, no movement of the film.

The angle of view of the camera depends, not on the optical characteristics of the lens, but on the angle through which it can swing about its rear nodal point, and the length of film that is stretched along the drum. In all other cameras the angle of view is conditioned practically entirely by the optical characteristics of the lens, and the field over which the lens will give good definition and even illumination. These are dealt with in a later chapter.

While this type of camera is interesting from a theoretical point of view, and while it is useful in that it helps to emphasise the importance of the nodal points, in actual practice at the present day it is restricted to a few very highly specialised jobs, and it would be out of place to give any further and more detailed account of it here.

ANGLE OF VIEW

One topic allied to the perspective furnished by a lens is the angle of view of the lens.

The angle of view of the lens is the angle between the most widely separated rays which can be usefully recorded on a plate, and which go to a light patch sufficiently small and bright to be useful. Or, looked at from another aspect, the angle of view is the angle between the rays that go to opposite corners of a plate which has a sufficiently good definition over the whole of its area.

From what has been said above, the logical points from

48

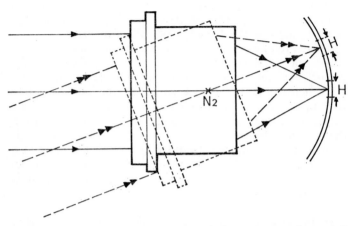

Fig. 17. In the *panorama camera* the lens covers only a small instantaneous field, and pivots about its rear nodal point N2. The sensitised film is wound on a cylindrical drum which is concentric with the nodal point.

OBJECT AND IMAGE POSITIONS

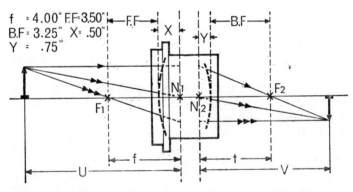

Fig. 18. From the relative positions of focal points, nodal points, principal planes, and object and image positions, the position and size of the image may be determined by drawing the rays shown.

49

which to draw these limiting rays are the forward and rear nodal points. Hence the definition of the angle of view can be more completely stated as this: Draw lines from the rear nodal point to opposite corners of the plate used. The angle between these lines is the angle of view of the lens.

There are one or two points to notice in connection with this definition. In the first place the distance of the rear nodal point from the plate depends on the distance of the object on which the lens is focused, and on the corresponding shift of the lens to get a sharp focus. As a result the angle between the lines depends on the distance of the plate from the rear nodal point, and is a maximum when the lens is focused on an infinitely distant object, with the plate at a minimum distance from the nodal point. Unless any special statement is made, it can be taken for granted that it is this maximum angle which is referred to as the angle of view.

In the second place a clear distinction must be made between the total angle of view just described, and what is often stated, namely the semi-angle of view. This is half the above angle, and it is the angle made by one of the lines described above with the line joining the nodal point of the lens and the centre of the negative, i.e., the lens axis.

Table 1 gives the diagonal covered by a lens of 1 in. focus in terms of the angle of view of the lens. To get the diagonal covered by a lens of greater focal length, 4 in. say, merely requires the multiplication of the figures given by 4.

POSITIONS OF OBJECT AND IMAGE

So far the positions of an object and its corresponding image, relative to the lens, have been fully discussed only for one particular case.

When the object is at an infinite distance in front of the lens, and so at an infinite distance in front of the forward nodal point, its image is in the rear focal plane. In other words, the distance from the rear nodal point to the image position is then equal to the equivalent focal length of the lens. In fact it defines the equivalent focal length.

There are cases of equal importance, however, especially in enlarging work, where the distance of the object from the front of the lens is comparatively small. The method of determining the image position in these circumstances, of

Film Size	Diagonal (Inches)	Diagonal (mm.)
·129″ × ·172″	·215	5·46
·138″ × ·188″	·233	5·92
·158″ × ·211″	·264	6·71
·166″ × ·227″	·281	7·14
·284″ × ·380″	·474	12·05
·292″ × ·402″	·497	12·62
·600″ × ·825″	1·020	25·90
·631″ × ·868″	1·073	27·24
18 × 24mm.	1·181	30·00
26 × 26·3mm.	1·455	36·98
24 × 36mm.	1·704	43·27
$2\frac{1}{4}″ × 2\frac{1}{4}″$	3·182	80·85
6 × 6 cm.	3·341	84·84
$2\frac{1}{2}″ × 3\frac{1}{2}″$	4·30	109·3
$3\frac{1}{2}″ × 4\frac{1}{2}″$	5·70	144·9
4″ × 5″	6·40	162·7

The first eight sizes all refer to movie film formats. (See fig. 83) 18 × 24 mm. is single frame 35 mm.; 26 × 26·3 mm. is the *Instamatic* format; 24 × 36 mm. is the standard double=35 mm. format.

Field in Degrees	Diagonal ÷ E.F.L.	Field in Degrees	Diagonal ÷ E.F.L.	Field in Degrees	Diagonal ÷ E.F.L.
8	·140	32	·573	56	1·063
10	·175	34	·611	58	1·109
12	·210	36	·650	60	1·155
14	·246	38	·689	65	1·274
16	·281	40	·728	70	1·400
18	·317	42	·768	75	1·535
20	·352	44	·808	80	1·678
22	·389	46	·849	85	1·833
24	·425	48	·890	90	2·000
26	·462	50	·932	95	2·182
28	·499	52	·975	100	2·384
30	·536	54	1·019	110	2·856

The field in degrees is the angle between the extreme rays which can be usefully recorded on the film or plate. The E.F.L. is the focal length of the lens used. The values given are for the lens focused at infinity. Thus a 4″ lens with a field coverage of 44 degrees covers a diagonal of 4 × ·808 = 3·232″.

working out how it lies relative to the lens, is the next subject to be tackled.

There are two main forms which the formulae relating the object and image positions may take. One is most suitable for dealing with such things as the size and arrangement of a focusing scale. The other is more of service when dealing with enlarging and projection problems.

Consider form number one first.

All distances of the object are measured from the forward nodal point towards the object, as shown in Fig. 18. The distance of the object from the forward nodal point is denoted by u.

In the same way the distances of the corresponding image positions are taken from the rear nodal point, and are denoted by v.

The equivalent focal length of the lens is denoted by f. f is positive when the lens is converging, as already explained on page 32.

The basic formula is

$$\frac{1}{u} + \frac{1}{v} = \frac{1}{f}$$

which can be put in two other convenient forms

$$v = \frac{u \times f}{u - f} \text{ or } u = \frac{v \times f}{v - f}$$

A concrete example or two will show how these formulae are to be used.

Suppose that some work is to be done with a lens of 4 in. focal length.

The first thing to do is to locate the positions of the nodal points. A method has been described on page 35 which is mainly applicable to cases where the focal length has to be measured. If the focal length is known with sufficient accuracy, for instance if it is taken from the values engraved on the lens, or if it has been measured by one of the methods explained on pages 38–40, a simpler procedure can be followed. The lens is focused on an object at a thousand yards or more, and the back focal length of the lens found. Suppose that this is $3 \cdot 25$ in. The lens is then turned round, stopped down if necessary to get sharp definition, and the back focus of the reversed lens is found. Suppose that this is

3·50 in. Then the positions of the nodal points are as shown in Fig. 18.

If an object is at 4 ft. in front of the foremost lens surface, then it is $48·00 + ·50 = 48·50$ inches in front of the forward nodal point, as shown in Fig. 18, i.e., $u = 48·50$. Remembering that $f = 4·00$ in., and using the formula

$$v = \frac{u \times f}{u - f}$$

then $v = \dfrac{48·50 \times 4·00}{48·50 - 4·00} = \dfrac{194·0}{44·50} = 4·360$ in., to the nearest ·001 in. The image is $4·360$ in. from the rear nodal point, and so is $4·360 - ·750 = 3·610$ in. from the rearmost surface of the lens, as shown in Fig. 18.

Suppose that with the same lens an image is formed $3·500$ in. from the rearmost surface of the lens, then it is $3·500 + ·750 = 4·250$ in. from the rear nodal point, i.e., $v = 4·250$ in. Using the formula

$$u = \frac{v \times f}{v - f}$$

then $u = \dfrac{4·250 \times 4·00}{4·250 - 4·00} = \dfrac{17·00}{·250} = 68·00$ in.

The object that gives an image in this position is $68·00$ in. in front of the forward nodal point, and so $68·00 - ·50 = 5$ ft. $7\frac{1}{2}$ in. in front of the foremost surface of the lens.

Some typical examples of the use of these formulae are found in calculations concerning focusing scales, and examples of their employment in dealing with questions arising in this work are given below. The examples are worked out for the lens already discussed, whose nodal points are shown in Fig. 18.

FOCUSING TRAVEL

The first type of question is this: how long must be the focusing travel of a lens if it is to focus from infinity down to 4 ft., say. The lens has an equivalent focal length of $4·00$ in.

When the object is at infinity the image is in the rear focal plane, and
$$v = 4·00 \text{ in.}$$

A calculation of the first type on page 52, for $48·5$ in.,

gives the image position for an object at 4 ft., i.e., 48 + ·5 in. from the forward nodal point.

Namely, with $u = 48 \cdot 50$. $v = 4 \cdot 360$ in.

The focusing travel in this case is ·360 in. If the upper limit is, say, 50 ft., and not infinity, the calculation is done for $50 \times 12 + \cdot 5 = 600 \cdot 5$ in., and the v worked for this value of u. The focusing travel is then obtained straight-forwardly for this upper limit of distance.

It should be noted that in this case there is really no need to know the position of the rear nodal point. For many practical purposes there is no need either to know the position of the forward nodal point. In the majority of lens constructions it is not far removed from the foremost surface of the lens, half an inch has been used in the present instance. And there is not a very appreciable difference between 3 ft. $11\frac{1}{2}$ in. and 4 ft. when it comes to focusing a lens, so no appreciable error is made if the distance from the forward nodal point is taken to be 48·00 in. In this particular case it makes a difference of ·004 in. in the lens position. For distances greater than 4 ft. the error is even less. Where pedantic accuracy is needed the extra half inch must be taken into account. But where common-sense accuracy is enough, the distance of the forward nodal point from the foremost lens surface can be neglected.

In many instances an approximate formula may be used. If we denote the distance of an object from the front of the lens by D, then the lens must be racked out from its infinity focus by a distance x, in order that a picture may be obtained which is in focus, and x is given by the equation

$$x = f^2 \div D$$

where f is the focal length of the lens.

INCREASING THE FOCUSING RANGE

The second type of question is met with when a lens is fitted to a camera with a restricted focusing range. Suppose that a 4 in. lens is used and the camera is designed to give enough travel of the lens so that it will focus down to 6 ft. By fitting an adaptor the lens can be made to focus down to 3 ft. The question is: What must be the thickness of this adaptor, and what focusing range will be provided by the lens travel which is possible with the given design of camera?

54

A calculation of the type just described shows that with

$u = $ infinity $\qquad v = 4\cdot000$ in.
$u = 72\cdot50$ in. $\qquad v = 4\cdot233$ in.

and so the lens travel provided is $\cdot233$ in.

With $u = 36\cdot50$ in. $\qquad v = 4\cdot492$ in.

Then the thickness of the adaptor to take the lens a maximum distance of $4\cdot492$ in. away from the plate is $\cdot492 - \cdot233$ in. $= \cdot259$ in.

With the existing focusing travel the minimum distance from the plate is $4\cdot492 - \cdot233 = 4\cdot259$ in., i.e., $v = 4\cdot259$ in. Using the formula

$$u = \frac{v \times f}{v - f}$$

then the corresponding object distance is, for $v = 4\cdot259$ in.

$$u = \frac{4\cdot259 \times 4}{4\cdot259 - 4} = \frac{17\cdot036}{\cdot259} = 65\cdot8 \text{ in. to the nearest } \cdot1 \text{ in.}$$

And so, with an adaptor of this thickness, the lens will focus from 3 ft. to $65\cdot8 - \cdot5 = 65\cdot3$ in.

When a lens has to focus an object inside the nearest point of its normal range, either an adaptor can be used, as just described above, or else a positive supplementary lens (see below) can be used, and in fact a positive supplementary lens is more commonly used.

SUPPLEMENTARY LENS AND ITS FOCUSING RANGE

Suppose for instance that, in place of an adaptor as just described, a supplementary lens is used in order to give the required focusing distance with the same lens.

A supplementary lens is usually a simple thin lens, and is fitted immediately in front of the lens with which it is used, so that the distance between the nodal points of the supplementary lens can be neglected, as can the distance between these nodal points and the foremost lens surface. The arrangement of the supplementary lens is shown in Fig. 19, but the relative distance between the supplementary lens and the foremost lens surface is exaggerated.

The camera lens in its focusing mount is set for infinity. In the present case the equivalent focal length of the thin supplementary lens is 36 in. With the object at 36 in. in

55

front of the lens, the rays that emerge from the supplementary lens are all parallel, as shown in Fig. 19, as if they came from an object at infinity. These rays are picked up by the camera lens, which is set to focus parallel rays at its infinity setting, and brought to a sharp focus on the film.

The question which then arises is: what focusing range is possible with the existing lens movement, and how does it compare with the range worked out above for the case where an adaptor is used?

The answer to this is interesting, among other things, in that it explains what happens when one of the formulae on page 52 gives a negative number.

The existing lens travel is enough to bring to a sharp focus rays coming from a point 6 ft. in front of the foremost lens surface. The nearest object that can be focused with the supplementary lens is thus one which will have the light rays it sends out bent by the supplementary lens, so that they appear to come from an object 6 ft. in front of the lens in the camera.

Denote the values of u and v for the particular case where the lens under consideration is a supplementary lens by $u(s)$ and $v(s)$ respectively. Now, remembering what has just been said about the positions of the nodal points of the thin supplementary lens, and remembering that u and v are measured as being positive quantities in the directions of the arrows in Fig. 18, then we require $v(s) = -72$ in., as shown in Fig. 19.

When u and v are negative, all it means is that they are on the reverse sides of the nodal points to their usual positions.

If $v(s) = +72$ in. the rays from the supplementary lens converge to a point 6 ft. behind the rear nodal point of the supplementary lens, and this in turn is 6 ft. behind the foremost lens surface. With $v(s) = -72$, as it is here, the rays of light from the supplementary lens seem to diverge from a point 6 ft. in front of the foremost lens surface, as shown in Fig. 19.

Putting $v(s) = -72$ in the formula, and remembering that $f(s) = 36$ in., then from the formula

$$u(s) = \frac{v(s) \times f(s)}{v(s) - f(s)}$$

Fig. 19. As the position of an object point moves toward a lens the lens must be moved away from the film to secure a focused image. For close-range work a supplementary lens may be used. This extends the focusing range of the lens.

57

we have $u(s) = \dfrac{(-72) \times 36}{(-72) - 36} \quad \dfrac{-(72 \times 36)}{-(72 + 36)} = \dfrac{(72 \times 36)}{(72 + 36)}$

$$= \dfrac{72 \times 36}{108} = 24 \text{ in.}$$

and so, with the supplementary lens in position, the camera can focus from 3 ft. down to 2 ft.

With an adaptor to take the lens focusing down to 2 ft., instead of the 3 ft. for which a calculation was done above, the focusing range for the same lens is from 2 ft. $9\frac{1}{4}$ in down to 2 ft. Hence from the point of view of focusing range there is little to choose between the two methods of getting down to close work. As a rule it is a simpler job to fit a supplementary lens, in the same way that a filter is fitted on to the front of the lens. And in fact this is the only way which is possible when a between lens shutter is fitted.

From the point of view of optical quality there is no general ruling to be made. Everything depends on the individual lens, on the way in which the correction of its aberrations is maintained down to these short distances, and on the comparative effect of new aberrations, then introduced, relative to those introduced by the supplementary lens. This will be clearer after the account of lens aberrations given in the next chapter. With a supplementary lens used in this way the f-number of the combination is just that of the camera lens, and this value is to be used in working out exposure times.

ENLARGING AND PROJECTION FORMULAE

The other fundamental lens formula is specially of use when dealing with enlarging and projection problems.

Suppose that a picture is being projected from a negative behind the lens to an enlarging board in front of the lens. Call the position of the negative the projection position, and the position of the board the enlarging position, as shown in Fig. 20a.

As before we denote the distance of the enlarging position in front of the forward nodal point of the lens by u, and the distance of the projection position behind the rear nodal point by v.

The picture on the enlarging board is exactly that carried by the negative, but on a larger scale. The scale of the

58

enlarged picture, relative to the negative picture, is the *magnification* of the arrangement, and is denoted by M.

When M = 2 then every length in the enlarged picture is twice the corresponding length on the negative. When M = $\frac{1}{2}$ then every length in the projected picture is only half the length of the corresponding part of the negative picture, and, instead of enlarging, the lens is being used for copying on a reduced scale.

It will save time if we talk throughout of enlarging, and set up the convention that when M is less than unity, it is reducing, and not enlarging, that is meant.

If the focal length of the lens is f, then the fundamental formulae are

$$u = (M + 1) \times f; \quad v = (1 + \frac{1}{M}) \times f$$

as shown in Fig. 20a.

Neglecting the separation between the nodal points of the lens, the overall length from projection to enlarging positions is

$$(M + \frac{1}{M} + 2) \times f$$

In actual practice the separation between the nodal points has to be added on to this overall length, but in many cases it gives only a small correction, on the average much less than $\cdot 15 \times f$.

Two examples of the use of these formulae are given below.

MAXIMUM ENLARGEMENT

Suppose that with the 4 in. lens already described, and illustrated in. Fig. 20a, the separation of the nodal points is one inch, and that when the lens is used in an enlarger the greatest distance from the projection position to the enlarging position is 49 in. What is the maximum degree of enlargement permitted in this enlarger?

Using the fact that the length overall from projection position to enlarging position is

$$(M + \frac{1}{M} + 2) \times f$$

plus the separation of the nodal points, then

$$(M + \frac{1}{M} + 2) \times 4 \cdot 00 + 1 = 49 \text{ in.}$$

and so $(M + \frac{1}{M} + 2) = \dfrac{49 - 1}{4} = 12$

$$\text{i.e., } M + \frac{1}{M} = 10.$$

To get the value of M from this formula means solving a quadratic equation, or finding it from the graph drawn in Fig. 20b. The second is much the simpler, as a rule, for the range covered by the graph, i.e., up to M = 10.

Values of M are measured off from left to right, and the values of

$$M + \frac{1}{M}$$

corresponding to these are measured vertically. To get the correct value of M draw a line at the correct height, in this case 10 units, above the base line OX, to cut the graph in two points marked A and B in Fig. 20b. Draw lines from A and B, namely AC and BD, parallel to the side line OY, to cut the base line OX in C and D. The positions of C and D give the possible values of M.

For every arrangement, with a given distance between projection and enlarging positions, there are two lens positions where the two planes are mutually in focus, corresponding to enlarging and reducing, as shown in Fig. 20b. Corresponding to this there are the two values of M, found as described above, one greater than unity, and the other less than unity, representing enlarging and reducing respectively.

When it happens that M = 1 the two magnifications given by the above procedure are the same, and the lens has only one possible position. It is then giving a 1:1 enlargement or reduction.

When the line drawn parallel to the base line fails to cut the curve, as shown by the line LM, then the physical set up is impossible. The projection and enlarging positions are then too close together to be brought into focus with the lens of the given focal length.

60

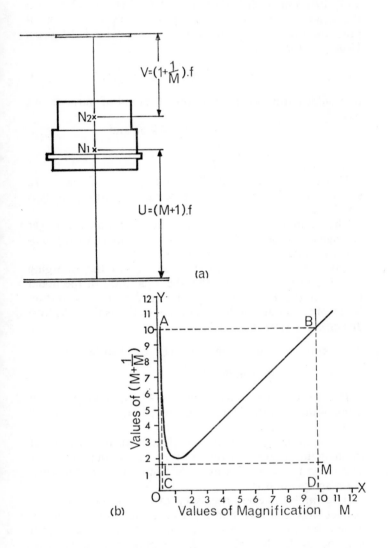

Fig. 20. (a) The relative positions of negative, lens and enlarging easel for an M-fold enlargement with a lens of focal length F. (b) By the use of this graph the value of the magnification M may be related to the distance from negative to enlargement.

In the case drawn in Fig. 20b, the values of M are $9 \cdot 899$ and $\cdot 101$, and so the maximum enlargement possible, with the arrangement provided, is approximately $9 \cdot 9$, or for all practical intents and purposes the magnification is 10 times. Using the formulae

$$u = (M + 1) \times f \text{ and } v = (1 + \frac{1}{M}) \times f$$

to a sufficient approximation for all practical purposes we have

$$u = (10 + 1) \times f = 44 \text{ in., and}$$
$$v = (1 + \frac{1}{10}) \times f = 4 \cdot 4 \text{ in.}$$

Using the data about the nodal points of this lens, already given in Fig. 18, the exact enlarger arrangement is obtained.

The main use of the graph is in determining enlarger arrangements for small degrees of enlargement. An approximate formula may be arrived at in this way:

Take the distance from the negative to the enlarging board, and subtract from this the separation of the nodal points in the lens. (A rough figure for this separation is $\cdot 15$ of the focal length of the lens). Call this the "effective distance". Then the formula is

Degree of Enlargement $= \Big[$(Effective distance) \div

(Focal length)$\Big]$ minus 2.

Thus if the effective distance is 48 in., and the focal length 4 in., then the degree of enlargement $= (48 \div 4) - 2 = 12 - 2 = 10$.

This formula gives an error of 1 per cent in the value of the magnification when this is 10 or thereabouts, of 4 per cent when the magnification is 5, and of 10 per cent when the magnification is $3 \cdot 2$.

It is rarely, if ever, necessary to get the magnification correct to within less than 1 per cent, and so for values of M greater than 10, the approximate formula just given may be used. The value of M so obtained can be used immediately in the determination of u and v by the formulae given. The error in u is negligible; that in v is less than 1 per cent when the enlargement is more than 10 fold.

Another example of the use of these formulae is in answering questions which arise in slide or cine film projection. Thus, if a 35 mm. slide is to be projected to give a picture 3 ft. × 4½ ft. and the length of the room in which the demonstration is to take place is 15 ft., the problem arises of determining what focal length of lens is needed in order to give the required size of projection.

The absolutely accurate way is to proceed exactly as was done for the enlarging problem discussed above, except that in this case M is known and f has to be worked out. But for practical purposes it is quite sufficient to proceed on slightly simpler lines. Call the distance of the front of the lens from the projection screen u. Actually, of course, u should be the distance of the screen from the forward nodal point, but the error introduced in the calculation by measuring u from the front of the lens is usually negligible.

Then use the formula

$$u = (M + 1) \times f.$$

In the case quoted the magnification required is $(54 \times 2 \cdot 54) \div 3 \cdot 6$, since the longer side of the projected picture is to be 54 in., i.e. $54 \times 2 \cdot 54$ cms.; and the longer side of the picture frame of the miniature slide is $3 \cdot 6$ cms. The magnification works out to be $M = 38 \cdot 1$, and $M + 1 = 39 \cdot 1$. It can safely be assumed that with a room 15 ft. long the maximum distance of the screen from the front of the lens will be 13 ft., i.e., 156 in. Then

$156 = 39 \cdot 1 \times f$ and $f = 4 \cdot 00$ in. to the nearest $\cdot 01$ in.

A 4-in. lens in the case quoted will just give the size of picture required, and as it happens this is about the minimum focal length of simple projection lens normally used in order to handle this size of slide.

A final formula needs only brief mention. It serves to relate the two classes of formulae used, viz.:

$$\frac{1}{u} + \frac{1}{v} = \frac{1}{f}$$

and $u = (M + 1) \times f;$ $v = (1 + \frac{1}{M}) \times f$

already used and described. It is

$$M = u \div v.$$

63

In this case the object distance u is the distance of the screen, and the image distance is taken as the distance of the slide from the rear nodal point of the lens.

DEFINITION IN DEPTH

When dealing with lenses from the point of view of the previous section, that is to say from the point of view of relating the position of an object to the position and size of its image, the only concern is with the plane where a perfectly sharp image is formed.

No fault can be found with such an image no matter how high a standard is set. However, when only a reasonably high standard of reproduction is required, no fault will be found with the images given by objects which lie slightly nearer to, and farther from, the lens than the object which is in sharp focus. The images produced are slightly out of focus, and they fail when judged by the criterion of absolute perfection, but by a reasonably high and critical standard they are of acceptable sharpness and quality.

This general fact, that images produced by a lens may be of acceptable crispness, even when they are slightly out of focus, is referred to as the *depth of focus* or *depth of field*.

In optical terminology the term depth of focus means the total allowable variation of the sensitive surface, from the position of best focus, within which the image is tolerably sharp, according to a given standard of performance. Depth of field means the difference between the object distances corresponding to these limits of sharpness. In the common parlance of photographers, the term depth of focus is sometimes used with both meanings interchangeably.

CRITERION OF SHARPNESS

The first step, in arriving at a quantitative estimate of the depth of field of a lens, is to establish some conclusions about the size of a light patch which will give sufficiently good definition, assuming that the out-of-focus light patch is circular, i.e., that it is the so called *circle or disc of confusion*.

The criterion generally accepted is that a circle of light one hundredth of an inch in diameter, viewed from a distance of 10 in., which is the average value of the closest distance down to which the adult eye can focus, is not distinguishable from a point.

Suppose that a lens of 4 in. focal length is used, which is focused on some particular distance, then light from a point on the lens axis at a nearer point is brought to a focus at a point farther away from the lens, and the rays coming from the lens thus form a circular light patch, as shown in Fig. 21b, of diameter D inches.

It has already been explained, in the section dealing specially with perspective, that a lens views the scene from the forward nodal point, and sees it framed in an area which has the size and shape of the sensitive film or plate, held at a distance of 4 inches from the forward nodal point. This is the impression of the scene recorded on the negative.

To see things as the lens sees them, and as an eye placed in the position of the lens would see them, means that the print should be viewed from a distance of 4 in. The eye cannot focus down to this distance, without artificial aid such as a magnifying glass (which incidentally acts for the eye in the same way that a supplementary lens acts for a camera lens, bringing its focusing range down to a new low value). To get the correct perspective either a magnifying glass must be used, or the print must be enlarged in the ratio of $10 \div 4$, i.e., $2\frac{1}{2}$ times, and the enlargement viewed at a distance of 10 in., the closest distance to which the normal eye can focus. (Wrong perspective effects may become particularly noticeable with telephoto lenses— see page 277.)

In any case the result is the same: the disc of light of diameter D, corresponding to an out-of-focus point, is enlarged $2\frac{1}{2}$ times to a diameter of $2 \cdot 5 \times D$ in. Since the diameter of the disc is now to be $\cdot 01$ in., so that when viewed from a distance of ten inches it will be sufficiently small to seem a point, then

$$2\frac{1}{2} \times D = \cdot 01, \text{ i.e. } \frac{10 \times D}{4} = \cdot 01 \text{ in.}$$

That is to say, when a lens of 4-in. focus is used, the diameter of the out-of-focus disc must not exceed $\cdot 004$ in.

The same line of argument shows that when a lens is used whose focus is f inches, the diameter of the disc on the plate must not exceed

$$\frac{f}{10} \times \cdot 01 \text{ in., i.e., } f \times \cdot 001 \text{ in.}$$

65

where f is the distance of the plate from the rear nodal point.

Before finding what lens position will give a disc of light of this size, it is essential to specify what diameter of light beam is used to produce the image. This is best done by using the f-number of the lens.

In any actual lens the amount of light which traverses it is limited by the edges of the lens elements and by the metal parts of the mount, or by an iris diaphragm. The amount of light getting through depends on the actual path that the light takes inside the lens, and this depends in turn on the position of the object point from which it comes. When the object point is not on the lens axis, the calculation of the amount of light going through is apt to be complicated. As a result, the only straightforward way is to deal with the light-passing power of a lens when the incident light is a parallel beam coming from a point at infinity on the lens axis. The amount passed through when the object point is somewhat nearer the lens, and still on the axis, is slightly less than the amount passed through by the lens when the object point is at infinity, but in dealing with depth of field this difference may be neglected.

When the light arriving at a lens is a parallel beam, from a point at infinity, the path of the largest diameter beam which gets through the stop or iris diaphragm is shown in Fig. 21d. The beam goes into the lens aiming at the points A and B on the first principal plane (this is defined on page 30), and comes out of the lens directed away from the points C and D on the rear principal plane, as shown in Fig. 21.

If the diameter of the parallel beam is B in., and the focal length of the lens is f in., then the f-number of the lens is $f \div B$. Thus if the lens is of 4-in. focus, and the diameter of the beam is half an inch, then the lens is working at $f(4 \div \frac{1}{2}) = f8$.

f-NUMBERS FOR CLOSE-UPS

The f-number of a lens measures its light-passing power. The smaller the f-number, the greater the quantity of light concentrated in the image furnished by the lens; an $f2$ lens

66

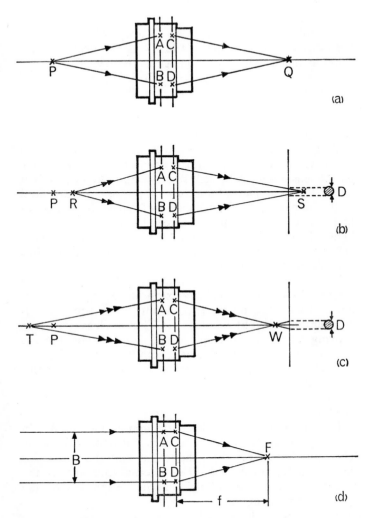

Fig. 21. (a) Rays from an object point P that is in focus meet in the image plane in a point Q. (b) Rays from a closer point such as *R* meet behind the image plane and produce a disc of light in the image plane. (c) Rays from a more distant point T meet in front of the image plane and also produce a disc of light in the image plane. (d) The *f*-number of the lens is f÷B.

67

concentrates 4 times as much as an $f4$ lens, and twice as much as an $f2\cdot8$ lens. Hence, the smaller the f-number, the shorter the exposure needed in any given set of lighting conditions.

The rule is: if we have two lenses, one working at fn and the other at fm, then the first lens concentrates $(m \div n)^2$ times as much light into its image as the second lens. For instance, if the first lens works at $f5\cdot6$, i.e., $n = 5\cdot6$, and the second works at $f4$, i.e., $m = 4$, then $m \div n = 4 \div 5\cdot6 = \cdot71$ (approximately), and $(m \div n)^2 = \cdot71^2 = \cdot5$. The first lens passes through only half as much light as the second lens.

The aperture of a lens is controlled by the way in which the leaves of an iris diaphragm open and close, as a ring on the lens mount is turned, so allowing more or less light to get through. The calibrations of the ring are arranged so that in passing from one figure to the next the amount of light passed by the lens is halved. From $f2$ to $f2\cdot8$ the light is halved; similarly from $f2\cdot8$ to $f4$ it is halved again. (There may be an exception to this rule in the first two f-numbers on the iris ring).

When the object is at a distance of S times the focal length of the lens the effective stop value or f-number is not that engraved on the lens mount, but is equal to this number multiplied by $S \div (S - 1)$. Thus if a lens is used for copying work or close-ups, where $S = 3$, and the iris aperture is set at $f4$, the lens is effectively working at $f4 \times (3 \div 2)$, i.e., at $f6$, and allowance has to be made for this in working out exposure times.

Effective f-numbers when a lens is used with supplementary lenses are discussed on page 58.

There is no need to use this correction to the f-number in working out depths of field, as it is not applicable there. The f-number engraved on the lens mount is accurate for depth-of-field calculations. The relevant quantity is the diameter of the beam of light, as it is expressed by the f-number on the mount.

CALCULATION OF DEPTH OF FIELD

The points A, B, and C, D, are taken as limiting the areas on the principal planes at which light rays may aim, when they come from points on the axis and enter the lens, and from

DEPTH OF FIELD

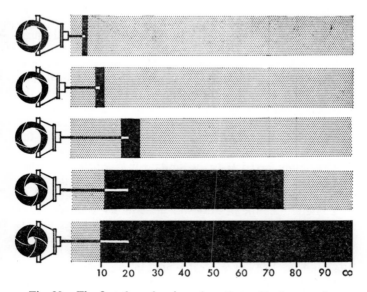

Fig. 22. The first three drawings show that, with the same lens at the same aperture, the depth of field grows as the focused point moves away from the lens; it grows from top to bottom. The last three drawings show how, with a constant focusing distance, the depth of field increases dramatically as the lens is stopped down.

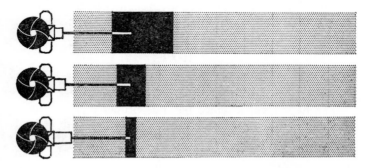

Fig. 23. At a fixed aperture, and with a fixed focusing distance the depth of field decreases rapidly as the focal length of the lens increases. It decreases from top to bottom.

which they proceed as they come to a focus. This is shown in Fig. 21. P is a point on the lens axis whose image is the point Q. The extreme rays that the lens transmits are shown by the rays joining P with A and B, and Q with C and D. The plate or film is at right angles to the lens axis, through the point Q.

The point R has its image at S. The extreme rays from R which go through the lens are shown in Fig. 21. They form a disc of the correct size on the plate at Q, according to the formula given on page 65, i.e., ·004 in. for a 4-in. lens.

In the same way the point T has its image at W, and the extreme rays again are shown. Once again the disc is of the correct size according to the formula on page 65.

The points R and T set the limits within which objects are sufficiently sharply defined. They measure the depth of field of the lens, when the lens is focused on the point P.

To determine the positions of these limits of the depth of field, in view of the principles already laid down in this section, is purely a question of manipulating mathematical symbols. It results from this manipulation that the limits of the depth of field are best calculated in two stages.

Hyperfocal Distance: The first stage is to calculate the "hyperfocal distance" of the lens, denoted by H.

The formula for H (measured from the nodal point) is given by

$$H = f + \frac{1000f}{N} \text{ in.}$$

where f is the focal length of the lens in inches, and N is the f-number of the lens. For all practical purposes this may be simplified to

$$H = \frac{1000f}{N} \text{ in.}$$

Thus for a 2-in. f3 lens, H = (2 × 1000) ÷ 3 = 667 in.

The hyperfocal distance has this property: If a lens is focused on the hyperfocal distance, then the depth of field extends from infinity down to half the hyperfocal distance. In the above case, if the lens is focused on 55 ft. 7 in., then the depth of field means that all objects are reproduced sufficiently sharply from infinity down to half of 55 ft. 7 in. i.e., 27 ft. 9½ in.

II – HYPERFOCAL DISTANCES (IN FEET AND INCHES)

Aperture

Focal Length	f 1.5	f 2.0	f 2.5	f 3.0	f 3.5	f 4.0	f 4.5	f 5.6	f 6.3	f 8	f 11	f 16	f 22	f 32	f 45
1" 25 mm.	55-6	41-9	33-4	27-9	23-10	20-10	18-6	14-8	13-4	10-5	7-6	5-3	3-9	2-7½	1-10¼
1⅛" 28 mm.	62-6	46-11	37-6	31-3	26-9	23-6	20-10	16-9	15-9	11-9	8-6	5-10½	4-3	2-11	2-1½
1⅜" 35 mm.	76-6	57-4	45-10	38-3	32-9	28-8	25-6	20-6	18-4	14-4	10-5	7-2	5-3	3-7	2-7½
1⅝" 42.5 mm.	90-4	67-9	54-3	45-1	38-9	33-11	30-1	24-2	21-8	17-0	12-4	8-6	6-2	4-3	3-1
2" 50 mm.	111-0	83-6	66-8	55-6	47-7	41-9	37-1	29-9	26-8	20-11	15-1	10-6	7-6	5-3	3-9
2½" 62.5 mm.	138-9	104-2	83-4	69-6	59-6	52-1	46-4	37-3	33-4	26-0	18-11	13-0	9-6	6-6	4-9
3" 75 mm.	166-6	125-0	100-0	83-4	71-5	62-6	55-7	44-7	40-0	31-3	22-9	15-7½	11-5	7-10	5-9
3½" 87.5 mm.	194-6	146-0	116-8	97-3	83-4	73-0	64-10	52-0	46-8	36-6	26-6	18-3	13-3	9-1½	6-7½
4" 100 mm.	222-0	166-9	133-4	111-0	95-3	83-5	74-2	59-6	53-4	41-9	30-4	20-10½	15-2	10-5	7-7
4½" 112.5 mm.		187-6	150-0	125-0	107-2	93-10	83-5	67-0	60-0	46-11	34-2	23-6	17-1	11-9	8-7
5" 125 mm.		208-6	166-8	139-0	119-1	104-4	92-8	74-6	66-8	52-2	37-11	26-1	19-0	13-0	9-6
5½" 137.5 mm.		229-3	183-4	152-9	131-0	114-7	101-10	81-10	73-6	57-4	41-9	28-8	20-11	14-4	10-6
6" 150 mm.		250-0	200-0	166-9	142-11	125-0	111-2	89-3	80-0	62-6	45-7	31-2	22-10	15-7½	11-5
7" 175 mm.			233-4	194-3	166-9	146-0	129-9	104-3	93-6	73-0	53-0	36-6	26-6	18-3	13-3
8" 200 mm.			266-8	222-0	190-6	166-9	148-3	119-0	106-8	83-5	60-6	41-9	30-3	20-11	15-2
10" 250 mm.			333-4	277-9	237-11	208-6	185-3	149-0	133-4	104-3	75-8	52-7½	37-10	26-4	18-11
12" 300 mm.			400-0	333-3	285-9	250-0	222-3	178-0	160-0	125-0	90-10	62-6	45-5	31-3	22-9
15" 375 mm.				416-9	357-0	312-6	278-0	223-0	200-0	156-3	113-6	78-11½	56-9	39-1	28-4
18" 450 mm.				500-0	428-9	375-0	336-3	268-0	240-0	187-6	136-6	93-9	68-5	46-11	34-2
20" 500 mm.				555-6	476-0	417-0	371-0	298-0	266-6	208-6	151-6	104-3	75-9	52-2	37-10

The hyperfocal distance is not something definite for a lens alone. It is definite only for a lens at a particular *aperture*, and changes as the lens is stopped down. The more the lens aperture is reduced, the shorter is the hyperfocal distance. It must be worked out separately for each lens aperture. A table of typical values is given on page 71.

Nearest and Farthest Limits of Depth: The second stage is to calculate the depth of field when the lens is focused on a point at a distance u from the forward nodal point. Actually it is sufficiently accurate to measure u from the front of the lens, and in what follows it will be assumed that u is the distance of the point from the front of the lens.

The formulae for the nearest and farthest limits of the depth of field are

$$\text{Nearest limit} = \frac{fu(f + \text{CN})}{f^2 + u\text{CN}}$$

$$\text{Farthest limit} = \frac{fu(f - \text{CN})}{f^2 - u\text{CN}}$$

where u is the distance from the lens nodal point to the object, C the diameter of the disc of confusion, and N the f-number.

The following simplified formulae may be used, without serious loss of accuracy, for most practical purposes

$$\text{Nearest limit} = \frac{\text{H} \times u}{\text{H} + u}$$

$$\text{Farthest limit} = \frac{\text{H} \times u}{\text{H} - u}$$

When the denominator in any of the above formulae for the farthest limit is zero or negative, the farthest limit of acceptable focus is at infinity.

For object distances less than 10 times the focal length the following formula is preferable

$$\text{Total depth (far to near)} = \frac{2\text{CN}(\text{M} + 1)}{\text{M}^2}$$

where M is the scale of reproduction (object size to image size). This is less than unity when the image is smaller than the object.

This illustrates the fact that, for a given size of the disc of confusion, the depth of field is only dependent on the magnification between the object and its image, and on the relative aperture of the lens. This fact is not immediately apparent from the tables on pages 79–94, since these assume a variable size of disc of confusion equal to $f \div 1000$.

As an example of the use of these formulae, we may suppose that with the lens in use the hyperfocal distance is 667 in., as in the case described above, and that the lens is focused on a distance of 15 ft., i.e., 180 in. The formulae then gives for the depth of field limits

$$\text{Nearest limit} = \frac{667 \times 180}{667 + 180} = \frac{667 \times 180}{847} = 141 \cdot 5 \text{ in.}$$

to the nearest half inch.

$$\text{Farthest limit} = \frac{667 \times 180}{667 - 180} = \frac{667 \times 180}{487} = 244 \cdot 5 \text{ in.}$$

to the nearest half inch.

To get a complete depth of field chart for the lens these two stages of calculation have to be carried out for every lens stop and for every focusing distance. Tables for a number of popular lenses are given on pages 79–94.

There is one point to mention: In some cases a lens when set for infinity, according to its focusing scale, actually focuses on the hyperfocal distance of the largest aperture of the lens. While this results in a gain in the depth of field, when the lens is focused on this distance—the depth of field now extends from half the hyperfocal distance to infinity, whereas when the lens is focused on infinity the depth of field extends only from the hyperfocal distance to infinity—something in sharpness of definition is lost when it is required to photograph an object beyond the hyperfocal distance. It will be assumed, throughout this book, that the lens is focused on infinity when the focusing scale is set for infinity.

DEPTH OF FOCUS

There is one subject closely allied to depth of field, namely the question of how far the plate or film can be moved from the position of exact focus, and yet reproduce a

73

sufficiently good quality image of the object on which the lens is supposed to focus. This is the *depth of focus*.

A formula that can be worked out along the lines used in laying down the principles governing depth of field, and that is accurate to within about 15 per cent is as follows

the permissible shift of the plate $= f^2 \div H$

where f is the equivalent focus of the lens, and H the hyper-focal distance.

Alternatively the permissible shift can be obtained from the formula

$$\text{Permissible shift} = \frac{C \times (f\text{-number}) \times 2}{f}$$

where C is the diameter of the disc of confusion, v the conjugate distance from lens to image. For very distant objects v is practically equal to f, so that the permissible shift is C × f-number.

Thus, in the case worked out above, where H = 667 in. and f = 2 in., the permissible displacement (i.e., depth of focus) is $2^2 \div 667 = 4 \div 667 = \cdot006$ in.

It is worth noting that the formulae just given provide an indication of how closely a lens must be set on its nominal focusing position, so that the subject thought to be in focus will provide an image of acceptable quality. At the same time it is not good practice to use the depth of focus in this way, in order to provide a manufacturing tolerance. If we pre-empt it for this purpose, there is nothing left with which to accommodate objects at different positions within the depth of field.

AN ALTERNATIVE CRITERION OF SHARPNESS

Finally, although the question of depth of field has been treated above from the point of view of using the diameter of the disc on the film, when seen at the least distance of clear vision and enlarged to give the correct perspective at this distance, there is another way of looking at the matter. In this case no attention is paid to enlarging, for standard viewing conditions, but attention is concentrated on the actual size of the disc of confusion on the film. This may result in demanding from the lens a very high standard of performance. For instance, with the 2-in. focus

74

lens commonly used in miniature work, the diameter on the film of the circle of least confusion is taken, in this type of treatment, to be ·002 in. The limit of sharp definition is taken as being reached when the disc of confusion reaches $\frac{1}{500}$ in. This, of course, is just the diameter of the disc demanded from the treatment given earlier. However, when a diameter of ·002 in. is required with a 4-in. lens, the standard of performance is higher than that demanded by the earlier treatment. When lenses of different focal lengths are used on the same camera, then we may assume that viewing conditions will be the same no matter what lens is used, and it is best to use the formulæ which relate to a fixed size for the circle of confusion, even though this implies a considerably more restricted depth of field with long-focus lenses than that indicated by using a disc of confusion related to the focal length of the taking lens.

The value of dealing directly with the actual size of the disc of confusion, rather than using a formula to give its size implicitly, becomes evident when the formula gives sizes of the disc which are comparable with the grain sizes of the film. It may happen, for example, that a straightforward application of the formula, relating the diameter of the disc to the focal length of a short-focus lens, will give an unrealistically small diameter for the disc of confusion. In such instances the best procedure is to derive the depth of field in a general way, denoting the diameter of the disc of confusion by C, measured in thousandths of an inch.

The method of working out the depth of field is exactly the same as that used previously, except that a new hyperfocal distance H(new) is worked out and used where H was used before. The formula for H(new) is

$$H(new) = \frac{1000 \times f^2}{C \times N} \text{ in.}$$

where f is the equivalent focal length of the lens, N is the f-number of the lens stop used, and C is the number of thousandths of an inch in the diameter of the disc of confusion.

For instance with a 15 mm. $f2 \cdot 5$ lens of the type sometimes used on 16 mm. cameras, assuming that because of the graininess of the film it is of no value to consider that the image on the negative may be smaller than ·001 in., i.e.,

fixing the diameter of the disc of confusion at ·001 in., then
$C = 1$ and the formula for H(new) is

$$H(new) = \frac{1000 \times \left(\dfrac{15 \cdot 0}{25 \cdot 4}\right)^2}{1 \times 2 \cdot 5} = 140 \text{ in., to the nearest in.}$$

The factor $15 \div 25 \cdot 4$ is needed to measure the equivalent focal length in inches.

Therefore, with this standard of definition, which has been assumed to be dictated by the graininess of the film, all objects are equally sharp from 70 in. to infinity. Since this is a useful working range for the camera it is feasible to fit a lens to the camera without a focusing mount.

Once the H(new) has been calculated everything goes ahead as before.

For 35 mm. double frame work there is rarely, if ever, any need to take a disc of confusion of less than ·002 in. in diameter, or at the most ·0015 in., although smaller sizes are sometimes used for specially critical work. For 35 and 16 mm. cine work the same standard will suffice with an upper limit of ·001 in. For 8 mm. and Super-8 mm. movie cameras, it is convenient to take $C = \cdot 8$, i.e. a disc of ·0008 in. diameter.

Some still further aspects of depth of field are dealt with on pages 137–141 and 194–196.

COMPARATIVE DEPTHS OF FIELD

The question often arises: *A scene is to be photographed in such a way that the depth of field is to be a maximum. Is it better to use a long focus lens and make a contact print, or to use a short focus lens and make an enlargement?*

The answer is in favour of the short focus lens.

Take a concrete example. The given scene is photographed with an 8-in. lens and with a 2-in. lens, both working at the same aperture, say f 4, and both at 10 ft. from some feature of the scene to be recorded. Since they are both working at the same f-number the same exposure is needed in each case. The negative obtained with the 8-in. lens is used to make a contact print. A four-fold enlargement is given to the negative produced by the 2-in. lens. Which will have the greatest region of the scene in sufficiently sharp focus?

The hyperfocal distance H(1) for the 8-in. lens is $(8 \times 1000) \div 4 = 2000$ in. (cf. page 70).

The nearest distance in focus when the lens is focused on

10 ft., i.e., 120 in., is $\dfrac{2000 \times 120}{2000 + 120} = 113 \cdot 2$ in.

The farthest distance is $2000 \times 120 \div (2000 - 120)$, i.e., $127 \cdot 7$ in.

The hyperfocal distance for the 2-in. lens is 500 in., and correspondingly the nearest distance is $96 \cdot 8$ in., and the farthest distance $157 \cdot 9$ in.

The range with the 8-in. lens is $14 \cdot 5$ in., and with the 2-in. lens $61 \cdot 1$ in., i.e., just over 4 times as great.

A rough rule is that the range at the same f-number is doubled if the focal length is halved, and so on.

The condition that the contact print and the enlargement should have the same standard of definition is taken care of by the method of calculating the hyperfocal distance, as described on page 70.

PRODUCTION OF DEPTH BY LENS MOVEMENT

A topic which is related, on the one hand to the possibility of increasing the depth of field of the lens, and on the other hand to the production of a soft focus effect (page 278) which is demanded by some classes of photography, is the effect of moving the lens, or adding a supplementary lens, while the exposure is being made.

Neglecting all lens aberrations, as has been done consistently throughout this chapter, in any focus setting of the lens the points of light lying in a particular plane in front of the lens give bright point images on the sensitive plate or film. Points of light in other planes give discs of light on the film or plate. These are not so bright as the exactly focused points of light, since the light transmitted by the lens is spread over the area of the disc, instead of being concentrated at its centre. Up to a certain limiting size it is not easy, except on close inspection, to see that the discs of light are not exact points, and within these limits the subjects to be photographed are reasonably well defined. Outside these limits the subject is out of focus, and each point of light is reproduced as a more or less tenuous disc.

Now suppose that the lens position is shifted during the

exposure so that a point of light, which previously gave a disc of light, is brought into focus on the plate or film. What is then recorded on the sensitised surface is a bright point of light, together with a fainter disc surrounding it. This is perceived by the eye as being more in the nature of a point image than does the out-of-focus disc of light, and the definition seems sharper, as far as those elements of the picture are concerned which were previously out of focus. Those parts which were sharply in focus before are now softened somewhat, as they are out of focus when the other elements are sharply focused.

The net result is that the definition is somewhat softened overall, but the definition is more even throughout the picture.

Alternatively the focus of the lens can be changed to varying values with the aid of supplementary lenses, and a series of exposures made.

This idea of changing the focus of a lens is not new, but it is difficult to carry out unless a comparatively long exposure is being made, say of an indoor scene. An ingenious patent of the *Bausch and Lomb Company* describes a lens in which the focal length is changed, by the movement of one of the component glasses in a lens, at the rate of more than 20,000 times a second. This lens is meant for work in cine studios.

DEPTH OF FIELD TABLES

Depth of field tables (in feet and inches) are given in the following pages for a number of focal lengths, lens apertures, and focusing distances. These are calculated on the basis of a circle of confusion of ·001 in. per inch of focal length, i.e. with a circle of ·005 in. diameter for a 5 in. lens. Metric equivalents of these tables are given in the appendix (p. 561).

The range of availability of these tables can be extended by bearing in mind the following facts.

Suppose in the first place that the lens aperture is not among those listed. At small apertures and high f-numbers these latter are fairly well standardised, except for an occasional variation such as $f7\cdot7$ in place of $f8$ or $f33$ in place of $f32$, deviations which are quite negligible. But at the other end of the scale there are lenses listed of apertures $f1\cdot3$, $f1\cdot4$, $f1\cdot9$, $f2\cdot7$, $f2\cdot8$, etc. Consider the

78

III – DEPTH OF FIELD FOR LENSES OF 1 INCH (25 mm.) FOCAL LENGTH

Distances in feet and inches. For each aperture the upper figure is the near limit, the lower figure the far limit; the bold centre figure is the distance focused on.

	∞	50	30	20	15	12	10	9	8	7	6	5	4	3	2½	2
f 1.5	55–6	26–4	19–6	14–9	11–10	9–10½	8–5½	7–9	7–0	6–2½	5–5	4–7	3–8½	2–10	2–4⅔	1–11¼
	∞	**50**	**30**	**20**	**15**	**12**	**10**	**9**	**8**	**7**	**6**	**5**	**4**	**3**	**2½**	**2**
	∞	605–0	65–4	31–3	20–7	15–4	12–2½	10–9	9–4	8–0	7–0	6–8½	5–6	4–3¼	2–7½	2–1
f 2.0	41–8	22–9	17–6	13–6	11–0	9–4	8–0½	7–5	6–8½	6–0	5–3	4–5½	3–7½	2–9½	2–4¼	1–10⅞
	∞	**50**	**30**	**20**	**15**	**12**	**10**	**9**	**8**	**7**	**6**	**5**	**4**	**3**	**2½**	**2**
	∞	∞	62–6	38–5	23–5	16–10	13–2	11–6	9–11	8–5	7–0	5–8½	4–5	3–2¼	2–8	2–1¼
f 2.5	33–4	20–0	15–9½	12–6	10–4	8–10	7–8½	7–1	6–5½	5–9½	5–1	4–4½	3–6¾	2–9	2–3⅞	1–10⅝
	∞	**50**	**30**	**20**	**15**	**12**	**10**	**9**	**8**	**7**	**6**	**5**	**4**	**3**	**2½**	**2**
	∞	3000–0	50–0	27–3	18–9	14–3½	12–4	10–6¼	8–10½	7–3¾	6–0	5–0	4–5	3–3½	2–8½	2–1½
f 3.0	27–9	17–10	14–5	11–7½	9–9	8–4½	7–4½	6–9½	6–2½	5–7	4–11	4–2½	3–6	2–8½	2–3½	1–10⅜
	∞	**50**	**30**	**20**	**15**	**12**	**10**	**9**	**8**	**7**	**6**	**5**	**4**	**3**	**2½**	**2**
	∞	∞	32–7½	71–7	21–2	15–7½	13–4	11–3	9–9	8–0	6–4	4–8	4–6	3–4	2–9	2–1¾
f 3.5	23–10	16–1½	13–3	10–10½	9–2½	7–10½	7–0	6–6½	6–0	5–5½	4–9½	4–1½	3–5½	2–8	2–3¼	1–10⅛
	∞	**50**	**30**	**20**	**15**	**12**	**10**	**9**	**8**	**7**	**6**	**5**	**4**	**3**	**2½**	**2**
	∞	∞	124–6	40–6	24–2	17–3	14–5½	12–0½	11–3	9–11	8–0	6–9	4–9½	3–5½	2–9½	2–1¾
f 4.0	20–10	14–8½	12–3½	10–2	8–8½	7–7¼	6–9	6–3¼	5–9¾	5–2¼	4–4	3–11⅛	3–4¾	2–7¾	2–2¾	1–9⅞
	∞	**50**	**30**	**20**	**15**	**12**	**10**	**9**	**8**	**7**	**6**	**5**	**4**	**3**	**2½**	**2**
	∞	∞	500–0	53–7	28–4	19–3	15–10	13–0	10–6½	8–5	6–7	4–11⅛	4–0	3–6	2–10½	2–2½
f 4.5	18–6	13–6	11–5½	9–7	8–3½	7–3½	6–6	6–0½	5–7	5–1¼	4–2¾	3–3½	3–1¼	2–7	2–2¼	1–9⅝
	∞	**50**	**30**	**20**	**15**	**12**	**10**	**9**	**8**	**7**	**6**	**5**	**4**	**3**	**2½**	**2**
	∞	∞	∞	79–4	34–2	21–9	17–6	14–1	11–3	10–2¼	7–7	5–6	4–6	3–3	2–7	2–2⅛
f 5.6	14–8	11–4	9–10	8–6	7–5	6–7	5–11½	5–7	5–2½	3–9¼	3–9¼	3–0⅛	2–5¾	2–1⅝	2–0¾	1–9⅛
	∞	**50**	**30**	**20**	**15**	**12**	**10**	**9**	**8**	**7**	**6**	**5**	**4**	**3**	**2½**	**2**
	∞	∞	∞	792–0	31–5	23–3	17–7	13–5	10–2	7–7	5–6	3–11½	3–4½	2–3⅜	2–3⅜	2–1¾
f 6.3	13–4	10–6	9–3	8–0	7–0½	6–4	5–8½	5–4	5–0	4–7	3–7½	3–1	2–5⅝	2–1¼	2–0¾	1–8⅞
	∞	**50**	**30**	**20**	**15**	**12**	**10**	**9**	**8**	**7**	**6**	**5**	**4**	**3**	**2½**	**2**
	∞	∞	∞	120–0	40–0	27–8	20–0	14–9	14–9	10–11	8–0	5–8½	4–0	3–1	2–4¼	2–1
f 8	10–5	8–7½	7–9	6–10	6–2	5–7	5–1¼	4–10	4–6½	4–1¼	3–9½	3–2¼	2–10½	2–4	2–0¼	1–8⅛
	∞	**50**	**30**	**20**	**15**	**12**	**10**	**9**	**8**	**7**	**6**	**5**	**4**	**3**	**2½**	**2**
	∞	∞	∞	250–0	66–2	34–6	21–4	14–9	10–0	7–9½	6–6	4–2½	3–3½	3–0	2–5¾	2–1
f 11	7–6	6–6	6–0	5–5½	5–0	4–7½	4–3½	4–1	3–10½	3–7	3–3	3–0	2–7¼	2–1¾	2–1¾	1–7
	∞	**50**	**30**	**20**	**15**	**12**	**10**	**9**	**8**	**7**	**6**	**5**	**4**	**3**	**2½**	**2**
	∞	∞	∞	∞	105–0	30–0	15–0	8–7	8–7	5–0	3–9	3–0	5–0	3–9	2–8¾	2–8¾
f 16	5–3	4–8½	4–5	4–1½	3–10½	3–7½	3–5	3–3½	3–2	3–0	2–9	2–6¼	2–3	1–10½?	1–5¼	1–8¼
	∞	**50**	**30**	**20**	**15**	**12**	**10**	**9**	**8**	**7**	**6**	**5**	**4**	**3**	**2½**	**2**
	∞	∞	∞	∞	125–0	17–3	15–0	7–1	7–1	4–9¼	3–4	2–6½	2–3	2–3	4–9¼	3–3
f 22	3–9	3–6	3–4	3–2	3–0	2–8	2–6½	2–5¼	2–3½	2–1¾	1–11¼	1–9	1–6	1–3½	1–3½	1–6
	∞	**50**	**30**	**20**	**15**	**12**	**10**	**9**	**8**	**7**	**6**	**5**	**4**	**3**	**2½**	**2**
	∞	∞	∞	∞	∞	∞	∞	∞	∞	∞	2–8	3–0	4–3½	15–0	7–6	4–3½

IV – DEPTH OF FIELD FOR LENSES OF 1⅛ INCH (28 mm.) FOCAL LENGTH

	2	2½	3	4	5	6	7	8	9	10	12	15	20	30	50	∞
f 1.5	1-11¼	2-4⅞	2-10¼	3-9	4-7½	5-5½	6-3½	7-1	7-10½	8-7½	10-1	12-1	15-2	20-3	27-9	62-6
	2	**2½**	**3**	**4**	**5**	**6**	**7**	**8**	**9**	**10**	**12**	**15**	**20**	**30**	**50**	**∞**
	2-0¾	2-7¼	3-1½	4-3¼	5-5½	6-7½	7-10½	9-2	10-6	11-11	14-10	19-9	29-5	57-9	250-0	∞
f 2	1-11	2-4¼	2-9½	3-8¼	4-6¼	5-3¾	6-1	6-10	7-6¼	8-3	9-6¼	11-4	14-0	18-3	24-2	46-11
	2	**2½**	**3**	**4**	**5**	**6**	**7**	**8**	**9**	**10**	**12**	**15**	**20**	**30**	**50**	**∞**
	2-1	2-7½	3-2½	4-4½	5-7½	6-10½	8-2½	9-8	11-1½	12-8½	16-1½	22-1	34-11	83-6	∞	∞
f 2.5	1-10¾	2-4⅛	2-9⅛	3-7⅜	4-5	5-2	6-0	6-7	7-3	8-0	9-1	10-8	13-0	16-8	21-5	37-6
	2	**2½**	**3**	**4**	**5**	**6**	**7**	**8**	**9**	**10**	**12**	**15**	**20**	**30**	**50**	**∞**
	2-1¼	2-8⅛	3-3⅛	4-5⅞	5-9¼	7-1¼	8-5½	10-2	11-10	13-7½	17-8	25-0	42-10	150-0	∞	∞
f 3.0	1-10½	2-3¾	2-8⅞	3-6½	4-3¾	5-0½	5-8¾	6-4½	7-0	7-7	8-8	10-1½	12-2	15-4	19-9	31-3
	2	**2½**	**3**	**4**	**5**	**6**	**7**	**8**	**9**	**10**	**12**	**15**	**20**	**30**	**50**	**∞**
	2-1½	2-8⅝	3-3½	4-7	5-11½	7-5	8-11	10-9	12-7½	14-8½	19-6	28-10	55-6	750-0	∞	∞
f 3.5	1-10¼	2-3⅜	2-8⅛	3-5¾	4-2½	4-11	5-6½	6-2	6-9	7-3½	8-3½	9-7	11-5	14-2	17-5	26-9
	2	**2½**	**3**	**4**	**5**	**6**	**7**	**8**	**9**	**10**	**12**	**15**	**20**	**30**	**50**	**∞**
	2-1¾	2-9⅛	3-4⅛	4-8½	6-2	7-9	9-6	11-5	13-7	16-0	21-9	34-2	79-2	30	50	∞
f 4	1-10⅛	2-3⅛	2-7⅞	3-5	4-1½	4-9½	5-4¾	6-0	6-6	7-0	8-0	9-2	10-9	13-2	16-0	23-6
	2	**2½**	**3**	**4**	**5**	**6**	**7**	**8**	**9**	**10**	**12**	**15**	**20**	**30**	**50**	**∞**
	2-2¼	2-9½	3-5¼	4-10	6-4¼	8-0	10-0	12-1½	14-7	17-5	24-6	41-6	134-6	30	50	∞
f 4.5	1-9⅞	2-2¾	2-7¾	3-4¾	4-0½	4-8	5-3	5-9½	6-3½	6-9	7-7½	8-8½	10-2	12-4	14-8	20-10
	2	**2½**	**3**	**4**	**5**	**6**	**7**	**8**	**9**	**10**	**12**	**15**	**20**	**30**	**50**	**∞**
	2-2½	2-9¾	3-6	4-11¼	6-7	8-5	10-6	13-0	15-10	19-2	28-4	53-6	500-0	30	50	∞
f 5.6	1-9¼	2-2¼	2-6½	3-2¾	3-10¼	4-5	4-11¼	5-5	6-3½	7-0	7-1	9-1½	10-9	12-6	16-9	
	2	**2½**	**3**	**4**	**5**	**6**	**7**	**8**	**9**	**10**	**12**	**15**	**20**	**30**	**50**	**∞**
	2-3¼	2-11¼	3-7½	5-3	7-1½	9-4	12-0	15-4	19-6	24-10	42-4	143-6	20	30	50	∞
f 6.3	1-9¼	2-1¾	2-6	3-2	3-9	4-3½	4-9¼	5-2¼	5-7¼	6-0	6-10	7-6	9-1½	10-9	11-6	15-0
	2	**2½**	**3**	**4**	**5**	**6**	**7**	**8**	**9**	**10**	**12**	**15**	**20**	**30**	**50**	**∞**
	2-3¼	3-0	3-9	5-5½	6-0	9-0	13-1½	17-2	22-6	30-0	60-0	15	20	30	50	∞
f 8	1-8½	2-0¾	2-4⅜	3-1⅛	3-6	4-0	4-4	4-9	5-1½	5-5	5-5	6-7	8-5	9-6	11-9	
	2	**2½**	**3**	**4**	**5**	**6**	**7**	**8**	**9**	**10**	**12**	**15**	**20**	**30**	**50**	**∞**
	2-5	3-2	4-0½	6-0½	8-8½	12-3	17-4	25-0	38-6	67-0	20	30	50	∞		
f 11	1-7½	1-11¼	2-2¼	2-8⅜	3-2	3-6	3-10	4-1½	4-4½	5-0	4-7	6-0	6-8	7-3	8-6	
	2	**2½**	**3**	**4**	**5**	**6**	**7**	**8**	**9**	**10**	**12**	**15**	**20**	**30**	**50**	**∞**
	2-7½	3-6½	4-7½	7-6½	12-2	20-5	39-8	136-0	15	20	30	50	∞			
f 16	1-6	1-9	1-11½	2-4¼	2-8½	3-0	3-2½	3-6½	3-8½	3-11⅛	4-2¼	4-6	4-11	5-3	5-10⅞	
	2	**2½**	**3**	**4**	**5**	**6**	**7**	**8**	**9**	**10**	**12**	**15**	**20**	**30**	**50**	**∞**
	3-0	4-4	6-1½	12-6	33-6	8	30	50	∞							
f 22	1-4½	1-7	1-9	2-0½	2-3½	2-5¼	2-7½	2-9¼	3-0	3-1⅛	3-3¾	3-6	4-11	3-8½	3-11	4-3
	2	**2½**	**3**	**4**	**5**	**6**	**7**	**8**	**9**	**10**	**12**	**15**	**20**	**30**	**50**	**∞**
	3-9½	6-1	10-2½	68-0	∞	20	20	30	50	∞						

V—DEPTH OF FIELD FOR LENSES OF 1⅜ INCH (35 mm.) FOCAL LENGTH

Focus distance (ft) across the top; for each aperture the upper figure is the near limit and the lower figure is the far limit (feet–inches; ∞ = infinity).

f	2	2½	3	4	5	6	7	8	9	10	12	15	20	30	50	∞
f 1.5 near	1-11⅜	2-5	2-10⅝	3-9½	4-8¼	5-6½	6-5	7-3	8-0½	8-10	10-4¼	12-6½	15-10	21-6	30-3	76-6
far	2-0⅝	2-7	3-1½	4-2½	5-4¼	6-6	7-8½	8-11¼	10-2¼	11-6	14-3	18-8	27-1	49-5	144-4	∞
f 2 near	1-11¼	2-4¾	2-10¼	3-9	4-7¼	5-5½	6-3	7-0	7-9½	8-6	9-11	11-10½	14-10	19-8	26-8	57-4
far	2-0⅞	2-7⅛	3-2	4-3½	5-5½	6-8½	7-11¼	9-3½	10-8	12-1½	15-2	20-3	30-9	63-0	390-0	∞
f 2.5 near	1-11	2-4½	2-9¾	3-9	4-6	5-3½	6-1	6-9½	7-6	8-2½	9-6	11-3	14-0	18-2	24-0	45-10
far	2-1⅛	2-7¾	3-2½	4-4½	5-7½	6-11	8-3	9-8	11-2	12-9	16-3	22-3	35-6	87-0	∞	∞
f 3 near	1-10¾	2-4¼	2-9¾	3-7½	4-5	5-2¼	5-11	6-7½	7-3¼	7-11	9-1½	10-9	13-1	16-9	21-7	38-3
far	2-1⅜	2-8⅛	3-3	4-5	5-9	7-1½	8-7	10-1½	11-9	13-6	17-9	24-8	42-0	140-0	∞	∞
f 3.5 near	1-10⅝	2-3⅞	2-9	3-6¾	4-4	5-1	5-9½	6-5¼	7-0½	7-8	8-9½	10-3½	12-5	15-8	19-10	32-9
far	2-1½	2-8½	3-3½	4-6¾	5-10½	7-4	8-11	10-7	12-5	14-4	18-11	27-8	51-3	357-0	∞	∞
f 4 near	1-10½	2-3½	2-8⅞	3-6	4-3	5-0	5-7½	6-3	6-10	7-5	8-5½	9-10	11-9	14-8	18-2	28-8
far	2-1¾	2-9	3-4¼	4-7¼	6-0¾	7-7	9-3	11-1	13-1	15-4	20-8	31-5	66-3	∞	∞	∞
f 4.5 near	1-10¼	2-3¼	2-8¼	3-5½	4-2	4-10½	5-6	6-1	6-8	7-2	8-2	9-5	11-3	13-9	16-11	25-6
far	2-2	2-9½	3-5½	4-9	6-2½	7-10	9-8	11-8	13-11	16-5	22-8	36-6	92-9	∞	∞	∞
f 5.6 near	1-9⅞	2-2¾	2-7⅞	3-4½	4-0¾	4-7¾	5-2	5-9	6-3	6-8½	7-7	8-8	10-2	12-2	14-6	20-6
far	2-2⅝	2-10¼	3-6¾	4-11½	6-7¾	8-6	10-7½	13-1	16-0	19-6	28-11	56-0	820-0	∞	∞	∞
f 6.3 near	1-9⅞	2-2⅝	2-7	3-3½	3-11	4-6¼	5-0½	5-7	6-0½	6-5½	7-2½	8-3	9-7	11-4	13-5	18-4
far	2-2⅞	2-10¾	3-7	5-1½	6-11	8-11	11-4	14-2	17-8	22-0	34-9	82-6	∞	∞	∞	∞
f 8 near	1-9	2-1¾	2-5½	3-1½	3-8½	4-3	4-8½	5-1½	5-6½	5-10½	6-6	7-4	8-4	9-9	11-2	14-4
far	2-3⅞	3-0¼	3-9½	5-6¼	7-8	10-4	13-8	18-1	24-2	33-0	73-9	∞	∞	∞	∞	∞
f 11 near	1-8	2-0¼	2-4	2-10½	3-4½	3-9¾	4-2¼	4-6¼	4-10	5-1	5-7	6-2	6-10	7-9	8-7	10-5
far	2-5¼	3-3½	4-7	6-6	9-7	14-2	21-4	34-6	66-3	250-0	∞	∞	∞	∞	∞	∞
f 16 near	1-6¾	1-10¾	2-1½	2-7	3-0	3-3	3-6½	3-9½	4-0	4-2	4-6	4-10	5-3	5-9	6-3	7-2
far	2-9½	3-10	5-2	9-0	16-6	36-10	301-0	∞	∞	∞	∞	∞	∞	∞	∞	∞
f 22 near	1-5½	1-8½	1-11	2-3	2-7	2-9½	3-2	3-4	3-5½	3-8	4-2	4-10½	5-3	4-5½	4-9	5-3
far	3-2¼	4-9½	7-0	16-10	105-0	∞	∞	∞	∞	∞	∞	∞	∞	∞	∞	∞

VI – DEPTH OF FIELD FOR LENSES OF 1⅝ INCH (42·5 mm.) FOCAL LENGTH

Each cell gives the near and far limits of sharpness (feet-inches) for the focus setting shown in the column head.

Aperture	Limit	2	2½	3	4	5	6	7	8	9	10	12	15	20	30	50	∞
f1.5	near	1-11½	2-5¼	2-10⅞	3-10	4-8⅞	5-7½	6-6	7-4¼	8-2¼	9-0	10-7⅛	12-10⅜	16-4½	22-6¼	32-2¼	90-4
f1.5	far	2-0½	2-6⅞	3-1¼	4-2¼	5-3½	6-5⅛	7-7	8-9⅜	10-0	11-3	13-10	18-0	25-8¼	45-0	111-8	∞
f2	near	1-11¼	2-4⅞	2-10½	3-9⅜	4-7⅞	5-6⅛	6-4⅛	7-1⅞	7-11⅜	8-8⅝	10-2⅜	12-3⅜	15-5¼	20-9½	28-9¼	67-9
f2	far	2-0¾	2-7⅛	3-1⅝	4-3	5-4¾	6-7	7-9⅝	9-0⅞	10-4½	11-8¾	14-7	19-3¼	28-4½	53-10	191-0	∞
f2.5	near	1-11⅛	2-4¾	2-10⅛	3-8¾	4-7	5-4⅞	6-2⅜	6-11⅝	7-8⅝	8-5⅜	9-10	11-9	14-7⅜	19-3⅞	26-0¼	54-3
f2.5	far	2-0⅞	2-7½	3-2⅛	4-3⅞	5-6⅛	6-9	8-0½	9-4⅝	10-9½	12-3⅛	15-4⅞	20-8¾	31-8⅛	67-1⅜	650-0	∞
f3	near	1-11	2-4½	2-9¾	3-8⅛	4-6	5-3½	6-0¾	6-9½	7-6	8-2¼	9-5¾	11-3	13-10¼	18-0¼	23-8½	45-1
f3	far	2-1⅛	2-7¾	3-2⅝	4-4⅝	5-7½	6-11	8-3½	9-8¾	11-3	12-10¼	16-4¼	22-5¾	35-11⅜	89-6	∞	∞
f3.5	near	1-10¾	2-4¼	2-9⅜	3-7½	4-5⅛	5-2⅜	5-11⅛	6-7½	7-3⅝	7-11⅜	9-2	10-9¾	13-2¼	16-11	21-10	38-9
f3.5	far	2-1⅜	2-8	3-3	4-5½	5-8⅞	7-1¼	8-6½	10-1	11-8¾	13-5¾	17-4⅝	24-5¾	41-4	133-0	∞	∞
f4	near	1-10⅝	2-4	2-9	3-7	4-4¼	5-1¼	5-9⅝	6-5¾	7-1⅜	7-8⅝	8-10⅜	10-4¾	12-7	15-11	20-2	33-11
f4	far	2-1½	2-8⅜	3-3½	4-6⅜	5-10⅜	7-3½	8-9⅞	10-5⅝	12-3	14-2¼	18-6⅞	26-10¾	48-9	260-0	∞	∞
f4.5	near	1-10½	2-3¾	2-8¾	3-6⅜	4-3½	5-0	5-8⅛	6-3⅞	6-11⅛	7-6	8-7	10-0	12-0	15-0	18-9⅜	30-1
f4.5	far	2-1¾	2-8¾	3-4	4-7⅜	6-0	7-6	9-1½	10-10¾	12-10⅛	14-11¾	20-0	29-11	59-8	∞	∞	∞
f5.6	near	1-10⅛	2-3¼	2-8	3-5¼	4-1¾	4-9¾	5-5⅛	6-0	6-6¾	7-0⅞	8-0¼	9-3	10-11⅜	13-4⅝	16-3½	24-2
f5.6	far	2-2⅛	2-9½	3-5⅛	4-9½	6-3⅝	8-0	9-10¼	11-11½	14-4	17-0¾	23-10	39-6½	116-0	∞	∞	∞
f6.3	near	1-10	2-2⅞	2-7⅝	3-4½	4-0¾	4-8⅜	5-3½	5-10⅛	6-4¼	6-10⅛	7-8⅝	8-10⅜	10-4¾	12-7	15-1½	21-8
f6.3	far	2-2½	2-10	3-5¾	4-10⅞	6-6	8-3½	10-4	12-8¼	15-4¾	18-6⅞	26-10¾	48-9	260-0	∞	∞	∞
f8	near	1-9½	2-2⅛	2-6⅝	3-2⅞	3-10⅜	4-5¼	4-11½	5-5¼	5-10⅝	6-3½	7-0⅜	7-11⅝	9-2	10-10	12-8	17-0
f8	far	2-3¼	2-11⅛	3-7¾	5-2¾	7-1	9-3¼	11-10¾	15-1⅜	19-1½	24-3½	40-9⅝	127-6	∞	∞	∞	∞
f11	near	1-8⅝	2-1	2-5	3-0¼	3-6¾	4-0½	4-5⅝	4-10¼	5-2½	5-6¼	6-1	6-9	7-7½	8-9	9-10	12-4
f11	far	2-4⅝	3-1⅝	4-0	5-11	8-5	11-8¼	16-2¼	22-9¼	33-3⅝	53-0	444-0	∞	∞	∞	∞	∞
f16	near	1-7½	1-11¼	2-2⅝	2-8⅝	3-1¾	3-6¼	3-10	4-1½	4-4½	4-7⅛	4-11¾	5-5	5-11⅝	6-7	7-3	8-6
f16	far	2-7⅜	3-6½	4-7⅝	7-6⅝	12-1¾	20-4¾	39-8	140-0	∞	∞	∞	∞	∞	∞	∞	∞
f22	near	1-6⅛	1-9⅜	2-0¼	2-5⅛	2-9⅛	3-0½	3-3½	3-5½	3-8	3-9¾	4-0⅞	4-4½	4-8½	5-1½	5-6	6-2
f22	far	2-11½	4-2½	5-10⅛	11-4⅝	26-5	222-0	∞	∞	∞	∞	∞	∞	∞	∞	∞	∞

82

VII – DEPTH OF FIELD FOR LENSES OF 2 INCH (50 mm.) FOCAL LENGTH

f/		2	2½	4	5	6	7	8	9	10	12	15	20	30	50	∞
f1.5	near	1-11⅝	2-5¼	3-10¼	4-9¾	5-8½	6-7	7-5½	8-4	9-2	10-10	13-2½	16-11	23-7	34-5	111-0
	far	2-0⅜	2-6¼	4-1¾	5-2¼	6-4	7-5⅝	8-7½	9-9½	10-11¾	13-5½	17-4	24-5	41-0	91-0	∞
f2	near	1-11½	2-5⅝	3-9½	4-8¼	5-7⅞	6-5½	7-3½	8-1½	9	10-6	12-8	16-1	22-1	31-3	83-6
	far	2-0¾	2-7	4-1½	5-3½	6-5¼	7-7¾	8-10	10-1	11-4	14-0	18-3	26-4	47-0	125-0	∞
f2.5	near	1-11¼	2-4⅞	3-9¼	4-7⅞	5-6	6-4	7-1½	8	8-8	10-2	12-3	15-4½	20-8	28-6	66-8
	far	2-0½	2-7¼	4-3	5-5	6-8½	7-10	9-1	10-5	11-9	14-7½	19-4	28-6	54-7	120-0	∞
f3	near	1-11⅛	2-4¾	3-8½	4-7	5-5	6-2½	7-0	8	8-5½	9-10	12-3	14-8½	19-6	26-4	55-6
	far	2-0⅞	2-7½	4-3½	5-6	6-8¾	8-0	9-4	10-9	12-2½	15-3½	20-6	31-3	65-6	500-0	∞
f3.5	near	1-11	2-4½	3-8¼	4-6½	5-4	6-1½	6-10	7-7	8-3	9-7	11-5	14-1	18-5	24-4	47-7
	far	2-1	2-7¾	4-4½	5-7	6-9½	8-2½	9-7½	11-1	12-8	16-0	21-11	34-7	55-0	∞	∞
f4	near	1-10⅞	2-4¼	3-7½	4-5½	5-3	6-0	6-8½	7-4¾	8-0½	9-4	11-0	13-6	17-6	22-9	41-8
	far	2-1⅛	2-7⅞	4-5	5-8½	7-0	8-5	9-10½	11-5½	13-2	16-10	23-5	38-4	107-0	∞	∞
f4.5	near	1-10¾	2-4⅛	3-7¼	4-5⅛	5-2	5-11	6-7	7-3	7-10½	9-1	10-8	13-0	16-7	21-3	37-1
	far	2-1¼	2-8	4-5¼	5-9½	7-2	8-7½	10-2½	11-10½	13-8	17-9	25-2	43-5	157-0	∞	∞
f5.6	near	1-10½	2-3⅝	3-6¼	4-3¾	5-0	5-8	6-3½	6-11	7-5½	8-6½	10-0	12-0	14-11	18-8	29-9
	far	2-1½	2-8¾	4-7	5-11½	7-6	9-2	10-11	12-11	15-1	20-1	30-3	61-0	∞	∞	∞
f6.3	near	1-10¼	2-3½	3-5½	4-2¾	4-10½	5-6½	6-2	6-8	7-3¾	8-3½	9-7	11-5	14-1	17-5	26-8
	far	2-2	2-9½	4-8½	6-2	7-9	9-6	11-5	13-7	16-0	21-10	34-3	80-0	∞	∞	∞
f8	near	1-9¾	2-2¾	3-4½	4-0½	4-8	5-3	5-9½	6-3½	6-9	7-7½	8-8½	10-2	12-3½	14-9	20-10
	far	2-2½	2-9½	4-11½	6-7	8-5	10-6½	13-0	15-10	19-3	28-4	53-6	500-0	∞	∞	∞
f11	near	1-9½	2-1¾	3-2	3-9	4-3½	4-9½	5-2½	5-7½	6-0	6-7	7-6	8-7	10-0	11-7	15-1
	far	2-3½	3-0	5-5½	7-6	9-11½	13-1	17-0	22-4	29-8	58-9	∞	∞	∞	∞	∞
f16	near	1-8½	2-0½	2-10½	3-4½	3-9½	4-2¼	4-6¼	4-10	5-1¼	5-7	6-2	6-10	7-9	8-7	10-5
	far	2-5¼	3-3½	6-6	9-7½	14-2	21-4	34-6	66-6	250-0	∞	∞	∞	∞	∞	∞
f22	near	1-7	1-10½	2-7¾	3-0	3-4	3-7½	3-10½	4-1	4-3½	4-7½	5-0	5-5½	6-0	6-6	7-6
	far	2-8½	3-9	8-7	15-0	30-0	105-0	∞	∞	∞	250-0	∞	∞	∞	∞	∞

83

VIII – DEPTH OF FIELD FOR LENSES OF 2½ INCH (62·5 mm.) FOCAL LENGTH

The values in each cell are given as *near limit – far limit* (feet‑inches). The bold figures across the top are the focused distances (feet).

	3	4	5	6	7	8	9	10	12	15	20	25	30	50	100	∞
f1.5	2‑11¼ – 3‑0¾	3‑10⅝ – 4‑1⅛	4‑9⅞ – 5‑2¼	5‑9 – 6‑3¼	6‑8 – 7‑4¼	7‑6¾ – 8‑6	8‑5½ – 9‑7¼	9‑4 – 10‑9½	11‑0¾ – 13‑1½	13‑6¼ – 16‑9¼	17‑6 – 23‑4	21‑2 – 30‑5	24‑8 – 38‑3	36‑9 – 78‑2	58‑0 – 351‑0	138‑9 – ∞
f2	2‑11 – 3‑1⅛	3‑10¼ – 4‑2	4‑9¼ – 5‑3	5‑8 – 6‑6¼	6‑6¾ – 7‑5	7‑5 – 8‑8	8‑3½ – 9‑10	9‑1½ – 11‑1	10‑9 – 13‑7	13‑1¼ – 17‑6	16‑9 – 24‑9	20‑2 – 32‑11	23‑4 – 42‑0	33‑9 – 96‑2	51‑0 – 2500	104‑2 – ∞
f2.5	2‑10¾ – 3‑1½	3‑9¾ – 4‑2½	4‑8½ – 5‑3½	5‑7¾ – 6‑5½	6‑5¾ – 7‑7½	7‑3¾ – 8‑10	8‑1½ – 10‑1	8‑11½ – 11‑4½	10‑6 – 14‑0	12‑8½ – 18‑3½	16‑1 – 26‑4	19‑3 – 35‑8	22‑1 – 46‑10	31‑3 – 125‑0	45‑6 – ∞	83‑4 – ∞
f3	2‑10½ – 3‑1¾	3‑9½ – 4‑3	4‑8 – 5‑4¼	5‑6¾ – 6‑6½	6‑4¼ – 7‑8	7‑2 – 8‑9	7‑11½ – 10‑4	8‑9 – 11‑8	10‑2¼ – 14‑6	12‑4 – 19‑1½	15‑6 – 28‑1	18‑4 – 39‑0	21‑0 – 52‑9	29‑1 – 173‑6	41‑0 – ∞	69‑6 – ∞
f3.5	2‑10¼ – 3‑1⅞	3‑9 – 4‑3½	4‑7¼ – 5‑5½	5‑5½ – 6‑8	6‑3¼ – 7‑11	7‑0½ – 9‑3	7‑9¼ – 10‑7	8‑6¼ – 12‑0	10‑0 – 15‑0	12‑0 – 20‑0	15‑0 – 30‑1½	17‑7 – 43‑0	20‑0 – 60‑6	27‑2 – 313‑6	37‑4 – ∞	59‑6 – ∞
f4	2‑10 – 3‑2¼	3‑8½ – 4‑4	4‑6¾ – 5‑6⅜	5‑4½ – 6‑9⅜	6‑2 – 8‑1	6‑11¼ – 9‑5½	7‑8 – 10‑10½	8‑4¾ – 12‑6	9‑9 – 15‑7	11‑7¾ – 21‑1	14‑6 – 32‑6	16‑10 – 48‑0	19‑0 – 71‑0	25‑6 – 1250	34‑3 – ∞	52‑1 – ∞
f4.5	2‑9¾ – 3‑2½	3‑8¼ – 4‑4½	4‑6 – 5‑7¼	5‑3¾ – 6‑10¾	6‑1 – 8‑3	6‑9 – 9‑8	7‑6½ – 11‑2	8‑2¾ – 12‑9	9‑6¼ – 16‑2	11‑4 – 22‑2	14‑0 – 35‑2	16‑3 – 54‑3	18‑2 – 85‑0	24‑0 – ∞	31‑8 – ∞	46‑4 – ∞
f5.6	2‑9¼ – 3‑3⅛	3‑7¼ – 4‑5¾	4‑5 – 5‑9¼	5‑2 – 7‑1½	5‑10¾ – 8‑7½	6‑7 – 10‑2	7‑3 – 11‑10½	7‑10½ – 13‑8	9‑1 – 17‑8	10‑8½ – 25‑1	13‑0 – 43‑2	15‑0 – 76‑0	16‑7 – 154‑0	21‑4 – ∞	27‑0 – ∞	37‑3 – ∞
f6.3	2‑9 – 3‑3½	3‑6⅞ – 4‑6½	4‑4 – 5‑10½	5‑1 – 7‑3¾	5‑9½ – 8‑10	6‑5½ – 10‑6	7‑1 – 12‑4	7‑8¼ – 14‑3½	8‑10 – 18‑9	10‑4 – 27‑3	12‑6 – 50‑0	14‑3 – 100‑0	15‑9 – 300‑0	20‑0 – ∞	25‑0 – ∞	33‑4 – ∞
f8	2‑8¼ – 3‑4¾	3‑5⅝ – 4‑8¾	4‑2¼ – 6‑2¼	4‑10½ – 7‑9½	5‑6¼ – 9‑6⅞	6‑1⅜ – 11‑6¾	6‑8¼ – 13‑9	7‑2⅝ – 16‑3	8‑2½ – 22‑3½	9‑6 – 35‑6	11‑3 – 86‑8	12‑9 – 650‑0	13‑11 – ∞	17‑0 – ∞	20‑8 – ∞	26‑0 – ∞
f11	2‑7 – 3‑6¾	3‑3⅝ – 5‑0⅞	3‑11½ – 6‑9½	4‑6⅝ – 8‑9½	5‑1⅛ – 11‑1⅜	5‑7½ – 13‑10	6‑1¼ – 17‑2	6‑6½ – 21‑2	7‑4 – 32‑10	8‑4½ – 72‑6	9‑9 – ∞	10‑9 – ∞	11‑7 – ∞	13‑9 – ∞	16‑0 – ∞	18‑11 – ∞
f16	2‑5¼ – 3‑10¾	3‑0¾ – 5‑9¼	3‑7⅜ – 8‑1½	4‑1¼ – 11‑1¾	4‑6⅝ – 15‑2	4‑11½ – 20‑9	5‑4 – 29‑9	5‑8 – 43‑6	6‑3 – 156‑0	6‑11½ – ∞	7‑10½ – ∞	8‑6½ – ∞	9‑1 – ∞	10‑4 – ∞	11‑6 – ∞	13‑0 – ∞
f22	2‑3⅜ – 4‑4½	2‑9¾ – 6‑11	3‑3¼ – 10‑6	3‑8 – 16‑3	4‑0½ – 26‑7	4‑4 – 50‑6	4‑7½ – 171‑0	4‑10½ – ∞	5‑3¾ – ∞	5‑9¾ – ∞	6‑5¼ – ∞	6‑10½ – ∞	7‑2½ – ∞	8‑0 – ∞	8‑8 – ∞	9‑6 – ∞

IX – DEPTH OF FIELD FOR LENSES OF 3 INCH (75 mm.) FOCAL LENGTH

Bold figures indicate the distance focused upon (in feet); the upper and lower figures give the near and far limits of sharp focus (feet-inches).

f/no.	limit	3	4	5	6	7	8	9	10	12	15	20	25	30	50	100	∞
f1.5	near	2-11⅛	3-10½	4-10¼	5-9½	6-8½	7-7½	8-6½	9-5	11-2¼	13-9	17-10	21-9	25-5	38-4	62-6	166-6
f1.5	far	3-0⅝	4-1⅛	5-1¾	6-2¼	7-3⅜	8-5	9-6	10-7½	12-11	16-5½	22-8½	29-5	36-7	71-6	250-0	∞
f2	near	2-11⅛	3-10¼	4-9¾	5-8¾	6-7¼	7-6¼	8-4½	9-3	10-11½	13-4¾	17-3	20-10	24-2	35-9	55-6	125-0
f2	far	3-0⅝	4-1⅛	5-2¼	6-3½	7-5	8-6½	9-8½	10-10½	13-3½	17-0	23-10	31-3	39-6	83-4	500-0	∞
f2.5	near	2-11	3-10⅛	4-9½	5-8	6-6½	7-5	8-3	9-1	10-8½	13-0½	16-8	20-0	23-1	33-4	50-0	100-0
f2.5	far	3-1⅛	4-2	5-3⅛	6-4½	7-6¼	8-8½	9-10½	11-1½	13-8	17-8	25-0	33-4	42-10	100-0	∞	∞
f3	near	2-10¾	3-9½	4-8⅝	5-7⅝	6-5½	7-3½	8-1½	8-11	10-6	12-8½	16-1	19-3	22-1	31-3	45-6	83-4
f3	far	3-1⅛	4-2½	5-4	6-5⅜	7-7½	8-10	10-1	11-4½	14-0	18-4	26-4	35-9	47-0	125-0	∞	∞
f3.5	near	2-10½	3-9¼	4-8	5-6½	6-4¼	7-2¼	8-0	8-9¼	10-3	12-5	15-7½	18-6	21-2	29-5	41-8	71-5
f3.5	far	3-1⅜	4-2¾	5-4½	6-6¾	7-9	9-0	10-3½	11-7¼	14-5	19-0	27-9	38-5	51-9	166-8	∞	∞
f4	near	2-10¼	3-9⅛	4-7½	5-5¼	6-3¼	7-1	7-10½	8-7½	10-1	12-1	15-2	17-10	20-3	27-9	38-6	62-6
f4	far	3-1½	4-3¼	5-5¼	6-7½	7-10½	9-2	10-6	11-10½	14-10	19-8½	29-5	41-8	57-9	250-0	∞	∞
f4.5	near	2-10½	3-8¾	4-7	5-5	6-2½	7-0	7-9	8-5½	9-10½	11-10	14-8½	17-3	19-6	26-4	35-9	55-7
f4.5	far	3-2	4-3¾	5-6	6-8¾	7-11½	9-4	10-9	12-2½	15-3¾	20-6	31-3	45-5	65-2	498-0	∞	∞
f5.6	near	2-9½	3-8	4-6	5-3½	6-0½	6-9½	7-6	8-2	9-5½	11-2½	13-9½	16-0	17-11	23-7	30-10	44-7
f5.6	far	3-2⅛	4-4¼	5-7½	6-11¼	8-3½	9-9	11-3	12-11	16-5	22-7	36-3	57-0	91-8	∞	∞	∞
f6.3	near	2-9½	3-7½	4-5¼	5-2½	5-11	6-8	7-4	8-0	9-2¼	10-1	13-4	15-4½	17-1½	22-5	28-6	40-0
f6.3	far	3-2½	4-5½	5-8⅝	7-0½	8-6	10-0	11-7½	13-4	17-1½	24-0	40-0	66-8	120-0	∞	∞	∞
f8	near	2-8⅞	3-6½	4-3¾	5-0½	5-8⅝	6-4½	7-0	7-7	8-8	10-1½	12-0½	13-10½	15-3¼	19-3	23-10	31-3
f8	far	3-3¼	4-7	5-11½	7-5	8-6	10-0	11-7½	14-8½	19-6	28-10	55-6	125-0	750-0	∞	∞	∞
f11	near	2-7¾	3-4¾	4-1¼	4-9	5-4¾	6-1¼	6-5½	7-0	8-8	10-1½	11-11	11-11	12-11	15-7½	18-6	22-9
f11	far	3-5½	4-10¼	6-5	8-1¾	10-1½	12-4	14-10½	17-10	25-4	44-0	165-6	∞	∞	∞	∞	∞
f16	near	2-6¼	3-2¼	3-9½	4-4	4-10	5-5¾	5-8½	6-1	6-9½	7-7¼	8-9½	9-7½	10-3½	11-11	13-6	15-7½
f16	far	3-8½	5-4½	7-4¼	9-9	12-8	16-4½	21-3	27-9	51-8	375-0	∞	∞	∞	∞	∞	∞
f22	near	2-4½	2-11½	3-5¾	3-11¼	4-4	4-8½	5-4	5-10½	6-5¾	7-3	8-3½	7-10	8-3½	9-3½	10-3	11-5
f22	far	4-4½	6-2	8-10½	12-8	18-1½	26-9	42-6	80-6	∞	∞	∞	∞	∞	∞	∞	∞

85

X – DEPTH OF FIELD FOR LENSES OF 3½ INCH (87·5 mm.) FOCAL LENGTH

f/		∞	100	50	30	25	20	17½	15	12	10	9	8	7	6	5	4
f2	near	146-0	59-4	37-3	25-9	21-4	17-7	15-7½	13-7¾	11-1	9-4¾	8-5½	7-7	6-8	5-9½	4-10	3-10¾
	far	∞	318-6	76-0	37-9	30-2	23-2	19-10½	16-8	13-1	10-9	9-7	8-5½	7-4	6-3	5-2	4-1¼
f2.5	near	116-8	53-10	35-10	23-10	20-7	17-1	15-2½	13-3¾	10-10½	9-2½	8-4	7-5¾	6-7¼	5-8½	4-9½	3-10⅜
	far	∞	700-0	87-6	40-5	31-10	24-2	20-7	17-2½	13-4½	10-11	9-9	8-7	7-5¾	6-4	5-2¼	4-1¾
f3	near	97-3	49-4	33-0	22-11	19-10½	16-7	14-10	13-0	10-8	9-0½	8-2¼	7-5	6-6½	5-7¼	4-9	3-10
	far	∞	∞	103-0	43-5	33-8	25-2	21-4	17-9	13-8	11-2	9-11	8-8½	7-3½	6-4½	5-3½	4-2
f3.5	near	83-4	45-6	31-3	22-1	19-3	16-1	14-5	12-8½	10-6	8-11	8-1	7-3½	6-5½	5-6¾	4-8⅜	3-9¾
	far	∞	∞	125-0	47-0	35-9	26-4	22-2	18-3	14-0	11-4½	10-1	8-10	7-7½	6-5½	5-4	4-2¼
f4	near	73-0	42-2	29-8	21-3	18-8	15-8	14-1½	12-5	10-3½	8-8½	8-0	7-2½	6-4½	5-6½	4-8½	3-9½
	far	∞	∞	159-0	51-0	47-8	27-7	23-0	18-10½	14-4	11-7	10-3	9-0	7-9	6-6¼	5-4½	4-2¾
f4.5	near	64-10	39-4	28-3	20-6	18-0	15-3½	13-9½	13-1	10-1½	8-8	7-11	7-1½	6-4	5-6	4-7¾	3-9¼
	far	∞	∞	218-6	55-10	40-9	28-11	24-0	19-6	14-9	11-10	10-5½	9-1½	7-10	6-7¼	5-5	4-3¼
f5.6	near	52-0	34-3	25-6	19-0	16-11	14-5	13-1	11-8	9-9	8-4½	7-8	6-11¼	6-2	5-4½	4-6¾	3-8½
	far	∞	∞	1250	70-10	48-0	32-6	26-4	21-1	15-7	12-4½	10-10½	9-5½	8-1½	6-9½	5-6½	4-4
f6.3	near	46-8	31-10	24-2	18-3	16-3¼	14-0	12-8½	11-4	9-6½	8-3	7-6¼	6-10	6-1	5-3¾	4-6¼	3-8¼
	far	∞	∞	∞	85-0	53-10	35-0	28-0	22-1	16-2½	12-9	11-2	9-8	8-2¾	6-10½	5-7¼	4-4½
f8	near	36-6	26-9	21-1	16-5½	14-10	12-11	11-10	10-7½	9-0½	7-10¼	7-2¼	6-7	5-10¼	5-1⅜	4-4¾	3-7½
	far	∞	∞	∞	168-6	79-4	44-3	33-8	25-5	17-11	13-9½	11-11½	10-3	8-7½	7-2½	5-9½	4-6
f11	near	26-6	21-0	17-4	14-1	12-10½	11-5	10-6½	9-7	8-3	7-3	6-8½	6-1¼	5-6½	4-10¾	4-2¾	3-5½
	far	∞	∞	∞	∞	441-6	81-6	51-6	34-7	21-11	16-0½	13-7½	11-5½	9-6	7-9	6-2	4-8½
f16	near	18-3	15-6	13-4	11-4	10-7	9-6½	8-11	8-3	7-2½	6-5½	6-0¾	5-6¾	5-0¼	4-7	4-0½	3-3⅜
	far	∞	∞	∞	∞	∞	426-0	84-3	35-0	22-2	17-9	14-3	11-4	9-6	8-0½	6-10½	5-1½
f22	near	13-3	11-8	10-6	9-2	8-8	7-11½	7-6½	7-0½	6-3¼	5-8¾	5-3¾	5-0	4-7	4-1½	3-7½	3-0¾
	far	∞	∞	∞	∞	∞	∞	426-0	84-3	35-0	22-2	17-9	14-3	11-4	9-6	8-0½	5-8¾
f32	near	9-2	8-5	7-9	7-0½	6-8½	6-3½	6-0	5-8¼	5-2½	4-9½	4-6½	4-3¼	3-11½	3-7½	3-2¾	2-9¾
	far	∞	∞	∞	∞	∞	∞	∞	∞	135-6	40-0	28-0	20-2	14-10	11-4	9-0	7-1½

86

XI—DEPTH OF FIELD FOR LENSES OF 4 INCH (100 mm.) FOCAL LENGTH

Each aperture has two limits (near limit / far limit) for the focus distances (ft–in.) shown in the bold centre row of the original table.

f/	limit	4	5	6	7	8	9	10	12	15	17	20	25	30	50	100	∞
f2	near	3-11	4-10¼	5-9½	6-8¼	7-7¼	8-6½	9-5	11-2½	13-9	15-5	17-10	21-9	25-5	38-6	62-6	166-8
	far	4-1¼	5-1½	6-2¼	7-3½	8-5	9-6	10-7½	12-11	16-5½	18-11	22-9	29-5	36-7	71-6	250-0	∞
f2.5	near	3-10⅝	4-9¾	5-9	6-7¾	7-6¾	8-5	9-3¾	11-0	13-6	15-1	17-5	21-1	24-6	36-5	57-2	133-4
	far	4-1⅜	5-2¼	6-3¼	7-4¾	8-6¼	9-7¾	10-9¾	13-2	16-11	19-6	23-6¾	30-6½	38-9	80-0	400-0	∞
f3	near	3-10¼	4-9⅜	5-8⅜	6-7	7-5½	8-4	9-2	10-10	13-2½	14-9	16-11½	20-5	23-7½	34-6	52-8	111-0
	far	4-1½	5-2¾	6-4	7-5¼	8-7½	9-9½	11-0	13-5	17-4	20-1	24-4	32-3	41-1	91-0	1000-0	∞
f3.5	near	3-10⅛	4-9	5-7¾	6-6⅜	7-4¾	8-2¾	9-0½	10-7¾	12-11	14-5	16-6⅝	19-9¼	22-10	32-9	48-9	95-3
	far	4-1¾	5-3⅛	6-5	7-6¾	8-8½	9-11	11-2	13-9	17-9½	20-8	25-4	33-11	43-10	105-6	∞	∞
f4	near	3-9¾	4-8⅝	5-7¼	6-5½	7-3½	8-1½	8-11	10-6	12-8½	14-1½	16-1½	19-2¾	22-1	31-3	45-6	83-4
	far	4-2½	5-3⅞	6-5¾	7-7¾	8-10	10-1	11-4½	14-0	18-3¼	21-4	26-4	35-9	46-10	125-0	∞	∞
f4.5	near	3-9½	4-8¼	5-6⅝	6-4¾	7-2⅝	8-0⅜	8-9¾	10-4	12-5¾	13-10	15-9	18-8⅜	21-4	29-10	42-7	74-2
	far	4-2¾	5-4¼	6-6⅜	7-8¾	8-11½	10-3	11-6¾	14-3¾	18-9⅝	22-0⅝	27-4½	37-8½	50-5	153-6	∞	∞
f5.6	near	3-9	4-7½	5-5½	6-3	7-0½	7-9¾	8-6¾	10-0	11-11¾	13-2⅝	14-11⅝	17-7¼	19-11	27-2	37-4	59-6
	far	4-3½	5-5½	6-8	7-11¼	9-2⅞	10-7¼	12-0¼	15-0⅜	20-0¾	23-9½	30-1½	43-1½	60-6	313-2	∞	∞
f6.3	near	3-8⅝	4-7	5-4¾	6-2¼	6-11½	7-8⅜	8-5	9-9½	11-8½	12-10¾	14-6½	17-0¼	19-2⅜	25-9⅝	34-9	53-4
	far	4-3⅞	5-6¼	6-9⅛	8-0¾	9-5	10-9⅞	12-3¾	15-5⅞	20-10½	24-11½	32-0	47-0¾	68-7	800-0	∞	∞
f8	near	3-7¾	4-5½	5-3	5-11⅞	6-8½	7-4⅞	8-0¾	9-3¾	11-0⅜	12-0⅞	13-6⅛	15-7½	17-5⅜	22-8¾	29-5	41-8
	far	4-5⅛	5-8¼	7-0⅛	8-5	9-10¾	11-5¾	13-1⅞	16-10¼	23-5¼	28-8½	38-5½	62-6	107-1	∞	∞	∞
f11	near	3-6⅜	4-3½	5-0	5-8¼	6-4	6-11¼	7-6¼	8-7⅛	10-0½	10-10¾	12-0⅝	13-8½	15-1	18-10½	23-3¼	30-4
	far	4-7¼	6-0	7-5¾	9-1¼	10-10⅜	12-9½	14-11	19-10	29-8⅛	38-8¼	58-9	143-1	∞	∞	∞	∞
f16	near	3-4¼	4-0½	4-8	5-3	5-9⅜	6-3½	6-9	7-7⅜	8-8⅝	9-4⅜	10-2½	11-4⅓	12-3⅝	14-8½	17-2⅞	20-10
	far	4-11	6-7	8-5⅛	10-6½	12-11⅞	15-10⅛	19-2⅞	28-4	53-6	92-6	500-0	∞	∞	∞	∞	∞
f22	near	3-2	3-9⅛	4-3⅝	4-9½	5-2⅞	5-7¾	6-0⅜	6-8⅜	7-6½	8-0	8-7½	9-5¼	10-0⅞	11-7⅝	13-2	15-2
	far	5-5¼	7-5½	9-11	13-0	16-11	22-2	29-4	57-6	∞	∞	∞	∞	∞	∞	∞	∞
f32	near	2-10¾	3-4½	3-9¾	4-2¼	4-6¼	4-9⅞	5-1¼	5-6⅞	6-1¾	6-5½	6-10¼	7-4¼	7-8¾	8-7½	9-5¼	10-5
	far	6-6	9-7⅜	14-2	21-4	34-6	66-6	250-0	∞	∞	∞	∞	∞	∞	∞	∞	∞

XII – DEPTH OF FIELD FOR LENSES OF 4½ INCH (112·5 mm.) FOCAL LENGTH

	4	5	6	7	8	9	10	12	15	17	20	25	30	50	100	∞
f2 (near)	3-11	4-10½	5-9¼	6-9	7-8	8-7	9-6	11-3¾	13-11	15-7	18-1	22-1	25-10	39-5	65-3	187-6
f2 (far)	4-1	5-1⅛	6-2¼	7-3¼	8-4¼	9-5¼	10-6¾	12-10	16-3¼	18-8	22-5	28-10	35-9	68-2	214-6	∞
f2.5 (near)	3-10¾	4-10	5-9¼	6-8½	7-7¼	8-6	9-4½	11-1½	13-7½	15-3	17-8	21-5	25-0	37-6	60-0	150-0
f2.5 (far)	4-1¼	5-2	6-3	7-4	8-5½	9-7	10-8½	13-0½	16-8	19-2	23-1	30-0	37-6	75-0	300-0	∞
f3 (near)	3-10¼	4-9¾	5-8¾	6-7½	7-6¾	8-4¾	9-3	10-11½	13-4½	14-11½	17-3	20-10	24-2	35-9	55-6	125-0
f3 (far)	4-1⅛	5-2½	6-3⅜	7-5	8-6½	9-8½	10	13-3	17-0½	19-8	23-10	31-3	39-5	83-4	500-0	∞
f3.5 (near)	3-10¼	4-9¼	5-8⅛	6-7	7-5½	8-3½	9-2	10-9½	13-2	14-8	17-0	20-3	23-5	34-2	51-9	107-2
f3.5 (far)	4-1⅞	5-3	6-4¼	7-6	8-7½	9-10	11-0½	13-6	17-6	20-0	24-7	32-7	41-8	93-10	1500	∞
f4 (near)	3-10	4-9	5-7⅞	6-6	7-4½	8-2½	9-0½	10-7½	12-11	14-8	16-6	19-9	22-9	32-7	48-5	93-10
f4 (far)	4-2¼	5-3¾	6-5	7-7	8-9	9-11½	11-2½	13-9	17-10	20-9	25-5	34-1	44-0	107-0	∞	∞
f4.5 (near)	3-9¾	4-8⅝	5-7¼	6-5½	7-3½	8-1½	8-11	10-6	12-8½	14-1½	16-1	19-3	22-1	31-3	45-6	83-5
f4.5 (far)	4-2¼	5-3¾	6-5½	7-7½	8	10-1	11-4½	14-0	18-3½	21-4	26-4	35-9	46-10	125-0	∞	∞
f5.6 (near)	3-9¼	4-8	5-6	6-4	7-1¾	8-8½	10-2	12-3	13-7	15-8	18-3	20-9	28-8	40-0	67-0	
f5.6 (far)	4-3	5-5	6-7	7-10	9-1	10-5	11-9	14-7½	19-4	22-9	28-6	40-0	54-4	197-0	∞	∞
f6.3 (near)	3-9	4-7½	5-5½	6-3¼	7-0½	8-7	10-0	12-0	13-3	15-0	17-8	20-0	27-3	37-6	60-0	
f6.3 (far)	4-3¼	5-5½	6-8	7-11	9-2¾	10-7	12-0	15-0	20-0	23-11	30-0	42-11	60-0	300-0	∞	∞
f8 (near)	3-8½	4-6¾	5-4	6-1	7-6½	8-3	9-6½	11-4½	12-6	14-0	16-4	18-4	24-3	31-10	46-11	
f8 (far)	4-4½	5-7½	6-10	8	9-7½	11-1½	12-8½	16-1½	22-1	26-8	34-10	53-6	83-4	∞	∞	∞
f11 (near)	3-7	4-4½	5-1¼	5-9¾	6-5¼	7-1½	8-10½	10-5	11-4	12-7½	14-5	16-0	20-4	25-6	34-2	
f11 (far)	4-6½	5-10¼	7-3½	8-9½	10-5½	12-2½	14-2	18-6	26-9	33-10	48-3	93-4	246-0	∞	∞	∞
f16 (near)	3-5	4-1¼	4-9½	5-4¾	6-1¼	7-0	7-11½	9-2	10-10½	12-1¼	13-2	16-0	19-0	23-6		
f16 (far)	4-9½	6-1¼	8-0½	10-5½	12-1½	14-7	17-5	24-6	41-6	61-6	134-6	∞	∞	∞	∞	∞
f22 (near)	3-2⅝	4-5½	4-11½	5-5½	5-10½	6-3½	7-0½	8-0	8-6	8-6	10-2	12-9	14-7	17-1		
f22 (far)	5-2½	7-1	9-2½	12-1¼	15-0½	19-0	24-2	40-4	123-0	∞	25	25	20	20		
f32 (near)	2-11¾	3-6	3-11½	4-4½	4-9	5-1¼	5-11¼	6-7	7-0½	8-6	6-11½	8-0	9-6	10-6		
f32 (far)	6-0¾	8-8½	12-3	17-4	25-1	38-6	67-0	∞	∞	∞	∞	∞	∞	∞		

XIII – DEPTH OF FIELD FOR LENSES OF 5 INCH (125 mm.) FOCAL LENGTH

Focus distance (ft-in), shown in **bold**, with near limit (upper) and far limit (lower).

f-stop		5	6	7	8	9	10	12	15	17	20	25	30	40	50	100	∞
f2	near	4-10½	5-10	6-9¼	7-8½	8-7½	9-6½	11-4	14-0	15-8	18-3	22-4	26-3	33-7	40-4	67-6	208-6
	far	5-1½	6-2¼	7-2⅞	8-3¼	9-4¾	10-6	12-9	16-1½	18-6	22-1½	28-5	35-1	49-6	66-0	192-6	∞
f2.5	near	4-10¼	5-9½	6-8½	7-7½	8-6½	9-5	11-2	13-9	15-5	17-10	21-9	25-5	32-3	38-5	62-6	166-8
	far	5-1¾	6-2¾	7-3½	8-4½	9-6	10-7½	12-11	16-6	18-11	22-9	29-5	36-7	52-8	71-6	250-0	∞
f3	near	4-10	5-10	6-8	7-6¾	8-5½	9-4	11-0½	13-6½	15-1½	17-6	21-2	24-8	31-0	36-9	57-9	139-0
	far	5-2¼	6-3¼	7-4½	8-6	9-7½	10-9½	13-1½	16-11	19-4	23-4	30-6	38-3	56-2	77-11	357-0	∞
f3.5	near	4-9½	5-8½	6-7¼	7-6	8-4¾	9-2½	10-11	13-4	14-10½	17-1½	20-8	24-0	29-11	35-3	54-6	119-1
	far	5-2½	6-3½	7-5¼	8-7	9-9	10-11	13-3	17-2	19-10	24-0	31-8	40-1	60-3	86-3	625-0	∞
f4	near	4-9¼	5-8	6-6½	7-5¼	8-3½	9-1½	10-9	13-1	14-7½	16-9	20-2	23-4	28-10	33-10	51-0	104-4
	far	5-3	6-4½	7-6	8-8	9-10	11-0½	13-7	17-6	20-4	24-9	32-11	42-2	65-0	96-0	2500	∞
f4.5	near	4-9	5-7¾	6-6	7-4½	8-2½	9-0½	10-7½	12-11	14-4½	16-5	19-8	22-8	27-11	32-6	48-0	92-8
	far	5-3½	6-5	7-7	8-9½	9-11¼	11-2½	13-9½	17-11	20-10	25-6	34-3	44-4	70-5	108-6	∞	∞
f5.6	near	4-8½	5-6¾	6-4½	7-2½	8-0½	8-10	10-4	12-6	13-10	15-9½	18-9	21-4	26-0	29-11	42-8	74-6
	far	5-4¼	6-6¼	7-8½	8-11½	10-3	11-6½	14-4	18-9	22-0	27-4	37-8	50-3	86-6	152-0	100	∞
f6.3	near	4-8	5-6	6-4	7-1½	7-11	8-8½	10-2	12-3	13-6	15-4½	18-2	20-8	25-0	28-7	40-0	66-3
	far	5-5	6-7	7-10	9-1	10-5	11-9	14-8	19-4	22-10	28-7	40-0	54-7	100-0	200-0	100	∞
f8	near	4-6¾	5-4½	6-2	6-11¼	7-8	8-4½	9-9	11-8	12-10	14-5	16-10	19-0	22-7	25-6	34-3	52-2
	far	5-6½	6-9½	8-1	9-5¼	10-10½	12-4½	15-8	21-1	25-3	32-5	48-0	70-10	172-0	1250	100	∞
f11	near	4-5	5-2	5-11	6-7¾	7-3¾	7-11	9-1½	10-9	11-9	13-1	15-1	16-9	19-6	21-7	27-6	37-11
	far	5-9	7-1½	8-7	10-1½	11-10	13-7	17-6	24-10	30-10	42-4	73-4	144-0	40	50	100	∞
f16	near	4-2½	4-10½	5-6¼	6-1½	6-8½	7-3	8-2½	9-6	10-3	11-4	12-9	13-11	15-9	17-2	20-8	26-1
	far	6-2¼	7-9½	9-7	11-6¼	13-9	16-3	22-3	35-4	48-9	85-8	602-0	30	40	50	100	∞
f22	near	3-11½	4-6¾	5-1½	5-7½	6-1	6-6½	7-4	8-4½	9-0	9-9	10-9½	11-7½	12-10	13-9	16-0	19-0
	far	6-9½	8-9	11-1	13-10	17-1	21-1	32-7	71-3	161-6	25	25	30	50	50	100	∞
f32	near	3-7¼	4-1¼	4-6¼	5-3¼	5-8	5-8	6-3	6-11¼	7-4¼	7-10½	8-6¼	9-1	9-10	10-4	11-6	13-0
	far	8-1½	11-2	15-2	20-10	29-3	43-4	156-0	15	17	20	25	30	40	40	100	∞

XIV – DEPTH OF FIELD FOR LENSES OF 5½ INCH (137·5 mm.) FOCAL LENGTH

Values given as feet–inches. For each aperture the upper row is the near limit and the lower row the far limit; the bold figures are the focus settings.

Aperture	5	6	7	8	9	10	12	15	20	25	30	40	50	100	∞
f2 near	4-10¼	5-10½	6-9½	7-8¼	8-8	9-7	11-4½	14-1	18-5	22-6	26-6	34-0	41-0	69-8	229-3
f2 far	5-1½	6-2	7-2¼	8-3½	9-4½	10-5½	12-8	16-0½	21-11	28-1	34-6	48-6	64-0	177-6	∞
f2.5 near	4-10¼	5-9¾	6-9	7-8	8-7	9-6	11-3	13-10	18-0	22-0	25-10	32-10	39-3	64-9	183-4
f2.5 far	5-1½	6-2½	7-3½	8-4½	9-5½	10-7	12-10	16-4	22-4	29-0	35-10	51-2	68-9	220-0	∞
f3 near	4-10	5-9½	6-8½	7-7	8-6	9-4½	11-1½	13-8	17-8	21-6	25-0	31-8	37-8	60-5	152-9
f3 far	5-2	6-3	7-4	8-5½	9-7	10-8½	13-0	16-7½	23-0	30-0	37-4	54-2	74-4	290-0	∞
f3.5 near	4-9½	5-9	6-7½	7-6½	8-5	9-3½	11-0	13-5½	17-4	21-0	24-5	30-7	36-2	56-8	131-0
f3.5 far	5-2½	6-3½	7-4½	8-6	9-8	10-10	13-2½	16-11	23-7	31-0	38-11	57-6	81-0	422-6	∞
f4 near	4-9½	5-8½	6-7	7-5¾	8-4	9-2½	10-10½	13-3	17-0	20-6	23-9	29-8	34-10	53-6	114-7
f4 far	5-2½	6-4	7-5½	8-7½	9-9	10-11½	13-5	17-3	24-3	32-0	40-8	61-6	88-9	785	∞
f4.5 near	4-9¼	5-8	6-6½	7-5	8-3	9-1½	10-9	13-1	16-9	20-1	23-2	28-8	33-6	50-5	101-10
f4.5 far	5-3	6-4½	7-6	8-8½	9-10½	11-1	13-7½	17-7	24-10	33-2	42-3	66-0	98-6	∞	∞
f5.6 near	4-8½	5-7	6-5½	7-3½	8-1½	8-11	10-5½	12-8	16-1	19-2	22-0	26-10	31-0	45-0	81-10
f5.6 far	5-4	6-5½	7-8	8-10½	10-1½	11-5	14-1	18-4	26-6	36-0	47-4	78-3	128-8	∞	∞
f6.3 near	4-8¼	5-6½	6-4½	7-2½	8-0½	8-9½	10-4	12-5	15-8	18-8	21-4	25-11	29-9	42-4	73-6
f6.3 far	5-4½	6-6½	7-9	9-0½	10-3	11-7	14-4	18-10	27-6	37-11	50-8	87-9	156-6	∞	∞
f8 near	4-7¾	5-5½	6-3	7-0	7-9½	8-6	9-11	11-11	14-10	17-5	19-9	23-7	26-9	36-6	57-4
f8 far	5-5¼	6-8½	8-0	9-3½	10-8½	12-1½	15-2	20-4	30-9	44-4	63-6	132-6	391-0	∞	∞
f11 near	4-5½	5-3	6-0	6-8½	7-5	8-1	9-4	11-0	13-6	15-8	17-5	20-5	22-9	29-5	41-9
f11 far	5-8½	7-0	8-5	9-11	11-6	13-2	16-10	23-5	38-6	62-6	107-0	1000	∞	∞	∞
f16 near	4-3	4-11½	5-7½	6-3	6-10	7-5	8-5½	9-10	11-9	13-4	14-8	16-8	18-3	22-3	28-8
f16 far	6-0½	7-7	9-2	11-1	13-1½	15-3	20-3	31-6	66-3	198-6	∞	∞	∞	∞	∞
f22 near	4-0½	4-8	5-3	5-9½	6-3½	6-9	7-7½	8-9	10-2	11-4½	12-3½	13-8	14-9	17-3	20-11
f22 far	6-7	8-5	10-6½	13-0	15-10	19-3	28-4	53-7	92-4	500-0	∞	∞	∞	∞	∞
f32 near	3-8½	4-2¼	4-8½	5-1½	5-6½	5-11	6-6½	7-4	8-4	9-1½	9-8½	10-7	11-2	12-6	14-4
f32 far	7-8	10-4	13-8	18-2	24-2	33-0	73-9	∞	∞	∞	∞	∞	∞	∞	∞

XV - DEPTH OF FIELD FOR LENSES OF 6 INCH (150 mm.) FOCAL LENGTH

The bold figures are the focus settings (in feet and inches); for each aperture the upper figure is the near limit and the lower figure the far limit of depth of field.

f/	5	6	7	8	9	10	12	15	17	20	25	30	40	50	100	∞
f2 near	4-10¼	5-10¼	6-9¾	7-9	8-8	9-7½	11-5½	14-2	15-11	18-6	22-9	26-10	34-6	41-8	71-6	250-0
f2 far	5-1¼	6-2	7-2½	8-3½	9-4½	10-5	12-7	15-11½	18-3	21-9	27-9	34-1	47-7	62-6	166-8	∞
f2.5 near	4-10½	5-10	6-9¼	7-8¼	8-7½	9-6	11-4	13-11½	15-8	18-2	22-9	26-1	33-4	40-0	66-8	200-0
f2.5 far	5-1½	6-2¼	7-3	8-4	9-5	10-6	12-9	16-2½	18-7	22-3	28-7	35-4	50-0	66-8	200-0	∞
f3 near	4-10¼	5-9½	6-8½	7-7½	8-6½	9-5	11-2	13-9	15-5	17-10	21-9	25-5	32-0	38-5	62-6	166-8
f3 far	5-2	6-2½	7-3½	8-5	9-6	10-7½	12-11	16-6	18-11	22-9	29-5	36-7	52-8	71-5	250-0	∞
f3.5 near	4-10	5-9	6-8	7-7	8-5½	9-4	11-1	13-7	15-2	17-6	21-3	24-10	31-3	37-1	58-9	142-11
f3.5 far	5-2¼	6-3½	7-4½	8-5½	9-7½	10-9	13-1	16-9	19-3½	23-3	30-4	37-10	55-8	77-0	333-4	∞
f4 near	4-9¾	5-8¾	6-7½	7-6¼	8-4½	9-3	10-11½	13-5	15-0	17-3	20-10	24-2	30-3	35-9	55-7	125-0
f4 far	5-2½	6-3½	7-5	8-8½	9-8½	10-10½	13-3	17-0	19-8	23-10	31-3	39-5	58-9	83-4	500-0	∞
f4.5 near	4-9½	5-8½	6-7	7-5½	8-4	9-2	10-10	13-2½	14-9	16-11	20-5	23-8	30-0	34-6	52-8	111-2
f4.5 far	5-3	6-4	7-5½	8-7½	9-9½	11-0	13-5½	17-4	20-1	24-5	32-3	40-0	62-6	91-0	∞	∞
f5.6 near	4-8½	5-7½	6-6	7-4	8-2	9-0	10-7	12-10	14-3	16-4	19-6	22-6	27-7	32-0	47-2	89-3
f5.6 far	5-3½	6-5½	7-7	8-9½	10-0	11-3½	13-10½	18-0	21-0	25-9	34-9	45-2	72-6	113-6	∞	∞
f6.3 near	4-8½	5-7	6-5½	7-3½	8-1	8-10½	10-5	12-7½	14-0	16-0	19-1	21-10	26-8	30-9	44-6	80-0
f6.3 far	5-4	6-6	7-8	8-10½	10-1½	11-5	14-1½	18-4	21-7	26-8	36-4	48-0	80-0	113-4	∞	∞
f8 near	4-7½	5-5½	6-3¾	7-1	7-10½	8-7½	10-1	12-1	13-4	15-2	17-10	20-3	24-4	27-9	38-6	62-6
f8 far	5-5½	6-7½	7-9½	9-0	10-6	11-11	14-10	19-9	23-4	29-5	41-8	57-8	111-0	250-0	∞	∞
f11 near	4-6	5-3½	6-0½	6-9½	7-6	8-2½	9-6	11-3½	12-5	13-11	16-2	18-1	21-4	23-10	31-4	45-7
f11 far	5-7½	6-11	8-3½	9-8½	11-2½	12-10	16-3½	22-4	27-1	35-8	55-6	87-6	326-6	∞	∞	∞
f16 near	4-3¾	5-0½	5-8½	6-4½	7-0	7-7	8-8	10-1½	11-0	12-2	13-11	15-4	17-6	19-3	23-10	31-2
f16 far	5-11½	7-5	9-0	10-9	12-7½	13-10½	19-6	28-10	37-3	55-6	125-0	750-0	∞	∞	∞	∞
f22 near	4-1½	4-9	5-4½	5-11	6-5½	7-0	7-10½	9-0½	9-9	10-8	11-11	13-0	14-6	15-8	18-5	22-10
f22 far	6-5	8-1½	10-1	12-4	14-10	17-10	25-4	43-9	66-8	161-0	∞	∞	∞	∞	∞	∞
f32 near	3-9½	4-4	4-10	5-3½	5-8½	6-1	6-9½	7-8	8-1½	8-9	9-7	10-3	11-3	11-10	13-6	15-7
f32 far	7-4½	9-9	12-9	16-5	21-4	27-10	52-3	400-0	∞	∞	∞	∞	∞	∞	∞	∞

91

XVI – DEPTH OF FIELD FOR LENSES OF 7 INCH (175 mm.) FOCAL LENGTH

Focus distances set (ft) across the top (bold in original); for each aperture the upper figure is the near limit and the lower figure is the far limit (ft-in).

f /	6	7	8	9	10	12	15	17	20	25	30	40	50	100	200	∞
f2 near	5-10¼	6-10	7-9½	8-8¼	9-8	11-6¼	14-3	16-1	18-8¼	23-0	27-2	35-2	42-8	74-6	118-6	291-8
f2 far	6-1½	7-2	8-2¾	9-3½	10-4½	12-6½	15-10	18-0	21-6	27-4	33-6	46-6	60-6	152-0	636-6	∞
f2.5 near	5-10¼	6-9½	7-8¾	8-8	9-7	11-5	14-1	15-10	18-5	22-7	26-7	34-2	41-2	70-0	107-6	233-4
f2.5 far	6-2	7-2½	8-3½	9-4½	10-5½	12-8	16-0	18-4	21-10½	28-0	34-5	48-4	63-8	175-0	1400	∞
f3 near	5-10	6-9	7-8¼	8-7¼	9-6	11-3½	13-11	15-7½	18-2	22-2	26-0	33-4	39-9	66-0	98-8	194-3
f3 far	6-2¼	7-3	8-4	9-5¼	10-6½	12-9½	16-3	18-7½	22-3	28-8	35-6	50-4	67-4	206-0	∞	∞
f3.5 near	5-9½	6-8½	7-7½	8-6½	9-5¼	11-2½	13-9	15-5	17-10½	21-9	25-5	32-3	38-6	62-6	91-0	166-9
f3.5 far	6-2¾	7-3¾	8-5	9-6	10-7½	12-11	16-5½	18-11	22-9	29-5	36-7	52-8	71-6	250-0	∞	∞
f4 near	5-9	6-8¼	7-7	8-5¾	9-4¼	11-1	13-7	15-3	17-7	21-4	24-11	31-4½	37-3	59-4	84-6	146-0
f4 far	6-3	7-4¼	8-5½	9-7	10-9	13-1	16-8	19-3	23-2	30-2	37-9	55-0	76-0	318-0	∞	∞
f4.5 near	5-8½	6-7½	7-6½	8-5	9-3½	11-0	13-5	15-0	17-4	21-0	24-4	30-8	36-0	56-6	78-9	129-9
f4.5 far	6-3½	7-4¾	8-6½	9-8	10-10	13-2½	17-0	19-7	23-8	31-0	39-0	57-10	81-6	436-0	∞	∞
f5.6 near	5-8	6-6¾	7-5	8-3½	9-1½	10-9	13-1	14-7	16-9	20-2	23-4	28-11	33-9	51-0	68-6	104-3
f5.6 far	6-4½	7-6	8-8	9-10½	11-0½	13-7	17-6	20-4	24-9	32-11	42-2	65-0	96-0	2500	∞	∞
f6.3 near	5-7¼	6-6	7-4½	8-2½	9-0¼	10-7½	12-11	14-4	16-5	19-8	22-6	27-11	32-6	48-0	63-4	92-6
f6.3 far	6-5	7-7	8-9	9-11¼	11-2¼	13-9½	17-11	20-10	25-6	34-3	44-5	70-5	109-0	∞	∞	∞
f8 near	5-6½	6-4½	7-2½	8-0	8-9	10-3½	12-5	13-9½	15-8	18-8	21-3	25-10	29-6	42-2	53-6	73-0
f8 far	6-6½	7-9	8-11¾	10-3¼	11-7	14-4	18-10	22-2	27-7	38-0	51-0	88-6	159-0	∞	∞	∞
f11 near	5-4¾	6-2¼	6-11½	7-8¼	8-5	9-9½	11-8	12-10½	14-6	17-0	19-2	22-9½	25-9	34-8	42-0	53-0
f11 far	6-9¼	8-0¾	9-5	10-10	12-4	15-6	20-11	25-0	32-1	47-4	69-2	163-0	883-4	∞	∞	∞
f16 near	5-1¾	5-10½	6-6¾	7-2¾	7-10	9-0	10-7½	11-7	12-11	14-10	16-5½	19-1	21-1	26-9	30-10	36-6
f16 far	7-2	8-8	10-3	11-11½	13-9½	17-10½	25-6	31-10	44-3	79-5	168-6	∞	∞	∞	∞	∞
f22 near	4-10½	5-6¼	6-1¾	6-8¾	7-3	8-3	9-7	10-4	11-5	12-10	14-1	15-11	17-4	21-0	23-5	26-6
f22 far	7-9	9-6	11-5½	13-7½	16-1	21-11	34-7	47-6	81-6	441-6	∞	∞	∞	∞	∞	∞
f32 near	4-6¼	5-0¾	5-6¾	6-0¾	6-5½	7-3	8-3	8-9½	9-6½	10-6½	11-4	12-6	13-4	15-5	16-9	18-3
f32 far	8-11½	11-4½	14-3	17-9	22-2	35-0	84-2	248-6	∞	∞	∞	∞	∞	∞	∞	∞

XVII – DEPTH OF FIELD FOR LENSES OF 8 INCH (200 mm.) FOCAL LENGTH

	7	8	9	10	12	15	17	20	25	30	40	50	60	100	200	∞
f2	6-10¼	7-9½	8-9	9-8½	11-7	14-4	16-2	18-10¼	23-3	27-7	35-9	43-6	50-10	77-0	25-0	333-4
	7-1½	8-2¼	9-3	10-3½	12-5½	15-8½	17-11	21-3	27-0	32-9	45-6	58-10	73-0	143-0	500-0	∞
f2.5	6-10	7-9¼	8-8½	9-7½	11-6	14-2½	16-0	18-7	22-10	27-0	34-10	42-1	49-0	72-9	114-6	266-8
	7-2¼	8-3	9-3½	10-4½	12-7	15-11	18-2	21-7	27-7	33-10	47-1	61-8	77-6	160-0	800-0	∞
f3	6-9½	7-8½	8-7¾	9-6½	11-3½	14-0½	15-9½	18-4	22-6	26-5	33-10	40-10	47-3	69-0	105-0	222-0
	7-2½	8-3½	9-4½	10-5½	12-8	16-1	18-5	22-0	28-2	34-8	48-9	64-7	82-3	182-0	2020	∞
f3.5	6-9	7-8	8-7	9-6	11-4½	13-11	15-7½	18-1	22-1	25-11	33-0	39-7	45-8	65-6	97-6	190-6
	7-3½	8-4	9-5½	10-7	12-9½	16-3	18-8	22-4	28-10	35-7	50-7	67-11	87-9	210-6	∞	∞
f4	6-8½	7-7½	8-6½	9-5	11-2½	13-9	15-5	17-10	21-9	25-5	32-3	38-6	44-1	62-6	91-0	166-8
	7-3½	8-5	9-6	10-7½	12-11	16-5½	18-11	22-9	29-5	36-7	52-8	71-5	93-9	250-0	∞	∞
f4.5	6-8¼	7-7	8-6	9-4½	11-1	13-7½	15-3	17-7½	21-5	25-0	31-6	37-6	42-9	59-9	85-0	148-3
	7-4½	8-5½	9-7	10-8½	13-0½	16-8	19-2	23-1	30-0	37-7	54-7	75-6	101-0	304-6	∞	∞
f5.6	6-7½	7-6	8-4½	9-2½	10-11	13-4	14-10½	17-1	20-8	24-0	30-0	35-3	39-11	54-4	74-6	119-0
	7-5½	8-7	9-9	11-0	13-4	17-2	19-10	24-1	31-8	40-0	60-3	86-3	121-0	625-0	∞	∞
f6.3	6-7	7-5½	8-3½	9-2	10-10	13-2	14-8	16-10	20-3	23-5	29-1	34-0	38-6	51-8	69-7	106-8
	7-6	8-8	9-10	11-1	13-6	17-6	20-3	24-7	32-8	41-9	64-0	94-0	137-6	1600	∞	∞
f8	6-5½	7-3½	8-1½	8-11	10-6	12-8½	14-1½	16-2	19-3	22-1	27-0	31-3	35-0	45-6	58-9	83-4
	7-7½	8-10	10-1	11-4½	14-0	18-3	21-4	26-4	35-9	46-10	77-0	125-0	214-2	∞	∞	∞
f11	6-3½	7-0¼	7-10	8-7	10-0	12-0	13-3	15-0	17-8	20-1	24-1	27-4	30-7	37-8	46-5	60-6
	7-11	9-2½	10-7	12-0	15-0	20-0	23-8	29-10	42-8	59-6	118-0	288-0	∞	∞	∞	∞
f16	6-0	6-8½	7-5	8-0½	9-4	11-0	12-1	13-6	15-8	17-5	20-5	22-9	24-7	29-5	34-6	41-8
	8-5	9-11	11-6	13-2	16-0	23-5	28-8	38-5	62-6	107-0	1000	∞	∞	∞	∞	∞
f22	5-8	6-4	6-11¼	7-6	8-7	10-0	10-11	12-0	13-8	15-1	17-3	18-10	20-2	23-3	26-4	30-3
	9-1½	10-10½	12-10	14-11	19-11	29-9	38-10	59-0	144-0	∞	∞	∞	∞	∞	∞	∞
f32	4-8	5-9½	6-3½	6-9	7-7½	8-8½	9-4	10-2	11-4½	12-3½	13-8	14-8½	15-6	17-3	18-10	20-10
	10-6	13-0	15-10	19-3	28-4	53-6	91-6	500-0	∞	∞	∞	∞	∞	∞	∞	∞

93

XVIII – DEPTH OF FIELD FOR LENSES OF 10 INCH (250 mm.) FOCAL LENGTH

The bold middle row for each f-number is the focus distance setting (in feet); the upper value is the near limit and the lower value is the far limit of depth of field (feet-inches).

f	Focus → 7	8	9	10	12	15	17	20	25	30	40	50	60	100	200	∞
f2 near	6-10½	7-10	8-9½	9-9	11-8	14-6	16-4	19-1	23-7	28-0	36-6	44-8	52-6	82-4	135-0	416-8
f2 far	7-1½	8-2	9-2½	10-3	12-4	15-6½	17-9	21-0	26-7	32-4	44-3	56-9	70-0	131-6	384-0	∞
f2.5 near	6-10¼	7-9½	8-9	9-8½	11-7	14-4	16-2	18-10	23-3	27-6	35-9	43-6	51-0	77-0	125-0	333-4
f2.5 far	7-2	8-2¼	9-3	10-3½	12-5½	15-8½	17-11	21-3	27-1	33-0	45-6	58-10	73-3	143-0	500-0	∞
f3 near	6-10	7-9½	8-8½	9-8	11-6	14-3	16-0	18-8	22-11	27-1	35-0	42-4	49-4	73-6	116-6	277-9
f3 far	7-2¼	8-2½	9-3½	10-4½	12-6½	15-10	18-1½	21-6½	27-6	33-8	46-9	61-0	76-8	156-0	714-0	∞
f3.5 near	6-9½	7-9	8-8	9-7	11-5	14-1	15-10	18-6	22-7	26-8	34-3	41-4	48-0	70-6	109-0	238-3
f3.5 far	7-2½	8-3¼	9-4	10-5	12-7½	16-0	18-4	21-10	27-11	34-4	48-0	63-4	80-3	172-0	1234	∞
f4 near	6-9¼	7-8½	8-7½	9-6½	11-4	14-0	15-8½	18-3	22-4	26-3	33-6	40-3	46-8	67-3	102-0	208-6
f4 far	7-8	8-4	9-5	10-6	12-9	16-2	18-6	22-2	28-5	35-1	49-6	65-10	84-2	192-6	5000	∞
f4.5 near	6-9	7-8	8-7	9-6	11-3½	13-10½	15-7	18-0	22-0	25-10	32-11	39-4	45-4	65-0	96-0	185-3
f4.5 far	7-8¼	8-4½	9-5½	10-7	12-10	16-4	18-8½	22-5	28-10	35-10	51-2	68-6	88-9	217-6	∞	∞
f5.6 near	6-8½	7-7	8-6	9-4½	11-2	13-7½	15-3	17-8	21-5	25-0	31-6	37-6	42-9	60-0	85-5	149-0
f5.6 far	7-4	8-5½	9-7	10-8½	13-0½	16-8	19-2	23-1	30-0	37-7	54-7	75-3	100-0	304-0	∞	∞
f6.3 near	6-8	7-6½	8-5	9-3½	11-0	13-6	15-1	17-5	21-0	24-6	30-9	36-4	41-5	57-2	80-0	133-4
f6.3 far	7-4½	8-6	9-8	10-10	13-2	16-11	19-6	23-6	30-9	38-9	57-0	80-0	109-0	400-0	∞	∞
f8 near	6-6¾	7-5½	8-3½	9-1½	10-9	13-1	14-7	16-9	20-2	23-4	29-0	33-10	38-0	51-0	68-6	104-3
f8 far	7-6	8-8	9-10	11-0½	13-7	17-6	20-4	24-9	33-0	42-2	65-0	96-3	141-6	2500	∞	∞
f11 near	6-5	7-3	8-0½	8-10	10-4½	12-6	13-10½	15-10	18-10	21-6	26-2	30-1	33-0	43-0	55-0	75-8
f11 far	7-8½	8-11½	10-2½	11-6½	14-3	18-9	21-11	27-2	37-4	49-8	84-8	147-0	283-4	∞	∞	∞
f16 near	6-2	6-11¼	7-8	8-4½	9-9	11-8	12-10	14-5½	16-11	19-0	22-7	25-6	27-10	34-3	41-4	52-7
f16 far	8-1	9-5½	10-10½	12-4½	15-7	21-1	25-3	32-6	48-0	71-0	172-6	125-0	∞	∞	∞	∞
f22 near	5-11	6-7¾	7-3¾	7-11	9-1½	10-9	11-9	13-1	15-1	16-9	19-5	21-6	23-2	27-6	31-10	37-10
f22 far	8-7	10-2	11-10	13-7	17-7	24-10	30-10	42-6	73-9	145-0	∞	∞	∞	∞	∞	∞
f32 near	5-6½	6-1½	6-8¼	7-2¼	8-2½	9-6	10-3	11-4	12-9	13-11	15-9	17-1	18-2	20-8	23-0	26-4
f32 far	9-7	11-6½	13-9	16-3	22-4	35-6	49-0	86-8	650-0	∞	∞	∞	∞	∞	∞	∞

specific case of a 4-in. $f2\cdot7$ lens. The lenses given in the tables are $f2\cdot5$ and $f3$. If the depth of field for a 4-in. $f2\cdot5$ lens is used for the $f2\cdot7$ lens this corresponds to the use of a circle of confusion, not of $\cdot004$ in. diameter for a 4-in. lens, but to a diameter of $\cdot004$ in. \times $(2\cdot5/2\cdot7)$, or a difference in diameter of $7\frac{1}{2}$ per cent. On the other hand if the depth of field listed for a 4 in. $f3$ lens is taken as being applicable to a 4 in. $f2\cdot7$ lens, this amounts to assuming a circle of confusion of $\cdot004$ in. \times $(3\cdot0/2\cdot7)$ or a difference of 11 per cent. Taking the $f2\cdot5$ figures as being applicable to an $f2\cdot7$ lens means that a standard of definition higher by $7\frac{1}{2}$ per cent is adopted. Taking the $f3$ figures means that the definition is 11 per cent below the standard value of $\cdot001$ in. per inch of focal length.

Since the fall off in definition is taken to be uniform from the position of sharp focus, and not a slow fall off up to the limits of the depth of field, followed by a catastrophic degeneration, there is a considerable arbitrary element in fixing the limits of the depth of field. They have been worked out on the assumption of a disc of confusion of $\cdot001$ in. for each inch of focal length, and serve very well as a guide in fixing the region where the definition is up to standard. But it is to be remembered that they are a guide only, and that limits worked out with a disc of confusion 10–15 per cent larger or smaller would not yield very different pictorial results.

For all practical purposes a deviation of 10–15 per cent in the diameter of the disc of confusion is negligible. Hence the figures for $f2\cdot5$ or $f3$ are applicable to an $f2\cdot7$, or $f2\cdot8$ lens, and the $f3$ figures to an $f2\cdot9$ or $f3\cdot1$ lens. The same things holds for other unlisted apertures.

In the next place the lens focus may not be listed. Suppose for example that the lens to be used is a $4\frac{1}{4}$ in. $f4\cdot5$. If the figures for a $4\frac{1}{2}$ in. $f4\cdot5$ are assumed to be applicable, this amounts to taking a disc of confusion smaller than the standard by $(4\frac{1}{4}/4\frac{1}{2})$ i.e., by 6 per cent. Taking the 4 in. $f4\cdot5$ figures as applicable to a $4\frac{1}{4}$ in. $f4\cdot5$ means assuming a disc of confusion greater than the standard by $(4\frac{1}{4}/4\frac{1}{2})$ i.e. by 6 per cent. Again these discrepancies are negligible in practical work, and the same holds for other unlisted foci which can be dealt with in this way.

When both focus and aperture are unlisted the situation is

not essentially more complicated. Suppose for instance that the lens is a $3\frac{1}{4}$ in. $f2\cdot8$. Taking the $f3$ figures means assuming a disc that is larger by $(3/2\cdot8)$ i.e. by 7 per cent. Taking the $3\frac{1}{2}$ in. figures means assuming a disc smaller by $(3\frac{1}{4}/3\frac{1}{2})$ i.e. by 7 per cent. Hence the figures for a $3\frac{1}{2}$ in. $f3$ are applicable to a $3\frac{1}{4}$ in. $f2\cdot8$ with no appreciable error. The 3 in. figures mean a disc larger by $(3\cdot25/3)$ i.e. by 8 per cent and the $f2\cdot5$ figures a disc smaller by $(2\cdot5/2\cdot8)$ i.e. by 11 per cent, and hence the use of the 3 in. $f2\cdot5$ figures for a $3\frac{1}{4}$ in. $f2\cdot8$ lens mean that a disc of confusion is adopted that is smaller than the standard by 3 per cent, a negligible difference. The rule in these cases is that both the f numbers and the focus must move together in the same direction, e.g. $3\frac{1}{4}$ in. and $f2\cdot8$ to $3\frac{1}{2}$ in. and $f3$, or $3\frac{1}{4}$ in. and $f2\cdot8$ to 3 in. and $f2\cdot5$.

The tables have been calculated on the basis of a circle of confusion of $\cdot001$ in. for each inch of focal length, as this is probably the best value for all round use. Other values that are used are diameters two-thirds and one-half of this diameter, for the disc of confusion. These can be dealt with by taking the f number of the lens and multiplying it by two-thirds and by a half respectively, to get an equivalent f number, and then dealing with the lens solely on the basis of this equivalent f number. For instance, suppose that a lens in use is a 2 in. $f3$ and that the depth of field is to be calculated on the basis of a disc of half the standard diameter, i.e. $\cdot0005$ in. per in. of focal length, then the depth of field limits are those given for a lens of $f1\cdot5$ aperture and 2 in. focus. Alternatively the same circumstances can be dealt with by multiplying the focal length of the lens by $1\frac{1}{2}$ and 2 respectively, keeping the f number the same. Thus, in the example quoted, the limits of the depth of field are those listed for a 4 in. $f3$ lens.

The case where the focusing distance is not listed is not quite so easy to handle. Suppose that a 4 in. $f4\cdot5$ lens is focused on 22 ft. The limits for a focusing distance of 20 ft. are 15 ft. 9 in. and 27 ft. 4 in.; for a distance of 25 ft. they are 18 ft. 8 in. and 37 ft. 9 in. Hence for 20 ft. the range inside the focus is 4 ft. 3 in. and outside the focus 7 ft. 4 in., while for 25 ft. the range is 6 ft. 4 in. inside and 12 ft. 9 in. outside. For a focusing distance of 22 ft., what can be said is that the range inside the focus is between 4 ft. 3 in. and

6 ft. 4 in. and is nearer to the 4 ft. 3 in. position, say 5 ft., giving a near limit of 17 ft. Similarly we can set a far limit of about 31 ft. 6 in. An actual calculation gives the values 17 ft. 0 in., and 31 ft. 3 in. Estimates of this type give useful indications when the focusing distances are not listed.

In a minority of cases it may be advisable to recalculate the depth of field table for a particular set of apertures and focusing distances, and for a particular lens focus, but in the majority of cases the tables given, used as explained above, will suffice.

Depth of field values may also be obtained by the use of a calculating device, one form of this being the scale that is an integral part of the focusing movement of a lens on a miniature camera. A variety of charts and calculators have been available to meet individual needs, but in most instances depth of field tables give more accurate results.

For further remarks on depth of field see pages 137–141 and 194–196.

97

The Defects in Every Lens

The perfect lens described in the previous chapter is an abstraction which allows us to predict the general behaviour of a lens. It represents only a first approximation to the true state of affairs, and does not take into account the quality aspects of optical images.

In actual fact all lenses differ from one another in the quality or sharpness of the images that they produce. Some may come quite close to meeting the ideal performance of a perfect lens, while others may depart very considerably from this happy state. None achieves the level of perfect performance, and this is true in spite of claims in patents, and in advertisements which assert that perfection has been achieved. The faults in lens performance, which cause a degradation in quality from that associated with a perfect lens are the *aberrations*, and a statement that a lens is perfect is usually phrased in terms of correction of the aberrations.

A complete correction of the aberrations is not possible, and any claim relating to their correction must be interpreted as a conventional way of saying that they have been reduced to acceptable levels for a particular application.

In order to get a clear idea of what quality may be expected from a lens, we have to examine, in some detail, the mechanism of image formation, the types of aberrations which may arise, and the way in which a balance may be achieved between these various aberrations.

As an important first step we examine the way in which a lens bends light rays, so that an image is formed.

REFRACTION OF LIGHT

Whenever a ray of light crosses a surface separating glass and air it suffers an abrupt bending or refraction, as shown in Fig. 24. The angle that the ray makes with the line ON, perpendicular to the surface, is the *angle of incidence*. The

98

ANGLES OF INCIDENCE, REFRACTION AND DEVIATION

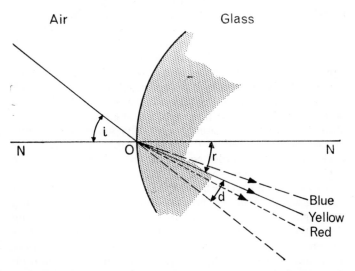

Fig. 24. A ray of white light is bent as it crosses the surface between air and glass, and is split into its component spectral colours. The *angle of incidence* is *i*. The *angle of refraction* for yellow light is *r*. The *angle of deviation* is *d*.

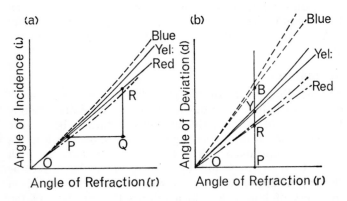

Fig. 25. (a) The curves in this graph show the relation between the angles of incidence and refraction for blue, yellow and red light. (b) The relations between the angles of deviation and refraction for blue, yellow and red light result from the *dispersion* of glass.

angle which it makes with the same line ON, after it has been refracted at the surface, is the *angle of refraction*. The amount of bending that the ray undergoes, the amount by which it deviates, after refraction, from the direction which it pursues before hitting the surface, is the *angle of deviation*, or merely the *deviation*, and is shown in Fig. 24.

One way of showing the amount of bending that a ray of light undergoes, for varying angles of incidence, is to draw two graphs dealing with different aspects of the bending. In the first graph, in Fig. 25a, the angle of incidence is plotted on the vertical line, and the angle of refraction is plotted along the horizontal axis. The graph shows how the two are connected. In the second graph, in Fig. 25b, the angle of deviation is plotted on the vertical line, against the angle of refraction on the horizontal.

It will be seen that the first part of each curve is very nearly a straight line. A point, moving along the curve connecting the angles of incidence and refraction, starts off moving along the line OPR. Once the slope of the line OPR is known, the rest of the curve follows in a perfectly definite way, and is obtained by purely mathematical calculation. Because of this fact, the behaviour of the glass in bending light can be described by giving the slope or gradient of the line OPR.

The slope of the line OPR, i.e., the height QR that a point on the line rises, when it travels a distance PQ equal to one unit in the horizontal direction, is called the *refractive index* of the glass, and measures the bending power of the glass.

DISPERSION

The bending power of the glass is not the same for all colours of light. A ray of blue light is bent more strongly than a ray of yellow light, and this in turn is bent more strongly than a ray of red light. This is shown in Fig. 24, where the unbroken line in the glass represents the path taken by a ray of yellow light, incident on the surface as shown; the dotted line shows the path taken after refraction by a ray of blue light which follows the direction of the yellow ray before striking the glass surface; the chained line shows the same situation for a ray of red light. This means that, when graphs are drawn, the curves relating to

100

different colours lie apart from one another, as shown in detail in Fig. 25. Here the dotted line again refers to rays of blue light, and the chained line to rays of red light. The slopes of the three curves, and the straight lines with which they coincide in their early stages, are different for the three colours mentioned. In other words the glass has a distinctive refractive index for each colour of light.

When the refractive index of a glass is mentioned, without any statement of the colour of light used, it can be assumed quite safely that the index has been measured for yellow light, and it will be assumed throughout this chapter that, unless a special mention is made, the index of refraction is that for yellow light.

The fact that glass bends light of different colours to different extents is known as the *dispersion* of the glass.

The graph in Fig. 25b comes in very useful in forming an estimate of the dispersion of the glass, and in measuring its dispersive power. Suppose that the straight lines from the early parts of the curves for blue light, yellow light, and red light, cut a vertical line drawn through the point P, in the points B, Y, and R, as shown in Fig. 25b. PY gives an estimate of the deviating power of the glass as far as yellow light is concerned. The same thing holds with PB and PR for blue and red light. BR gives an estimate of the difference of deviating power, as the colour of the light changes from blue to red. The dispersive power is then measured by giving the *Abbe number* of the glass, usually denoted by V, where

$$V = \text{length of PY} \div \text{length of BR.}$$

When the refractive index of a glass is given, and its Abbe number also, it is specified sufficiently closely for most optical purposes.

The exact value of the refractive index and Abbe number of a glass depends on the constituents of the glass. By using different materials glasses of very many types can be made.

For instance, in the case of Hard Crown glass, which has very nearly the same properties as ordinary plate glass, the index of 1·518 means that the slope of the straight line OPR in Fig. 25a, is 1·518, and the line is rising upwards at 1·518 times the rate at which it is travelling horizontally. The Abbe number of 60·3 means that in Fig. 25b the length of PY is 60·3 times the length of BR. (It does not matter

101

Glass Type	Refractive Index	Abbe Number (V)
Borosilicate Crown	1·5097	64·44
Hard Crown	1·5190	60·42
Light Barium Crown	1·5407	59·54
Medium Barium Crown	1·5694	55·77
Dense Barium Crown	1·6056	60·02
Dense Barium Crown	1·6134	59·27
Dense Barium Crown	1·6570	50·81
Telescope Flint	1·5303	51·19
Barium Light Flint	1·5743	52·02
Barium Flint	1·6048	43·83
Light Flint	1·5761	43·35
Dense Flint	1·6055	38·03
Dense Flint	1·6479	33·80
Double Dense Flint	1·8012	25·50
Special Barium Crown	1·6910	54·80
Special Barium Flint	1·7440	45·78
LaK 16	1·7335	51·04
LaK 19	1·7550	53·24
LaK 20	1·6935	51·56

where the vertical through BR is drawn. A new position merely scales up the lengths. The ratio of PY to BR stays the same).

All the glasses mentioned above, and many more, find their place in giving a good lens a high standard of performance.

Until recently the basic material of all optical glasses was silica—a very pure form of sand. There a high refractive index implied a low Abbe number. By the introduction of other rather expensive materials, such as lanthanum oxide, new glasses have been made which contain very little silica, and in which high Abbe numbers are associated with high refractive indices.

THE PATH OF LIGHT IN A LENS

The paths of the rays of light through a simple lens are shown in Fig. 26a.

Each ray, as it enters the glass, is bent towards the line which is perpendicular to the bit of the surface where the ray hits the glass. The area very near to each of the points where a ray meets the surface can be considered as flat, and

so there is no difficulty in drawing a line at right angles to the local portion of the surface. The relation between the angle of the ray in air and in the glass is given by the graphs in Fig. 25.

When each ray leaves the refracting medium, it is bent away from the line at right angles to the surface, but the relations between the angles in air and in the glass are the same as before. The net result of these two bendings is shown in Fig. 26a.

The main thing to notice is that the rays do not come to a sharp focus after they leave the lens. They cut the lens axis in different points, and the best that can be achieved in the way of forming an image, when all the rays that go through the lens are taken into account, is a disc of light on a sensitive surface or focusing screen.

When the rays come from a point which does not lie on the lens axis, exactly the same type of thing is found, but in an aggravated form, and the light patch produced on the plate is of a more complicated shape. The paths of the rays in this case are shown in Fig. 26b.

In addition to this type of behaviour there is the complication introduced because of the varying extents to which light of different colours is bent by the glass. The effects of this for one of the rays is shown in Fig. 27a. A ray of white light, containing in itself rays of red, orange and other colours, throughout the range of the spectrum, is shown meeting a single lens. The differing extents, to which light of different colours is bent by the glass, means that the single ray of white light is split up into a group of rays as soon as it crosses the first surface. This is shown in Fig. 27a. The red and blue rays are shown flanking the yellow ray. When the rays cross the second surface this divergence between the different colours is emphasised, and the rays of different colours cut the lens axis in different points.

To the extent that useful images are produced by such a lens, they are found at varying distances from the lens, depending on their colour. The blue image is nearest the lens, the greenish-blue next, followed by the green, the yellow, and so on down to the red image, which is farthest away.

When the initial ray comes from a point which does not lie on the lens axis there is another quite different colour

103

effect, as shown in Fig. 27b, where blue, yellow and red rays are drawn. The rays derived from an initial white ray, when they leave the lens, cut any plate in different points. In place of forming a clear cut image point, each ray of white light produces a tiny spectrum on the plate or focusing screen.

These colour effects are, of course, superimposed on the effects already mentioned, as a result of which a light patch is produced instead of an image point.

THE PERFECT LENS AGAIN

It is only by courtesy that such a piece of glass can be called a lens. The quality of definition it gives is unacceptable. But the performance can be improved by stopping it down, and by using a filter (page 347) which cuts off all except a very narrow band of colours. As the lens aperture is decreased, and the colour band restricted in width by the filter, there is a progressive improvement in the definition afforded by the lens. The limit that the lens is aiming at, as these restrictions on aperture and range of colour transmitted are tightened up, and the goal which it never attains, is that of a perfect lens. But, at the same time, to ensure this result, the field of the lens, the size of the plate it covers, must be cut down drastically to a quite infinitesimal area.

It is on the basis of this goal of lens performance under severe restrictions that all calculations on lens performance, such as those concerned with focal points and nodal points, are made.

Any lens when stopped down far enough, when used over a severely restricted field, and restricted to one colour of light, tends to behave as a perfect lens. (There is one feature of the way in which light travels and spreads, namely diffraction, which enters into the picture at very low lens apertures, and that tends to vitiate what has been said above. But for the present diffraction can safely be left out of things. A description of what it is, and how it introduces a new factor into the performance of a lens, is given later on page 128. It is out of place to discuss it at this stage.)

As the lens aperture and field, and colour range are opened out, from the quite impractical values needed to give the lens a semblance of being a perfect lens, flaws in the performance begin to appear, the so-called *aberrations*.

104

REFRACTION AND THE SIMPLE LENS

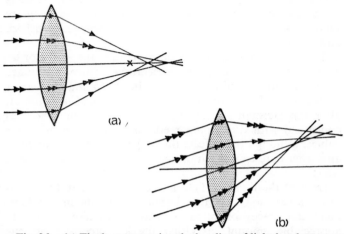

Fig. 26. (a) The laws governing the bending of light by glass mean that the rays bent by a simple lens do not meet again in the point required of a perfect lens. (b) When the rays of light are not parallel to the lens axis the bending of the light, according to the laws of refraction, results in a light patch being formed which is of a decidedly complicated form.

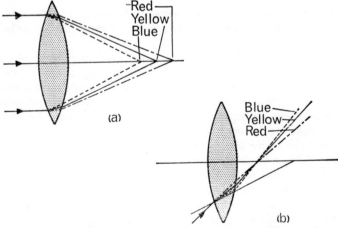

Fig. 27. (a) Blue light is bent more strongly than yellow and red light and so the blue rays cut the axis nearest to the lens. (b) In general a simple lens breaks up an oblique ray into a group of coloured rays which give a small spectrum on a focusing screen.

The aberrations are classed in several *orders*. For reasons which are beyond the scope of this book to detail, they are known as *third-order*, *fifth-order*, *seventh-order aberrations*, and so on.

The first aberrations to appear are the third-order aberrations. They are the only aberrations of any importance at lens apertures and fields below about *f*16 and 10 degrees respectively. They are often called the *Seidel aberrations*, after the German mathematician of that name who was concerned with developing methods of working out their values, although the defects themselves had been known at an earlier date to English opticians such as *Coddington* and *Airy*.

Even at the limits of field and aperture where the third-order aberrations are the dominating faults in the lens, there are traces of other aberrations. These appear in appreciable amounts as either the lens aperture or lens field, or both, are opened out beyond the values to which they must be restricted if only the third-order aberrations are to be taken into account. These traces of other aberrations are, of course, the initial values of the fifth-order, seventh-order aberrations, and so on. They are usually grouped as *higher-order aberrations*. As a rule it is of doubtful value to deal in detail with aberrations of higher order than the fifth.

Many accounts of lens aberrations have limited themselves to the third-order aberrations, which are, after all, the simplest to describe and deal with. But it is really the higher-order aberrations that in many cases finally determine a lens performance. It is a comparatively simple matter, especially with the most recent types of glass, to correct a lens for all the third-order aberrations. When that is done, however, the fifth and higher-order aberrations come into play strongly, and steps have to be taken to correct these new defects. These same steps, which are taken to eliminate the higher-order aberrations, as far as this is possible, lead to the re-introduction of the third-order aberrations.

The whole art and science of producing a new lens consists in balancing the third and higher-order aberrations so that a minimum amount of each remains. None of them

are entirely eliminated. It is these residual amounts of aberration which determine the quality of a lens performance, and it is appropriate, therefore, to give a short account of what they are and the results that they produce.

The aberrations can best be described as belonging to six different types, each having its own characteristic contribution to the quality of the picture produced by a lens. They are

1. Spherical Aberration
2. Coma
3. Astigmatism and Field Curvature
4. Oblique Spherical Aberration
5. Distortion
6. Chromatic Effects,

and are dealt with in this order.

SPHERICAL ABERRATION

Whatever else a lens may be expected to do, it is expected, except in the case of an avowedly soft-focus portrait lens (page 278), to give a really crisp and sharp image in the centre of the negative. Whether this result is achieved, or not, depends on the amount of *spherical aberration* in the lens.

And whether the focal plane of the lens changes, or not, as the lens is stopped down, depends as far as central definition is concerned, i.e. definition in the centre of the picture, on the amount of spherical aberration.

In Fig. 28a rays of light parallel to the lens axis are shown as they are bent by a simple converging lens. Next in Fig. 28b are shown the same rays as they are bent by a simple diverging lens. The fact to note is that, in each case, the rays which pass through the margins of the lenses converge to, or diverge from, points nearer to the lens than do the rays from more central parts of the lenses. In each case the marginal rays are bent more strongly than the rays through the more central parts of the lens.

This feature of the performance of any lens, namely that rays of light (of one particular colour) initially parallel to the lens axis are bent by the lens, so that the rays from the margin of the lens cut the axis in points other than those in which it is cut by rays from inner zones, is the *spherical aberration* of the lens.

107

Using the fundamental laws of refraction discussed in the early part of this chapter, it is a simple matter to prove mathematically that if the polished surfaces of a single lens are spherical in shape, then all the rays passing through the lens from a point object cannot converge to a single point image. Hence the name *spherical aberration*. This aberration can, however, be completely removed in single lenses whose surfaces are not spherical. Photographic lens surfaces have to be made to a very high accuracy of shape, an accuracy measured in terms of a few millionths of an inch. Since the desired precision is only possible, economically, on spherical surfaces, it follows that spherical aberration is an important limitation on lens performance.

When the rays are bent by a lens, so that the rays from the margin of the lens cut the axis nearer to the lens than those from inner zones, as shown for a simple lens in Fig. 28, then the lens has *under-corrected spherical aberration*.

A simple lens always has under-corrected spherical aberration. The exact amount, for a lens of a given focus, depends on the shape of the lens. With a single lens of crown glass, having a refractive index of $1 \cdot 52$, the minimum amount of spherical aberration is obtained when the shape of the lens is as shown in Fig. 28c, which shows a lens of 4-in. focus.

A simple diverging lens, as illustrated in Fig. 28b, always tends to make the rays of light through the marginal parts diverge away from the axis to a greater extent than rays through the more central zones, as also shown in Fig. 28b. The excessive divergence of the marginal rays depends on the shape of the lens, on the ratios of the curvatures of its two surfaces, in exactly the same way that the excessive convergence of the marginal rays in a converging lens depends on the shape of the lens.

The most important result of this fact is that a converging lens can be combined with a diverging lens of lesser power, so that the combination of the two lenses is converging, and by a proper choice of the shape of the diverging lens the excessive convergence and divergence of the two lenses can be balanced. In such a combination of two lenses the marginal rays through the pair may be brought to the same focus as the rays through the innermost zones of the lenses.

108

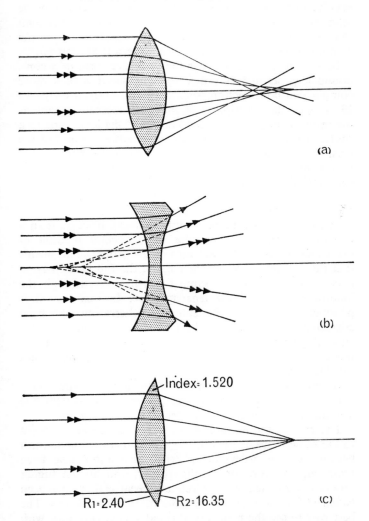

Fig. 28. (a) With a simple converging lens the rays farthest from the axis converge too strongly, and cut the lens axis in points that lie progressively closer to the lens. (b) The rays which are bent by the marginal parts of a diverging lens appear to come from points which are progressively closer to the lens. (c) By a suitable choice of lens shape, as shown, the spherical aberration of a simple lens may be reduced to a minimum, but not to zero.

109

By a suitable choice of the shape of the negative lens, the rays through the margin of the compound lens may be made to come to a focus farther away from the lens than that corresponding to the innermost zones. In this case the compound lens has *over-corrected* spherical aberration.

In any lens, whether it has the primitive form of a compound lens, as just described, or whether it is of a more complicated construction, such as that described on pages 233 *et seq.*, the description of spherical aberration remains the same: If rays through the margin of the lens come to a shorter focus than rays through the innermost zones of the lens, the lens has under-corrected spherical aberration; if they come to a longer focus, the lens has over-corrected spherical aberration.

ZONAL ABERRATION

When a lens is of a more complicated construction than a primitive compound lens, the same general method of using one or more negative lenses of the proper shape means that rays of light through the edge of the full lens aperture may be brought to the same focus as rays through the innermost zones of the lens aperture. In this case it is possible to say that the spherical aberration has been corrected, but this cannot be taken as indicating that the lens will give good central definition. It may still happen that the definition in the centre of the film or plate is not satisfactory.

Because of the importance of having a really sharp definition in the centre of the picture, it is worthwhile examining the matter in more detail.

The rays at the margin of the lens aperture are brought to the same focus as rays through the innermost zones, not because all the orders of spherical aberration have been removed, the third order, fifth order, and all the higher orders as explained on page 106, but because they have been *balanced* for the rays through the margin of the lens. The best way to see the results of this balancing, is to deal with the effects of third order and fifth order spherical aberration separately, and then to combine the two aberrations.

Suppose that a lens suffers from third-order spherical aberration only, and has under-corrected spherical aberration only. Then all the rays through the lens show a

progressive shortening of focus as their distance from the lens axis increases. This is shown in Fig. 29a; the graph on the right of the figure measures off more clearly the shortening of focus for rays from a particular zone. The distance which a point on the graph is to the left of the vertical line shows how much the rays from a zone, at that height above the lens axis, fall short of the focus of rays through the innermost zone.

Next, suppose that a lens suffers from fifth-order overcorrected spherical aberration only. The rays from different zones of the lens come to progressively longer foci as the distance of the zone from the lens axis increases. This is shown in Fig. 29b, where again the graph at the right of the diagram shows the progressive lengthening of focus in a clearer way. The point to notice about the graph in this case is the following: in its early stages it hugs the vertical line much more closely than does the curve for third-order spherical aberration, and in the later stages of its course it is leaving the vertical line at a much more rapid rate than the third-order curve.

And now take the type of thing which occurs in practice, where the lens contains both aberrations at the same time.

At the edge of the lens aperture the under-correction from the third-order just balances the over-correction from the fifth-order, and the rays from this region of the lens aperture come to the same focus as the rays from the innermost zones of the aperture, as shown in Fig. 29c.

In regions not too remote from the centre of the lens aperture the third-order spherical aberration dominates everything else, and there is a progressive shortening of the focus of rays through succeeding zones. As these zones move out from the centre of the lens aperture, the fifth-order aberration tends to slow up the rate at which this shortening takes place, and finally stops it. Beyond this point the fifth-order aberration takes control, and there is an increasingly rapid lengthening of focus until the margin of the lens aperture is reached. The whole behaviour is shown in Fig. 29c.

This is the type of performance of practically every lens made. The fact that the rays through an intermediate zone come to a shortest focus is referred to as the *zonal spherical aberration* of the lens. The zonal spherical aberration is of

the greatest importance in determining the quality of definition given by a lens.

In many cases the fifth and higher-order aberrations (only the fifth order was dealt with explicity above, but the higher-orders of spherical aberrations have exactly the same effect) are adjusted so that the rays through the extreme margin of the lens come to a slightly longer focus than do the rays from the innermost zones of the lens aperture. This procedure helps to move the position of shortest focus away from the lens, but it cannot be over-done without giving the lens poor definition because of too much over-corrected spherical aberration in the marginal zones.

Since the rays from each zone of the lens come to a different focus, each zone of the lens aperture produces a ring of light on a plate or film, instead of a point of light. From the whole lens aperture there is produced a disc of light. The size of this disc depends on the size of the zonal spherical aberration, and it should be realised that the zonal aberration cannot be eliminated. All that can be done is to try to reduce it to a reasonably small amount.

Enough has been said in this section to show that only a conventional value can be put upon any claim that the spherical aberration in any lens has been corrected. All that such a statement implies is that there is not too much over-correction of spherical aberration at the margin of the lens aperture, nor too much zonal spherical aberration.

Whether the judgment of the maker as to what constitutes "too much" agrees with the judgment of the photographer can only be determined by actual test. More about the effects of spherical aberration, and the techniques of examining a lens for its presence, are described in the less theoretical pages 151 *et seq.*, dealing with lens evaluation.

COMA

Suppose, although it cannot be realised in practice, that the spherical aberration of a lens has been absolutely and completely corrected. It simplifies matters considerably in the following discussion to make this assumption, and then afterwards to make an allowance for the fact that it is not an exact statement of the truth.

In just the same way all the other aberrations that afflict

Fig. 29. (a) The effect of third order or Seidel under-corrected spherical aberration is to make rays from zones of the lens aperture come to progressively shorter foci as the zone diameters increase. (b) Fifth order over-corrected spherical aberration causes a progressive lengthening of the focus of rays from zones of the lens aperture. (c) The case of practical importance when both are present results in a shortening to a minimum followed by a lengthening of the focus positions. It gives rise to *zonal spherical aberrations*.

113

a lens, and which cannot be completely eliminated, will be assumed to be absent, with the exception of *coma*.

Coma comes into play only when a point object which does not lie on the lens axis is sending light to the lens. As far as central definition is concerned spherical aberration is the only aberration, apart from chromatic aberrations (cf. pages 130–137), that has any effect. Away from the centre of the field other aberrations, of which coma is one, come into play and the *lens stop* has a new role to fulfil.

When the *stop* or *iris diaphragm* is used to cut down the diameter of a beam of light which is parallel to the lens axis, as explained at an earlier stage (on page 66), then the same part of the lens surface is used, no matter what the stop position may be.

But when a point which is not on the lens axis is being considered, the position of the stop determines what part of the actual glass surface is to be used. This is shown for the case of a simple lens in Fig. 30. The fact that a different part of the glass is used when the stop is in front of the lens, from that which is used when the stop is behind the lens, means that the aberrations are different in the two cases, and that they depend on the position of the stop. This is of the utmost importance in establishing a lens construction which will give good definition, and holds whether the lens is of the simple construction shown, or whether it is of a more complicated form. Among other things this fact was responsible for the early vogue of the *rapid-rectilinear* and *symmetrical* type of lens (page 235).

When a lens is used to form an image of an object point not far away from its axis, and when the lens aperture is closed down to a very small diameter, say *f*64, the lens behaves sensibly as a perfect lens.

As the stop diameter is increased, to *f*8 say, and the field increased to 4 or 5 degrees, the light on the focusing screen is drawn out into a patch of light due to the operation of third-order coma. The shape of this patch is shown in Fig. 31. It is formed by the super-imposition of circular rings of light which come from different zones of the lens aperture. These rings are progressively displaced as the diameter increases. While its absolute size varies from lens to lens, its shape remains always the same. The light patch fades away in intensity from the head of the patch like the

114

Fig. 30. When the stop is in front of the lens, as shown in (a), a different part of the lens is used from that which is used when the stop is behind the lens, as shown in (b).

Fig. 31. The third order or Seidel coma patch is built up from a series of rings of light from zones of the lens aperture. These rings are displaced from one another. In (a) we have *outward coma* in (b) we have *inward coma*.

115

tail of a comet, hence the name. The coma tail may point away from the lens axis, in which case there is *outward coma*, or it may flare in from the head of the patch towards the lens axis, forming *inward coma*, as also shown in Fig. 31.

As the lens aperture and field are opened out other orders of coma begin to appear, particularly those of the fifth order. There are two types of fifth order coma. The first is *circular coma*, in which circular light rings are formed after the manner of third order coma. The second is *elliptical coma*, in which elliptical light rings are successively displaced from an ideal image point. The density distribution in the two types of coma is different, and the ways in which the light patches change in size over the field of the lens also obey different laws.

In general we can say that the effect of third, fifth and higher orders of coma, is to give an unsymmetrical flaring away of the patch of light in the image plane. The coma tail, as before, may be either inwards towards the lens axis, or outwards away from the axis. The amount, and even the direction, of the major coma flare may vary over the field covered by the lens, according to the relative amounts of the different orders of coma which are present.

ASTIGMATISM AND FIELD CURVATURE

The characteristic effect of astigmatism is that one set of lines on a photographic plate is sharply in focus, and at the same time another set, at right angles to the first, is out of focus. When there is pure curvature of field both sets of lines are equally well in focus on a curved plate or film. The two things, astigmatism and curvature of field, are so intimately connected that it is best to deal with them at the same time.

To start with it will be taken for granted that all the aberrations, with the exception of astigmatism and curvature of field, are absent, and that the lens has been restricted both in aperture and field covered to small limits, say $f16$ and 5 degrees respectively, although these are only very approximate figures to give something concrete to go by.

When there is pure curvature of field in the lens, sharp images of object points are formed, but in place of such image points lying on a plane, the flat surface of a plate or

116

ASTIGMATISM
AND FIELD CURVATURE

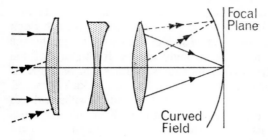

Fig. 32. With pure *field curvature* the image points lie on a spherical surface.

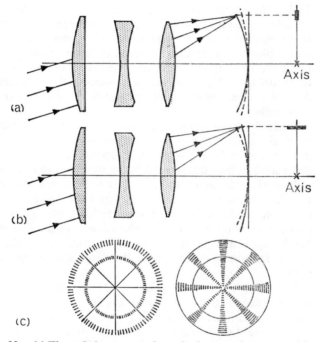

Fig. 33. (a) The *radial astigmatic focus*, for image points reasonably close to the axis, also lies on a spherical surface. (b) The *tangential astigmatic focus* also lies on a spherical surface, whose position relative to the surface in (a) is shown in this diagram. (c) Radial astigmatism causes a progressive blurring of circular lines in the image (*left*), while tangential astigmatism causes a progressive blurring of radial lines (*right*).

117

film, they lie on a curved surface. Quite accurately enough for small fields, they lie on the cap of a sphere, of which a section is shown in Fig. 32. The radius of this sphere depends only on the glasses of which the lens is made, and the respective powers of the elements, and is given through a number called the *Petzval sum* of the lens. The greater the Petzval sum the more strongly curved is the cap of the sphere, and the smaller its radius. With a normal type of anastigmat, such as a symmetrical lens or Cooke Triplet (cf. page 240), the Petzval sum is positive and the spherical cap is concave to the lens, as shown in Fig. 32. With some types of telephoto lens the Petzval sum is negative and the sphere is convex to the lens.

With the sharp image points lying on a curved surface the field of the lens is curved, in the sense that the best definition would be obtained on a film bent to fit the spherical surface. If the Petzval sum of a lens is zero the sphere flattens out into a plane. It is rarely, if ever, a practical proposition to make the Petzval sum zero, as other aberrations have also to be looked after, but a certain amount of flattening of the field of the lens may be carried out by a judicious use of astigmatism.

When there is astigmatism in the lens, as well as curvature of field, each object point in front of the lens has two images, one behind the other. Each of these images is a short straight line, instead of a point, and the two lines are at right-angles to each other. The two lines are shown in Fig. 33a, b. One line points away from the lens axis, like a fragment of the spoke of a wheel: this is the *sagittal* or *radial* astigmatic line, or just the *radial image*. The other line image is at right angles to a line drawn from the lens axis to the image point, and is the *tangential* or *transverse* image.

The relative positions of the radial and transverse images are also shown for one typical case in Fig. 34a, and their varying positions, for different positions of the object point in front of the lens, are indicated by the curves which are cross-sections of image surfaces. When there is only curvature of field the sharp image points lie on the cap of a sphere marked PP in Fig. 34a. With astigmatism present, however, the radial lines lie on the cap of the sphere marked RR, and the transverse lines on the cap of the sphere

118

Fig. 34. Because of astigmatism, there is a separation of the relative positions of the Petzval surface and the radial and tangential focal surfaces. (b) Between the radial and tangential surfaces the image is circular. By varying the amount of astigmatism present the radial and tangential focal surfaces may be made to take the forms shown in (c), (d) and (e).

marked TT in Fig. 34a. Midway between the spheres RR and TT of the radial and transverse image lines, the bundle of rays from the lens which converge to form these lines have a circular cross-section. For various positions of the object point the corresponding circular sections lie on the sphere marked CC in Fig. 34b.

By suitably arranging the astigmatism in the lens, the surfaces RR and TT can be bent over to have the shape shown in Fig. 34c, and in this case the circular sections or circular image discs lie on a flat surface. It is often assumed that the best all-round performance, which a lens suffering from curvature of field can give, is obtained when the astigmatism is adjusted so that the circular sections lie in a plane, in which the sensitive film can be placed. The diameter of the disc, obtained as the image in this case, is only half the diameter of the out-of-focus disc which would have been obtained if a flat plate had been used with a lens suffering from pure curvature of field.

Other possibilities are shown in Fig. 34d, e. The astigmatism may be adjusted so that either the radial or transverse image lines are made to lie on a flat surface.

When the radial lines lie on a flat surface, then the edges of the image in the focal plane which stretch away from the lens axis are sharply defined, and the edges that stretch across the field, as shown in Fig. 33c, are blurred. When the transverse lines lie on a flat surface the order of sharp definition and blurred definition is reversed, as also shown in Fig. 33c.

In practice it is not possible to make the Petzval sum zero and to correct the astigmatism at the same time, so that sharp image points are obtained on a flat surface. With a good quality lens of about $f3$ aperture, having a focal length of 4 in., the radius of the sphere given by the Petzval sum is about 10 in. to 16 in.

HIGHER ORDER ASTIGMATISM

When a lens has to cover a larger size of field than the small field referred to on page 116, such as the field required in still photography, there is another particularly important feature of the lens performance which has to be taken into account. This is the fact that, while the radial and transverse image surfaces are spheres in the early parts of their careers,

120

ASTIGMATIC SURFACES

Fig. 35. With images that lie further away from the lens axis the astigmatic focal surfaces may fold back and take the shapes whose cross-sections are shown in (a) and (b). These astigmatic surfaces are adjusted for a narrow angle in (c), and for a wider angle in (d).

and are then quite rapidly diverging from one another, in the later stages of their careers higher-order astigmatism may come into play and bend the two surfaces back again. Typical examples of such behaviour are shown in Fig. 35.

There are no simple rules giving the rate at which the two astigmatic surfaces bend back. In any lens, in order to get the best possible average performance over the field covered, the astigmatism and curvature of field have to be adjusted so that the radial and transverse image surfaces deviate as little as possible from the plane of the sensitive film. Even in the best lenses this deviation is by no means negligible, and with a 4-in. focus lens, covering a plate with a diagonal of 4 in., and having the radial and transverse surfaces as shown in Fig. 35a, the surfaces may each deviate from the plane of the film or plate by ·02 in., and give a pronounced falling off in image quality.

Because of this behaviour of astigmatism in a lens, it is always advisable to use the lens which is designed for the plate size of the camera employed. If the lens has been designed for a smaller field then the marginal definition will suffer considerably, especially owing to the tendency of the transverse image surface to go racing away, as shown in Fig. 35c. If the lens has been designed for a larger field, then some quality of definition is lost because the astigmatism has been adjusted so that there will be no severe falling off in definition at the edge of the larger field, and a sacrifice of definition in the intermediate regions has to be made in order to ensure this result. In Fig. 35c, d are given diagrams showing the typical image surfaces for a lens designed to cover various sizes of field. These emphasise the need for choosing the lens carefully to cover just the field for which it was designed.

OBLIQUE SPHERICAL ABERRATION

Astigmatism, as described in the preceding pages, is observed when the lens is used at comparatively low apertures. As the lens aperture is opened up the simple astigmatic behaviour is complicated by the onset of other aberrations. Some of these have already been described, namely spherical aberration and coma. Spherical aberration results in a symmetrical light fringe, surrounding the

astigmatic lines, which remains the same size throughout the field of the lens, and remains in evidence even in the centre of the field. Coma of all orders gives an unsymmetrical light flare, which varies in size over the field covered by the lens.

When an analysis is made of the fifth order aberrations it is found that a new type of aberration must also be taken into account, the so-called *oblique spherical aberration*. This gives a symmetrical light flare, surrounding the astigmatic lines, which increases rapidly in size as the image point moves away from the centre of the field. It vanishes in the centre of the field.

In actual fact this aberration is compounded from two separate aberrations, which vary at the same rate as the image point moves away from the centre of the field. The first of these aberrations gives a circular light patch. The second, the *bow-tie* (or *alate*) aberration gives a light patch shaped like a figure eight, with its length stretching along a line joining the image point to the centre of the field, as shown in Fig. 36a. The relative amounts of these two aberrations in any lens depend on the detailed characteristics of the lens radii, thicknesses, etc., but they remain constant over the field of any individual lens construction. A feature of particular interest is the resultant shape of light patch which corresponds to varying proportions of the two aberrations, as shown in Fig. 36. With pure bow-tie aberration we get the figure-eight patch already referred to. As the proportion of the circular aberration is increased, the figure-eight light patch changes, as shown, until it becomes the *asteroid* figure. After that, as the proportion increases, there is a progressive change until a figure eight light patch is obtained which is at right angles to the original light patch of the same shape.

DISTORTION

The last of the aberrations which are not concerned with colour effects is *distortion*, and it is probably the easiest to describe and to deal with.

What has been discussed above has been related to the quality of an image from the point of view of obtaining perfectly sharp rendition. In dealing with distortion, however, attention is directed to the aspect of definition which is

123

reflected in the faithful reproduction of the shape of the object being photographed.

Since an object point in front of the lens has as its image a patch of light on the focusing screen or sensitive material, the first question to settle is: what is the shape of the image when it is not perfectly defined? How can the position of the light patch be defined?

The method of fixing the image shape, and of locating the image of a point, is to stop the lens down so that only a single ray of light can get through. This is the *principal ray*. In actual practice this is something that cannot be realised, since it is not possible to define anything as inexact as the diameter of a ray of light. But if the lens is stopped down to about f64, the rays which go through it are following so nearly the same path, that it is not stretching things too far to think of them as being a single ray filling this small lens aperture.

If the lens is focused on the plate so that the central definition is at its best, then the point where the principal ray cuts the focal plane is the position of the image point. The convention is adopted that further rays, which get through when the aperture is opened out, serve only to mar the definition of the image, and not to disturb its position.

The image position so defined may be either nearer to, or further from the axis of the lens, than the position it would occupy if the shape of the image were exactly that of the object. Call this last position the ideal image position. The two possibilities are shown in Fig. 37. In either event, the deviation of the actual image position from the ideal position increases rapidly as they both move away from the lens axis. From this it follows that, when the actual image position is further away from the lens axis (and the centre of the negative) than the ideal position, the lens suffers from *pin-cushion distortion:* a square grille of lines in front of the lens is reproduced with the shape shown in Fig. 37c. When the actual image position is nearer to the lens axis than the ideal position, the lens suffers from *barrel distortion*, and a square grille of lines is reproduced with the shape shown in Fig. 37d.

Exactly the same results hold when the lens aperture is opened out, even though the quality of definition falls off

124

OBLIQUE SPHERICAL ABERRATION

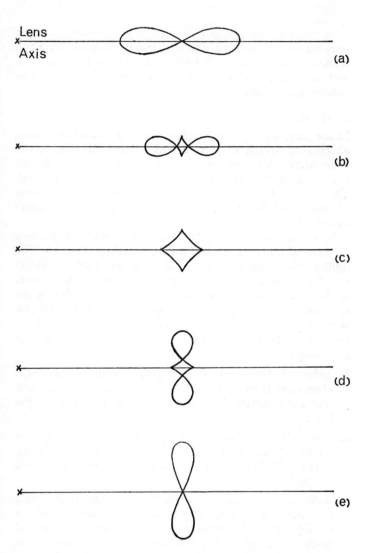

Fig. 36. In the presence of fifth order *oblique spherical aberration* the light patch may take on a variety of shapes, as shown in (a)-(e).

125

slightly. A grille of straight lines is reproduced with just the same types of shape as those shown in Fig. 36.

Zonal distortion effects are of negligible importance in dealing with most photographic lenses.

In practice most modern lenses of good quality possess only traces of distortion, and to detect it needs a careful and scientific examination. (Telephoto lenses are an exception, and so are afocal attachments. Zoom lenses will also exhibit distortion).

In the previous pages we have discussed the monochromatic aberrations which may be found in any lens, i.e., those aberrations which are not related to the chromatic or colour effects, as if only one aberration at a time were present. This represents a convenient abstraction, since the character of individual defects in performance can be more clearly described.

In actual practice, of course, there is present in any lens a mixture of all these aberrations, in varying amounts. The light patches which are then obtained may have decidedly complex forms. Up to a few years ago no attempts were made, in the course of the design process, to evaluate the complex shapes arising from a mixture of all the aberrations. We were content to classify the shapes of the light patches in terms of general characteristics, such as the following:

1. *Spherical Aberration.* A light patch exhibiting spherical aberration is characterised by a symmetrical flare, which remains constant in size throughout the field of the lens;

2. *Coma.* With coma present the light patch exhibits an unsymmetrical flare, whose size and shape may change over the field of the lens, but which vanishes at the centre of the field;

3. *Astigmatism.* With a light patch exhibiting astigmatism two focusing positions may be found. In the first position the light patch becomes a short fine line; in the second position the light patch also becomes a short fine line, at right angles to the line encountered in the first focusing position;

PINCUSHION AND BARREL DISTORTION

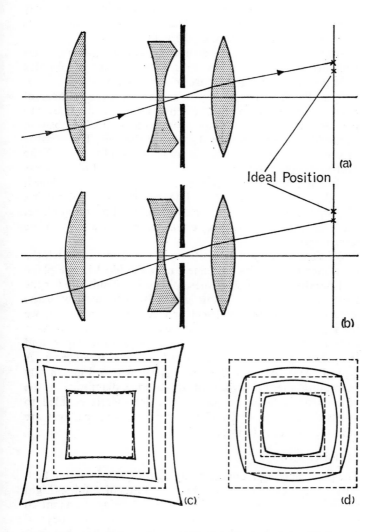

Fig. 37. When there is *pincushion distortion* in a lens, the actual image point lies further from the axis than the ideal image position, as shown in (a). With *barrel distortion* the corresponding situation is shown in (b). The effect of pincushion distortion is shown in (c), of barrel distortion in (d).

127

4. *Oblique Spherical Aberration.* In this case a symmetrical light patch is obtained (with two axes of symmetry). Its size increases rapidly as the image point moves away from the centre of the field, and the light patch shrinks to a point in the centre of the field.

With the widespread use of electronic computers it has become feasible to examine in detail the forms of complex light patches, through the use of *spot diagrams.*

In order to generate a spot diagram a large number of rays are traced through the lens. They are divided into groups, each group corresponding to a particular position of the ideal image point in the field of the lens. The number of rays in each group depends somewhat on the taste of the optical designer, but in a typical instance it will be in excess of four hundred rays. The rays in any group are so chosen that the points in which they intersect the plane of the iris diaphragm of the lens are evenly distributed over that plane. Each ray thus represents an equal amount of energy in the image plane.

We then compute the positions of the points in which the rays intersect a series of planes, near the ideal image plane and parallel to it. Each of these planes is a candidate for the location of the film or plate which is to be used with the lens. Using suitable electrical or electronic equipment, we then plot on paper the points whose locations we have computed. Each ray gives rise to a *spot* on the paper, and the whole group of them constitutes a *spot diagram.* A typical array of spot diagrams is shown in Fig. 38. By examining the behaviour of these spot diagrams in the various possible image planes, the designer is enabled to assess the lens quality, and to determine what changes are desirable in order to improve it.

DIFFRACTION

The passage of light energy along light rays is, in actual fact, only an approximation to the true state of affairs. Light energy is more precisely regarded as being transmitted by wavefronts of electric and magnetic force. It is beyond the scope of this book to discuss this in detail, but it is important to recognise at least one of the consequences of this more accurate view of light propagation.

The rays of light are perpendicular to the wavefronts of

SPOT DIAGRAMS

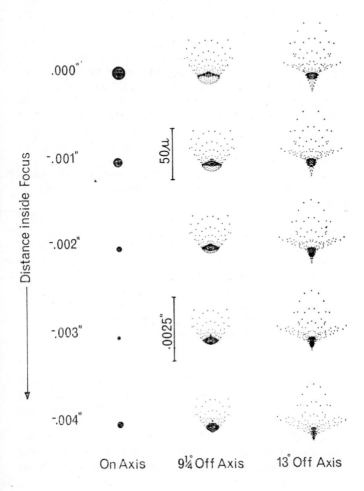

Fig. 38. This array of spot diagrams, for a point on the axis, at the margin of the field (13° for a 12-in. $f5 \cdot 6$ lens) and at an intermediate image position, shows how the light patch changes as the image plane takes up a sequence of positions. The spot size shown is about 130 times actual.

129

the light. In general the light tends to travel along these rays, and as a result of this to form sharp and well defined shadows. Because of the wave-front propagation, however, light also has a tendency to spread out, to curl round the edges of an obstacle which is casting a shadow, so that the boundaries of the shadow are no longer sharp and clear-cut. For example the wavefront theory demands that, under carefully arranged conditions, there should be a bright spot at the centre of the shadow of a small disc, such as a six-pence. When this was first deduced on theoretical grounds it seemed to mark the end of the wavefront theory, but careful experimentation proved that such a bright spot does exist, and the theory was validated.

The spreading of light, beyond the confines of the areas defined by light rays, is known as the *diffraction of light*, or more simply as *diffraction*.

For most photographic work the effects of diffraction are small compared with those arising from the presence of aberrations, and the shape of the light patch given by a spot diagram represents a very good approximation to the form of light patch which the lens will yield.

As the lens is stopped down, however, the relative importance of the aberrations and of diffraction undergoes a change, and ultimately diffraction becomes the more important. This is further discussed on page 145.

CHROMATIC ABERRATIONS

The last types of fault which may afflict a lens are those connected with the unequal bending of light of different colours by the same piece of glass, as explained on page 100.

The difference in bending for different colours varies from glass type to glass type, depending on the Abbe number as already explained. For instance in Fig. 39a, b the relative positions of red, yellow and blue images are shown as they are produced by two converging lenses of the same power, but of different glasses. The first glass is a hard crown glass with an Abbe number of $60 \cdot 3$, and the second an extra-dense flint glass with an Abbe number of $32 \cdot 5$. The coloured images are much more widely spread out in the case of the second glass; it is more *dispersive*. The curves at the right hand side of each diagram show in a

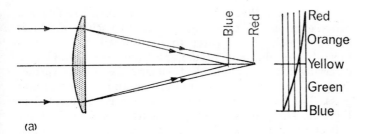

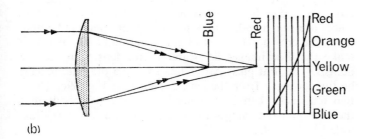

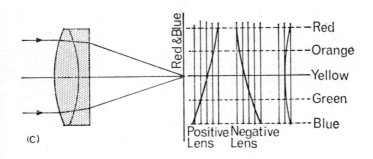

Fig. 39. Because of the *dispersion* of glass the focus positions of red, yellow and blue light lie progressively closer to the lens, as shown in (a). With more dispersive glass this spread is accentuated, as shown in (b). By combining a positive and a negative lens, as shown in (c) we can bring the blue and red foci into coincidence.

131

more evident way how the images creep nearer to the simple lens, as the colour deepens from red to blue and violet.

Now suppose that two lenses are combined. The first is a converging lens of crown glass. Left to itself it produces images which come nearer to it, as their colour shifts towards the blue end of the spectrum. The second is a diverging lens, which tends to throw the images further away as their colour moves to the blue, and is made of flint glass. The behaviour of the two lenses is represented in Fig. 39c. The two lenses are producing opposite effects.

Because the glass of the diverging lens is of greater dispersive power than that of the converging lens, the power of the diverging lens may be less than that of the converging lens, and yet the distance between the blue and red images may be the same in each case. Then if the two lenses are put together they form a compound converging lens. The crown glass part of this compound lens tends to make the blue images lie nearer to the lens than the red images. The flint glass part tends to make the blue images lie further away from the lens, as shown in Fig. 39c. These two tendencies can be balanced, with the net result that the blue and red images lie in the same position, as illustrated in Fig. 39c.

This bringing together of images of two different colours to the same focus is spoken of as *achromatising* the lens, and a lens in which this has been done is an *achromatic lens* or *achromat*. All camera lenses today, except the very cheapest and simplest kinds, are achromatised.

The need for achromatising a lens may be illustrated by considering photography with process or orthochromatic plates. The maximum sensitivity of these plates lies at the blue end of the spectrum. The maximum sensitivity of the eye lies more in the apple-green and yellow region of the spectrum, where the light wave-length is about 1/50,000 in. If the images formed by the lens for colours in these two regions do not coincide, then focusing cannot be done in a straight-forward way on a focusing screen, as used in either a normal or reflex camera. The eye picks out the best focus for greenish-yellow light, and the plate uses the best focus in the blue or violet regions of the spectrum. If these are not in the same plane the definition on the plate is not sharp

132

when the visual image is sharply focused on the focusing screen.

When dealing with chromatic effects it is convenient to describe the colours of light by *spectrum lines*. A spectrum line is produced by the set-up shown in Fig. 40. The light from a suitable source illuminates a slit S, which is located in the focal plane of a lens L1. The light from every point in S emerges from L1 as a parallel beam of light. (Because there is more than one point in S we have a number of parallel beams). Such an arrangement of slit and lens is known as a *collimator*. The parallel beams emerging from L1 encounter a prism P. Each beam remains parallel after it is deviated by the prism, but the actual amount of deviation depends on the wavelength and colour of the parallel beam (see pages 22–26). The parallel beams, after deviation by the prism, are received by a second lens L2 and come to a focus in the focal plane of L2. Parallel beams of any one wavelength or colour of light form an image of S in the focal plane of L2. Because the parallel beams of different colours are deviated to different extents by the prism P, we obtain a series of coloured line images in the focal plane of L2. This is the *spectrum* of the source.

If the source is composed of glowing sodium vapour then there is one dominant yellow line in its spectrum. This is the *Fraunhofer* D-line. By using other source materials we can obtain lines which have different colours and wavelengths, and use them to define regions of the spectrum. The more important lines, their colours and wavelengths are given below: the units of wavelength are milli-microns, i.e. one milli-micron is one millionth part of a millimetre.

XX – CHARACTERISTICS OF SPECTRUM LINES

Line	Source	Colour	Wavelength
A′	Potassium	Red	768·2
C	Hydrogen	Red	656·3
D	Sodium	Yellow	589·3
e	Mercury	Green	546·1
F	Hydrogen	Blue	486·1
g	Mercury	Blue	435·8
g′	Hydrogen	Blue	434·0
H	Mercury	Violet	404·7

133

For many years the practice with photographic lenses has been to favour the blue end of the spectrum, where the sensitive material has its greatest response. In more recent times, however, the widespread use of colour film has caused a revision of this balance in favour of the visual region, so that the C and F lines are brought to the same focus. This is the standard correction for telescope lenses, since it matches the maximum sensitivity of the human eye.

SECONDARY SPECTRUM

With panchromatic materials and films for colour photography another aspect of achromatism becomes of importance, and that is the size of the *secondary spectrum*.

It has been explained above how the achromatic correction of a lens is brought about. In the case of a more complex lens the procedure is the same in principle as that described for a compound lens, and illustrated diagrammatically on page 131. Converging lenses are combined with weaker diverging lenses made of glass having greater dispersive power. The converging lenses pull the blue images nearer to the lens than the red images, and the diverging lenses throw the blue images further away from the lens. The two tendencies can be represented by curves such as those drawn in Fig. 39c. A suitable choice of the powers of the diverging elements results in images of two colours being brought to the same focus.

If the curves showing the tendencies of the converging and diverging lenses were of the same shape, then bringing images of two colours to the same focus would automatically result in the images of all other colours coming to that same focus.

In actual fact the two curves are not of the same shape, and all the images of different colours do not come to the same focus. The effect is shown in Fig. 39c. Suppose that the images of the colours centred around the C and g' lines are brought to the same focus, then images of colours between these limits come to foci nearer the lens than the common C and g' focus, and the images of colours outside these limits come to foci further away from the lens.

This residual spreading out of the coloured images, when two of them have been brought to the same focus, is the *secondary spectrum*. It is of importance in dealing

134

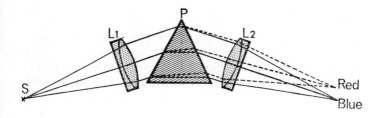

Fig. 40. Spectrum lines which are sharply defined are produced by the spectrometer whose construction is shown in this diagram. S and L1 form a *collimator*. Spectrum lines are formed in the focal plane of L2.

LIGHT RAYS NEAR A FOCUS

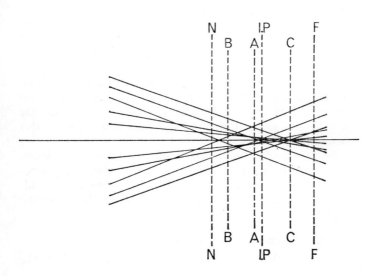

Fig. 41. The behaviour of rays in a lens which suffers from aberrations is much more complex, near a focus, than is contemplated in simple depth of focus calculations. IP is the image plane and NN and FF are the near and far limits of the depth of focus.

135

with films and plates which are sensitive throughout the whole spectrum, as with panchromatic and colour negative material. To flatten out the secondary spectrum the colours centred about the C and g' lines may be brought to the same focus. And for critical work special lenses of unusual complexity have been designed. Up-to-date lenses pay more attention to this flattening of the secondary spectrum than did those of an earlier date, and it is worth bearing this in mind when critical definition is needed with colour material.

When a very high degree of flattening of the secondary spectrum is required, as in process lenses, an *apochromatic* correction may be used. In this correction images of three different colours are brought to a common focus.

In general those lenses having an apochromatic correction are limited to low apertures, of the order of $f11$ and thereabouts. The reason for this lies in the types of glass which have to be used in order to establish such a correction. They require deep curves, and these in turn introduce heavy aberrations at higher apertures.

Of greater importance than secondary spectrum, for most photographic applications, is the variation with colour of the aberrations such as spherical aberration, coma, and astigmatism. As standards of performance have become more demanding in recent years, more attention has been devoted to these. Particular attention has been paid to the variation with colour of spherical aberration, and the name *sphero-chromatism* has been coined to describe this phenomenon.

The spread of the positions of images of different colours, when a best balance has been achieved, after taking spherochromatism into account, and after minimising the secondary spectrum as much as is practical, is the *axial chromatic aberration.*

LATERAL CHROMATIC ABERRATION

There is in addition another quite independent effect, the *lateral chromatic aberration.*

The axial chromatic aberration takes care of the positions of the planes in which the images are formed. But it may happen, assuming that the axial aberration has been corrected, that each individual ray going through the lens, from a point which does not lie on the lens axis, is split up into a

136

group of coloured rays, and these produce a spectrum on the plate. This has already been described on page 105. The blue end of this spectrum may be nearest to or farthest from the lens axis, depending on the position of the spot that limits the rays which go through the lens.

In order to correct the lateral chromatic aberration, groups of lenses, not necessarily restricted to being convergent or divergent, are used which have opposing tendencies. One set tends to produce a spectrum with its blue end nearer the lens axis. The other tends to produce a spectrum with its red end nearer the axis. The two sets are balanced, so that the two tendencies neutralise one another, and the spectrum is folded back on itself. For instance, the rays of coloured light centred about the C and F lines may be brought to the same position on the plate. This does not mean that all other colours will come to the same point. Again in this case there may be a lateral chromatic secondary spectrum. It is of quite negligible importance, except in very rare instances in scientific work.

The main things to look for in testing a lens, as far as chromatic aberrations are concerned, are the achromatism, the axial secondary spectrum, especially where colour film is used, and the lateral aberration, which again is of importance with colour film. Lateral aberration, which does not show up in black and white to any great extent, produces images with badly coloured edges with colour film, or images of different size on the different plates of a set of separation negatives taken through red, green and blue filters respectively. The actual testing of lenses for chromatic aberrations is described on pages 205 and 208.

ABERRATIONS AND DEPTH OF FIELD

Now that the aberrations of lenses have been described, the time is ripe to say a few words more about depth of field.

The method of calculating depth of field is described on pages 68 and 74 for the two usual cases. In the first case the calculation is based on the convention that the print is to be enlarged to get the correct perspective at the closest viewing distance of 10 inches. In the second case the calculation is based on the assumption that the grain size of the film limits the size of the light patch to a minimum of either ·002 in. or ·001 in. But in both calculations it is assumed

137

that the lens is perfect, that rays of light going through the lens all come together in a point. This cannot be realised in practice.

The lens suffers from aberrations that have to be balanced one against the other, and which cannot be eliminated. The rays do not converge to exact points, but cut any plane in a light patch of finite size, and it cannot be taken for granted that this will not influence the results of the calculation of the depth of field.

Consider for instance the simplest case of a lens with an appreciable amount of zonal and marginal spherical aberration in it. The spherical aberration is under-corrected for rays through intermediate zones of the lens aperture, and slightly over-corrected for rays through the margin of the lens. This is the normal type of correction encountered in practice. The exact arrangement of the rays near their ideal focusing point is shown in Fig. 41.

What corresponds to a focus, in a lens with this type of aberration, is the position where the bundle of rays has its smallest diameter, as shown at AA in Fig. 41. The image at this point is a small hard disc of light. When the focusing screen is moved to the position BB in Fig. 41 the light patch then obtained consists of a small bright core surrounded by a diffuse halo. When the focusing screen is taken still further away the light patch increases in size, and becomes a fairly even disc of light. With the focusing screen at the position CC the light patch is an even disc with slightly woolly edges. This is not the type of performance contemplated in calculating the depth of field scales on page 68. What is envisaged there is an absolutely sharp focus at the image point, and a perfectly even disc of light when the focusing screen is either inside or outside this image position.

The net result, obtained with a lens having the correction described above, is that images of objects in the centre of the field, nearer to the camera than the object on which the camera is focused, are sharper than objects an equal distance farther removed from the camera. There is an unequal balance between foreground and background, with the foreground better defined. This is the reverse of what is usually desired in practice, where the definition of the background is preferably to be maintained. A lens has

138

been designed (*Taylor, Taylor & Hobson*) to provide this latter type of correction by making the zonal spherical aberration over-corrected and the marginal rays under-corrected. To do this, however, means using non-spherical surfaces with greatly increased manufacturing difficulties.

In order to obtain an estimate of the importance of spherical aberration the best thing is to discuss some figures and numerical results which can be expected for typical lenses.

It follows, from the results quoted in the section on depth of field, that the distance between the images of the nearest and farthest points which are in sufficiently sharp focus is given approximately by,

Separation $= 2 \times$ (focal length) \times (stop No.) \div 1000 in.

In a 2-in. $f2$ lens as used for miniature cameras this gives a separation between the two images of $2 \times 2 \times 2 \div 1000$, i.e., ·008 in. With a good quality lens of this type the zonal aberration, or the distance between the points where the longest and shortest foci lie for different rays through the lens, as shown in Fig. 41, may be expected to have an average value of about ·004—·006 in. That is to say, the region over which the rays are coming to the waist of the bundle, as shown in Fig. 41, has a size which is about half the length allowed by the depth of focus calculation for the image separation. This must have a definite effect on the depth of field of the lens. And quite apart from the difference in size of the light patch, when there is spherical aberration present, to that envisaged on pages 68 and 74, there is the complicating fact that the distribution of light in the image patch is not the even filling of a disc previously envisaged.

When this $f2$ lens is stopped down to $f2·8$ or $f3$, i.e. when the aperture is reduced to one stop below its maximum, the spherical aberration is usually cut down very considerably, and at the same time the distance between the images of permissible quality goes up by nearly 50 per cent. The spread of the spherical aberration effect, relative to the image separation permitted by the depth of field, as calculated on pages 68 and 74, is much smaller. The depth of field calculation is giving a more exact picture of the actual limits of passable definition. By the time the lens is stopped down to $f4$ the orthodox depth of field calculation is giving a very

139

good approximation to the depth of field actually obtainable with the lens.

With another lens, say a 4-in. $f2$, all that has been said above holds in principle. Because of the greater focal length, 4 in. compared with 2 in., the separation between the images of the nearest and farthest objects in reasonable focus is doubled, and is now ·016 in. At the same time the spherical aberration spread-out is scaled up two-fold. The ratio of the two is unchanged and as a consequence the conclusions already given are unchanged.

Even the above treatment is not complete. What has been said above is for depth of field in the centre of the field. This, of course, is important. But equally important is the depth of field away from the centre of the negative, the depth of field in the foreground and background of the principal subject. There are two comments to make on the value of the orthodox calculation in this respect.

In the first place the depth of field, as calculated on pages 64–77, holds good if the lens brings all rays to a point focus, and if for points not at the centre of the negative the lens still passes the same amount of light. In actual fact it does not do so. As explained more fully on page 211, the lens aperture is effectively less when the image point is not at the centre of the field, except in some special cases. This tends to increase the depth of field.

In the second place there are two types of definition away from the centre of the field, as explained in the section of this chapter which deals with astigmatism. Either radial or transverse lines may be better in focus when the plate or film is moved from its ideal position. In a 2-in. $f2$ lens the shift of one of the image planes from its ideal position may amount to ·003—·004 in., and the separation between the two may amount to ·008 in. This is just the image separation demanded by the depth of focus calculation, and it naturally affects the validity of the depth of field calculation. By the time that the lens has been stopped down to $f8$ the depth of focus separation between the images has gone up four-fold, but the separation of the astigmatic image surfaces is unchanged, and has much less influence on the validity of the calculation.

As far as average definition is concerned, the values obtained from the central field calculation, taken in con-

junction with the remarks given above, give a moderately good approximation to the truth. The image definition is of too complicated a nature, with the entry of astigmatism and vignetting (although the latter is small over most of the field) to say anything more precise.

Depth of field tables have been of great use to photographers for many years, but their limitations must be realised. The early ideas, and many of the present ideas about depth of field, date from the days when an $f7 \cdot 7$ lens was considered to be reasonably fast—apart from Petzval portrait lenses covering a small field. Things have changed since then and a modern lens can hardly be considered fast with an aperture below $f1 \cdot 4$ to $f2 \cdot 5$. The influence that this change of lens aperture has had on the validity of depth of field calculations must be taken into account, and the reliability of depth of field tables for large aperture lenses must be judged with reservations of the kind discussed above.

CAMERA LENSES IN ENLARGERS

It is a well-known fact that a lens which gives excellent results in a camera may give results in an enlarger that are definitely not first class.

It is not exactly fair, however, to expect a camera lens to give results of the highest quality when it is used in an enlarger. It is working under quite different conditions from those for which it has been designed.

The normal photographic lens is designed to photograph objects at a considerable distance from the lens. It is on this assumption that rays are traced through the lens, that the heights are noted at which these rays encounter the various refracting surfaces, and that the deviations which the rays undergo at each of these surfaces are measured. And the lens aberrations depend on these.

At the various lens surfaces aberrations of all the types described earlier in this chapter are introduced, usually in very considerable amounts, much greater than the amount of any of them that is left in the lens as a whole. The aberrations that are introduced at each surface have to be balanced against one another very carefully indeed, in order to get the final correction of the lens. And this balancing is usually done under the prescribed conditions, namely that

141

the object in front of the lens is at a large or infinite distance, which determines the incidence heights and bending of light rays at the various surfaces. The final correction is sensitive to changes in these conditions.

In Fig. 42 are shown the paths traced by two rays through a lens, one from a distant point on the lens axis, the other from a near point. The deviations between their paths through the lens are shown on an exaggerated scale. In actual practice they are much smaller, but still quite large enough to be significant and to affect appreciably the lens performance. The delicate balance of aberrations is upset and the quality of the lens performance is changed to a greater or less extent.

In some cases the correction of spherical aberration, axial colour, and astigmatism may be upset when a camera lens is used under enlarging conditions. In most cases, however, it is the coma correction of the lens that is upset under these conditions. The amount of change in the correction of the aberrations depends very much on the detailed lens construction.

With a normal type of photographic lens the definition is maintained fairly well until the distance of the object, from the front of the lens, is seven or eight times the focal length of the lens. At closer distances the chances are, except in some individual cases, that the definition falls off. This means that, when using the lens to make enlargements, satisfactory results should be obtained with a good camera lens for enlargements with a magnification of six or seven diameters upwards. For lower degrees of enlargement the lens may not give really good definition without stopping down.

ENLARGING AND PROCESS LENSES

For those occasions when the very highest performance is needed in enlarging work special lenses have been designed to work under such conditions. They are designed so that the lens correction is established when the distance from the negative to the enlarging board is about 4 times the focal length of the lens, so that the lens is giving either a reduced image on the enlarging board, or a slightly enlarged image.

The main aberrations to which special attention has to be

142

RAY PATHS IN A LENS

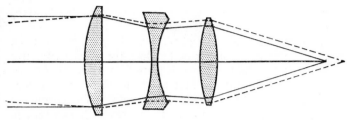

Fig. 42. The paths of rays from a near object point differ from those from a distant object point, and the aberrations may not be well-corrected in both cases. This means that a camera lens may not perform well in an enlarger.

EFFECTS OF DECENTRATION

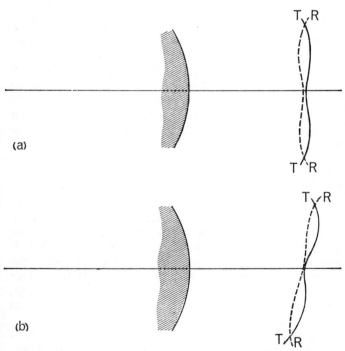

(a)

(b)

Fig. 43. In a well-centred lens the radial and tangential astigmatic focal surfaces are symmetrical about the lens axis, as shown in (a). In a decentred lens these surfaces are tilted, as shown in (b).

paid in an enlarging lens are the chromatic aberrations, both axial and lateral, although the correction of the other aberrations has also to be maintained well up to the standard of the best photographic lenses.

The focusing of an enlarger lens is always done visually, and the region of the spectrum to which the paper is sensitive is not that to which the eye is most sensitive. As already pointed out this requires that to get good results the lens must be achromatised for these two regions. The chromatic correction is of such importance in process lenses that in some of them an apochromatic correction is established, so that light of three colours is brought to a common focus.

When the enlarger lens is to be used in colour work, especially in the making of separation negatives, the lateral chromatic aberration must be very highly corrected, to a degree higher than that which often suffices in photographic lenses of the same aperture and covering the same field. When a lens is used in a camera to photograph distant objects the spread of the spectrum may be quite small, and less than that of the size of the emulsion grain. When the same lens is used for enlarging the spread of the lateral aberration spectrum is also enlarged, and may very easily reach inadmissible dimensions. Hence the importance of dealing thoroughly with lateral chromatic aberration—the more so since it cannot be remedied by stopping down the lens.

The best way to discuss the manner in which the lateral chromatic aberration is enlarged is to give some figures. It may very easily happen that a camera lens, of 4-in. focus say, when used between comparatively near object and image planes, has a lateral colour spectrum extending over ·0025 in. in its focal plane. This means that, if the lens is used in an enlarger to give a ten-fold enlargement, the spread of the lateral colour spectrum is one-fortieth of an inch in the enlargement. Such a spreading of the image, which is quite unaffected by stopping down the lens, would be quite fatal in exact colour work of any sort.

And finally there is one comparatively recent development that may emphasise also the importance of the chromatic correction of a lens under enlarging conditions, namely, the introduction of variable contrast papers.

144

With ordinary papers the situation as regards chromatic aberrations and their corrections is eased, as far as black and white work is concerned, by the limited region of the spectrum to which the paper is sensitive, in the deep blue mainly. The variable contrast paper depends for its operation on the fact that it is sensitive to two regions of the spectrum. It comprises in effect two emulsions, one of hard contrast sensitive to one region of the spectrum, and another of soft contrast sensitive to quite a different part of the spectrum. The lens is used with filters which transmit light that is a mixture of both regions of the spectrum in varying proportions, according to the individual filter used. As a result the enlargement is given a mixture of hard and soft contrast, in proportion to the amount of light from each region of the spectrum that the filter transmits.

The importance of the correction of the chromatic aberration as far as using this type of paper is concerned is obvious. Lack of correction that might not be seen with normal black and white papers may show up as a relative displacement of the regions of hard and soft contrast.

DEFINITION AND STOPPING DOWN

One topic to which a few words should be devoted is the effect on the image definition of stopping the lens down.

The general rule is that as a lens is stopped down the definition it gives is improved. The size of the light patch given by any of the aberrations is decreased as the lens aperture is reduced, with two exceptions. Lateral chromatic aberration and distortion are completely unaffected by stopping down the lens. Spherical aberration and coma are most rapidly affected by stopping down the lens, astigmatism is changed much more slowly.

The net result is that, with lenses of greater apertures than $f3$ it can be taken as a safe rule that there will be a progressive improvement in definition as the lens is stopped down. With lenses of higher aperture, up to $f1 \cdot 4$ and even larger apertures, it is sometimes found that the definition improves as the lens is stopped down, say from $f1 \cdot 5$ to $f4$ and remains at this level as the optimum definition that the lens can afford until the lens is stopped down to about $f6$,

145

at which point any further stopping down of the lens causes a drop in the lens definition.

This type of behaviour is essentially due to *diffraction*.

In many photographic phenomena the diffraction of light is not of major importance. The size of the effects it produces is so small in general compared with the effects produced, for instance, by the aberrations of a lens used at full aperture, that it can be left aside. But there is one important feature about diffraction which has to be taken into account, namely the fact that as the lens is stopped down the size of the diffraction effects increases.

Neglecting all the lens aberrations, and assuming that the lens is perfect, then because of the diffraction of light the lens produces, not a point image, but a disc of light in the centre of the negative, the *Airy disc*. The diameter of this is given by the formula:

Diameter = ·000045 × (Stop number of lens) inches.

For instance with any perfect $f4$ lens the diameter of the Airy disc, when the lens is working at full aperture, is ·000045 × 4 = ·00018 in.

The diameter of the Airy disc depends on the wavelength of light forming the image. The value given above corresponds to the wavelength of green light, to which the eye is most sensitive. For blue light the Airy disc is smaller in diameter, for red light it is larger.

Stopping down the lens, and so increasing the stop number of the lens, means that the diameter of the Airy disc is increased. Since the definition provided by the lens depends on the size of the light patch corresponding to an object point, it follows that, in the region where diffraction becomes important, a stopping down of the lens results in a deterioration of image quality.

We then have the following sequence of events as a lens is stopped down, a sequence that is important when critical performance is required, as for example in making graticules. In the first stages of stopping down the lens performance shows a fairly rapid increase in quality. At later stages the rate of improvement slows down and finally ceases. At this point diffraction becomes the controlling factor and the definition decreases in quality as the lens is further stopped down. In the case of an $f2$ lens for 35 mm. still cameras, the

146

region of best critical definition occurs in the region of $f5\cdot6$ to $f6\cdot3$, with a diameter of the Airy disc in the neighbourhood of $\cdot00025$ in. (i.e. one quarter of one thousandth of an inch). A lens originally designed to work at $f5\cdot6$ will not normally yield this standard of definition, since it will represent a compromise design in which simplicity of construction has been required at the expense of the highest possible performance.

When diffraction is the controlling factor in lens definition the image structure is much more complex than that envisaged when depth-of-focus and depth-of-field calculations were carried out earlier in this book. It is beyond the scope of this discussion to detail the ways in which depth of focus is calculated with diffraction the controlling factor. The results of appropriate calculations are given in the *Focal Focusing Chart*.

DECENTRATION ABERRATIONS

The aberrations which lead to a degration of image quality, and which have been described in the earlier pages of this chapter, are those which result from the design of a particular lens type. It requires the imagination and ingenuity of the optical designer in order to reduce them to acceptable limits.

In addition to these aberrations, however, there is a second group of aberrations which arise because of minute imperfections in the manufacture of an individual lens, the so-called *decentration aberrations*. To reduce or eliminate these aberration demands meticulous care in all manufacturing processes. It cannot be taken for granted, however, that the steps which are taken in order to eliminate decentration aberrations will be universally successful. Because of this fact it is worth spending some time discussing these aberrations.

In an ideal lens the centres of all the spherical surfaces of the individual elements making up the lens lie on a straight line, the axis of the lens. In an attempt to achieve this line up a series of manufacturing steps are taken:

1. The edge of each element is ground, while it is mounted in a special centring and edging machine, so that the diameter of the element is concentric with the line joining the centres of the two spherical surfaces. Details

147

of how this is accomplished are beyond the scope of this book. It is sufficient, for our purposes, to note that this concentricity may be established within close limits, and that the residual wedge in an element may be reduced to less than a few ten-thousandths part of an inch. The diameters of such elements are also held within a tolerance of less than one-thousandth part of an inch.

2. If two elements are to be cemented together to form a compound lens, then each element is separately edged and centred, and they are held in close alignment while the cement hardens.

3. The seats in the lens mounts, on which the elements rest, are machined in such a way that they are exactly parallel and concentric. Tolerances once more are measured in fractions of a thousandth of an inch. Diameters of the bores of the metal parts containing the lenses are also held to tolerances measured in fractions of a thousandth of an inch, so that there will be no movement of the glass elements away from their proper positions.

4. The metal and glass parts are assembled with extreme care, so that no element is cocked as it is placed in its metal cell, and so that no particle of dust may upset the alignment of the lens cells.

The proper execution of these steps requires first class machinery, skilled workmanship and expensive tooling. If any step is not carried out successfully then decentration aberrations are introduced.

For our purposes it is sufficient to classify these decentration aberrations as follows:

1. *Image Run-Out.* As the lens is rotated about its axis the image does not remain stationary, but wanders around in a small circle. For the general run of lenses this wander is not too important: it creates a negligible pictorial effect.

2. *Decentration Coma.* When this is present the image shows a coma flare which is in evidence even in the centre of the field, and which remains constant in size and in absolute direction over the whole of the field. If the coma tail points to the left at one point in the field, then it points to the left at all points in the field. It differs from the coma which has been previously des-

148

cribed, in that the latter retains its orientation relative to the centre of the field, always pointing towards the centre of the field or away from it, but varying in size over the field of the lens, vanishing at the centre of the field and becoming progressively larger as the image moves towards the edge of the field.

It is worth noting that if there is astigmatism in evidence at the centre of the field, this does not result from decentration of the elements. Such an effect results only from imperfect lens surfaces.

3. *Tilted Focal Surfaces.* It has already been explained that, because of astigmatism, there are two surfaces in which images of different kinds are formed. In one surface, the sagittal focal surface, the image consists of a short line which points towards the centre of the field, in the same way that a short length of the spoke of a wheel points towards the centre of the wheel. In the other surface, the tangential focal surface, the image is a short straight line at right angles to the line in the sagittal focal surface. It may be regarded as a short length of the circumference of a wheel. In a well made lens the two focal surfaces are symmetrical about the lens axis, as shown in the diagram in Fig. 43a.

The result of decentration aberrations is to cause these surfaces to be tilted relative to the lens axis, as shown in Fig. 43b. The sagittal and tangential focal surfaces are tilted to differing extents, and may even be tilted about different axes. As a matter of practical experience the tangential focal surface is usually tilted much more than the sagittal surface.

4. *Tangential Distortion.* When this is present the image is displaced from its proper position, but the displacement is always in the same direction. It thus differs from the radial distortion, described earlier in this chapter, where the displacement of the image point is always towards or away from the centre of the field. Except for special mapping lenses this tangential distortion is not of major importance.

It is important to note that the absence of image wander, described in (1) above, does not guarantee that there will be no decentration coma or tilted focal surfaces. There may be

149

decentration effects, arising at several surfaces in the lens, which balance one another as far as image wander is concerned, but which do not balance in the same way for decentration coma or tilting of the focal surfaces. This is due to the detailed way in which a decentred surface bends light rays, and it is beyond the scope of this book to consider it in detail.

In the same way the absence of decentration coma does not imply the absence of tilting in the focal surfaces. Each of the aberrations listed in (1)—(4) must be regarded as being independent of the others.

There has been a tendency in many treatments of photographic optics to under-emphasise the importance of the decentration aberrations. It may be recorded, as a matter of practical importance, that decentration aberrations may play a bigger part in determining lens performance than the aberrations usually described, which are those associated with a perfectly constructed lens. The reduction of decentration aberrations is responsible for a very significant part of the cost of a lens.

The examination of a lens for decentration aberrations is discussed in a later chapter.

Picture Quality

In previous chapters we have discussed the general character-
istics of image formation, assuming that perfect imagery is
attained. We have also pointed out that any real lens fails
to achieve this perfect imagery, and that, because of the
aberrations which are always present, an object point is not
reproduced as a point of light in the image plane. In the
present chapter we will consider in detail how we may
relate the aberrational performance of a lens to its picture
taking quality.

Major advances have been made in this area in the past
few years, mainly within about the last ten years. Important
concepts have been introduced, such as Optical Transfer
Functions and Acutance, and the use of electronic computers
has led to techniques such as Image Synthesis. These are
discussed in the following pages.

RESOLVING POWER CHARTS

One of the earliest methods of assessing the picture-taking
quality of a lens was in terms of its *resolving power* or
resolution. This notion was taken initially from the
astronomers. Some of the stars which appear to be single
points of light in the sky, when they are observed with the
naked eye or with a poor telescope, are in fact double stars,
and appear as twin points of light when they are observed
with a telescope of sufficient magnification and of adequate
quality. The ability to distinguish these twin points of light
can be used to define the quality of a telescope.

When the two points of light can be distinguished they
are said to be *resolved*, and the capability of the telescope to
effect their separation is its *resolving power*.

An obvious extension of this concept was made in the
field of microscopy, where the resolving power of the
instrument was related to its ability to distinguish the
separation between two closely spaced object lines.

When the concept was taken over into the photographic

area the approach adopted was an extension of that used in microscopy, with attention paid to linear object sources rather than to the point objects of astronomy, and *resolving power charts* have been prepared.

A resolving power chart comprises a pattern of light and dark areas, arranged in groups as shown in Fig. 44. In each group we have light and dark strips, and the convention is established that the width of a light strip is equal to that of a dark strip. The combination of a light strip and a dark strip constitutes a *line*. [It is important for the use of lenses in television cameras to note that a different definition is used in such cases. For television purposes either a dark strip *or* a light strip is a line.] From group to group of lines there is a progressive narrowing of the widths of the lines. The exact law of progression may vary from one type of chart to another. For example in the chart shown in Fig. 44 the ratios of line widths, from the coarsest to the finest, are in the progression 1; 1/2; 1/3; 1/4; 1/5; 1/6; 1/7; 1/8; 1/9; 1/10.

In the chart shown in Fig. 45 the ratio of line width between any neighbouring pair of lines is $1:1\cdot22$. The significance of this ratio is that after six steps the ratio of line width has been doubled or halved. [$1\cdot122$ is the sixth root of $2\cdot0$] It is common practice to refer to the light and dark strips as *lines* and *spaces*, but this in no way must be confused with the definition of a *line* given above. A *line* in the complete sense comprises both a line *and* a space.

There are other features which distinguish various forms of resolution charts. One is the number of lines and spaces within each group. In the charts shown in Figs. 44 and 45 there are three of each in every group. In a form of chart which has been popular in England, the so-called *Cobb chart*, there are only two lines or spaces; and in the National Bureau of Standards type of resolution chart there are five in each group. These two forms of chart are shown in Fig. 46. Another distinguishing feature of various styles of resolution chart is the ratio of the pattern length to the line width. This is brought out in Figs. 44, 45 and 46. It should be pointed out that these are not trivial differences. Different types of chart may give different values for the resolving power of the same lens, and in any critical application it is important to specify which form of chart will be used.

152

TEST CHARTS

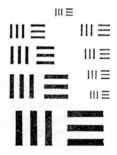

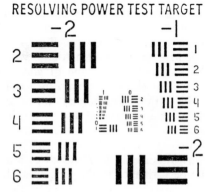

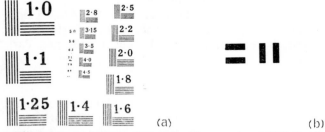

(a) (b)

Fig. 44. (*top*). This resolution chart has spacings which give lines/ millimetre in the ratios of 1, 2, 3, 4, 5, 6, 7, 8, 9.

Fig. 45. (*centre*). A standard form of resolution chart widely used in the United States.

Fig. 46. (*bottom*). (a) The National Bureau of Standards test chart. (b) A typical pattern in the *Cobb chart* favoured in England; a number of such patterns, of decreasing size, are used.

Another important feature is the *contrast* of the resolution chart. This is measured as the ratio of brightness between the light areas and the dark areas. Ideally the dark areas should be perfectly black. In other words they should not reflect or transmit any light at all. This is a difficult thing to achieve, and in practice we settle for a brightness ratio of 1000:1 in a high contrast target. It is probable that the picture quality provided by a lens in normal use may be better related to the results obtained with a low contrast test chart, one in which the light areas are a light gray and the dark areas are dark gray, with a brightness ratio of about 2:1. The technical problems of working with such charts are very severe, and results may be quite unreliable. It is probably best to stay with high contrast test charts.

Finally we have the choice of using a test chart which consists essentially of dark areas on an overall bright background, as shown in Figs. 44, 45 and 46, or of using a negative of any one of these, with light areas on a black background. Each type of chart shows up different lens faults, or shows them up in a different way.

Note that in each chart we have sets of lines and spaces running at right angles to each other. The reason for this is that the behaviour of a lens may be severely modified by astigmatism, as described in the previous chapter. The performance in the radial direction is then no indication of its performance in the tangential direction.

Before going on to describe the use of resolving power charts, one very interesting form may be mentioned, namely the *Siemens star*. This is shown in Fig. 47. The lines and spaces of equal width, as used in the charts already described, have been replaced by equal light and dark sectors.

RESOLVING POWER TESTING

In order to evaluate a lens by using resolving power charts a series of small charts are mounted on a flat surface, so that they cover the field of view of the lens as shown in Fig. 48. With each small chart one set of lines and spaces points towards the centre of the field, as shown in Fig. 48. This set is used in order to determine radial resolution. The other set of lines and spaces, at right angles to the first, is used in order to determine the tangential resolution.

Fig. 47. A resolution pattern which is very popular on the Continent for determining the resolution of a lens is the *Siemen's Star*.

Fig. 48. When testing the performance of a lens the resolution charts are distributed over the field of view as shown above.

The lens under test, mounted either in its own camera or in a substitute test camera, is set up to photograph the flat surface on which the charts are mounted. It is important to know the scale of reduction between the charts and their images in the camera. This can be determined by using the formulae given in the first chapter of this book or else it can be determined by measuring the size of a chart and its image size. In general the degree of reduction between the chart and its image should be not less than about 20 to 1. With short focus lenses, such as those used on 35 mm. cameras, it is not usually too difficult to set up for a 50:1 or 100:1 reduction. The only exceptions to this 20:1 rule should be those occasions when the lens under test is a copying or enlarging lens.

The images of the charts may be examined directly in the focal plane of the camera, or a photograph may be taken and the negative (or positive) images subsequently examined. We then obtain the visual or the photographic resolution respectively. In either event we examine the images of the charts and note the finest pattern which is resolved. This examination implies a strong subjective element, and the convention which is adopted, in an attempt to minimise it, states that a pattern is resolved if we can tell the direction of the lines within the pattern, and that when we count them the number of lines is correct.

This last requirement is inserted in order to take care of *spurious resolution*. As we progress from coarser to finer patterns in a resolution chart the contrast between lines and spaces in the image decreases. A point is reached when it becomes zero, and resolution is lost. However, if we examine still finer targets the contrast re-appears, and the pattern of light and dark areas is restored. However, a count of the number of light and dark strips will show that the number is incorrect, and that we have a dark area where there should be a light area, and vice versa. In this case we have *spurious resolution*. The true resolution limit of the lens is reached at the point where the contrast between light and dark areas first becomes zero. Spurious resolution is not a rare and unusual phenomenon, on the contrary it is observed with most lenses.

In the case of a resolution target in the form of a Siemens star the same general procedure is followed and small

156

targets are distributed over the field of the lens in the fashion already shown in Fig. 48. In the chart images we find that a clear distinction between light and dark areas is apparent in the outer zones of each chart. As we move towards the centre of the chart the contrast decreases, but the boundary of the zero contrast area is not usually circular in form. It is only circular in the absence of astigmatism and coma.

Resolution is usually specified in lines per millimetre. Suppose that the width of a line plus a space, in the finest pattern of the resolution chart which is resolved in the image plane, is one half millimetre, and that the ratio of reduction from the chart to its image is 20 to 1. Then the width of the finest resolved line plus space, in the image plane, is one fortieth of a millimetre, and the lens is capable of resolving 40 lines per millimetre.

There are a number of precautions which must be taken in order to obtain accurate measurements of resolving power. For example, if we wish to obtain the visual resolving power of a lens, it is not permissible to examine the image formed on a ground glass screen. Such a screen has a grainy structure, with a resolving power of its own, and will appear to reduce the resolving power of the lens. If we require the photographic resolving power, then the exposure and development of the film must be carefully controlled; both have a very pronounced effect on the measured resolving power. And finally it is important to examine the contrast between light and dark in each group of lines over the whole length of each line. There is usually an end effect, which creates the impression of higher resolution if we examine the ends of the lines only.

VALUE OF RESOLVING POWER

There has been a distinct tendency in recent years to over-emphasise the value of resolving power measurements as a means of assessing lens performance. There is no doubt that it can fulfil a useful role as a tool for evaluating lenses, but it is a dangerous idea to believe that it is the only tool or even the most important tool.

One glaring weakness that resolving power possesses, as an assessment tool, is that it gives no indication of the results to be expected from a lens-film combination, or from

a more complex operation, which starts with a camera lens and ends up with an image on a projection screen. It is important, for example, to realise that, because of its graininess, a film has a definite resolving power of its own. This is pictured on page 265, which shows an image of a resolution chart recorded on two kinds of film having different graininess. (Typical values of film resolving power are given by *Kodak* in *Pamphlet No. P.49.*)

An early attempt was made by *Katz* to predict the resolving power R_c, of a lens-film combination, from the resolving power of the lens, R_L, and the resolving power of the film R_F. *Katz's* formula states

$$\frac{1}{R_c} = \frac{1}{R_L} + \frac{1}{R_F}$$

Later work has used the more general formula

$$\frac{1}{(R_c)^n} = \frac{1}{(R_L)^n} + \frac{1}{(R_F)^n}$$

with $n = 1 \cdot 8$ or $n = 2$.

These are heuristic formulae, derived from limited experimental work and with no valid theoretical basis.

The use of resolving power as an assessment tool also overlooks the fact that the contrast given by a lens is of particular importance in relation to the picture quality it produces. It is a comparatively simple matter to design a lens with a high resolving power which gives a washed-out and very flat picture, without satisfactory contrast. With such a lens, also, there is a marked difference in the resolving power measured with targets on an overall dark background, and the resolving power obtained with targets on an overall bright background.

EDGE GRADIENT

Our understanding of the part played by resolving power in defining picture quality may be increased by considering another aspect of image formation, namely the way in which a lens images the border between a light and a dark area.

If we measure image brightness in the neighbourhood of the boundary between a bright area and a dark area, then a perfect lens would give the distribution shown in Fig. 49a.

158

EDGE GRADIENT

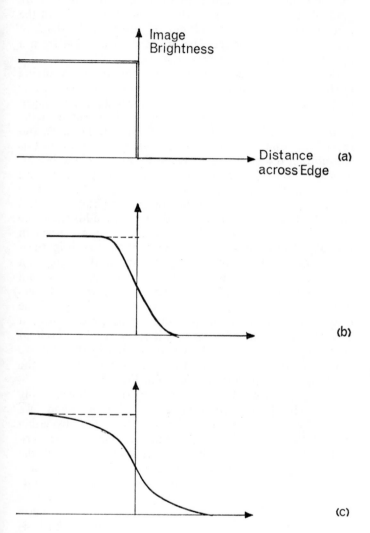

Fig. 49. The brightness transition across a boundary in an ideal case is shown in (a). In practice we may obtain transition curves as shown in (b) and (c). The shape of these transition curves gives valuable information about the picture quality provided by the lens.

There would be an abrupt transition from full brightness to zero brightness. With any actual lens the transition is more gradual, as shown in Figs. 49b and 49c. The quality of the picture taken with any lens is closely related to the shape of the curve which describes the brightness transition from a light to a dark area, the *edge-gradient*.

From the edge-gradient we can obtain the resolving power in the following way, as shown in Fig. 50. We assume that we have a resolution chart pattern which, if it is imaged by a perfect lens, overlays the edge-gradient curve in the manner shown in Fig. 50a. We start with the point P_0 and record the brightness in the edge-gradient curve. From this we subtract the brightness value at P_1, and add the brightness at P_2. We follow this procedure until the point P_8 is on the flat part of the curve, as shown. From the result so obtained we subtract the value of the brightness at P_{-1}, and add that at P_{-2} until we come to an additive value P_{-6} which lies on the flat part of the curve, as shown in Fig. 50a. The value so obtained gives the actual brightness of the image at the edge of a bright space, in the image of a resolution chart pattern. We then repeat the process with a base point such as Q in Fig. 50b. This gives us the brightness of the image at a corresponding point in the image of the resolution chart pattern. We repeat this process with a variety of positions of Q, so that it covers a whole cycle of positions relative to the chart pattern, and in this way we obtain the brightness distribution within the image of the resolution chart pattern, as shown in Fig. 51.

We repeat the whole process described above, using successively finer resolution chart patterns, and we obtain the results shown in Fig. 51. Note that by going beyond the point where the brightness variation is zero we find an increase in the brightness variation, but with the phase of the variation shifted, so that we obtain brightness where we expect darkness. This corresponds to spurious resolution. It is important, also, to note that even before we reach the spurious resolution stage there may be a phase shift, so that the maximum of brightness and darkness is shifted away from the centre of the resolution pattern. This is primarily due to coma.

Note also, that when we speak of the edge gradient between light and dark areas, these are small local areas in
160

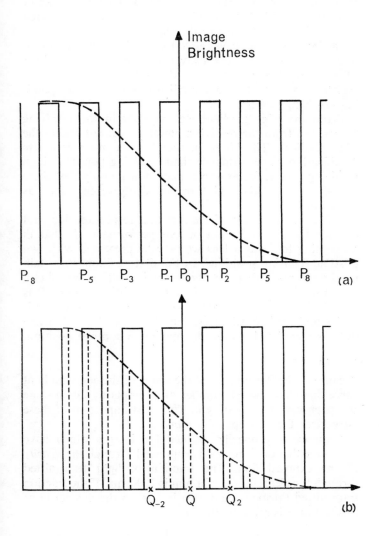

Fig. 50. The resolving power of a lens is determined from the edge-gradient by super-imposing the structure of the resolution chart pattern on the edge-gradient curve, as shown in (a). The brightness at points other than P_0, such as Q for example, is obtained by using displaced measuring points as shown in (b).

161

the field covered by the lens. They are small in comparison with the size of the field covered by the lens, but large in comparison with the spread of light in the light patch produced by aberrations in the lens. Because of the effects of astigmatism we have also to consider two types of boundary, one stretching away from the lens axis, and the other at right angles to this. From these we obtain the sagittal and tangential edge gradients, and the corresponding resolving powers.

From the edge gradient we may obtain the resolving power, but from the resolving power we cannot obtain the edge gradient. The latter is, therefore, a more complete specification of performance than resolving power. A high resolving power, for example, may indicate only that there is a sharp but shallow kink in the edge gradient curve, as shown in Fig. 49c.

One practical result of the fact that resolution does not provide the only criterion of lens performance is that in attempting to focus a lens we may be presented with two possible focusing positions. In the first position we obtain maximum resolution. In the second position we obtain maximum image contrast, or sharpest edge gradients. It is not possible to make a categorical statement as to which is to be preferred in all cases, but the general trend, when there is a choice, is to use the maximum contrast position.

ACUTANCE

Because of the importance of the shape of the edge-gradient curve there have been a number of attempts to obtain some compact way of evaluating it. The most important of these introduces the concept of *acutance*.

Acutance is primarily defined for images which have been recorded on film, and is expressed through the *density* of the exposed film. The fraction of light transmitted through the clearest part of a film is $1 \cdot 00$, and if the fraction transmitted through a test area is T, then the density D of this test area is given by the formula

$$D = \log_{10} \frac{1}{T}$$

where \log_{10} means the common logarithm used for everyday calculations. When the density is zero then $T = 1 \cdot 00$ and

162

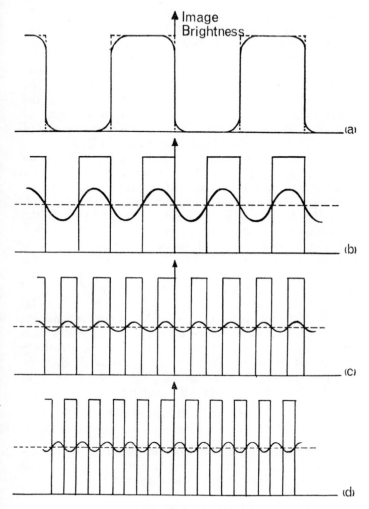

Fig. 51. Because of aberrations in a lens the sharp images of a coarse resolution chart pattern are rounded, as shown in (a). With a pattern of finer pitch the brightness variation takes the form shown in (b). With a very fine pattern the brightness variation becomes very small, as in (c), and resolution is lost. With still finer patterns *spurious* resolution may appear.

the test area is completely transparent. When $D = \cdot 5$ then $T = \cdot 32$, and so on.

In place of drawing the brightness curve across the boundary between a light and a dark area, we now draw the graph of film density as we cross the boundary between light and dark areas, as shown in Fig. 52. In an ideal situation the transition curve would be abrupt, of the form shown by the dotted line in Fig. 52. In practice, of course, we obtain a smooth curve, as also shown in Fig. 52. The quality of picture reproduction is intimately related to the shape of this curve, and we obtain a concise means of describing picture quality if we can derive a concise way of describing the shape of the density curve of Fig. 52.

A number of attempts have been made to derive an adequate description of the density curve. The most successful to date is in terms of *acutance*, as defined by workers at *Eastman Kodak*. The acutance of the curve, and, by a simple extension of meaning, the acutance of the photographic definition, is obtained in the following way:

In Fig. 52 we divide the whole area under the graph into a number of strips of equal width. We denote the width of a strip by a. The change in density, from the beginning to the end of strip number s, is D_s. The average rate of change of density in strip number s, denoted by R_s is given by $R_s = D_s \div a$. We start the strips at the point X_1, where the density is D_1, and where R_s is sufficiently small, usually less than $\cdot 006$. We end the strips at the point X_2, where the density is D_2, and where once again R_s is sufficiently small. Suppose that the number of strips enclosed in the region from X_1 to X_2 is N. Then the formula for the acutance is

$$\text{Acutance} = \frac{R_1{}^2 + R_2{}^2 + R_3{}^2 \dots + R_n{}^2}{N} \times \frac{1}{D_2 - D_1}$$

The acutance is a measure of the spread of the density variation across a boundary, and is more closely related to the picture contrast than is resolving power.

ACUTANCE VS. RESOLVING POWER

The relative effects of resolving power and acutance are brought out in pages 266 and 267. Page 266 shows how resolving power patterns and solid areas are reproduced, for the case where the resolving power is high but the acutance is

164

low, and for the case where the resolving power is much lower but the acutance is higher. With a high resolving power we may be able to detect fine structure in an image, but the picture in general will lack sharpness because the edges of the images are soft. With a higher acutance the edge sharpness is improved, but we may lose fine detail in the image.

The same situation is shown in page 267 for pictorial subject matter where the higher acutance picture is much more satisfying than the higher resolution picture. Finer detail may certainly be detected by close examination of the higher resolution picture, but the edges of larger detail are much softer than in the higher acutance picture. As a matter of record the resolution in the higher resolution picture is twice that in the higher acutance picture.

A question to be resolved, for any picture-taking situation, is the relative importance of acutance and resolving power. It would be a pleasant situation if we could combine the acutance and resolving power into an overall formula, which would give due weight to each, and enable us to attach one numerical value to a quantity which would express picture quality. Such a formula has been proposed by the *Eastman Kodak* workers, namely the *E.K. Definition* defined as

$$\text{E.K. Definition} = \text{Acutance} \times [1 - \exp(-k.\overline{R.P.^2})]$$

where $\exp[-k.(R.P.)^2]$ may be obtained from mathematical tables when the resolving power, R.P., is known and where k is a suitable constant. When the resolving power is given in lines per millimetre then $k = \cdot 007$.

In a given lens we may encounter the situation where the distribution of the aberrations gives two possible focal planes. In the first the resolution may be at its best, and we will be able to detect fine detail. In the other focal plane the acutance may be at its highest and the image contrast at its best. From the discussion of the previous paragraphs it is evident that we should not assume that the correct focus setting is that which provides the highest resolution. We may focus a lens for either the maximum acutance or for maximum resolution when these two positions differ from each other. In one case we focus for fine detail while in the other we focus for the sharpest edges on solid areas. The

165

focus which is chosen depends on the type of picture that is desired.

Within the recent past there has been too much concentration in popular literature on resolving power alone as a criterion of lens performance. We must not, however, go to the other extreme and deny any validity to resolving power as a criterion of performance. It is valuable, for example, in assessing the workmanship of a well designed lens. When such a lens is stopped down by two or three stops its performance should be limited by diffraction, and its resolving power can be predicted on theoretical grounds. Any deviation from this value is due to poor workmanship in the lens, in particular it may be due to poor centering of the components in the lens.

SPATIAL FREQUENCY ANALYSIS

The most important step taken in recent years has been the introduction of *frequency response* concepts as a means of analysing optical performance.

Suppose that we examine a small local area of a picture, as illustrated in Fig. 53. Within this area there are variations of picture brightness. Some of these variations are due to the fact that the scene to be recorded is not without structure, so that corresponding variations of picture brightness are to be expected. Some of the brightness variations, however, are due to lens and film imperfections which cause light to spill over into picture areas that should be dark. We need a technique which will allow us to combine the brightness variations, in an ideal reproduction of a scene, with the light distributions generated by lens and film imperfections, so that we obtain the light distribution in a picture as it is actually recorded. *Spatial frequency analysis* provides this tool.

Suppose that we scan the brightness variation in the local picture area along the line AA, as shown in Fig. 53, and plot the results on a graph. We obtain a rather irregular curve, as also shown in Fig. 53. We may rotate the scan direction to the line BB, and we then obtain the corresponding brightness distribution curve. [In practice we traverse a fine slit, or the image of a slit, as shown at SS in Fig. 53, across the picture area, in the direction of the line AA or BB. The light which comes through the slit is gathered by a lens

166

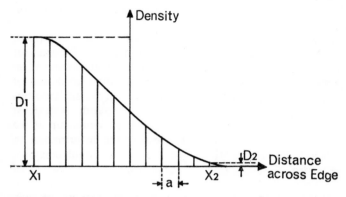

Fig. 52. In place of drawing a curve which shows the brightness variation across an edge, we may draw a curve which shows the *density variation*. This may be used to calculate the *acutance*, which provides a means of measuring picture quality.

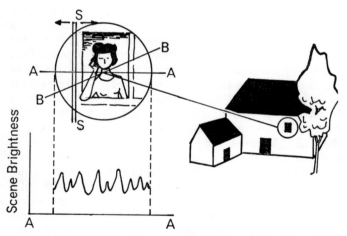

Fig. 53. In order to analyse picture quality we take a small area, indicated by the small circle, and examine the brightness variation within this area along directions such as AA and BB. A typical brightness curve of this type is shown. This curve is analysed by means of super-imposed basic brightness patterns to give the *frequency response* of the lens.

167

system and thrown upon a photo-electric cell. The output of the cell measures the light passing through the slit. When we plot the cell output against the distance that the slit has travelled, we obtain the brightness distribution curves of Fig. 53].

By rotating the lines AA or BB to all possible orientations, and by obtaining the light distribution curves for each of these scanning directions, we acquire complete information about the brightness distribution in the small local area of the picture. The information about the brightness distribution may not be in a readily usable form, but the important fact is that the information is complete. Moreover, if we derive a suitable means of processing the information in each individual scan, then, because of the completeness of the information contained in the scans, we have a means of processing all of the information about the light distribution in the small local picture area. For this reason we may concentrate our attention on the way in which we can handle the brightness information in a single scan.

The line of thought, outlined above, has already led us to a considerable simplification in discussing the pattern of light and shade in an element of a picture or of an image. We have reduced a problem, where we have initially to consider a two dimensional situation, the pattern of light and shade in an area, to one where we discuss a one dimensional situation, the brightness variation in a scan along a line.

We may make a further important simplification. Any brightness curve, of the form shown in Fig. 53, can be built up from a series of basic patterns. One such pattern is shown in Fig. 54a. The shape of the curve is that of a trigonometrical sine function, i.e. it is a sinusoidal curve. The unit of length of the basic pattern is its *periodic length* or *wavelength*, and the reciprocal of this is the *frequency* of the pattern. Thus, if the distance *a* in Fig. 54a is ·10 mm., the frequency of the pattern is 10 cycles per millimetre; if *a* is ·05 mm. the frequency is 20 cycles per millimetre, and so on. The *amplitude* of the pattern is one half of the variation between maximum and minimum values of the basic curve or pattern. In Fig. 54a the amplitude of the pattern is A. A basic pattern is fully described if we give its amplitude A, its frequency *n*, and one other quantity, the *phase* of the pattern. The phase is a measurement of the starting point of

168

BASIC PATTERNS OF BRIGHTNESS CURVES

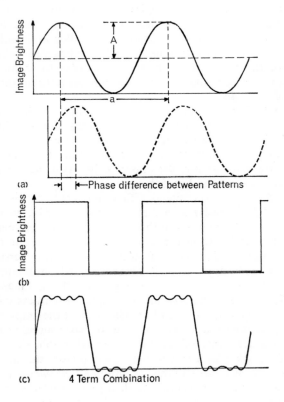

Fig. 54. Any brightness curve can be built up by super-imposing a set of basic patterns of the form shown in (a). Such a pattern is characterised by its *amplitude* A, and its *frequency* $1 \div a$. It also has a *phase* whose meaning is shown in the lower part of (a). By a suitable choice of basic patterns a distribution of brightness of the kind shown in (b) may be synthesised. By using only four basic patterns we arrive at the approximate synthesis shown in (c).

a pattern. In Fig. 54a we show patterns of equal frequency and amplitude, but with different phases.

If we have a light intensity curve of the simple form shown in Fig. 54b, with a pattern frequency of n per millimetre, we may build up this pattern by using basic (sinusoidal) patterns with frequencies of n, $3n$, $5n$ and so on. The amplitudes and phases of these basic patterns have to be properly chosen, and mathematical formulae are available which permit this to be done. We add the brightness due to each of the several basic patterns, in order to obtain the brightness at any point in the more complex pattern, such as that of Fig. 54b.

In Fig. 54c are shown the curves which result from a proper combination of basic curves of frequencies n, $3n$, $5n$ and $7n$. The closeness of fit of the brightness curve obtained by adding these four terms is already evident in Fig. 54c. The more terms we use, the closer is the fit of the curve to the pattern shown in Fig. 54b.

When we have to contend with a more complex distribution of light intensity than that shown in Fig. 54b, we need many more basic curves in the combination of such curves which is intended to fit the brightness distribution curve. In fact we need basic curves of all frequencies from zero upwards. Each basic curve has its own associated amplitude and phase. We may then draw two graphs which, taken together, will completely define a complex brightness curve. In the first graph, shown in Fig. 55a, we plot the amplitudes corresponding to various frequencies of basic curves against the frequencies themselves. In the second graph, shown in Fig. 55b, we plot the corresponding phases against the frequencies. We may call the first graph a *frequency distribution curve*, and the second graph a *phase variation curve*.

This notion, that we may completely describe a brightness distribution by a frequency distribution curve and a phase variation curve, is central to all modern work in photographic optics. It corresponds in many ways to a well established technique in music, where we may define the quality of sound by specifying the loudness of all the pure tones in the musical scale which are sounding at the same time. Each pure tone corresponds, of course, to a definite frequency of air pressure pulsations. The total air pressure variation when an orchestra is playing is very complex, but,

170

GRAPHIC DEFINITION
OF BRIGHTNESS DISTRIBUTION

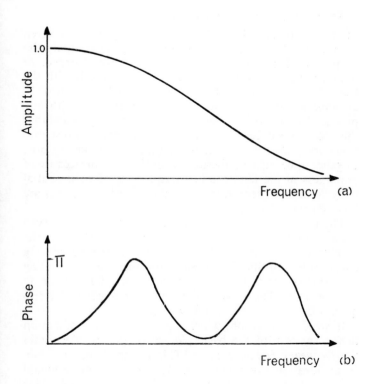

Fig. 55. In order to describe the total range of basic patterns which are needed to synthesise an arbitrary brightness variation we may plot a curve of the necessary amplitudes against frequency, as shown in (a), and a curve of the appropriate phases against the frequencies of the basic patterns, as shown in (b).

171

by analysing the sound in terms of the content of different musical tones, we may arrive at simple techniques for evaluating the quality of sound reproduction. In a parallel way, by analysing a brightness distribution in terms of standard basic patterns, we may derive simple techniques for evaluating the quality of picture reproduction.

SPATIAL FREQUENCY RESPONSE AND O.T.F.'S

In order to discuss the quality of picture reproduction given by a lens, or by a lens-film combination, we compare the frequency distribution curve, which we should expect to obtain if the reproduction of a scene were ideal, with the frequency distribution curve which is actually obtained. In an ideal situation the two curves are identical. With any practical combination of lens and film, however, we find that the two curves differ, and that the actual frequency distribution curve falls below the ideal curve, as shown in Fig. 56a. In general, because of aberrations in the lens, or because of graininess in the film, the low frequencies of basic spatial patterns are well reproduced, but the higher frequencies are less well reproduced.

The ratio, at some particular spatial frequency, between the amplitude which we actually obtain in a picture, and the amplitude which we would expect if there were no degrading effects of lens or film, is the *modulation factor* corresponding to that frequency. It is never greater than $1 \cdot 00$, but it may become zero. The modulation factor at a particular frequency is the ratio $P'X \div PX$ in Fig. 56a.

If we draw a graph, which shows how the modulation factor varies with the basic pattern frequency, we obtain the *frequency response* curve. This is shown in Fig. 56b. In an ideal situation the frequency response curve would have the form shown by the dotted line in Fig. 56b. This type of curve is never realised in practice.

Another difference must be noted between an actual reproduction of a scene and the ideal reproduction, namely the fact that there may be relative phase changes for basic patterns of different frequencies. For low spatial frequencies there is no phase change, and the reproduced patterns essentially coincide with the ideal patterns, as shown in Fig. 56c. For higher frequencies the reproduced patterns have a lower amplitude, and they may be shifted relative to

172

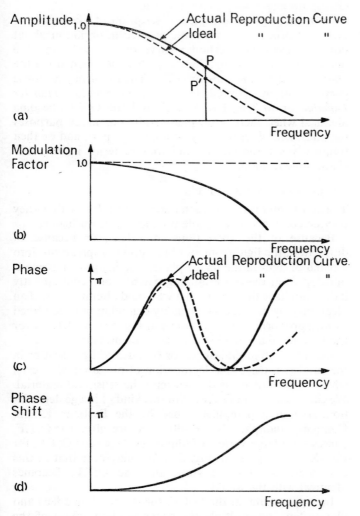

Fig. 56. If a scene were reproduced under ideal conditions the distribution of amplitudes would be given by the continuous curve in (a). Because of aberrations the distribution of amplitudes in the scene reproduction is given by the dotted line in (a). From these we derive the *modulation* factor curve shown in (b). The corresponding situation for phases is shown in (c) and (d).

173

the ideal pattern, as also shown in Fig. 56c. We may draw a graph, as shown in Fig. 56d, which expresses the phase change for any basic pattern frequency.

In order to give a complete description of the quality of picture reproduction, we must provide information about both the frequency response curve of Fig. 56b, and the phase shift curve of Fig. 56d. Together these constitute the *Optical Transfer Function* or *O.T.F.* The frequency response curve is often referred to as the *Modulation Transfer Function* or *M.T.F.* The M.T.F. and the O.T.F. become identical when there is no phase shift. For many purposes the phase shift does not play an important part, and we then frequently use the O.T.F. and M.T.F. terms in an interchangeable fashion.

APPLICATIONS OF O.T.F'S

The most important characteristic of O.T.F's is that they may be combined in a simple way, as described below.

Because of the aberrations in a lens, or because of diffraction, the light from an object point is spread out into a patch of light in the image plane. The image of a scene is built up from these overlapping patches, and consequently it does not have the quality that we would obtain if we had an ideal imaging process. This quality degradation is described by an appropriate O.T.F., shown in Fig. 57a, b. O.T.F's for the lens alone are readily calculated or measured.

Because of film graininess, or because of light scatter in the emulsion, there is a degradation of picture quality even when an ideal image is thrown onto the sensitised material. We can associate an O.T.F. with this kind of image degradation, and in a pamphlet issued by the Eastman Kodak Company (Pamphlet No. P–49) there are given the O.T.F. curves for a large variety of film types. One such O.T.F. for Plus-X film is given in Fig. 57c. We may note that in this case there is no phase shift, and the O.T.F. becomes identical with the M.T.F.

In order to obtain the O.T.F. for the combined lens and film system, we multiply the corresponding values of the modulation factors in each M.T.F., and we add the individual phase shifts. Thus in Fig. 57 we multiply P_1X_1 from the curve of Fig. 57a, and P_2X_2 from the curve of Fig. 57b, to obtain the appropriate value of P_3X_3 in Fig. 57c. In general

174

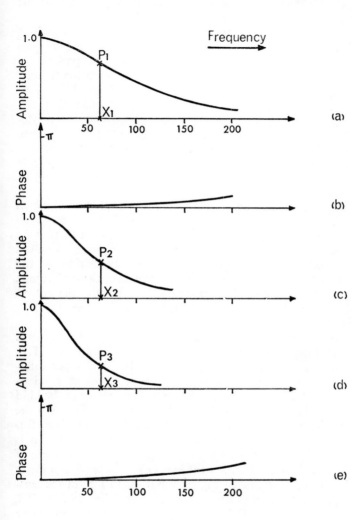

Fig. 57. If the characteristics of a lens are shown by the O.T.F. curves of (a, b), and if the characteristics of a film are shown by the M.T.F. curve of (c), then the characteristics of the lens-film combination are shown by the O.T.F. curves of (d, e). These are derived as explained in the text.

we add the phase shifts of Figs. 57a, b to obtain the appropriate phase shift of Fig. 57c. (As already mentioned the phase shift in 57b is zero).

When we have a complex image-forming process, which involves more than two stages, with each having its own O.T.F., we obtain the O.T.F. of the total process by multiplying together the corresponding modulation factors, and by adding together the individual phase shifts. This ease of combining O.T.F's is due to the fact that any degradation process, of the kind we encounter in photographic work, does not destroy the shape of a basic pattern. The shape is always that of a trigonometric sine function. The degradation process may only reduce the amplitude of the pattern and change its phase, without changing its basic shape or its frequency.

An important fact emerges from the simple way in which O.T.F's may be combined: if any one O.T.F. becomes zero at a certain frequency, a cut-off frequency, then there is no point in maintaining the other O.T.F's at non-zero values beyond this frequency, particularly if any sacrifice in the value of the other O.T.F's at lower frequencies has to be made in order to establish non-zero values beyond the cut-off frequency. Beyond the cut-off frequency the overall O.T.F. is zero because one O.T.F. is zero.

An example of the situation described in the previous paragraph is that in which we have a film with an O.T.F. (or M.T.F.) which becomes zero at 100 cycles per millimetre, as shown in Fig. 58a. It is possible to have a lens with an O.T.F. of the kind shown in Fig. 58b, or of the kind shown in Fig. 58c. With the form shown in Fig. 58b the O.T.F. of the lens alone is maintained to quite high frequencies, but the O.T.F. of the lens-film combination is shown by the continuous line in Fig. 58d. With the form of O.T.F. shown in Fig. 58c the lens O.T.F. cuts off at a lower frequency than that of Fig. 58b, but the O.T.F. of the lens-film combination is shown by the dotted line in Fig. 58d. A lens having the O.T.F. of Fig. 58b would show up better in a resolution chart test, with visual examination of the image, than would a lens with the O.T.F. of Fig. 58c. In a photographic test, however, using the specified film, a lens with the O.T.F. of Fig. 58c would show up better than a lens with the O.T.F. of Fig. 58b. There is an inversion

176

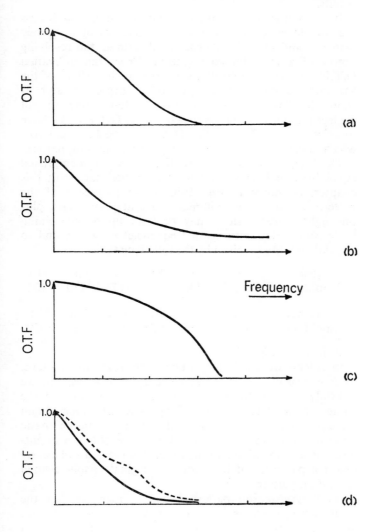

Fig. 58. If we combine a film having an M.T.F. as shown in (a) with the M.T.F. of a lens which has the form shown in (b) or (c) we obtain the M.T.F. curves of the lens-film combinations which are shown in (d). The M.T.F. of the combination is zero beyond the point at which the M.T.F. of the film becomes zero.

177

between the visual resolution results and the photographic results.

It is a matter of some interest and importance to discuss the way in which we may use the concepts of frequency response and O.T.F's in order to determine the resolving power of a lens-film combination. From the individual O.T.F's of the lens and film we arrive at the O.T.F. of the lens-film combination, as previously explained and as shown in Figs. 57c and 59a. (For the time being we will neglect the phase variation aspect of the O.T.F.). We have to examine the effects of this O.T.F. on the basic patterns which make up the brightness curve of a resolution pattern.

The brightness curve of a resolution pattern, comprising equal light and dark spaces, as described earlier in this chapter, is shown in Fig. 59b. If the frequency of the pattern is n units per millimetre (a unit is one dark plus one light space) then it may be built up by combining basic (sinusoidal) patterns of frequencies n, $3n$, $5n$, and so on, with amplitudes given by the following table:

Frequency	n	3n	5n	7n	9n	11n
Amplitude	1·272	·420	·248	·173	·130	·102

Frequency	13n	15n	17n	19n	21n	23n
Amplitude	·082	·066	·054	·044	·036	·030

and shown in Fig. 59c.

In order to obtain the amplitudes in the resolution pattern, *as it is reproduced by the given lens-film combination*, we multiply the amplitudes given in the preceding table by the values of the O.T.F. at those frequencies. We then obtain the amplitudes shown in Fig. 59d. When we combine basic patterns with these relative amplitudes we obtain a brightness curve of the kind shown in Fig. 59e. We can still clearly detect a pattern, but it is not the original crisply defined resolution pattern.

As the resolution pattern becomes finer, so that the frequency n increases, we may apply the same treatment. We then obtain brightness curves such as those shown in Fig. 60a and 60b. Special interest attaches to the case where n is so great that $3n$, $5n$ and so on lie in the region where the O.T.F. of the lens-film combination is zero. In this region the brightness curve, for the resolution pattern as it is

178

RESOLVING POWER
OF LENS-FILM COMBINATION

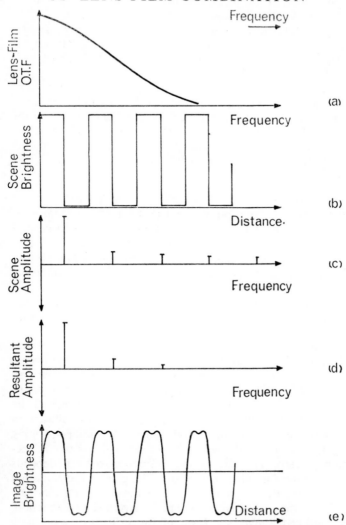

Fig. 59. In order to obtain the resolving power of a lens-film combination we combine the M.T.F. curve of this combination with that of the test chart. The brightness distribution of the chart is shown in (b) and its frequency distribution is shown in (c). The M.T.F. for the combination is shown in (d). By recombining basic patterns with this frequency distribution we obtain the brightness curve shown in (e).

179

reproduced by the lens-film combination, is of pure basic (sinusoidal) form, as shown in Fig. 60a. Its amplitude is approximately $1 \cdot 3$ times the value of the lens-film O.T.F. at that frequency. When this amplitude falls below a certain value we can no longer see a discernible pattern in the brightness curve, and at this point the resolution pattern is no longer resolved.

The exact value of the amplitude, where the pattern ceases to be resolved, is somewhat nebulous and a matter of conjecture. A useful criterion is to take the point where the value of the O.T.F. becomes $\cdot 07$. Hence, in order to obtain the resolving power of a lens-film combination, we need only to determine the frequency where the value of its O.T.F. becomes $\cdot 07$.

TYPES OF O.T.F'S

It has already been pointed out that the O.T.F. comprises two parts, an M.T.F. and a phase change curve. In general the phase variation is of lesser importance than the M.T.F. The phase variation is primarily due to asymmetric aberrations, such as coma and lateral colour. The symmetrical type of aberrations, such as spherical aberration and astigmatism, do not give rise to a phase change. In the present section, therefore, we will primarily concentrate on the M.T.F. aspect of the O.T.F.

When the aberrations of a lens are so well corrected that the rays of light which traverse the lens appear to converge into a point focus, then the lens performance is determined by the diffraction of light. The image is then of a standard *Airy disc* form, with a central nucleus surrounded by progressively fainter outer rings. The size of the diffraction pattern depends on the wavelength of the image-forming light. The shorter the wavelength the smaller is the diffraction pattern. The size of the diffraction pattern depends also on the *f*-number of the lens. The greater the *f*-number of the lens the larger is the size of the diffraction pattern.

When the performance of a lens is governed by diffraction, as outlined above, the form of the O.T.F. is universally constant. The limiting frequency, at which the O.T.F. becomes zero, depends on the wavelength of the light and the *f*-number of the lens, according to the following formula:

Limiting Frequency $= 1 \div$ (wavelength \times *f*-number)

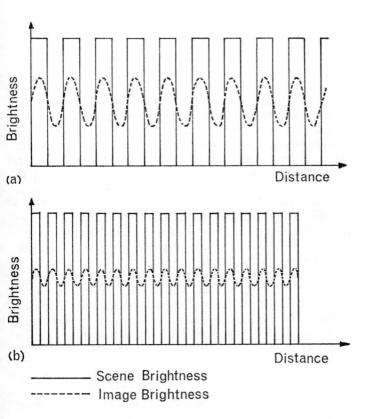

(a)

Brightness

Distance

(b)

Brightness

Distance

——— Scene Brightness
------- Image Brightness

Fig. 60. When the frequency of the resolution chart exceeds a certain value the brightness variation of its reproduction by a lens becomes sinusoidal, as shown in (a). With increasing frequency of the resolution pattern the amplitude of this variation is reduced, as shown in (b), until it is not clearly discernible. At this point resolution is lost.

181

In terms of the wavelengths corresponding to the spectrum lines normally used in photographic work, as described on page 133, the limiting frequencies are as shown in the following table.

XXI – LIMITING FREQUENCIES

Spectrum Line	Wavelength	Limiting Frequency	
A′	768·2	1302 ÷	f-number
C	656·3	1524 ÷	,,
D	589·3	1697 ÷	,,
e	546·1	1832 ÷	,,
F	486·1	2058 ÷	,,
g′	424·0	2304 ÷	,,

The wavelength is measured in milli-microns, and the limiting frequency is expressed in cycles per millimetre.

Since the form of the O.T.F. is always the same for a diffraction limited lens, with only its scale changing according to the wavelength of the light and the lens f-number, we may draw a universal curve which expresses the O.T.F. in terms of fractions of the limiting frequency. This is shown in Fig. 61.

When there are aberrations present we can no longer express the O.T.F. in a universal way. Each lens then has its own characteristic O.T.F., depending strongly on the aberrations which are present.

There is, however, one situation in which we may describe a standard O.T.F., namely that in which a lens is sufficiently defocused that the image patch becomes an even disc of light. We encounter this situation when we are discussing depth of focus and depth of field. If the diameter of such a disc is D, then the limiting frequency, for which the M.T.F. becomes zero, is given by the formula:

$$\text{Limiting Frequency} = 1 \cdot 22 \div D$$

If the diameter D is expressed in millimetres the limiting frequency is expressed in cycles per millimetre.

The shape of the O.T.F. curve has a standard form in this case. It is shown in terms of fractions of the limiting frequency in Fig. 62. (When the O.T.F. is negative we have spurious resolution).

In dealing with depth of field in our first chapter we used a circle of confusion having a diameter ·001 × focal length of the lens. Substituting this value in the formula given immediately above means that, if the focal length is measured

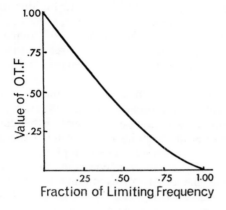

Fig. 61. The form of the M.T.F. for a diffraction limited system is constant for all such systems. Its scale depends on the f number and the wavelength of light.

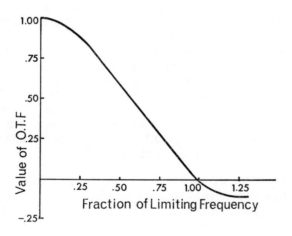

Fig. 62. The M.T.F. curve for a defocused system has a standard shape. Its size depends on the amount of defocusing and on the f-number of the lens.

183

in inches, the limiting frequency in cycles per millimetre is approximately equal to $48 \div f$.

We have also used a fixed diameter circle of confusion of ·00075 in., for example, in which case the limiting frequency is 52 cycles per millimetre. This value, and the $48 \div f$ value given above, are well below the cut-off frequencies for film, published in the Kodak pamphlet referred to on page 174, and in this case the lens performance is the limiting factor.

In the centre of the field of a well made lens the image patch is circular, and because of this symmetry we can specify the monochromatic performance of the lens by one O.T.F. When the image point does not lie at the centre of the field there is normally astigmatism present. In this case we give two O.T.F. curves, one corresponding to the radial direction, and the other corresponding to the tangential direction, as explained in the previous chapter. Because of chromatic aberrations, including the chromatic variation of spherical aberration, coma, astigmatism and so on, we should really give O.T.F. curves for each colour of light. When this is done, however, we find that we have an excessive amount of information to digest. It is preferable, therefore, to combine the O.T.F's for light of different colours, using a weighting factor for each light which depends on the colour sensitivity of the plate or film, so that we obtain a composite O.T.F. for all colours of light.

The O.T.F. varies over the field of the lens, and a complete statement of the lens performance must exhibit this variation. In practice it is sufficient to show the value of the O.T.F. in the centre of the field covered, at the edge of the field, and at one or two intermediate points. By using electronic computers and modern print-out equipment, the whole process of preparing O.T.F. curves can be mechanised. Typical curves are shown in Fig. 63.

THE EFFECTS OF CONTRAST

The discussion of the reproduction of resolution patterns in terms of O.T.F's, as carried out in previous pages, has been restricted to the special case where the contrast in the resolution patterns is infinite. In other words, the dark spaces are completely black and the light spaces are perfectly white. Since contrast is defined as the ratio of maximum

184

LENS PERFORMANCE FROM M.T.F. CURVES

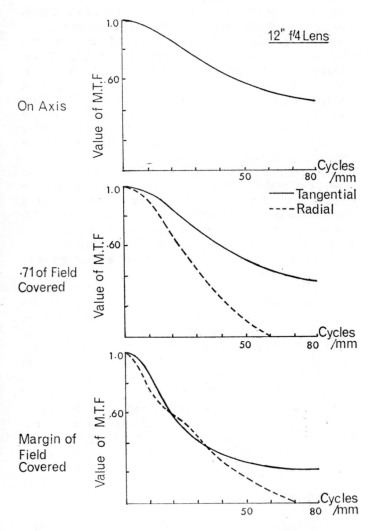

Fig. 63. The performance of a lens, such as a 12-in. *f*4, may be described by giving the M.T.F. curves for the centre of the field and for two field positions. A composite of all colours is used in order to simplify the presentation.

brightness to minimum brightness, and since the minimum brightness is zero, we thus arrive at an infinite value for the contrast in this special case.

In the case of infinite contrast we may regard the brightness curve as being generated from a uniform level curve, shown in Fig. 64a, on which is superimposed a pattern of the kind shown in Fig. 64b. In regions such as AA, etc. the brightness of the pattern in Fig. 64b is added to the brightness in Fig. 64a, to give the brightness shown at AA in Fig. 64c. In regions such as BB the brightness of Fig. 64b is subtracted from the even level of Fig. 64a, to give the zero brightness of BB in Fig. 64c. The amount that we add or subtract from the even level is equal, in this case, to the average level shown in Fig. 64a.

When the limit of resolution is reached, which we have taken as being the point on the O.T.F. curve where it has the value ·07, the brightness pattern of Fig. 64c becomes a shallow ripple on the level curve, as shown in Fig. 64d. The amplitude of this ripple is approximately ·10 of the average level, so that there is an overall brightness variation of 20 per cent, and this can also be taken as a criterion to define the limit of resolution.

When we have a finite or low contrast in the resolution pattern, denoted by C:1, then we may build up the brightness curve as before, but the amplitude of the pattern of Fig. 64b is reduced to that of the pattern in Fig. 64e. The resultant brightness curve is shown in Fig. 64f. If the amplitude of the pattern in Fig. 64e is X times the average level of Fig. 64a, then the contrast C is given by

$$C = (1 + X) \div (1 - X) \text{ or } X = (C - 1) \div (C + 1).$$

Thus when $C = 2$, $X = 1/3$. Relative to the infinite contrast situation, the amplitude of the pattern of Fig. 64e has been reduced to one third of the value of Fig. 64b.

In order to obtain the resolution limit with this contrast level, we may apply the treatment given in the previous section, but we now use amplitudes for n, $3n$, $5n$, etc. which are one-third of the values we used in the earlier treatment. In the previous treatment we arrived at the resolution limit, to give the ripple shown in Fig. 64d, by taking the frequency for which the O.T.F. has the value ·07. We now obtain the same ripple, by choosing the frequency for which the O.T.F. has the value $(\cdot07 \div 1/3) = \cdot21$.

186

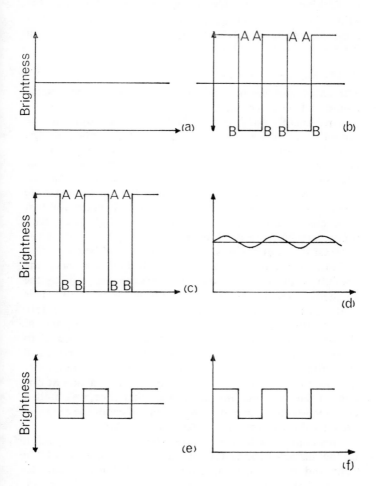

Fig. 64. In discussing the effects of contrast we can regard the light distributions of (a) and (b) combining to give the brightness curve (c). The brightness curve as reproduced by the lens is shown in (d). With reduced contrast the brightness variation of (b) is replaced by that of (e) to give the low contrast brightness variation shown in (f).

187

The general rule is that we obtain the limit of resolution by seeking the frequency for which the O.T.F. has the value ·07 ÷ X. This is sufficiently accurate for all practical purposes. In this way, from the O.T.F. curve, we may obtain the resolution values for low contrast patterns.

MEASUREMENT OF O.T.F'S

The exact measurement of O.T.F's requires precise electronic and scientific equipment.

A reasonably good idea of the M.T.F., however, may be obtained by using the contrast effects described in the preceding section. Suppose that we have a resolution test chart with variable contrast, as shown in Plate 4a. At one edge of the chart the contrast is infinite, meaning that the light areas are perfectly white and the dark areas are completely black. At the other edge of the chart the contrast is practically zero: the whole pattern is a light grey, with minor variations in brightness. Between the two edges the contrast varies in a manner which is discussed below.

Along the edge of the chart with high contrast, the resolution of the test pattern is maintained out to the frequency limit where the O.T.F. drops to about ·07. This is the situation which we discussed on pages 178 to 180. At the other edge of the chart we obtain resolution only at the beginning of the pattern, where the O.T.F. is equal to unity. Along an intermediate line, such as XX on page 268 the pattern resolution is lost at an intermediate point. By moving the line XX to a series of positions, starting at one edge of the chart and finishing at the other edge, we obtain a contour which is generated by the boundary of the resolved area, as shown in the lower half of page 268.

This contour will give a reasonably good approximation to the shape of the O.T.F. curve if the brightnesses of the light and dark areas, at appropriate distances from the edges of the chart, are given by the curves of Fig. 65. Note that with the brightness curves shown in Fig. 65 the average level of illumination is constant along any line such as XX on page 268. In this way we avoid any problems due to an overall change in brightness.

In place of using a variable contrast chart, as described above, we may use a series of resolution test charts, each with its own contrast ratio. The resolution measurements are

188

Fig. 65. An idea of the M.T.F. curve of a lens may be obtained from a variable contrast resolution chart in which the brightness of the light and dark areas is given by the curves of this diagram.

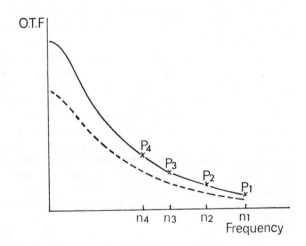

Fig. 66. This curve shows the way in which the data obtained from a variable contrast resolution chart or series of charts may be reduced to graphical form.

189

carried out with these charts, in the same way as they are carried out for the infinite contrast charts, as described earlier in this chapter.

In order to reduce the data, so obtained, to a suitable form we proceed as follows. We assume that the limit of resolution is reached when the ripple on the brightness curve, as discussed on page 186, has an amplitude which is $\cdot 10$ of the average brightness. The modulation factor corresponding to this value, at the limit of resolution on the high contrast test chart, is then equal to $\cdot 07$. If this limit of resolution is n_1 cycles per millimetre we then obtain the point P_1 in Fig. 66. If the contrast ratio in another test chart is C:1, then the modulation factor is equal to $\cdot 07 \div X$, where $X = (C - 1) \div (C + 1)$. If the limit of resolution for a contrast ratio of 3:1 is equal to n_2, then $X = (3 - 1) \div (3 + 1) = 1/2$, and the modulation factor is $\cdot 07 \div 1/2 = \cdot 14$. We thus obtain the point P_2 in Fig. 66. In a similar way, by using a range of charts, we obtain points such as P_3 and P_4, etc., corresponding to limiting frequencies of n_3 and n_4 for the respective resolution limits. By drawing a curve through a range of points such as P_1, P_2, P_3, etc. we obtain the M.T.F. curve of Fig. 66.

There is a certain arbitrary element about the choice of the $\cdot 07$ value as defining the limit of resolution. If another value is chosen, say $\cdot 05$ for example, then we obtain a curve of the type shown by the dotted line in Fig. 66. In order to remove such an ambiguity we have to use quite complex electronic and scientific measuring equipment. The simple procedure described above, however, even though it is only an approximation, brings out the main features of the M.T.F. curve. In particular it shows that, with an M.T.F. curve of the type shown in Fig. 67a, we may lose high contrast resolution quite quickly, but we maintain low contrast resolution quite well. On the other hand, with the M.T.F. curve of Fig. 67b we maintain the high contrast resolution out to quite high frequencies, but we lose low contrast resolution very quickly.

A curve of the kind shown in Fig. 67a also results in a sharper edge gradient than does the curve of Fig. 67b, and as also explained earlier in this chapter this is an important factor in defining picture quality.

190

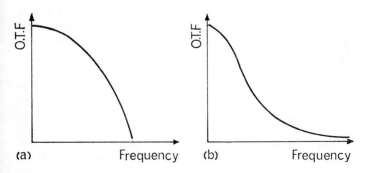

Fig. 67. Of the two forms of O.T.F. curve (a) gives a sharper edge gradient than curve (b), but (b) gives higher resolution; (a) gives better low-contrast resolution but (b) gives better high contrast resolution.

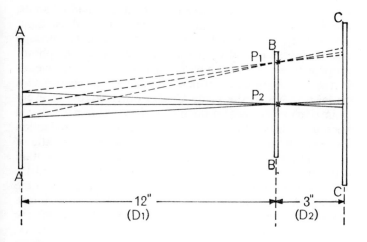

Fig. 68. In carrying out *image synthesis* a negative of a spot diagram is placed at AA, with a target in the plane BB, and a plate or film in the plane CC. The image recorded in the plane CC shows the effects of aberrations in the lens.

The discussion of picture quality given in the previous pages has been in some ways an indirect approach in that we have considered the effects of aberrations by discussing some aspects of image quality which are related to the aberrations present, such as resolution, acutance and O.T.F's. There is another somewhat more direct way of relating picture quality to the light patches produced by aberrations, namely by using *image synthesis*. This technique is particularly associated with *N. S. Kapany*.

The arrangement for the form of image synthesis technique that is used as a design and evaluation tool in the *Bell and Howell Company* is shown in Fig. 68. A negative of a spot diagram, as described on page 126, is placed in the position shown at AA in Fig. 68. This negative is illuminated from behind, using a flashed opal screen in order to obtain even illumination. An enlarged element of part of a scene is placed at BB, and a viewing screen or photographic plate is placed at CC, as shown in Fig. 68. The distance from the plane AA to BB is D_1, and from BB to CC it is D_2.

Since we have a negative of the spot diagram, we have transparent dots which correspond to the individual spots, and light is transmitted through each of these dots. Light proceeds from each and every one of these dots, through points such as P_1 and P_2 in Fig. 68, and reaches the photographic plate at CC. Each point, such as P_1 or P_2, behaves as if it were a fine pinhole which is imaging the negative spot pattern of AA in the plane CC. In other words, to every point such as P_1 or P_2 in the plane BB, we obtain a reduced version of the spot diagram in the plane CC. The reduction in size from the plane AA to the plane CC is in the ratio of $D_2 \div D_1$. Thus if D_1 is 12 in., and D_2 is 3 in., we obtain image patches, corresponding to points such as P_1 and P_2, which are one-quarter of the size of the spot diagram in the plane AA. For all points in BB we obtain such image patches, and we record in the plane CC the effects which are produced by a multitude of such overlapping patches. This is, of course, just the image forming process which operates when we are taking pictures with a lens that suffers from aberrations. We are thus able to simulate the image-forming process, with a calculated spot diagram

192

which has the same form as the light patch given by an actual lens.

The scale of the picture in the plane CC is increased over the picture size in the plane BB in the ratio $(D_1 + D_2) \div D_1$. Thus for the values of D_1 and D_2 already quoted, the picture in CC is $1 \cdot 25$ times larger than the picture in the plane BB. Picture quality depends, of course, on the size of the image patch in the plane CC relative to the size of picture detail in the plane CC.

With the aid of modern electronic computers we can readily prepare such spot diagrams, representing the aberrations which are present in any proposed lens design, and by using this image synthesis technique we may evaluate the corresponding way in which any scene detail will be reproduced. For the spot diagrams we may use black and white negatives, in order to get a reasonably complete indication of lens performance, particularly as it is affected by the monochromatic aberrations. For the most complete information, however, we use the coloured spot diagrams shown in the Frontispiece to this book, and at the same time we use colour film in the plane CC. For an intermediate level of information we may use a coloured spot diagram in the plane AA, but black and white film in the plane CC.

We have to choose a reasonable scale of representation of the actual image patch, through the medium of the spot diagram, in the plane CC so that we may reduce diffraction effects. With the dimensions for D_1 and D_2 already given a convenient scale of reproduction is $100:1$. In other words the spot diagram, which is formed in the plane CC, is one hundred times the size of the light patch which we expect the lens to give. This means, of course, that the computed spot diagram in the plane AA is four hundred times the size of the light patch which the lens will produce. In the same way, if we are discussing the ability of the actual lens to resolve a pattern of 100 lines per millimetre, the image pattern in the plane CC is one line per millimetre: the resolution pattern in the plane CC is one hundred times as coarse as the actual image pattern. In order to obtain this size of pattern in the plane CC we have to use a pattern of $1 \cdot 25$ lines per millimetre in the plane BB.

We can use a variety of scene elements in the plane BB. For example, we can use a good enlargement of a picture of

193

part of a human face, such as an eye, so that we may determine the way in which this kind of image will be reproduced by a lens whose image patch is represented by a particular spot diagram. In another kind of example, we may use a suitably scaled reproduction of typescript or of printing, in the plane BB, so that we may determine how a particular type of lens image will record printing or typescript on microfilm. In order to attempt a correlation of high or low contrast resolution targets with picture quality we may attach resolution test patterns to the scene in the plane BB, and determine how they are reproduced in the plane CC.

The use of image synthesis provides a means by which we may predict the quality of picture reproduction, using computed results only, before a lens is fabricated. The only requirement is that the aberrations in the lens should be sufficiently large, so that we may predict image structure, in a reasonable way, without using diffraction theory. Under these conditions we may use a variety of negative spot diagrams in the plane AA.

In the extreme case, when the aberration curves are so well-corrected that light rays appear to converge in a point, the light distribution in the focal plane is determined by the diffraction of light, as previously discussed. In this case we cannot use the standard techniques to prepare a spot diagram. A computer programme, however, has been developed in order to produce a spot diagram in this special case. This special spot diagram is shown in Fig. 69. A negative of this figure may be used in the plane AA of Fig. 68, in order to carry out image synthesis with a simulated diffraction limited light patch. The diameter of the diffraction pattern, defined by PP in Fig. 69 is given by the formula

Distance PP $= 2 \cdot 44 \times$ (light wavelength) \times (f-number)

Wavelengths of light are given on page 133.

DEPTH OF FOCUS

There is one other light patch which is of a standard type, namely the light patch produced by a de-focused lens, when the defocusing is sufficient for its effects to be large compared with the aberrations present. This situation is

194

AIRY DISC SPOT DIAGRAM

Fig. 69. The *Airy disc*, which is the image patch produced by the diffraction of light when all rays through the lens would come to a point focus may be represented by this spot diagram. It corresponds to the best performance that a lens can yield. The diameter of the disc is taken to be PP. The outer ring is located at the first maximum of intensity outside the central disc.

195

readily encountered when a de-focused lens is stopped down two or three stops from its maximum aperture. The spot diagram, which is to be mounted in the plane AA for a programme of image synthesis, takes a very simple form in this case. We may, in fact, simply use a hole of the proper diameter which is cut through an opaque support.

If we start with a sharp negative in the plane BB of Fig. 68 we obtain a defocused picture in the plane CC, the degree of defocusing corresponding to the size of the image patch in the plane CC.

Experiments may be carried out with varying sizes of light patches in the plane CC of Fig. 68, corresponding to varying degrees of defocusing, so that a correlation may be established between the maximum acceptable degree of picture blur and the corresponding size of the light patch. Criteria of picture sharpness were proposed in the first chapter; the present technique permits an evaluation of these criteria to be made. In order to verify that the diameter of the light patch, in the plane CC of Fig. 68, has the proper diameter, we may attach resolution charts to the sides of the negatives, as shown in Fig. 70. If the width of the bright plus dark space, in the last pattern which is just resolved when there is the maximum acceptable amount of image blur in the plane CC, is equal to a, then the diameter of the light patch in the plane CC is equal to $a \div 1 \cdot 22$. This is the diameter of the circle of confusion which may be used in depth-of-focus calculations, as detailed on pages 64–76.

If a limited objective is established, namely to investigate the effects of defocusing only, without any reference to image degradation by aberrational defects, then a simpler technique than image synthesis may be used. A negative with attached resolution charts, of the form shown in Fig. 70, is placed in an enlarger and out-of-focus enlargements are made. These are evaluated for acceptable, not for perfect, standards of definition. In the print with an acceptable picture blur the last resolved pattern is noted, and from that pattern the diameter of the disc of confusion is obtained, in the way described in the previous paragraph.

LENS TESTING

We may divide lens testing into two distinct kinds, what we may call functional testing on the one hand, and diagnostic

196

(a)

(b)

Fig. 70. The quality of a picture that may be anticipated when the images are slightly out of focus, can be linked to the diameter of a circle of confusion by making enlargements which carry resolution charts. In (a) the picture is in sharp focus; in (b) it is out of focus and the diameter of the corresponding circle of confusion may be obtained from the resolution charts shown.

197

testing on the other. By functional testing we mean the type of examination of a lens which will indicate the quality of the picture it will yield. By diagnostic testing we mean the type of examination which will determine why a lens falls short of its ideal performance. Diagnostic testing is intended to determine the presence of those aberrations described on pages 98–150. The present chapter has so far been concerned with functional testing, the determination of the level of picture taking quality in the lens. In the following sections we will consider some aspects of diagnostic testing.

For this purpose we may consider the aberrations under the following heads:
1. Aberrations due to decentration (workmanship defects)
2. Spherical aberration, both axial and oblique
3. Coma
4. Astigmatism and Field Curvature
5. Distortion
6. Axial Colour
7. Lateral Colour.

DECENTRATION ABERRATIONS

Unless we have a well-centred lens the aberrations which are specifically introduced by this decentration, and described on page 147 may be such as to mask or severely modify the aberrations which we normally consider, such as spherical aberration, coma and so on. For this reason it is important, at the beginning of a test programme involving any lens, that we check the lens for decentration. If excessive decentration aberrations are discovered then remedial action to correct them must be taken before any attempt is made to determine the amounts of other aberrations which may be present. Such remedial action is, of course, best carried out by the lens manufacturer.

The simplest way of examining a lens for decentration effects is by means of a *star test*, as described below and shown in Fig. 71. P is a star, a small bright source of light. In normal practice it consists of a fine pinhole pierced through thin sheet metal, and illuminated from behind with a low power bulb. Some diffusion must be provided, as shown at G in Fig. 71, so that the pinhole may be evenly illuminated.

198

Fig. 71. In carrying out a *star-test* a fine illuminated pinhole P is imaged by the lens L and the image observed with a microscope M. Various positions of P and M are shown for testing the axial and off-axial performance of the lens.

Fig. 72. We may check for *spherical aberration* by masking off various zones of the lens aperture, using masks of the form shown, and by examining the image obtained in each case.

199

The distance from the pinhole P to the lens L should be at least twenty times the focal length of the lens. The diameter of the pinhole should be chosen, using the formulae on page 59, so that its image in the focal plane of the lens will have a diameter of about ·0005 in. The useful diameter of the pinhole image depends somewhat on the aberrational correction of the lens under test, and it is often worth while trying a variety of sizes. The image of the pinhole is examined with the microscope M, and suitable provisions must be made to centre the microscope on the image, and to focus it. The lens itself is mounted in a lens-holder H, using its own mounting thread and mounting flange, in such a way that the lens may be rotated about its own axis. It is important that this rotation may be carried out smoothly.

If the lens is perfectly centred then there will be no change in the pinhole image, as seen through the microscope, when the lens is rotated smoothly about its own axis. In general, as a result of minute manufacturing flaws, the image may wander a little. Except for some unusual lenses this small image wander is not of any significance. What is significant is an image structure of a non-symmetrical kind, whose orientation changes as the lens is rotated about its own axis. Such an unsymmetrical pattern may often take the form of a bright nucleus, displaced away from the centre of a circular flare of light, the position of the nucleus changing relative to the circular flare as the lens is rotated. Such a pattern arises from a combination of decentration coma and whatever spherical aberration is originally present in a well centred lens of this design.

Only a small amount of such lack of symmetry may be tolerated. In a well made lens it will be barely discernible at any focus setting of the observing microscope.

If the star is moved to the position P′ in Fig. 71 then its image may be observed by moving the microscope to the position M′. (It may be necessary on occasion to pivot the microscope about a point just in front of the objective, in order to pick up all the light from the test lens.) The image point does not now lie in the centre of the field, and we cannot expect that the image will show the symmetry that we expect of it when it lies in the centre of the field, as described in the previous paragraphs. In a well centred lens,

200

however, the form of the image will not change as the lens is smoothly rotated about its own axis. When there is decentration in the lens, however, the image will appear to grow and to diminish, it will appear to "breathe" as the lens is rotated.

The amount of breathing is a measure of the decentration present, and only very small amounts may be tolerated.

It is worth pointing out that the freedom from decentration errors on the axis of the system, i.e. with the star in the position P in Fig. 71, does not imply freedom from decentration effects at off-axis points, with the star in the position P' in Fig. 71. The two defects arise in different ways within the lens.

SPHERICAL ABERRATION AND COMA

A check of a lens for either spherical aberration or for coma is best carried out by a star test of the type described above. The difference between the previous testing, and that presently contemplated, is that we now consider the form of the light patch rather than its variation as the lens is rotated.

The examination for spherical aberration is carried out with the star in the position P of Fig. 71, so that its image lies on the axis of the lens. Spherical aberration then results in the light patch, as observed through the microscope M of Fig. 71, taking a circular form of finite size. As the focus of the microscope is changed the circular patch takes on a variety of forms, with different brightness distributions, depending of course on the amount of spherical aberration which is present.

When the lens suffers only from over-correct spherical aberration, so that rays through margins of the lens aperture come to a focus at a greater distance from the lens than rays through the inner regions of the aperture, we can find one focus position for the microscope where the light patch takes the form of a bright nucleus and a rather tenuous halo. This is the *paraxial focus*. As the microscope focus is moved further away from the lens, the light patch shrinks in diameter until it reaches a minimum size. This is the *maximum contrast focus*. Any further movement of the microscope in the same direction results in an increase in the diameter of the light patch. If the lens suffers from

201

under-correct spherical aberration then the focusing sequence is reversed and, starting from the paraxial focus, we move towards the lens in order to reach the maximum contrast focus.

In most cases the correction of a lens is such that there is under-correct spherical aberration in the inner zones of the lens aperture, and over-correct spherical aberration in the outer zones of the aperture, as explained on page 110. In this event we may examine the behaviour of rays through different parts of the lens aperture by using masks, of the form shown in Fig. 72, in order to isolate different zones of the aperture. The corresponding light patches, as they appear through the observing microscope, then take the form of light rings. These collapse to small discs of light, as the microscope focus is changed to the point where rays through a particular zone come to a focus. In this way we may explore the behaviour of the spherical aberration over the aperture of the lens.

In order to check for coma and oblique spherical aberration we have to move the star to a point such as P′ in Fig. 71, and move the microscope to the position shown at M′. In a typical case the image patch, as seen through the microscope, comprises a bright hard nucleus of light, with a surrounding halo which may be more or less tenuous. If the halo is symmetrically located around the nucleus (but not necessarily of circular form) then we have what we may, for present purposes, class as *oblique spherical aberration*. A more complete breakdown of this aberration has been given on page 122. This oblique spherical aberration may be under-correct, over-correct, or a mixture of both, as for the spherical aberration described above.

When the halo has an unsymmetrical shape then we have *coma*. It is very rare for us to see the pure coma form described on page 115. As a rule the coma which is present is combined with oblique spherical aberration, to give a rather complex light patch. The unsymmetrical form of the pure coma pattern modifies the symmetrical form of the oblique spherical aberration, and only coma can provide this unsymmetrical effect. In some cases, of interest primarily to professional designers, we may have an unsymmetrical light patch which is due to the presence of third order and fifth order coma.

202

If we observe the hard nucleus of light, described in the previous section on coma, as the microscope focus is moved towards and away from the lens, we find two focus positions of special interest. In one position the nucleus becomes a short vertical line of light. In the other position it becomes a short horizontal line. The lens then exhibits *astigmatism*, as defined on page 116. The position of the short vertical line (assuming that the line PP′ is horizontal) is the *tangential focus*. The position of the short horizontal line is the *sagittal focus*.

By traversing the star from the point P to the point P′, in Fig. 71, and by following its image with the microscope, we can determine the positions of the sagittal and tangential foci over the field that the lens covers. These foci are located relative to the ideal focal plane. If the star is traversed in a line that is perpendicular to the lens axis, as shown in Fig. 71, then the ideal image would be a point of light lying on the line pp′ in Fig. 71, and we would be able to observe this image by traversing the microscope, without any fore-and-aft focusing movement. Any fore-and-aft movement, which may be necessary to pick up the horizontal or vertical line focus, measures the amount of astigmatism that is present. Note that it is important to examine the astigmatism over the whole field of the lens. It will often happen that the position of the tangential focus, for example, will move away from the lens as the star first moves away from P towards P′ in Fig. 71, but that, with a further movement of the star, the image motion away from the lens will stop, and will then reverse itself. This is due to the presence of *zonal tangential astigmatism*. The same general type of behaviour may be found for sagittal astigmatism, in which case we have *zonal sagittal astigmatism*.

It may happen that the sagittal and tangential foci coalesce into a point image, but that some fore-and-aft focusing of the microscope is needed in order to pick up the image. In this case we have *field curvature*.

We may also use the terms astigmatism and field curvature in a more general sense than we have used them above, in accordance with the definition given on page 116. Suppose that we arrange resolution charts, of the form shown in Fig. 44, along a line such as PP′ in Fig. 71, so

that some of the lines and spaces are horizontal and some are vertical (we assume that the line PP′ is horizontal). The images of these charts are examined with the microscope M or M′. In one focusing position, for a particular resolution chart, the "best" definition is obtained for the horizontal lines and spaces. In another focusing position, for that same chart, we obtain the "best" definition for the vertical lines and spaces.

The term "best" has been placed in quotation marks because it merits special discussion. We may use the position of maximum resolution, of either horizontal or vertical lines, to define the position of best focus. On the other hand it has been explained earlier in this chapter that we cannot rely on resolving power as an exact criterion of picture quality. We cannot, therefore, assume that the position of best focus is that which yields the highest resolution. A factor of more importance, as already discussed, is the way in which the edges of the coarser lines are clearly defined. This quality of performance may then be taken as defining the position of best focus for both horizontal and vertical lines. As before, the position of best focus for the horizontal lines is taken as the sagittal focus. The position of best focus for the vertical lines is the tangential focus. If the sagittal and tangential foci, according to the criterion that we adopt, coincide but do not lie in the ideal image plane, then we have field curvature.

DISTORTION

We can most readily measure the distortion in a lens by using it to image two plumb lines. Preferably they should be of white cord in front of a black background. (It may be necessary to floodlight them in order to get enough light in the images). The plumb lines should be so arranged that their images will lie at the edges of the field which the lens will cover, as shown in Fig. 73. The images may be recorded on a plate or film, or they may be viewed on a ground glass screen.

If the lens suffers from pincushion distortion then the images of the lines are shown by the dotted lines in Fig. 73. If the lens has barrel distortion then the images of the plumb lines take the form shown by the chained lines in Fig. 73. Suppose that the width of the picture is a, and that its

204

height is *b*, as shown in Fig. 73. Suppose further that the increase, or decrease, in the width of the images, at their narrowest or widest point, is *x* as shown in Fig. 73. Then the distortion in the lens, expressed as a percentage at the corner of the field, is given by the formula

$$\text{Percentage Distortion} = \frac{x}{b} \times \frac{a^2 + b^2}{ab} \times 100 \text{ per cent.}$$

When we have pincushion distortion we count it positive; when we have barrel distortion we count it negative.

In measuring distortion the lens should be stopped down to about one half its full aperture. Under these conditions the sharpness of definition is about at its best, and the images of the plumb lines are most clearly defined. Distortion, of course, is not changed when the lens is stopped down.

AXIAL COLOUR

Axial colour, or the shift in focus position with the colour of light, may be measured in an approximate way by using a star test. For this measurement the star is placed in the central position, shown at P in Fig. 71. The image is observed with the microscope M.

Colour filters are placed between the light source and the small pinhole which constitutes the star, so that light of different colours is transmitted to the lens, and through the lens to the microscope. The focus of the microscope is adjusted for each successive colour of light, and the focusing travel is measured. Usually it amounts to a few thousandths of an inch. This determines the axial colour. An important point that must be considered is the type of focus which is to be picked up by the microscope. In the presence of spherical aberration, which is the normal situation, we have two possible foci. In the first focus position the light patch comprises a hard bright nucleus of light and a tenuous flare: this is the paraxial focus. In the second focus position the light patch becomes a disc of minimum size: this is the maximum contrast focus. The same criterion of focus must be used consistently for each colour of light. Technically the axial colour, as defined on page 130 is measured by the shift with colour of the paraxial focus. For practical photographic purposes the shift of the maximum contrast focus is probably more important.

When a measurement of this kind is carefully carried out we find that, as we progress from the blue end of the spectrum towards the red end, the focus position moves closer to the lens until it reaches a minimum distance. It then recedes from the lens. This behaviour is due to *secondary spectrum*.

A problem which we face in measuring axial colour is that the sensitivity of the photographic plate differs considerably from that of the human eye, in particular the eye is much less sensitive to blue light. It is preferable, therefore, to use a photographic technique in order to measure axial colour.

A series of resolution charts are arranged in front of the lens as shown in Fig. 74. They are so disposed that the separation of their images is about ·002 in. for still camera lenses, and ·001 in. for cine camera lenses. The arrangement which is needed in order to effect this separation may be calculated by using the formulae on page 52. The lens is focused visually on the central object C, and pictures are taken with either black and white or with colour film. White light may be used for such picture taking, or a series of pictures may be taken through colour filters.

If there is no axial colour present then the chart denoted by C in Fig. 74 will be in sharpest focus. In the presence of axial colour one or other of the test charts will be in best focus, and by recognising the position of this chart, relative to the central chart C, we obtain a measure of the axial colour. Any criterion of best focus may be used, either maximum resolution or maximum contrast, but the same criterion should be used in a consistent way.

When a single exposure is made with white light, then the focus that we obtain is the average focus for all colours of the spectrum. When a series of exposures are made, using a series of colour filters, then we obtain the behaviour of the focus position as the colour of light changes from one end of the spectrum to the other.

An examination for axial colour, using the photographic technique just described, should be made if it is proposed to use a lens for infra-red photography. This type of photography has a number of special advantages and applications, which are too numerous to detail here, but it may be worth mentioning one that is of particular importance, namely the

CHECKING LENS CORRECTION

Fig. 73. *Distortion* may be measured by photographing taut white cords against a black background.

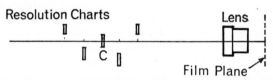

Fig. 74. We may check for *axial colour* by photographing test charts which are arranged as shown. The lens is focused on the central chart C.

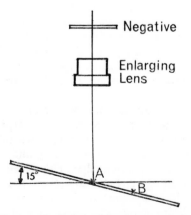

Fig. 75. We may check the axial colour correction of an enlarging lens by making an enlargement on a sloping enlarging easel. The visual focus is at A. The best photographic focus is at B.

fact that with infra-red photography we can penetrate light haze, and obtain pictures under conditions which would be impossible with visible light. However, unless a lens has been specifically designed for infra-red use, the secondary spectrum in the lens will separate the infra-red focus from the visual focus. An average value for this separation is about ·004 times the focal length of the lens. It varies, however, from lens to lens, and hence it is worth investigating it in detail before starting any infra-red work.

LATERAL COLOUR

Lateral colour is a chromatic defect which is quite independent of axial colour, and freedom from one of these defects is no guarantee of freedom from the other. If axial colour is present at any point in the field of a lens, then it is present over the whole field of the lens, and is constant in amount over this field. Lateral colour, on the other hand, is present only at points which do not lie in the centre of the field, and it grows progressively larger the farther the image point moves from the centre of the field. This increase in size is strictly proportional to the distance of the image point from the centre of the field: the lateral colour exhibited at a point which is twice as far from the centre of the field as some reference point is just twice the colour exhibited at that reference point.

We may examine a lens for lateral colour by using a modification of the star test shown in Fig. 71. The modification consists in replacing the fine pinhole at the point P′ by a fine vertical slit (assuming that the line PP′ is horizontal). We may use a fine pinhole at P′ in order to carry out this test, but the effects are much more clearly discernible with a fine slit.

The characteristic appearance of lateral colour, as seen through the viewing microscope M′ in Fig. 71, is a patch of light which is spread out like a rainbow, with deep blue at one edge, shading through green, yellow and orange, to a deep red colour at the other edge. The width of the light patch, between its deep blue and deep red edges, is a measure of the lateral colour which is present in the lens. This type of colour spread differentiates lateral colour from axial colour: with axial colour we obtain a light patch which exhibits symmetrical colour fringing.

208

The blue edge of the light patch due to lateral colour may be either closer to the lens axis than the red edge, or the other way round, depending on the lens construction, but it is always in the same direction relative to the lens axis and the centre of the field. Thus, if the blue edge appears on the right hand side of the image when the fine slit is at P′ in Fig. 71, then the blue edge appears on the left hand side of the image when the fine slit moves to P″.

One very important aspect of lateral colour must be noted, namely that it is not affected by stopping down the lens. It remains constant when the lens is stopped down. In fact it may appear to become more pronounced as the lens is stopped down, so that other aberrations are reduced and monochromatic image edges appear to be sharper, but this is an illusion.

ENLARGING AND COPYING LENSES

In describing the star test on page 198 it was stipulated that the distance from the star to the lens under test should not be less than twenty times the focal length of the lens. This is a condition that should be imposed whenever the lens under test is a normal taking lens or projection lens. Such lenses are primarily designed for use with light coming from (or going to) quite distant object points, and the lens aberrations are balanced for these conditions.

With enlarging or copying lenses the situation is radically different. These lenses are designed for use with object points that lie comparatively close to the lens. The aberrations are balanced for these conditions, and may not be balanced for distant object points. (The converse is true, of course, that the aberrations in a photographic lens may not be balanced for close-up object points. Hence there is no guarantee that a good camera lens will make a good enlarging lens, or that a good enlarging lens will make a good camera lens.)

The techniques of star testing, and of testing with resolution charts for astigmatism and field curvature, as well as testing for distortion and so on, that have been described in the previous pages, may be applied to the examination of enlarging and copying lenses, the only difference now being that distances of the star or testing charts are reduced to two to four times the focal length of the lens, or thereabouts.

209

In the case of enlarging lenses we may test for overall performance by using special test negatives from which to make enlargements. Fine small scale resolution charts are distributed over the field of such negatives, in the same way that resolution charts are used to cover the field of a camera lens in Fig. 48. The preparation of such test negatives requires extreme care and meticulous photographic technique. Resolution patterns down to about 100 lines per millimetre should be incorporated in the small scale test charts. The value of these negatives lies more in what we have called functional testing rather than in diagnostic testing.

A simple way, and yet one that is eminently satisfactory, of carrying out a functional test on an enlarging lens is to use it firstly as a taking lens to make a three to one reduction, for example, of fine newsprint. Fine grain film and fine grain developers must be used to produce this negative. The negative is then mounted in an enlarger and a three times enlargement made, so that the enlargement has the same scale as the original newsprint. A side by side comparison of the original, and of the reproduction, will readily show up the overall performance of the lens. Note that there is no cancellation of aberrations in this technique: the effects of lens aberrations are doubled, not removed.

With one exception it is not recommended to use this enlarging technique to carry out diagnostic testing. The one exception is for axial colour. By using either a special negative containing small scale resolution charts, or a newsprint negative of the kind described above, and by using a sloping enlarger easel, as shown in Fig. 75, we may examine the lens for axial colour. A useful slope for the enlarging easel is about 15 degrees. The enlarger is focused visually along the line A in Fig. 75, and an enlargement is made. Suppose that the degree of enlargement is M, and that the enlargement itself is in best focus along the line B, where the distance AB is x inches. The axial colour shift in the negative plane of the enlarging lens, for a 15 degree slope, is given approximately by the formula

$$\text{Axial Colour Shift} = x \div 4M^2.$$

Thus if M = 5 and $x = 1$ in., the axial colour shift is ·010 in. The axial colour shift is practically constant for all

210

degrees of enlargement. This technique gives a simple and quite sensitive way of measuring axial colour shift in an enlarging lens.

VIGNETTING

There is another aspect of lens performance which has a bearing on the picture quality that is obtained, namely the way in which the image brightness varies over the field that is covered by the lens.

Except for some unusual lenses, such as the *Wild Aviogon*, the maximum brightness I(x) that we can expect, at a point which is x inches away from the centre of the field of a lens having a focal length of f inches, is given by the formula

$$I(x) = I(o) \times \frac{f^4}{(f^2 + x^2)^2}$$

where I(o) is the image brightness in the centre of the field. For example, if we have a lens with a normal coverage, at the edge of the field x may attain a value of $\cdot 5f$. In this case I(x) = I(o) \times $\cdot 64$ at the edge of the field. For a wide angle lens x may reach the value $1.0.f$, in which case I(x) = I(o) \times $\cdot 25$ at the edge of the field.

It is evident that, for all but narrow angle lenses, there is an intrinsic reduction of image brightness of considerable magnitude at the edges of the field, even in the most favourable circumstances. The illumination at the edge of the field, or near the edge of the field, may be still further reduced by *vignetting* in the lens.

The way in which vignetting arises is shown in Fig. 76a, where we contrast the behaviour of rays, going through a lens, which start from a point at infinity on the lens axis, and those which start from a point, also at an infinite distance, which lies away from the lens axis. In each case the rays going through the lens are limited by the edges of the lens elements, or by the metal parts in which these elements are mounted. These restrictive elements permit a full bundle of light rays to pass through the lens, if they come from a point on the lens axis. If, however, the rays come from an object point which is not on the lens axis, then the restrictive elements, referred to above, permit only a partial bundle of light rays to traverse the lens. The

reduction in size of an off-axis bundle of light rays, by the boundaries of the lens elements, is known as *vignetting*. It results in a still further reduction in the brightness of an off-axis image, above and beyond the brightness reduction previously described. In extreme cases the vignetting which is present in a lens may completely block off light rays which belong to an image point near the edge of the field.

Since vignetting cuts down the amount of light which is going to an off-axis image point, it reduces the spread of the light patch, and so improves the performance of the lens. It is difficult to control the off-axis aberrations in most lenses, and vignetting is judiciously used as a standard designing practice in order to improve the off-axis performance of lenses.

When a lens is stopped down, as shown in Fig. 76b, the vignetting is reduced. There is greater equality between the bundles of light rays which are transmitted through the lens for object points both on the lens axis and near the edge of the field. This is due to the fact that, when the lens is stopped down, the iris diaphragm becomes the dominant restrictive element, as shown in Fig. 76b. As the lens is stopped down we come closer to the ideal relationship, given on page 211, for the off-axis image brightness.

The amount of vignetting in a lens depends very much on its detailed construction. A *Petzval* lens, for example, tends to have much heavier vignetting than a *Cooke triplet* lens, and there are pronounced variations within each constructional type. The vignetting characteristics of a lens may be calculated, if the lens data are known, or they may be measured, as explained below.

The first thing that we have to do is to place a fine source of light in the focal plane of the lens. In order to do this we locate the focal plane of the lens, as explained on page 28. In this plane we place an opaque screen in which a fine pinhole is pierced, and we illuminate this pinhole from behind, as shown in Fig. 76c. The light from this pinhole emerges from the front of the lens as a parallel beam of light, and is intercepted by a screen S, as shown in Fig. 76c. This screen may be a ground glass viewing screen, so that the pattern generated by the beam of light may be observed visually, or it may be photographic paper, if we want a permanent record. When the fine pinhole is in the centre of

212

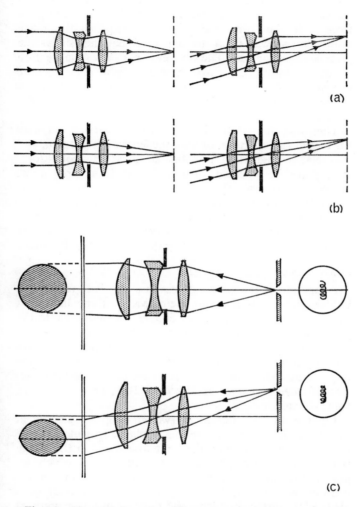

(a)

(b)

(c)

Fig. 76. *Vignetting* is produced because the diameter of an oblique beam which is transmitted by the lens is smaller than the diameter of an axial beam, as shown in (a). When the lens is stopped down, as shown in (b), this disparity of beam diameters is reduced. The vignetting may be measured by mounting an illuminated pinhole in the focal plane, as shown in (c).

213

the field of the lens the light patch formed on the screen S is circular, as shown in Fig. 76c. When the pinhole moves away from the centre of the field the light patch takes on the cat's-eye shape, also shown in Fig. 76c. This transition from a circular form to the cat's-eye shape, as the image point moves away from the centre of the field, shows the presence of vignetting. The cat's-eye area shows the fraction of the lens aperture through which light rays may be transmitted to an off-axis image point. The ratio of the cat's-eye area to the circular area is a measure of the vignetting.

The procedure outlined above may be carried out with the lens at full aperture, or with the lens stopped down, and the relative vignetting investigated for these conditions. It may also be repeated for a variety of off-axis positions, in order to examine the vignetting characteristics over the field of the lens. As a by-product the f number setting of the lens may be checked: the diameter of the axial circular patch is compared with its predicted value, namely the focal length of the lens divided by the f-number of the lens.

FLARE AND GHOST IMAGES

The function of the glass surfaces in a lens is to refract the light rays which encounter them. Most of the light that encounters the surfaces is, of course, transmitted into the glass and is properly refracted. Some of the light, however, is reflected at each surface and is lost to the normal image-forming process. This loss of light is not now of the same importance that it was a few years ago, before the introduction of *surface coating* or *blooming*. It is, however, worth some discussion.

Light must be reflected at two air-to-glass surfaces in order that it may reach the image plane. In general these reflections will not bring the light to a focus in the image plane, and there results only a spread of light which degrades the image contrast. Before the days of surface coating there was a 5–6 per cent reflection loss at each air-to-glass surface in a lens, and this loss of image contrast was significant. This loss by reflection has been greatly reduced by surface coating, as described below, and the loss of image contrast is not as important as it used to be.

On occasion it may happen that the conditions are right

214

and we obtain an image, after two reflections, which is almost in focus. In this case we have a *ghost image*. Such a ghost image may be formed, for example, by light which is reflected from the surface of the sensitised material, and subsequently returned to this plane by a lens surface which is concave towards the image plane.

What is usually more significant is the way in which light from a single bright object point, such as the sun, may be reflected by the lens surfaces so that a reasonably sharp image of the iris diaphragm is formed in the film plane. This is due to the fact that the light which is reflected by two surfaces, if it comes from a small bright source, will pass through a comparatively small area, the image of the source, after the two reflections. This image then acts very much like the pinhole in a pinhole camera, as described in the Introduction, and forms an image of the diaphragm. With a small bright source this image may be reasonably sharp. Such images may be formed even when the bright source of light is just outside the field of view of the lens, and even when the lens surfaces are coated. There may also be a multitude of such images formed by light which is reflected at a variety of air-to-glass surfaces in the lens. For this reason it is advisable not to point a camera too close to the sun.

There is no simple way of predicting the existence of such images in any particular lens. They are best sought by placing a single very bright light source in or near the field that a lens is to cover, and by looking for the images in the field of the lens. They may be somewhat reduced by using lens hoods (see page 230).

LENS COATING

One factor which could not be deliberately controlled, until a few years ago, was the amount of light reflected at the air-to-glass surfaces in a lens. In the case of some fairly old lenses, which had acquired a *bloom* on their surfaces with the passing of time, the amount of light reflection was cut down at each of these surfaces. But this blooming could not be produced in a repeatable manner, on a basis suitable for volume manufacture. It can be counted as one of the most significant advances of recent years that processes have been found by which the surface reflections may be eliminated

215

on a routine basis. These processes have been developed to the point that they are a completely practical proposition for the average photographer, and in fact it is the exception, rather than the rule, to have an uncoated surface in any but the cheapest lens. The surface coatings are sufficiently durable to stand up to very rugged conditions of camera use.

In order to understand how the surface films, which are applied in order to cut down surface reflections, succeed in doing just this, we have first to consider in detail how light is reflected and refracted.

When rays of light strike a surface separating glass and air, every point on that surface is stimulated to send out secondary rays of light, as shown in Fig. 77a. The arrow heads on the secondary rays show how far the light energy has travelled along these rays at a given time. Because the rays of light which encounter the surface are not perpendicular to it, the same state of stimulation is given to points on the surface at different times, and the secondary rays which are sent out are correspondingly retarded by different amounts.

All of these stimulated or secondary rays interfere with one another. As explained in the Introduction there is a repeated pattern of electric and magnetic forces along any light ray. At any point in space which is traversed by more than one of the secondary rays, it may happen that the electric force due to some rays will have a certain size and will point in a certain direction, while the electric force due to the other rays will have the same size, but will point in the opposite direction. The two forces then cancel one another out, and there is no resultant electric force. Or, what is the same thing, there is no resultant light energy at that point. This happens at the vast majority of points in space. In only a finite number of directions are the conditions just right, so that the electric forces do not cancel one another. These are the directions of the reflected rays.

The same thing happens with rays which cross the surface and are refracted. Fig. 77b shows the only rays which survive when this interference process is taken into account.

Although this process has been described explicitly for a surface separating glass and air, it remains essentially the same when we have a surface which separates media of two

216

REDUCING SURFACE REFLECTIONS

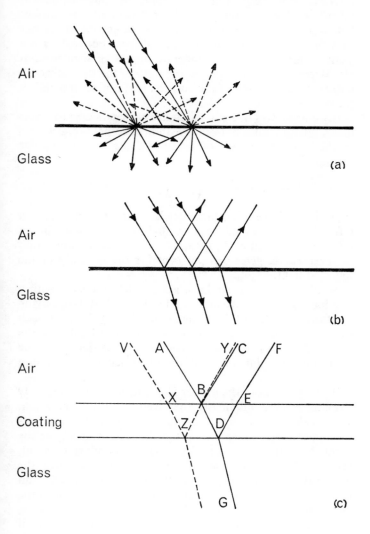

Fig. 77. When rays of light encounter the surface of glass *secondary rays* are sent out in all directions, as shown in (a). Because of *interference* only a few of these survive, as shown in (b). By using the same principle for rays encountering two surfaces, as shown in (c), the reflection of light may be minimised or eliminated.

different refractive indices. Some light is reflected at the interface, but the greater part crosses the interface and is refracted. The amount of light reflected at the surface between two media depends to some extent on the angles that the light rays make with the surface, but it does not change very rapidly for moderate angles of incidence. It also depends very strongly on the ratio of the two refractive indices on either side of the surface, and not on the indices themselves.

If we have rays of light which are perpendicular to a surface, and if the ratio of refractive indices across the surface is x, then the percentage of reflected light is given by the formula

$$\text{Reflected light} = \frac{(1-x)^2}{(1+x)^2} \times 100 \text{ per cent}$$

Thus if we have a surface which separates air, having a refractive index equal to $1 \cdot 0$, and a glass which has a refractive index of $1 \cdot 69$, then $x = 1 \cdot 69$ and an application of the formula gives $6 \cdot 5$ per cent for the intensity of the reflected light.

Next suppose that we have glass which is coated with a film having a refractive index of $1 \cdot 30$, the glass itself having a refractive index of $1 \cdot 69$, as shown in Fig. 77c. At each surface x has the value $1 \cdot 30$, $(1 \cdot 69 \div 1 \cdot 30 = 1 \cdot 30)$, and the same fraction of light is reflected at each surface, the one separating the film from air, the other separating the film from glass.

If now we choose the proper film thickness we can greatly reduce, or even eliminate, the overall surface reflection. The incident ray of light, shown as AB in Fig. 77c, meets the upper surface (separating the thin film and air) at the point B. At the point B it gives rise to secondary rays but, because of the interference of light as described above, the only rays which survive are the reflected ray BC and the refracted ray BD. The refracted ray BD encounters the lower surface (the boundary between the thin film and the glass) at the point D. Of all the secondary rays which it stimulates at the point D the only ones to survive are the reflected ray DE and the refracted ray DG. The intensity of the reflected rays at the points B and D are equal, because x is equal at each surface and the intensity of the reflected

218

ray is given by the formula on page 218. At E the refracted ray emerges once more into air along the path EF: note that EF is parallel to the original reflected ray BC.

The same thing happens with other rays, of which VX is typical. This ray emerges from the point B. The intensity of light along this emerging ray, which we may call BY to distinguish it from the ray BC, even though it has the same direction and goes through the same point B, is equal to the intensity of light along the original ray BC.

The light which comes to the point B along the path VXZB has a longer distance to travel than the light which comes along the path AB. As a result the electric forces produced at the point B, by the light which comes by the path VXZB, may be at a different stage in their pattern of changes, at any time, to the stage of light which comes along the path AB. By choosing the film thickness properly, we can adjust this path difference between VXZB and AB so that the electric forces at B cancel one another out. In this case neither of the secondary rays BY or BC survive, they are mutually annihilated, and no light is reflected from the point B. This happens for all points on the surface, of which B is a typical representative, and as a result no light is reflected from the surface.

The light which should have been reflected from the upper surface, back into air, and which is no longer reflected in this way, is a form of energy and is indestructible. It must have been diverted into other channels. In fact a detailed treatment of the type given above, taking the interference of light into account, shows that this energy augments the light energy flowing along the refracted ray DG. The transmission of light into the glass is enhanced.

In order to obtain complete suppression of reflection, as described above, the conditions must be exactly right. The refractive index of the thin film must be such that x, as defined on page 218, is the same at the interface between air and the film, as it is at the interface between the film and glass. This requires that the refractive index of the film be equal to the square root of the refractive index of the glass. As a rule this is not easy to achieve with a thin film having a reasonable mechanical strength. The refractive index of the type of glass used in photographic lenses will lie between $1 \cdot 509$ and $1 \cdot 805$ for the most part. This requires a refractive

index for the thin film which lies between 1·24 and 1·34. The material usually used for thin films is magnesium fluoride, which has a refractive index of 1·38, approximately. This is higher than the ideal value, but it is still quite effective, as shown in the table below.

XXII – REFRACTIVE INDEX AND REFLECTIVITY

Refractive Index of Glass	Reflectivity (per cent) of Uncoated Surface	Reflectivity (per cent) of Coated Surface
1·50	4·00	1·40
1·55	4·66	1·04
1·60	5·34	·74
1·65	6·02	·49
1·70	6·72	·31
1·75	7·43	·18
1·80	8·14	·10
1·85	9·00	·02

It will be seen that the reduction of reflection loss is greatest where it is most needed, for high index glasses.

A second condition to be fulfilled in order that reflection of light may be completely suppressed is that the electric forces, produced by light which arrives along two paths, be in exact opposition. This requires a precise relationship between the thickness of the thin film and the wavelength of light which is used, as well as with the inclination of the light rays to the surface of the glass.

As a rule we consider primarily the case where the light rays are incident on the surface in a perpendicular direction. In this event the film thickness, in order to suppress reflection, must be one-quarter of the wavelength of the light used. This means that the suppression of reflection is most effective for one wavelength or colour of light only. For example if we have a glass substrate with a refractive index of 1·650, on which we deposit a film of magnesium fluoride having a refractive index of 1·38, and if we choose the film thickness in such a way that reflection of light is most effectively suppressed for the wavelength of yellow light (the D-line having a wavelength of 593 millimicrons, as given on page 133) then the table given above shows that the reflection is reduced from 6·02 per cent to 0·49 per cent.

At the blue end of the spectrum, for the g line with a wavelength of 434 millimicrons, the reflectivity with the same film thickness is ·64 per cent. At the red end of the spectrum, for the A line with a wavelength of 768 millimicrons, the reflectivity with the same film thickness is ·85 per cent.

This variation of reflectivity with the wavelength of the incident light gives a characteristic colour to the reflected light. It is no longer white. The shade of the colour depends on the film thickness, and its depth or saturation depends on the effectiveness of reflection suppression. The more complete the suppression for a particular wavelength, the deeper in hue is the reflected light.

When the film is thin the suppression of reflection is most effective for blue light. As a result the reflected light returned from the surface is deficient in blue, and the surface seems to have a straw colour. For a film of greater thickness the region of maximum suppression moves into the yellow region of the spectrum, and the surface appears to have a purple colour. With a still greater increase in film thickness the surface appears to have a deep blue colour.

When light is incident upon the surface from any direction other than the perpendicular the film thickness is effectively reduced, and the maximum suppression wavelength moves towards the blue end of the spectrum.

The actual production of coated surfaces has been reduced to a routine operation.

In the early days of lens coating a number of different methods were tried. One of these, for example, was to subject a glass surface to attack by a chemical agent. This dissolved out some of the glass constituents and left a thin surface layer of silica: this layer constituted the thin film of low refractive index, which we have discussed in detail in previous pages. In another method a thin film of an organic soap-like material was deposited from the surface of a liquid. This gave a film with excellent reflection reducing efficiency, but with no mechanical strength.

Today practically all surface coating films are produced by evaporating magnesium fluoride in a vacuum, so that it condenses on the surface of the glass. The film thickness is adjusted by controlling the rate and time of evaporation, and the surface is observed, either visually or with scientific instruments, in order to determine that the reflected light

221

from it has the right colour. Special care has to be taken in cleaning the glass surfaces, so that a tough and tenacious coating may be deposited on the surface. The films themselves may also be baked in order to increase their mechanical strength and their resistence to abrasion, although this baking tends to produce a more compact coating, and one that is less efficient in suppressing reflection.

T-STOPS AND TRANSMISSION

In the days before the surface coating of lenses, the transmission losses due to surface reflections were a matter of major importance. The light loss in a Cooke triplet, for example, with six air-glass surfaces, amounted to about 30 per cent. The light loss in a more complex lens, with ten air-glass surfaces, amounted to 45–50 per cent. This meant that the two lenses, when stopped down to the same f-number, would transmit different amounts of light to the sensitised material.

A calibration system in terms of *T-stops* was developed in order to cope with this situation. If the light transmitted by a lens working at fN is the same as that transmitted by a lens of the same focal length, with 100 per cent transmission, working at fN', then we say that we have a TN' lens. Note that N' is always greater than N. The exact relation between N' and N depends on the reflection and absorption losses in the lens.

This system is still occasionally used, but it never became popular. The advent of surface coating, as a means of reducing reflection losses, minimised the importance of T-stops.

In recent times, however, another aspect of the effects of reflection losses has become important, particularly when the lens surfaces are coated. Zoom lenses, of the type used in 8 mm. and 16 mm. movie taking, may have up to twenty-two or twenty-four air-to-glass surfaces. Without surface coating the transmission of such a lens would be in the neighbourhood of 30 per cent. With surface coating the transmission is increased considerably. It is necessary, however, to balance the coatings on the various surfaces in order to even out the reflection losses throughout the spectrum. In Fig. 78 the chained line shows the spectral transmission for a typical zoom lens, taking into account

222

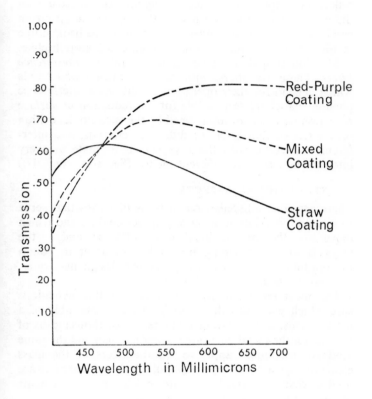

Fig. 78. In a lens with many surfaces, such as a zoom lens, the overall light transmission will depend quite strongly on the coating thickness on each glass surface, and its corresponding colour.

absorption losses in the glass, if all the surfaces are coated for maximum suppression of reflections at a wavelength of 589·3 millimicrons. Note the fall off in transmission at the blue end of the spectrum. The transmitted light would then give to the picture a very warm golden cast. By balancing the coatings on the different surfaces, so that the peak of reflection suppression varies throughout the spectrum on different surfaces, the transmission throughout the spectrum can be made much more even, as shown by the broken line in Fig. 78. The colour rendition is then much more lifelike.

Mention should be made, at this point, of *interference filters*. These are filters, with narrow transmission bands which depend for their operation on the same interference phenomena as are responsible for the reduction of surface reflection losses. They are formed by the vacuum deposition of a series of thin layers of different materials, and interference arises between the rays which originate at every interface between two different media. (See also page 347.)

CONSTRUCTIONAL ASPECTS

There are some miscellaneous aspects of lenses that serve to give an overall impression of product quality, and which depend on the constructional details of lenses and on the ways in which steps have been taken in order to obtain the optimum results which a particular design may offer. Some of these are discussed below.

The most important thing to realise is the meticulous care which goes into the manufacture and assembly of a modern lens. Tolerances of a few tenths of thousandths of an inch on the metal parts are common-place, and the same kinds of tolerances apply to the diameters of the glass elements. Special methods of manufacture and assembly are used so that the metal bores, into which the glass elements fit, are concentric within extremely close limits.

The proper centring of the glass elements is one of the most important aspects of lens manufacture, and any lens whose mount has been at all damaged must be regarded with suspicion as being a potential victim of decentration. The test for decentration which was recommended in early tests, namely to rotate the lens, while observing the images reflected from the various surfaces, is useless except as a means of determining that the lens is fit only for the junk

barrel. The more sensitive tests for decentration, which were described earlier in this chapter, are needed in order to determine whether decentration is present in significant amounts.

A special word is in order regarding between-lens shutters. One set of optical elements is mounted in a cell which is attached to the front of the shutter, and another set is mounted in a cell which is attached to the rear of the shutter. The concentricity and parallelism of the metal bores on both sides of the shutter are extremely critical. In the best manufacturing practice the final machining of these bores is carried out with matched sets of cells and shutters. Any damage to the seat on the shutter, to which either the front or rear lens cell is mounted, will introduce decentration errors.

The surfaces of the glass elements themselves are, of course, made accurately spherical within a few millionths of an inch.

The glass elements in some lenses are cemented together with a perfectly clear and transparent cement. In Europe and Japan the practice is still largely to use *Canada Balsam* for this purpose, but in the United States synthetic cements are extensively used. These synthetic cements have the advantage of reducing manufacturing costs, and of being more durable under extreme climatic conditions. Whether Canada Balsam or a synthetic cement is used, it is possible on occasion for the cement film to break. The main danger with such cement breaks is that they may spread, and for this reason it is wise to reject any lens which shows them. Apart from this such cement breaks may affect the lens performance to a quite negligible extent, even though they do not look very pretty. There is one situation, however, where a cement break may be a symptom of a much more important defect, namely when such pressure has been brought to bear upon a cemented component, in the course of the lens assembly, that the two elements have been distorted. They may have been forced apart by this pressure. The rear doublets of some early *Tessar* type lenses were quite sensitive to this type of defect. This type of damage completely ruins the performance of a lens.

One question which is quite frequently raised relates to the effects produced by bubbles in the glass of which the

225

lens elements are made. Such bubbles do not significantly affect the lens performance. They rob a very small percentage of light from the image, and diffuse it over the picture area, but the amount is so small that it is not detectable. Bubbles are more prevalent in some glasses than in others, and it seems that the more valuable a glass is to the optical designer, the more likely it is to have bubbles in it. In spite of this no glasses are used in modern reputable designs if the bubble count is high enough to have any effect at all on lens performance.

Another related topic is the effect on image quality of fine scratches on the lens surfaces. A few very fine hair-line scratches will not harm the image quality. If a lens surface, however, is covered with a network of scratches, such as may be produced by vigorous scrubbing with a hard brush, then the image will be softened, and light from the picture highlights will be scattered into the shadow areas, so diminishing the overall picture contrast.

Occasionally a low cost lens is encountered where light is scattered from poorly polished surfaces, but this is a rare event today. A glass surface which is chipped will scatter light, and severely degrade picture quality. A lens with a chipped surface should, of course, be rejected. If a lens is, however, damaged in this way, and is urgently needed for picture taking, then first-aid treatment may be carried out by painting the flaked surface, with nail enamel for example.

There are a number of different kinds of *stain* which may be found on the surfaces of a lens. In some older types of lenses a bloom may appear on the surface, a faint colouration rather like the colours that are seen with a thin film of oil on water. This is not harmful to the lens performance. It is, in fact, a naturally produced form of surface coating or blooming. It is better to tolerate this kind of bloom on the surface of a lens than to attempt to remove it by vigorous scrubbing. Drastic treatment is needed in order to get rid of it. Most uncoated glass surfaces acquire this kind of stain, in varying degrees, with the passage of time, and if the surfaces of an old lens are gleaming like crystal, it is worth while looking at them closely for a myriad of tiny scratches, put there by a primitive polishing process. Essentially the same kind of stain may sometimes be found on the surfaces of coated lens elements. This may arise if the freshly

226

polished surfaces are attacked by chemicals in the air before they are coated. We then have, in effect, a surface coating whose optical thickness varies from one part of the lens surface to another.

The staining described above must, however, be distinguished from another more harmful type. This gives to the surface a *frosted* effect, rather than a bloomed effect. The lens surface then seems rather grey and milky, like very thin ground glass. This type of staining is mainly encountered in lenses which have been used in tropical climates, where conditions of temperature and humidity favour the growth of a fungus, the chemical constituents of which attack and etch the glass surfaces. A lens which has been damaged in this way is useless for picture taking without a complete factory overhaul. Special anti-fungus treatments are given to lenses which are to be used in tropical climates.

Some loss of picture contrast may also result from light being scattered or reflected by internal parts of the lens which are not properly blackened, either because of a manufacturing oversight or because the blackening has worn off. These parts may be, for example, the edges of the lens elements, sloping shoulders (chamfers) on the elements, or metal parts of the mount. It is worth checking for such defects in a lens by holding it up to a bright light and then looking into the rear of the lens from the side of the plate or film. Any reflections of light which are then seen, or any scattered light, is sound cause for rejecting the lens.

The one biggest cause of degradation of picture quality, other than the presence of aberrations, is fingerprints on the lens surfaces. A fingerprint covers a considerable area, and is remarkably effective in scattering light. Moreover the acids in fingerprints will attack the surfaces of many optical glasses. There is one outstanding implication from this—fingerprints should be kept off the surfaces of lens elements, and if one is placed on a surface of an element it should be cleaned off right away.

In all high quality lenses, except zoom lenses, the focusing adjustment is made by bodily moving all the lens elements, away from or towards the plate or film. In some low cost lenses the focusing action is effected by changing the separation between lens elements. This is not to be recommended, apart from zoom lenses, except where cost is of

227

dominating importance. The aberrational balance of the lens is upset by this change, and a great deal of picture quality is lost. (For a discussion of zoom lens focusing see page 300.) In lenses which are focused in the normal way, by moving all elements in unison, a check should be made for backlash in the focusing action. Any backlash may cause a focusing error if the lens is focused by using the focusing scale. It can usually be detected quite easily by moving the focusing ring and by looking for any lack of corresponding fore-and-aft movement of the lens.

A check of the accuracy of the focusing scale of a lens may be made by setting up targets, in the fashion described on page 206 for the check of axial colour, at distances such that the target C of Fig. 74 corresponds to the distance shown on the focusing scale. This distance is measured from an index mark which is engraved on the camera body, and which usually indicates the film plane. The pictures obtained for each focusing scale setting are examined in the same way as the axial colour pictures, in order to determine that the plane which is nominally in focus is actually in focus. This procedure may be extended, by locating targets at various points in the field of the lens, to check the squareness of the film plane in a camera.

The aperture of a lens, except for some very low cost cameras, and except for *electric eye* systems (see page 342) is controlled by an *iris diaphragm*. In the lowest cost cameras *Waterhouse* stops are used. These are merely holes of the appropriate diameters which are drilled in a thin metal plate, as shown in Fig. 79a. By rotating this plate the desired opening is brought into place. This is a lost cost, but very cumbersome, way of changing the *f*-number of a lens.

In the simplest type of iris diaphragm there are two leaves, as shown in Fig. 79b. The iris opening is then square, and in carrying out any work involving the *f*-number of the lens we use the diameter of the circle which has the same area as this square opening.

The standard type of iris diaphragm, shown in Fig. 79c, uses a number of overlapping leaves, with circular boundaries. One end of each leaf pivots about a fixed point, while the other end carries a pin which slides in a slot carried by a control ring. As the latter is rotated the leaves move to a position, such as that shown in Fig. 79c, and close down the

228

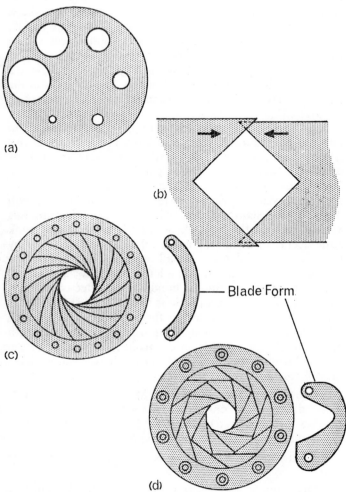

Fig. 79. The simplest form of diaphragm which may be used to limit the passage of light through a lens is the *Waterhouse diaphragm* shown in (a). It consists of holes in a metal sheet with a 1·4:1 progression of diameters. The next simplest form is the *barn-door* iris, comprising two sliding metal leaves, as shown in (b). In the standard form of iris, shown in (c), the individual leaves have the form also shown in (c). In a more advanced type which gives a better action at low apertures, shown in (d), the iris leaves have the unusual shape also shown in (d).

aperture through which light may be transmitted. An important defect of this simple blade form is that the smaller apertures, corresponding to the higher f-numbers, tend to crowd together, so that a change from $f22$ to $f32$, for example, may require a very small movement of the iris control ring. In order to correct this situation iris leaves may be used of the form shown in Fig. 79d. In this way a more nearly linear iris scale is obtained. The accuracy of the iris scale may be checked by using the technique described on page 213.

One further device which may be used, in order to improve picture quality, is a *lens hood*. The function of this is to prevent, as far as is possible, any light from areas outside the immediate picture area from reaching the lens. Such light may be reflected and scattered within the lens, even with coated surfaces on the glass elements, and will degrade the picture contrast. In order to minimise this extraneous light the front glasses of a lens are usually sunk quite deeply into the lens mount. The protection given by this may not be adequate for all purposes, and in order to provide additional protection a lens hood may be attached, as shown in Fig. 80. Such a hood is most effective when it has the same relative proportions as the film or plate that is used in the camera. The longer the hood the more effective it is in cutting down extraneous light. Suppose that the length of the hood, measured from the front glass surface of the lens, is M times the focal length of the lens. Then we have these formulae:

Long side of hood opening = M × long side of film + diameter of front glass of the lens.

Short side of hood opening = M × short side of film + diameter of front glass of the lens.

If a lens hood is used which is circular in form then we have:

Diameter of hood opening = M × film diagonal + diameter of front glass of the lens.

Lens hoods may be either rigid or collapsible. In the latter event the sizes given above must be calculated for the greatest extension of the lens hood.

A final word may be in order regarding the care of lenses. There is no point in babying a lens: it is not a particularly

LENS HOOD CONSTRUCTION

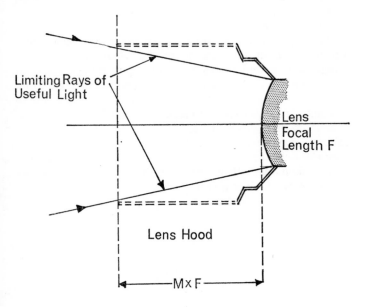

Limiting Rays of Useful Light

Lens
Focal
Length F

Lens Hood

|←———— M x F ————→|

Fig. 80. The entry of stray light into a lens may be reduced by using a *lens hood*. The greater the length of the lens hood the greater is its effectiveness in eliminating stray light. Its size must be chosen so that it will not cut off any of the rays that will form a useful image. Appropriate formulae are given in the text.

fragile thing. Nor is there any point in abusing a lens: it is, after all, a piece of precision equipment. The main point is to keep the glass surfaces clean. This is helped, of course, by keeping the lens caps, provided by most manufacturers, in place when the lens is not in use. Dust or grit which does settle on the lens should be brushed off lightly, so that the polished surfaces do not get progressively scored. Any dust or grit which does not brush off in this way may be removed by gently rubbing the surface with a soft cloth, moistened with detergent solution or with industrial alcohol. Fingerprints may be removed in the same way.

Modern coated or bloomed surfaces are sufficiently durable to stand up to this method of cleaning. In no case should an attempt be made to clean or polish the surfaces of a lens with a cleaning material that has a scouring action.

If a lens is taken apart, for any reason, it is important to see that screw threads are clean before it is re-assembled, and that the cells seat down properly. Otherwise the centring may be upset and the lens definition spoilt. It is important also to treat the iris diaphragm very carefully if a lens is taken apart. If the leaves are buckled it will probably mean a new iris diaphragm.

Basic Lens Types

The simplest kind of lens is a burning-glass, a piece of glass polished on both sides to convex spherical surfaces. This is useless for all but the crudest type of photography. As a lens it suffers heavily from every type of aberration, and in particular from spherical aberration and axial chromatic aberration, both of them strongly under-corrected. In other words the rays through the edge of the lens come to a decidedly shorter focus than do the rays through the inner-most zones of the lens area, and the blue image is much nearer the lens than are the images formed by yellow or red light.

It is possible to alleviate the spherical aberration some-what by making the lens nearly convex and plano, that is with one surface of convex spherical shape and with the other practically plane or flat. This does nothing to help the axial chromatic aberration.

Such a lens can be used, in the form of a spectacle lens for instance, with a crude form of camera provided that it is stopped down to about $f16$, that critical definition is not required, and that no visual focusing is attempted. The definition in the field, away from the centre of the negative, is poor compared even with the central definition given by such a lens.

The best compromise with a single glass lens, of the kind used in cheap and simple cameras, is to utilise a meniscus lens either with the stop behind the lens or with the stop in front of the lens, as shown in Fig. 81a. When the aperture stop is at a suitable distance from the lens, astigmatism and coma can be reasonably well corrected. Spherical and chromatic aberrations, distortion and field curvature remain uncorrected, and the lens can only be used at very small apertures. Such lenses cannot be considered in any way where serious work is concerned, but they can give reasonably satisfactory results on cheap cameras.

The next type of lens, in the order of simple and primitive construction, is a compound lens corrected for chromatic aberrations and spherical aberration. It is possible, by a judicious choice of glasses, to obtain quite a good correction for coma with this type of lens, but in spite of this a construction of this form has not been used appreciably for photographic lenses. The main problems with such a lens are astigmatism and distortion.

What was used extensively during the last century was a lens consisting of two identical doublets with a stop between them, as shown in Fig. 81b. This is the "R-R" or Rapid-Rectilinear form of lens, invented by *Dallmeyer* and *Steinheil* in England and Germany respectively. With such a construction, coma, distortion and lateral chromatic aberration are very thoroughly corrected, and, by a suitable choice of glasses, astigmatism is reduced. Axial chromatic aberration is also corrected. What remains is to correct the lens for spherical aberration and pure curvature of field. This cannot be done entirely. The spherical aberration correction, in particular, limits the lens to a maximum aperture of about $f8$. The field curvature may be artificially removed by introducing astigmatism, as explained in the previous chapter, but to do this effectively means introducing a considerable amount of astigmatism, much larger than that found in any modern anastigmat. While a coma-free field of about 40 degrees total angle may be obtained, the astigmatism or curvature of field, whichever is left in the lens, softens the definition considerably in the outer regions of the field.

The lenses described above, together with the *Petzval* lenses described below, did sterling work in the early days of photography. But today neither rapid-rectilinear lenses nor single glass lenses can be considered where serious work is intended. The standard of definition or speed demanded of, and supplied by, a modern anastigmat far surpasses that which sufficed when these were standard lenses. They now belong to history.

PETZVAL LENSES

The original Petzval lens was designed by the Hungarian *Joseph Petzval* in 1840, and was intended as a portrait lens, with the large aperture, for those days, of up to $f3$. Its

234

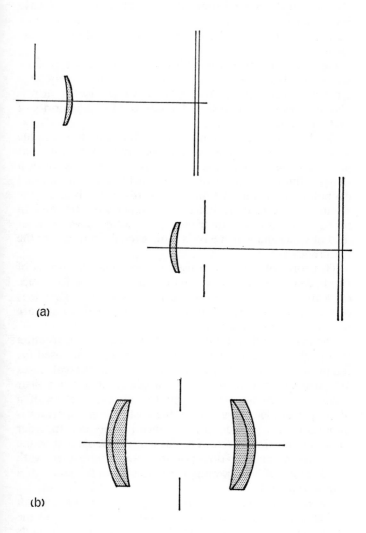

(a)

(b)

Fig. 81. The simplest kind of photographic lens is a single meniscus with a stop either in front or behind, as shown in (a). An early form of photographic lens was the *Rapid-Rectilinear* shown in (b).

235

construction is shown in Fig. 82a. The basic design remains the same at the present time although, of course, there have been numerous detailed changes made in order to obtain a standard of definition more in line with modern requirements.

Essentially it consists of two sets of positive lenses, each set separately achromatised, and with a comparatively large separation between the two sets. In some cases a stop is placed between the two sets of lenses, but in the majority of cases this is dispensed with.

The Petzval lens is in limited use today as a photographic lens. At one time variants of this construction were used as portrait lenses, having the characteristic performance of a sharp definition in the centre of the field, and a substantial degradation of this definition towards the edges of the picture. More recently it has been superseded by modern forms of symmetrical or triplet lenses which cover a wider field of view, and which have a more even definition over the picture area.

This form of lens is still used in some cheaper forms of 8 mm. camera lenses. A reasonable standard of performance for 8 mm. work may be obtained with a 13 mm. $f2 \cdot 5$ lens of the Petzval form. Practically no lenses of this form are used for 16 mm. cameras.

The major field of application of the Petzval construction is in projection lenses, particularly those which are used for the projection of 8, 16 and 35 mm. cine film. Petzval lenses are particularly valuable in this application because their general construction lends itself to the manufacture of a high aperture lens at a reasonable cost. A high aperture is important in a projection lens, since it is needed in order to achieve maximum screen brightness. At the same time the projection of cine film does not normally require a lens with a wide angle of field coverage, and this permits the use of a Petzval type of lens.

The remarks made in the preceding paragraph are worth further amplification and clarification. As explained in the previous chapter, the field curvature of a lens depends on its Petzval sum. In order to reduce this Petzval sum we use a combination of positive and negative lenses, with appreciable separations between them. This means that we introduce an excessive amount of positive power, with a large amount

236

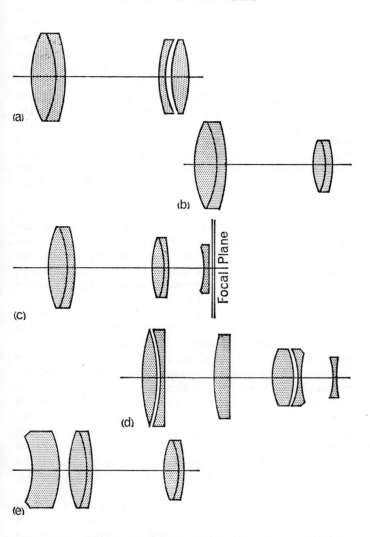

Fig. 82. (a) The basic form of the *Petzval* lens. (b) An $f\,1\cdot6$ lens which is used for 8mm. and 16mm. projection. A significant improvement is effected by adding a field-flattener, as shown in (c). (d) A form of Petzval lens with a field flattener which achieves an aperture of $f\,1\cdot2$. Another way of flattening the field is by means of a front negative lens, as shown in (e).

237

of negative power, so that the power of the complete lens is the difference between the positive and negative powers. As a result it becomes difficult to correct spherical aberration, coma and oblique spherical aberration in high aperture lenses. We have to resort to the complex constructions described in later sections. In the case of the Petzval lens we do not resort to this stratagem in order to reduce the Petzval sum. We use only positive lenses, so that the positive power of each component does not need to overcome the negative power of another component. The curves on the glass surfaces can be made less steeply curved. As a result it becomes a simpler matter to correct spherical aberration, coma and oblique spherical aberration. At the same time we are able to reduce the chromatic variation of these aberrations.

The price that we pay, in order to improve the correction of the aberrations listed above, is a rather high Petzval sum in the lens. The field covered by the lens is therefore distinctly restricted. A half angle of ten degrees is about the most that can be expected. In the form of lens shown in Fig. 82b a half angle of approximately 8 degrees is reached at an aperture of $f1 \cdot 5$ to $f1 \cdot 6$.

An important variant of the Petzval lens is the form in which a *field flattener* is added to the lens, as shown in Fig. 82c. In this lens construction a thin negative lens is placed close to the focal plane. It has very little effect upon the so-called *aperture aberrations*, namely spherical aberration, coma and oblique spherical aberration. It does, however, significantly reduce the Petzval sum, and as a result the field curvature and astigmatism are markedly reduced. In fact it is possible to introduce a field flattener of such strength that it makes the total Petzval sum become negative. In this event the field becomes convex towards the lens, whereas in the normal Petzval lens the field is concave towards the lens.

One problem which is encountered, in using a field flattener in order to improve the performance of a Petzval lens, is that every bit of dirt or dust on the field flattener is close to the focal plane. As a result it shows up in the projected image. In order to ease this situation it has become customary to move the field flattener forward from the focal plane. It is necessary then to modify the basic

238

MOVIE FILM FORMATS

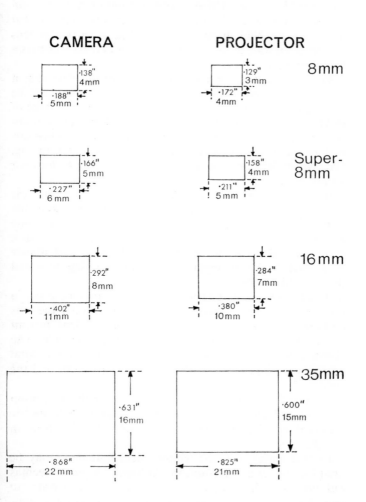

Fig. 83. The sizes of some important movie-film picture formats. The projector formats are deliberately made smaller than the camera formats in order to take care of manufacturing tolerances in the camera and projector.

lens in order to compensate for the aberrations introduced by the field flattener. Under extreme circumstances the field flattener may become absorbed into the basic lens, and it may then be difficult to recognise that a particular lens construction was, in fact, derived from a Petzval lens plus a field flattener.

This situation is further complicated by the fact that a field flattener enables a good off-axis lens performance to be achieved at higher apertures. In order to take advantage of this fact it is often desirable to split the converging components into compact groups of positive components. When this is done we arrive, for example, at the form shown in Fig. 82d, which represents a 23 mm. $f1 \cdot 2$ projection lens for 8 mm. film.

In some projectors, particularly 16 mm. projectors, the mechanical construction near the film plane does not readily permit the use of a field flattener in a fixed position. In these circumstances a field flattener may be mounted on a spring-loaded sleeve in the projection lens, so that it may be retracted, for example, when film is to be threaded through the projector.

Another technique of lens design which may be used, in order to provide an increased clearance between the lens and the film in a projector, is to use a negative lens in front of the positive members. This is shown in Fig. 82e. The negative lens both reduces the Petzval sum of the total combination and provides the needed clearance behind the lens.

Since Petzval lenses are primarily used for the projection of 8, 16 and 35 mm. film it is appropriate to indicate the standardised sizes of these film frames. This is done in Fig. 83.

Petzval lenses, with or without field flatteners, may be used for special applications in photographic work, such as radiography, where high apertures are needed in order to cope with low light levels. Even in these applications, however, the modern tendency is to replace them with high aperture anastigmats of one of the forms described below.

SYMMETRICAL LENSES

The vast majority of photographic lenses today are of *anastigmat* form. In order words they are of such a construc-

240

tion, with such an arrangement of positive and negative elements, that they may be well-corrected for spherical and chromatic aberrations, coma, astigmatism, field curvature and distortion, over fields that are considerably larger than are permissible for a Petzval lens, even with a field flattener. This, in fact, defines an *anastigmat*.

Such lenses are, almost exclusively, the logical developments of two main types, the symmetrical lens, and the *Cooke triplet* of *H. D. Taylor*. There are, of course, cases where it is difficult to say from which basic form a particular lens has been derived, and in what follows a certain arbitrary element of choice must enter where such lenses are concerned. And, although some lenses may be said to be logically derived from these basic lenses, it must not be taken for granted that the actual development did take place in this way. The development of better lenses is not a rigorously logical process. It may proceed in several ways. Sometimes it proceeds by a series of minor changes. At other times major changes are made by a process of invention, so that only by hindsight can the line of development be determined. In spite of all these facts, the relating of lens forms to the basic types mentioned above is the best and easiest way to classify them.

The simplest form of symmetrical lens is the rapid-rectilinear already described. The earliest development of this type into a lens approaching the modern standard of performance was made when new glasses were discovered at Jena towards the end of the last century. In fact it was only the discovery of these glasses that made possible the construction of a symmetrical anastigmat.

The great virtue of the symmetrical lens construction is the almost automatic correction for coma, distortion, and lateral chromatic aberration. One set of glasses really constitutes a lens with a stop behind it, and the other set constitutes a lens with a stop in front of it. Each of these contributes coma, distortion, and lateral chromatic aberration of the same amount but of opposite signs or directions, provided—and it is an important proviso—that the object and its image are at the same distance from the lens, as happens in full-size copying work. When the lens is used with the object at a considerable distance from the lens, as is normal in photographic work, this automatic balancing of

241

aberrations is no longer obtained. But the lack of balancing, which is now introduced, is not responsible for more than a small amount of any of these aberrations appearing in the lens. What coma, distortion and lateral colour are introduced, by the change from copying to normal conditions, can be removed by making slight changes to the curves of one set of glasses, while retaining the other set unchanged. In the majority of the lenses mentioned below it will be taken for granted that this change has been made, even if it is not specifically referred to; and since it does not appreciably upset the symmetry of the constructions they will still be referred to as symmetrical lenses, although in fact they depart slightly from this precise condition.

When new optical glasses were introduced in Germany at the end of the last century it became possible to reduce the field curvature of the rapid-rectilinear type of lens. Unfortunately, the glass characteristics which permitted this reduction also prevented the correction of spherical aberration, and relative apertures therefore had to be severely restricted in these early anastigmats. Simultaneous correction of field curvature and spherical aberration was achieved by a combination of the old and new glasses in more complicated systems, in which the two doublets of the rapid-rectilinear type were each replaced by triplet, quadruplet or even quintuplet combinations. Many of these forms were developed in Germany and they have become known as the *Continental Type*. Although spherical aberration was corrected in these forms, residual zonal spherical aberration still limited relative apertures to about $f5 \cdot 6$. Lenses of this basic form are not now used in any quantity for photographic work, with the exception of the *Goerz Dagor*, shown in Fig. 84, which is still an excellent lens. The development of the symmetrical lens in recent times has led to two distinct sub-types.

The first sub-type of symmetrical lens is the wide-angle, or semi wide-angle form, of comparatively low aperture. This will be described later in the present chapter, but it may be remarked, at this point, that a *normal* lens is one which covers a plate or film area having a diagonal whose maximum value is approximately equal to the focal length of the lens. This corresponds to a field of view in the neighbourhood of 52 degrees. A semi-wide-angle lens is one which covers a

Fig. 84. An important type of symmetrical lens is the *Goerz Dagor*.

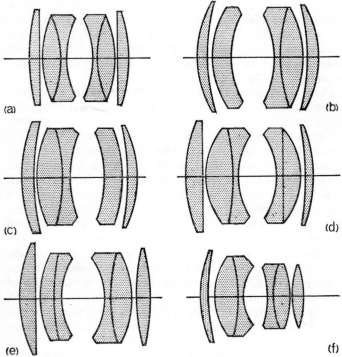

(a)

(b)

(c)

(d)

(e)

(f)

Fig. 85. The *Planar* of (a) is the starting point for a family of lenses. (b) A modification of (a), a 5-element *Planar*. A related form is the *Biometar* of (c). The modern era of high aperture symmetrical lenses began with the *Speed-Panchro* shown in (d). A modified form of (d) is shown in (e). The form shown in (f) is a *Canon* 50mm. $f\,1\cdot4$ lens.

243

field of view in the region of 65–70 degrees, while a wide-angle lens covers a field of view of 90 degrees. In this latter case the film area diagonal is equal to twice the focal length of the lens. An extreme-angle lens may cover up to 140 or 160 degrees, or even more.

The second sub-type comprises normal angle lenses, with apertures which range from $f2 \cdot 8$ to $f0 \cdot 95$.

The starting point for this line of development may be taken as the six-element *Planar*, shown in Fig. 85a. This is an early form, dating back to about 1896, which was designed by *Dr. Rudolph* of the *Zeiss Company*. In later versions, such as that shown in Fig. 85b, it has been found possible to achieve satisfactory results with a five element Planar having an aperture of $f2 \cdot 8$. A lens of this form, having a focal length of 100 mm. covers a standard double-35 mm. (*Leica*) film area. What may be regarded as a related type is the *Biometar* $f2 \cdot 8$ lens, shown in Fig. 85c: a lens of this form, having a focal length of 80 mm. covers a standard double-35 mm. film area.

The main line of development of this lens, however, started in the early 1920's under the impetus of demands for high aperture lenses for the Hollywood film studios. Subsequently there was added the needs for high-aperture lenses for what were then known as *miniature cameras*, what we now refer to as double-35 mm. film cameras (to distinguish them from single-35 mm. film frame cameras, and from cameras with the *Instamatic* format). The need for high-speed camera lenses had long been recognised, but the weight or bulk of an $f2$ lens of, for example, 4 or 5 in. focal length were prohibitive. It was only the introduction of the smaller film size, with the consequent reduction in the acceptable lens focal lengths, which made it possible to use higher aperture lenses, and to begin the modern era of popular photography.

The basic lens in this line of development is that shown in Fig. 85d. This is the form that is variously described as the *Double-Gauss*, *Biotar* or *Speed Panchro* type, and which reaches an aperture of $f1 \cdot 9$. It is the author's belief that the transition from the earlier Planar form to this type, and the recognition of its potentialities, represented a major step forward by *H. W. Lee* of the *Taylor, Taylor and Hobson Company* when he designed the first Speed Panchro lens for

244

the film studios. In what follows this construction will, therefore, be referred to as the Speed Panchro type. This is one of the most widely used types of lens construction, and derivatives of the basic design are produced by almost all lens manufacturers.

A field coverage of up to 54 degrees may be achieved with an excellent standard of performance. Characteristics of this lens include its excellent spherical aberration correction, and a low Petzval sum, which gives a very flat field. The general form of construction also lends itself to the production of lens designs with low zonal astigmatism. There is a tendency, in some versions of this design, for the chromatic variation of spherical aberration (sphero-chromatism) to be noticeable, because of the prevalent high apertures. The main weakness of this design (if it really can be described as a weakness, rather than as a blemish) is the presence of oblique spherical aberration at off-axis image points. This may tend to degrade the contrast somewhat, without impairing the resolving power significantly, and in any comparison which is made, between lenses having this basic construction, attention should be particularly directed towards the rendition of contrast. (See the previous chapter for a more complete discussion of this point.)

A significant part of all the optical design work which has been done since the 1920's has been devoted to attempts to improve the quality of this type of lens, in particular to effect an improved correction of oblique spherical aberration, and to provide still wider apertures (and sometimes to avoid patent infringement).

The first line of attack, in this type of development, consists in changing the detailed form of the inner cemented doublets, so that the cemented surfaces change from convex to concave, or vice versa. A typical example of one of these variants is shown in Fig. 85e. By using modern high-index glasses, shown by shading in Fig. 85f, the *Canon Company* have achieved an aperture of $f1\cdot2$, in a 50 mm. lens which covers the standard double-35 mm. film frame.

In a somewhat more elaborate line of development the inner doublet components may be replaced by triplet components, as shown in Fig. 86a. A somewhat more sophisticated approach is taken in the *Voigtlander Ultron* lens, as shown in Fig. 86b. In this lens the components of

245

the doublet members, in place of being cemented together, are slightly separated. Under the proper conditions this gives a powerful means of controlling the oblique spherical aberration.

Another line of development from the basic *Speed Panchro* form consists in replacing the single rear lens by a pair of thin lenses, as shown in Fig. 86c, which illustrates the construction of the *Leitz Summarit*. This technique of replacing a thin lens by a pair of thin lenses is one which is frequently used. It means that we now have four surfaces available to carry out the refraction of light, where formerly we had only two, and each surface can work less vigorously. The same line of attack may be used on the front member of the basic form, so that this element is replaced by two thin elements, as shown in Fig. 86d. This is a *Canon* lens of 50 mm. focal length, which covers the standard double-35 mm. film frame at an aperture of $f1 \cdot 2$. The same company has developed this form of lens to give one of the fastest lenses available for the standard double-35 mm. film area, namely a 50 mm. $f0 \cdot 75$. These lines of attack, namely of modifying the inner cemented doublets, and of splitting the outer members into pairs, may be combined to give the construction shown in Fig. 86e.

A very interesting development, along these lines, is the *Voigtlander* 50 mm. $f2$ *Septon*, shown in Fig. 86f, in which the front cemented doublet has been replaced by a singlet meniscus and a doublet member.

Yet another line of development consists in replacing the outer single elements of the basic Speed Panchro by cemented doublet members. One form is shown in Fig. 87a, in which the rear single member has been replaced by a doublet. This is the *Kodak Cine Ektar*. The same treatment may be given to the front element, as shown in Fig. 87b. As a rule it is more profitable to make the rear element into a doublet than it is to make the front element into a doublet. In some designs both elements have been made into doublets.

An interesting lens, in which a number of these lines of attack have been combined, is the *Voigtlander* 50 mm. $f1 \cdot 5$ *Nokton*, shown in Fig. 87c.

In refreshing contrast to the increasing complexity of lenses which stem from this basic design, is the *Wray*

SPEED PANCHRO VARIANTS

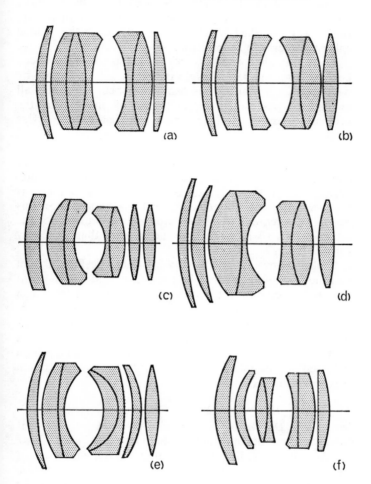

(a)

(b)

(c)

(d)

(e)

(f)

Fig. 86. (a) The front doublet member of the Speed-Panchro may be replaced by a triplet. (b) Another variant, the Voigtlander *Ultron* uses front elements which are slightly separated. (c) The Leitz *Summarit* uses a twin rear member. The *Canon* 50mm. *f* 1.2, shown in (d), uses a twin front member. A combination of lines of attack gives the construction shown in (e). Another line of attack gives the Voigtlander *Septon*, shown in (f).

Unilite shown in Fig. 87d. In this design, due to *C. G. Wynne*, the rear doublet member has been replaced by a singlet member, and the central separation has been increased. In this way a marked improvement is effected in the oblique spherical aberration correction.

There is an almost endless series of lenses which have been derived from the basic form, and hardly a month goes by without a new variant or two being described. A listing of all available types would be primarily of interest to the professional optical designer, and is outside the scope of this book.

With modern glasses, and using this general type of construction, an excellent control may be established over spherical aberration, coma, astigmatism and field curvature. What really distinguishes these lenses from one another is the correction of oblique spherical aberration. For this reason such lenses should be examined particularly for the image contrast which they produce, rather than primarily for resolution.

It also follows, from the way in which the Petzval sum and the field curvature may be controlled, that a lens of this type is best employed to cover the angular field for which it was designed. The field curvature and astigmatism are specifically adjusted for this field coverage. A lens which has been designed for 35 mm. movie film will not cover a standard double-35 mm. film frame, and one which has been designed for double-35 mm. film will not give optimum performance on movie film.

THE TYPE OF THE COOKE TRIPLET

When *H. D. Taylor* developed the *Cooke triplet* lens (named after the optical manufacturing company *Cooke and Sons* in York, England) a step was taken which was of the greatest importance, as far as the design and production of photographic lenses was concerned. An early form of the lens is shown in Fig. 88a. It represented a complete break from existing tradition, as constituted at that date by Petzval lenses and by early symmetrical anastigmats.

H. D. Taylor tackled the problem of reducing the Petzval sum and the field curvature from a new point of view. He argued that the field curvature could be significantly reduced by separating the positive and negative lenses in an

248

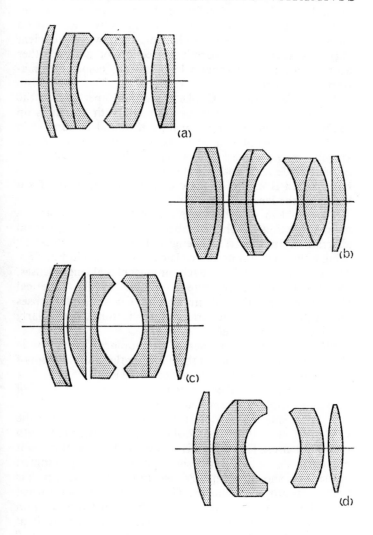

Fig. 87. In the Kodak *Cine-Ektar*, shown in (a), a doublet rear member is used. A doublet front member may also be used, as shown in (b). A combination of lines of attack, shown in (c), gives the Voigtlander 50mm. *f* 1·5 *Nokton*. The rear inner doublet of the Speed-Panchro is replaced by a singlet in the Wray *Unilite*, shown in (d).

achromatic doublet lens (such as a telescope objective, for example), and that by splitting the positive element into two parts, and by placing one of these positive elements on either side of the negative element, there were sufficient variables available to permit correction of all the other aberrations, namely spherical aberration, coma, astigmatism and distortion.

The earlier forms of Cooke triplet had apertures in the region of $f6 \cdot 3$. Modern types are made with apertures up to about $f2 \cdot 8$ in moderate focal lengths, and up to $f2 \cdot 3$ in the focal lengths of 1 in. and less which are used for 8 and 16 mm. movie cameras. This type of lens is essentially a normal angle lens, and the maximum coverage which may be expected is a film or plate diagonal equal to the focal length of the lens.

The problem with the simple triplet type is to obtain a good correction of spherical aberration and zonal spherical aberration. In short focal lengths this may be helped by using a thick central negative element, as shown in Fig. 88b. This is not a practical approach for longer focal length lenses, and for these the aperture is limited by the spherical aberration correction. A number of Cooke triplet lenses are on the market for a variety of applications, particularly where cost is important.

There are two main lines of development of the basic Cooke triplet form, both of them having the common aim of improving the overall performance of the lens.

In the first line of development the single components of the Cooke triplet are replaced by pairs of lenses.

Fig. 88c shows a Taylor-Hobson $f2 \cdot 5$ lens in which the single rear element of the Cooke triplet has been split into two thin lenses. This design is due to *H. W. Lee*. It has not proven to be as useful a design approach as that adopted in the form shown in Fig. 88d, where the front element has been split into two elements. This form has, in fact, turned out to be extremely valuable, particularly for lenses used on 8 and 16 mm. movie cameras, where it provides an excellent correction for spherical aberration. Fig. 88d shows a *Bell & Howell* 20 mm. $f1 \cdot 9$ lens used for 16 mm. film. Apertures up to $f1 \cdot 4$ may be reached with this construction.

In Fig. 88e is shown the *Taylor-Hobson Aviar* lens. This was originally developed by *A. Warmisham* during World

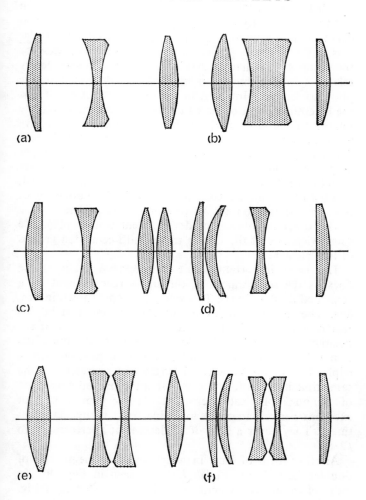

Fig. 88. (a) An early form of *Cooke Triplet*. For cine lenses it is possible to use a thick central element, as shown in (b). An increased aperture may be achieved by using the twin rear member shown in (c). An alternative approach, shown in (d), is to use a twin front member. In the *Aviar* lens, shown in (e), a twin central member is used. By splitting both front and central elements, as shown in (f), we obtain an *f* 2·5 *Aviar* lens.

251

War I. By using this type of construction it is possible to establish an excellent control over oblique spherical aberration, and to effect a significant reduction in field curvature and astigmatism. Closely related to it is the _Celor_ lens of the _Goerz Company_. A good case may be made for the point of view that the Aviar and Celor are more closely related to the symmetrical type of lens described in the previous section. However, in the case of the Aviar it was the inventor's point of view that this lens was more closely related to the Cooke triplet, in that the central negative elements were kept at a small separation. Usually just enough space was allowed for the insertion of an iris diaphragm and a shutter.

In Fig. 88f two of these lines of attack have been combined, and both the front and central elements of the Cooke triplet have been split into pairs, to give an $f2\cdot5$ Aviar lens.

The other major line of development is to replace the single elements of the Cooke triplet with cemented groups of lens elements.

The most important single development, along these lines, is the replacement of the single rear element by a cemented doublet in the _Tessar_ form of lens, shown in Fig. 89a. The refractive index of the negative element in this rear doublet must be less than the refractive index of the positive element in the doublet. By means of this construction a flatter field may be obtained than is possible with a triplet lens of the same focal length and aperture. At the same time it is possible to establish an improved correction of oblique spherical aberration. Tessar type lenses of excellent performance are available from many manufacturers. They cover a field of 52 degrees at apertures up to $f2\cdot8$.

Another form of lens, in which the rear member is of doublet form, is the _Kodak Ektar_, shown in Fig. 89b. In more elaborate constructions, such as that shown in Fig. 89c, the rear member may be of triplet form.

In yet another form of lens, which results from this line of development, the front member may be made into a doublet, or even into a triplet, as shown in Fig. 89d. An important type of lens, incorporating the kind of thinking which led to the Tessar form of lens, is the _Pentac_ type, shown in Fig. 89e. This construction is characterised by the

252

DERIVED TRIPLET FORMS

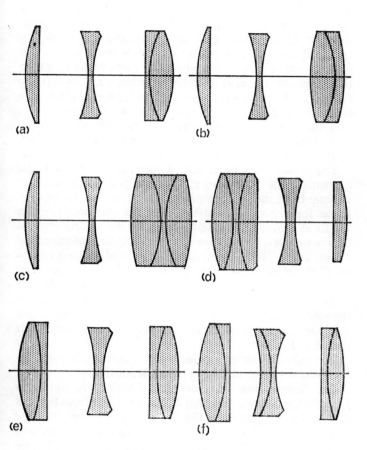

Fig. 89. A very important type is the *Tessar* form, shown in (a)·
(b) A form in which the rear member is reversed. In (c) and (d) are
lens forms in which the front and rear members become triplets.
In the *Pentac* form, (e), both front and rear members are compounded.
In the Leitz *Hektor* (f) all members are doublets.

fact that the refractive index of the positive element, in both front and rear doublets, is greater than the refractive index of the negative element in each of the doublets. This means that the Petzval sum of the lens may be significantly reduced, with a consequent reduction in field curvature and astigmatism. At the same time an even better correction of oblique spherical aberration is obtained than is possible with the *Tessar* form of lens (with a somewhat more costly construction). The chromatic variation of spherical aberration is also reduced, but for most purposes the zonal spherical aberration limits the design to an aperture of about $f2 \cdot 8$ to $f2 \cdot 7$.

In the *Leitz Hektor* lens, shown in Fig. 89f, all the members of the basic Cooke triplet are made into doublet lenses. With this construction an aperture of $/2 \cdot 5$ may be reached.

These two lines of attack, namely splitting the single elements of the basic Cooke triplet into pairs of elements, or making them into compound members, of doublet or even triplet form, may be combined. For example, we may take the form shown in Fig. 88d, and make the second element into a doublet, so that we arrive at the lens construction shown in Fig. 90a. This system may be used at apertures up to $f1 \cdot 9$. In another form, shown in Fig. 90b, the front element is split into a pair of elements and the rear element is made into a Tessar-style doublet. Another form, in which the second element of a twin front pair is compounded, and the rear element is made into an Ektar type of doublet, is shown in Fig. 90c.

The culmination of this line of development is found in the *Zeiss Sonnar* and *Biogon* constructions.

The *Sonnar* lens, two versions of which are shown in Figs. 90d, e, may be regarded as being derived from the lens of Fig. 90a by absorbing the central negative lens into the second member, or partially into the second member and into the third member. With this design an important feature is the thick second member. This serves the same general purpose as the thick negative members in the Speed Panchro, namely to reduce the Petzval sum. With the Sonnar construction it is possible to realise an excellent standard of performance with apertures up to $f1 \cdot 5$.

In the *Biogon* construction, shown in Fig. 90f, the central single element has been absorbed into the second member of a twin front system and into the rear member, while the

254

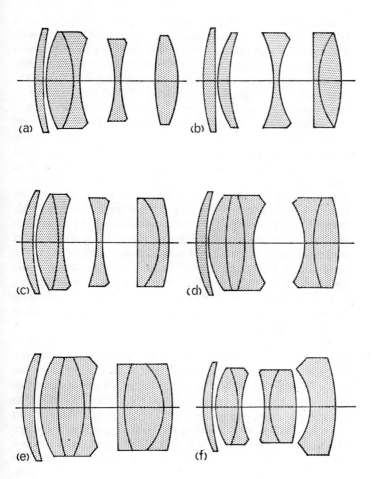

Fig. 90. Lenses which may be considered as derived from the triplet form are shown above. (d) and (e) are *Sonnar* lenses, and (f) is a 35mm. *f*2.8 *Biogon* lens. In (a) the front member becomes a single element and a doublet; (b) is a *Tessar* form with a twin front, and in (c) both front and rear members are compound.

latter has taken on a much more complex form, so that the lens may cover a wider angle at comparatively high apertures. A 35 mm. focal length lens of the form shown covers a standard double-35 mm. film frame at an aperture of $f2 \cdot 8$.

One point that merits discussion is the focusing of a triplet or Tessar type of lens. In some low cost cameras with between lens shutters an expensive focusing mechanism is avoided by changing the focal length of the lens, rather than by moving the lens as a whole. The separation between the first and second elements is increased slightly, and this in turn decreases the focal length. (This kind of approach is not practical with lenses of the symmetrical type, since both halves of such a lens have a positive power and an excessive movement would be needed in order to effect the desired change of focal length.) Inevitably, however, there is a certain loss of definition which results from the change in separation of the elements. Generally the lens is adjusted on the camera in such a way that the separation which yields best definition causes it to focus on an object at a medium distance. This ensures that focusing for infinity, or for short distances, does not demand considerable variations of the separations from their ideal values. At the same time, because of these variations, it is much better designing practice to focus by moving the lens as a whole, and focusing by moving individual elements should only be used when cost is of paramount importance.

Significant improvements have been made in recent years in all lens types derived from the basic Cooke triplet, including the simplest members of this family, by using the newer high-index glasses based on the use of exotic materials such as lanthanum oxide. In fact one may say that the simpler the lens, the more is it likely that an improvement may be effected by the use of such glasses. A few years ago the use of these glasses was rather restricted, but they are now employed in a routine fashion, except where cost is the dominant consideration, and so it will hardly be worthwhile mentioning their use in a lens.

WIDE-ANGLE LENSES

In this section we will consider not only wide angle lenses, but also semi-wide-angle lenses. It has already been explained that a semi-wide-angle lens covers an angular

256

field in the neighbourhood of 65 to 70 degrees, and a wide-angle lens covers a field in the region of 90 degrees.

An important field of application of wide-angle lenses is interior photography, particularly for architectural studies, where the limitations of space are most strongly felt. With a normal-angle lens only a restricted field may be recorded with the distance between camera and subject which is permitted in indoor work, and the extra field covered by a wide-angle lens is invaluable here. An associated use of wide-angle lenses is in connection with a *rising front* camera (see page 44), and the most frequent use of such a camera is for architectural photography. The displacement of the lens relative to the centre of the negative, in such a camera, means that the lens must cover a larger field than would otherwise be required of it, and a wide-angle lens permits a larger movement of the rising front than would be possible if a normal angle lens were to be used.

There are, of course, a number of other applications of wide-angle lenses which are of value, but these are to be judged from the artistic point of view, and for further discussion reference should be made to works which are devoted to the aesthetic side of photography.

There are two basic types of wide-angle lenses in use today. These are, firstly, the *symmetrical* type, and, secondly, the *retrofocus* type. The retrofocus type of lens will be discussed in the following section. In the present section we will consider the symmetrical type of wide-angle lens.

Within the symmetrical category there are two sub-types of wide-angle lenses. In each sub-type the two halves of the lens, which are nominally identical apart from minor differences which are needed in order to correct coma, are both positive lenses. The difference between the sub-types lies in the nature of the outermost members of the lens, both front and rear. In the one sub-type these outer members are positive; in the other they are negative.

The simplest member of the first sub-type is shown in Fig. 91a. This lens suffers from both spherical aberration and oblique spherical aberration, especially the latter. The aperture of the lens may be as high as $f6 \cdot 3$ or $f7 \cdot 7$, but this aperture can be used for focusing only. The definition at full aperture is good enough for focusing and composing, but is not good enough for photographic recording. This is

257

particularly true at off-axis image points. For this reason the lens must be stopped down to an aperture of $f16$ or lower in order to take pictures. When this is done the spread of the light patch, due to oblique spherical aberration, is considerably reduced or even eliminated, and the performance of the lens is then governed by astigmatism and field curvature. Both are low with this form of lens.

The symmetrical form of lens shown in Fig. 91b belongs to this sub-type, and may be used as a low aperture wide-angle lens. Once more a higher aperture may be used for focusing and composing than is used for picture taking. The same general form of lens construction, with detailed variations within the cemented triplets, is used in the *Schneider Angulon*, shown in Fig. 91c. This lens covers an angular field of 85 degrees at an aperture of $f6 \cdot 8$.

The need to stop down such wide-angle lenses has always been regarded as a weakness in these simple designs. In order to provide wide-angle coverage at comparatively high apertures the *Zeiss Topogon* form of lens was developed, as shown in Fig. 91d. Closely allied is the *Bausch and Lomb Metrogon* lens, of the form shown in Fig. 91e. These were originally developed for use in aerial reconnaissance, and covered an angular field of 85–90 degrees at an aperture of $f5$. In a version which was developed for use on standard double-35 mm. film the *Topogon* covers a field of 85 degrees at an aperture of $f4$. A similar construction is used in the *Canon* lens, shown in Fig. 91f, which covers an angular field of 85 degrees at an aperture of $f3 \cdot 5$.

An important line of attack on the problem of designing higher aperture wide-angle, or semi wide-angle lenses, is adopted in the second sub-type of symmetrical lenses. The outer members are negative, as shown in Fig. 92a. This has the effect of reducing the inclination to the axis of rays from off-axis object points, as they traverse the dominant positive components in the lens. The net effect of this is to reduce zonal astigmatism and to permit the use of a low *Petzval sum*, so that good coverage is obtained over a reasonably wide angle. At the same time the spherical aberration is well-corrected, and this permits a working aperture of $f4 \cdot 5$ or $f4$. By making the positive elements, in the outer negative members, of glass which has a higher refractive index than the mating negative elements in these doublets,

258

WIDE-ANGLE LENSES

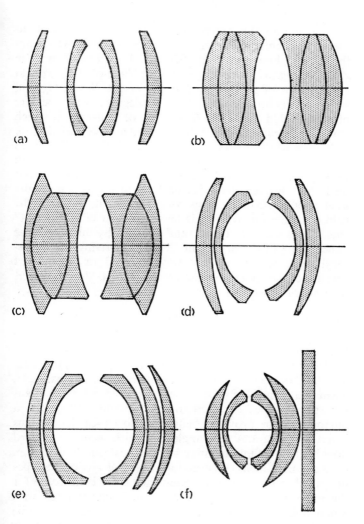

Fig. 91. (a) The simplest kind of wide-angle lens uses four elements.
(b) Another simple form using two positive groups. Both (a) and (b) must
be stopped down for picture taking. The Schneider *Angulon* is shown
in (c). (d) and (e) show respectively the Zeiss *Topogon* and Bausch &
Lomb *Metrogon* types of lens. (f) A *Canon f* 3.5 which covers a field
of 85 degrees.

the oblique spherical aberration is brought under control. The *Ross Xpres*, shown in Fig. 92a, covers an angular field of 70 degrees at an aperture of $f4$.

By exploiting this general line of development, namely to use outer meniscus elements of negative power, we obtain the forms shown in Figs. 92b,e,d. Fig. 92b shows the *Zeiss Biogon*, which covers an angular field of 90 degrees at an aperture of $f4 \cdot 5$. Fig. 92c shows the *Super-Angulon*, which covers an angular field of 90 degrees at an aperture of $f4$. Fig. 92d shows the *Grandagon* of *Rodenstock*, which covers an angular field of 100 degrees at an aperture of $f5 \cdot 6$.

A point which merits some discussion is the depth of field of a wide-angle lens. It is sometimes suggested that, in dealing with wide-angle lenses which cover an angular field of 90 degrees, the hyperfocal distance that is normally used should be divided by two. This is the ratio of the field coverage for wide-angle lenses, to that of a "normal" lens. There seems to be no valid reason why this should be done. None of the arguments, used in deriving the hyperfocal distance, are in any way changed or invalidated because of the wider angular coverage. (See also, however, the remarks on p. 74).

INVERTED TELEPHOTO (RETROFOCUS) LENSES

In a number of cases it is necessary to have a lens whose back focus, i.e. the distance from the last glass surface of the lens to the focal plane, is distinctly longer than the focal length of the lens. Such a requirement arises, for example, when beam splitting prisms are to be used behind the lens for special types of photography, or when space for a mirror must be provided behind a short focal length lens in a reflex camera. A wide-angle lens which covers a standard double-35 mm. film area may have a focal length of 35 mm. or less, and if a lens construction is used of any of the types described in the previous section then there is no room for the reflex mirror. The same problem is encountered with 8 mm. and 16 mm. movie cameras, where clearance must be provided so that lenses may be mounted on a turret, or where there must be adequate space between the lens and the film for the camera shutter and film advance mechanism. In order to overcome these problems an *inverted telephoto* or *retrofocus* lens is used.

260

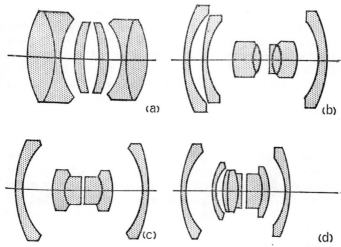

Fig. 92. (a) The Ross *Xpres* construction uses outer negative members. (b) The form of the Zeiss *f*4·5 *Biogon*. (c) The *Super-Angulon* with an aperture of *f*4. (d) The *f*5·6 Rodenstock *Grandagon*.

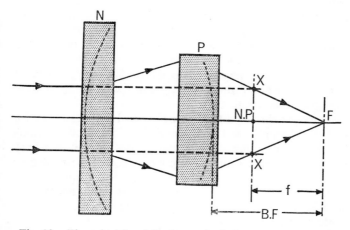

Fig. 93. The principle of the *inverted telephoto* or *retrofocus* type of lens. The incoming rays are caused to diverge to the front negative member and subsequently made to converge by the rear positive member. The back focus is greater than the focal length.

261

The principle of a retrofocus lens is shown in Fig. 93. It comprises a front negative lens system, shown at N in Fig. 93, and a rear positive lens system, shown at P in Fig. 93. The last glass surface of the lens is also shown in Fig. 93. Rays of light, which are initially parallel to the lens axis, are made to diverge by the negative lens system N. The rays then encounter the positive lens system P, and come to a focus at the point F. The back focus is the distance of the point F from the last glass surface of the lens, and is marked BF in Fig. 93. The focal length of the lens, denoted by f, is the distance of F from the rear principal plane or rear nodal point. These were defined in the first chapter. According to the definitions given there, the rear principal plane is obtained by continuing the ingoing rays until they meet the emerging rays in the points XX. The plane XX is the rear principal plane, which cuts the lens axis in the rear nodal point NP. The focal length is then the distance marked f in Fig. 93. It is obvious that the back focus is greater than the focal length of the lens.

While this form of lens was originally developed in order to provide a long back focus for normal angle lenses, it has more recently been realised that this form of lens has some very desirable characteristics, for wide angle use, compared with the conventional type of wide-angle lens described in the previous section. In particular it is possible to design a wide-angle lens of this kind with less vignetting than a conventional wide-angle lens, and with a more even illumination over the whole area of the negative. Quite complex forms of negative lens system are needed in order to correct the aberrations of the system, particularly in order to correct distortion.

Lenses of this kind tend to be rather long and bulky for their focal length, and their use is therefore almost entirely limited to providing normal angle lenses with a long back focus for 8 and 16 mm. movie cameras, and to providing wide-angle lenses for standard double-35 mm., single-35 mm., and *Instamatic* film areas. In this latter application such lenses can provide excellent wide-angle coverage at quite high apertures.

Fig. 94a shows a *Bell and Howell* 6·5 mm. $f1·9$ lens which covers 8 mm. movie film. (According to the terms used in describing movie lenses this is a wide-angle lens;

262

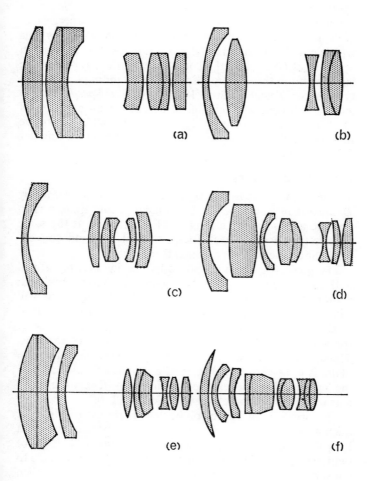

Fig. 94. (a) A 6·5mm. ƒ1·7 8mm. movie lens. (b) The Kodak *Ektanar* with an aperture of ƒ3·5. (c) The Zeiss 35mm. ƒ2·8 *Flektogon*. (d) The Zeiss 25mm. ƒ2·8 *Distagon*. (e) The Taylor-Hobson 18mm. ƒ1·7 *Speed-Panchro*. (f) The new Zeiss 20mm. ƒ4 *Flektogon*.

according to the definition which we have used it is a normal-angle lens.) Fig. 94b shows the *Kodak* 35 mm. *Ektanar* which covers an angular field of 62 degrees at an aperture of $f3 \cdot 5$. Fig. 94c shows the *Zeiss* 35 mm. *Flektogon* which covers the double-35 mm. film area at an aperture of $f2 \cdot 8$. In Fig. 94d is shown the *Zeiss* 25 mm. *Distagon* lens which covers the standard double-35 mm. film area at an aperture of $f2 \cdot 8$: note the complexity of the front negative lens system in this form of lens. An outstanding lens of this type is the *Taylor-Hobson* 18 mm. *Cooke Speed Panchro* lens, which covers a field of 80 degrees at an aperture of $f1 \cdot 7$; this lens is shown in Fig. 94e. In Fig. 94f is shown the new *Zeiss* 20 mm. $f4$ *Flektogon*, which covers an angular field of 93 degrees.

TELEPHOTO LENSES

The telephoto lens was developed in the 1890's, mainly by *Dallmeyer* in England. The main idea, at that time, was to provide a lens having a long focal length and at the same time having a short back focus, so that it would conveniently fit on the bellows cameras then in use.

The goal of modern telephoto lens design may be defined as the development of lenses with a short back focus, and with a short overall length, so that a long focal length lens will still be reasonably compact. The *telephoto ratio* is defined as the ratio of the distance, from the first glass surface of the lens to the film plane, to the focal length of the lens. Thus, if the distance from the first glass surface to the film plane is d, as shown in Fig. 95a, and if the focal length of the lens is f, then the telephoto ratio is $d \div f$. In a telephoto lens the telephoto ratio must be less than $1 \cdot 0$.

The principle of the telephoto lens is shown in Fig. 95a. Such a lens comprises a front positive lens system, shown at P in Fig. 95a, and a rear negative lens system N. Rays of light, which are initially parallel to the lens axis, are made to converge by the front positive lens system P. They then encounter the negative lens system N, and are rendered less convergent. They come to a focus in the point F. The back focus of the lens, denoted by BF in Fig. 95a, is the distance of F from the last glass surface.

The focal length of the lens is the distance of F from the rear principal plane or rear nodal point of the lens. These

264

Polarising filters may be used in order to examine the stress in transparent material such as glass or plastic. The illustration here shows the stress pattern in a condenser lens which has been tempered to give it additional strength and the ability to resist the effect of heating.

The value of using a polarising filter when shooting through water. The reflections from the surface of the water, when no filter is used, make the fish almost invisible.

Reflections are removed by the polarising filter, so that the fish is clearly visible.

Top: A flexible fibrescope which comprises a bundle of optical fibres. An image may be transmitted along a curved path in such a fibrescope.

Bottom: The appearance of the image so transmitted. In this case the individual fibres had a diameter of .0004 in.

The quality of an image may, in certain circumstances, be restored by *spatial frequency filtering. Top:* The image shows the effect of astigmatism.

Middle: The improved image with the effect of astigmatism removed.

Bottom: The picture on the left is out-of-focus, but its focus is restored in the picture on the right.

Top: A *hologram,* produced as described on page 422. This pattern of light and shade contains all the data that is needed to reconstruct *both* of the scenes shown at left.

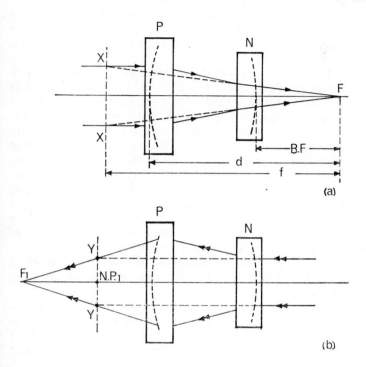

(a)

(b)

Fig. 95. The principle of the *telephoto lens* is shown in (a). The incoming rays are made to converge too strongly by the front positive member and this convergence is then reduced by the rear negative member. This shortens the overall length of the lens. The location of the front nodal point is established by drawing the rays shown in (b).

273

have been defined in the first chapter. According to these definitions, we obtain the rear principal plane and rear nodal point by continuing the emergent rays, so that they encounter the in-going rays in the points XX, shown in Fig. 95a. The plane through the points XX is the rear principal plane. This plane cuts the lens axis in the rear nodal point. The focal length f is then the distance marked f in Fig. 95a. Note that the back focus is very much shorter than the focal length, and that the overall length is also shorter than the focal length.

In the case of a telephoto lens it is of some interest to locate the front nodal point. This also has been defined in the first chapter. According to its definition we may locate it by bringing rays of light, which are parallel to the lens axis, into the rear of the lens, as shown in Fig. 95b. These rays meet the negative lens system N, and are made to diverge as shown in Fig. 95b. They then encounter the positive lens system P, and are brought to a focus at the point F^1. If we continue the ingoing rays until they intersect the emerging rays in the points YY, then the plane through YY is the *front principal plane*, and the point NP1 in which this plane cuts the lens axis is the *front nodal point*. This is the point of view from which a telephoto lens surveys the world, and its position at a location which is at a considerable distance in front of the lens must be taken into account for close-up work.

The simplest type of telephoto lens is shown in Fig. 96a. With this construction it is possible to realise an aperture of $f5 \cdot 6$ for longer focal lengths, and an aperture of $f4 \cdot 5$ for 35 mm. and 16 mm. movie cameras, with a *telephoto ratio* of about $\cdot 80$ to $\cdot 85$. The angular field which is covered, particularly with the lower aperture lenses, may reach about 25 to 30 degrees. Lenses that are closely related to this basic form are made by almost all manufacturers. A closely allied form is shown in Fig. 96b, which represents the *Wray Plustrar*.

An important defect in this simple construction is the presence of rather heavy pincushion distortion. In an attempt to reduce this distortion, and at the same time to reduce zonal spherical aberration so that the lens aperture could be opened up, *H. W. Lee* developed the form shown in Fig. 96c. The positive front system now becomes a doublet

274

TELEPHOTO LENSES

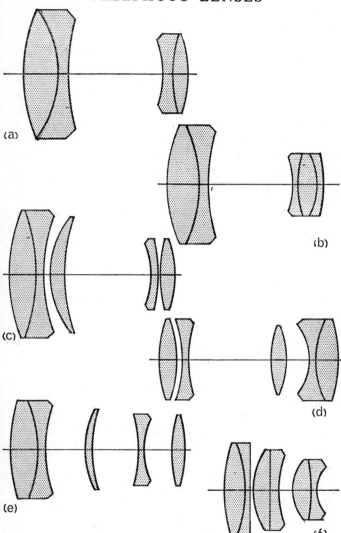

Fig. 96. The classical form of *telephoto lens* is shown in (a). Closely related is the Wray *Plustrar* (b). In the form shown in (c) *H. W. Lee* was able to reduce distortion. (d) The form of the Voigtlander *f5·5 Telomar*. (e) The 100mm. *f3·5 Canon* telephoto lens. A high aperture lens developed by *Cox* is shown in (f).

275

lens plus a single element, while the components of the rear negative lens system are separated from one another. This lens may be used at an aperture of $f3\cdot3$, and has significantly less distortion than the forms shown in Figs. 96a,b.

Apart from the heavy pincushion distortion, which tends to be a characteristic feature of telephoto lenses, there are also major problems which are associated with rather heavy zonal spherical aberration, chromatic variation of all the aberrations, and rather heavy oblique spherical aberration. (Incidentally the Petzval sum of a telephoto lens is negative, so that with pure field curvature the surface of best definition is convex towards the lens. With normal anastigmats this surface is concave towards the lens.) These heavy aberrations result from the basic concept of a telephoto lens. A large amount of positive power is contributed by the front lens system, well in excess of the overall power of the complete lens, and a large part of this positive power is counter-balanced by the negative power of the rear lens system, which is at a considerable distance from the front system. This adds greatly to the problem of correcting aberrations.

In efforts to provide an improved standard of performance we arrive at more complex forms of telephoto lenses. Some of these are shown in Figs. 96d, e, f. Fig. 96d shows the *Voigtlander Telomar*, which covers an angular field of 34 degrees at an aperture of $f5\cdot5$. A modern form of telephoto lens, in which the telephoto ratio is allowed to increase somewhat, in order to obtain an overall increase in performance, is the *Canon* lens shown in Fig. 96e. This lens covers the standard double-35 mm. film frame, with a focal length of 100 mm. and an aperture of $f3\cdot5$. The negative lens system, in this case, may be taken to be the last two single elements.

Quite another approach towards obtaining a high aperture in a narrow angle telephoto lens was taken by *Cox* in the *Taylor-Hobson Panchrotal*, shown in Fig. 96f. In this lens all of the negative power of the telephoto is concentrated on the rear surface of the last glass element. In earlier forms of this lens an aperture of $f2\cdot5$ was reached in a 3-in. lens which covered the 16 mm. movie film area. In later versions of this lens, for special applications, it has been found possible to reach an aperture of $f1\cdot8$.

276

It is worth commenting on the telephoto ratios which may be expected from modern telephoto lenses. Such ratios must be related to the characteristics of designs in which, at the very least, an adequate correction of aberrations may be achieved. This puts some practical limitations on feasible constructions, and as a general rule we may say that an adequate standard of performance, by present-day criteria, is not possible with a telephoto ratio which is less than ·75.

There are two further topics relating to telephoto lenses which merit discussion, namely the creation of distorted perspective when such lenses are used, and their depth of field.

The distorted perspective is usually more in evidence in movie work, particularly in long range newsreel shots. The essential factor, which is responsible for its creation, is that the distance of the camera from the scene is comparatively great, while the resultant picture, by its sheer scale of detail recording, suggests a close viewing point. The fact that two objects are photographed from a distant point means that their images are almost of the same size (all other things being equal): this is in contrast to the case where a comparatively near viewpoint is utilised, where size differences become appreciable, as shown in Fig. 97. The resultant image, when viewed from a normal viewing distance, either as a print or as a projection in a movie theatre, appears then to be strongly foreshortened, because the expected change of scale for normal separation of various objects is not realised under the viewing conditions. This effect is further enhanced because the distant viewpoint of a telephoto lens means that we see less of the sides of objects, and this takes away some of the impression of depth.

In calculating the depth of field of a telephoto lens we have to realise that the advantage which is sought from the use of such a long focus lens is the creation of a telescopic effect. We want to see detail in the picture which would not be apparent with a short focus lens. As a result we can say that the point of view from which the picture will be examined is the same as that which would be used for a short focus camera lens. This upsets the basic premise on which the calculations of depth of field in the first chapter were founded. In dealing with telephoto lenses, therefore,

277

we should either use a circle of confusion of constant size, unrelated to the focal length of the lens, as discussed on page 74, or we should use the size of the circle of confusion related to the focal length of the camera lens which would normally be used. The procedure to be followed, if we use a standard fixed size for the disc of confusion, has already been discussed in the first chapter.

If we adopt the second procedure outlined above, and relate the circle of confusion to that which is appropriate for a normal lens, we may proceed as follows. Suppose that the normal lens has a focal length of f inches, with a circle of confusion of $f \div 1000$ in. Suppose that the telephoto lens has a focal length of F inches, and has the same diameter circle of confusion. Then the *hyperfocal distance* of the telephoto lens, call it H^1, is given by the formula of the first chapter, namely

$$H^1 = \frac{F^2}{C \times N} = \frac{F^2}{N} \times \frac{1000}{f} = \frac{1000 \, F}{N} \times \frac{F}{f}$$

and we obtain the depth of field values by using H^1 from this formula. H^1 is the hyperfocal distance of a lens which has a focal length $(F \div f)$ times the focal length of the telephoto lens, or alternatively of a lens which has an f-number that is $(f \div F)$ times the f-number of the telephoto lens. We may obtain the depth of field values by consulting tables which have been drawn up for either of these cases.

What has been discussed above is admittedly a refined application of the principles of depth of field, but it is worth considering by the advanced amateur who is prepared to use it as a starting point for his own thinking.

SOFT-FOCUS LENSES

Portrait work, especially commercial or professional portrait work, is as much subtle flattery as photography. Among the things which may be controlled and chosen in order to produce a satisfying picture from this point of view are lighting, camera angle, and distance of the subject from the lens, focal length of the camera lens, and lastly the hardness of the lens definition.

The relation between the focal length of the lens, perspective, and the impressions of modelling have already been

278

Fig. 97. When a telephoto lens is used for shooting distant scenes there is an impression of perspective distortion when the pictures are viewed from normal distances.

279

discussed. What remains to be taken into account is the hardness of the lens definition.

The normal aim of the lens designer, and of the manufacturer, is to produce a lens which has both needle sharp definition and a large aperture. This goes a long way towards satisfying the demands of the practical photographer who uses the lens. There are times, however, when really first-class definition may be considered as a drawback, when a "better" pictorial result is sought with the help of a rather softer definition. In order to get this softer definition either a specially designed lens has to be used (as discussed below), or some device has to be used which will soften the definition provided by a good modern lens.

One method of softening the definition is to move the lens, or to add a supplementary lens, while the exposure is being made. The result of this is to superimpose a sharply defined picture on another which is out of focus and diffuse. Such a procedure is closely allied to that proposed in order to obtain an increased depth of field, and has already been described (see page 77).

Variants of this method are to make two negatives, one sharply focused and the other out of focus, and print one after the other on the same sheet of paper, or in making an enlargement to make part of the exposure with the enlarger sharply focused, and part with the enlarger out of focus.

Another way of softening the focus is to use a *diffusion disc*. The aim of such a disc is to scatter and disperse part of the light which enters the lens, so that after it has been refracted by the lens it forms a more or less tenuous veil of light round the proper image point. This gives a softening of the focus. It produces the same result, in effect, as that which is observed in the early morning, when a thin mist is clearing away, and there seems to be a film of light over the landscape.

A diffusion disc may be used either in producing the negative or in making an enlargement. When such a disc is used with a camera lens light is scattered from the highlights of the scene into the shadows, and an impression of lightness is obtained. On the other hand, when it is used in an enlarger its function is to scatter light from the transparent parts of the negative, corresponding to the shadows of the original picture. Hence, a diffusion disc (or for that

280

Fig. 98. Soft focus effects may be created in the camera or in the enlarger. The two effects are not identical. In the camera, light is spread into the shadows. In the enlarger, the shadows infringe the highlights.

281

P.O.—S

matter a soft focus lens of the type described below) when used with a camera, spreads light over the picture; when used with an enlarger it spreads shadow. This point, which is illustrated in Fig. 98, is of aesthetic rather than of optical interest.

One time-honoured method of producing the effects of a diffusing disc in an enlarger is to stretch thin chiffon over the enlarging lens. This softens the definition of the enlargement. The softening is due to the operation of two factors: One of these is the reflection and scattering of the light which strikes the fibres of the chiffon; the other factor is the diffraction of the light which avoids the fibres (see pages 128–130 for a discussion of diffraction). It is practically impossible to predict in advance the exact amount of diffusion which will be produced, and still less to judge whether it will be sufficient or not for the particular subject being dealt with.

The earliest method of introducing diffusion with a camera lens was to use the shimmering effect produced by the hot air rising from a gas flame. It served well enough with the rather long exposures then needed, but at the present time it is of hardly more than antiquarian interest.

One method which has been used, although it is rather complicated and not particularly well adapted to use with panchromatic plates or films, is to use a plate of glass that actually consists of two glasses of different dispersions cemented together, so that they upset the chromatic corrections of the lens with which they are used.

Alternatively special diffusion discs are available from optical houses which consist of fine diamond lines ruled on optically polished glass. These discs fit onto the front of the lens mount in the same way as a filter. The diamond rulings scatter light into the parts of the image which would otherwise receive no illumination. In some cases the rulings are straight lines, but preferably they are concentric circles. In any case it is advisable to leave a clear central area on such a disc so that, if necessary, hard definition may be obtained by stopping down the lens.

Incidentally it may be mentioned that many cheap filters are, involuntarily, excellent diffusion discs. This is true especially of the type of filter which consists of gelatin mounted between cover glasses, unless such filters are

carefully made. A star test with a filter in front of the lens will show how a poor filter performs in this way.

The alternative method of obtaining a diffused effect is to use a lens with a soft focus, and preferably one in which the softness of definition may be controlled. Of such lenses there are two types. In the first type the definition has its maximum softness at full aperture, and is hardened by stopping down the lens. In the second type the definition at any aperture is under full control.

In either case the softness of focus is introduced by leaving more or less spherical aberration in the lens. As a result of this spherical aberration, every point on the film is surrounded by a moderately diffuse halo, so that the hard contrast, obtained with a lens which is well corrected for spherical aberration, is softened by the veil of light which the halo spreads over the edge of an image, into its surrounding region. The effect is not the same as that obtained by merely putting the lens out of focus, as this gives a light patch which is inclined to be of finite size, but with an even distribution of light, so that the spread-over of light is too severe and spoils the definition instead of softening it.

Soft-focus lenses are not a special type or types to be added to those already described. They are just existing types, mainly of Petzval, Cooke triplet or Tessar form, in which provision is made so that one or more of the glasses may be moved in order to introduce a variable amount of spherical aberration, or which are just lenses of these types with uncorrected spherical aberration. There is one point to notice, and that is the change in the position of the focus of the lens with any change in the amount of spherical aberration. Lenses of these types are always focused on a screen in the camera, and, because of the fact just mentioned, it is important that the focusing should be done with the iris aperture and amount of diffusion which are to be used in making the exposure.

Examples of the first type of soft focus lens are the *Kodak f*4·5 *Portrait* lenses and the *Rodenstock Deep Field Imagon*. These lenses are not well corrected for spherical aberration at full aperture, and the light patch consists of a halo surrounding a hard core. When the aperture is cut down the halo is reduced until at about *f*16 the definition is sharp.

Examples of the second type are the *Dallmeyer* and *Taylor-Hobson Portrait* lenses with apertures of $f3\cdot5$. In each of these lenses the amount of spherical aberration may be controlled by separating some of the glass elements, and this determines the degree of diffusion given by the lens.

ENLARGING AND PROCESS LENSES

With enlarging and process lenses there is normally no need for a large aperture. On the other hand, however, a very high standard of performance is demanded.

The chromatic aberrations, astigmatism and curvature of field must be especially well corrected, although this does not mean that any relaxation of the standards of performance may be tolerated as far as other aberrations are concerned. In some cases the correction of camera lenses under enlarging conditions is sufficiently good for them to be used, but for the best performance a specially designed enlarging lens is desirable.

There are two major differences between enlarger lenses and camera lenses, from the aberrational point of view.

Firstly, the monochromatic aberrations described in a previous chapter vary with object and image conjugate distances. The extent of the variation will depend upon the detailed construction of the lens. But in nearly all cases a lens which is corrected for very distant objects will not remain well corrected when it is used in an enlarger, especially at low magnification values.

Secondly, the spectral sensitivity of most printing papers demands best performance in the blue end of the spectrum, whereas camera lenses intended for use with panchromatic emulsions may not yield their best definition in that region.

A feature which adds to the usefulness of enlarging lenses is a clicking arrangement on the iris control, so that it is possible to know the lens aperture without fumbling in the dark or switching on darkroom lights. As the iris aperture passes through its successive stages a definite click is heard or felt, and the lens aperture is known at once by counting these clicks.

Copying lenses are usually special types of enlarging lenses which have been designed to give a high standard of performance over a more restricted range of working

conditions. Process lenses for half tone, line and colour work have to yield a particularly high standard of performance. The large plate sizes which are necessary for this class of work, and the fact that so far it has proved impossible to achieve the required standard of definition with wide angle lenses, demand the use of lenses with unusually long focal lengths. Fortunately a high lens speed is not required and an adequate performance is usually provided at apertures in the region of $f10$. In this class of work the types of glasses must be carefully chosen in order to obtain a small secondary spectrum. For rigorous colour work an apochromatic correction is highly desirable. The forms of lens which are most popular are the Aviar type of lens, and the Tessar type of lens, although more complicated forms are also used.

The general practice is to use a prism in front of the lens in process work, the effect of which is to bend the beam of light, forming the image, through a right angle. It cannot be emphasised too strongly in this connection that the quality of the prism is of paramount importance.

The main requirements for such a prism are that the glass blank from which it is cut shall be singularly free from faults, such as strain and striae in the body of the material; that the angles shall be accurate to their nominal values within about one minute of arc; and that the surfaces shall be polished flat within less than half a wavelength of yellow light, i.e. within less than ten-millionths of an inch. A very slight curvature, either spherical or cylindrical, of any of the surfaces—particularly the long reflecting surface—will introduce astigmatism. The production of prisms of a really excellent quality is a most highly skilled job.

One point of importance in connection with process prisms which is very easily overlooked (it is actually of importance in all optical instruments) is the fact that the blackening put on optical surfaces so that they will not reflect unwanted light, must in fact absorb all light which is incident on it. One cannot take any arbitrary black paint or varnish and expect to find this total absorption of light, or anything approaching it. Suitable compounds are not usually publicly divulged by the firms using them. It follows from this, that if by any chance blackening is worn off the face of a prism (the triangular end face that is), or the edge of a lens, it is best

285

returned to the maker for refinishing. The use of a medium which is not perfectly suitable may result in an increased scattering of light which will impair contrast: This is, of course, of greatest importance under the rigorous conditions of process work.

CONVERTIBLE LENSES

In order to add flexibility to the use of standard double-35 mm. film cameras, the custom has grown up of building a camera, in fact, round a battery of lenses of different focal lengths and apertures. The film frame which is covered is always the same size, and the differing focal lengths of these lenses means that the proportion of the picture occupied by any particular object increases as the focal length of the taking lens is increased.

The same thing could be done with larger size cameras, and in fact is still done to a certain extent, namely, to provide a battery of lenses with each camera. But, whereas in the case of the 35 mm. camera the lens is carried forward by building it up with extra metal work on the lens mount, with other types of camera the longer focal length lenses have to be taken further away from the plate or film by extending the camera bellows, and it is only where a good extension is possible that a longer focal length lens may be used.

One method which has been used in order to provide three lenses in a battery is to build them into one lens, a *convertible* lens. This consists of two lenses, which we may call A and B, of fairly long focal length, usually different from one another. As a rule each of these lenses has to be used with the iris diaphragm or stop in front of it. The aberrational corrections of the two lenses are adjusted so that the two lenses A and B may be attached to one another, and so provide a lens of shorter focal length than either of the separate components. Inevitably a certain amount of definition and correction of aberrations have to be sacrificed in order to produce a lens of this type, but with skilful design the residual aberrations are sufficiently small to be acceptable for all but the most critical work.

In Fig. 99a is shown a typical convertible lens, made by *Taylor-Hobson*. The results of using this lens are shown in Fig. 99b.

286

CONVERTIBLE LENS

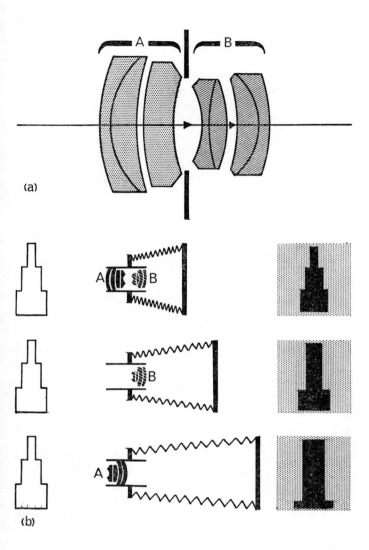

Fig. 99. (a) The construction of a *Taylor-Hobson Cooke* convertible lens. The variety of pictures which may be taken with this lens is shown in (b). Three different focal lengths are available and consequently three different pictures may be obtained.

This type of lens is derived almost exclusively from the early *Continental* forms of symmetrical lenses, and it supersedes the older type of so-called *Casket* lenses. The latter relied on the replacement of components in a Cooke triplet or Tessar construction, and serious amounts of aberrations were inevitable. In spite of the superiority of the true convertible lens over the true Casket forms, even the former fails to reach the high standard set by more conventional and less expensive forms of modern lenses. Most manufacturers now only produce these lenses to special order.

Another type of convertible lens, which became popular for a while with 35 mm. cameras, uses interchangeable front components. The rear components of the lens, behind the iris diaphragm, are common to all the focal lengths provided, and their distance from the focal plane of the camera remains constant. Focusing for different object distances is provided by movement of lens elements in the interchangeable front units.

This arrangement is particularly useful in cameras incorporating a between-the-lens shutter of the *Compur* type, since it avoids interference with the shutter when lenses are changed. The front sections may only be used with the particular rear components for which they were designed.

In Figs. 100a, b, and c are shown the interchangeable front components for a lens of this type which is made by *Rodenstock*. The basic lens shown in Fig. 100a is a 50 mm. $f2$ *Heligon-C* which covers a 24×36 mm. negative, which is, of course, the standard double-35 mm. film frame. This lens belongs to the Speed Panchro family which has already been described in this chapter. The front half of the 50 mm. lens is replaced by the unit shown in Fig. 100b in order to provide a 35 mm. $f5 \cdot 6$ lens, and is replaced by the unit shown in Fig. 100c in order to provide an 80 mm. $f4$ lens.

Very similar constructions, yielding the same focal lengths, are made by *Schneider*, and the system was also taken up by *Zeiss*. The signs are, however, that this type of lens system is being superseded by fully interchangeable sets of lenses which are mounted in front of the iris diaphragm and the shutter.

288

INTERCHANGEABLE
FRONT COMPONENTS

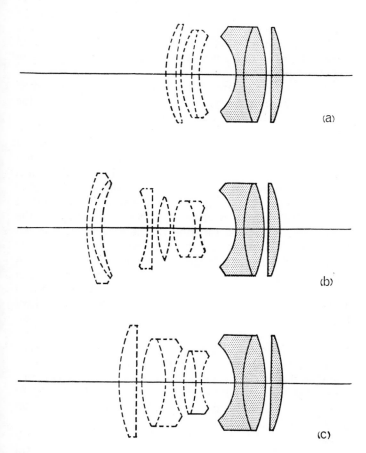

Fig. 100. The same rear component is used in lenses which are derived from a *Rodenstock* interchangeable lens form. (a) is a 50mm. *f2 Heligon-C*; (b) is a 35mm. *f5·6* and (c) is an 80mm. *f4* lens. The iris diaphragm or shutter may be located in a fixed position in front of the rear components.

When it is required to change the focal length of a lens without changing its distance from the plate or film, an *afocal attachment* may be used. This is, in fact, a telescope which is attached to the front of the camera lens. The focus of the camera lens is set at infinity, and focusing is carried out by changing the separation between groups of lenses in the attachment.

Such attachments are of two kinds. The first kind, when used with a camera lens, produces a larger image on the film than would be produced by the camera lens alone. Thus, such an attachment effectively increases the focal length of the camera lens. The basic form of this kind of attachment is shown in Fig. 101a. It comprises a front positive lens system which is quite widely spaced from a rear negative lens system. In order that the system may be afocal, and so have no effect on the position of the camera lens relative to the film plane, it is necessary that, when the attachment is focused for infinity, the separation between the positive and negative systems be equal to the difference in values of their focal lengths. Because of its construction and function an attachment of this kind is known as a *telephoto attachment*. The magnification given by a telephoto attachment is the ratio of the focal length of the front positive lens system to the focal length of the rear negative lens system. This gives the relative increase in image size which is obtained when such an attachment is used with a camera lens.

In order to correct the aberrations of a telephoto attachment, so that it may be used with a high-grade camera lens, we are led to constructions such as that shown in Fig. 101b: This illustrates the form of a *Bell and Howell* $2\frac{1}{2}\times$ telephoto attachment for use on 8 mm. movie cameras.

The other kind of afocal attachment is the *wide-angle attachment*. As its name implies, when used with a camera lens it increases the field of view of the camera. In effect a wide-angle attachment reduces the focal length of the camera lens. A wide-angle attachment, as shown in Figure 101c, comprises a front negative lens system which is quite widely spaced from a rear positive lens system. As in the case of the telephoto attachment, the separation between the positive and negative systems is equal to the difference between their focal lengths.

290

AFOCAL ATTACHMENTS

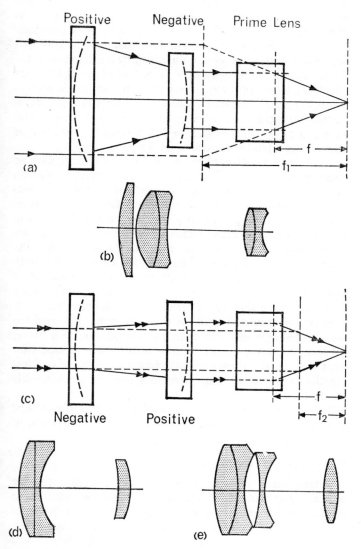

Fig. 101. (a) The principle of a *telephoto afocal attachment*. (b) The form of a Bell & Howell 2½X attachment. (c) The principle of a *wide-angle afocal attachment*. (d) One form of such an attachment. (e) A low-distortion construction which may be used with zoom lenses.

In order to obtain a good correction of the aberrations it is necessary to use complex lenses for the positive and negative lens systems. We thus arrive, for example, at the construction shown in Fig. 101d, which illustrates a *Bell and Howell* $1\frac{1}{2}\times$ wide-angle attachment. The $1\frac{1}{2}\times$ means that the attachment, when used with a camera lens, increases the linear field of view by a factor of $1\cdot5$. One of the aberrations which tends to appear quite strongly in wide-angle attachments is barrel distortion. In order to correct this distortion we may use the form of attachment shown in Fig. 101e: This is a $1\cdot5\times$ *Bell and Howell* distortion-free wide-angle attachment intended for use on an 8 mm. zoom lens.

The main field of application of afocal attachments is in connection with 8 and 16 mm. movie cameras, although some attachments have been proposed for standard double-35 mm. cameras. These attachments tend to be rather bulky, and this is particularly true of the telephoto form. For a while these attachments came into widespread use with 8 mm. electric eye cameras. The basic lens and the automatic iris are an integral part of such a camera, and both wide-angle and telephoto attachments are mounted on a turret so that they may be placed in front of the main camera lens. In this way a series of focal lengths are made available without the need for duplicating the iris mechanism. Wide-angle and telephoto attachments are also made, by some Japanese manufacturers, which may be used with zoom lenses. By using such attachments the range of focal lengths provided by the zoom lens may be considerably extended.

The importance of afocal attachments has diminished greatly in recent times with the widespread introduction of zoom lenses.

VARIABLE FOCUS (ZOOM) LENSES

A zoom lens is one in which the focal length may be continuously varied, between limits, while the focal plane of the lens remains fixed in position. In this way the composition of a scene may be varied to suit the picture taking conditions, or a focal length may be used which will reproduce some detail in the picture on a suitable scale. The need for zoom lenses has long been realised, and a number of attempts have been made to design such lenses.

292

ZOOM PROJECTION LENS

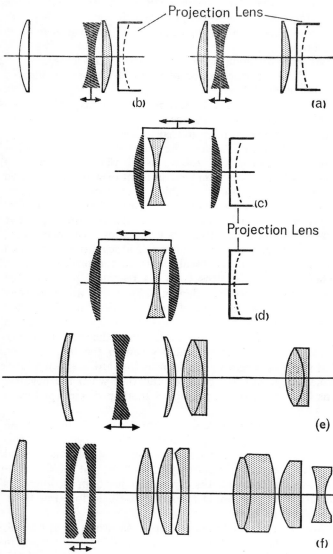

Fig. 102. A simple zoom projection lens uses three elements. (a) Short focus position of moving element (shaded). (b) Long focal length position of same element. Alternatively (c and d), outer elements move as a unit. (e) *Bell & Howell* 15-25 mm. *f* 1·6 8 mm. projection lens with single moving negative element. (f) *Bell & Howell* 19-33 mm. *f* 1·2 Super-8 projection lens with double negative lens system as moving part.

293

The advantages which they offer are obvious. It may be counted as one of the most important developments of the past few years that ways have been found to design high performance zoom lenses, and to produce them in massive quantities.

We may distinguish three classes of zoom lenses:

1. Lenses for projection of 8 and 16 mm. movie film, or colour slides;
2. Lenses for 8 and 16 mm. movie cameras;
3. Lenses for still cameras,

and we will discuss them in that order.

Zoom Projection Lenses. The simplest way to approach a discussion of projection zoom lenses is to consider any such lens as a basic projection lens, in front of which is mounted a *zoom unit*, which is a variable power telescope, as shown in Fig. 102a. As a rule this zoom unit consists of an inner negative lens which may move between two outer positive lenses. When the negative lens is in its forward position the zoom unit behaves like a wide-angle afocal attachment, and effectively reduces the focal length of the projection lens. When the negative lens is in its rearmost position, the zoom unit behaves as a telephoto afocal unit, and effectively increases the focal length of the projection lens. When the negative lens is in an intermediate position, there is an intermediate effect on the focal length of the projection lens. It follows, from the formulae given in the first chapter, that when the negative lens is in its forward position a large projected picture is obtained, and that when the negative lens is in its rearmost position a small projected picture is obtained.

With such a simple lens it is not possible to maintain an exact focus as the focal length of the projection lens is changed. The end points of the zoom range are maintained in focus, and the picture goes slightly out of focus at intermediate focal lengths. By careful design procedures this deviation from an exact focus may be held to a few thousandths of an inch.

A variant of this design concept is shown in Figs. 102c, d. In this construction the negative lens remains fixed in position, while the two positive lenses move as a unit. With the positive lens pair in the position shown in Fig. 102c, we have, in effect, a telephoto afocal attachment, which

294

increases the focal length of the basic projection lens. When the positive lens pair is in the position shown in Fig. 102d we then have, in effect, a wide-angle afocal attachment, which decreases the focal length of the basic projection lens. There is no essential difference in principle between the system shown in Figs. 102c, d and that shown in Figs. 102a, b, and whatever we may say about the latter system, may be equally applied to the former system.

In general it has been the practice to make the positive lenses of simple form. This leads to the introduction of lateral colour, which varies as the focal length of the lens is changed and usually changes in direction (from red on the outside to red on the inside) as the lens is zoomed from one end of its focal length range to the other.

In order to effect a suitable correction of aberrations, other than lateral colour, the shapes of the positive elements have to be properly chosen, and it may be necessary to split the central negative element into a pair of elements. In Fig. 102e is shown a *Bell and Howell* 15–25 mm. $f1 \cdot 6$ projection lens for 8 mm. film. This uses a simple central element in a zoom unit which is mounted in front of a four element Petzval lens. In Fig. 102f is shown a 19–33 mm. $f1 \cdot 2$ zoom projection lens for the new Super 8 mm. movie film format: In this system the central negative element has been split into a pair of elements.

Zoom lenses for 8 and 16 mm. projection of either of the types described, either in Figs. 102a, b or in Figs. 102c, d, are made by all of the leading manufacturers. The same basic approach is used for zoom lenses for slide projection, with a Cooke triplet construction for the basic fixed focus part of the zoom lens.

8 *and* 16 *mm. Movie Camera Lenses.* The simple form of zoom lens described above is suitable for projection purposes, but is not suitable for use in cameras. The change in position of the focal plane, which occurs at an intermediate focal length of the lens, cannot be tolerated in a camera. (When it occurs in a projection lens we can touch up the focus of the projector.) Moreover, unless we make the individual components of more complex form, the range of focal length variation is limited.

In order to obtain a greater range of focal length variation, and in order to achieve an aberrational correction

which is adequate for a camera lens, we must resort to more complex forms of lenses.

As before we can best discuss the performance of a camera zoom lens by considering it as composed of two parts, a telescopic *zoom unit* in front of a fixed focal length *prime lens* or *basic lens*. These two components act together to produce a *zoom lens*.

There are two basic forms of camera zoom lenses, their classification depending on the basis of operation of the zoom unit. These are the *optical compensation* and *mechanical compensation* forms of zoom lenses respectively.

The optical compensation zoom lens may be regarded as a logical extension of the projection zoom lens. By using the construction shown in Fig. 103a, which shows the basis of an early *Pan-Cinor* zoom lens, where the two positive lenses move as a unit, it is possible to bring the focal planes corresponding to three focal lengths of the zoom lens to a common position. This greatly reduces the residual variation of the focal plane positions, compared with that which is obtained for the projection lens system described above. In a further development, shown schematically in Fig. 103b, which represents the principle of later *Pan Cinor* lenses, we may bring the focal planes corresponding to four focal lengths to a common position, and so still further reduce the residual variation below the level of that which remains in the lens form shown in Fig. 103a. The two negative lenses in the construction shown in Fig. 103b move as a unit.

The focal lengths of the individual lenses in the lens forms shown in Figs. 103a, b must be carefully chosen in order that the three or four focal planes will coincide when the zoom elements move as a unit. By optical means we may thus reduce the variation of focusing position as the lens is zoomed through its focusing range, hence the term *optical compensation* zoom lens.

In order to correct the aberrations of the system it is necessary, of course, to replace the simple elements shown in the schematic diagrams of Figs. 103a, b by more complex units. Thus in Fig. 104 is shown the constructional form which is actually used in the 17–68 mm. $f2 \cdot 3$ *Berthiot Pan-Cinor* for 16 mm. movie film. Zoom lenses of this type have been produced by a number of manufacturers, mainly with a three-fold variation of focal length, and with aper-

296

ZOOM LENS CONSTRUCTION

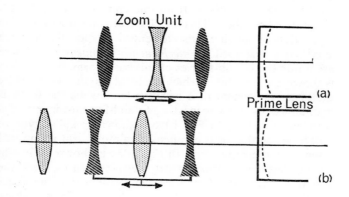

Fig. 103. In an early optically compensated zoom lens two positive lenses move as a unit about a negative lens, as shown in (a). In a later form, as shown in (b), two negative lenses move as a unit between positive lenses. (b) shows the principle of the *Pan-Cinor*.

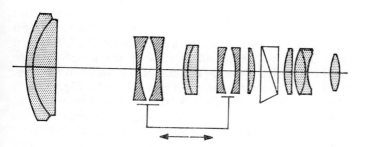

Fig. 104. The actual form of the 17-68mm. *f*2·3 *Pan-Cinor* requires more complex components than those shown in Fig. 103 so that the aberrations may be corrected to a satisfactory degree.

P.O.—T

tures up to $f1 \cdot 8$. Lenses with a range of focal length variation of about 6:1 have also been produced.

In the second type of zoom lens, the *mechanically compensated* form, the constant position of the focal plane is secured by a cam which accurately controls the changing distance between sets of optical components in the lens as the system is zoomed from one end of its focal length range to the other. This mechanical adjustment of the separation of moving lens elements is responsible for the lens being described as *mechanically compensated*. There are a number of sub-species of this basic form. In Fig. 105a is shown a zoom unit in which the focal length is changed by the linear movement of a negative lens, while the focus is maintained by a compensating to-and-fro movement of a front positive lens. In Fig. 105b is shown a similar type of unit in which the focus compensating movement is imposed upon a rear positive lens. In Fig. 105c is shown a form in which the outer elements are negative lenses, and the zooming action is effected by the movement of an inner positive lens, while the focal plane is held in a fixed position by the to-and-fro movement of one of the outer lenses. In Fig. 105d is shown a system having two outer positive lenses, with the zooming action effected by the movement of an inner pair of negative lenses, and with the position of the focal plane held constant by varying the separation between the inner negative lenses.

The forms of lenses shown in Figs. 105a, b, c, d are, of course, schematic only. In actual practice more complex forms of both positive and negative components are needed in order to correct aberrations. In Fig. 106a is shown the *Watson* 3–15 in. $f3$–$f4 \cdot 5$ zoom lens, of the basic form shown in Fig. 105d, which was designed by *H. H. Hopkins*: This lens covers the field of view of the *Image-Orthicon* used in television work. (The size of this field is quite close to that of standard double-35 mm. film.) In Fig. 106b is shown a zoom lens with a 4:1 focal length variation, belonging to the type of Fig. 105b, which is intended for use with 16 mm. movie film. This lens is unusual for a zoom lens because of the high degree of distortion correction. In Fig. 106c is shown the *Angenieux* 9–35 mm. $f1 \cdot 8$ lens for 8 mm. movie film. It also belongs to the type of Fig. 105b. In Fig. 106d is shown the *Cooke Studio Varotal* which has a

298

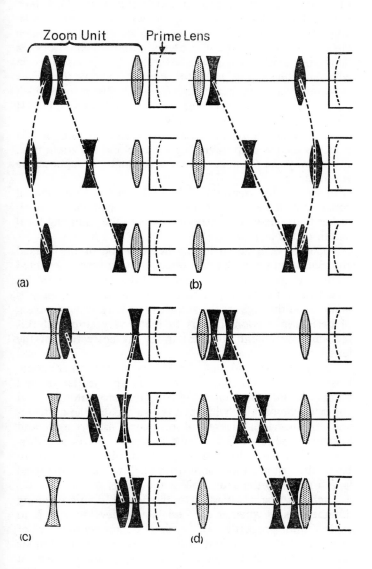

Fig. 105. (a), (b), (c) and (d) show the movements of the variable elements in four types of mechanically compensated zoom lenses.

range of focal lengths from 2·25 to 8 cms. at an aperture of $f1\cdot8$, covering the standard vidicon format (·625 inch diagonal) for television use. This belongs to the form of Fig. 105a. In Fig. 106e is shown the *Schneider Variogon* which varies from 8 to 48 mm. focal length, and which covers the 8 mm. movie film area at an aperture of $f1\cdot8$. It has the form corresponding to Fig. 105b. In Fig. 106f is shown the *Canon* lens which varies in focal length from 8 to 40 mm. and which covers the 8 mm. movie frame at an aperture of $f1\cdot2$. It belongs to the form shown in Fig. 105b.

In all modern zoom lenses for 8 and 16 mm. movie cameras the iris diaphragm is placed behind the zoom unit. In this way the f number remains constant throughout the zoom range.

In calculating depth of field tables for a zoom lens a constant diameter of the circle of confusion should be used, rather than one which varies in size with the changing focal length of the lens.

Focusing of a zoom lens, whether it be of the optical compensation or mechanical compensation type, is effected by moving the front outer member of the zoom unit. In this way the exact focus of the lens, for any focusing distance, is maintained throughout the zoom range. Part of the problem of designing a zoom lens is to make very sure that this focusing movement does not upset the correction of the lens.

The quality of modern 8 and 16 mm. movie camera zoom lenses is really outstanding, considering the design and manufacturing problems which are encountered, and compares favourably with, or even surpasses, the performance of individual lenses of the same focal length and aperture. The most difficult aberration to correct is distortion, which tends to vary from pincushion distortion to barrel distortion as we zoom from the long end of the focal length range to the short end of the range.

There has been a certain difference of opinion among designers as to whether the best line of development is to exploit the properties of optical compensation or of mechanical compensation zoom lenses. More freedom is given to the optical designer in the case of the mechanical compensation zoom lens, but this is somewhat offset by the problems of making the accurate cam mechanism which is

300

ZOOM LENSES

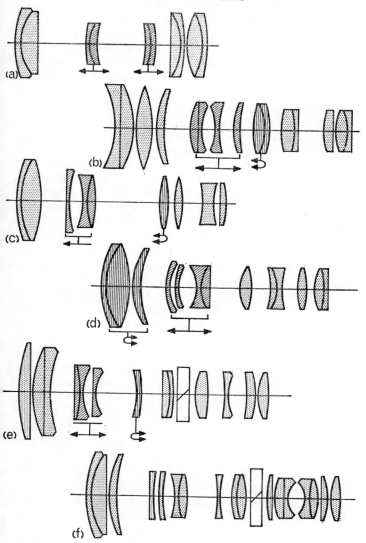

Fig. 106. (a) The Watson 3-15 in. $f3$-$f4 \cdot 5$. (b) Bell & Howell low distortion zoom lens for 16mm. film. (c) The Angenieux 9-35mm. $f1 \cdot 8$. (d) The Cooke *Studio-Varotal* which covers a Vidicon format with a range of $22 \cdot 5$-80mm. at an aperture of $f1 \cdot 8$. (e) The 8-48mm. $f1 \cdot 8$ Schneider *Variogon*. (f) The 8-40mm. $f1 \cdot 2$ Canon lens.

needed. The mechanical compensation type of zoom lens, however, tends to be smaller and more compact than the optical compensation type, and the tide appears to have turned in favour of the mechanical compensation type.

Still Camera Zoom Lenses. Zoom lenses have been developed for use on still cameras, as well as on movie cameras. But whereas in the case of zoom lenses on movie cameras we are concerned with two aspects of performance, namely the composition of a picture, so that desirable parts of a scene are included on a proper scale, and the zoom effect which is created as the focal length is changed while the camera is running, so that we get an impression of moving in on a scene, in the case of still camera zoom lenses we are concerned only with the aspect of picture composition. For this reason there has been some comment to the effect that zoom lenses on still cameras are not really needed. In the author's view it is doubtful whether, in the long run, this conservative point of view will prevail: It seems probable that the future will see a more widespread use of still camera zoom lenses, a number of which are already on the market.

No new principles are involved in the design of still camera zoom lenses, over and above those which have been applied in the development of 8 and 16 mm. movie camera zoom lenses. We do, however, have a problem with the physical size of still camera zoom lenses. The very fact that such a lens has to cover a double-35 mm. film frame, as compared with an 8 mm. movie camera film area, means that all other dimensions of the lens tend to be scaled up in proportion. As a result of this, there is a tendency for modern lenses of this type to work at lower apertures than movie camera zoom lenses. This helps to reduce the overall size of the lens. There is also a tendency to reduce the range of focal length variation, in comparison with 8 mm. camera zoom lenses, since this also helps to reduce the size of the lens.

The basic problem which is encountered in all zoom lenses, and which tends to prevent the use of short focal lengths at the shorter end of the range, is the correction of distortion. This sets a practical lower limit to the focal length of still camera zoom lenses.

In Fig. 107a is shown the *Voigtlander-Zoomar* 36–82 mm. $f2\cdot8$ zoom lens. This is an optical compensation zoom

302

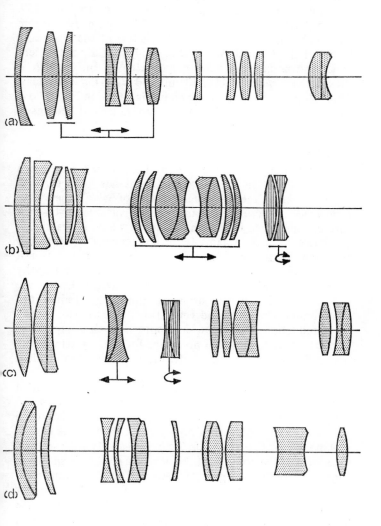

Fig. 107. (a) The 36-82mm. *f2·8 Voigtlander-Zoomar* lens for 24×36mm. (b) The 35-75mm. *f2·8 Zoomalik*. (c) The 80-240mm. *f4 Schneider Tele-Variogon*. (d) The 55-135mm. *f3·5 Canon* zoom lens.

lens, of the same basic form as that illustrated in the Pan-Cinor lens described on page 297. Historically this was the first still camera zoom lens, and was introduced in 1959. In Fig. 107b is shown the *Zoomalik* 35–75 mm. $f2 \cdot 8$ zoom lens. This lens is notable in that it is one of the few zoom lenses of the form shown in Fig. 105c, with a positive lens which moves between outer negative lenses. In Fig. 107c is shown the *Schneider* 80–240 mm. $f4$ *Tele-Variogon* lens. This belongs to the family shown in Fig. 105d. In Fig. 107d is shown the *Canon* 55–135 mm. $f3 \cdot 5$ zoom lens. It belongs to the family shown in Fig. 105a.

MIRROR LENSES

The image-forming systems described so far have been orthodox lenses in the sense that light has gone through the transparent media, usually glass, of which they have been made, suffering refractions at the various air-to-glass surfaces embodied in the lens. A defect which is practically inevitable in such systems is the existence of a *secondary spectrum*. In many cases this secondary spectrum is not unduly objectionable, but there are occasions—especially where high aperture and long focal length lenses are concerned—when it is a matter of importance to reduce it to a minimum. For this, and for various other reasons, such as a reduction in weight, attempts have been made at various times to produce an image-forming system which uses reflection, rather than refraction, to bend the incident light rays.

An increased impetus was given to the investigation of such systems following the development of the *Schmidt* camera which is shown in Fig. 108a. This consists of a spherical mirror M with a hole pierced through its centre, a plane mirror P, and a plate S carrying an aspheric surface. One form of the contour of the aspheric surface is shown in Fig. 108a on an exaggerated scale. The deviation from flatness is very small, of the order of a few thousandths, or at the most hundredths, of an inch. With such a simple system apertures up to more than $f1$ have been realised, with practically no secondary spectrum to speak of. Such *Schmidt* lenses have been proposed, in more or less this simple form, for the projection of television images formed on the surface of a cathode ray tube.

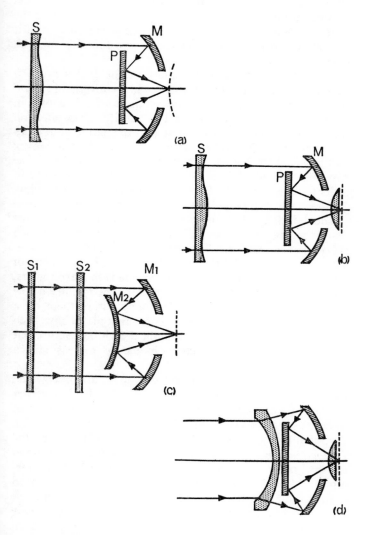

Fig. 108. (a) The classical form of *Schmidt camera*. In (b) a *field flattener* is added to provide a flat field in a Schmidt camera. Another form of flat field system is the *two plate Cassegrainian* shown in (c). A system using only spherical surfaces, due to *Gabor*, is shown in (d).

305

The principal defect of the *Schmidt* lens, as just described, is the fact that its field is curved. In order to get the best definition the plate or film must be bent to take up the spherical shape shown by the dotted line in Fig. 108a, or if it is used as a projection lens the cathode ray tube face must be curved in the same way.

Two principal ways of flattening the field of a *Schmidt* lens have been described. One is to add a converging system of a simple type, such as a plano-convex lens, as shown in Fig. 108b, near the focal plane. This has little or no effect on the other aberrations, to a first approximation, but does flatten the field. The other method is to use both a convex and a concave spherical mirror, as shown in Fig. 108c. The two mirrors should have the same radius of curvature in order to flatten the field. Systems of this second type employ, for the most part, two plates each bearing aspheric surfaces.

The defect, and it is an important one, of the systems just described, is that at least one surface has a curve on it which is not of spherical form. The production of such surfaces on a commercial scale, to the desired accuracy, is a problem of outstanding difficulty. They have been made by astronomers, but there is a world of difference between making a few surfaces for observatories, and manufacturing them on a mass production scale. Aspheric correcting plates have been moulded from transparent plastic in the United States, but the production of satisfactory moulding dies is still a difficult problem.

For this reason special interest attaches to attempts which have been made to design a lens based on reflection, rather than refraction, which relies on spherical surfaces. One of these lenses is shown in Fig. 108d. Other forms have been proposed by the Russian *Maksutov*, by *C. G. Wynne*, by the *Taylor-Hobson Company*, and others. Particularly noteworthy are the reflecting systems developed in Holland during World War II by *Bouwers*, using deep meniscus lenses to correct the aberrations introduced by a concave mirror. A 400 mm. $f5 \cdot 6$ mirror lens made by *De Oude Delft Company* is commercially available for use with 35 mm. cameras such as the *Leica*. Systems of comparable performance, and even larger apertures, have been manufactured by *Carl Zeiss* of *Jena*, and other manufacturers. The focal lengths sometimes reach up to 2000 mm., with apertures of $f8$ or $f11$.

306

Examples of this type are mirror lenses made by *Tewe* in Germany, as well as by *Canon* and *Nippon* in Japan.

These mirror lenses seem an attractive proposition when we compare their simplicity with the complexity of standard refracting lenses, especially of high aperture, and when we take into account the fact that they are virtually free from chromatic effects, in particular that they have no secondary spectrum. In the longer focal lengths also, they represent a considerable saving in weight over standard types.

It should be realised that the beam of light incident on these mirror lenses is obstructed by that part of the system which lies in front of the concave mirror. Moreover special mechanical masking is necessary in order to prevent light from passing through the various apertures in the system, and from reaching the focal plane without suffering any reflection at all. These two factors are the main reasons why such forms of lenses have no adjustment for relative aperture. Usually they are designed and made for use under special conditions of magnification, aperture and field of view; they are not always listed in manufacturers' publications.

ASPHERIC LENS SYSTEMS

While optical elements with non-spherical surfaces have been used for some time in mirror lenses, they have only comparatively recently found their way into all-refracting lens systems. The problems of manufacture are still enormous, because normal polishing and grinding operations for lenses only produce spherical surfaces. Surfaces of any other shape thus require individual treatment, which greatly adds to the cost of the lens. The lens elements in refracting systems are, however, smaller than the corrector plates in mirror systems.

An aspheric lens element may have a simple non-spherical (e.g. parabolic) curvature, or it may have a complex contour which is positive in the centre and negative at the edge of the lens. In either case it may provide a degree of correction of spherical and other aberrations in one step, where spherical lens elements would need much more complex assemblies of components. In economic terms there is thus the question of balancing the cost of a non-spherical element against the cost of a more complex system.

In practice aspheric lenses have been used in order to correct residual aberrations in large aperture wide-angle systems, and for special applications which call for extreme standards of performance. For further details reference should be made to more advanced texts on optical design.

A significant application of aspherics lies in the possibility of using them in fairly simple lens systems of high correction and aperture. This development is still very much in its infancy. Progress in this field must be intimately linked to advances in techniques of commercial production of aspheric surfaces.

Aspheric lens surfaces are used to a greater extent for condensers in projectors. Here production problems are much easier, since such lenses can sometimes be moulded; moreover, the required standard of precision is much less, as no image corrections are involved.

ANAMORPHIC SYSTEMS

The introduction of wide screen exhibition of 35 mm. films has directed attention once more to so-called *anamorphic systems*, which have properties quite different from those of the systems described earlier in this book. With the normal type of optical system the shape of the field which is recorded on the sensitive material is the same as that of the area of sensitive material exposed to the action of light rays. This follows from the properties of the nodal points of a lens described in the first chapter.

The area of film, which is exposed at any one time in normal 35 mm. movie film, is approximately a rectangle with 4:3 proportions (or an *aspect ratio* of $1\cdot33:1$). Thus the subject area which is covered by the lens will be a rectangle of the same proportions, and these will be the proportions of the scene as it is reproduced on the projection screen. If, then, it is desired to present a scene on the projection screen having different proportions, say those of an 8:3 rectangle, the straightforward approach shows that the exposed film in the camera should have the shape of an 8:3 rectangle. This also should be the shape of the area of the film which is to be projected.

In the case of cinema projection of movies the desire was created to establish a new projection screen format with 8:3 proportions (aspect ratio $2\cdot67:1$). The straightforward

308

approach of using film with an 8:3 area was not feasible because of the large investment which had been made in taking and in projection equipment, particularly in the latter. In order to obtain the desired end result, with a minimum change in existing projection equipment, it was necessary to use *anamorphic systems*. These have the power of compressing a scene into a narrow area on the film during the taking process, and of expanding the area on the film, so as to fill a larger screen width, during projection. Not only the scene, but all elements in it, are compressed or expanded with an anamorphic system. If the same expansion ratio is used in projection as was used in taking the picture, then we get an accurate reconstitution of the original scene on the projection screen. This is, of course, the normal procedure.

There are two main types of anamorphic units, the *prismatic* and the *cylindrical* forms.

The prismatic type of anamorph depends for its action upon the compression of a beam of light which traverses a prism, as shown in Fig. 109a. If the width of the entering beam is D, and of the emerging beam is D_1, then the compression ratio M is equal to $D_1 \div D$. This is also equal to the magnification ratio of the prism. If the angle between two parallel beams is A when they enter the prism, then the angle between the emerging beams is equal to $A \times M$ when they emerge from the prism. In other words, while an individual beam of light is compressed as it traverses a prism, the various beams of light are spread apart as they traverse the prism. Because of the shape of the prism such beams are spread apart only in one plane, namely the plane which is perpendicular to the edges of the prism.

In order to make a practical system two prisms are used in tandem, as also shown in Fig. 109a, and each prism is achromatised by using two or more elements of different glass in its construction. If the magnifications of the two prisms are M1 and M2, then the overall magnification is equal to $(M1) \times (M2)$.

The system described is that which is applicable to projection, where a narrow field on the film is broadened out so as to fill a wide screen. If the same system is to be used for taking, then the arrangement shown will compress a wide field of view into the confines of a narrow strip of film.

309

The anamorphic unit must always be backed up by a standard taking or projection lens.

The cylindrical type of anamorphic system is essentially a wide-angle afocal attachment in which cylindrical surfaces are used in place of the usual spherical surfaces. This means that in one direction the unit behaves as a wide angle afocal attachment, but that in the direction at right angles to this it has no significant effect on the image spread.

As shown in Fig. 109b this unit essentially comprises a positive cylindrical lens P, widely separated from a negative cylindrical lens N. As in the case of the prismatic type, an entering beam of light is compressed from D to D_1, giving a compression ratio M which is equal to $D \div D_1$. Again this is equal to the magnification of the system, so that if the angle between two entering beams of light is A, the angle between the corresponding emerging beams of light is $M \times A$. Because of the use of a cylindrical lens, this spreading out of the beams of light occurs only in the plane which is perpendicular to the axes of the cylindrical surfaces.

In practice it is necessary to achromatise the positive and negative cylindrical lenses. This is effected by combining different types of glass in each component, in the same way that lenses with spherical surfaces are achromatised by using crown glass and flint glass.

One further point which may be mentioned, in connection with the cylindrical type of anamorph, is the need for an extremely precise alignment of the axes of the various cylindrical surfaces. Without this exact alignment astigmatism is introduced, and a sharp focus cannot be obtained. If the spacing between the components of the anamorphic unit is varied for focusing purposes (see below), then the motions of the components must be controlled in such a way as to preserve this exact alignment.

The positive and negative components of a cylindrical anamorphic unit may be of much more complex form than simple doublets. In a design patented by *Bell and Howell*, for example, the front or negative component comprises two doublet members as shown in Fig. 110a.

The cylindrical anamorphic unit, like the prismatic form, must be backed by a projection lens when it is used for projection, and by a taking lens when it is used for taking pictures. The relative position of the anamorph is the same

310

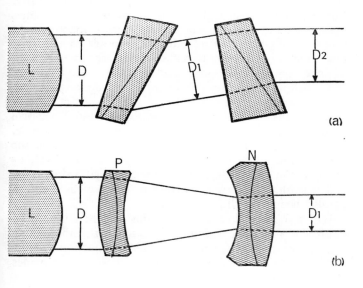

Fig. 109. (a) The prism anamorph depends for its action on the compression of a beam of light from D_1 to D_2 and D as the beam of light traverses the prisms. The individual beams are spread farther apart. (b) In a cylindrical anamorph the beams of light are compressed in one direction only as they traverse the system and it follows that individual beams are spread out in this direction.

311

in both taking and projection: it is *not* reversed end for end in the two applications.

For both types of anamorphic unit some focusing action is necessary. This may seem obvious for the cylindrical type, since it does partake of some of the characteristics of a lens, with its curved surfaces, but it may not seem so obvious with the prismatic type. The need for focusing of the prismatic variety arises because any beam of light which enters the prism, other than a parallel beam, has its degree of convergence or divergence changed by its passage through the prism. Furthermore, the change is not the same in the planes parallel to, and perpendicular to, the edges of the prism. As a result, astigmatism is introduced. In order to eliminate this defect it is necessary to reduce the divergence of a beam of light from an object point, and to make it into a parallel beam before it traverses the prism. This is done by using a *focusing doublet*.

A focusing doublet comprises a positive and a negative element, the separation between the two being variable. When the separation is at a minimum, the power of the combination is zero: As the separation is increased, as shown in Fig. 110b, c the power of the combination increases, and it is able to convert a divergent beam of light into a parallel beam of light.

With a focusing doublet used in this way there is no need to provide a focusing action on the prime lens, either taking lens or projection lens, which is used in conjunction with the anamorphic unit. The focusing action of the doublet provides all of the adjustment which is necessary.

A focusing doublet may be used in conjunction with a cylindrical anamorphic unit in order to provide the same action as that described above. With this type of anamorphic unit, however, there is another possible way of obtaining a focusing adjustment, namely by varying the separation between the positive and negative components. It is of critical importance to maintain the alignment of the components while this separation is varied, a fact which demands the highest grade of workmanship in the mount construction. With this type of adjustment, also, it is necessary to provide additional focusing action for the prime taking or projection lens. The reason for this lies in the fact that the cylindrical surfaces can influence only the spread of light

312

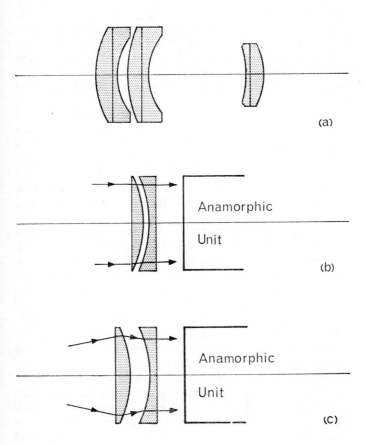

Fig. 110. (a) A Bell & Howell anamorphic unit uses only plano-convex or plano-concave cylindrical elements but two doublets are used in the front member. (b) and (c) show the action of a focusing doublet. The two members are separated when it is necessary to focus on a near distance.

313

rays in one plane, and have no effect on rays in a plane at right angles to this.

A practical problem, of some importance, is the extent to which an anamorphic unit may be used with a particular lens because of the way in which the lens mount is designed. In some lenses the glass elements are sunk very deeply into the mounts, so that a sunshade effect may be obtained. This prevents the close approach of the anamorphic units to the lens, and vignetting is introduced. In other words, the front lens of the anamorphic unit restricts the field which may be recorded.

Both varieties of anamorphic unit, cylindrical and prismatic, are commercially available. In general the prismatic type finds its main application in projecting movies. It gives an excellent picture quality under these conditions, where the field of view of the projection lens is comparatively restricted. Where the angular coverage of the prime lens becomes larger, as is commonly the case for picture taking, the cylindrical type may be preferred.

The anamorphic power most frequently encountered is $2\times$, although there are a few $1\frac{1}{2}\times$ systems. With a $2\times$ system the field of coverage in a vertical direction is obtained by consulting the tables for the focal length of the prime lens. The coverage in a horizontal direction is obtained by looking up the tables for a focal length one-half of that of the prime lens. This gives the horizontal coverage within about two per cent; detailed lens constructions, and the varying distortion corrections they lead to, will modify the exact coverage within these limits.

The depth of focus and depth of field obtained with an anamorphic system are difficult to determine because of the unusual characteristics of the system. As a rough rule, with a $2\times$ anamorph the depth of field is greater than that of the prime lens alone by a factor of about $1\cdot4$. This general conclusion, however, may be modified by the detailed form of the anamorphic unit, and it is strongly recommended that the depth of field be checked experimentally.

Miscellaneous Systems

The simplest and most obvious way of finding out exactly what picture a lens is throwing onto the surface of the sensitised material in a camera, is to replace the film or plate by a ground glass screen and to examine the image formed on this screen. The ground surface of the glass screen must occupy exactly the same position as the surface of the sensitised material. This procedure is still followed in many studio cameras (where the fact that the image is upside down does not give rise to undue concern). Rather more devious ways of obtaining equivalent results, or nearly the same results, comprise the use of *viewfinders* and *rangefinders*.

As far as getting the position of exact focus is concerned, when using a focusing screen, two points should be borne in mind. The first is to use a magnifier with a reasonably high power, about 8X to 15X is most suitable. The second is to be certain that the magnifier is focused exactly on the ground surface of the glass. This can be done fairly easily by drawing fine pencil lines on the ground surface, by focusing carefully on these, and by making sure that both the image and the pencilled lines are in sharp focus together when examined with the magnifier. The screen, of course, is used with its ground surface towards the lens.

This type of focusing serves for most cases. When a really critical focus setting is needed a clear glass screen should be used, with fine rulings engraved on it or photographed on it. The magnifier is focused on these rulings, and the image given by the lens is brought into sharp focus. The final focus setting is done by adjusting the lens, with a precise movement, in order to eliminate all parallax between the image and the lines. This simply means that, when the eye is moved slightly, there is no relative movement of the lines and of the image as seen through the magnifier. A very exact setting can be made in this way.

A glass screen which is suitable for this work can be made

315

by photographing lines about ·01 in. wide, drawn in black ink on a matt white surface, at a reduction of about 20:1. A fine grain process plate should be used, and the lens that is employed should be stopped down to one or two stops below its maximum aperture in order to get the best definition.

While a clear glass screen and parallax focusing are more accurate, a ground glass screen is more useful in composing the picture. A useful compromise to use is a ground glass screen with a clear centre. The ground area is used for composing while the clear centre is used for precise focusing.

Another method of getting the position of sharp focus most easily is to put a mask in front of the lens, consisting of a series of parallel slits about 1/8 in. wide, or consisting of holes about 1/8 in. square. Such a mask can be improvised quite readily from stiff card and an old filter holder. With this mask in place the out-of-focus light patch is split up into a number of separate patches, and this gives a more definitely diffuse appearance to the image on the screen. The image then seems to snap into focus more abruptly. The mask should, of course, be removed before the actual picture taking.

It pays as a rule to focus the lens as close to its full aperture as possible, so that sharpest discrimination may be exercised in establishing the proper adjustment of the focal setting.

REFLEX CAMERAS

The first variant of this simple use of a focusing screen is found in the *reflex camera*. The light coming from the lens is intercepted by a mirror which reflects it onto a viewing screen, so that the image to be recorded on the sensitised material is visible right up to the moment of making the exposure. This mirror is swung out of the way before the picture is taken. This is the basic feature of the single lens reflex camera.

The viewing screen may be used not only to compose the picture but also to focus it. In this event it is preferable to use some degree of magnification, to aid in getting a sharp focus, and most reflex cameras incorporate a magnifier with which to examine the centre of the viewing screen. This magnifier can be swung out of the way when picture

316

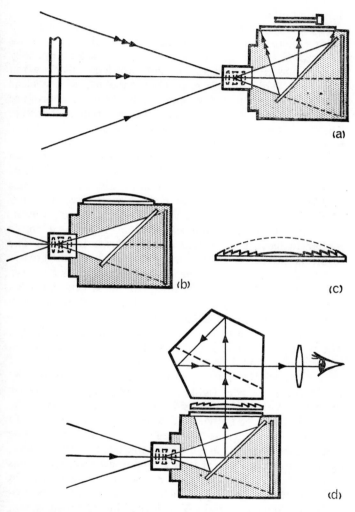

Fig. 111. (a) The basic form of a single-lens reflex camera. The image brightness in the corners of the field may be enhanced by using a positive lens, as shown in (b). The convex lens of (b) may be replaced by a *Fresnel* lens, as shown in (c). In the eye-level reflex camera, shown in (d), the light is reflected in a *penta-roof prism* before it reaches the eye.

317

composition is the prime consideration. In this case, also, it is customary to leave a clear centre in the viewing screen, so that the image in that region may be viewed without the softening effect of the ground surface.

For many years the only practical viewing screens in reflex cameras were of ground glass or frosted glass. In order to direct as much light as possible to the viewing eye they were frequently backed up with collector lenses as shown in Fig. 111b. This, of course, precluded the use of the clear centre for sharp focusing, and established a compromise between the picture brightness and the accuracy of focusing. The current practice is to use a *Fresnel lens* screen as shown in Fig. 111c.

A Fresnel lens has the power of behaving very much like a regular lens, but without the bulk or weight of such a lens. Fresnel lens screeens are moulded in plastic, and the master mould may quite readily be cut so as to give a higher efficiency, from the point of view of light gathering power, than a regular lens. With a screen of this type it is a simple matter to leave a clear centre for accurate focusing. The result is increased image brightness, as well as greater accuracy of focus setting in order to obtain picture sharpness.

It should be noted that the image on the screen of a reflex finder is the right way up, but that it is reversed left to right. This reversal is known as *handing*.

Many miniature reflex cameras have an *eye level* finder. The camera is held at eye level, and the image on the focusing screen is viewed through a roof pentaprism, a prism of rather complicated form as shown in Fig. 111d. In this way the image is seen the right way up, and appears correctly oriented, i.e. the right-hand side of the object appears on the right-hand side of the viewing screen. An eyepiece lens (a low power magnifier) is provided to enable the image to be clearly seen with the eye close to the back of the camera, as also shown in Fig. 111d. In a Japanese camera which has recently been introduced a *Porro* prism system is used in order to obtain an image which is erect and which is properly oriented left to right. This is the kind of prism system used in binoculars. It allows a low silhouette for the camera styling.

In order to improve the focusing accuracy in a reflex finder a *bi-prism* may be mounted in the centre of the viewing

318

FOCUSING AIDS

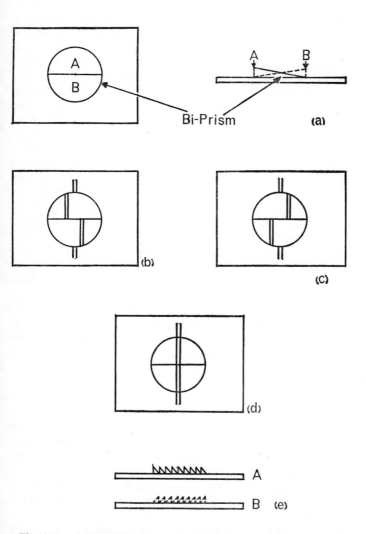

Fig. 112. A *bi-prism*, of the form shown in (a), may be used to provide a better discrimination of the focus position. On one side of focus the image is broken, as shown in (b). On the other side of focus it is broken as shown in (c). Only in exact focus does it take the form shown in (d). The bi-prism shown in (a) may be replaced by the *Fresnel bi-prism* shown in (e).

screen, as shown in Fig. 112a. The function of such a bi-prism is to deviate light so that it goes in two different directions. Light which falls on one-half of the bi-prism is deviated in one direction, while light which falls on the other half of the bi-prism is deviated in another direction. If an image lies in front of the bi-prism then the light is deviated in such a way that the two halves of the image appear to be displaced as shown in Fig. 112b. If the image lies behind the bi-prism then the two halves appear to be displaced as shown in Fig. 112c. It is only when the image lies in the proper plane of the bi-prism that the two halves of the image do not appear to have any relative displacement, as shown in Fig. 112d. The detection of the relative displacement of the two images calls into play the *vernier acuity* of the eye, which is of a high degree of sensitivity. It is much easier to detect the relative displacement of two halves of an image than it is to determine that an image is not in precise focus as judged by its sharpness. An auxiliary magnifier may be used in order to examine the central part of the field occupied by such a bi-prism.

Just as a collector lens may be replaced by a Fresnel lens, so a bi-prism of the type shown in Fig. 112a may be replaced by a *Fresnel bi-prism* of the type shown in Fig. 112e. The function of a Fresnel bi-prism is the same as that of the bi-prism shown in Fig. 112a, but we can cover a larger focusing area with a Fresnel bi-prism than we can profitably use with a regular bi-prism.

TWIN LENS REFLEX CAMERAS

In the twin lens reflex camera two lenses are used. The first is the normal camera lens, for focusing an image on the sensitive material. The second is a lens of the same focal length which forms an image identical to that formed by the first lens, but in this case the image is thrown onto a viewing screen. The lenses are coupled together so that the image on the sensitive material is in focus at the same time that the image on the viewing screen is in sharp focus. The second lens must be of good quality, and is normally a triplet anastigmat.

With the twin lens reflex camera there is no change in image brightness as the taking lens is stopped down. The loss of image brightness on stopping down is a definite

320

disadvantage with the single lens reflex camera, particularly when high speed film is used, although it may be overcome by using an iris diaphragm coupled to the exposure button: when the button is pressed in order to take a picture it releases the iris diaphragm, so that this may close to a preset value before the shutter opens.

The viewing lens in a twin lens reflex camera sees the picture from a slightly different point of view to that of the taking lens. This is due to the separation between the taking lens and the viewing lens. The error which is introduced because of this separation is known as *parallax error* or *parallax*. This is a distinct disadvantage of the twin lens reflex camera.

On the other hand one rather definite psychological advantage of the twin lens reflex camera is that the picture is in view at all times. However, most current single lens reflex cameras incorporate a mechanism which returns the mirror to the viewing position immediately after the exposure is made. In the *Pellix* camera of the *Canon Company* the reflex mirror is made of a very thin reflecting membrane which is fixed in position. In this way the image is always in view and the psychological disadvantage of the single lens reflex is overcome.

In order that a reflex camera, of either the single or of the twin lens type, may work effectively, it is necessary that the image on the viewing screen be in sharp focus at the same time that the image on the sensitised material is in sharp focus. This can be checked quite simply in the following way: A series of test charts are set up in front of the camera, as shown in Fig. 113, so that their images are separated by about ·003 to ·004 in. Some of the images will lie in front of the nominal focal plane, while others will lie behind the nominal focal plane. The separation between test objects, which is needed to effect this separation of images, can readily be calculated using the formulae of the first chapter. The central object, marked C in Fig. 113, is brought into sharp focus on the viewing screen. A picture is then taken of this array of test objects. In the developed picture it is quite easy to see which of the objects is in sharpest focus. If the adjustment of the camera is correct then it should be the central object, marked C as already described. If there is any error in the camera adjustment then one of

321

the other test charts will be in sharp focus. By noting which chart is in sharp focus, it is possible then to estimate what is the camera error.

In using a focusing screen or a reflex arrangement of the types mentioned above, the picture is composed and focused at the same time. Other devices deal with only one of these functions at a time, either focusing or composing the picture, and so can be classed as either *rangefinders* or *viewfinders*. Viewfinders will be dealt with first in the following pages, and after that we will consider rangefinders. Viewfinders and rangefinders for movie cameras will be considered later.

DIRECT VISION VIEWFINDERS

The simplest type of viewfinder comprises a mask or frame mounted in front of a small viewing hole cut through a piece of metal. The distance between the sighting hole and the frame is normally equal to the focal length of the camera lens with which the viewfinder is used. The frame of the viewfinder is the same size as the film area covered in the camera. Then, apart from a slight parallax error, the picture seen in the area of the wire frame or mask, with the eye at the sighting hole, and with the taking lens focused for infinity, is just the picture that the lens throws onto the surface of the film.

As a rule a lens is focused by varying its distance from the plate or film, in order to take into account the varying distances of the objects to be photographed, although with some lenses the focusing is done by varying the separation between elements within the lens. When the focusing is carried out by moving the whole lens bodily, there is a definite advantage to be gained by mounting the frame or mask of the viewfinder on the lens panel. As the lens moves away from the film or plate, in order to focus on close-up objects, its rear nodal point also moves away from the film or plate. Now, as previously explained (page 40), the perspective frame is separated from the viewpoint by the same distance that the rear nodal point is separated from the film surface. If then the wire frame or mask, which serves to mark off the area of the picture which will be recorded on the film, is fixed to the lens panel, it automatically moves forward through the same distance as does the rear nodal

322

Test Charts

Fig. 113. The arrangement of test-charts shown above may be used to check the focusing accuracy of a reflex camera. The camera is focused on the central chart, marked C.

Fig. 114. The simplest form of optical viewfinder is shown at (a). The image brightness is improved by adding a convex lens, as shown in (b). Another form of optical finder comprises a front negative and a rear positive lens, as shown in (c). By using a semi-reflecting surface, as shown in (d), we obtain an *Albada viewfinder*.

point of the lens. The distance of the sighting hole from the wire perspective frame is automatically kept the same as the distance of the rear nodal point of the lens from the surface of the plate or film. The picture then covered by the viewfinder frame is just that which the lens will record on the film or plate.

If the lens is moved without any corresponding movement of the wire perspective frame the field recorded on the film is smaller than the field seen through the frame, except when the lens is focused on an object at infinity, and so at its nearest approach to the plate. The amount of the discrepancy may be judged from the figures given below.

Suppose that a plate $2\frac{1}{4}$ in. \times $2\frac{1}{4}$ in. is used in a camera with a 3-in. focus lens, and that the wire frame is correspondingly $2\frac{1}{4}$ in. \times $2\frac{1}{4}$ in., and 3 in. away from the sighting hole. When the lens is focused on infinity the picture seen through the wire frame is just that which is thrown on the sensitive material. When the lens is focused on an object at a distance of 2 feet the picture recorded is only about 90 per cent of that seen through the viewfinder frame.

Another form of direct vision viewfinder consists of two metal masks mounted one behind the other, so that when the rear mask opening just covers that of the front mask the rays of light which reach the eye are correctly limited when the lens is focused for infinity. When the lens is focused for infinity the picture seen through the two frames is just that recorded on the film or plate.

OPTICAL VIEWFINDERS

The types of viewfinder described immediately above are simple and straightforward, and without optical elements in their make-up. Equally common types of viewfinder employ inexpensive optical elements. Because of their simplicity no provision is made as a rule for the change in the field recorded as the lens is focused at close range.

The simplest type of optical viewfinder consists of a moulded converging lens, a mirror, and a small ground glass screen as shown in Fig. 114a. The focal length of the moulded lens, and the size of the ground glass screen, are matched so that the picture on the screen is, on a small scale, just the picture which is thrown on the plate when the lens is focused for infinity.

An improvement on this simple type of viewfinder consists in mounting a convex lens in contact with the ground glass screen, so that rays of light are more concentrated near a point where the observer's eye may be placed, as shown in Fig. 114b. This is the *brilliant* viewfinder.

Another type of viewfinder consists of a telescope, as shown in Fig. 114c, where a diverging lens is followed by a converging lens. The field of view seen by a finder of this type is governed by the distance apart of the two lenses, and by the size of the clear aperture of the diverging lens. These two factors are matched, so that the field viewed is that which is recorded on the film or plate when the lens is focused for infinity. The focal lengths of the two lenses are so chosen that distant objects may be viewed through the finder without eye strain. Such a finder is not particularly accurate, from the point of view of defining the field which is to be covered, since there is always a certain amount of freedom in positioning the observer's eye. It does, however, have the merit of being a compact unit for use on small cameras.

ALBADA FINDER

A more complicated type of construction is adopted in the *Albada* type of viewfinder, in which a larger field is covered by the finder than is recorded on the film or plate. The part of the field which is recorded is marked off by a white frame, which seems to be superimposed on the scene to be photographed. This type of finder is of special use in sports photography, where it is desirable to determine what part of the action is coming into the field of view of the camera before it actually does so. One particularly ingenious type is shown in Fig. 114d. The negative, or diverging, lens is lightly silvered on its inner surface, so that a white frame on the mount of the converging lens is reflected at this surface. The radius of the inner lightly silvered surface is chosen so that the image, which it gives of the white frame, may be comfortably viewed at the same time as a distant object.

This is the simplest type of *Albada* viewfinder. There are others of more complicated construction which give an improved performance, but the basic principle remains the same, namely to cover more than the exact area to be recorded on the film or plate, and to mark off this latter

325

area with an easily visible line which is in good focus at the same time as the scene to be viewed.

Another type of viewfinder uses two positive lenses, the first forming an image in the plane of a suitable mask, and the second serving as a magnifying lens to view this image. A prism system is inserted in such a finder in order to provide an erect image. Finders of this type are used on the *Leitz* and *Zeiss* 35 mm. cameras. In the *Leitz* finder provision is made for using the finder with taking lenses of different focal lengths by varying the mask size in the viewfinder by rotating a knurled ring. In the *Zeiss* finder the same problem is handled by mounting a series of lenses on a turret, and by bringing the appropriate lens into place to form an image on the mask. In these constructions the ratio between the size of the mask and the focal length of the lens system in front of it, is equal to the ratio between the size of the negative and the focal length of the camera taking lens.

MOVIE CAMERA VIEWFINDERS

No new principles are involved in mounting a viewfinder on a movie camera, but the space limitations are usually such that the form of viewfinder differs somewhat from that which is used in a still camera.

In the lowest cost type of movie camera a finder is used of the kind shown in Fig. 115a. This comprises a front negative lens and a rear positive lens, and the field coverage is determined by the relation between the size of the front element and the distance between the two elements. Such a viewfinder tends to suffer from distortion, but by making the internal surface of the negative element of aspheric form this distortion may be considerably reduced.

An important variant of this simple type of viewfinder is shown in Fig. 115b. This comprises a front positive lens, a central negative lens, and a rear positive lens. The field of view of this viewfinder is modified by sliding the central negative element between the two positive elements. In this way the field of view of the finder may be matched to the field which is covered by a zoom lens. By a suitable choice of powers it is possible to maintain the apparent size of the viewfinder mask, as seen by the observer's eye, and to have the scene appear to expand or contract to fill up this frame.

326

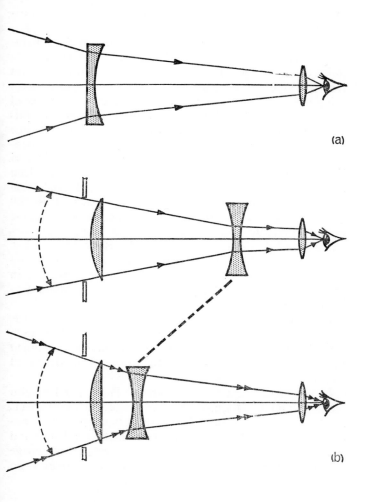

(a)

(b)

Fig. 115. (a) The simplest form of movie-camera viewfinder, the so-called *negative* viewfinder, consists of a front negative lens and a rear positive lens. The field coverage is determined by the size and position of the negative lens. By using a moving negative element, as shown in (b), we obtain a *negative zoom viewfinder*, for use with zoom lenses.

327

This is a desirable feature in such a finder. The coupling of the negative lens movement to the movement of components in the zoom lens, is a straightforward mechanical proposition.

Both of the viewfinders described in the preceding paragraphs suffer from the fact that they view the scene from a point of view which differs slightly, but significantly, from the viewpoint of the camera taking lens. As a result there is a *parallax error* introduced, of the kind already discussed in connection with still cameras. In order to overcome this defect reflex viewfinders may be used. At the present time the main field of application for such viewfinders is in connection with zoom lenses, and their application in this area will be discussed in detail, although the principles involved may be applied to camera lenses which are of fixed focal length. The basic principle of the reflex camera is still utilised, namely to divert the light which comes through the taking lens into such a path that it reaches the observer's eye. As a rule the take-off point is located between the zoom unit and the prime lens in the total zoom lens, and is preferably also located in front of the iris diaphragm. In this way a constant brightness of the scene is maintained as the lens is stopped down.

In the case of a reflex viewfinder in a movie camera it is not practical to remove the take-off mirror before each exposure is made. The mirror must be permanently mounted in place. A number of basic types are used, as described below.

In the first, as used in the *Berthiot Pan-Cinor* lens and viewfinder combination, a completely reflecting small area is located on the lens axis. This directs light into the viewfinder, as shown in Fig. 116a. The combination of lenses and reflecting surfaces shown in Fig. 116a ensures that the image is erect, and properly disposed left to right, i.e. there is no *handing*.

In place of the completely reflecting spot described above, a somewhat larger semi-reflecting spot may be used in order to direct light into the viewfinder, as shown in Fig. 116b. Light is transmitted through the semi-reflecting spot, and comprises part of the image forming light. Because of the fact that in the present case, as contrasted with that described in Fig. 116a, there is no complete obstruction in the

328

REFLEX MOVIE VIEWFINDERS

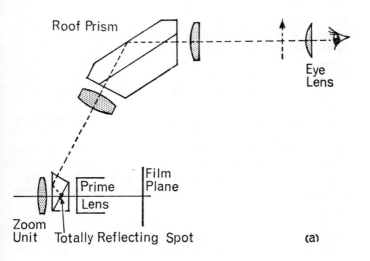

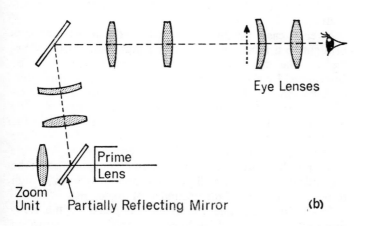

Fig. 116a, b. Reflex viewfinders for movie cameras: (a) The *Berthiot Pan-Cinor* viewfinder with an axial totally reflecting spot. (b) A viewfinder covered by a *Kodak* patent in which a larger semi-reflecting spot is used on the lens axis.

centre of the field as the lens is stopped down, it is possible to use a reflecting spot of larger size. The intensity of light is, of course, less than with a totally reflecting spot, but the total image brightness, as seen by the observer's eye, is more than made up by the larger spot area which transmits light to the viewfinder. This arrangement has a further advantage, in that the necessary exposure levels on the film may be secured without stopping the lens down to apertures which are too small. Such small apertures cause loss of image quality because of diffraction. This is a matter of importance with modern high speed films.

In another form of take-off system a completely reflecting "peek-in" mirror is mounted outside the main beam of light, as shown in Fig. 116c. With this arrangement we may obtain the advantages of the fully reflecting spot, namely higher intensity of light reflection, and of the partially reflecting spot, namely a larger diameter of the reflected beam.

Some of the light which is intended for the film plane is abstracted by these reflecting mirrors, although this loss is smallest with the version shown in Fig. 116c. Allowance for this loss must be made in calculating the camera exposure. The loss varies from one design to another, and appropriate details can usually be obtained from the camera manufacturers.

In each case, the light reflected by the reflex mirror is brought to a focus in an interior image plane in the viewfinder. The state of focus of the zoom lens may be determined by checking the focus of the image in this interior viewfinder plane. In order to assist in judging the focus of this viewfinder image a number of techniques may be used. In one technique a fine ground spot is placed in the centre of the viewfinder image plane, and the focus of the image is determined by observing this ground spot. As a rule this is not the most effective method of judging the focus: the magnification of the viewfinder is normally sufficiently high to render the grain of the ground spot objectional.

In another technique a clear glass is placed in the viewfinder image plane, and fine lines are etched or photographed on this glass. The zoom lens is in focus when the image, as seen through the viewfinder, and the fine lines in the image plane are in focus at the same time.

330

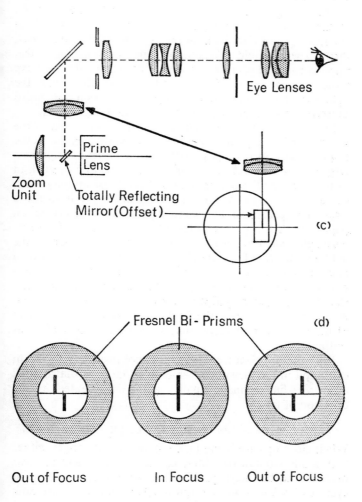

Eye Lenses

Prime
Lens

Zoom
Unit

Totally Reflecting
Mirror (Offset)

(c)

Fresnel Bi - Prisms (d)

Out of Focus In Focus Out of Focus

Fig. 116c, d. Reflex viewfinders for movie cameras: (c) An off-axis totally reflecting spot is used in order to secure the advantages of both of the viewfinders shown in Fig. 116a, b. (d) The scene as perceived through the viewfinder when a *Fresnel bi-prism* is used in order to make focusing more exact.

The effective use of either of the techniques described above requires a large *exit pupil* in the viewfinder. The size of this exit pupil may be determined by flooding the front of the zoom lens with light, and by noting the size of the smallest spot of light, behind the eye lens of the viewfinder, through which light appears to come. In some cases this pupil is round, but in others it may be rectangular, or have some irregular shape. If this pupil is too small it limits the light accepted by the observer's eye and makes it difficult to exercise a discriminating judgment of the image focus.

In another technique a small bi-prism is mounted in the viewfinder image plane. This serves the same purpose as the bi-prism described on page 319. Such a bi-prism requires a larger take-off or reflex mirror than is otherwise needed, in order that light from both halves of the bi-prism may reach the observer's eye. A variant of this technique is to use a Fresnel bi-prism, of the same type as that described on page 319. Again this requires an oversize take-off mirror. As a rule such a bi-prism covers only the central part of the field, as shown in Fig. 116a. Occasionally a Fresnel bi-prism is used which covers the complete field of view of the viewfinder. In this case, unless it is specifically stated otherwise, the focus should be judged only in the centre of the field. Away from this region the field curvature and astigmatism of the viewfinder objective may give rise to incorrect focus settings.

With the bi-prism techniques it is not necessary to use an exit pupil in the viewfinder which is as large as that needed when viewfinder image quality alone is accepted as the criterion of focus.

EXTREME CLOSE-UPS AND PARALLAX CORRECTION

When close-ups are being taken at very short ranges, either with a still camera or with a movie camera, there are two problems to be faced, problems which are encountered in every case when a photograph is taken, but which are now of enhanced importance. These are, firstly, to make sure that the scene is in sharp focus, for there is very little depth of field at these close ranges, and, secondly, to make sure that the correct area of field is seen by the camera, since parallax errors then assume a much greater importance.

Such problems are, of course, automatically avoided by

332

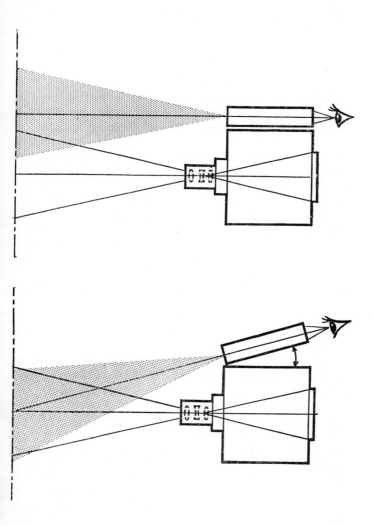

Fig. 117. *Parallax error* arises because the viewfinder sees the scene from a viewpoint different from that of the camera lens. In one form of correction it may be compensated by tilting the view-finder as a whole.

the use of a single lens reflex camera. The twin lens reflex camera is not quite so suitable, as there is an appreciable parallax error between the twin lenses, as described on page 321.

Devices have been developed by *Zeiss*, *Leitz* and *Kodak* with the aim of avoiding these difficulties. The basic principle is to fasten to the camera a frame, which may be either a wire bent to the shape of a rectangle or rods sticking out from the camera, whose ends locate the corners of a rectangle. This frame covers the area which is seen by the lens for a particular distance, and any object in the plane of the frame is in sharp focus. The size of the frame has, of course, to be decided according to the focal length of the lens and the distance of the close-up. It is a straightforward application of the methods discussed in the first chapter to work out the size of frame for any particular case. Alternatively, it is a simple job to determine it practically if a ground glass focusing screen can be mounted on the camera. We can focus the lens at the required distance on fine lines, ruled on plain white paper or card, for example. Then we move a pencil point over the paper until it just comes into view on the glass screen. The boundary of the area seen by the lens is soon determined in this way. It only remains to fix a frame of metal or wood to the camera in the plane of the paper, and of a size indicated by the boundary marked on the paper.

The lens may be focused down to the short distances required by using an adapter as described on page 54, or by using a supplementary lens as described on page 55.

The main fault with all viewfinders which are not of reflex type is the introduction of parallax error, as mentioned previously. The point of view from which such viewfinders see the scene is not the same point as the forward nodal point of the lens. Consequently they see a slightly different picture to that which is seen by the lens, just as each eye in normal use sees a slightly different picture. When the object is at infinity this difference is negligible. But when the lens is used for close-ups the difference becomes appreciable.

One way of judging the importance of the parallax effect is this: The separation between the eyes of an average individual is about $2\frac{3}{4}$ in. If first one eye is closed, and then the other, a general idea is obtained of the difference in

334

appearance of a scene when examined from two viewpoints $2\frac{3}{4}$ in. apart. A few trials will soon show how the difference increases with the approach to the eyes of the picture to be examined.

In the camera the separation of the two viewpoints is the distance between the axis of the lens, or the centre of the camera negative, and the viewpoint of the viewfinder. This latter is the centre of the viewfinder lens, in any of the types described above, or the centre of the viewing hole in the simple wire frame finder. The fact that one viewpoint is further away from the scene than the other is of negligible importance as a rule.

If the separation between the viewpoints is less than $2\frac{3}{4}$ in., the effect of their separation is less than that produced by viewing the scene with each eye separately. If it is greater than $2\frac{3}{4}$ in. the effect is greater.

Not only is the scene viewed from a rather different angle, when a viewfinder of non-reflex type is used, but the area seen through the finder is displaced laterally, through a distance equal to that between the viewpoints of the lens and the viewfinder. This is shown in Fig. 117. When distant objects are being dealt with this lateral shift is negligible, but with close-ups, and with a physically smaller scene therefore being photographed, it becomes of importance. For a given distance of close-up it can be corrected by tilting the finder, as shown in Fig. 117. The angle of tilt of the finder depends on the distance of the close-up, and on the separation of the viewpoints of lens and finder. It is given sufficiently closely by this formula,

Angle of tilt = 60 degrees × (viewpoint separation) ÷ (close-up distance)

For example if the separation of the viewpoints is $1\frac{1}{2}$ in., as shown in Fig. 117, and the close-up is taken at a distance of 3 ft. (i.e. 36 in.) the angle of tilt is 60 degrees × $1\frac{1}{2}$ ÷ 36 which is equal to $2\frac{1}{2}$ degrees.

With the type of finder which consists of a sighting hole and a wire frame, the parallax correction is most readily obtained by raising or lowering the sighting hole so as to take it further away from the lens axis. This is, in effect, the same as tilting the finder. With the preferred type, where the distance of the viewing hole from the frame is about equal to the

focal length of the lens (depending on the focusing position of the lens), the movement of the sighting hole, away from its infinity position, for close-up use is given by the formula

Movement of sighting hole
= (viewpoint separation) × (focal length) ÷ (close-up distance)

For instance with a separation of $1\frac{1}{2}$ in. between the viewpoints, a lens of 4-in. focal length, and a close-up at a distance of 4 ft. (i.e. 48 in.), then the movement of the sighting hole is equal to $1\frac{1}{2}$ × 4 ÷ 48, which is equal to 1/8 in.

With some types of viewfinder the simplest way is to tilt the finder through the angle needed as worked out above, but there are various other possibilities.

For example with a finder which consists of a diverging and a converging lens as shown in Fig. 115a above, one method is to rule fine lines on the diverging lens. These are unsymmetrically set about the centre line of the finder so as to allow for this parallax error. With a twin lens reflex camera the separation of the viewpoints is equal to the distance between the centres of the two lenses. The parallax error due to this may be counteracted by using a ground glass screen which is larger than the film or plate size used in the camera. A mask on this glass screen exposes an area which is equal to the size of the film or plate. This mask is movable. When the camera is focused on infinity the mask is in the normal position expected in a reflex camera, and the area of a distant scene thrown on the screen is the same as that which is recorded on the film or plate. When the lens is focused for close-up work the mask is moved backwards in the plane of the ground glass through a distance given by the formula

Mask movement = (viewpoint separation) × (focal length) ÷ (close-up distance)

These corrections for parallax error may be carried out automatically by coupling the necessary adjustments to the lens focusing action.

RANGEFINDERS

The principle on which almost all rangefinders are built is the same: Rays of light from an object go through two
336

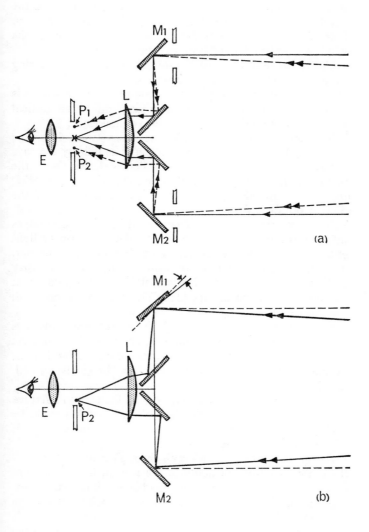

Fig. 118. (a) The adjustment of a rangefinder when it is directed towards an object at infinity is such that the individual images coincide in the field of view. (b) The corresponding adjustment for a near object point is made so that once more the individual images coincide.

337

windows in the camera and form two images. The rays entering the two windows make an angle with each other which depends on the distance of the object from the windows. The relative positions of the two images, so formed, depend on the angles between the rays entering the windows, and so depend on the distance of the object.

The distance of the object is then measured by measuring the separation of the two images.

For photographic purposes the separation of the images is measured by finding out what adjustment to an optical system will bring the two images into coincidence.

The simplest type of rangefinder uses two mirrors as shown in Fig. 118a. When the object is at infinity the rays entering the two windows are parallel as shown. With the mirrors in the positions shown in Fig. 118a the rays entering the lens L are also parallel, and only one image of the distant object is formed.

If the mirror setting is unchanged while the object moves into a position nearer to the rangefinder, the rays of light entering the windows make an angle with one another. They then also make an angle with one another when they come to the lens L, and this therefore forms two images, at P1 and P2 as shown in Fig. 118a. These are examined with the eye lens E.

By rotating mirror M1 through the correct angle the rays of light leaving it in this second case are rotated, so that the two sets of rays are parallel when they come to the lens L, as shown in Fig. 118b. Then only one image is formed, namely at P2.

To measure the distance of an object then means that we measure the angle through which the mirror M1 must be turned, so that the two images, seen through the eye lens E of the rangefinder, fuse into one.

As far as the two images seen through E are concerned, there are variations in detail in the way in which they are formed. In some cases the visual field is split into two halves, and one half is viewed, in effect, through each window. The adjustment is made so that the image seen through E is continuous, so that one half is not sheared relative to the other. In most modern cameras, however, the visual field is not split up in this way but the reflective coatings on the mirrors are produced by means of interference layers, of the

338

type described for the reduction of surface reflection losses in the previous chapter, and the images are of complementary colours. One will be red, for example, and the other will be green. This helps in creating contrast between the two images, so that they may be easily seen, and the setting is established by getting an exact overlap of the two images. There are quite a number of individual variants on these detailed image arrangements.

The problems encountered with this simple type of range-finder relate to the small size of the angle through which the mirror M1 must be rotated in order to bring the images into coincidence. The angle of rotation from the infinity position is given by the formula

Angle of Rotation = 30 degrees × (window separation) ÷ (object distance)

For example with camera windows which are 3 in. apart, and with an object which is at a distance of 4 ft., the angle is given by 30 degrees × 3 ÷ 48 which is equal to 1·875 degrees. With an object which is 6 ft. away the angle of rotation is equal to 30 degrees × 3 ÷ 72, which is equal to 1·25 degrees. Therefore the difference in angular rotation to obtain a rangefinder setting, between objects at a distance of 4 ft. and objects at a distance of 6 ft., is only ·625 degrees.

The aim of several different types of rangefinder designs is, therefore, to develop a method of displacing one image relative to the other which is not quite so dependent on small movements, such as that involved when we use a rotating mirror, as described above. Of these methods of rotating light rays through a small angle with an appreciable movement of some mechanical part, two are particularly important, namely, the rotating wedge method, and the swinging wedge method.

The arrangement of the rotating wedges is shown in Fig. 119a. The angle of each wedge is quite small. The maximum deviation that each can produce is approximately one half of the wedge angle. The angle of each wedge is about 5 degrees, giving a range from infinity down to about 3 ft. with a reasonable camera window separation.

When a ray of light goes through the wedge it is bent toward the thick end of the wedge. When this latter is vertical the ray is bent either up or down, according to

339

whether the thick or thin end of the wedge is uppermost. When the wedge is horizontal the ray is bent to left or right. This is shown in Fig. 119a. With the wedge rotated to a position between the horizontal and vertical positions the ray is bent up or down and to right or left at the same time, so that the total bending is still the same.

In this form of rangefinder two wedges are used, with the same angle on each. They can rotate in opposite directions, one rotates in a clockwise direction, while the other rotates in an anti-clockwise direction, from the position in which they are parallel, as shown in Fig. 119a, to the position where they are opposed, as also shown. This means a quarter of a revolution turn by each wedge.

When the wedges are parallel they behave as a block of glass with parallel sides, and there is no resultant deviation of the light which reaches the finder window. When they are opposed the light is deviated to the left or right, without any deviation up or down. In any intermediate position, the deviation up and down, given by one wedge, is cancelled by that given by the other wedge, but the deviations to left or right reinforce one another. Consequently, in any position of the wedges, when they are correctly adjusted so that each turns through the same angle from the parallel position, there is no up and down deviation, but simply a sideways deviation. By creating the proper amount of deviation in this way, the images seen through each window of the rangefinder may be superimposed.

If there is any maladjustment of the wedges, so that they do not automatically turn to the same angle on each side of the opposed position, there is a residual vertical displacement and the images cannot be brought into exact co-incidence.

In the case just described, a rotation of each wedge through 90 degrees gives control over a small deviation of the light rays, from the full amount when the prisms are opposed, to zero when the prisms are parallel.

The large movement of the wedges which is required for a small angular deviation of the light rays helps considerably in rendering the rangefinder easy to manufacture, and helps considerably in coupling it up to the focusing movement of the camera lens.

In the second type of rangefinder the deviation is still
340

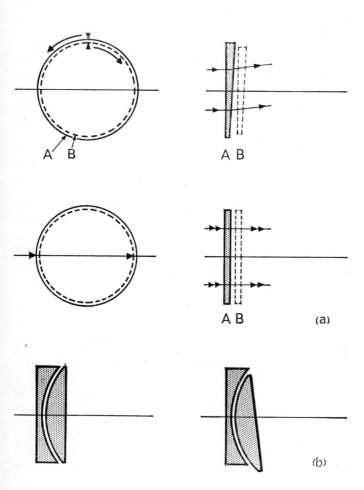

Fig. 119. The angular deviation in a rangefinder may be produced by a *rotating wedge* (a), or by a *swinging wedge* (b). In either case a considerable movement of the components gives a small deviation of the light rays and eases the problems of making practical viewfinders.

341

caused by a wedge or prism of varying angle, but different means are provided in order to vary the angle of the wedge. The arrangement is shown in Fig. 119b. There are two pieces of glass, one with a plain surface and a concave cylindrical surface, the other with a convex cylindrical surface, of the same radius, and a plain surface. The glass with the convex surface is free to pivot about the centre of curvature of the curved surfaces. Consequently the external form of the two glasses can vary from that of a parallel plate, to that of a wedge or prism, as shown in Fig. 119b. The angle through which the wedge must swing is four times as great as the angle through which a mirror must rotate in order to produce the same deviation of the light rays. Once again this helps considerably in the manufacture and assembly of a rangefinder system which is coupled to the lens movement.

This type of system was incorporated by *Zeiss* in a combined rangefinder and viewfinder for use on *Contax* cameras.

The details of the ways in which rangefinders are coupled to camera lenses are of mechanical rather than optical interest, and are outside the scope of this book.

ELECTRIC EYE SYSTEMS

One of the most signficant developments of recent years is the introduction of the so-called *Electric Eye Systems*. These are photoelectric devices which automatically set the iris opening of a camera lens so that the correct exposure is recorded on the film.

Photoelectric exposure meters are, of course, nothing new, and have been used for a number of years. An early development consisted in mounting such an exposure meter as an integral part of the camera. The needle of the exposure meter was observed through the viewfinder, and a second needle, coupled to the iris diaphragm, was brought into coincidence with the first needle. When this was accomplished the iris diaphragm was set for the correct exposure. The next step was to make this an automatic process.

In one of the first automatic systems used on a *Bell & Howell* 16 mm. movie camera, a small electric motor is used to drive the iris ring of the lens, so opening and closing the iris. Current to operate this motor is furnished by a small

342

dry-cell battery. Light from the scene to be photographed falls upon a selenium cell mounted on the front of the camera. The output of this cell is fed into a milli-ammeter causing a deflection of the needle in this instrument. As this needle moves it comes up against one of two metal stops and closes a circuit feeding electric current to the iris drive motor. If it touches one stop it causes the motor to drive the iris to a wider open position: if it touches the other stop it causes the motor to close down the iris. These two stops are mounted on the case of the meter, and the latter is geared to the iris drive ring, so that they move when the iris is opened or closed. When the iris is stopped down to its proper value the meter needle is midway between the two stops.

When there is not enough light to take a picture a red warning signal appears in the viewfinder. Corrections for film speed are made by varying the initial setting of the two circuit-closing stops. In the same way a correction is made for the camera taking speed in frames per second.

This system is an example of one which utilises a *photo-voltaic* cell. The photo-electric cells which are used for exposure control in photography may be divided into two classes, the *photo-voltaic* and the *photo-resistive*. The former may be used without a battery and rely for their operation on the power which they generate when light falls upon them. The material normally used in photo-voltaic cells is *selenium*, a gray semi-metallic element. Photo-resistive cells, on the other hand, must be used with a battery, usually a small mercury battery in a still camera. In an electrically driven movie camera the main battery may be used in order to supply power, or an auxiliary mercury battery may be used. Such cells depend for their operation upon the fact that their electrical resistance changes when light falls upon them. The material which is most commonly used for photo-resistive cells is *cadmium sulphide*.

Practically all automatic electric eye systems in use today are of the *direct drive* type, or of the *needle trap* type.

In the direct drive type the current from a battery, controlled by a photo-resistive cell, or the current generated directly by a photo-voltaic cell, is fed into an electric meter, usually based on a milli-ammeter or like instrument. This has a meter movement which is mechanically coupled to two iris blades, as shown in Fig. 120a. As the meter movement

343

rotates, under the influence of the current fed into it, it causes the iris blades to rotate about their pivot points P_1 and P_2, as shown in Fig. 120b, so that they close down the opening through which light may be transmitted.

In a form of system described in a *Kodak* patent only one moving blade is used, and the other has the form shown in Fig. 120d. This has the advantage of reducing the cost of the whole mechanism, but it has the disadvantage that, at full aperture, it does not make use of the whole of the lens aperture, and so reduces the maximum lens aperture below its nominal value. The direct drive systems are mainly used in movie cameras, where the blade systems are usually mounted in front of or behind specially designed lenses. In the case of zoom lenses the blades are mounted between the zoom unit and the prime lens as shown in Fig. 120e.

The blades tend to become too large for use in still cameras, and the needle trap system is commonly used. In this system a short length of a meter needle acts as a bar, so that it limits the movement of the iris ring. The latter is spring loaded, so that when the shutter release is pressed, the iris ring is forced round to this needle-limited position. This system has the added advantage that the iris diaphragm is fully open right up to the time that the exposure is made. A number of automatic cameras embodying such systems are now on the market. A normal type of iris diaphragm may be used with this needle trap system.

Selenium photocells are comparatively large, and must be mounted on the outside of the cameras. Various locations and shapes may be used in order to conform to the camera styling. Selenium cells vary from one maker to another, and at the manufacturing level particular care must be taken to obtain cells with a colour response that is appropriate to the sensitivity of the photographic film, usually colour film. With care an excellent match may be obtained. Selenium cells also show quite a strong dependence on temperature. For this reason *thermistors* are included in the photocell and meter circuit, so that this temperature dependence is greatly reduced or even eliminated. In some lower cost cameras these thermistors are omitted. In order to compensate for variations in film speed, when a selenium cell is used, a masking system is used that reduces the area of the cell upon which light is falling when a slow film is used. This has the

344

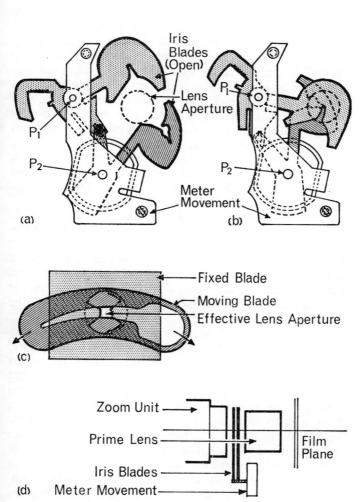

Fig. 120. In (a) and (b) are shown the open and closed positions of the two iris blades in a *Bell & Howell* "electric eye" automatic exposure system. In (c) is shown a construction which uses a fixed blade and one moving blade. In a modern zoom lens the iris blades are located between the zoom unit and the prime lens, as shown in (d).

345

same effect as diminishing the light intensity and forces the iris to open to a wider aperture.

One important advantage of the other type of cell, namely the cadmium sulphide cell, is its comparatively small size and high sensitivity. Because of this such a cell may be mounted in many places in a camera, in particular it may be used behind the taking lens. When it is used in this way it may be so disposed that it receives only light from that part of the scene which is to be recorded on the film. One such arrangement is shown in Fig. 121a, which shows the system utilised in a *Bell & Howell* 8 mm. camera. A similar type of arrangement is used in an 8 mm. camera by the *Bauer Company*. This through-the-lens exposure system is particularly valuable with zoom lenses. As the scene coverage is changed by zooming, the exposure is maintained at an optimum level.

In one interesting application of the cadmium sulphide cell, in the *Topcon* still camera shown in Fig. 121b, the photoelectric material is mounted on the rear surface of the reflex mirror. Light which strikes the upper surface of this mirror is directed to the observer's eye, while light which traverses the semi-reflecting surface on the front of the reflex mirror reaches the cadmium sulphide layer and so determines the proper iris opening.

In the *Canon Pellix* camera shown in Fig. 121c, a pellicle reflex mirror is used. This is a mirror which is fixed in place, and which is made of an extremely thin plastic sheet, with a semi-reflecting layer deposited on one of its surfaces. Light from this semi-reflecting surface is directed towards the observer's eye, while light which traverses the semi-reflecting layer goes to form an image on the film in the camera. Because the pellicle is so extremely thin it does not introduce the aberrations which would be introduced by a mirror of finite thickness, for example by a mirror having a thickness even of 1/10 of an inch. The cadmium sulphide photosensitive material is carried on a bracket which may be raised into position behind the reflex mirror as shown in Fig. 121c, in order to determine the proper exposure.

Film speed variations, when cadmium sulphide cells are used, may be taken into account either electrically or by introducing a mask or iris diaphragm which reduces the light going to the photoelectric cell.

346

THROUGH-THE-LENS
EXPOSURE CONTROL

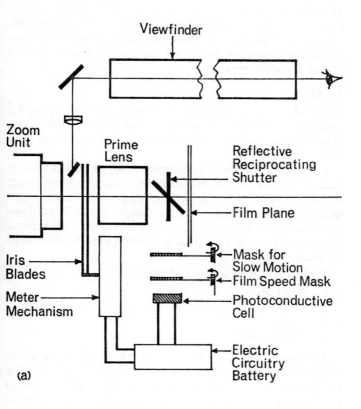

Fig. 121. (a) The optical system of an "electric eye" method used in a Bell & Howell movie camera. Light is reflected from a reciprocating shutter to a cadmium sulphide photo-cell. The output of the cell is used to drive the iris blades until a balance is achieved.

Recent improvements in cadmium cell manufacture have resulted in a better match between the colour sensitivity of the cell material and the sensitivity of the colour film normally used, and an excellent match may now be obtained.

Automatic exposure devices of the types described above have amply proved their value in present day photography. They are more rugged than they might, at first sight, appear to be, and may be regarded as reliable pieces of equipment.

In almost all cases a manual override is provided, so that individual judgment may be exercised in special picture taking circumstances.

FILTERS

The aesthetic use of filters, as a means of adding artistic values to a photograph, is beyond the scope of this book. We will be concerned only with the optical aspects of their use.

The purpose of a filter is to remove part of the light that is incident upon it, and to transmit the remainder to an image in such a way that the detailed quality of the image is not degraded. If some part of the picture, for example, contains too much blue light, then a pale yellow filter will remove some of this excess blue light and help to restore the colour balance.

There are four basic types of filter:

1. Solid glass
2. Laminated
3. Gelatin
4. Interference.

The solid glass filter is made of optical glass to which chemicals have been added in order to impart colour. The techniques of manufacture which are required in order to produce normal optical glass are needed for the production of filter glass. The filter surfaces must also be polished optically flat. A glass filter may be coated, in the same way that lens surfaces are coated, with a film of magnesium fluoride, in order to reduce surface reflection losses in the regions of the spectrum where the filter transmits light.

In the case of a laminated filter a thin sheet of a coloured plastic is cemented between thin clear glass plates. The outer surfaces of these plates must be polished optically

348

THROUGH-THE-LENS
EXPOSURE CONTROL

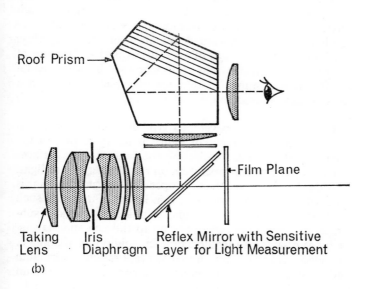

Roof Prism

Film Plane

Taking Lens

Iris Diaphragm

Reflex Mirror with Sensitive Layer for Light Measurement

(b)

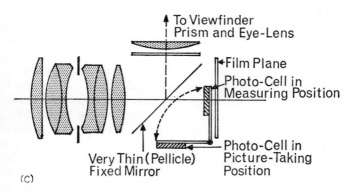

To Viewfinder Prism and Eye-Lens

Film Plane

Photo-Cell in Measuring Position

Very Thin (Pellicle) Fixed Mirror

Photo-Cell in Picture-Taking Position

(c)

Fig. 121 (b) In the *Topcon* camera, the photo-cell is mounted on the reflecting mirror (c) In the *Canon Pellix* camera, the reflex mirror is fixed and the photo-cell is swung into position behind it.

flat. These surfaces may also be coated in order to improve the transmission in selected regions of the spectrum. Excellent filters may be made in this way.

A large variety of filters may be produced by using very thin sheets of coloured gelatin. It is important that such filters be kept flat and free from wrinkles. Any wrinkles will result in a very significant degradation of picture quality. An important advantage of such filters is that, because of their light weight, they may readily be used in experimental set-ups. It is a simple matter, for example, to cut such a filter to any desired shape and to attach it to a lens with adhesive tape.

The most recently developed type of filter is that which relies on the interference of light for its operation, in the same way that the anti-reflection coatings on glass surfaces of lenses rely for their operation on the interference of light. In order to obtain satisfactory operation of such filters it is necessary to coat a number of thin layers of material, such as magnesium fluoride, or zinc sulphide, on a glass substrate. In some filters there are up to thirteen such layers, each layer having a thickness of a few millionths of an inch. The successive layers are formed by evaporation in a vacuum under extremely carefully controlled conditions. The main use of such filters is in scientific work, since they can be made with very narrow transmission bands.

Some typical transmission curves are shown in Fig. 122. Note particularly the narrow transmission band for the interference filter.

The use of a filter means that less light reaches the plate or film than when no filter is employed. The exposure must therefore be lengthened in order to obtain the same amount of light on the sensitised material. This is taken care of by a *filter factor*, which states by what ratio the exposure must be lengthened.

Filters as a rule are used in front of the lens, particularly when they are solid glass or laminated filters. Their finite thickness means that if they are used behind the lens there is a shift of the focal plane of the lens. This shift is approximately equal to one-third of the filter thickness. If, for some reason, it is necessary to use a filter behind the lens, then a dummy clear glass must be used when the filter is not in use, so that the focal plane position may be maintained. Gelatin

350

FILTER TRANSMISSION CURVES

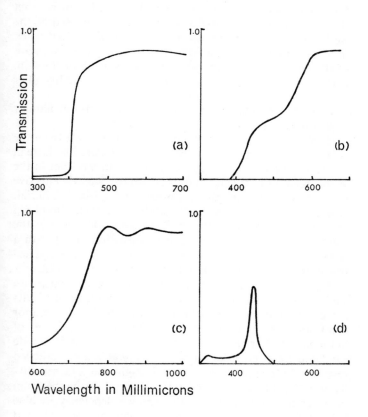

Fig. 122. The characteristics of a filter may be described by its *transmission curve*. (a) The transmission curve of a *haze filter*. (b) The curve for a *Type A* filter. (c) The transmission curve for an *infra-red filter*. (d) The transmission curve for an *interference filter:* note the narrow transmission width.

filters are sufficiently thin, a few thousandths of an inch, so that they may frequently be used behind the lens.

One of the most important aspects of filter performance to be considered is that a filter should not degrade the image quality given by the lens. This may be checked by measuring the axial resolving power of a lens, both with and without the filter in place. A typical filter specification used at the *Bell & Howell Company*, for example, stipulates that when used with a 4 in. *f*4 lens a filter shall not drop the resolution of the lens below 100 lines/mm. No re-focusing of the 4-in. lens is permitted in making this test. A good quality filter will measure up to this specification.

Three types of filter are worth special mention, namely haze filters, Type A filters, and infra-red filters.

Haze filters are used to remove ultra-violet light from the radiation reaching the lens. Such light is scattered by haze in the atmosphere to a much greater extent than is light in the visible region of the spectrum. It is also particularly effective in creating a photographic exposure on sensitised material. As a result there may be an overall level of background fog on the photographic plate or film which will degrade the picture contrast. By removing this ultra-violet light with a *haze filter* the overall contrast is improved. The typical transmission curve for a haze filter is shown in Fig. 122a.

When colour film is used under outdoor conditions, with sunlight as the source of illumination, the pictorial results are different from those which are obtained under indoor conditions, with incandescent lights as the source of illumination. For this reason two grades of film are made available by companies such as *Eastman Kodak*, labelled respectively for indoor use or for daylight use. The sensitivity of indoor film is increased at the blue end of the spectrum in order to compensate for the relative deficiency in blue light of the incandescent sources. If such film is then used to take outdoor scenes the resultant pictures show a pronounced blue tinge. In order to eliminate this a Type A filter may be used, with the transmission curve shown in Fig. 122b. Many modern movie cameras have this Type A filter built in, so that the one type of film may be used in the camera for both indoor and outdoor picture taking.

The third type of filter is the *infra-red filter*. As its name implies, this filter removes all visible light from the incident

352

radiation, and transmits only infra-red light to the plate or film. The main uses of infra-red photography are in the scientific and forensic fields, where it may bring out contrast which is not perceptible with light in the visible region of the spectrum, and to penetrate mist and haze in outdoor picture-taking including aerial reconnaissance. It must be realised that with infra-red photography the whole colour balance of a scene is upset. The colour of an object depends on two things, on the light striking it, and on the pigment in its surface layers. Two pigments may behave in a very similar manner in the visible region of the spectrum, but show a very different behaviour in the infra-red. The pigment molecules react differently to the two classes of radiation or two wavelengths of light. Contrast that is barely noticeable when visible light is used may become quite marked when infra-red light is used.

The application to haze penetration depends upon a rule worked out by *Rayleigh* which states that the fine particles in the atmosphere, which make up thin mist or the smoke pall over a town, scatter blue light having a wavelength of 450 millimicrons sixteen times as much as they scatter infra-red light with a wavelength of 900 millimicrons. By filtering out the scattered blue and other visible light with an infra-red filter a clear picture may be obtained through mist or smoke. The transmission curve of a typical infra-red filter is shown in Fig. 122c. The use of infra-red filters may be regarded as a logical extension of the use of haze filters.

Special infra-red film must, of course, be used for this work. It is also necessary to take into account the fact that the lens focus changes in the infra-red region of the spectrum. Some lenses carry a red dot to indicate the infra-red focus. For other lenses it may be necessary to carry out a calibration, using the technique described on page 206.

POLARISING FILTERS

For the most part, in discussing photographic optics, it is sufficient to know that light is a form of energy which travels along the so-called light rays, that it is reflected and refracted at the appropriate kind of surfaces, and that a ray of white light is decomposed into coloured rays when it is refracted at a glass surface.

There are, however, two situations in which a more

detailed knowledge of the nature of light is of importance. These relate to the mode of operation of the surface coatings which reduce surface reflection losses, and to the basis of operation of *polarising filters*.

It has been pointed out in the Introduction and in the third chapter that there is a pattern of electric and magnetic forces along the length of a light ray. These forces not only vary along the ray, but they vary with time at any point traversed by the ray. There is an important simplification that can be made. Once the direction of the light ray and of the electric force at any point are specified the magnetic force at that point can be readily found by a mathematical calculation. For instance in the simplest case the magnetic force is perpendicular to the electric force and stands related to it in a fixed ratio. Because of this simplification we may omit any explicit mention of the magnetic force, and discuss only the electric force.

The electric force at any point P, through which a light ray is passing, may be specified by drawing a line PX, as shown in Fig. 123a. The length of PX measures the strength of the electric force, and the direction of PX specifies the direction of the force. The line PX is known as a *vector*, and we may call it the *electric field vector*. The electric field vector PX is always perpendicular to the direction of the light ray.

Suppose, for the moment, that we concentrate our attention on the behaviour of the end point X of the field vector which describes the electric force at a particular point P. With the passage of time this point X describes a definite pattern about the point P, as shown in Fig. 123a. At a neighbouring point Q we have an electric field vector QY, as shown in Fig. 123a. The end point of this vector describes the same kind of pattern as does the end point X of the vector PX. There is a time lag between the movements of the points X and Y, corresponding to the time that it takes light to travel from P to Q, but the basic pattern described by X and by Y is the same in each case.

The exact path traced out by the point X, with the passage of time, defines the *polarisation* of the light passing through the point P.

If X describes a straight line passing through the point P then the light is *plane polarised*. If X describes a circle or an

354

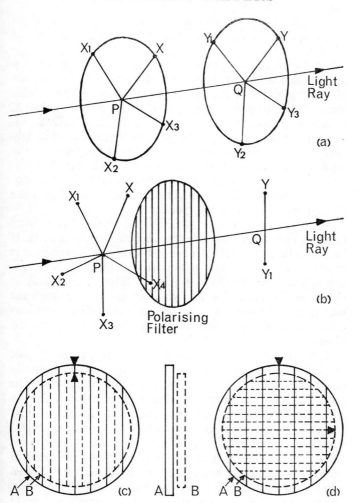

Fig. 123. At any point on a light ray, such as P or Q, we may draw lines as shown at (a) which describe the electric forces which are introduced at P or Q by the passage of light. A *polarising filter* passes light on which the electric forces lie along a line Y_1QY, as shown in (b). When two polarising filters are *parallel*, as shown in (c), the light passing through the first is transmitted unchanged by the second. When the filters are *crossed* the second blocks off the light transmitted by the first.

355

ellipse, with P as centre, then the light is *circularly* or *elliptically polarised.*

The light from ordinary sources consists of radiation in which all of these states of polarisation are mixed or combined.

A *polarising filter* acts on light of any colour in such a way as to create a definite type of polarisation. As a rule, for photographic work, it produces plane polarised light. This means that it transmits only light in which the end points X of vectors such as PX move in a plane through the light ray, as shown in Fig. 123b. In the polarising filters most widely used, namely those made by the *Polaroid Corporation*, the light which is not transmitted through the filter is absorbed by it. An ideal polarising filter would transmit 50 per cent of the non-polarised light incident upon it. In actual practice the figure is closer to 40–45 per cent.

An important feature is the effect of a second polarising filter on light which has traversed a first polarising filter. If the two filters are parallel, as shown in Fig. 123c, the light is transmitted, with minor reflection and absorption losses, through the second filter. If the two filters are *crossed*, as shown in Fig. 123d, then no light is transmitted through the second filter. When the filters are in intermediate positions a fraction of the incident light is transmitted by the second filter.

The value of polarising filters for general photographic work lies in the fact that there are a number of naturally occurring situations in which polarised light is created. The most important of these are when light is reflected from a glass window surface, for example, or from any similar reflecting surface such as the surface of water. In general this light is partially polarised. In other words the mixed states of polarisation have not been completely reduced to one final stage, but a major step in this direction has been taken. On the other hand, the light which comes from objects behind such a window or below the surface of water is, in general, not polarised at all. If the light reflected from the window and that which is transmitted through the window are incident upon a polarising filter the orientation of the latter may be so chosen that it is a *crossed filter*, as far as the reflected light is concerned. The reflected light is thus removed from the light which may reach a camera lens. The light

356

transmitted by the window is reduced to one half its previous intensity by the polarising filter. The net effect is to increase the visibility of objects behind the reflecting surface. This is shown on page 269, where detail below the surface of water is made visible by the use of a polarising filter.

In practice it is not easy to predict always what will be the best orientation of the polarising filter in order to suppress unwanted reflections of this type. It is best to insert the polarising filter on the front of the camera lens, and to experiment to obtain the best results. For this type of work, of course, it is essential that a reflex camera be used, and, if a twin lens reflex camera is used, that polarising filters be mounted in front of both viewfinder and taking lenses or, at least, that composing is carried out through the polarising filter before transferring it, in relatively the same position, to the taking lens.

Polarising filters are only of use to suppress unwanted light from reflecting or glossy surfaces. Light which is scattered from matt surfaces has a random polarisation and is not suppressed by polarising filters.

An important scientific use of polarising filters depends upon the fact that glass or transparent plastic, when under stress, modifies polarised light which is traversing it. By mounting a transparent plastic model of a bridge, for example, between two polarising filters and by photographing the model with the light which comes through the polarising filters, we may examine the stress pattern in the model under various loads. This information is of immense value to the structural designer. On page 269 is shown the stress pattern in a tempered condenser element which is made evident by using polarising filters in the way just described. This constitutes an important method of testing such condensers to make sure that they will not crack when in use.

Work of this type has grown into the major field of *photo-elasticity*. Further details are beyond the scope of this book.

STEREOSCOPY

The normal practice is to use both eyes when looking at one's surroundings. This plays a great part in building up an impression of depth, in placing objects at their respec-

tive distances, and in giving a feeling of the solidity of things.

The two eyes see the scene from slightly different viewpoints, and as a result the observer is really seeing two pictures at the same time. The optical axes of the eyes also converge slightly so that they meet in the objects on which attention is concentrated at any instant.

Mental processes fuse the two pictures into one, and provide the sensation of solid relief. In order to get the full impression of relief it is essential that the mental fusion of two pictures takes place.

The way in which the use of the two eyes helps to build up our impression of depth and relief is the *stereoscopic effect*.

This true impression of depth is lost when pictures are taken in straightforward photography. A camera sees things from one angle only. There is no longer the perception of two scenes and the possibility of their fusion in order to give a feeling of depth. Skilful lighting and placing of shadows can do a lot towards creating the illusion of depth and solid relief, but it cannot do everything.

In order to recapture the full sense of the depth of the scene it is necessary that we take two photographs of the scene, a *stereoscopic pair*, with a stereoscopic camera. Such a camera has two lenses side by side, so that its action copies that of the human eyes. The photographs, when taken and printed, are examined in pairs, one with each eye, using a *stereoscopic viewer*.

While the questions which arise when dealing with stereoscopic photography cannot be taken as being of major importance in the total field of photographic optics, there are some points of optical interest that should be dealt with. These arise both in the use of the taking camera and in the use of the stereoscopic viewer.

In taking the pictures it is most important that the two taking lenses should be of the same equivalent focal length, and in focus together. This equality of focal length means that the two pictures are on the same scale, and that, moreover, when the lenses are mounted in the camera so that they focus together for one taking distance, then they focus together for all taking distances.

Normally there is a variation in the equivalent focal length of lenses of the same batch as they come from the

358

factory. As a rule this is something under one per cent. For stereoscopic work, however, the lenses should be matched so that any discrepancy in their focal lengths is well below this value. This can be done by selecting lenses or by adjusting lenses at the factory.

At the same time the position of the seat on each lens mount, which locates it on the camera body, may be adjusted so that both lenses will automatically focus together.

It is important to pay careful attention to depth of field considerations, since any parts of the picture which are not reasonably sharp cannot be viewed satisfactorily with any true perception of depth.

Brief mention may be made of an alternative taking arrangement, using a single camera and a single camera lens. In this an arrangement of prisms or mirrors divides the aperture of the lens into two halves, and simultaneously separates the viewpoints of these two halves by the correct amount. Two separate pictures are recorded on the one film, side by side, and these can be printed and processed in the usual way.

We now have to consider the problems associated with viewing the pictures. Suppose, for example, that taking lenses of 4-in. focal length have been used to photograph a distant scene, and that contact prints have been made from the respective negatives. Suppose further that these prints are mounted as shown in Fig. 124a, in the focal plane of each of two lenses, also of 4-in. focal length. Then if the separation of the taking lenses is the same as that of the normal human eyes, (this is, of course, the same as the separation of the viewing lenses), one may look through the viewing lenses at the prints, and then see the two scenes exactly as the camera saw them.

But since the camera lenses have just been specified as having the same distance apart as the human eyes, namely about $2\frac{3}{4}$ in., this last fact simply means that, when one looks through the viewer, one sees just the two scenes which would have been seen by the naked eyes at the camera position when the pictures were taken. The two pictures seen through the viewer can be fused together in exactly the same way that the original scenes could have been fused, and the same impression of depth is created.

Cases of special interest are those in which the separation of the camera lenses is not the same as that of human eyes, or in which the focal length of the lenses in the viewer is not the same as that of the camera lenses, and the effect that these conditions have on the impression of depth.

A measure of the stereoscopic effect is the angle between the rays from any single point which enter the two eyes and the differences between such angles for varying object point positions.

Suppose that we take a concrete case where the lenses are of 4-in. focal length in both viewer and camera, and the separation of the camera lenses is that of the normal human eyes, i.e., about $2\frac{3}{4}$ in. The separation of the viewing lenses is necessarily equal to this figure. An object which is at a distance of 150 in. in front of the lens sends rays to both lenses, as shown in Fig. 124a. For simplicity imagine that the ray through one lens coincides with the axis of this lens, and that the image of the object point formed by this lens is consequently in the centre of the film area. The ray going through the other lens makes an angle of just under one degree with the lens axis, and its image is displaced just under 1/16 in. away from the centre of the negative.

When contact prints are made, and are examined with the viewer, the ray which comes from the image in the centre of the print area coincides with the lens axis. The ray from the image point which is displaced 1/16 in. from the centre of the picture makes an angle of just under one degree with the lens axis. As a result there is an angle of about one degree between the rays which enter the two eyes and which are mentally fused to give the impression of one image point.

If, however, the distance between the camera lenses is increased to $5\frac{1}{2}$ in., i.e., to twice its previous value, with the focal lengths, etc., remaining as before, the image on the plate or film is now displaced $\frac{1}{8}$ in. away from the centre of the negative. When the prints are viewed, under the conditions described above, the ray from this point on the print now makes an angle of about two degrees with the lens axis. The angle between the two rays entering the two eyes is thus twice its previous value, and the same holds for the pairs of rays from all other object points. As a result, the sensation of depth and relief is increased and objects in

360

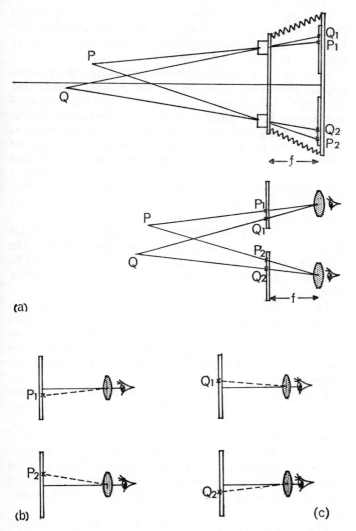

Fig. 124. If two prints, which are obtained by using two lenses in a stereoscopic camera with the same separation as the human eyes, are examined in a *stereo-viewer*, as shown in (a), the depth of the scene is made apparent. It is necessary that rays from corresponding points be divergent, as shown in (b), and not convergent as shown in (c).

361

the picture stand out from one another in a more pronounced way than before.

By using a camera which has a lens separation greater than that of the human eyes, and by using a stereoscopic viewer under the conditions described above, we obtain an enhanced impression of depth.

Next we must examine the effect of using enlargements instead of contact prints in the stereoscopic viewer, and determine what difference is made when the focal lengths of the viewing lenses differ from those of the camera lenses.

When enlargements are used, say for example enlargements in the ratio of 3:1, the angle between any pair of corresponding rays which would enter the eyes is increased threefold. At the same time every object in the picture seems three times as large. The net effect is the same as that of looking at an object which is three times as bulky as the original subject but looked at from the same viewpoint. It will be apparent, from geometrical considerations, that this effect is *not* the same as that obtained by looking at the original subject from a camera position which is reduced to one-third of the original value of the camera to subject distance.

This is quite a different effect from that which is met with when we use a camera with more widely separated lenses than the human eyes. In this case each object retains its proper size but there is produced an impression of an enhanced stretching out, away from and towards the camera.

The effect of using viewing lenses of shorter focal length than that of the camera lenses is the same as that of using enlargements instead of contact prints.

In other words the effects of using enlargements, or of using short focal length viewing lenses, are just the same as those encountered in normal photography. What is novel and of importance in stereoscopic photography is the enhancement of relief obtained with widely spaced camera lenses.

The same effect may be produced by taking two photographs with a normal camera, with a lateral displacement of the camera between the two exposures, taking care to keep the camera in parallel positions when the exposures are made.

362

There are a number of points to notice in connection with mounting the prints in the viewer. The first is to make sure that lines which join the corresponding points in the two prints are parallel, and that they are parallel to the line joining the centres of the viewing lenses. The second is to place the prints in the correct order, with the lefthand print in the lefthand position in the viewer. The third point is to make sure that lines from corresponding points diverge to the eyes as shown in Fig. 124b, and that they do not converge, as shown in Fig. 124c. When the rays are converging the axes of the observer's eyes are diverging, and although it is possible to fuse the images in this case, it is very much more difficult to do so, and with anything beyond a slight degree of convergence the fusion of the two images becomes impossible. If any difficulty is encountered in fusing the two scenes, with the simple and straightforward kind of viewer normally used, and described in outline above, the fault most likely to be responsible for this is that the corresponding rays are converging instead of diverging. This difficulty may be overcome by moving the two prints closer together until fusion is obtained.

In the same way that the normal type of stereoscopic viewing requires two separate pictures, taken from two camera viewpoints, so the viewing of stereoscopic moving pictures in the cinema requires two images projected from two different areas of the film. In this case the two images on the screen are not positioned side by side, but are approximately superimposed.

In order to ensure that each eye may see only the image intended for it polarising filters are inserted in front of each projection lens and the viewer wears polarising spectacles. The axes of the polarising filters are oriented in such a manner that the light from the left eye picture is polarised at right angles to the polarising angle of the right eye spectacle so that the right eye cannot see the left eye picture and vice versa. The projection screen surface must be metallised, usually with a thin aluminium coating, to avoid loss of polarisation when light is reflected back from the screen.

Red and green filters have been used in a similar way to separate the two images, but these are not very suitable and they cannot be used for colour films.

Although two images are projected simultaneously, the

363

light transmission through both sets of filters is so low that the picture appears considerably less than half as bright as normal, unless brighter arc lamps or wider aperture projection lenses are used. The degree of separation between the two image points which constitute one point of the object being viewed will depend upon the distance of that object as seen by the two cameras, and hence the convergence of the eyes to fuse these points gives the stereoscopic effect.

Other systems for cinema stereoscopy attempt to achieve the separation of right and left eye images at the screen itself. These screens are highly complex and depend on the use of lenticular or similar grids on or in front of the screen. The two images are then split up into vertical strips and interlaced, causing the lenticular grid to present each component picture to the appropriate eye.

ENLARGING

In the following pages we will consider only some optical aspects of the use and construction of enlargers. Aesthetic and photographic aspects are dealt with in books specifically devoted to photographic enlarging.

The relative arrangements of negative, enlarging lens, and enlarging easel for any degree of magnification, may be worked out by using the formula given in the first chapter.

The importance of using a lens which is specifically corrected for enlarging conditions has been pointed out in earlier chapters.

One of the most important components of an enlarger is its illuminating system. The function of this system is to provide an adequate and even level of illumination over the whole of the negative, so that an exposure may be made in a comparatively short time, and so that no special precautions must be taken in order to even out the exposure over the whole of the enlargement. It is most important, in particular, that the illumination be maintained at the corners of the negatives.

Enlarger illuminating systems may be divided into two main classes. The first is the *condenser illuminating system*. The second is the *diffuse illuminating system*.

In the condenser system of illumination a comparatively small source of light is used, and the radiation from this source is collected by the condenser and directed into the

enlarging lens. As a rule this small light source is a compact filament in an incandescent lamp with a clear envelope. The distance between the condenser and the negative to be enlarged is kept as small as possible, in order to keep down the diameter of the condenser which is needed, and at the same time to keep up the corner illumination. The diameter of the condenser is just larger than the largest diagonal of the negative which is to be enlarged.

An enlarger which uses condenser illumination and a compact filament light source is not very different from a projector, as described later in this chapter, and shares some of the condenser problems of the latter. As a rule the type of condenser used in an enlarger comprises two plano convex elements, with their convex sides facing each other, as shown in Fig. 125a. The focal length of the condenser has to be matched with the film size, and with the aperture of the enlarging lens, so that as much light as possible may be directed into the enlarging lens. This type of illumination is somewhat inconvenient in that an adjustment of the light source has to be made when the degree of enlargement is changed significantly. Without this adjustment the corners of the negative may not be sufficiently well illuminated.

A more common form of condenser illuminating system which is used in enlargers employs an opal bulb as a light source, as shown in Fig. 125b. This is nowhere near as efficient as the compact filament type of condenser system, from the point of view of image brightness in the enlargement. It does, however, have the great advantage that there is no need for any critical lamp adjustment when enlarger changes are made for different degrees of magnification. The lamp recommended by the makers should be used: A lower wattage lamp may have a smaller envelope, and may drop the illumination in the corners of the negative. It should also be noted that a pearl or frosted bulb is not an effective substitute for an opal bulb in this type of enlarger. A fairly high degree of diffusion is needed in the bulb envelope, so that no trace of the filament may show through, otherwise there is uneven illumination in the enlargement. The condenser itself may be of the form shown in Fig. 125a, or, especially for 35 mm. film, it may be a single bi-convex element.

In the second type of illuminating system a sheet of opal

365

glass, or of dense ground glass, is mounted close to the negative. This opal glass is evenly illuminated and the light which it scatters is used to illuminate the negative. A number of different methods may be used in order to effect this even illumination. In the simplest system, shown in Fig. 125c, a pearl or opal light bulb is used, preferably the latter. In a somewhat more elaborate system mirrors are used, as shown in Fig. 125d, so that the level of illumination is greatly increased by light which is reflected from these mirrors. Special care must be taken to arrange the mirrors so that even illumination is produced. In yet another form of this system a condenser element may be used in order to improve the level of illumination, as shown in Fig. 125e.

One well-known fact is that harder contrast is obtained with a condenser enlarger than with one which relies upon a diffusing screen. This is due to the so-called *Callier effect*. The silver grains in the negative not only cut off light by absorbing it, but they also scatter the light which is incident upon them.

With condenser illumination the rays of light which traverse the negative are all going in more or less the same direction, towards the enlarging lens, and any light that is scattered by the grains of the emulsion is deviated so that it does not reach the enlarging lens. As a result no light from the opaque parts of the negative reaches the enlarging easel, and contrast is hard.

When a diffusing screen is used, however, the light which is incident on the negative has already been scattered by the screen, and is coming from all directions. As a result some light is scattered by the silver grains in the dark parts of the negative, so that it reaches the enlarging lens. The opaque parts no longer seem to be perfectly black and the contrast is softened.

A proposal has been made by *Zeiss*, in British Patent No. 535,290, to apply this phenomena to a variable contrast enlarger. The method there described is to use a condenser enlarger arranged as shown in Fig. 126, with a compact filament lamp. Between the lamp and the condenser is mounted a polarising filter F1, and between the negative and the enlarging lens is mounted another polarising filter F2. This arrangement ensures that the light reaching the negative is plane polarised. The light which is transmitted

366

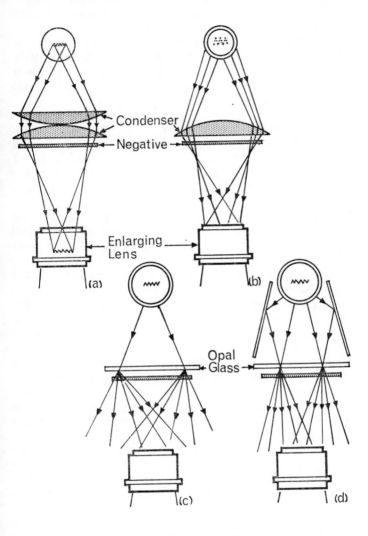

Fig. 125. (a) A condenser illuminating system, without diffusion, for use in an enlarger. In (b) the envelope of the electric bulb provides diffusion. In (c) the illumination is created entirely by the diffusion of the opal glass. The brightness of the illumination may be increased by using mirrors, as shown in (d).

directly by the negative has its polarisation unchanged. If F1 and F2 are parallel all the directly transmitted light goes through F2. If F1 and F2 are crossed then none of this light goes through F2.

The light which is scattered is de-polarised and is not affected by any change in the position of F2. Consequently by turning F2 relative to F1 the proportion of diffused and directly transmitted light may be varied continuously, and so the contrast in the negative may also be varied.

CORRECTION OF DISTORTION

When a photograph is taken with a camera whose axis is inclined to the horizontal the most obvious result is that lines in the negative which should be parallel, such as the vertical edges of buildings, are actually inclined at an angle to one another.

For convenient reference this effect, produced by an inclined camera, may be called *convergence of perpendiculars*, since it is most evident in the convergence of the perpendicular edges of buildings in a photograph taken in this way.

It is sometimes stated, without sufficient emphasis on the conditions to be observed, that the convergence of perpendiculars may be corrected when an enlargement is being made. It is true that the use of a sloping enlarging easel, either alone or taken in conjunction with a tilted negative or pivoted lens, leads to restoring these lines to parallelism. But in actual fact this is not the only condition which has to be observed in making a satisfactory enlargement.

Consider a concrete case. Suppose that a photograph is taken of a square object, with the camera sloping up at an angle as shown in Fig. 127a. As a result the image on the plate or film is not a square but a trapezium. An enlargement is to be made from this negative under these conditions: Firstly, in the enlargement the sides of the figure shall be parallel to one another, not inclined at an angle; secondly, the figure is to be a square, and not a rectangle, as so often happens; and thirdly, the enlargement is to be in focus over its whole area. There are thus three conditions to be fulfilled.

In general (leaving the case of a pivoting lens for later consideration, see page 380) there are three possible enlarger adjustments which may be made. These are, firstly, the angle

368

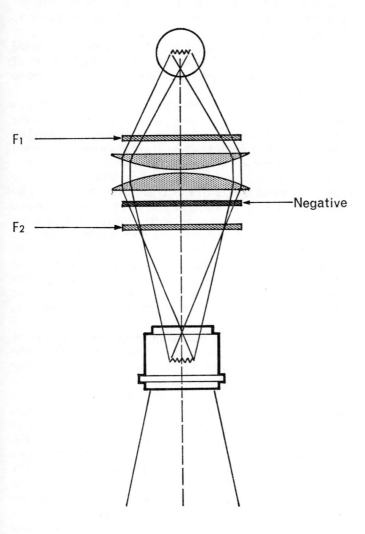

Fig. 126. The contrast in an enlargement may be varied by using polarising filters, F1 and F2. This has been proposed by Zeiss in British Patent No. 535,290.

of tilt of the negative in the enlarger; secondly, the tilt of the enlarging easel; and thirdly, the choice of the focal length of the enlarger lens and the degree of enlargement that is to be required of it.

While an exact fulfillment of the three conditions stated above cannot in general be established, a suitable choice of the enlarger setting enables quite a good approximation to be made.

In the case of the reproduction of a square, which was mentioned above, it is a simple matter to determine that the proportions of the enlargement are just those of the original scene which was photographed. This example was quoted because it brings out clearly the conditions to be fulfilled in a satisfactory enlargement. In practice, however, there are not geometrical figures of this type in this photograph by which the correct rendering of proportions may be judged. The best procedure then, in discussing the correction of convergence of perpendiculars, is to indicate under what conditions the production of the desired parallelism will automatically involve the reproduction of the scene in correct proportions. Failing this we should be able to give an estimate of the degree of elongation which will be produced in the enlargement, if the required conditions cannot be exactly fulfilled.

The simplest way in which the perpendiculars may be rendered parallel is to keep the negative square on to the enlarging lens, as shown in Fig. 127b, and to tilt the enlarging easel only. It is a simple matter to tilt the enlarging easel to such an angle that the converging perpendiculars are rendered parallel. But at the same time it usually happens that the proportions of the original are not reproduced in the enlargement; a square is reproduced as a rectangle. The picture is much too drawn out in one direction, and usually things are too tall and thin as a result of the camera being pointed slightly upwards. Also, in order to get reasonable definition over the whole area of the enlargement, the lens must be stopped down considerably.

Under these conditions the factor which determines whether or not there is any lack of proportion in the enlargement is the ratio of two distances. The first of these is the distance of the rear nodal point of the enlarging lens from the negative in the enlarger; call this for short the

370

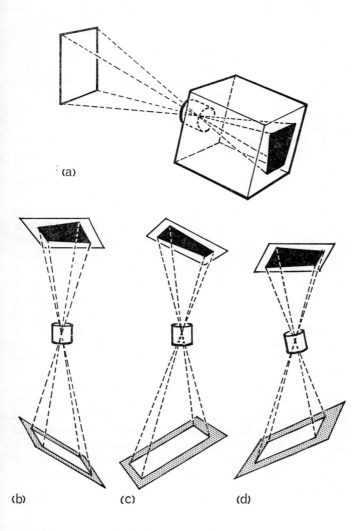

(a)

(b) (c) (d)

Fig. 127. When a camera is tilted, as shown in (a), we obtain a picture which shows *convergence* of *perpendiculars*. The simplest approximate way of correcting this effect is to tilt the enlarging easel, as shown in (b). A better way is to tilt both negative and enlarging easel, as shown in (c), or to tilt both lens and enlarging easel, as shown in (d).

enlarging nodal distance. The second is the distance of the rear nodal point of the taking lens from the film or plate in the camera; call this the *taking nodal distance.* In order to get proper proportioning of the enlargement, when parallelism is obtained by tilting only the enlarger easel, these two distances should be equal.

If the enlarging nodal distance is greater than the taking nodal distance, as usally happens, then the picture is more drawn out than it should be. If the reverse is the case, then the picture is much too squat and compressed.

The methods by which we may obtain the appropriate nodal distances have been fully explained in the first chapter.

The general conclusion to be drawn, for this type of rectification, is that the enlarger lens should be of shorter focal length than the taking lens. This follows from the fact that in normal circumstances where a tilt of the camera is noticeable, for example in architectural studies, the subject is at a distance of more than say 20 times the focal length of the camera lens away, and without serious error for pictorial work the taking nodal distance may be taken as equal to the focal length of the camera lens. The enlarging nodal distance is necessarily greater than the focal length of the enlarger lens; in the case of a $2\times$ enlargement it is $1\cdot5\times$ the focal length, and for a $3\times$ enlargement it is $1\cdot33\times$ the focal length. The general formula is given in the first chapter.

The difficulty which is encountered when we use a lens for enlarging, which has a smaller focal length than the camera taking lens, is that such a lens may not cover the whole of the field covered by the taking lens, even when it is stopped down. In such a case a useful procedure is to use a wide angle lens of the type described in the previous chapter and to stop this lens down sufficiently far that it will give good definition all over the sloping enlarging easel.

In practice it often happens that the same lens is used both for taking the negative and for enlarging it. In this case it is not possible, by tilting only the enlarger easel, to obtain an exactly proportioned enlargement. The rule in this case is that the greater the degree of enlargement the more nearly correct are the proportions of the enlargement when parallelism is attained.

372

It is not worth while trying to shorten the focal length of a camera lens used in an enlarger, so that the conditions about the equality of the nodal distances may be fulfilled, by using a converging supplementary lens. A supplementary lens of sufficient power to be of use upsets the correction of the original enlarging lens in too marked a fashion.

Pertinent mathematical formulae relating to the discussion given above are these:

Focal Length of Camera Lens	f
Camera Focused on a Distance	u
Taking Nodal Distance	$T = (u \times f) \div (u - f)$
Focal Length of Enlarger Lens	F
Degree of Enlargement	M
Enlarging Nodal Distance	$E = F \times (M + 1) \div M$
Ratio of Distances	$R = E \div T$
Tilt of Camera	i degrees
Degree of Elongation $=$	$\dfrac{1 + R^2 \tan^2 i}{1 + \tan^2 i}$

A rough rule which gives the f-number of the lens aperture, so that it will give a circle of confusion of less than $\cdot 01$ in. at any point on the enlarging easel, is this: If the edge of the enlarging easel is raised or dropped d inches away from its square-on position; if the degree of enlargement is M diameters; then the f-number is given by the formula

$$N = 100d \div (M + 1)$$

Thus for a 10x enlargement with $d = 2$ inches, $N = 2 \times 100 \div 11$, i.e., N is approximately 18, and the lens should work at about $f18$.

In a more sophisticated use of the enlarger in order to correct the convergence of perpendiculars, both the negative and the enlarging easel are tilted as shown in Fig. 127c.

By matching the tilt of the negative and that of the enlarging easel, the correct proportions may be guaranteed when the parallelism of the perpendiculars is established. In carrying out the enlarger adjustments there are two

373

factors which have to be related to one another. The first is what may be called the *tilt ratio* of the enlarging easel and of the negative, which measures the slope of the enlarging easel compared with that of the negative. The second is the ratio of the enlarging and taking nodal distances already defined above.

The relative tilts of the negative and enlarging board are measured, not by the ratio of the angles which these make with their square-on position, which they occupy in normal enlarging work, but by the tangents of these angles. What this means is shown in Fig. 128. AB is the height of a point above its square on position. OB is the distance of the point from the axis about which the negative pivots. This latter, in the case drawn in Fig. 128, is on the lens axis. The distance OB has to be measured along the square-on position, and not along the sloping negative; this is also shown in Fig. 128. The negative makes an angle of s degrees with its square-on position. Then the tangent of s, written tan s, is equal to AB \div OB. Similarly for the enlarging board the tangent of s_1, written tan s_1, is equal to $A_1B_1 \div O_1B_1$, as shown in Fig. 128. E is the enlarging nodal distance referred to already.

Suppose that the taking nodal distance is T. (As a rule it is very closely equal to the focal length of the taking lens. In actual fact it is the value of v worked out by using the formulae given in the first chapter.) The ratio R of the enlarging and taking nodal distance is equal to E \div T.

Then the condition to be established in order that both correct proportions and parallelism of perpendiculars may be established simultaneously is given by the formula

$$\tan s_1 = \frac{R^2 + 1}{R^2 - 1} \times \tan s.$$

In general it will still be necessary to stop down the lens in order to get good definition over the whole of the enlargement.

A concrete example of the way in which the enlarger adjustment may be carried out in order to establish this condition may make things clearer.

Suppose that a photograph is taken with a lens of 2-in. focal length, and that the lens was focused for infinity when the exposure was made, then the taking nodal distance is

374

CORRECTION OF DISTORTION
IN ENLARGING

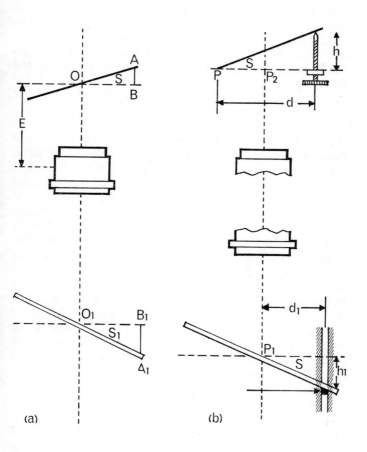

(a) (b)

Fig. 128. By a proper relative arrangement of negative and enlarger easel it is possible to reduce the elongation in an enlargement while correcting the convergence of perpendiculars. The practical details of such an adjustment are shown in (b).

just equal to the focal length of the lens, i.e., it is equal to 2 in.

Suppose that an enlargement is to be made which is $5\times$ the size of the picture negative, using a lens which has a focal length of 3 in. Then the enlarging nodal distance as calculated using the formula in the first chapter, is equal to $3 \cdot 6$ in. The pertinent ratio R is thus equal to $3 \cdot 6 \div 2$, i.e., it is equal to $1 \cdot 8$, and the value of the first term on the right-hand side of the formula given above is obtained in the following way.

$$(R^2 + 1) \div (R^2 - 1) = (1 \cdot 8^2 + 1) \div (1 \cdot 8^2 - 1)$$
$$= 4 \cdot 24 \div 2 \cdot 24 = 1 \cdot 89$$

Then for any setting of the negative, when it is tilted through an angle s, the enlarging easel should be tilted through such an angle s_1 that $\tan s_1$ is equal to $1 \cdot 89 \tan s$. This may be arranged without recourse to mathematical tables in the following way, which also indicates the general principle to be followed in making the enlarger adjustments.

Suppose that the tilt of the negative is adjusted by a screw, as shown in Fig. 128b, where the negative carrier, or even the negative itself, pivots about an axis through the point P shown. The distance from this point to the centre of the adjusting screw is d. The height through which the end of the screw raises the negative is h. Then the tangent of the angle s is equal to $h \div d$. If, for example, the distance d is 2 in., then $\tan s = h \div 2$. It is preferable, if possible to have the pivoting point P on the lens axis, as in this event there is no need to re-focus the enlarger as the negative is tilted. If P is not on the lens axis then a re-focusing is required as the negative adjustment is changed.

As far as the adjustment of the enlarging easel is concerned, it is of more importance that the axis about which it pivots should be on the lens axis. Otherwise the effective overall distance from negative to the centre of the enlarging board changes rather rapidly as the latter is tilted, with a consequent change in the degree of enlargement, so upsetting the calculation made in order to ensure correct proportions. While this same effect is present in the case of the negative tilt, it may be neglected there as a rule, since the change in overall distance it produces is normally quite small. In Fig. 128b, if the tilt of the enlarging board is controlled by a bar

376

which supports it, and which travels in a vertical slot, and if the drop is h_1 for an offset distance d_1, then $\tan s_1 = h_1 : d_1$.

Suppose that in a particular case $d_1 = 10$ inches. Then $\tan s_1 = h_1 \div 10$.

Comparing this with the figures given above for the negative tilt, the base h_1 is five times the base h (i.e., 10 in. and 2 in.). Hence in order to produce the same tangent at P^1 as at P, means that the drop of the bar h_1 must be five times the elevation h given to the negative.

Hence to produce the required ratio of the tangents, namely, $1 \cdot 89$, the drop of the bar h_1 must be $5 \times 1 \cdot 89 = 9 \cdot 45$, or with sufficient approximation $9 \cdot 5$ times the elevation h produced by the screw which raises the negative.

In order to get the proper setting of negative and enlarging easel we start from the position where both are square on to the lens axis, and the perpendiculars in the enlargement are convergent. We raise the negative by means of the adjusting screw through a definite distance, say $\cdot 05$ in., and drop the enlarging board through $9 \cdot 5 \times \cdot 05$, i.e., $\cdot 475$ in. Probably this will not be sufficient. A certain amount of re-focusing may also be needed, and it will then be found that the perpendiculars are still convergent. This process of adjusting the two heights in the correct ratio has to be carried out until the perpendiculars are parallel. When this happens the enlargement is correctly proportioned.

It will usually be necessary to stop the lens down in order to get good definition over all the enlargement. The latter is in sharp focus when the enlarging board is dropped through 25 times the elevation given to the negative, so that the tilts are in the ratio of $5:1$.

There are one or two points worth mentioning. When the ratio R is equal to 1, then the negative should be kept square-on to the lens axis, and only the enlarging easel tilted. This has already been discussed. When R is less than 1, as might happen with an enlarging lens of shorter focal length than the camera taking lens, the negative and enlarging board must be tilted in the same direction, instead of in opposite directions, as they have been drawn throughout in the diagrams. This is distinctly unfavourable for obtaining good definition, and requires a very severe stopping down of the enlarging lens.

377

In order to get sharp definition in the enlargement the requirement is that

$$\tan s_1 = M \times \tan s$$

where M is the degree of enlargement.

In general this is not consistent with the requirement that

$$\tan s_1 = \frac{R^2 + 1}{R^2 - 1} \tan s$$

and hence correct proportions and sharp definition, without stopping down, cannot be obtained together.

They can be obtained together only in the special case where the focal length F of the enlarging lens is related to focal length of the taking lens f, by the following formula

$$F = f \times M \div (M^2 - 1)$$

or alternatively the magnification M is given by the formula

$$M = \frac{F^2}{F^2 - f^2}$$

Thus if $F = 3$ in., and if $f = 2$ in.

then $M = 1 \cdot 34$. When this is the case the image on the sloping enlarging easel is both correctly proportioned and is in sharp focus, and the tilt that is required to give the correct proportioning, in the way already described, is just that which is required to give a sharp focus all over the enlargement.

A similar type of convergence of perpendiculars is produced when a swinging back is used in the camera, but the conditions of remedying it in an enlarger are not the same. This case is of less importance than that just dealt with, and for specific details works concerned with enlarging should be consulted.

The methods, for both the exact and approximate solutions, which have been discussed in the previous pages, have assumed that the distance from the nodal point of the enlarging lens to the negative, measured along the lens axis, has been related to the focal length F by the formula

$$d = F \times (M + 1) \div M$$

where d is the distance in question. There are two methods, the same in principle but differing in detail, which sacrifice

CHARLES' METHOD
OF CORRECTING DISTORTION

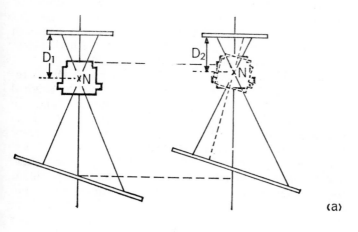

(a)

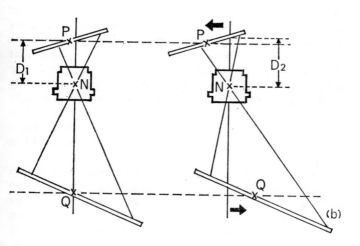

(b)

Fig. 129. The degree of elongation or compression depends on the distance D1. By tilting the lens this distance may be varied, as shown in (a). Another approximate method of correcting the convergence is due to *David Charles*, and is shown in (b).

this requirement and yet provide a reasonable standard of definition over the enlargement. The first is that involving the use of a tilting lens; the second is a method described by *David Charles*. They are considered below in this order, but it is worth pointing out at this stage that they are both approximate methods only, and not exact methods in the sense that is used in the previous discussions.

The angles involved in tilting the negative and the enlarging easel, relative to one another, depend on the original camera tilt, the focal length of the taking lens, and the distance of the nodal point of the enlarging lens from the negative. This latter may be measured along some arbitrary fixed line, not necessarily coinciding with the lens axis. The relative proportions, when parallelism is established, depend only on the relative tilts and on the camera tilt. If the enlargement is of the wrong proportions, either too compressed or too elongated, the distance of the lens from the negative is varied, and the distance of the enlarger easel is also changed in order to provide the same degree of enlargement, without regard being taken for the moment to the standard of definition. The enlarging board tilt is varied once again in order to ensure parallelism, and finally the lens is tilted about its rear nodal point, so that its axis lies along a line such as that shown dotted in Fig. 129a. By making such a tilt the distance of the nodal point from the negative, measured along the lens axis, is so adjusted that the definition is made fairly even over the whole of the enlargement. In the simplest case the enlarging board only is tilted and the enlarging lens is moved along a line at right angles to the negative. In such a case the requirement for the elimination of any elongation, when parallelism is established, is that the distance D, shown in Fig. 129b, should be equal to the focal length of the taking lens.

In the *Charles* method an adjustment is made, as shown in Fig. 129b, so that parallelism is established and the definition made even all over the enlargement. The latter is then examined to see how its proportions are, whether it is elongated or not. In general the proportions will not be correct. In this case the negative is moved in one direction, for instance as shown in Fig. 129b, and the enlarging easel is moved in the opposite direction. Notice that the points P and Q, about which the negative and enlarging easel may

pivot, remain in the same plane. In general it will be found that parallelism has been upset. This may be rectified by tilting either the enlarging easel, or the negative, or both. As a first approximation it may not be necessary to perform any re-tilting, as the lack of parallelism introduced may not be too noticeable. A certain amount of stopping down may be needed, as the method is essentially an excellent approximation, rather than an exact method of satisfying the laws of optics.

PROJECTION

The projection of images is one of the most important branches of photography. It includes the presentation of cine pictures, 8 mm., 16 mm., and 35 mm., as well as of larger sizes, and the projection of coloured slides, both 35 mm. slides and the new half frame and *Instamatic* slides. It ranks with the production of photographic prints as a means of picture reproduction.

The essential components of a projection system are a projection screen, a projection lens, a projection aperture, a condenser system, and a light source, as shown in Fig. 130.

The first aspect of projection to be considered is the brightness of the image on the projection screen.

The most important point to realize is that the picture brightness may be evaluated by imagining that an observer's eye is located at the screen, looking towards the projection lens. In an ideal situation the whole of the projection lens aperture appears to be filled with light. The observer perceives a bright disc of light. The brightness at the projection screen is measured by the *solid angle* subtended by this disc at the observer's eye. If the diameter of the disc is a, and if its distance from the projection screen is D, then this solid angle is given by the formula

$$\text{Solid Angle} = \pi \times a^2 \div 4D^2$$

The brightness of the image on the projection screen also depends on the apparent brightness of the luminous disc perceived by the observer. It is most important to realize that the brightness of this disc can never exceed that of the lamp filament. No optical tricks can remedy this situation. In fact the brightness of the disc will usually be less than

381

that of the lamp filament because of absorption losses in the projection lens and in the condenser system.

The function of the condenser system and of the light source is to make sure that, if one looks from the scene towards the projection lens, then from all points within the area of the projected picture one sees a complete disc of light. It may be that vignetting in the projection lens will reduce the possible size of this disc, in which case the condenser design must permit one to see the full aperture which is allowed by this vignetting. If the condenser system does not completely fill the aperture of the projection lens the screen illumination is decreased in proportion to the part of the lens aperture that is filled.

If the distance from the projector to the screen is doubled, then the solid angle which the aperture subtends at the screen, according to the formula given above, is reduced to one quarter. The illumination on the screen is also reduced to one quarter of its previous value. This is true whether the condenser system completely fills the projection lens aperture, or whether it only partially fills the aperture: The degree of filling is practically unchanged when the projector to screen distance is changed.

The relation of the screen brightness to the f-number of the projection lens, when the condenser completely fills the aperture of the projection lens, may be examined in the following way. Suppose that the focal length of the projection lens is F, that it has an f-number N, and that the degree of magnification from the film or slide to the projection screen is M, then D is equal to $(M + 1) \times F$. The diameter a of the lens aperture is equal to $F \div N$. Hence the solid angle is given by the formula

$$\text{Solid angle} = \frac{\pi}{4} \times \frac{F^2}{N^2} \times \frac{1}{(M+1)^2 F^2} = \frac{\pi}{(M+1)^2} \times \frac{1}{4N^2}$$

Notice that the brightness of the projection depends on the degree of magnification but that it does not depend on the focal length of the lens.

Note that if we double the focal length of the projection lens we must double the projector to screen distance in order to maintain the same degree of magnification. If the f-number of the projection lens remains the same, its increased diameter is offset by the increased projector to

382

PROJECTION SYSTEM COMPONENTS

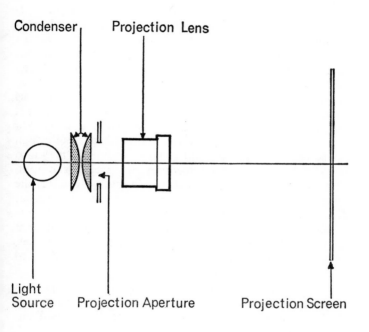

Fig. 130. The essential components of a projection system are a projection screen, a projection lens, a projection aperture and a light source and condenser system which act together to fill the aperture of the projection lens. The film or slide to be projected is located in the projection aperture and its image formed on the projection screen.

screen distance, and the illumination remains the same. Note also that, for a given degree of magnification, an $f1\cdot2$ projection lens gives $1\cdot78$ times the screen illumination given by an $f1\cdot6$ lens.

The screen illumination may be measured in *foot candles*, in *foot-lamberts*, or in *lumens*. If we measure it in *foot candles* we are concerned with the brightness produced at the screen by the projection lens. If we measure it in *foot-lamberts* we are concerned with the apparent screen brightness that results from this incident illumination. If we have a perfectly diffusive projection screen, an incident illumination of one foot-candle produces a screen brightness of one foot-lambert. If we measure the screen illumination in *lumens*, then we are concerned with the total luminous energy which reaches the screen. If the area of the screen is one square foot, and if it is illuminated with an intensity of one foot-candle, then one lumen of radiation passes through the screen. The measurement in terms of lumens may also be regarded as a measurement of the projector output. This follows from the fact that, with a given projector, the same lumen figure is obtained for screens at different distances. If the projector to screen distance is doubled, the illumination in the foot-candles is reduced to one quarter of its previous value. The size of the screen is, however, increased by a factor of four. The two factors combine to give a constant lumen figure.

The function of the condenser system is to fill the aperture of the projection lens with light from the light source. It must be tailored to fit both the light source that is used and the individual projection lens.

A number of different types of light source may be used.

For professional cine projection the light source is usually a carbon arc. The carbons may be cored and impregnated with metallic salts in order to increase the brightness. The arc is placed at the focus of a reflecting ellipsoid and an image of it is formed at the other focus of the ellipsoid, in the projection aperture of the projector. This is a highly specialized projection system, and will not be discussed further in this book.

The types of light source which are used for 16 mm. projection and for the projection of 8 mm. film and slides, are tungsten filament lamps and xenon light sources.

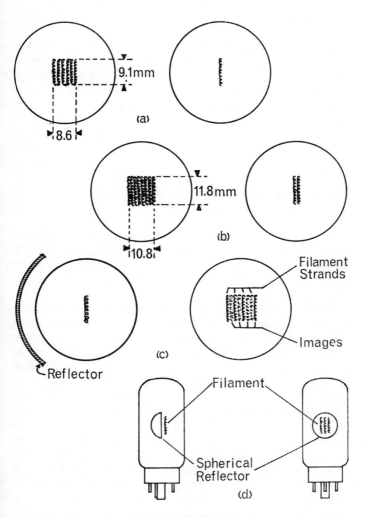

Fig. 131. In a projection lamp the filament consists of tight coils of wire arranged in legs. In (a) the filament legs all lie in one plane. In a higher wattage lamp the filament legs lie in two planes, as shown in (b). The efficiency of the system is increased by using a concave mirror centred on the filament, as shown in (c). In a lamp with a *proximity reflector* the concave mirror is located within the lamp envelope, as shown in (d).

385

An essential feature of the tungsten filament lamps is the compact form of the light sources. The filament wire is tightly coiled up and arranged in legs in the way shown in Fig. 131a. Typical dimensions of the filament are also shown in Fig. 131a. In some cases the filament legs all lie in one plane, as shown in Fig. 131a. In other cases the filament legs lie in two close planes, as shown in Fig. 131b, in which case we have a *bi-planar* filament. The aim in either case is to present to the condenser the appearance of a solid mass of glowing tungsten.

The aim of creating a solid looking light source is considerably helped by placing a concave mirror behind the lens, with the filament located at its centre of curvature, as shown in Fig. 131c. The concave mirror forms an image of the filament, of the same size and in the same plane as the filament itself. The appearance of the filament and its image is shown in Fig. 131c.

In some modern lamps the reflector is mounted inside the lamp envelope itself, as shown in Fig. 131d. These we will refer to as *proximity* reflectors. This gives a more compact light source system, and prevents misalignment of the filament and reflector.

This type of lamp, with an internal spherical reflector having the filament at its centre of curvature, the proximity type of reflector lamp, must be distinguished from another important type, the *elliptical reflector* type. In this type of lamp the filament is located at the focus of an internal elliptical mirror. An enlarged image of the filament is formed at the other focus of the ellipse, outside the lamp envelope. This type of lamp is used primarily in 8 mm. and 16 mm. projectors, in which case it is so positioned that the filament image is formed in or near the plane of the aperture plate of the projector. This results in a very efficient illuminating system. This kind of lamp must be tailored to the needs of the projection lenses. A number of basic patterns are available, but the present trend is for a collaboration between the projector manufacturer and the lamp manufacturer, so that the best form of elliptical reflector may be used to conform to the particular needs of a series of projection lenses. This is a recent development, and one that is quite important, since it imposes an undue restriction on the design of the projection lens to make

386

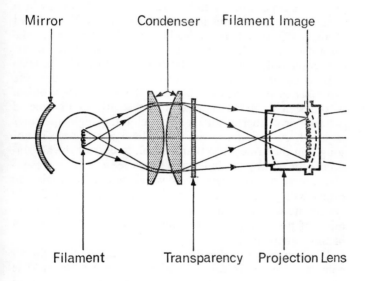

Fig. 132. In the first approximation to condenser design the lamp filament is imaged on the front surface of the projection lens. The theoretical place in which to focus the filament is the entrance pupil of the projection lens, but in practice the best results are obtained with the conditions shown.

it to conform to the dimensions of a specific elliptical reflector.

With the internal elliptical reflector type of lamp there is no need for any other condensing system. With all other types of lamp a condenser is needed. The problem, in all cases, is to collect enough light from the filament and to direct it through the projection lens. As a first approximation this is secured by designing the condenser so that it forms an image of the filament on the front surface of the projection lens, as shown in Fig. 132. The focal length which is necessary, so that this image will completely fill the front of the projection lens, is readily calculated by using the formulae of the first chapter. The clear aperture of the condenser is determined by the diagonal of the film or slide area to be projected. Together these two factors give the *f*-number of the condenser system. The immediate problem is to design a condenser which is sufficiently well corrected for spherical aberration and coma at the high apertures required. An exact correction of these aberrations is not sought in the same sense that we seek to correct the aberrations of a photographic lens. What is required is a reasonable correction of aberrations which would otherwise be rather wildly uncorrected. The various forms of condenser system now in use have been developed with the aim in mind of providing some reasonable measure of correction of these aberrations.

The simplest possible form of condenser, a single bi-convex element, is rarely used in modern systems. The simplest form of condenser in widespread use comprises two plano convex elements, as shown in Fig. 133a. Another slightly more complex form, with a bi-convex central element, is shown in Fig. 133b. The two systems shown in Figs. 133a and 133b use spherical surfaces. A marked improvement in performance is obtained by using an aspheric element in a system of the kind shown in Fig. 133c. A moulded aspheric surface is quite good enough for most systems of this kind. Up to the present such aspheric condenser systems have been found mainly in 8 mm. and 16 mm. movie projectors.

In some special applications a more complex form of condenser system may be needed, as shown in Fig. 133d, in order to satisfy space requirements. Such complex systems

388

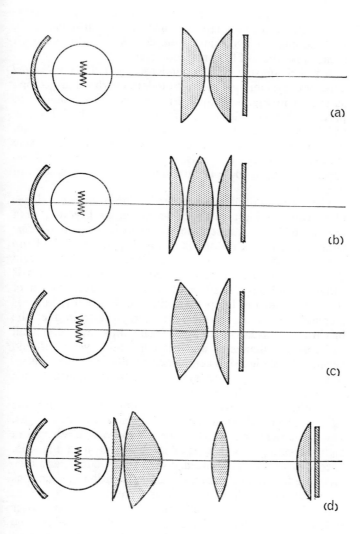

Fig. 133. A variety of practical condenser systems are used in modern projectors. For slide projectors, the form shown in (a) is in common use. For higher aperture lenses the form shown in (b) is preferred. Better results are obtained with an aspheric surface (c). Space requirements may necessitate the more complex form of (d).

389

are not normally favoured because of the light loss that they entail.

When a condenser system has excessive spherical aberration the screen illumination is uneven. In particular there may be characteristic dark blue circles or kidney shaped areas appearing on the projection screen.

A rather unusual type of condenser system is the *Fresnel* condenser system used in some modern overhead projectors, as shown in Fig. 134. Such Fresnel lenses are moulded in plastic. They constitute an effective way of obtaining low weight condenser elements for this application. They can, however, only be used where steps can be taken to eliminate excessive heating. For this reason they have found no application up to date in anything except this one area of use.

The majority of filament projection lamps have envelopes filled with an inert gas such as argon or krypton, or a mixture of both. A recent development is the *quartz-iodine* lamp. In this the envelope is of fused quartz and the lamp itself is filled with iodine vapour. When the lamp is cold the iodine condenses but it vaporizes when the lamp is running, and has the effect of suppressing evaporation of tungsten from the lamp filament. The life of the lamp is increased, without sacrificing its brightness; in fact the brightness is usually increased. Such lamps have very small and compact filaments, and the condenser systems should be specially designed to get the best results from these lamps. A number of projection systems which use quartz-iodine lamps are now on the market.

Another light source is the *xenon* lamp. In this source the light is generated by an electrical discharge in xenon gas. The discharge is sustained between two heavy electrodes in high pressure gas. This type of lamp is shown in Fig. 135. Special power packs are needed with xenon lamps, and they therefore find their most important application in situations where a very high light output is mandatory.

It is important, for the efficient operation of a condenser system, that the lamp filament or glowing gas column be correctly located relative to the condenser. In order to secure this with filament lamps a special type of base is used on the lamp, which then always takes up the same position when the lamp is mounted in the projector. In the course of

FRESNEL CONDENSER LENS

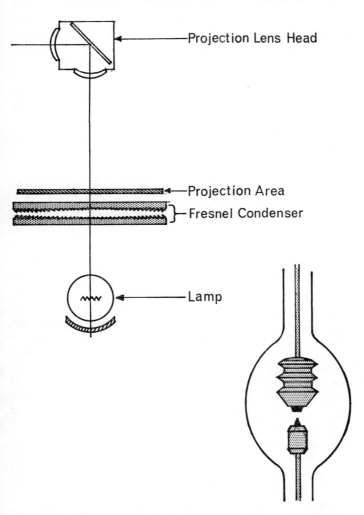

Projection Lens Head

Projection Area

Fresnel Condenser

Lamp

Fig. 134. (*top*) The form of condenser system used in a modern overhead projector. This is a *Fresnel* condenser lens and is made by moulding transparent plastic.

Fig. 135. (*bottom*) The form of a *Xenon lamp*. The light is formed by an arc between the heavy electrodes. The envelope of the lamp is filled with Xenon gas under pressure and the light from the glowing gas is particularly intense.

manufacture an assembly operation is performed so that the lamp filament is accurately located relative to this special type of base. There are a number of standard base types. Details may usually be obtained from lamp manufacturers or from the projector manufacturers.

If a lamp filament is incorrectly placed in the projector a number of typical defects will be found in the screen illumination. (A projector may be checked for these defects by operating it without film, or without a slide in place, with the projection lens focused on the film or slide plane):

1. If the projection lamp filament is too high, or too low, a dark shadow will appear in one or two corners of the illuminated area on the projection screen. The same thing will happen if the lamp filament is too far to the left or to the right.

2. If the lamp filament is too far away from the condenser, then dark shadows will appear in all four corners of the illuminated area on the projection screen.

3. If the lamp filament is too close to the condenser then dark rings, or kidney shaped dark areas, will appear on the projection screen.

In projectors which use a concave mirror behind the lamp, some unevenness of illumination may be produced if this mirror is not properly adjusted. In order to check this adjustment a supplementary lens (a simple spectacle lens will do) is used to form an image of the lamp filament on the projection screen. If the concave mirror is properly adjusted, the image of the filament which it forms will be in focus at the same time as the lamp filament, and will be interlaced with the lamp filament. This image formed by the concave mirror may be recognised by the fact that it is less bright than the direct filament image. In some projectors an adjustment is provided so that the image formed by the concave mirror, and by the filament itself, may be brought into proper alignment. This is more expensive to manufacture than the type of projector which lacks such an adjustment, but the extra cost is worth while. In projectors using lamps with built-in reflectors this problem is eliminated.

It is worth remarking on the relation between the lamp wattage and the screen brightness. In a projector with a

392

well designed condenser system the use of a lamp with a higher wattage will result in only a marginal gain in the screen illumination. This follows from the fact that the main difference between lamps of different wattages lies in the increase of filament size which goes with an increase in wattage. If the condenser system is so designed that the filament image of the smaller wattage lamp fills the aperture of the projection lens, then the increase in size of the image of the larger filament will be nullified by the inability of the projection lens to handle this larger image. A marginal increase in illumination will be observed since the central areas of the filament are brighter and hotter, and more of this enhanced brightness area is imaged at the aperture of the projection lens when we use the higher wattage lamp.

In order to obtain an increase in illumination it is necessary that an increase in projection lens aperture be associated with an increase in lamp wattage.

Because of condenser design to some extent, but primarily because of vignetting in the projection lens, the projection screen brightness may vary from the centre to the corners of the illuminated area. It may be taken as a rough rule that a 2:1 variation in brightness from corner to centre is acceptable for normal viewing.

One factor which has an important bearing on the apparent brightness of the projection screen is the type of anti-reflection coating on the projection lens. If the coatings on the various surfaces are of a straw colour, so that the reflection of blue light is minimised, the projection screen takes on a faint bluish tinge, and appears brighter to the human eye. On the other hand if the lens surfaces are blue or purple the projection screen appears faintly yellow, and less bright, but instrument readings give higher values. There is at times a conflict between the demands of high instrument readings, as an assessment of screen brightness, and of the sensation presented by the observer's eyes. There seems to be no doubt that this conflict should be resolved in favour of the coatings which will produce the highest visual sensations of screen brightness.

HEAT PROBLEMS

A major problem which is encountered in all projectors is to avoid the effects produced by the heat that is

393

generated. These problems arise in several areas: In the lamp itself; in the condenser system; and in the film or slide.

The heat problem in the lamp itself arises from the fact that projection lamps are operated close to the temperature limits set by the evaporation of the tungsten filament. The envelope of the lamp darkens as the tungsten evaporates. The evaporation is partially suppressed by the gas in the lamp, particularly if iodine vapour is used for this purpose. Suppressor grids may also be used inside the lamp envelope in order to collect the evaporated tungsten from the filament. Because the lamp burns so close to the maximum permissible temperature its life is limited. Normally projection lamps are specified as having a 10-hour or a 25-hour life. The 25-hour lamp operates at a slightly lower temperature than does the 10-hour lamp, and as a result is not quite as bright.

The mechanical support of the filaments is critical in projector lamps. For this reason the lamps are designed so that they will have an appreciable life only if they are burned in the maker's specified position, either vertical or horizontal, base up or base down.

The condenser element which is closest to the lamp usually gets very hot. In many instances it is made of heat resisting glass that is almost pure silica. As a rule also the condenser element is tempered: it is heated to quite a high temperature, and then chilled with blasts of cold air. A skin is formed on the glass which strengthens the element, and which reduces the risks of breakage due to heating.

Of much greater importance is the heating of the film or slide in the projector aperture. The light which pours through the projector aperture is accompanied by radiant heat. This may be absorbed by the film or slide, which is heated up as a result. The amount of temperature rise in the film depends, of course, on the extent to which this radiant heat is absorbed, and in this connection it is important to note that black and white film is a much more efficient absorber of radiant energy than is colour film. The heat absorption in 8 mm. and 16 mm. black and white film, in modern projectors, is so great that the film will be badly burnt if it stops at all in the projector aperture. A fire

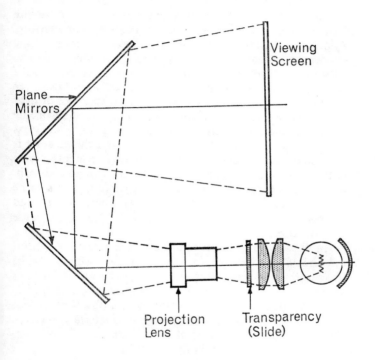

Fig. 136. A compact rear screen projection system may be realised by folding the optical path with mirrors. By folding the optical system larger focal length projection lenses can be used. As a rule these are less costly to produce than short focus projection lenses of the same quality and aperture.

shutter must therefore be provided in such projectors in order to prevent accidental film burning.

The heat absorption in colour film is sufficient to make it buckle in the projector aperture, whether it is in the form of cine film or of colour slides.

In order to minimize this film buckling a number of techniques are used in an attempt to keep the film cool. The most obvious of these techniques is to direct a cooling blast of air onto the film while it is in the projector aperture. Another technique is to use *heat absorbing glass* in the condenser system. This is a type of glass which has the property of absorbing all radiant energy in and beyond the infra-red region of the spectrum, while it allows almost free passage of visible light. A ten to fifteen per cent loss of light in the visible region is normal. As a rule the heat absorbing glass is used in the form of plain parallel plates. The glass heats up as it absorbs the radiant heat, and this heating is most even and regular with plain parallel elements. Some of the condenser elements may also be made of heat absorbing glass. In this case special tempering techniques must be used so that the uneven absorption of radiant energy, and the resulting uneven heating of the element, will not cause it to fracture.

Another more recent type of heat filter reflects the infra-red and longer wavelength regions of the spectrum, while transmitting the visible region of the spectrum. It operates in this way by using the same principles which were described on page 215 in connection with anti-reflection lens coatings. Several very thin layers of materials such as magnesium fluoride, zinc sulphide, cerium oxide, and so on, are used in order to obtain the desired result.

In the case of lamps with an internal reflector, whether these are concentric spherical mirrors, or elliptical mirrors with the filament at one focus, the heat which reaches the film is greatly reduced by using a *dichroic reflector*. This is a mirror which reflects visible light while it transmits the infra-red and longer wavelength region, of the spectrum. Once again it obtains this result by using a series of thin layers of the proper types of material, and by using the interference of light in the same way that anti-reflection coatings use this principle, as described on page 215. Such mirrors are now in volume production.

A type of system which has much in common with an enlarger, is the *rear screen projector*, shown in Fig. 136. Such projectors are used for the display of 35 mm. slides, 16 mm. and 8 mm. film, and microfilm, as well as for special purposes.

A projector of this kind is normally used in a room with a moderately high level of lighting, and as a result the screen brightness becomes a matter of major importance. At the same time the standard of definition is not usually required to be quite as high as the definition given by an enlarger, and it becomes a practical matter to use a lens of somewhat higher aperture, for example one that has an aperture of about $f2 \cdot 8$.

The illumination problem with such a system is very much like that which is encountered in projectors of the kind described earlier in this chapter, and a condenser system is used together with a compact filament lamp. We do not encounter the problems of varying degrees of magnification which make it more difficult to use a condenser system in an enlarger. It is important, of course, that the light source and the condenser system combine to fill the aperture of the projection lens.

Once the size of the projector is known, the focal length of the projection lens may be determined by using the formulae of the first chapter.

The optical path, from the slide or film to be projected to the projection screen, may be increased by using mirrors in order to fold this path. This has two advantages. In the first place it enables a lens of longer focal length to be used, with a narrower angle of coverage, which usually means that a higher aperture may be achieved with a lower cost lens. In the second place it means that the light rays are less divergent when they come to the corners of the projection screen. This enables a less diffuse screen to be used, and this in turn increases the image brightness. The image may be handed, i.e. it may be reversed left to right, but this can easily be remedied as a rule by reversing the slide or film in the projector aperture, relative to the position which it would occupy in an enlarger.

A critical item in such projectors is the nature of the projection screen. The function of this screen is to direct the

image light into the observer's eyes. It may do this in one of two ways. In the first place it may scatter light, so that a proper amount reaches the observer's eyes. In the second place it may refract light, so that the proper amount of light reaches the observer.

The scattering efficiency of the screen varies greatly from one screen material to another. At any point on the screen we may indicate its scattering efficiency in various directions, relative to an incident ray of light, by drawing lines as shown in Fig. 137a. The length of a line in any direction represents the brightness of the light which is scattered in that direction. By drawing a curve which goes through the end points of all these lines we obtain a *brightness distribution curve*. The shape of this curve is a characteristic of the screen material.

When ground glass is used for a screen material the transmission curve is rather narrow, as shown in Fig. 137a, but the brightness is quite high in directions close to that of the incident light ray. With a flashed opal screen the brightness curve is much broader, as shown in Fig. 137b. The brightness in any direction, however, is much less than the brightness in the optimum direction of the ground glass screen. The ground glass screen is only effective when it is viewed from a direction close to that of the incident ray, as illustrated in Fig. 137a. The opal glass screen, on the other hand, may be used for quite oblique viewing directions. It is for this reason that the folding of the optical path by means of mirrors, which was mentioned above, allows us to use less diffusing screens, with a consequent gain in brightness. This is shown in Fig. 137c, d.

By using a condenser behind the screen, as shown in Fig. 138a, the incoming light rays may be directed into the screen so that they converge towards an observer's eye. Once again this enables a less diffusing screen to be used and the projection appears brighter. In most cases it is not practical to use a normal type of condenser lens, when a screen of any size is used. A *Fresnel* lens condenser may then be used, as shown in Fig. 137b. As explained earlier in this chapter, such a unit provides a means of obtaining the effects of a normal lens, without the weight or bulk of such a lens. A table viewer by *Kodak*, for examining 35 mm. slides, uses a screen of this type.

When a very fine pitch is used for the Fresnel lens, i.e., the

398

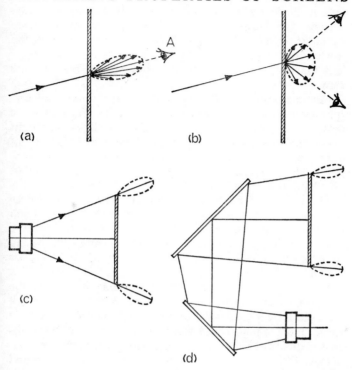

Fig. 137. The scattering power of a screen may be illustrated by drawing lines. (a) shows the scattering for ground glass. (b) is the scattering for opal glass. In a short system, as shown in (c) the narrow lobes of the scattering curves point outwards. In a longer folded system the divergence of the lobes is decreased, as shown in (d).

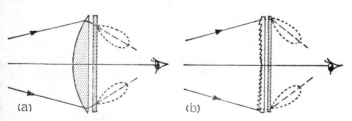

Fig. 138. By using a convex lens, as in (a), or a Fresnel lens, as in (b), the scattering curve lobes may be made to converge to the viewer's eye.

successive rulings on the Fresnel lens are close together, then it is often possible to dispense with any ground glass surface. The Fresnel lens is moulded in plastic and surface irregularities provide enough scattering action without the use of any further diffusion. With a fine pitch on the Fresnel lens the pattern of the rulings is not obtrusive at normal viewing distances.

In some more complex types of screen a number of tiny spheres are imbedded in a plastic support. Each of these acts like a lens, and refracts the incident light. The light passes through a small area, which is the image of the front aperture of the projection lens, and is spread into a reasonably wide coverage. This is a particularly effective way of obtaining the spread of light on a projection screen. It is used also in *beaded screens*, for normal front viewing, where the incident light is reflected and brought to a focus by small glass beads so that the projector light returned from the screen is compressed into a fairly narrow region, and within that region the picture appears much brighter than it does with a flat white screen.

In some cases of rear projection reference is made to the appearance of a *hot-spot*, or an area of the screen which seems to have a localised enhanced brightness. Occasionally this is due to a poor condenser design. Much more frequently it is due to the fact that, in the search for picture brightness, a diffusing screen has been used which is too *thin* and directional. The hot-spot is then due to the fact that we are effectively looking through the diffusing screen, into the aperture of the projection lens.

Closely allied to this type of equipment for viewing slides, is another form, as shown in Fig. 139. The slide is illuminated from behind, using a standard electric bulb and an opal glass diffusing screen. It is then viewed through the magnifying lens L. The degree of enlargement provided is not usually very high. For most practical purposes $2\frac{1}{2} \times$ to $3 \times$ is sufficient. This means that the focal length of the magnifying lens should be from $3\frac{1}{2}$ in. to 4 in. An approximate formula for the magnification is 10 divided by the focal length of the magnifying lens in inches.

The shape of the magnifying lens is important. The main problem is to prevent eye strain when the slide is examined with both eyes. This problem arises because there are two

adjustments of the human eye which must be taken into account. The first is the *accommodation* of the eye, which permits it to focus on an object of its attention. Muscles in the eyeball change the shape of a flexible lens, and so change its focal length to the extent needed in order to focus any particular object upon the retina of the eye. With normal sight the limiting distance with which the eye can deal in this way is about 10 inches. The change of focal length of the eye cannot be carried to such a stage that any object nearer than 10 inches to it can be sharply focused.

The other adjustment, by which the two eyes look at the same object, is the *convergence* of the two eyes. When we are looking at a distant object the two eyes are looking straight ahead. When the object moves up to a much closer distance we cannot still look at it with both eyes if they continue to look straight ahead. They must turn in slightly towards one another, i.e. they must converge.

Although optically these two adjustments are independent, in actual fact they are linked together automatically by psychological mechanisms, so that when the convergence of the eyes is suitable for an object at a distance of 3 feet the accommodation is also adjusted to ensure that this object at 3 feet is in sharp focus. Quite a considerable effort, with resulting eye strain, is needed in order to break down this automatic linkage.

Now if we look at a transparency through an improperly designed magnifying lens, using both eyes, particularly when we look through a lens with heavy spherical aberration and astigmatism, there may be a conflict between the demands of accommodation and convergence of the eyes. Because of this, in choosing a viewer of such a kind, it is worth spending some time looking through it: The effects of eye strain which such a viewing device may induce are not noticeable if only a casual examination is made. The eye will tolerate the conflict between accommodation and convergence for short periods of time, even though this tolerance will not be exercised over periods of prolonged viewing. Taking everything into account it seems that the best way of viewing slides, if any prolonged examination or demonstration is in order, is to use a slide projector of the normal type described earlier in this chapter.

Another type of device, which has some relation to a rear screen projector, is the *film editor*. This is used, as its name implies, in editing 8 mm. and 16 mm. movie film. In the normal course of projection of such films they are advanced through the projector in an intermittent fashion. A *frame* of the picture is projected on the screen, a shutter then cuts off light to the screen while the film is moved to its next position, and when the film is once more stationary the shutter opens and allows light to go to the screen.

In the film editor, on the other hand, the film runs continuously through the machine, and optical means are used in order to provide a steady picture on the viewing screen. A typical form of editor is shown in Fig. 140a. The glass block B is used to provide a steady image. Its mode of operation may be seen from Figs. 140 b, c, which show it on a larger scale. Successive positions of the glass block are shown in the two figures. If we consider the path of light reversed, so that it appears to come from the viewing screen to the film, then the block of glass may be considered as displacing the image on the film. This image, of course, corresponds to the picture which is examined on the viewing screen. By properly synchronising the movement of the glass block and of the running film the image of the viewing screen stays fixed relative to the film. In other words a constant area of the film corresponds to the area of the viewing screen, and we thus obtain a steady image.

The same principle may be used in high speed movie cameras, where the speed of operation is too great to permit the use of the normal intermittent motion. In this case it is customary to use a block of glass with six, eight or more sides. The reason for this is that the block of glass introduces very significant aberrations as it rotates. By using a thick block of glass, with many sides, these aberrations may be significantly reduced. It is necessary, of course, when using such a glass block behind the lens to use a lens which has been specially designed for this purpose. The glass block introduces other aberrations, particularly spherical aberration, astigmatism, and chromatic aberrations, and the lens design must make allowances for these. For further details reference should be made to works which deal specifically with high speed photography.

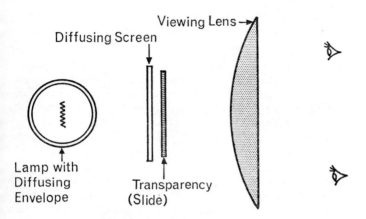

Fig. 139. The basic components of a slide viewer consist of an illuminated diffusing screen, usually opal glass, and a properly shaped magnifying glass which can be used with both eyes.

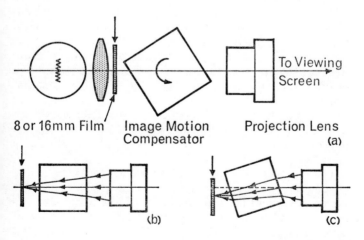

Fig. 140. (a) In a simple film editor the motion of the film is compensated by a rotating glass block placed behind the projection lens and synchronised with the film advance. The action of the image motion compensator is shown in (b) and (c).

403

Micrographics

For the purposes of this book we may define micrographics as the art of storing or presenting visual information which has been reduced to a condensed form, using some type of photo-sensitive material. When it seems appropriate we may depart from this somewhat narrow definition, but for the most part we will use it to define the scope of the topics to be discussed.

For the most part graphic material, such as printed pages, bank cheques or drawings, is copied on a very much reduced scale onto either 16 or 35 mm film, or on sheets of film known as *microfiches*. There is also a pronounced trend at this time to use 8 mm film. The information stored in this way is recovered by projection on to a screen, by making enlarged prints or by examining the reduced images with a magnifier of simple or of a complex form.

We may also distinguish between two types of usage of micrographics. In the first, which is exemplified by micro-filming cheques in a bank, the primary goal is to produce a record in a very compact form, but a frequent look-up is not expected. In the second type of use, where a more frequent look-up is expected, the user may prepare his own records from full size originals, or he may buy material which has already been condensed to a small volume. The provision of such pre-packaged condensed material is often referred to as *micro-publishing*. Quite a number of news-papers and technical journals are currently available in microfiche form.

There is a distinct trend also to use microfilm to record the output of electronic computers. These machines produce such a volume of information (a lot of which is really use-less) that the storage of their output becomes a matter of concern, and COM (Computer Output to Microfilm) becomes a very attractive proposition.

There is one very important aspect of micrographics which should not be overlooked. The fact that information

is recorded on strip film or on a microfiche in both a compact and a standardised form, means that the retrieval of information by mechanical means or under the control of a computer becomes a practical possibility. This is of particular importance in the modern world where the supply of information is so great that it is easy to overlook a significant item.

In its early days micrographics was a poor relation of other well developed areas of photography, and it improvised with hardware and with techniques borrowed from these areas. Since then, however, it has advanced to take its place as a major photographic discipline, with its own specialised approaches to problem solving. Within the scope of this book we can consider only the optical aspects of modern work in the micrographic area. No new optical principles are called upon in this work, but the emphasis on practical applications of established principles is somewhat different from that encountered in other areas of photography. In the following pages, therefore, some of the principles enunciated in earlier chapters of this book will be re-examined in a context more directly related to micrographics.

LEGIBILITY

The prime requirement of any micrographic system is that the information which has been recorded, stored and then retrieved, should be legible. Criteria of legibility have to be established so that the performance of a system may be evaluated, preferably in quantitative terms. Moreover such criteria should be expressed in a form which enables them to be related to the performance of the various components and processes which make up a micrographic system.

Pioneer work in this area was carried out in 1937 and 1938 by *Raymond Davis* and *Milo A. Durand* at the *National Bureau of Standards* (NBS) in *Washington, DC*. They established a correlation between the legibility of common type faces and the resolving power of the optical system which reproduced the images of these type faces. This resolving power was measured with an NBS resolution chart carrying test patterns with equal dark and light lines. One pattern unit comprises a dark line and an equal light line.

They found, for a variety of common type faces, that if the lower case *e* covered three of the finest pattern units that were just resolved, the printed material was decipherable: it could be read with some difficulty. If the lower case *e* covered five pattern units, the copy could be read without difficulty, although serifs and fine details of the type face were lost. If the lower case *e* covered eight or more of the finest pattern units that were just resolved, the details of the type face were clearly defined.

The size of type face is measured in *points*. One point is approximately 1/72 in. The smallest size of print in common use is 6-point. In this case the size of the lower case *e* is about 1 mm. The results of *Davis* and *Durand* can then be interpreted to read that if 6-point type is to be recorded and retrieved, the minimum resolution provided by the storage and retrieved process should be 3 lines per millimetre in the retrieved image. This will give a decipherable document, legible with some difficulty. If the resolution of the complete system is 5 lines per millimetre, the retrieved image will be readily legible. With 8 lines per millimetre fine details of the type face will be discernible. This has become a widely accepted standard of performance of micrographic systems.

This basic work was carried out in 1937 and 1938, well before methods of image assessment based upon modulation transfer functions (M.T.F.'s), as described earlier in this book, had come into practice. It seems reasonable, however, to assume that the resolution values used by *Davis* and *Durand* corresponded to an M.T.F. in the final image of 10 per cent and that this value can be used in predicting the legibility to be expected from a given micrographic system.

More recently work has been reported in 1965 by *M. E. Rabedeau* and *A. D. Bates*, and in 1966 by *C. K. Clauer* and *R. L. Erdmann*, all of the *I.B.M. Corporation*, relating the acceptability of typescript reproductions to the M.T.F.'s of the reproduction process. Their results indicate that the *Davis* and *Durand* criteria are on the conservative side, and that legibility is obtained at approximately two thirds of the resolution specified by *Davis* and *Durand*. It should be noted, however, that the more recent work reported was carried out for typescript, not for printed material, and that

406

MTF CURVE FOR MICROFILM

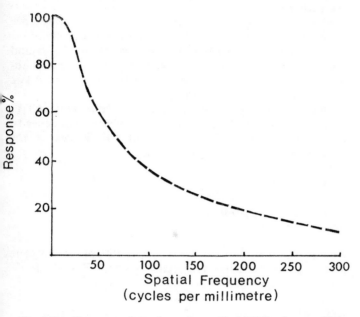

Fig. 141. The curve given above shows the M.T.F. of a very high resolution, but not grainless, microfilm.

INVERTED TELEPHOTO CONSTRUCTION

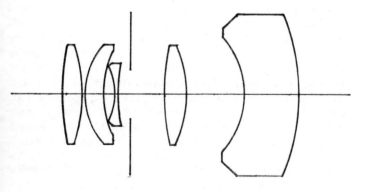

Fig. 142. An inverted telephoto form of lens is used to produce a focal length of 13 mm at an aperture of *f*4.

the judgment criteria were not necessarily those adopted in the earlier work.

Further investigations relating legibility to M.T.F.'s are under way in a number of laboratories. For the present a conservative approach indicates the use of the *Davis* and *Durand* criteria. The exact translation into lines per millimetre depends on the precise specification of the print size to be recorded and retrieved.

Once the idea of relating legibility to the overall M.T.F. of a system is accepted, we may use modern approaches to relate the system M.T.F. to the M.T.F. values of the component parts of the system. These are:

1. The recording lens
2. The recording medium
3. The reader or printer lens
4. The projection or reader screen.

As explained earlier in this book, the M.T.F. of the complete system is obtained by multiplying the M.T.F.'s of the individual components.

RECORDING MEDIA

A discussion of recording media, as such, is outside the scope of this book. We are concerned with them only insofar as they have M.T.F. values which exert considerable influence on the design of a micrographic system.

Broadly speaking they can be divided into two categories. The first has an M.T.F. curve of the form shown in Fig. 141, which drops to a value of 10 per cent at about 300 cycles per millimetre. The exact form of the curve, and the frequency corresponding to 10 per cent depend on a number of factors, including the film processing. What should be noted for future references is the initial rapid fall-off of the M.T.F. curve, followed by a rather longer tail to the graph where the M.T.F. decreases comparatively slowly. The second category of media comprises the so-called grainless emulsions, which rely on photographic processes at the molecular level rather than at the crystal grain level, and which have an M.T.F. curve that is almost flat at normal frequencies. The photographic speed of the grainless materials is so slow that they are only used for special circumstances

408

involving extreme degrees of reduction, where this almost unlimited resolving power is a necessity.

Corresponding to these two types of recording media we have two distinct types of micrographic system. The first, which we may call the classical system, is characterised by a maximum degree of reduction in the region of $40 \times$ to $48 \times$. The second, the so-called *ultra-fiche* system, is characterised by a degree of reduction which, for commercial applications, may reach $150 \times$. The ultra-fiche system normally works with pre-packaged material, where a complete parts catalogue, for example, may be carried on a single microfiche. Both types of system introduce their own optical problems.

RECORDING LENSES—CLASSICAL

In the case of the recording lens, with a degree of reduction less than $48 \times$, a compromise is usually made between performance and depth of focus.

For example, if we consider a lens whose performance is limited by diffraction, then for the spectral region to which microfilm is sensitive we may take its limiting resolution as $2058 \div N$, where N is the *f*-number of the lens. If $N = 5.6$ then the limiting resolution is approximately 365 cycles per millimetre. The M.T.F. of the lens goes to zero at a frequency which is just above that at which the film M.T.F. drops to 10 per cent. The limiting frequency of the lens–film combination, with a 10 per cent modulation criterion, is in the region of 180 lines per millimetre. According to the accepted criterion of the diffraction limited depth of focus (*Maréchal*'s quarter wave criterion) this has a value of plus or minus ·0012 in.

If the aperture of the lens is opened up to $f2.8$, the limiting resolving power of the lens goes up to 650 cycles per millimetre. The lens–film combination then has a limiting frequency in the region of 250 lines per millimetre, but the depth of focus has decreased to plus or minus ·0003 in. The depth of focus, in fact, is proportional to the square of the *f*-number. It requires a detailed analysis of the total system, including the reader lens and the screen structure, to determine whether the gain in performance is worth the trade-off in reduced depth of focus.

A good compromise is to use an $f4$ lens. This has a

409

diffraction limited resolution of about 520 cycles per milli-metre, and a diffraction limited depth of focus of plus or minus ·0006 in.

In practice, although it is very desirable to have the highest standard of performance in the recording lens, it is not usually feasible to use a diffraction limited lens in this class of micrography: economic factors do not favour its use. It is not difficult to design or manufacture a diffraction limited $f4$ lens which covers a narrow field. A telescope objective is an example of such a lens. Design problems arise when this standard of performance is to be provided over an angular field of reasonable extent. An extremely high degree of aberrational correction is needed so that the diffraction of light becomes the controlling factor in determining the resolving power of the lens, and this requires a complex structure for the lens.

The form of lens that has been most favoured for this use in the past is one derived from the symmetrical form, such as the *Biotar* or *Double-Gauss* type of lens described in earlier chapters of this book. This form of lens has a flatter field and less zonal astigmatism than the derivatives of the triplet form of lens. In recent times the inverted telephoto type of lens, also described in earlier chapters, has emerged as a possible form for very high standards of performance. One example is shown in Fig. 142. This is a 13 mm $f4$ lens which covers a total angle of field of approximately 38 degrees. On high resolution photographic plates this lens has a limiting resolution in the centre of the field of 400 lines per millimetre. The radial resolution elsewhere in the field does not fall below 360 lines per millimetre, while the tangential resolution does not fall below 320 lines per millimetre.

The standards of performance required for micrographic recording lenses are higher than those required, for example, for 16 mm movie camera lenses, in keeping with the higher resolving power of the micrographic recording medium. The best results are obtained by designing the micrographic system so that the angular field coverage of the recording lens is kept as small as possible. This means an increase in the track length from the original document to the plane of the recording medium, and the use of a recording lens with an increased ratio of focal length to the diagonal of the

410

recorded format. If the degree of reduction from the original document to the recording is M, and if the focal length of the lens is F, then to a good approximation the track length L is given by the formula $L = F \times (M + 2)$.

The recording unit may be made compact, with a reasonably long track length, by folding the optical path with plane mirrors. These mirrors must be very flat in order to preserve the image quality. As a rough guide the mirror surfaces should be flat within one-eighth of the wavelength of light over the area covered by the light that comes from any one object point in the original document.

The lens design has to be established for the degree of reduction required, so that the necessary delicate balance of aberrations can be achieved under operating conditions. Moreover if the location of the image plane is established by holding the film against a glass plate, the thickness of this plate must be taken into account when the lens is being designed. The aberrations introduced by such a plate are significant in the present context.

There is one further point to be considered in discussing classical micrographic systems, namely the difference between *planetary* and *rotary* cameras, and the implication that this holds for the lens requirements.

In the *planetary* type of camera, the microfilm record is made in the same way that a normal photograph is taken, namely with the original document and the recording material both stationary. The discussion of the previous pages is directly applicable to this style of camera.

In the *rotary* camera, on the other hand, both the original document and the recording medium are in motion simultaneously, as shown in Fig. 143. The ratio of their velocities is equal to the degree of reduction from original document to recording. The photographic exposure is made as the document passes an illuminated slit. This slit may be a narrow rectangle as shown in Fig. 143, or it may have curved sides, as also shown, in order to produce a more even time-integrated exposure in the plane of the recording medium. Typically the length of the slit is about 9 inches, and its width is about ·5 to 1·0 inches.

Any discrepancy between the reduction ratio and the relative velocities results in a loss of definition. For this reason it is particularly important to correct the distortion in

the recording lens. For example 1 % of distortion at the ends of the illuminated slit area means that there is a 1 % mismatch between the reduction ratio and the velocity ratio at the ends of the slit, if there is no mismatch at the centre of the slit. This can result in a significant loss of image quality. The distortion in such a lens should not exceed 0·2 %: this is not difficult to achieve once it has been specified.

ULTRA-FICHE RECORDING

An ultra-fiche recording on very high resolution film or on a grainless recording medium, with a reduction ratio of 150× for example, provides a tremendous information storage capacity, but it generates quite an array of problems. For example if the degree of reduction is 150× then the criteria of legibility discussed earlier in this chapter require a minimum resolution in the record of 450 lines per millimetre, and a value in excess of this is desirable.

The reduction from the original document is conveniently carried out in two stages, for reasons which are discussed below. For example a 150× reduction may be achieved by means of an initial 15× reduction, followed by a final 10× reduction.

The initial reduction can be made onto a comparatively fast silver halide film with a limited resolving power, in the region of 110 lines per millimetre for example, since all image spreads in this intermediate record are reduced by a factor of 10 in the final record. For the 15× reduction of an $8\frac{1}{2}$ × 11 inch document a lens with a focal length of 2 inches may be used, with an overall track length of about 34 inches. An aperture of $f4\cdot5$ or $f5\cdot6$ provides adequate illumination in the film plane, and a satisfactory standard of resolution. A symmetrical type of lens, such as the *Biotar* or *Double Gauss* type, provides the flattest field coverage and the least astigmatism. The film for this intermediate record must lie in the image surface within about plus or minus ·0015 in. in order to maintain the necessary standard of performance. This intermediate record is used as a transparency from which the final 10× reduction is made.

The second stage of the reduction is much more critical. The minimum resolution required in the record is 450 lines per millimetre, and preferably it should exceed 600 to 750 lines per millimetre. The performance of the lens which is

412

ROTARY MICROFILM CAMERA

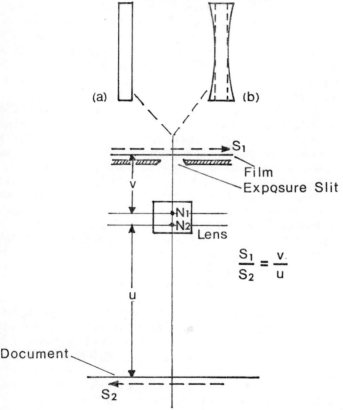

$$\frac{S_1}{S_2} = \frac{v}{u}$$

Fig. 143. The document and the film are in simultaneous movement. N1 and N2 are the nodal points of the lens. Exposure is through a narrow slit. Two slit shapes are shown at (a) and (b).

WIDE APERTURE HIGH PERFORMANCE LENS

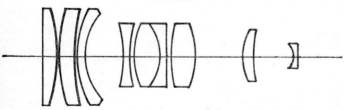

Fig. 144. A 30 mm *f*1·0 *Cerko* second stage lens. It may be regarded as a *Petzval* type of lens with a biconcave field flattener.

used in the final reduction, in order to provide this resolution, is limited both by residual aberrations in the lens and, to a more significant extent, by the diffraction of light.

Since ultra-fiche systems are normally used to provide a number of copies of reduced records of original material such as catalogues, parts lists and repair manuals, which will be distributed to a variety of end-users provided with readers, it pays to keep the quality of the recorded image as high as possible. The maximum value of the product of the M.T.F.s of the recording lens and recording medium should be provided. This allows us to keep the M.T.F. of the reader lens at a reasonable value, with consequent economies of manufacture, and still maintain satisfactory legibility.

For this reason, the lenses used in the final stage of image reduction have an aperture in the region of $f1·0$ to $f1·5$, with limiting resolving powers, for an M.T.F. value of 10 per cent, in the region of 1200 to 1000 lines per millimetre. One such type of lens, with an outstanding level of performance, is the *Cerco* 30 mm $f1·0$ lens shown in Fig. 144. This lens is designed for use at a $10 \times$ reduction ratio. It may be regarded as a derivative of the *Petzval* form of lens with a negative lens as a field flattener. The free working distance, from the lens mount to the image plane, with this particular lens is 2 mm. In other lenses of the same general type the back focal length is zero and the recording medium is brought into contact with the rear surface of the field flattener.

A problem of major concern is the depth of focus of such a lens. The exact value of this depends on the residual aberrations in the lens, but because of the part that is played by the diffraction of light in controlling the resolving power of the lens, we can give some guidelines based upon the nature of light rather than upon the detailed lens form. A generally accepted criterion is the *Rayleigh* quarter wave limit, according to which there is no perceptible degradation of image quality if the wavefront of light emerging from the lens does not depart from the ideal spherical form by more than one quarter of the wavelength of light. In terms of this criterion the depth of focus of such a lens does not exceed plus or minus ·0001 inches, and extreme care must be taken to locate the recording material in the correct image surface. Among other things, this means that the

414

image surface must be accurately perpendicular to the lens axis.

A lens of this kind is designed to work with a single wavelength of light. The *Cerco* lens referred to above, for example, is designed to work with light having a wavelength of 436 millimicrons. (The "g" line of mercury). The intermediate record, used as a transparency, is illuminated from behind with light of this colour.

The reason for using light of a single wavelength is to eliminate the effects of *secondary spectrum*, discussed in earlier chapters of this book. According to this effect there is a residual spread of the positions of the lens focus, with varying wavelengths of light, when light of two colours has been brought to a common focus. The spread may amount to ·0005 of the focal length of the lens. Such a spread would be intolerable in lenses used for the final reduction stage. Conceivably it might be possible to use special materials in the lens, as is done in microscope objectives, but it is distinctly difficult to use these materials except in a lens which covers a very narrow angle. The 30 mm $f1·0$ *Cerco* lens, for example, covers an image field up to 4·7 mm in diameter, which is much greater than an $f1·0$ microscope objective will cover. By photographic standards, however, the angular coverage of the lens is quite small. This condition is established so that higher order field aberrations will not be troublesome.

The use of a transparency as an intermediate reduction means that more light can be directed towards the final recording medium than would be possible if, for example, an attempt were made to use a single stage reduction with light scattered from an opaque original document. This is important in view of the low photographic sensitivity of the type of recording materials used for such work.

One point which must be emphasised is that the performance of the final recording lens depends in very large part upon the care exercised in its manufacture. The development of a design on paper is a comparatively straight forward matter, particularly with modern design techniques using electronic computers. In the fabrication of the lens, however, it is necessary to produce surfaces which are accurately spherical within a small fraction of the wavelength of light, that the glass be extremely homogeneous, and

that the lens elements be centred and mounted with the utmost precision. Selective assembly techniques have to be used to compensate for tolerances on the thickness of glass elements. These final reduction recording lenses are probably the highest quality optical product available on the commercial market.

READERS AND PRINTERS—GENERAL

The condensed information on a micrographic record is retrieved by means of a reader or a printer, depending on whether a screen image for visual examination is sufficient, or upon whether a *hard copy*, i.e. a printed output record is required. There are combined reader-printer units available on the market in which the visual image is first examined on a projection screen, and if it is satisfactory then a mirror is inserted into the optical path and a printed copy is made on a suitable sensitised paper. Typical optical layouts for a reader and for a printer are shown in Figs. 145 a, b. The optical problems for both forms of retrieval system have a good deal in common and they will be discussed together.

By and large the growth of micrographics over the past few years has been disappointing. To some extent this has been due to the cost and bulk of the available readers for purely visual retrieval. This situation has changed somewhat in recent times, however, with the introduction of lower cost and more compact readers. Two examples are shown in Fig. 146, a *Kodak Ektalite* 120 and a *Bell & Howell Briefcase Reader*.

The performance of a reader is governed by the characteristics of the lens that is used, by the proper placement of the record in the image plane of the lens, by the qualities of the mirror or mirrors which fold the optical path, by the efficiency of the condenser system, and by the characteristics of the viewing screen. In the case of a printer we have the same list of contributing factors except that we have the characteristics of the print-out paper replacing those of the viewing screen.

READER AND PRINTER LENSES

Reader and printer lenses fall into two broad categories, on a practical basis, according to whether they are used with

416

TYPICAL MICROFILM READER OR PRINTER

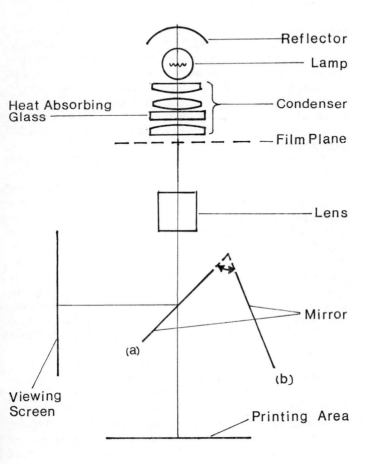

Fig. 145. The optical components which comprise either a microfilm reader or a printer are shown in outline. A swinging mirror may be used to transform the reader to a printer.

classical degrees of reduction and magnification, up to about 48×, or with ultra-fiche systems.

The criteria of legibility discussed earlier in this chapter imply minimum standards of resolving power for the reader lens. These should be regarded as rock-bottom values since they do not allow for degradations introduced by the recording lens and the recording medium. To put the standard of performance of the reader lens in the proper perspective, we may note that if a lens produces a resolution on a grainless screen of R lines per millimetre when it is working at a magnification M, then if it is used to create a reduced image at the same degree of reduction M it will produce a resolution of M × R lines per millimetre in the reduced image. Thus a lens which will provide a screen resolution of 5 lines per millimetre at a magnification of 24×, will show a resolution of 120 lines per millimetre in a 24× reduced image of a document.

In order to keep the bulk of the reader to a minimum, the focal length of the lens should be kept as short as possible consistent with providing a sufficiently flat field. The factors which influence the field flatness are the field curvature and astigmatism, discussed in earlier chapters. The smaller the angular field the easier it is to design a lens with a flat field, and the cheaper it is to manufacture such a lens. A compromise has to be reached between system compactness and cost. In the *Bell & Howell Briefcase Reader*, for example, the focal length of the lens is 20·31 mm, and the diagonal of the microfiche format is 7·75 mm, so that the total angular field at 20× magnification is 19·81 degrees.

In general the combination of angular coverage and high resolution imposes strict demands upon the performance of a reader lens. The aperture of the lens is governed by the system magnification and the desired screen brightness. For example with a magnification of 24× an aperture of $f4·5$ will provide an adequate level of illumination, with a proper condenser design. To maintain a constant level of screen illumination the value of $(M + 1) × N$ should be constant, where M is the degree of magnification and N is the f number of the lens. This means that an $f2·3$ lens working at 40× will produce the same screen illumination as an $f4·5$ lens working at 20× magnification.

With a magnification of 20× and an aperture of $f4·5$ an

TWO SMALL LOW-COST MICROFILM READERS

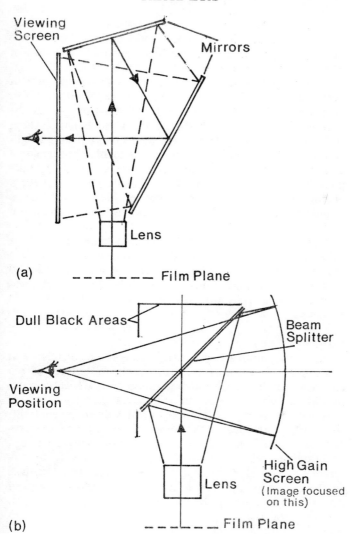

Fig. 146. Figure (a) shows the light path folding used in the *Bell & Howell Briefcase Reader*. Figure (b) shows the path in a *Kodak Ektalite 120 Reader*.

adequate standard of image resolution may be attained with a *Tessar* type lens, or a derivative of the *Cooke Triplet* type, with a pair of elements replacing the front element of the classical form of triplet. With a magnification of $30\times$ an aperture of about $f3\cdot1$ is needed, and a suitable lens form is the *Pentac* type or the *Double-Gauss* type of lens, both of which are described in earlier chapters.

At a magnification of $48\times$ a lens with an aperture of $f1\cdot9$ is needed. Normally the first choice of lens for this aperture would be one of *Biotar* or *Double-Gauss* type. The problem we encounter is that if the focal length is kept short, so that we may achieve a reduced overall track length and a compact reader unit, the lens elements become small and difficult to manufacture. It is, therefore, marginally preferable to use an inverted telephoto type of lens for a magnification of about $48\times$. The problem is that extra elements must be used in this kind of lens to keep distortion under control.

With the high degree of magnification required for ultra-fiche retrieval, apertures in the region of $f1\cdot2$ to $f1\cdot5$ are used. High intensity light sources are used in order to produce an adequate level of screen brightness. Inverted telephoto lens types are used for this kind of information retrieval.

COHERENT LIGHT

There is one important point which has to be considered in relation to ultra-fiche retrieval, namely the effects of the *coherence* of light. The distinction between *coherent* and *incoherent* light is one of major importance.

When an object is illuminated artificially or by sunlight, for example, it absorbs the luminous energy and then re-radiates it in a form which characterises the object. There is no sustained relation between the light coming from different points within the object area. The light is *incoherent*. In the case of photographic lenses all work in theoretical optics is based upon the behaviour of incoherent light, namely upon the lack of a sustained relationship between light from different object points.

When, however, a transparency is illuminated with light from a condenser system, without any diffusion in the system, then there is a sustained relationship between light

420

which traverses different areas of the transparency. The light is then *coherent*. The optical theory which applies to this situation is very different from that which applies to incoherent illumination. It shows, for example, that when the standard of performance of a lens is so high that it is governed by diffraction phenomena, as is the case for ultra-fiche retrieval lenses, the limiting resolution is only one half of that provided by a lens of the same aperture when used with incoherent light. The resolution values given on p. 182 have to be halved when the light is coherent. This situation reinforces the need for using a high aperture lens in ultra-fiche retrieval.

The properties of coherent light also explains why the resolution in normal microfilm applications is greater than would be expected on the simpler basis of using incoherent light.

The condenser system of a reader images the lamp filament in the plane of the entrance pupil of the reader lens. The filament image in effect defines the shape and size of the entrance pupil of the lens. With some of the lamp filaments used in low cost readers this results in a V-shaped entrance pupil area. On the basis of imagery with incoherent light such a pupil would provide a rapid fall-off in the M.T.F. curve and a low value for the diffraction limited lens resolution. This may be verified by cutting a V-shaped mask to simulate the pupil area defined by the filament image, and by testing the lens as a recording lens, using the incoherent light scattered from an original document. With the coherent illumination delivered by a condenser system, however, we have to take into account the light which is scattered and diffracted from different parts of the film area. The detailed theory then shows that the limiting resolution for the lens-condenser system is one half the value given on p. 182 for the lens alone. In somewhat simplified terms, we may say that the size and shape of the filament image determine the brightness of the screen image, but the lens aperture determines the limiting resolution. The lens pupil, of course, must be big enough to include the filament image.

IMAGE ROTATION

In some readers means are provided so that the screen image may be rotated. This is used when, for one reason or

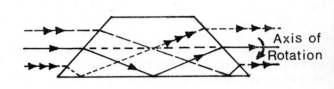

(a)

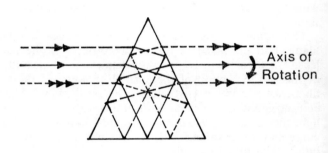

(b)

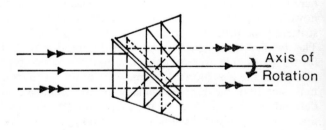

(c)

Fig. 147. (a), (b), (c). Three forms of *rotation* or *half-speed* prisms are shown, as well as the paths of light rays which produce image inversion.

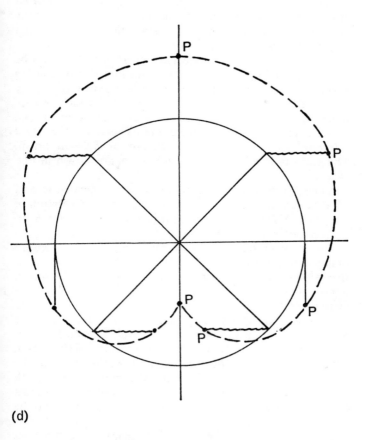

(d)

Fig. 147. (d) A combination of prism angle errors and alignment errors give the path of the image wander shown. Typical positions for the centre of the field are marked P.

another, the record on the microfilm or microfiche has been turned through 90 degrees from what may be called its normal position. As a result the screen image is in an uncomfortable orientation for reading.

The image on the screen may be brought to a normal position by physically rotating the microfilm carriage or the microfiche holder. Alternatively optical means may be used to provide the required rotation.

There are a number of optical arrangements which may be used in order to produce an image rotation, all depending upon the reflection of light at an odd number of mirror surfaces. In the case of micrographic readers these reflections occur inside glass prisms. Three forms of special importance are shown in Fig. 147. These are the *Dove prism*, the *Delta prism* and the *Péchan* or *Schmidt* prism. The paths of the light rays in each prism are shown in Fig. 147.

As each prism is rotated about its axis, indicated in Fig. 147, the screen image rotates at twice the rate of rotation of the prism. For this reason such prisms are often referred to as *rotation* or *half-speed* prisms.

The problem to be faced with rotation prisms is to ensure that the screen image rotates about a fixed central point. Because of errors in prism angles the centre of the screen image may wander, and describe a circle with the same angular rate of movement as the prism. If the reflecting surfaces as a group are not properly oriented relative to the axis of rotation then the screen image wanders and describes a circle at twice the angular rate of rotation of the prism. When both of these effects are combined, the centre of the image describes a path such as that shown in Fig. 147. Both prism angles and the location of the axis of rotation must be held to close tolerances so that this image wander can be held to acceptable values.

When the reflection of light takes place inside the glass of a prism it is not necessary to silver or aluminise the reflecting surface provided that the angle which the light ray makes with the normal to the surface exceeds the *critical angle*. This is illustrated in Fig. 148. When an incident ray lies within the critical angle, as shown in Fig. 148a, the refracted ray emerges into air as shown. When the incident ray is at the critical angle then the refracted ray

424

REFRACTION AND REFLECTION AT GLASS/AIR SURFACES

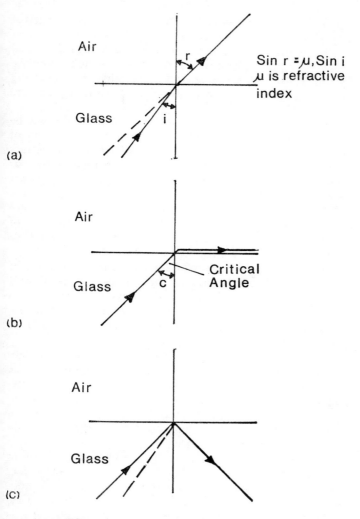

Fig. 148. When a light ray in glass lies within the critical angle as shown in (a) a refracted ray emerges as shown. At the critical angle (b) the refracted ray travels along the surface. Beyond the critical angle (c) the ray is reflected back into the glass.

425

that emerges into air lies in the plane of the surface, as shown in Fig. 148b. When the incident ray lies beyond the critical angle, as shown in Fig. 148c there is no transmitted or refracted ray and all of the light is reflected back into the glass. If the critical angle is C, and if the refractive index of the glass is N, then Sin C = 1 ÷ N. Thus if N is equal to 1·649 (as with a common type of flint glass), then C is equal to 37·3 degrees. When the ray is to be reflected inside the prism at less than the critical angle, then the reflecting surface must be silvered or aluminised. Such surfaces are marked M, in Fig. 147.

Both the *Delta prism* and the *Dove prism* should only be used in *collimated space*. This is a region where the rays of light from any significant object point have been so refracted by a lens or lenses that they form a parallel bundle of rays. This restriction is imposed because the rays of light encounter the entrance and exit faces of the prism at quite oblique angles, and unless the rays from an object point are then parallel to one another a considerable amount of astigmatism is introduced. If the space is not collimated then a Péchan type of prism should be used.

When the phenomenon of total internal reflection, for light rays beyond the critical angle, is used to produce a reflected beam of light inside the glass of a prism, it is important that the reflecting surface be scrupulously clean. Finger-prints, for example, on such a surface will destroy its usefulness.

The surfaces at which total internal reflection takes place must be accurately flat, usually within one quarter of the wavelength of light, otherwise they will introduce astigmatism. In the case of the *Dove prism*, with its rather unfavourably long base, it is important that it be mounted in such a fashion that it is not strained, otherwise again astigmatism will be introduced.

One interesting example of the use of a *Dove prism* to produce image rotation is the *Bell & Howell* zoom reader lens shown in Fig. 149. This comprises a front zoom unit, a *Dove prism*, and a rear prime lens. The region between the zoom unit and the prime lens is collimated space. This lens varies in focal length so that it produces a magnification from 20× to 40× with a fixed track length. A simpler non-zoom system is shown in Fig. 150, where the *Dove*

426

IMAGE ROTATION WITH A DOVE PRISM

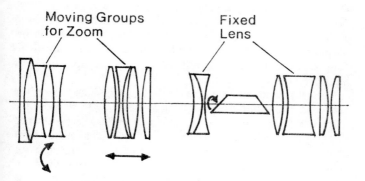

Fig. 149. A *Bell & Howell* zoom reader lens uses an internal *Dove prism* to provide image rotation.

OFFSET DOVE PRISM

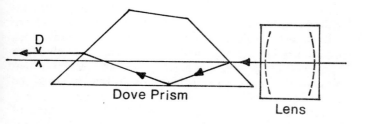

Fig. 150. In order to keep the prism size down a *Dove prism* for image rotation may be offset from the axis of the lens.

prism is arranged in such a way as to minimise the prism size.

ILLUMINATING SYSTEMS

A typical illuminating system comprises an incandescent lamp, a rear spherical reflector concentric with the average filament position, a condenser system and a heat absorbing glass plate. In some cases the heat absorbing glass is incorporated in one of the condenser elements. For ultra-fiche readers the incandescent lamp may be replaced by a high pressure xenon lamp.

The function of the condenser system, as described earlier in this book, is to collect as much light as possible from the lamp filament and to direct it into the entrance pupil of the reader lens in such a way that the same amount of energy passes through equal areas of the microfilm or microfiche. In order to do this the lamp filament is more or less imaged in the entrance pupil of the reader lens. It is usually stated without qualification that the filament is imaged in the pupil of the lens but this is an over-simplification. The condenser system which does this imaging usually shows very heavy spherical aberration and coma, even though special steps are taken to reduce these aberrations. Such steps include the use of multiple condenser elements and the use of aspheric surfaces. A four element condenser with only spherical surfaces and a three element condenser with one aspheric surface are shown in Fig. 151. The most obvious visual sign of a condenser system with inadequate corrections of the aberrations is the appearance of dark or brownish corners of the screen area, which can be eliminated by moving the projection lamp, but only at the expense of introducing a blue shading in an area about two thirds of the distance from the centre to the corner of the screen. It is a rare thing nowadays for a reader with such a defective condenser to reach the market. If these kind of effects are in fact observed it is usually a sign that a condenser element has been put in back to front after cleaning.

The standards of optical shape and surface quality which are required for condenser elements make it possible to use fire-polished elements. These are moulded from specially prepared glass rods. Either hard crown glass or pyrex may

428

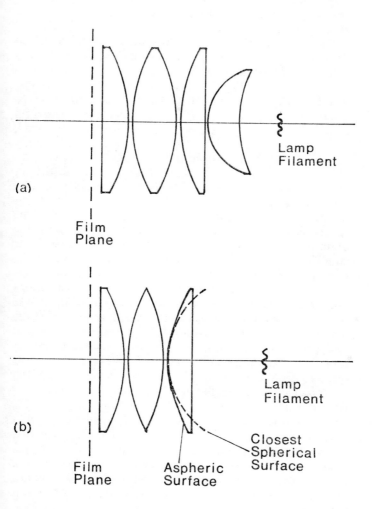

Fig. 151. In order to minimise condenser aberrations when high efficiency is needed we may use a 4 element system with only spherical surfaces (a), or a 3 element system with one aspheric surface (b).

429

be used. There is a considerable measure of skill and craftmanship required to produce the best quality of fire-polished elements, but there are a number of companies making them.

The use of a rear concave reflector increases the screen illumination, but it does not double it. The light which is reflected from this mirror has to go through the lamp envelope twice, with a loss of about 5% at each air-glass surface, for a total loss of 20%. The reflectivity of this type of mirror may be taken as 75%. As a result we may expect the use of a properly positioned, and properly dimensioned, rear reflector to add about 60% to the screen illumination.

A point which is worth considering is the sensitivity of an illuminating system to lamp filament position and to the adjustment of a rear reflector. This may best be examined by taking the function of the condenser system as being either to image the lamp filament (more or less) in the pupil of the reader lens, or to image the pupil of the lens in the plane of the lamp filament. If it does one it will do the other. If the lamp filament does not lie entirely within the area of the pupil image the total screen illumination is decreased. According to the detailed behaviour of the light rays used, this fall-off in screen brightness may be unevenly distributed over the screen area. If a rear reflector is maladjusted, so that the filament image which it creates does not fall within the area of the pupil image then there will also be an uneven reduction in screen illumination, not as pronounced as that resulting from lamp positioning errors. The position of the lamp filament is controlled by the physical construction of the lamp and by the type of socket used to hold it. If these do not locate the filament within the pupil image of a proposed lens, then a lens with a larger pupil, i.e. one with a lower f number, has to be used. The same situation prevails with a poorly designed condenser system. Thus with a properly designed condenser and lamp holder, as a matter of practical experience, an adequate standard of screen illumination may be achieved at a magnification of $24 \times$ with a lens aperture of $f4\cdot5$. With a poorly designed condenser it may be necessary to use an $f2\cdot8$ lens to be sure of obtaining the same screen brightness.

As the f number of a lens is decreased its cost and complexity increase. The economics of the situation, therefore,

430

indicate that it is worthwhile to devote a good deal of time and attention to the design of a condenser system so that the cost of the reader lens can be held to a minimum.

The best form of lamp filament is one of compact, almost square form, such as a tightly wound coil. In the interests of economy, V-shaped single strand filaments are sometimes used. With such a filament, particular care must be taken to avoid blemishes in the condenser elements. The small diameter of the filament wire causes such blemishes to appear as dark smudges on the viewing screen. The same holds for blemishes in the lamp envelope, and if such unsightly smudges appear on the screen it is worthwhile to try changing the lamp.

When a heat absorbing glass is used, either in the form of a plane parallel plate or as a lenticular condenser component, it is advisable to use tempered glass. In the course of the component manufacture it is heated and then cooled by a blast of cold air. This produces a stressed skin on the component which adds greatly to its physical strength and enables it to withstand the stress created when it heats up as it absorbs infra-red energy.

As an alternative to a heat absorbing glass we may use a *hot mirror*. This is a mirror whose reflecting surface is created by the evaporation of thin layers of materials such as magnesium fluoride, zinc sulphide, titanium oxide and so on. The reflectivity is created by the interference of light which is reflected at the surfaces separating the different layers. The thickness of the layers and their composition are chosen so that visible light is transmitted, while radiation in the infra-red region of the spectrum is reflected. The phenomena called into play are those which are used to produce anti-reflection coatings described earlier in this book, but the different film composition and order of deposition produces the results described.

The elimination of infra-red energy from the beam of light rays, whether by means of heat absorbing glass or by a hot mirror, is of particular importance when negative microfilm or microfiche are used. The extensive black area is a first class absorber of infra-red energy. The heating of the film that is then produced is not usually too important in itself, but it tends to result in a buckling of the film, so

that it is not possible to produce a sharp image over the whole of the image area.

The function of the projection screen is to accept the light which comes to the focused image from the lens in a narrow cone, and to diffuse it into a wider cone so that the image can be viewed from a range of positions.

The characteristics of a screen which determine its usefulness are:

a) Gain.
b) Scattering lobe.
c) Resolving power.
d) Scintillation.
e) Reflection of ambient light.

The *gain* of a screen is measured by comparing its apparent brightness with that of a completely diffusing surface, when the same amount of light falls on equal areas of each. A completely diffusing surface, known technically as a *Lambertian* surface, appears equally bright no matter from what angular aspect it is viewed. A good approximation to such a surface is a sheet of opal glass (not ground glass). For precise work the surface of a magnesium carbonate block is used to establish a reference from which screen gain may be measured.

The use of a completely diffusing surface is justified only when it is absolutely necessary to view the screen image from any angle. Otherwise it wastes light and is quite inefficient.

When the viewing angle of a screen can be restricted to less than the complete space in front of it, then a screen structure may be used which will diffuse light into a cone limited extent. The screen will not look uniformly bright from all points within this viewing area. It will look brightest from a direction which is a continuation of the direction of the light originally arriving at the screen, as shown in Fig. 152. The ratio of this brightness to that of a completely diffusing surface is usually referred to as the *gain* of the screen, although strictly speaking it should be called the maximum gain of the screen.

As the point of view moves from this maximum position the apparent screen brightness falls off. The rate of decrease

432

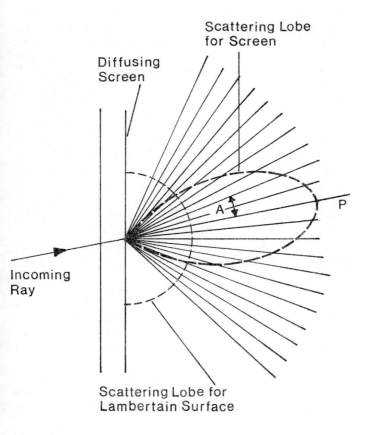

Fig. 152. The screen appears brightest from a point P which lies on the continuation of the incoming ray. For other directions we can measure the apparent brightness by putting a point at a proportionate distance from the screen and so generate a *scattering lobe*.

433

depends on the detailed screen structure. We can measure the brightness for a variety of positions, each defined by the angle A shown in Fig. 152, and draw a curve in which the brightness in a given direction is plotted against the corresponding angle A, as shown in Fig. 152. This curve is referred to as the *scattering lobe* of the screen. The scattering lobe for a complete diffuser is a semi-circle, as also shown in Fig. 152. The area within a lobe curve is always less than the area under the semi-circle, so that a high maximum gain must always be associated with a narrow lobe. Maximum gains up to $15\times$ are possible, but for most work a good compromise between lobe width and gain is obtained with a maximum gain in the region of $3\times$ to $5\times$.

The *illumination* falling upon the screen is measured in *foot-candles*. The term is largely historical in nature and is derived from the very earliest days of photometry, when candles made to a precise formulation were used to make measurements. Meters are available, using photo-electric cells, which measure the illumination in foot-candles. The amount of light which falls upon the complete area of the screen is measured in *lumens*. If the screen area is A square feet, and if its illumination is C foot-candles, then the amount of light is L lumens, where $L = C \times A$.

The *brightness* of the screen is measured in *foot-lamberts*. If the illumination of a completely diffusing screen is C foot-candles then its brightness is F.L. foot-lamberts, and $F.L. = C$. If the screen gain, for a particular viewing angle, is G, then the corresponding relation is that $F.L. = G \times C$. If G is the maximum screen gain then this value of F.L. is the maximum screen brightness.

For most applications of microfilm or microfiche readers, a screen brightness of 50 foot-lamberts is acceptable. This may be compared with the maximum highlight brightness of a colour T-V set which is about 65 foot-lamberts.

The screen brightness is not usually constant over the whole area of the screen. In part this is due to the Cos^4 *factor*. If the ray from the centre of the lens to the corner of the screen makes an angle B with the line joining the centre of the lens to the centre of the screen, then the maximum screen illumination is $Cos^4 B$ times that at the centre of the screen. Thus if a short overall track length length is used, so that B may have a value of 20 degrees,

434

MAKING ILLUMINATION EVEN WITH
A FRESNEL LENS

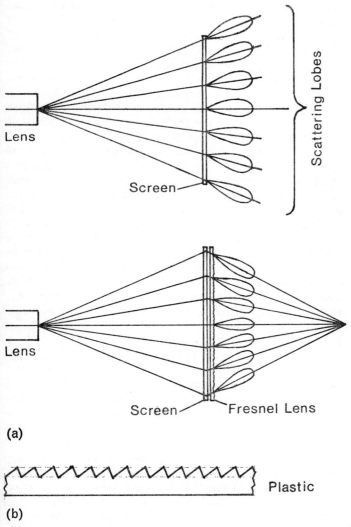

(a)

(b)

Fig. 153. (a) By using a *Fresnel lens* the scattering lobes may be directed in the direction of the observer's eyes. A magnified cross section of a *Fresnel lens* is shown at (b).

then Cos 20 = ·9397 and Cos⁴ 20 = ·7797, and the
maximum corner illumination is only 78% of the centre
illumination on the screen. *Vignetting* in the lens, as des-
cribed in earlier chapters will still further reduce the corner
illumination. A practical amount of vignetting will reduce
the transmission of light through the lens for the corner of
the screen to 75% of the transmission to the centre of the
screen. When these two factors are combined the corner
illumination becomes ·78 × ·75 = 58·5% of the centre
illumination. Such a decrease in the corner illumination is
minimised by keeping the overall track length as long as
possible. Not only is the *Cos⁴ factor* increased, but it is
easier to design a lens with less vignetting.

An extreme type of brightness variation sometimes shows
up as a *hot-spot* in the central area of the screen. When seen
head-on this area is very much brighter than its surround.
As the viewpoint changes, for example when the observer
moves his head, the bright area on the screen moves so that
it is always in line with the reader lens and the observer's
eye. This effect is due to the use of a high gain screen with a
very narrow scattering lobe. The screen area looks bright
only when the narrow lobe is pointing towards the ob-
server's eye. There are two ways to correct this situation.
The first is to substitute a lower gain screen, with a broader
scattering lobe, and with a reduction in peak screen bright-
ness. The second is to use a *Fresnel lens* in conjunction with
the high gain diffusing screen, as shown in Fig. 153. A
Fresnel lens consists of a thin moulded plastic sheet, usually
·10 inches thick or less, which carries concentric sawtooth
grooves on one surface, as shown in Fig. 153, the angles of
the grooves being so arranged that the sheet of plastic
behaves like a lens. Moreover the angles of the grooves can
be chosen so that the plastic sheet behaves like an aspheric
lens, so that it has considerable refractive power without
spherical aberration. The Fresnel lens directs the scattering
lobes of the screen so that they are directed towards an
average position of the observer's eye, so that all parts of
the screen appear equally bright, thus eliminating the hot
spot. Such Fresnel lenses are a standard item of commerce,
with ruling patterns available which range from 50 to the
inch up to 300 per inch.

In earlier types of systems the Fresnel lens was formed by

436

one sheet of plastic while the diffusing surface was provided by a second plastic sheet. This is still a viable approach but the modern trend is to form both Fresnel grooves and the diffusing surface on two sides of a single sheet of plastic.

The next thing that we have to consider is the *resolving* power of the screen. In viewers which are designed for use with pictorial material, such as landscapes or portraits and the like, the screen resolution is nowhere near as important as it is with microfilm or microfiche readers where it can contribute significantly to the legibility of the retrieved material. The resolving power of the screen is closely related to the screen structure adopted.

There are two major ways of producing the diffusion in a viewing screen. In the first method microscopic scattering particles are carried in a transparent matrix, much in the same way that pigment particles are carried in the binder of a common variety of paint. Steps are taken in the manufacturing process to control the size variation of the particles within quite close limits. Such a diffusing surface is capable of giving very high resolution. Thus a *Chromascreen CS*-140 of the *Panelgraphic Corporation*, which has a maximum gain of $3 \cdot 0 \times$, shows a resolution capability of 60 line pairs per millimetre. Such a screen has a negligible effect on system resolution degradation and is to be preferred when the highest quality of information retrieval is required.

In the second type of diffusion screen the surface is comparatively rough, so that on a microscopic scale it presents facets at random orientations to the incoming light rays, so that they are randomly refracted within a certain cone angle. The form of the scattering lobe depends upon the maximum refracting angles that are encountered, and this in turn depends upon the technique used to roughen the plastic mould surface. To produce the required type of mould surface is quite an art in itself. The resolution obtainable with such a surface depends largely on whether it has a coarse or a fine texture. The same type of scattering lobe can be obtained with either a fine or a course finish. In order that no system resolution be lost, it is advisable that the screen resolution should be in excess of 10 line pairs per millimetre.

The screen resolution, whether it be the microscopic particle type of screen or the roughened surface type of

screen, is best examined by projecting an image onto it under conditions which simulate its end use. This enables us to duplicate the relevant scattering mechanism.

The loss in resolution caused by the Fresnel lens rulings themselves is usually quite small, and is much less than might be expected on cursory grounds. For example if a Fresnel lens with 100 lines per inch is laid upon printed matter with 6 point type there is no difficulty in reading the print. This is due to the fact that the steep side of the saw-tooth Fresnel lens pattern occupies a small fraction of the groove spacing, and that the relative slope of the shallower sides of the pattern changes quite slowly over the height of a letter. This net effect is that the Fresnel lens creates fine dark lines across the area covered by a letter. The image break-up is similar to but less severe than the picture break-up caused by the scanning lines in a T-V picture.

The mechanism of diffusion by random refractions at a rough surface has a further consequence in that it introduces *scintillation*. From a statistical point of view any random distribution of refracting facets will contain some that are much larger than the average facet, or groups of facets which will act co-operatively, so that distinctly more than the average amount of light is scattered in a given direction. This produces a series of small highlights which give the screen a sparkling effect that can prove very tiring with prolonged use of the screen. This is what makes it less comfortable to use a microfilm or microfiche reader for any length of time as compared with reading a printed page.

To some extent this effect can be overcome by spraying the diffusing surface with a material which approximates the microscopic type of diffusion screen, but this reduces the screen gain if it is to be really effective. A better approach is to use a finer grain screen. This can be used to provide a substantial improvement, but for the best results and for maximum comfort in prolonged use the microscopic diffusion type of screen is to be preferred. As a rule such a screen has a lower gain than the rough surface screen, and the price that has to be paid for its use is that a larger aperture lens and a higher wattage lamp must be employed to produce the same screen brightness.

Since it is not practical to rely upon using a microfilm or microfiche reader in a darkened room we have to take

into account the effects of ambient light, particularly the loss of image contrast that it may cause. The contrast loss depends on the screen construction. The contrast can be enhanced by using a neutral gray tinted sheet in front of the diffusing surface, so that ambient light traverses this sheet twice before it reaches the observer's eye, while the light from the reader lens goes through this sheet only once. In any assessment of screen performance its behaviour with respect to ambient light must be taken into account.

FUTURE DEVELOPMENTS

The course of future developments will depend primarily on both market needs and technical feasibility. Within the scope of this book we can consider briefly only what possibilities are opened up by currently available optical technology.

The trend is towards a higher density of information storage of prepared material. The straightforward method is to use a high degree of reduction, and systems are available such as the N.C.R. system which use reduction ratios up to $150\times$. The problems of preparing and retrieving such highly condensed material have been discussed in previous pages.

An alternative method is to use a *holographic* technique. The general nature of holographic recording has been described elsewhere in this book.

Just as a hologram can be made from a solid object, it is equally possible to make a hologram from a transparency, such as that produced as an intermediate record in a two stage reduction process. Part of the light from a laser is transmitted through the transparency and a reference beam is brought from the laser by a second path, so that the two lots of light interfere in the plane of a high resolution film to form a hologram. By using a laser beam on the hologram, after the film is developed, an image of the transparency may be reconstructed from the hologram.

The advantage of using a hologram for high density storage is that the information content for any part of the reconstruction is spread over the whole area of the hologram. As a result the holographic technique gives a record which is less sensitive to the effects of dust and scratches. This is a major advantage when high degrees of reduction are used since any individual letter or number may be

439

comparable in size to a speck of dust or to a minute flaw or scratch in the emulsion. The holographic method of recording overcomes this problem.

One of the most important recent developments is the advent of the *phase hologram*, often referred to as a *bleached hologram*. Such a hologram is made in the same way as previously described, by developing the film on which is recorded an interference pattern created by light which has followed two separate paths from an original starting point. There follows, however, a further step in which residual silver is bleached out of the emulsion. What is left is a record in which the hologram information is stored as *phase differences*. In other words the effective path of light in the photographic emulsion carrying the hologram varies from point to point over the surface of the photographic plate. This is in contrast to earlier *amplitude* type of hologram in which the transparency of the hologram varies from point to point over the plate. The brightness of the image which is reconstructed from a phase hologram is greater by a factor of at least ten than that reconstructed, using the same energy, from an amplitude hologram. This opens up a host of possibilities that were not realisable with the lower intensity amplitude hologram.

There are still quite a number of severe technical problems to be solved before holographic techniques come into widespread use, but they offer interesting possibilities.

A quite different approach to expanding the use of microfiche storage of information is the *fly's eye* system.

In this system an array of short focus lenses is used, as shown in Fig. 154, each of which produces a much reduced image of part of an original document. Thus if we have a 25×25 array of small lenses, each working at $25\times$ reduction, then we obtain 625 small images each representing part of the original document. By suitably indexing a photographic plate relative to the lens array, as shown in Fig. 154, we can store a separate group of 625 images on the plate. Altogether this gives the possibility of recording 625 images of a document on a film or plate which has the same dimensions as the original document.

The retrieval is effected by means of an identical array of short focal length lenses. The short focal length of the lenses gives a very compact retrieval unit.

440

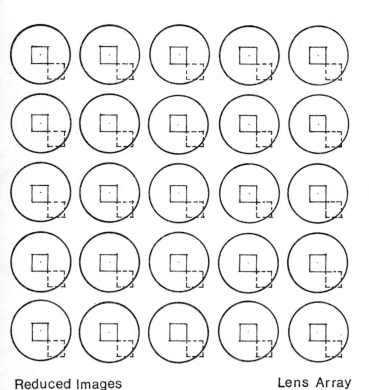

Reduced Images Lens Array

Fig. 154. In the *fly's eye* system a matrix of short focus lenses produces an array of small images, from an original document. By indexing the photographic plate relative to the matrix a second array (shown in dotted lines) can be produced from a second document.

441

The practical success of such a system depends upon the feasibility of moulding the lens arrays from transparent plastic. In particular any shrinkage of the plastic must be carefully controlled, and a proper allowance has to be made for film shrinkage. If these problems can be overcome as technology advances then this will be a very attractive approach for micro-publishing.

Epilogue

This book is a completely re-written edition of *Photographic Optics*. When the epilogue to the first edition of *Photographic Optics* was written in 1942 it represented an attempt to give an informal summary of the position of photographic optics at that time, together with some indication of likely paths of development. The personal views of the author were allowed to enter to a greater extent than in the body of the book, where every effort was made to preserve an impartial and impersonal point of view.

The aim of the epilogue remains the same, but the viewpoint has obviously changed over the years.

In recent years the introduction of electronic computers has had a marked effect on design techniques. The development of a finished lens design requires an enormous amount of calculation. When this had to be done by hand, using logarithmic tables or desk calculators, it was not always possible to explore the full implications of a design concept, because of the long drawn-out calculations which were needed. Excellent designs were, of course, completed. With the introduction of electronic calculators the computational process was speeded up considerably. For example, it used to take almost ten minutes to trace a skew ray through one surface, on a routine basis, using a desk calculator. The same process, with a modern high speed computer, takes less than one-tenth of a second. Facilities such as these provide means for making a much more complete evaluation of a proposed lens design, and are raising the general standard of lens performance.

An important development, within very recent times, is the introduction of techniques of automatic design. In the applications of these techniques we use not only the calculating powers of electronic computers but also their decision-making capability. We present them with alternative choices which they may make, in such a way that they duplicate the creative activities of the skilled optical

443

designer. It has taken a long time to develop the programmes which are necessary in order to carry out such an activity, but several successful programmes are now in routine operation in optical establishments throughout the world. The latest development along these lines is the application of automatic programmes in the design of zoom lenses. The labour of designing a lens has been reduced from weeks and months to days.

A by-product of the automatic design activity is an improvement in the performance of lenses designed in this way. A computer has none of the inhibitions of a human designer, and has more patience and persistence, so that it pursues a line of development to the point where the last ounce of performance is obtained from a given starting point. We may expect that significant improvements in performance will be seen in the coming years as these programmes of automatic design become more commonly used.

The problem still remains of finding a compact way in which to evaluate the performance of a lens. Ultimately it is the picture taking ability that defines the performance of a lens, but it would be desirable to remove all arbitrary elements of personal judgment, as far as possible. During the years of World War II the resolving power of lenses came into widespread use as a criterion of performance. This gave a numerical value which could be used for control purposes in a grossly expanded industry where such a control was badly needed. It gave some indication of the quality of an optical system, but in the years immediately following the war its range of validity was unduly expanded, to the point where, for a while, it became the only criterion of performance. In recent years it has been forced to abrogate this position. Largely as the result of the work of *Eastman Kodak* in the United States, and of others in England, Japan and Europe, the criterion of performance has been more closely related to the rendition of the boundary between a light and a dark area, as recommended by the author and by *H. W. Martin* in 1943. The resolving power is recognised as constituting only one aspect of the curve describing the reproduction of the boundary between light and dark areas; Kodak workers have coined the word *acutance* as a means of describing the curve, and have also introduced the specific term *definition*, discussed on page 165. Frequency

444

response notions have also been introduced as a means of describing picture quality. We are now in the middle of a very interesting period, where techniques have been developed, and where we now have to utilise these techniques in order to provide compact descriptions of lens performance.

Production techniques, both for glass and metal components of lenses, have advanced rapidly since the war years. Improved machine tools have greatly lowered the cost of making the metal parts, while new grinding and polishing materials, and even new techniques of cleaning glass surfaces with ultrasonic energy, for example, have reduced the cost of fabricating the glass components. Methods of controlling the refractive index of the glass itself, by suitable heat treatment, have led to a more uniform product. Aspheric surfaces have not yet found a widespread application, but zoom lenses embodying them have been offered for commercial scale by Taylor Hobson, and high aperture lenses which utilise aspheric surfaces have been offered by *Zeiss* and by *Canon*. So far, except in a restricted range of low priced cameras, no material of the plastics family has been found as an effective substitute for glass in camera or projection lenses.

The most interesting development, from the user point of view, is the development of low cost zoom lenses of outstanding quality.

Not many years ago a zoom lens was the exception, rather than the rule, on moderately priced photographic equipment. The need for zoom lenses had long been obvious. The problem was to design and make lenses of suitable quality at a reasonable price. The world does not stand still, and once the need was established a way was found to satisfy that need. Zoom lenses are now commonplace on 8 and 16 mm movie cameras, on television cameras and on still cameras. Zoom ranges up to 20:1 are available for television cameras, and apertures up to $f1\cdot2$ are in use on 8 mm movie cameras.

Two other recent developments are also worth noting. The first is the emergence of a family of very wide angle lenses based on the inverted telephoto type of construction. Angles up to 110 degrees diagonal coverage are available, with apertures in the region of $f2\cdot8$. These are particularly

445

useful for indoor work, although care has to be taken to avoid perspective distortion.

The second is the advent of multi-layer coatings. The theory of applying thin layers of magnesium fluoride, in order to cut down the reflection of light from the surface of glass, has been described earlier in this book. The theory of depositing several layers of high and low refractive index material, in order to produce a more effective suppression of reflection throughout the visible spectrum, has been established for quite some time. It is only in recent years that techniques of depositing such films in a satisfactory way have been developed. The gain in going from a single layer coating to a multi-layer coating is not as great as that in the first step, namely in going from an uncoated to a coated surface. Consequently it is not so easy to justify the use of multi-layer coatings. They are, however, becoming widely advertised, and over the next few years we can expect to see a continuing trend to their use.

Finally a word must be said about the emergence of the Japanese optical industry as the dominant force in the volume production market. This has been established by a combination of economic and technological factors which provides a fascinating study in itself. The optical industries of other major countries have taken the form where they satisfy comparatively low volume needs, or where they supply lenses for a product in its earlier stages of development. Once a product is mature we can expect the lenses to be procured from Japan. It will be interesting to see whether this trend can be reversed in the years to come.

Appendix

†The basic lens types described in the fourth chapter of this book cover an immense number of specific designs produced by manufacturers all over the world. While many of the more popular lenses are easily recognised as being derived from basic types, there are some which have been modified almost beyond recognition, and in some cases an arbitrary choice has had to be made.

The lens tables and diagrams given in pages 483–559 attempt to survey the field, and to give some idea of the lens forms made and marketed by the most important manufacturers. The lenses mentioned are those listed in the manufacturers' catalogues, and they are classified and set out largely according to information supplied by the makers themselves.

With the passage of time the contents of the lens manufacturers' catalogues change; different constructions may be used for lenses of the same focal length and aperture; and some manufacturers have even ceased to function. Deletion from the list of all designs that have been replaced by newer forms or that are no longer manufactured was considered. There are, however, quite a number of these lenses still

447

around. What has been done therefore is to mark with an asterisk the newer designs which have been added to the lists in this edition.

A problem that arose also was the classification to be used for wide angle lenses of inverted telephoto form. This is a class of lens that has taken on major importance in recent years, but whereas the emphasis used to be placed on the increased back focus of the inverted telephoto construction, the emphasis has now shifted to the wide angle aspect of this type of lens. An arbitrary decision had to be made. The wide angle type has been restricted to those lens forms of almost symmetrical construction, and wide angle lenses of inverted telephoto form have been listed under this category. Revisions to the earlier lists have been made to take this into account.

One point should be emphasised. In addition to the lenses listed or described here, it is often possible to get special lenses for individual jobs from the manufacturers: these are designs which have been developed, and variants of catalogued designs, that have not found their way into regular production, and for specialised work it is always worth while enquiring whether any of these are available and suitable.

Fibre Optics

Until recently an image could only be transferred from one place to another by using lenses and mirrors. Between each lens and mirror the image is transferred by light rays. These, of course, travel in straight lines, and this behaviour places some restrictions on the image transfer. Space must be provided for the light rays to travel between the mirrors and lenses.

By using *fibre optics* an image may be transferred along a curved path, and taken round corners without the restrictions imposed by the use of mirrors and lenses.

The operation of fibre optics depends upon the fact that light may be trapped inside a glass rod. When light rays encounter the surface separating glass and air from inside the glass, they can only escape if the angle of incidence of any particular ray is less than the *critical angle*, as shown in Fig. 155a. As the angle of incidence which any ray makes inside the glass goes from zero, up to the critical angle, the emerging light rays go from a position where they are perpendicular to the air-to-glass surface, to a position where they are parallel to the air-to-glass surface. If the angle of incidence inside the glass increases beyond this critical angle the light rays are reflected back into the glass.

When light enters a glass rod through an end face, some of the light rays escape from the rod the first time that they meet the surface of the glass. Other rays exceed the critical angle and are reflected back into the glass. The important fact is that, when the sides of the rod are parallel, the light which is once reflected back into the glass continues to be so reflected each time that the relevant light rays meet the surface between glass and air. Rays which behave in this manner are trapped inside the rod until they encounter the other end face of the rod. By feeding light into such a glass rod we can transmit it through a considerable distance. The only loss which is sustained, after the initial loss at the first encounter of light rays with the surface of the rod, is that

due to absorption in the glass. By a suitable choice of glass this absorption loss can be held to very low values.

By making the rod small in diameter, and comparatively long, we arrive at a *glass fibre*. What has been said previously about the behaviour of light in a glass rod now holds for a glass fibre. (When the fibres become very small in diameter there are some phenomena which appear because of the wave nature of light, but these are beyond the scope of this book). Light may thus be transmitted through considerable distances inside a glass fibre. However, because of its small diameter, a fibre may be bent, in the same way that a stiff metal wire may be bent. The amount of bending over any distance comparable to the diameter of the fibre is quite small, and because of this the light still remains trapped in the fibre even when the latter is bent. At the same time the amount of bending over distances of an inch or two may be quite large, and it is this fact which gives rise to the usefulness of a glass fibre as a means of transmitting light along a curved path. Fibres of this kind may be made in diameters down to less than one thousandth of an inch.

If some part of the image of a scene is thrown on to the end of a glass fibre, then the greater part of the light in this area is transmitted along the fibre to its exit face. However the detail within the area of the entrance face of the fibre is lost. What emerges from the exit face of the fibre is light which represents an average of the illumination on the entrance face of the fibre, and this light is evenly spread over the exit face of the fibre.

By using a *coherent* bundle of fibres we may transmit a substantial amount of information about an image from one place, where we have the entrance faces of the fibres, to another place where we locate the exit faces of the fibres, as shown in Fig. 155b. A *coherent* bundle is one in which the individual fibres have the same relative positions in the entrance and exit faces of the fibre optics bundle, as shown in Fig. 155b. Each elementary fibre in the bundle transmits only the average of the light which falls on it at the entrance face, but in many cases, as shown on page 270, this is sufficient to give an excellent reproduction of the image formed on the entrance face of the bundle, particularly when the individual fibres are very small in diameter.

The fibres themselves are produced by drawing a fine

FIBRE OPTICS

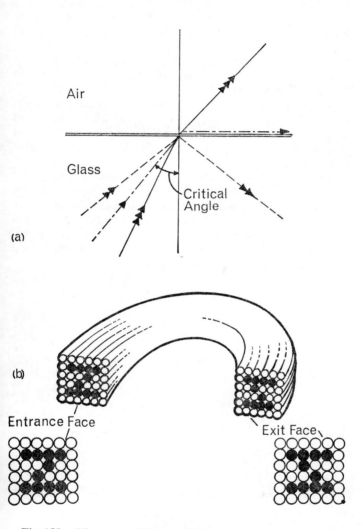

Fig. 155. When rays of light are incident on an air-to-glass surface from inside the glass at less than the *critical angle*, they escape into the air. At the critical angle, as shown in (a) they emerge parallel to the surface of the glass, and when they exceed the critical angle they are reflected back into the glass. By bending a bundle of fibres, as shown in (b) an image may be transferred along a curved path.

thread of molten glass through a small diameter hole. As the glass cools it solidifies into a fibre, and this is wound on to a large diameter drum to give a sheet of fibres. A fibre bundle is formed by placing such sheets of fibres on top of one another. As a rule each fibre is made in such a way that it comprises a central core of high index glass, and an outer skin of low index glass. The useful light is trapped inside the core. The function of the outer skin is to shield the cores from one another, since local pressures between the cores alone might cause flat spots to develop which would permit light to leak from one fibre into its neighbours. This, of course, would upset the proper functioning of the fibre optics bundle.

The manufacture of fibre optics bundles has progressed to the point where they are produced on a commercial scale by a number of companies. Their exploitation is still somewhat limited, particularly as far as photographic optics is concerned, but these fibre optics bundles hold out the possibilities of some very interesting applications which should be realised in the not too distant future.

Automatic Focusing

One of the most important adjustments which must be made in order to obtain the best performance from an optical system, whether it be a camera, an enlarger, a projector or other more complicated piece of equipment, is the focusing adjustment. As a rule this must be done by visual inspection of an image, particularly in the simpler kinds of systems. It is a constant temptation to look for ways in which this visual judgment of an image may be replaced by electronic measurements, so that the output of such an electronic device may be fed into the mechanism which affects the focusing of the system. In this way an automatic method of focusing might be achieved. The essential problem is to devise a substitute for the judgment of the human eye.

It must be realised at the very outset, because all objects in front of the lens do not lie in the same plane, that all images will not be in focus at the same time. In judging the composition of the scene the human observer selects those elements of the scene which have most significance, and the focus setting is established so that these are most sharply defined. If they cannot all be brought into focus at the same time, then a judgment is made as to which is to be preferred at a sacrifice of the others. It is not to be expected that this type of judgment will ever be replaced by the output of an electronic device.

It may be possible, however, to reach a more modest goal. The vast majority of pictures are taken under conditions where the area of main interest lies in the centre of the picture, and the needs of automatic focusing will be satisfied if the best standard of definition is established in this central area. The restriction to such a small central image area reduces the chances that objects in the corresponding region of the scene will lie at strongly varying distances from the lens, and the problem of focusing then reduces to one of obtaining the best average definition of all images which lie in this central area. If this premise is accepted then we are

453

faced with the more amenable problem of devising an instrumental means which will enable us to determine when we have the best overall definition in a small central area. (There will probably be discussion for years to come over the validity of this basic premise. In some ways there is a parallel between this approach to automatic focusing and to the use of electric eye systems as a means of establishing proper exposure levels. In the early days of such systems there was some concern over their validity. It was felt that they would not make adequate allowance for special cases. It is still true that for some kinds of work, particularly of an artistic type, it is preferable to use a combination of human judgment and an exposure meter, but for the majority of picture taking situations the electric eye systems give perfectly acceptable results. The parallel between the two situations is not exact, of course, but there may be the same basic justification in both cases, for the use of electric eye systems and for the use of possible automatic focusing systems, in that they serve for most, but not all, picture taking situations).

Two basic methods have been proposed as means by which the level of average definition may be established.

In the first method, which is exemplified in a system proposed by the *Canon Camera Company*, the light in the focusing area is allowed to fall on a photo-electric cell with non-linear characteristics. In other words, if we double the amount of light which falls on a part of such a cell, we do not double the output of electric current from the cell. The increase may be more or less than twofold, but in what follows we will consider only the case where the output is more than doubled when the light level on the photocell is doubled. When the scene is not in good average focus the image on the photocell is soft, and there are no pronounced variations of light and shade in the image falling on the cell. In fact in the limiting case the illumination on the cell is quite even.

As the focus is improved the light distribution is changed, some areas become brighter while others become less bright. There is a loss of electrical output from those areas of the photocell where the illumination decreases, but this is more than compensated by the increase in output from areas where the illumination increases. There is a net gain

454

AUTOMATIC FOCUSING

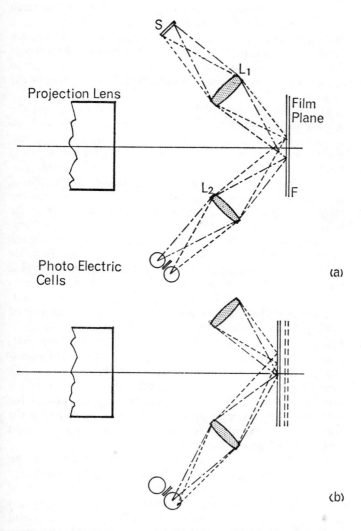

Fig. 156. The automatic focusing of a projector may be effected by reflecting light from the slide. When the focus is correct, as shown in (a), each photo-electric cell receives the same amount of light. With an incorrect focus, as shown in (b), the balance of light is upset and a focusing signal is generated.

in electrical output as the focus on the photocell is sharpened, and the output reaches its maximum when the scene is in best average focus. The lens is therefore moved through its focusing range until the output of the photocell is a maximum, and this is taken as the proper focal setting. An auxiliary photocell is used in order to maintain the average light level, so that variations in the scene brightness due to passing clouds and so on will not affect the operation of the system.

In the second method we make use of the fact that the brightness in a small area of an image may be built up from superimposed brightness patterns of standard form, as explained in detail in pages 166–174. These patterns range in frequency from zero to quite high levels, and at each frequency there is a corresponding amplitude or depth of brightness variation. When the image is in sharp focus the amplitude at any frequency is at a maximum, and as the image goes out of focus the amplitude decreases. We therefore obtain the position of best focus when the amplitude of light variation at any frequency is a maximum. In order to measure the amplitude of this variation a moving grid is placed in the focal plane of the lens. The light which comes through the grid falls on a photo-electric cell, and the output of the cell is fed into a tuned circuit, the frequency of tuning corresponding to the spatial frequency which is being examined and to the rate of movement of the grid. The lens is moved through its focusing range until the output of the cell at a given frequency reaches a maximum. In practice two frequencies are used, a high frequency and a low frequency, and the ratio between the amplitudes for these two frequencies is used as a means of establishing the focus. This eliminates the influence of factors other than a change of focus of the system.

There are quite formidable technical problems to be solved to make these into low cost and compact systems for incorporation in amateur cameras, and at the time of writing (1973) there are no still cameras on the open market which use automatic focusing. There is, however, a system available which embodies the first principle, the *Focatron Sharpness Meter*, but this is primarily intended for enlargers and for use in process cameras.

A problem of quite another type, which may be discussed

456

also under the general heading of automatic focusing, is that of maintaining the focus in a slide projector or in a film projector. As slides are fed into a slide projector they may not lie in focus for two reasons. The first is a variation in the slides themselves, some may be in cardboard mounts of varying thickness, while others may be in metal mounts, and neither kind of slide is made to very close tolerances. The second reason is that the film in the slide varies in position or "pops" under the influence of the heat which is radiated from the projection lamp. The general problem in this case is to maintain the proper relation between the slide and the projection lens once such a relation has been established by a preliminary focusing action.

The method of maintaining the focusing adjustment, as described in recent U.S. patents, is to reflect light from the slide and to observe the behaviour of this reflected light beam as the position of the surface of the slide is varied for one reason or another. Light from the source S and the lens L1 in Fig. 156a is reflected by the surface of the film F, and is directed to two photo-electric cells by the lens L2. This whole system is fixed relative to the projection lens. When the film plane is in its proper position, as shown in Fig. 156a, each photo-electric cell receives an equal amount of light. When the film plane moves from its proper position, as shown in Fig. 156b, the balance is upset and the amount of light falling on the two photo-electric cells is no longer equal. An electrical signal is then generated which causes the position of the film plane, relative to the projection lens and to the focusing system comprising S, L1, L2, and the photo-electric cells, to be changed until the film plane is once more in its proper position. This change may be accomplished either by moving the film plane, or by moving the projection lens and the focusing system as a unit. Infrared light may be used in the focusing system to improve its overall performance. Such a system as that described, or modifications of this type of system, give excellent results in slide projectors once the initial focus has been established.

P.O.—EE

Holograms –
Pictures Without Lenses

Within very recent years the possibility has arisen that it may be feasible to produce pictures in a completely new way, without the use of picture-taking lenses.

The starting point for this development was an optical process proposed by *Denis Gabor*. According to this process a plane transparent object, shown at O in Fig. 157a, is illuminated by a coherent beam of parallel light rays, all of the same colour or wavelength. By *coherent* we mean that the electric forces along each light ray have a fixed relation to one another: there are constant phase differences (preferably zero) and the amplitudes along the various rays have constant ratios. This light is diffracted by the transparency, as explained in earlier chapters in this book. The diffracted light which reaches any point P in the plane H, shown in Fig. 157a, comes from all points in the transparency. The electric forces of the light rays from some of these points will act together to increase the illumination at the point P, while the electric forces from other light rays will be in opposition and will tend to reduce the illumination at P. At any point, such as P, there will be a resultant electric force, characterised by an amplitude and by a phase, and this will describe the light reaching the point P. If we place a photographic plate in the plane H then the distribution of light and shade which is created on this plate is the *hologram* of the transparency. The hologram which is made in this fashion records only the amplitude of the electric force at any point such as P, corresponding to the brightness of illumination at P. No record is made of the phase of the electric force at P.

There is no immediate visual correlation between the pattern of light and shade in the transparency and that which is observed in the hologram. The important factor, however, is that if we illuminate the hologram, as shown in Fig. 157b, with coherent light of the same type that was used

458

in making the hologram, then the transmitted light seems to come from the original transparency located in the plane O_1 in Fig. 144b. This light can be picked up by a lens L, and handled from that point on as if it came from a transparency in the plane O_1 without any reference to the fact that we have used a hologram. We can, in fact, regard the hologram as a temporary means of trapping and holding the light rays from the transparency as they go from the transparency to the lens L.

The reconstruction of the original transparency from the hologram, as described above, is not all that could be desired because of the loss of information about the phase of the electric force at a point such as P in Fig. 157a. A major step was therefore made when *Emmet N. Leith* and *Juris Upatnieks* of the University of Michigan introduced a reference beam, as shown in Fig. 157c. There are a number of ways in which such a reference beam may be introduced, but that shown in Fig. 157c, where a prism is used, is one of the simplest and most effective. The light from this reference beam reaches the plane of the hologram, shown at H in Fig. 157c, and at any point such as P it interferes with the diffracted light which reaches the point P from the transparency in the plane O. In this way we can record, on a plate or film which is located in the plane H, not only the information about the brightness at the point P due to the light diffracted by the transparency, but also the phase of the electric force at P.

In order to effect a reconstruction from the hologram we illuminate the latter with coherent light of the same type that was used in its preparation. If we view the hologram along the direction shown at V1 in Fig. 157d, using a lens or some other viewing device, then we see a reconstruction of the transparency which has the incomplete characteristics of the original *Gabor* system. If we view the hologram along the direction V2, using a lens or telescope, we see a real image of the transparency in the plane I, and if we look at the hologram along the line V3, again using a lens or a telescope, we seem to be looking at the transparency itself in the plane O. The reconstruction seen along V2 or V3 is substantially better than the *Gabor* reconstruction, since it contains the phase information which is lost in the *Gabor* reconstruction.

459

An important further step was made by *Leith* and *Upatnieks* when they introduced a diffusing plate, such as opal glass, in the position shown at D in Fig. 157c. The reconstruction then can be readily observed without the use of an eyepiece or a lens; we seem to be looking at the transparency itself through a window whose size is that of the hologram. The whole process also becomes much less sensitive to imperfections such as dust and scratches on the hologram plate.

A situation of particular interest also develops in that it is possible to superimpose the diffraction patterns of two quite different transparencies in one hologram, and from that hologram to reconstruct the original scenes. This is shown on page 272, where the hologram shown at the top contains all the information which leads to the reconstruction of the scenes shown below.

Such a hologram may be created in a number of ways. In one method the transparencies may be placed at different distances from the hologram plane, and a single reference beam may be used. Alternatively the transparencies may be placed at the same distance from the hologram plane and the reference beam may be varied in direction from one location to another. There are fascinating possibilities of information storage which are opened up by the multiple recording of transparencies in one hologram.

What may be regarded as a natural evolution of holograms with diffusing plates is the application of hologram principles to three-dimensional picture taking. In place of a transparency we may use objects which are distributed in depth in front of the system, but which have no illumination other than the coherent illumination from a suitable source. The light that is returned from the objects which are so illuminated reaches the hologram plane together with light from a reference beam. A hologram is then formed which has both phase and amplitude information within it. When such a hologram is viewed with the aid of coherent illumination we appear to be viewing the original scene in three dimensions through a window constituted by the area of the hologram. As an observer moves his eye the relative positions of objects in the scene reconstruction undergo the same relative changes in position that would be observed if the objects in the original

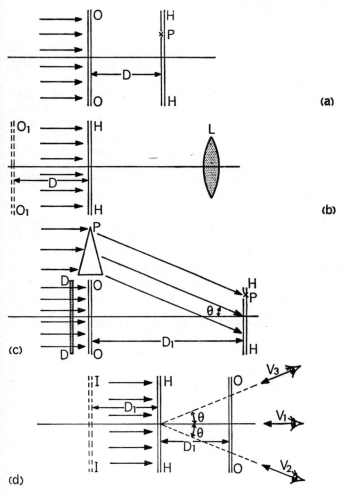

Fig. 157. In the original system proposed by *Gabor*, a *hologram* is prepared by illuminating an object OO in (a) with coherent light. The light diffracted by the object forms the hologram at HH. In reconstruction, as shown in (b), the hologram is illuminated with coherent light and the diffracted light appears to come from an object O_1O_1. (There is a second object picture to the right of HH which is not shown). A major improvement consists in adding a reference beam by means of the prism P, shown in (c). In the reconstruction of the hologram produced in (c), the best images are seen in the directions V2 and V3 of (d).

461

scene were viewed through the same window. We thus have a reconstruction which is much more complete than the reconstruction which is obtained with standard stereo viewing.

Until quite recently the biggest problem has been to obtain a source of monochromatic coherent light of sufficient intensity. It was necessary to use narrow band interference filters, and to pick up light from a very fine pinhole. This led to the production of low intensity coherent light beams. This situation has been radically changed by the development of *laser* light sources. It is beyond the scope of this book to discuss the nature of laser light sources, but it may be remarked that they provide a radically new way of providing high intensity monochromatic coherent light, which may be of considerable value in further developments in the application of holograms.

At the time of writing there is no commercial equipment nor any commercial application which make use of the principles of holograms, and there are considerable technical difficulties to be overcome in producing such commercial equipment, but it would not be a wise thing to predict that such practical applications will not be made in the comparatively near future.

For further information the reader is referred to a series of papers by Leith and Upatnieks in the *Journal of the Optical Society of America:* 52, pp. 1123–1130, October 1962; 53, pp. 1377–1381, December 1963; 54, pp. 1295–1301, November 1964; and to a paper by the same authors in *Scientific American*, 212, pp. 24–35, June 1965.

Spatial Frequency Filtering

It has long been an ambition of optical workers to restore an out-of-focus photograph to a sharply focused condition. There may not be too many occasions when it is really necessary to do this, but it is a source of satisfaction to know that it can be done if it is needed.

In recent years a technique for effecting such a transformation of an out-of-focus photograph has been proposed by *Maréchal* and *Croce*. This technique is known as *spatial frequency filtering*. It depends for its operation on the fact that the brightness distribution in a photographic image can be regarded as constituted by superimposed basic (sinusoidal) patterns of light and shade. Each such pattern is characterised by an amplitude, or depth of brightness variation, and a frequency. Patterns of all frequencies are present, from zero up to quite high values. In a sharply focused photograph the amplitudes will have a certain range of values throughout the frequency range. In an out-of-focus photograph these amplitudes will be less, at any given frequencies, than the amplitudes in a sharply focused photograph. The most important fact is that in an out-of-focus picture the amplitudes at the high frequencies are much more severely reduced than the amplitudes at low frequencies.

If we can develop a way in which the relative proportions of high and low frequency amplitudes may be restored, then we can restore the picture to a sharply focused condition. By using spatial frequency filtering we can do just this.

The principle of spatial frequency filtering is shown in Fig. 158. Light from a very small source S is brought to a focus in the plane F by the lens L1. The out-of-focus negative is placed in the plane O, and its image is formed in the plane I by the lens L2. The essential component in setting up a spatial frequency filtering operation is a special filter which is placed in the plane F. The form of this filter is

463

Fig. 158. The quality of an out-of-focus image on film may be restored by *spatial frequency filtering*, using the arrangement shown above. The critical element is the filter F. This filter receives the light which is diffracted by the high and low frequency components in the object O and favours the transmission of the high frequency components.

governed by the fact that the light from S is diffracted by the basic patterns of brightness variation which add together to give the brightness in the negative. The finer the basic pattern, i.e. the higher its frequency, the more it diffracts light, so that this light is spread away from the exact image of S. This light, of course, then goes on to form the image in the plane I. The filter which is placed at F is made in such a way that it favours the transmission of light which does not lie close to the image of S: in other words it favours the transmission of light which is diffracted by the higher frequencies in the negative. In this way the light from the higher frequencies in the negative is favoured over the light from the lower frequencies of basic patterns. By a proper choice of the filter F it is theoretically possible to restore the balance between light intensities for high and low frequencies in the negative, so that the positive which is obtained in the plane I has all of the characteristics of a sharply focused picture.

The manufacture of a suitable filter to be placed in the plane F is a rather difficult matter, but quite good filters have been made. The results obtained are shown on page 271.

In order to obtain the best results the light source S of Fig. 158 may be replaced by a laser beam of light.

At the present time this method of restoring picture quality finds an application only in special circumstances, but it does represent one of the most interesting optical techniques to be developed in recent years.

Coloured Spot Diagrams

The use of spot diagrams as a means of assessing image quality has been discussed in pages 126 and 128. It was pointed out that by tracing rays from an object point through an optical system, and by marking with a spot the point in which each ray cuts an image plane, we obtain an assembly of spots which shows the aberrations that are present in the system. Such an assembly of spots is a *spot diagram*.

Normally such spot diagrams are made in black and white, and a series of spot diagrams may be made for a range of colours of light. An important technique of making coloured spot diagrams has been developed by *Rudolf Hartmann* of the *Bell & Howell Company*. Such coloured spot diagrams, examples of which are shown in the Frontispiece to this book, represent an excellent way of showing what kind of image will be produced by white light from a point object.

The first step in making such a spot diagram is to prepare individual spot diagrams for each of three or four colours of light. A number of methods may be used for this purpose. At the *Bell & Howell Company* the output from the ray tracing programmes on high speed electronic computers is obtained on punched paper tape. This tape is fed into a specially modified IBM typewriter and the spot diagram for any one colour of light is typed out. (A pin feed is used for the typewriter paper so that precise relative registration of spot diagrams for different colours may be established.) Index marks are also typed on the spot diagram to assist in its accurate alignment for later work. Typical individual spot diagrams for three different wavelengths of light are shown in Fig. 159a.

Reduced photographs of these black and white spot diagrams are taken with a precision camera. In this way we obtain spot diagrams in which each spot is represented by a clear area in an otherwise opaque film.

Each such negative spot diagram is mounted as shown in

466

COLOURED SPOT DIAGRAMS

(a) 489 mμ 589 mμ 656 mμ

(b)

Fig. 159. In (a) are shown the monochromatic spot diagram. which are used to prepare the coloured spot diagrams of the Frontis-piece. In (b) is shown the arrangement for proper aligning of the monochromatic spot diagrams. The technique is explained in the text.

Fig. 159b. The first requirement is to line up the negative so that it is accurately placed for further work. In order to do this a light box is mounted in the viewing position, as shown in Fig. 159b. The projection lens, also shown in Fig. 159b, then forms an image of the spot diagram and its index marks on the viewing screen. The negative spot diagram is carefully adjusted both up and down, and for tilt, so that the index marks line up accurately with fiducial marks on the viewing screen.

The light box is then changed to its copying position, as shown by the dotted lines in Fig. 159b, and the negative spot diagram is photographed with the copy camera using negative sheet film. A colour filter is used, in taking this photograph, which corresponds to the colour of the light for which the spot diagram has been determined, so that a coloured negative of the spot diagram is obtained. This procedure is repeated for spot diagrams of three or four colours, the colour filters being changed for each individual spot diagram and the relative exposures being so adjusted that overlapping areas of the spot diagrams which should produce a white image will actually do so when a contact print or positive transparency is made from the negative sheet film. It is this print, or this positive transparency, which forms the coloured spot diagram.

Such a coloured spot diagram may be used for image synthesis, but even on its own it provides a very significant amount of information about the image of an object point which is formed by white light.

Low Light Level Lenses

In recent years there has been a great deal of interest generated in the use of lenses and optical systems at very low light levels, with conditions of illumination, in fact, which would not normally create any usable image on photographic film.

One area of interest, for example, has arisen in astronomy in connection with the photography of very faint interstellar objects. Of more immediate practical interest is the recording of x-ray images, and the development of observation devices which may be used with only the illumination provided by a star-lit sky. In each case electronic means are used to increase the brightness of an image.

In straight-forward radiological work the x-rays which traverse a patient, and which show features of medical interest, produce a rather dim image on a fluorescent screen. Even with the fastest lenses available it is not a practical proposition to photograph this screen and to record a closely spaced sequence of x-ray pictures. In order to obtain a permanent x-ray record, a sheet of film has to be used in place of a fluorescent screen, and a full sized image is produced on this film.

If a sequence of radiological pictures is to be taken, the problem becomes one of producing an image of sufficient brightness, so that it may be recorded in a fraction of a second, with a level of x-radiation that will not be harmful to the patient. This problem is solved by using an intensifier tube, as shown in Fig. 160.

The original x-ray shadowgraph is formed on a fluorescent screen which is located inside an evacuated envelope. A faint image is formed on the screen, with a brightness level that is too low to be immediately useful. The light from the screen, however, stimulates the emission of electrons from the photo-electric cathode, also shown in Fig. 146. This photo-cathode is placed directly behind the fluorescent

469

screen so that light from the screen does not spread significantly before it stimulates the emission of electrons. These electrons, therefore, are emitted from a pattern which corresponds very closely to the x-ray shadowgraph formed on the fluorescent screen.

The electrons are accelerated by a potential difference of up to 25 000 volts which is applied between the photocathode and an anode, also shown in Fig. 160. The anode, and other electrodes which are mounted in the vacuum of the intensifier tube, focus the streams of electrons in the same way that glass lenses focus bundles of light rays. As a result an inverted image of x-ray shadowgraph is formed on the output screen.

Because the electrons from the photo-cathode are crowded into a smaller area when they encounter the output screen, and because they are given additional energy by the voltage in the tube, the image on the output screen is very much brighter than the original x-ray shadowgraph. Figures quoted by the leading manufacturers claim brightness gains of 500:1 to 5000:1, depending on the intensifier tube model characteristics. Typically the input fluorescent screen may have a diameter of 9 inches, while the output screen has a diameter of ·8 inches or 1·0 inches. The bright image on the output screen of the intensifier tube may be examined visually or it may be recorded with a television or a film camera.

The output-screen image is comparatively small, and operating conditions normally imply that it has to be viewed from a considerable distance, with an appropriate degree of magnification. Thus, a special type of viewing system has to be used to provide both the required magnification and a reasonable degree of freedom in the allowable positions of the observers' eyes. Usually both eyes are used in looking at the magnified image.

One form of such a viewing system is shown in Fig. 161. The heart of the system is the objective lens, a long-focus high aperture lens. For example, in one popular system the objective lens has a focal length of 90 mm. and a $f1·0$ aperture. The performance of this lens has to be related to that of the intensifier tube. The image on the input screen of the intensifier shows a resolution of the order of 4 lines per millimetre. With an input screen having a diameter of

470

X-RAY INTENSIFIER TUBE

Input Fluorescent Screen and Photo-Cathode

Electron Focusing Electrodes (Anodes)

Output Fluorescent Screen

Electron Paths

Tube Envelope

Fig. 160. In an X-ray intensifier tube the electrons emitted from the input fluorescent screen are compressed in area and accelerated by an applied voltage so that they produce a brighter image on the output screen.

9 inches, and an output screen of ·8 inches diameter, with an 11:1 reduction in size, this corresponds to a resolution on the output screen of 44 lpm. At the very least the objective lens must have a resolution in excess of 44 lines per millimetre.

However, because the x-ray shadowgraph may have quite low contrast, it is best to specify the objective lens performance in terms of its modulation transfer function (MTF, see page 174), rather than in terms of its resolving power. The objective lens should have the maximum attainable MTF at 40 to 45 lpm, over the whole area of the output screen of the intensifier tube. If we were to regard such a lens as one intended for photography then the standards of performance required would impose very severe demands upon the design and fabrication of the lens. In particular a very flat field would be required: a departure from flatness of ·001 inches, with an $f1·0$ lens, drops the value of the MTF to 20 per cent at 40 lpm.

This situation is substantially alleviated, however, because the lens is used as a viewing device, and the observers' eyes can focus to compensate for any reasonable curvature of field. For example, with a lens of 90 mm. focal length (3·6 inches) a departure from flatness of ·050 inches requires the observers' eyes to re-focus through one sixth of a dioptre, an entirely acceptable amount.

It becomes feasible, for example, to use a Petzval type of lens if only visual use is required. It is important, however, to correct for spherical aberration, coma and astigmatism because any significant amount of these aberrations causes the image to "swim" and induces eye-strain. The optical problems are still further eased because of the predominantly green colour of light from the phosphor on the output screen. Because of this it becomes less important to correct for sphero-chromatism in such a high aperture lens, and this in turn permits a simpler lens construction.

The first lenses used in this kind of system were essentially scaled up photographic lenses, but in the interests of economy, as the market for intensifier tubes developed, special lenses were made for the purpose. A lens of this aperture is probably not suitable for photographic work.

When it comes to photography of the image on the output screen of the intensifier tube various systems are possible.

472

INTENSIFIER TUBE VIEWING SYSTEM

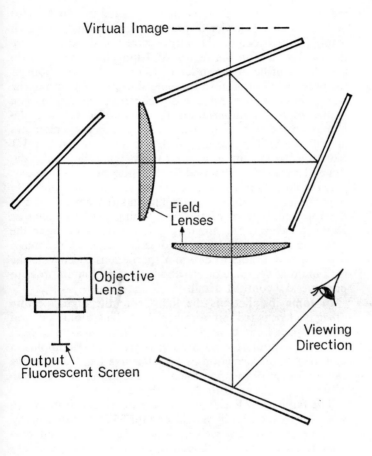

Virtual Image

Field Lenses

Objective Lens

Output Fluorescent Screen

Viewing Direction

Fig. 161. A viewing system comprising an objective lens, two field lenses and a mirror arrangement is used in order to view the image on the output screen of an X-ray intensifier tube.

In principle these systems are straightforward but care must be excercised in the choice of lenses, particularly because high aperture lenses are normally used in order to reduce the exposure of the patient to x-rays.

If the image on the ouput screen of the intensifier is recorded on 16 mm. film, its diameter is reduced by a factor of about three. In order to preserve the information which is initially recorded on the output screen of the tube, where the resolution is in the region of 4 lpm, the resolution on the film must be of the order of 130 lpm. This is about at the practical limit of most fast emulsions, and the use of the fine grain developer and carefully controlled processing is a matter of major importance. This also places heavy demands on the recording lenses because they must maintain as high an MTF value as possible to 130 lpm, with a 3:1 reduction from output screen to film plane. Specially designed lenses should be used for this purpose.

If the reduction is from the output screen to 35 mm. film then the image diameter on the film, apart from clipping at the top and bottom of the film frame, may be taken as about ·8 inches (approximately) and the demands upon the resolving power of the film become less heavy. Once again it becomes desirable to design a special lens to provide the maximum MTF value out to about 50 to 60 lpm in order to preserve low contrast detail.

In some installations the light from the high aperture objective lens is fed into a camera lens. This should be used only if space limitations prohibit the direct pick-up of light from the output screen. Among other things it implies a high degree of correction of the objective lens, because we can no longer draw upon the accommodation of the eye to offset any field curvature in the objective.

The families of lenses which were developed in previous years for 16 and 35 mm. movie, and for 35 mm. still cameras, have performed very well in new areas such as that described above, but as demands upon performance have arisen it has become necessary to design new lenses for these special purposes. This is particularly true in the case of low light level viewing devices, where it is only in very recent times that the military classification has been removed.

There are two basic forms of intensifier tubes which may

474

FORMS OF IMAGE INTENSIFIER

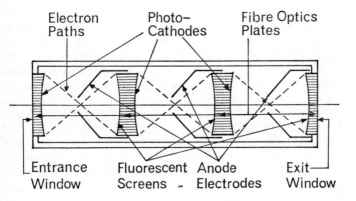

Electron Paths Photo-Cathodes Fibre Optics Plates

Entrance Window Fluorescent Screens Anode Electrodes Exit Window

Fig. 162. A three-stage night vision tube uses a series of photo-cathode and fluorescent screens, with suitable focusing electrodes (anode electrodes) to produce a bright output image. Fibre optics plates are used to couple the screens and cathodes.

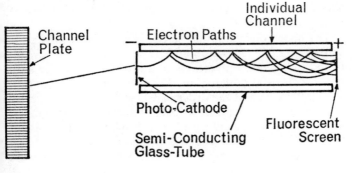

Channel Plate Electron Paths Individual Channel

Photo-Cathode Fluorescent Screen

Semi-Conducting Glass-Tube

Fig. 163. A channel plate image intensifier uses an assembly of small tubes made with semi conducting glass. A repeated increase in the electrons emitted whenever an electron hits the tube walls gives a rapid build-up and a brighter image.

be used for low light level viewing devices. In the older type of tube, shown in Fig. 162, the image of the outside world is formed on the entrance photo-cathode and stimulates the emission of electrons. These electrons are accelerated by a voltage difference between the photo-cathode and the first fluorescent screen. They are also focused by a system of electrodes, not shown in Fig. 162, so that an inverted image of the picture formed on the entrance photo-cathode is formed on the first fluorescent screen. This image is considerably brighter than the original image on the photo-cathode.

The light from this fluorescent screen falls upon a second photo-cathode and once again stimulates the emission of electrons, this time in much greater abundance than the electrons from the entrance photo-cathode. In some forms of intensifier tubes the coupling of the first fluorescent screen to the second photo-cathode is effected by placing them on opposite faces of a fibre optics plate. In this way the light from the phosphor on the fluorescent screen is conducted to the photo-cathode with a minimum of spreading and with a minimum light loss. Each combination of photo-cathode and fluorescent screen constitutes a "stage".

In each stage the image is inverted. In a commonly used device of this kind three stages are used. Since the original image formed on the entrance photo-cathode is inverted, this results in an erect image on the final fluorescent screen. This is coated on a fibre optics plate, the outside surface of which is viewed with an eyepiece.

The image on the output screen is roughly the same size as that on the entrance photo-cathode: no attempt is made to increase picture brightness by reducing image size as is the case for x-ray intensifiers. With such a three-stage tube a brightness gain of the order of 10 000:1 may be achieved.

A more modern form of image intensifier, first publicly shown by Mullard and by EMI in England in 1968, is the "channel plate". Each channel in such a plate consists of a tube of semi conducting glass, with a length that is between 40 and 100 times the tube diameter, as shown in Fig. 163. A voltage gradient is set up along each tube.

The radiation which initially falls upon such a tube stimulates the emission of electrons. These are guided by the voltage gradient so that they strike the walls of the tube,

476

FARRAND CATADIOPTRIC SYSTEM

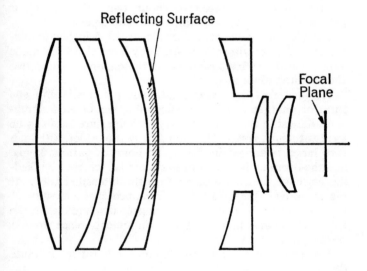

Fig. 164. The demands for long focal length, high aperture and high performance over an extended field, have led to the introduction of catadioptric systems such as that developed by M. Shenker of the Farrand Optical Company (U.S.P. 3,252,373).

where each incident electron then gives rise to a number of secondary electrons. This is a repetitive process, and a greatly increased number of electrons reaches the end of the tube for each electron that is released by the incident radiation. These electrons strike a fluorescent screen and produce an image that is many thousand times brighter than the original image. The maximum brightness which may be produced on the fluorescent screen is about twice that which is produced on a black-and-white television screen.

Channel plates have been made up to 5 inches in diameter on an experimental basis. They have also been made with channels having a diameter in the region of one to two thousandths of an inch.

The fact that light amplification is possible, using one form or another of an intensifier tube, has created significant interest in the design of very high aperture lenses to be used with such tubes. The gain in any intensifier, although very large, is limited by electronic noise of various kinds, and the overall efficiency of the system is increased by feeding as much light as possible into the intensifier tube. At the same time the detailed performance characteristics of an intensifier tube place more stringent demands upon the lens performance than the film requirements place upon a purely photographic lens.

The response to light of different intensifiers is quite different on an intensifier tube and on film. The comparatively faint light from higher order spherical aberration, coma, oblique spherical aberration and chromatic variation of spherical aberration, which would not do much more than raise the general background level on photographic film, provoke a much more harmful response in an intensifier tube. Such a tube is nowhere near as forgiving as photographic film. The same remarks apply to light which is scattered within the lens: particular care must be applied in designing and fabricating the lens mount so that stray light is kept to a minimum.

A second differentiating factor of particular importance between a purely photographic lens and a low light level lens is the greatly extended spectral range of the latter. A normal photographic lens does not have to be well corrected beyond the red end of the spectrum, but a low light level lens has to be corrected into the near infra-red. Secondary

478

spectrum (see page 134) then becomes a major problem, particularly in view of the high aperture that is normally used.

The secondary spectrum may be eliminated, or at least reduced to very small values, by using fluorite or the newest type of optical glass, such as Schott FK51. The problem that faces us with such materials is that they have quite low refractive indices. This makes it difficult to correct the aberrations because the curves on the elements are distinctly deeper than they would be with glasses having higher refractive indices, such as lanthanum crown glasses, which are also comparatively new. In some ways the use of fluorite or FK51 is a step back to the 1880's, with the only advantage that design concepts and design techniques have considerably advanced since that time. Aspheric surfaces prove very useful in designing systems of this kind.

The desire to avoid aspheric surfaces, and at the same time to reduce secondary spectrum, along with all the other aberrations, has directed attention to the so called "catadioptric" systems. This is a form of lens which uses a concave mirror surface to provide most of the required light bending power. In some forms of catadioptric system a smaller convex secondary mirror is also used, in order to obtain some telephoto effect and to neutralize some of the field curvature introduced by the primary concave mirror. The essential point about such a system, however, is that refracting elements are used in order to balance the aberrations of the mirrors, and that for the most part it is possible to effect a design which uses only spherical surfaces on the refracting elements.

An excellent example of such a lens is the Farrand Catadioptric System shown in Fig. 164. This system, designed by M. Shenker, has a focal length of 10 or 15 inches, depending on the model chosen; with a geometric speed of $f1\cdot78$ and, because of the secondary mirror, an effective aperture of T2·38. In both models it covers a field which is 40 mm. in diameter. The secondary mirror in this case is a reflecting area on the third element. The small diameter pair of rear elements is used in order to flatten the field by providing additional positive Petzval sum.

Many other forms of catadioptric system have been developed, some with a higher aperture, some with a

479

shorter focal length and greater angular field coverage, and some with a combination of both. Most of these have been designed for military applications and details of their construction are not available. The standards of performance are high, and the costs that this implies preclude their use for any but specialized applications. Such designs generate new thinking, and the time may not be too far off that this will lead to new lenses in less exotic fields.

Lenses and Their Makers[†]

PETZVAL LENSES AND ALLIED TYPES

Maker	Name of Lens	Focus	Aperture	Field Covered	Diagram
Agfa	Ocellar II	20–50 mm.	f1·6	8 & 16 mm. cine	P4
Aldis	Projection	4–8 in.	f3·2	—	P5
Berthiot	—	35 mm.	f1·3	8 & Super 8 mm.	—
Bell & Howell	—	1 in.	f1·6	8 & Super 8 mm.	P3
	—	23 mm.	f1·2	8 mm. Projection	P10
	—	25 mm.	f1·2	Super 8 mm.	P10
	—	2 in.	f1·2	16 mm.	P11
	Super-Proval	2 in.	f1·6	16 mm. proj.	P12
	Excessalite	2 in.	f1·6	16 mm. proj.	P3
	—	2 in.–4 in.	f1·6–f2·5	16 mm. proj.	P3
	—	2 in.	f1·4	16 mm. proj.	P11
Bolex	Hi-Fi	15 mm.	f1·3	8 & Super 8 mm.	—
		20 mm.	f1·3	8 & Super 8 mm.	—
		25 mm.	f1·3	8 & Super 8 mm.	—
Canon	P–8	19 mm.	f1·4	8 mm. proj.	—
	Canon	38 mm.	f1·8	8 mm. cine	P4
	Canon	50 mm.	f2·2	8 mm. cine	P4
Cerco	—*	30 mm.	f1·0	4·7 mm dia.	P13
	—*	24 mm.	f1·15	4·0 mm dia.	P13
	—*	20 mm.	f1·5	3·25 mm dia.	P14
Dallmeyer	Cine lens	13 mm.	f1·9	8 mm. cine	P2
	Cine lens	1–3 in.	f1·9	8 & 16 mm. cine	P1
	Maxlite	1–4 in.	f1·5	8 & 16 mm. cine	P4
Elgeet	Cine-Navitar	13 mm.	f1·9	8 mm. cine	P5
	Cine-Navitar	25 mm.	f1·9	8 & 16 mm. cine	P5
	Cine-Navitar	38 mm.	f1·5	8 mm. cine	P6
	Cine-Navitar	38 mm.	f1·9	8 mm. cine	P3
	Cine-Navitar	38 mm.	f2·5	8 mm. cine	P4
	Cine-Navitar	50–152 mm.	f1·5–f3·8	16 mm. cine	P3
Ichizuka	Kinotar	38 mm.	f1·4	8 mm. cine	P7
	Kinotar	75 mm.	f1·4	16 mm. cine	P7

† See note on page 447.

PETZVAL LENSES AND ALLIED TYPES

P1

P5

P2

P6

P3

P7

P4

P8

482

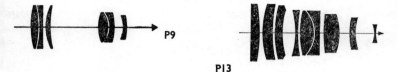

P9

P13

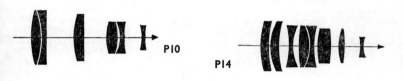

P10

P14

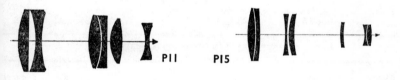

P11

P15

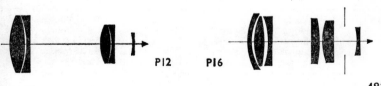

P12

P16

Maker	Name of Lens	Focus	Aperture	Field Covered	Diagram
Kodak	—	13 mm.	f1·9	8 mm. cine	P5
	Proj. Ektanon	0·7–4 in.	f1·6–f2·7	8 & 16 mm. proj.	P3
	Proj. Ektanon	2 in.	f1·6	16 mm. proj.	P8
	Proj. Ektar	2–4 in.	f1·5	16 mm. proj.	P9
	Cine Ektar	4 in.	f2·7	16 mm. cine	P3
	Cine Ektar	150 mm.	f4	16 mm. cine	P3
Norita	—*	400 mm.	f4·5	6 x 6 cm.	P15
Proskar Opt.	Proskar proj.	2–8½ in.	f2–f3·5	35 mm. proj.	P4
Co. Ltd.	Proskar proj.	¾–1 in.	f1·6	8 mm. proj.	P4
	Proskar proj.	1¼–4 in.	f1·6–f2	16 mm. proj.	P4
	Proskar proj.	127 mm.	f3·5	Slide proj.	P4
Ross	Rosskote	3¾–7½ in.	f2·2–3	35 mm. cine	P4
	Rosslyte	3¾–7 in.	f1·9	35 mm. cine	P4
T.T. & H.	Cine Proj.	1–4 in.	f1·6–2·8	8 & 16 mm. cine	P3
	Serital	1½ in.	f1·9	8 mm. cine	P4
	Telekinic	2 in.	f2	16 mm. cine	P1
Tewe	Telagon	125–200 mm.	f2·5–3·2	8, 16 & 35 mm. cine	P1
	Telagon	300–600 mm.	f3·5–5·0	24 x 36 mm.	P1
Wollensak	Cine Raptar	13 mm.	f1·9	8 mm. cine	P5
	Cine Raptar	38 mm.	f1·5	8 mm. cine	P3
Wray	Cine Unilite	4–6 in.	f1·9	35 mm. cine	P4
Zeiss	Kipronar proj.	90–250 mm.	f1·9	35 mm. cine	P3
	H-FT*	200 mm.	f5·6	24 x 36 mm.	P16

SYMMETRICAL LENSES AND ALLIED TYPES

Maker	Name of Lens	Focus	Aperture	Field Covered	Diagram
Agfa	Solagon	50 mm.	f2	50°	S5
Angenieux	—	50 mm.	f1·5, f1·8	24 x 36 mm.	S5
	—	25 mm.	f1·4	16 mm. cine	S5
	—	25 mm.	f0·95	16 mm. cine	S17
	—	28–100 mm.	f1·8	35 mm. cine	S5
Asahi	Takumar	55 mm.	f1·8–2·2	24 x 36 mm.	S13
	Takumar*	50 mm.	f1·4	24 x 36 mm.	S52
	Takumar*	55 mm.	f1·8	24 x 36 mm.	S53
	Takumar	83 mm.	f1·9	24 x 36 mm.	S22
	Takumar*	85 mm.	f1·8	24 x 36 mm.	S54

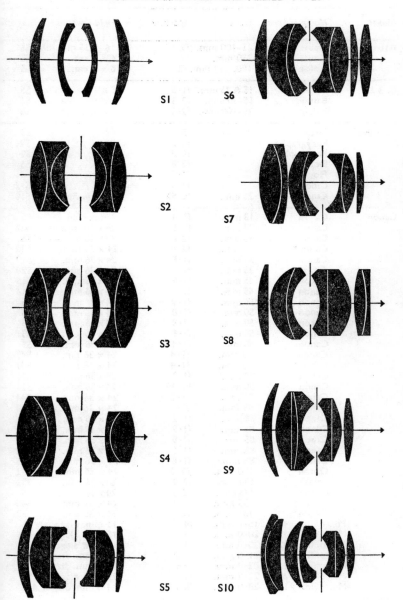

S1

S2

S3

S4

S5

S6

S7

S8

S9

S10

Maker	Name of Lens	Focus	Aperture	Field Covered	Diagram
Astro	Gauss Tachar*	25–100 mm.	f2	16 & 35 mm. film	S5
	Gauss Tachar*	250 mm.	f2	6 x 6 cm.	S5
	Color-Astrar*	100, 150 mm.	f2	6 x 6 cm.	S5
B. & L.	Animar	15 & 25 mm.	f1·5	8 & 16 mm. cine	S5
	Baltar	15–20 mm.	f2·3	16 mm. cine	S5
	Baltar	25–100 mm.	f2·3	35 mm. cine	S5
Berthiot	Orthor	—	f5	62°	S3
	Eurygraphe	—	f6·2	54°	S2
	Perigraphe	—	f6·8	65°	S2
	Flor	—	f2·8	45°	S5
	Flor	—	f1·5	45°	S6
	Cinor	—	f1·5	43°	S12
	Cinor	25 mm.	f0·95	16 mm. cine	S18
Canon	Canon	13 mm.	f1·4	8 mm. cine	S5
	Canon	28 mm.	f3·5	24 x 36 mm.	S32
	Canon	35 mm.	f2·8	24 x 36 mm.	S5
	Canon*	35 mm.	f2·0	24 x 36 mm.	S12
	Canon	35 mm.	f1·8	24 x 36 mm.	S19
	Canon	35 mm.	f1·5	24 x 36 mm.	S20
	Canon	45 mm.	f1·9	24 x 36 mm.	S15
	Canon	45 mm.	f1·7	24 x 36 mm.	S14
	Canon	50 mm.	f1·9	24 x 36 mm.	S5
	Canon	50 mm.	f1·8	24 x 36 mm.	S5
	Canon	50 mm.	f1·8	24 x 36 mm.	S5
	Canon	50 mm.	f1·8	24 x 36 mm.	S31
	Canon	50 mm.	f1·4	24 x 36 mm.	S5
	Canon*	50 mm.	f1·4	24 x 36 mm.	S42
	Canon*	50 mm.	f1·4	24 x 36 mm.	S43
	Canon	50 mm.	f1·2	24 x 36 mm.	S21
	Canon	50 mm.	f0·95	24 x 36 mm.	S21
	Canon*	55 mm.	f1·2	24 x 36 mm.	S44
	Canon*	55 mm.	f1·2	24 x 36 mm.	S48
	Canon	58 mm.	f1·2	24 x 36 mm.	S6
	Canon	85 mm.	f1·9	24 x 36 mm.	S5
	Canon	85 mm.	f1·9	24 x 36 mm.	S15
	Canon	85 mm.	f1·5	24 x 36 mm.	S22
	Canon*	85 mm.	f1·8	24 x 36 mm.	S45
	Canon*	100 mm.	f2·0	24 x 36 mm.	S32
	Canon	100 mm.	f2·0	24 x 36 mm.	S32
	Canon	135 mm.	f2·5	24 x 36 mm.	S5
	Canon*	135 mm.	f2·5	24 x 36 mm.	S46
	Canon*	135 mm.	f2·5	24 x 36 mm.	S32
	(Microfilm) x48*	16·7 mm.	f4	13 mm. diagonal	S5
	(Microfilm) x32*	20·0 mm.	f4	15 mm. diagonal	S15
	(Microfilm) x32*	20·0 mm.	f4	15 mm. diagonal	S5
	(Microfilm) x21·5*	21·0 mm.	f5·6	18·4 mm. diagonal	S5
	(Microfilm) x22*	22·2 mm.	f3·6	19·2 mm. diagonal	S5
	(Microfilm) x20*	22·9 mm.	f4	23 mm. diagonal	S5
	(Microfilm) x16*	28·0 mm.	f6·3	24·8 mm. diagonal	S5

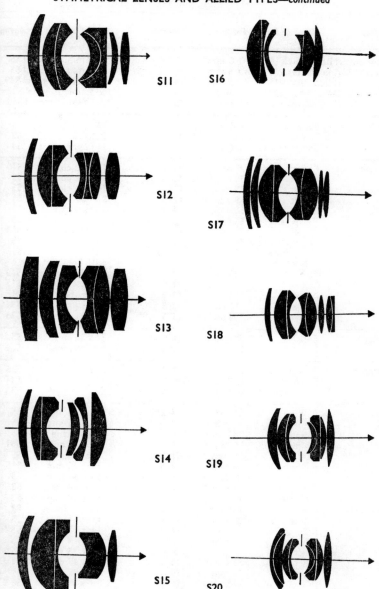

S11

S16

S12

S17

S13

S18

S14

S19

S15

S20

Maker	Name of Lens	Focus	Aperture	Field Covered	Diagr
Cannon —*cont.*	(Microfilm) x16*	30·0 mm.	f6·3	26·8 mm. diagonal	S5
	(Microfilm) x20*	40·5 mm.	f4	19·4 mm. diagonal	S5
	(Microfilm) x15*	40·5 mm.	f4	22·6 mm. diagonal	S49
	(Microfilm) x20*	55 mm.	f5	55·6 mm. diagonal	S33
	(Microfilm) x20*	60 mm.	f5	55·2 mm. diagonal	S50
Dallmeyer	SuperSix	1–8 in.	f1·9	50°	S5
	Septac	2 in.	f1·5	50°	S9
	Speed Anast.	0·6–3 in.	f1·5	16 mm. cine	S4
Elgeet	Elgeet	25 mm.	f1·5	16 mm. cine	S10
	Elgeet	35 mm.	f2·5	16 mm. cine	S5
	Elgeet	35 mm.	f2·0	16 mm. cine	S5
	Elgeet	38 mm.	f2·8	37°	S5
	Elgeet	50 mm.	f2·0	16 mm. cine	S5
	Relay Lens	55 mm.	f2·1	28°	S5
	Elgeet	76 mm.	f2·8	24 x 36 mm.	S33
	Oscillo-Navitar	76 mm.	f1·9	70 mm.	S5
	X-ray Super Navitar	120 mm.	f0·95	18° with field flattener	S17
	Elgeet	125 mm.	f2·8	24 x 36 mm.	S15
	Elgeet	152 mm.	f2·8	2¼ in. x 2¼ in.	S15
	Navitar	154 mm.	f1·9	4·5 in. circle	S17
	Navitar	259 mm.	f3·5	25°	S34
	Elgeet	305 mm.	f3·5	8°	S35
Enna	Ennalyt	50 mm.	f1·9	24 x 36 mm.	S5
	Ennalyt	85 mm.	f1·5	24 x 60 mm.	S26
Farrand	Aero-Farron	to 12 in.	f2·8	to 22½°	S36
	Farron	to 20 in.	f1·9	30°	S37
	Super-Farron	to 6 in.	f0·87	30°	S38
Fuji	Fujinon	38 mm.*	f4·5	24 x 24 mm.	S5
	Fujinon	50 mm.*	f3·5	24 x 36 mm.	S5
	Fujinon PJ	20*, 25 mm.*	f1·4	8 mm. cine	S5
	Fujinon	50 mm.*	f1·4	24 x 36 mm.	S51
	Fujinon	55 mm.*	f1·8	24 x 36 mm.	S5
	Fujinon-Macro	55 mm.*	f3·5	24 x 36 mm.	S15
	Fujinon-E	75 mm.*	f5·6	56 x 56 mm.	S3
	Fujinon-E	90 mm.*	f5·6	56 x 84 mm.	S3
	Fujinon-E	105 mm.*	f5·6	56 x 84 mm.	S3
	Fujinon-E	135 mm.*	f5·6	4 x 5 mm.	S3
	Fujinon-M	20 mm.*	f2·8	11 x 11 mm.	S5
	(Microfilm)	22 mm.*	f2·8	13 x 13 mm.	S5
	(Microfilm)	25 mm.*	f2·8	14 x 14 mm.	S5
	(Microfilm)	35 mm.*	f6·3	16 x 23 mm.	S5
	(Microfilm)	63 mm.*	f3·5	32 x 45 mm.	S5
	(Microfilm)	77 mm.*	f8·0	32 x 45 mm.	S5
	(Microfilm)	12·5 mm.*	f1·8	5·1 x 7·2 mm.	S6

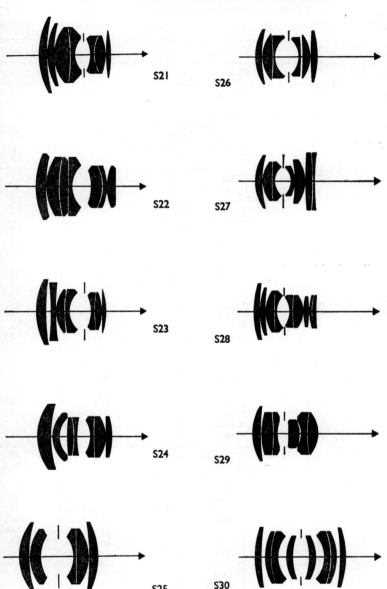

S21

S26

S22

S27

S23

S28

S24

S29

S25

S30

Maker	Name of Lens	Focus	Aperture	Field Covered	Diagram
Goerz	Dagor	1½–19 in.	f6·8–7·7	56°–87°	S2
Ichizuka	Kinotar	25 mm.	f1·4	16 mm. cine	S5
Isco	Westromat etc.	50 mm.	f1·9	24 x 36 mm.	S5
	Super-Kiptar	45–105 mm.	f1·7, 1·8	24 x 36 mm.	S5
Kilfitt	Kilar	62 mm.	f1·4	50°	S5
Kinoptic	Erax	32 mm.	f1·9	16 mm. cine	S5
Kodak	Cine Ektar	25 mm.	f1·4	16 mm. cine	S8
	Cine-Ektar	1 and 2 in.	f1·9	16 mm. cine	S5
	Cine-Ektar II	1 in.	f1·4	16 mm. cine	S8
	Retina-Xenon	50 mm.	f2	24 x 36 mm.	S5
Komura	Komura	35 mm.	f2·8	24 x 36 mm.	S5
	Komura	36 mm.	f1·8	24 x 36 mm.	S6
	Komura	85 mm.	f1·4	24 x 36 mm.	S21
Leitz	Summaron	28 mm.	f5·6	24 x 36 mm.	S3
	Summaron	35 mm.	f2·8	24 x 36 mm.	S5
	Summicron	35 mm.	f2	24 x 36 mm.	S30
	Summicron*	35 mm.	f2	24 x 36 mm.	S47
	Summilux	35 mm.	f1·4	24 x 36 mm.	S39
	Summitar	50 mm.	f2	24 x 36 mm.	S7
	Summicron	50 mm.	f2	24 x 36 mm.	S23
	Summicron*	50 mm.	f2	24 x 36 mm.	S26
	Summicron-R	50 mm.	f2	24 x 36 mm.	S40
	Summaret	50 mm.	f1·5	24 x 36 mm.	S6
	Summilux	50 mm.	f1·4	24 x 36 mm.	S6
	Noctilux*	50 mm.	f1·2	24 x 36 mm.	S5
	Summarex	85 mm.	f1·5	24 x 36 mm.	S11
	Elmaret-R	90 mm.	f2·8	24 x 36 mm.	S15
	Summicron	90 mm.	f2	24 x 36 mm.	S13
	Summilux*	90 mm.	f2	24 x 36 mm.	S13
Meyer	Doppel-anast.	180–240 mm.	f6·8	64°	S2
	Makro-plasmat	105 mm.	f2·7	43°	S14
Minolta	Rokkor	35 mm.	f2·8	24 x 36 mm.	S5
	Rokkor QF	35 mm.	f1·8	24 x 36 mm.	S5
	Rokkor PF	45, 50 mm.	f1·8–2	24 x 36 mm.	S13
	Super Rokkor	50 mm.	f1·8	24 x 36 mm.	S13
	Rokkor-PF*	50 mm.	f1·7	24 x 36 mm.	S40
	Rokkor-PG*	50 mm.	f1·4	24 x 36 mm.	S6
	Rokkor-PG*	50 mm.	f1·2	24 x 36 mm.	S6
	Rokkor-PF*	85 mm.	f1·7	24 x 36 mm.	S58
	Macro-Rokkor*	50 mm.	f3·5	24 x 36 mm.	S5
	Macro-Rokkor QE*	100 mm.	f3·5	24 x 36 mm.	S15
	Micro-Rokkor*	20–63 mm.	f2·8	5 x 9–32 x 45 mm.	S5

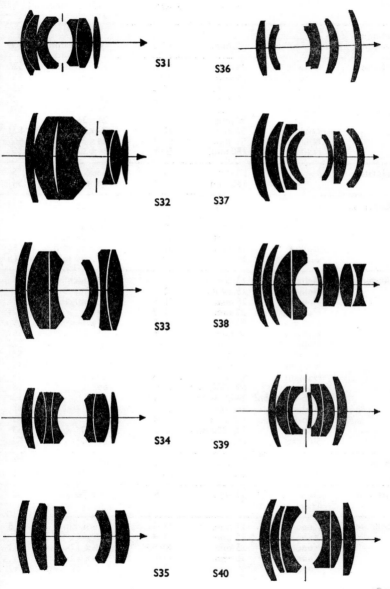

S31

S36

S32

S37

S33

S38

S34

S39

S35

S40

Maker	Name of Lens	Focus	Aperture	Field Covered	Diagram
Minolta —*cont.*	Micro-Rokkor*	32 mm.	f3·5	16 x 23 mm.	S59
Nikon	Cine-Nikkor	25 mm.	f1·8	16 mm. cine	S25
	Cine-Nikkor	25 mm.	f1·4	16 mm. cine	S5
	Nikkor	35 mm.	f2·5	24 x 36 mm.	S5
	Nikkor	35 mm.	f1·8	24 x 36 mm.	S27
	Nikkor	50 mm.	f1·1	24 x 36 mm.	S28
	Nikkor	50 mm.	f1·4	24 x 36 mm.	S6
	Nikkor	50 mm.	f2	24 x 36 mm.	S21
	Nikkor	85 mm.	f1·8	24 x 36 mm.	S5
	Nikkor	180 mm.	f2·5	24 x 36 mm.	S5
Norita	—*	80 mm.	f2	6 x 6 cm.	S5
	—*	135 mm.	f1·4	6 x 6 cm.	S41
Olympus	F Zuiko	38 mm.	f1·8	18 x 24 mm.	S13
	G Zuiko	44 mm.	f1·9	24 x 36 mm.	S8
	Zuiko*	50 mm.	f1·2	24 x 36 mm.	S55
	Zuiko*	50 mm.	f1·4	24 x 36 mm.	S55
	Zuiko*	50 mm.	f1·8	24 x 36 mm.	S56
	Zuiko-Macro*	50 mm.	f3·5	24 x 36 mm.	S15
Rodenstock	Heligon	12·5 mm.	f1·5	8 mm. cine	S5
	Heligon	16, 50 mm.	f2	16 mm. cine	S5
	Heligon	25 mm.	f1·5	16 mm. cine	S5
	Heligon*	32 mm.	f1·3	14·4°	S21
	Heligon	50 mm.	f2·8	24 x 36 mm.	S5
	Heligon	50 mm.	f1·9	24 x 36 mm.	S5
	Heligon*	70 mm.	f1·4	14·4°	S21
	XR Heligon*	75 mm.	f1·1	14·0°	S21
	Heligon	90 mm.	f3·2	60 x 90 mm.	S5
	Heligon	95 mm.	f2·8	60 x 90 mm.	S5
	Rodagon*	50*-300 mm.	f5·6	60°	S3
	Apo-Rodagon*	240,* 300 mm.	f5·6	60°	S3
	Rodagon*	360 mm.	f6·8	60°	S3
	Apo-Rodagon*	360 mm.	f6·8	60°	S3
	Sironar*	100-300 mm.	f5·6	60–70°	S3
	Sironar*	360 mm.	f6·8	60–70°	S3
Ross	Homocentric	7–12 in.	f6·3	60°	S1
	Xtralux	2 in.	f2	24 x 36 mm.	S5
Schacht	Super-Travelon	50 mm.	f1·8	24 x 36 mm.	S5
Schneider	Xenon	13 mm.	f1·5	8 mm. cine	S13
	Xenon*	25 mm.	f1·4	9·6 x 12·8 mm.	S7
	Xenon*	25 mm.	f0·95	9·6 x 12·8 mm.	S61
	Xenon*	35 mm.	f2·0	9·6 x 12·8 mm.	S5
	Xenon*	50 mm.	f2·0	9·6 x 12·8 mm.	S62

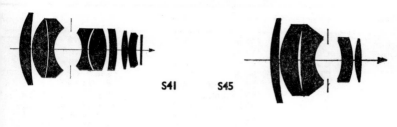

S41 S45

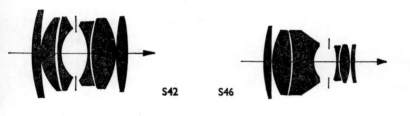

S42 S46

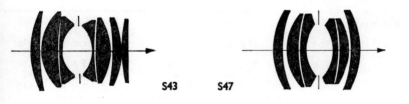

S43 S47

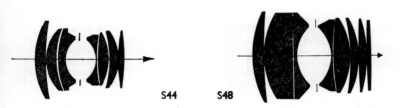

S44 S48

Maker	Name of Lens	Focus	Aperture	Field Covered	Diagram
Schneider —cont.	Xenon*	50 mm.	f0·95	9·6 x 12·8 mm.	S63
	Cine-Xenon	16 mm.	f2·0	16 mm. cine	S5
	Cine-Xenon	25 mm.	f1·4	16 mm. cine	S7
	Cine-Xenon	50 mm.	f2	16 mm. cine	S6
	Xenon*	28–40 mm.	f2·0	18 x 24 mm.	S5
	Xenon*	50–100 mm.	f2·0	18 x 24 mm.	S6
	Xenon*	300 mm.	f2·0	18 x 24 mm.	S60
	Xenon	40 mm.	f1·9	24 x 24 mm.	S13
	Xenon	50 mm.	f1·9	24 x 36 mm.	S5
	Xenon*	50 mm.	f1·8	24 x 36 mm.	S5
	Xenotar	80–150 mm.	f2·8	56–60°	S64
	Xenotar	135 mm.	f3·5	59°	S15
	Xenotar*	75 mm.	f3·5	6 x 6 cm.	S5
	Symmar*	100–360 mm.	f5·6	6·5 x 9 cm. –30 x 40 cm.	S3
	Componon*	16 mm.	f2·8	7·5 x 10·3 mm.	S5
	Componon*	25 mm.	f2·8	8·3 x 11·4 mm.	S7
	Componon*	28–40 mm.	f4·0	18 x 24 mm.	S5
	Componon*	50 mm.	f4·0	24 x 36 mm.	S64
	Componon*	60, 80 mm.	f5·6	4 x 4, 6 × 6 cm.	S3
	Componon-S*	100–360 mm.	f5·6	6·5 x 9 cm –30 x 40 cm.	S3
	Graphic Claron*	150–355 mm.	f9·0	38·2–95·7 cm. at 1:1	S3
	Copy Claron*	135–240 mm.	f4·5–f5·6	31·2 cm.–36·4 cm. at 1:1	S3
Steinheil	Orthostigmat	35 mm.	f4·5	64°	S3
Tomioka	Auto-Tominon*	55 mm.	f1·2	24 x 36 mm.	S57
	Tominon-Macro*	60 mm.	f2·8	24 x 36 mm.	S15
	Tominon-TV*	25 mm.	f0·95	9·5 x 12·7 mm.	S21
	Tominon-M*	15 mm.	f3·5	11·3 mm. dia.	S5
	Tominon-C*	150 mm.	f4·5	229 mm. dia.	S3
T.T. & H.	Deep Field Panchro	4 in.	f2·5	35 mm. & 24 x 36 mm.	S5
	Anastigmat	2 in.	f2	24 x 36 mm.	S5
	Double Speed Panchro	40, 50 mm.	f2	24 x 36 mm.	S5
	Ivotal	1 in.	f1·4	16 mm. cine	S5
	Speed-Panchro Series II	32–50 mm.	f2	35 mm. cine	S6
	Speed Panchro	25–75 mm.	f2	35 mm. cine	S5
Voigtlander	Ultron	50 mm.	f2	24 x 36 mm.	S13
	Nokton	50 mm.	f1·5	24 x 36 mm.	S10
	Septon	50 mm.	f2	24 x 36 mm.	S24
Wollensak	Cine Raptar	1–2 in.	f1·5	16 mm. cine	S5

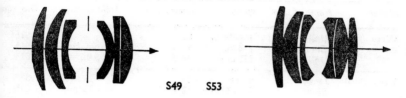

S49 S53

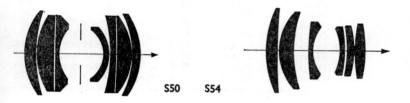

S50 S54

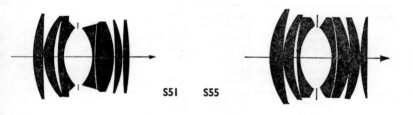

S51 S55

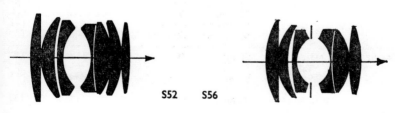

S52 S56

Maker	Name of Lens	Focus	Aperture	Field Covered	Diagram
Wray	Unilite	1⅜–5½ in.	f2	53°	S15
	Cine Unilite	1–4 in.	f1·9	35 mm. cine	S15
	Unilite	135 mm.	f4·5	4 x 5 in.	S15
Zeiss (Jena)	Jena B	58 mm.	f2	24 x 36 mm.	S5
	Biometar	80–120 mm.	f2·8	24 x 36 mm.	S15
				2½ x 2½ in.	
	Flexon	50 mm.	f2	24 x 36 mm.	S5
Carl Zeiss	Biometar	35 mm.	f2·8	24 x 36 mm.	S15
(Oberkochen)	Biotar	24–58 mm.	f1·5–2·0	40°	S5
	Planar	16 mm.	f2	42°	S5
	Planar	25 mm.	f2	28°	S5
	Planar	32 mm.	f2	49°	S5
	Planar	50 mm.	f2	24 x 36 mm.	S5
	Planar	55 mm.	f1·4	24 x 36 mm.	S6
	Planar	75 mm.	f3·5	60 x 60 mm.	S25
	Planar	80 mm.	f2·8	24 x 36 mm.	S16
	Planar	100, 135 mm.	f2·8, 3·5	58°	S25

COOKE TRIPLET LENSES AND ALLIED TYPES

Maker	Name of Lens	Focus	Aperture	Field Covered	Diagram
Agfa	Agomar	100–150 mm.	f2·8–3·2	—	T1
	Agnar	85–105 mm.	f4·5–6·3	56°	T1
	Apotar	50–105 mm.	f3·5–4·5	56°	T1
	Solinar	50–105 mm.	f2·8–4·5	56°	T4
	Kine-anast.	12 mm.	f2·8	8 mm. cine	T1
	Color-Ambion	35 mm.	f4·0	24 x 36 mm.	T4
	Color-Solinar	50 mm.	f2·8	24 x 36 mm.	T4
Aldis	Anastigmat	1·4–2 in.	f3	—	T1
	Projection	4–18½ in.	f2·8–4·5	—	T1
	—	50 mm.	f2·5	24 x 36 mm.	T2
	—	85 mm.	f2·5	24 x 36 mm.	T1
Angenieux	—	12·5 mm.	f1·8	8 mm. cine	T2
	—	35 mm.	f1·8	8 mm. cine	T5
	—	75 mm.	f2·5	16 mm. cine	T11
	—	90–135 mm.	f1·8–2·5	24 x 36 mm.	T11
	—	90–135 mm.	f2·5–3·5	24 x 36 mm.	T5
Asahi	Macro-Takumar*	50 mm.	f4	24 x 36 mm.	T4
	Takumar	58 mm.	f2·4	24 x 36 mm.	T31
	Ultra-Achromatic Takumar*	85 mm.	f4·5	24 x 36 mm.	T37

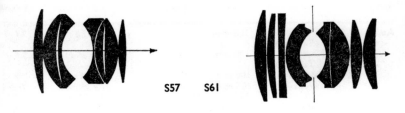

S57 S61

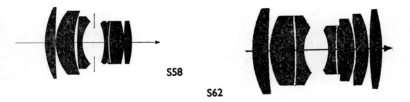

S58

S62

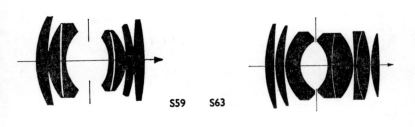

S59 S63

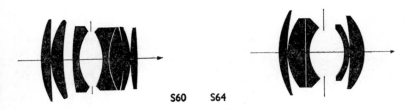

S60 S64

Maker	Name of Lens	Focus	Aperture	Field Covered	Diagram
Asahi —*cont.*	Bellows-Takumar*	100 mm.	f4	24 x 36 mm.	T7
	Macro-Takumar*	100 mm.	f4	24 x 36 mm.	T7
	Takumar	100 mm.	f3·5	24 x 36 mm.	T9
	Takumar	105 mm.	f2·8	24 x 36 mm.	T9
	Takumar*	105 mm.	f2·8	24 x 36 mm.	T38
	Takumar*	120 mm.	f2·8	24 x 36 mm.	T38
	Takumar	135 mm.	f3·5	24 x 36 mm.	T8
	Takumar*	135 mm.	f2·5	24 x 36 mm.	T39
	Takumar*	135 mm.	f3·5	24 x 36 mm.	T40
	Takumar	1000 mm.	f8	24 x 36 mm.	T1
Astro	Tachar*	125 mm.	f2·3	24 x 36 mm.	T2
	Tachar*	150 mm.	f2·3	24 x 36 mm.	T2
	Tachar*	150 mm.	f1·8	24 x 36 mm.	T2
	Telastan*	200 mm.	f3·5	24 x 36 mm.	T2
	Telastan*	300 mm.	f3·5	6 x 6 cm.	T2
	Telastan*	500 mm.	f4·5	6 x 6 cm.	T2
	T-V Tachar*	25–75 mm.	f1·5	9·6 x 12·8 mm.	T56
	Tachar*	100 mm.	f1·8	9·6 x 12·8 mm.	T56
	Tachonar*	25, 35 mm.	f1·0	9·6 x 12·8 mm.	T57
	Tachonar*	50, 75 mm.	f1·0	16 x 22 mm.	T57
	Tachon*	65 mm.	f0·75	27 mm. dia.	T58
B. & L.	Animar	12·5–50 mm.	f2·5–3·5	8 & 16 mm. cine	T1
	Animar	14–26 mm.	f1·9	8 & 16 mm. cine	T3
	Animar	75–100 mm.	f3·5	16 mm. cine	T5
Berthiot	Olor	—	f5·7–6·8	60°	T13
	Flor	—	f4·5	58°	T13
	Flor	—	f3·5	56°	T4
	Cinor	—	f1·9	27°	T2
	Cinor proj.	—	f1·8	41°	T19
	Stellor	—	f3·5	40°	T1
Canon	Canon	13 mm.	f1·8	8 mm. cine	T2
	Canon	25 mm.	f1·8	8 mm. cine	T2
	Canon SD	28 mm.	f2·8	18 x 24 mm.	T34
	Canon	28 mm.	f2·8	18 x 24 mm.	T34
	Canon*	38 mm.	f2·8	24 x 36 mm.	T4
	Macro-Canon*	50 mm.	f3·5	24 x 36 mm.	T4
	Canon	50 mm.	f3·5	24 x 36 mm.	T4
	Canon SD	50 mm.	f2·8	18 x 24 mm.	T36
	Canon	50 mm.	f2·8	24 x 36 mm.	T4
	Canon	50 mm.	f1·5	24 x 36 mm.	T18
	Canon*	85 mm.	f1·8	24 x 36 mm.	T41
	Canon*	100 mm.	f3·5	24 x 36 mm.	T43
	Canon	135 mm.	f3·5	24 x 36 mm.	T12
	Canon*	135 mm.	f2·5	24 x 36 mm.	T42
	Canop*	200 mm.	f2·5	24 x 36 mm.	T44
	Canon*	200 mm.	f4·5	24 x 36 mm.	T45

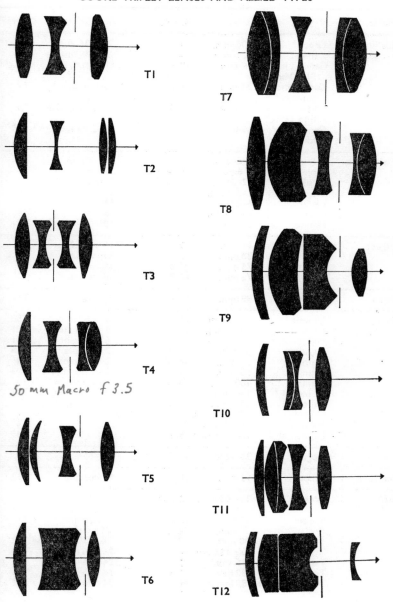

T1

T2

T3

T4

50 mm Macro f 3.5

T5

T6

T7

T8

T9

T10

T11

T12

Maker	Name of Lens	Focus	Aperture	Field Covered	Diagram
Canon	Canon*	300 mm.	f4	24 x 36 mm.	T46
—cont.	Canon*	400 mm.	f4·5	24 x 36 mm.	T46
	Canon Micro-film 24x*	16 mm.	f3·5	11·1 mm. diag.	T4
	Canon Micro-film 24x*	24 mm.	f3·5	18·0 mm. diag.	T4
	Canon Micro-film 13·4x*	48 mm.	f6·3	31·8 mm. diag.	T4
	Canon Micro-film 6·5x*	60·8 mm.	f8	65·0 mm. diag.	T68
Dallmeyer	Triple anast.	0·6–3 in.	f2·9	8 & 16 mm. cine	T1
	Projection	3–6 in.	f3·5–4·5	24 x 36 mm.	T1
	Epidiascope	12–24 in.	—	3¼ x 3¼ in.	T1
	Serrac	1–⅞–18 in.	f4·5	53°	T4
	Perfac	6–30 in.	f6·3	53°	T4
	Dalmac	1⅞–15 in.	f3·5	50°	T4
	Pentac	3–12 in.	f2·9	50°	T7
Elgeet	Elgeet	17 mm.	f2·8	16 mm. cine	T1
	Cinemater	38 mm.	f2·7	8 mm. cine	T2
	Elgeet	75 mm.	f2·8	16 mm. cine	T1
	Cine-Navitar	75 mm.	f2·9	16 mm. cine	T1
Enna	Ennalyt	95 mm.	f2·8	24 x 36 mm.	T1
Fuji	Fujinon*	11·5 mm.	f1·8	8 mm. cine	T50
	Fujinon PJ*	19·0 mm.	f1·3	8 mm. cine	T51
	Fujinon PJ*	25·0 mm.	f1·4	8 mm. cine	T51
	Fujinon*	38 mm.	f2·8	24 x 36 mm.	T48
	Fujinar-E*	50 mm.	f4·5	24 x 36 mm.	T4
	Fujinon	50 mm.	f1·2	24 x 36 mm.	T23
	Fujinon*	100 mm.	f3·5	56 x 84 mm.	T4
	Fujinon-T*	100 mm.	f2·8	24 x 36 mm.	T47
	Fujinon-T	135 mm.	f3·5	24 x 36 mm.	T5
	Fujinar*	180–300 mm.	f4·5	59°	T4
	Fujinon-L*	210–420 mm.	f5·6, 8	59°	T4
	Fujinon SF*	250, 420 mm.	f5·6	58°	T49
Goerz	Dogmar	3½–12 in.	f4·5	48°–55°	T3
Ichizuka	Kinotar	13 mm.	f1·4	8 mm. cine	T30
Isco	Westar	35–105 mm.	f2·8–f6·3	24 x 23 mm. to 60 x 90 mm.	T1
	Iscotar	50 mm.	f2·8	24 x 36 mm.	T1
	Projar*	50 mm.	f2·8	24 x 36 mm.	T1
	S-Projar*	90 mm.	f2·5	24 x 36 mm.	T52
	Isconar	100, 135 mm.	f4	24 x 36 mm.	T1
	Tele-Iscaron	135 mm.	f2·8	24 x 36 mm.	T12
	Tele-Iscaron	180 mm.	f2·8	24 x 36 mm.	T34
	Tele-Westanar	180 mm.	f4	24 x 36 mm.	T12

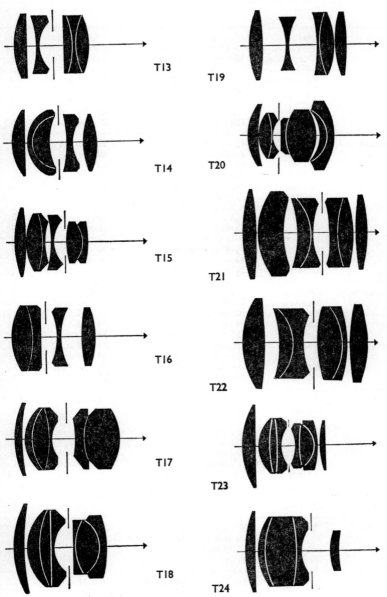

T13

T14

T15

T16

T17

T18

T19

T20

T21

T22

T23

T24

Maker	Name of Lens	Focus	Aperture	Field Covered	Diagram
Kern	Yvar	13–150 mm.	f1·9–4	8 & 16 mm. cine	T6
	Cine Switar	13–25 mm.	f1·4, 1·5	8 & 16 mm. cine	T22
	Photo Switar	50 mm.	f1·8	24 x 36 mm.	T21
Kilfitt	Makro-Kilar	40 mm.	f2·8	24 x 36 mm.	T4
	Kilar	90 mm.	f2·8	24 x 36 mm.	T4
	Kilar	135 mm.	f3·8	24 x 36 mm.	T1
	Kilar	150 mm.	f3·5	24 x 36 mm.	T1
	Grand-Kilar	180 mm.	f1·9	24 x 36 mm.	T5
Kodak	Cine Ektanon	13 mm.	f1·9	8 mm. cine	T1
	Anaston	35–52 mm.	f3·5, f4·5	50°	T1
	—	43 mm.	f8	62°	T1
	Anastar	44 mm.	f3·9	52°	T1
	Ektanar	44, 50 mm.	f2·8	52°	T1
	Kodar	72 mm.	f8	58°	T1
	Proj. Ektanon	4, 5, 7 in.	f3·5	slide proj.	T1
	Proj. Ektanon	5 in.	f2·8	20°	T5
	Cine Ektar	25 mm.	f2·5	16 mm. cine	T4
	Ektar	4–12 in.	f4·5	52°	T4
	Comm. Ektar	8½–14 in.	f6·3	60°	T4
	Cine Ektar	1 in.	f1·9	16 mm. cine	T9
	Cine Ektar	2½ in.	f2	16 mm. cine	T28
Komura	Komura	105 mm.	f3·5	24 x 36 mm.	T1
	Komura	105 mm.	f2·8	24 x 36 mm.	T11
	Komura	105 mm.	f2·5	24 x 36 mm.	T11
	Komura	105 mm.	f2·0	24 x 36 mm.	T11
	Komura	135 mm.	f3·5	24 x 36 mm.	T1
	Komura	135 mm.	f2·8	24 x 36 mm.	T11
	Komura	135 mm.	f2·3	24 x 36 mm.	T11
	Komur	135 mm.	f2·0	24 x 36 mm.	T11
	Komura	200 mm.	f3·5	24 x 36 mm.	T11
Leitz	Hektor	28 mm.	f6·3	24 x 36 mm.	T7
	Elmar	50, 65, 90 mm.	f2·8	24 x 36 mm.	T4
	Elmar	90 mm.	f4	24 x 36 mm.	T1
	Elmarit	90 mm.	f2·8	24 x 36 mm.	T32
	Summicron-R*	90 mm.	f2	24 x 36 mm.	T11
	Macro-Elmar*	100 mm.	f4	24 x 36 mm.	T4
	Hektor	125 mm.	f2·5	24 x 36 mm.	T10
	Elmar	135 mm.	f4	24 x 36 mm.	T5
	Elmarit	135 mm.	f2·8	24 x 36 mm.	T35
	Elmarit-R	135 mm.	f2·8	24 x 36 mm.	T35
Meyer	Trioplan	50–360 mm.	f2·8–4·5	24°–60°	T1
	Primotar	85–180 mm.	f3·5	26°–52°	T4
	Primoplan	58–75 mm.	f1·9	32°–41°	T14
	Helioplan	40 mm.	f4·5	56°	T3
Minolta	Rokkor	22–25 mm.	f2·8–3·5	10 x 14 mm.	T1
	W-Rokkor	35 mm.	f3·5	24 x 36 mm.	T4

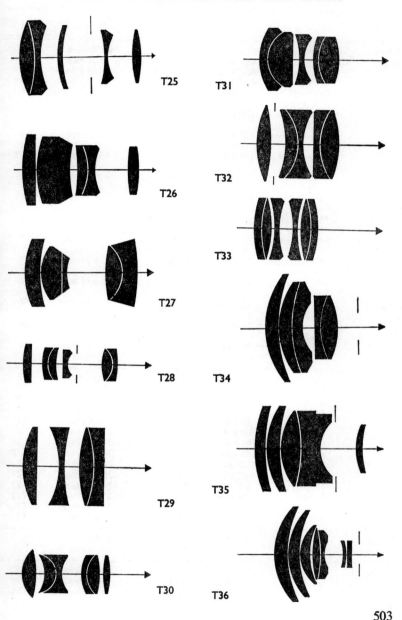

T25

T26

T27

T28

T29

T30

T31

T32

T33

T34

T35

T36

Maker	Name of Lens	Focus	Aperture	Field Covered	Diagram
Minolta —cont.	Rokkor	45 mm.	f3·5	24 x 36 mm.	T4
	Rokkor TE	45 mm.	f2·8	24 x 36 mm.	T7
	V-Rokkor	60–75 mm.	f2·8–3·2	4 x 4–6 x 6 cm.	T1
	Rokkor TD	60–75 mm.	f3·5	4 x 4–6 x 6 cm.	T4
	Bellows-Rokkor*	100 mm.	f4	24°	T1
	Tele-Rokkor-PF*	100 mm.	f2·5	24 x 36 mm.	T62
	Tele-Rokkor-QD*	135 mm.	f3·5	24 x 36 mm.	T5
	Tele-Rokkor-RF*	135 mm.	f2·8	24 x 36 mm.	T63
	Tele-Rokkor-PE*	200 mm.	f4·5	24 x 36 mm.	T64
	Tele-Rokkor-QF*	200 mm.	f3·5	24 x 36 mm.	T65
	Micro-Rokkor* x24	16 mm.	f2·8	10 x 12·7 mm.	T4
	Micro-Rokkor* x21	20 mm.	f2·8	10 x 14 mm.	T4
	Micro-Rokkor* x15	23 mm.	f2·8	12 x 17 mm.	T4
	Micro-Rokkor* x18	25 mm.	f3·5	12 x 15 mm.	T4
	Micro-Rokkor* x24	32 mm.	f3·5	12 x 16 mm.	T4
	Micro-Rokkor* x25	63 mm.	f5·6	32 x 45 mm.	T4
	Micro-Rokkor* x8·3	75 mm.	f4·5	32·5 x 46 mm.	T4
Nikon	Cine-Nikkor	13 mm.	f1·8	8 mm. cine	T2
	Cine-Nikkor	50 mm.	f1·8	16 mm. cine	T9
	Nikkor	35 mm.	f3·5	24 x 36 mm.	T4
	Nikkor	50 mm.	f3·5	24 x 36 mm.	T4
	Nikkor	50 mm.	f2	24 x 36 mm.	T17
	Nikkor	50 mm.	f1·4	24 x 36 mm.	T18
	Nikkor	85 mm.	f2	24 x 36 mm.	T24
	Nikkor	85 mm.	f1·5	24 x 36 mm.	T18
	Nikkor	105 mm.	f4	24 x 36 mm.	T1
	Nikkor	105 mm.	f2·5	24 x 36 mm.	T24
	Nikkor	135 mm.	f3·5	24 x 36 mm.	T12
	Nikkor	250 mm.	f4	24 x 36 mm.	T12
	Nikkor	350 mm.	f4·5	24 x 36 mm.	T1
	Nikkor	500 mm.	f5	24 x 36 mm.	T1
Norita	—*	160 mm.	f4	6 x 6 cm.	T53
	—*	240 mm.	f4	6 x 6 cm.	T53
Olympus	Zuiko*	85 mm.	f2	24 x 36 mm.	T54
	Zuiko*	100 mm.	f2·8	24 x 36 mm.	T55
	Zuiko*	135 mm.	f2·8	24 x 36 mm.	T55

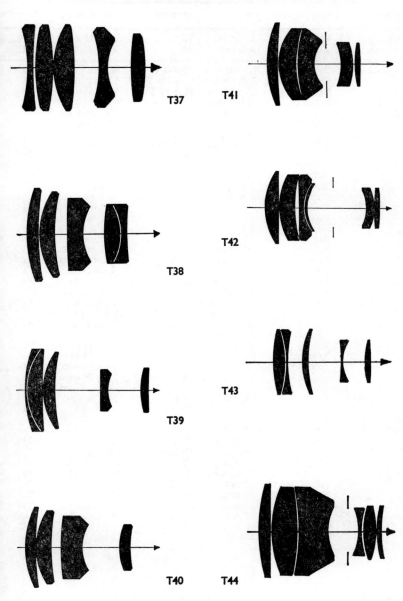

T37

T41

T38

T42

T39

T43

T40

T44

Maker	Name of Lens	Focus	Aperture	Field Covered	Diagram
Olympus	Zuiko*	135 mm.	f3·5	24 x 36 mm.	T11
—cont.	Zuiko*	200 mm.	f4	24 x 36 mm.	T11
Rodenstock	Trinar proj.	50–100 mm.	f2·8–3·6	46°–56°	T1
	Splendon proj.	200–600 mm.	f3·5–10·5	12°–38°	T1
	Ysar	50–420 mm.	f3·5, f4·5	50°–55°	T4
	Eurymar	180–300 mm.	f4·5	55°	T3
	Trinar*	20 mm.	f2·5	10·0 mm. dia.	T1
	Trinar*	25 mm.	f2·5	10·0 mm. dia.	T1
	Trinar*	30 mm.	f2·8	15·0 mm. dia.	T1
	Trinar	35–105 mm.	–4·5 f2·8	50°–55°	T1
	Trinar*	50 mm.	f4	24 x 36 mm.	T1
	Trinar*	75 mm.	f4·5	6 x 6 cm.	T1
	Trinar*	105 mm.	f4·5	6 x 9 cm.	T1
	Ronar*	5 mm.	f2	2·5 mm. dia.	T5
	Ronar*	7 mm.	f2	2·2 mm. dia.	T5
	Ronar*	7 mm.	f3·9	2·2 mm. dia.	T5
	Ronar*	8·5 mm.	f2	2·5 mm. dia.	T5
	Ronar*	8·5 mm.	f3·4	2·5 mm. dia.	T5
	Ronar*	10 mm.	f1·9	5·0 mm. dia.	T5
	Ronar*	10·5 mm.	f2·3	2·2 mm. dia.	T5
	Ronar*	10·5 mm.	f3·8	2·2 mm. dia.	T5
	Ronar*	12·5 mm.	f1·9	5 mm. dia.	T5
	Ronar*	12·5 mm.	f2·6	5 mm. dia.	T5
	Ronar*	16 mm.	f2	6·5 mm. dia.	T5
	Ronar	10, 12·5 mm.	f1·9	8 mm. cine	T5
	Euron	38, 75 mm.	f2·8, 3·5	8 & 16 mm. cine	T1
	Ysarex	40–50 mm.	f2·8, 3·5	24 & 36 mm.	T4
	Ysarex	75–210 mm.	f4·5	55°	T4
	Ysaron*	25 mm.	f4	12 x 18 mm.	T4
	Ysaron*	35 mm.	f4	18 x 24 mm.	T4
	Ysaron*	50 mm.	f3·5	24 x 36 mm.	T4
	Ysaron*	60–210 mm.	f4·5	24 x 36 mm. –13 x 18 cm.	T4
	Yronar	135 mm.	f3·5	24 x 36 mm.	T3
	Apo-Ronar*	15–60 cm.	f9	6 x 6 cm. –30 x 36 cm.	T3
	Apo-Ronar*	100 cm.	f16	40 x 50 cm.	T3
	Euron	12·5 mm.	f2·5	8 mm. cine	T1
	Splendar proj.	100–250 mm.	f2·5–f4	24 x 36 mm.	T1
	Kinemar*	18 mm.	f2	6·0 mm. dia.	T61
	Kinemar proj.	18, 22 mm.	f1·3, f1·6	8 mm. proj.	T9
	XR-Heligon*	50 mm.	f0·75	15 mm. dia.	T67
	TV-Heligon*	50 mm.	f0·75	15 mm. dia.	T67
	XR-Heligon*	65 mm.	f0·75	16 mm. dia.	T59
	XR-Heligon*	75 mm.	f0·85	17 mm. dia.	T67
	XR-Heligon*	90 mm.	f0·95	1 inch dia.	T67
	Kinemar*	100 mm.	f1·5	1 inch dia.	T60
Ross	Xpres	6–14 in.	f3·5–4·5	58°	T4
	Xtralux	135 mm.	f4·5	24 x 36 mm.	T4
	Xtralux	90 mm.	f3·5	24 x 36 mm.	T4
	Rosstar	75 mm.	f4·5	55°	T4

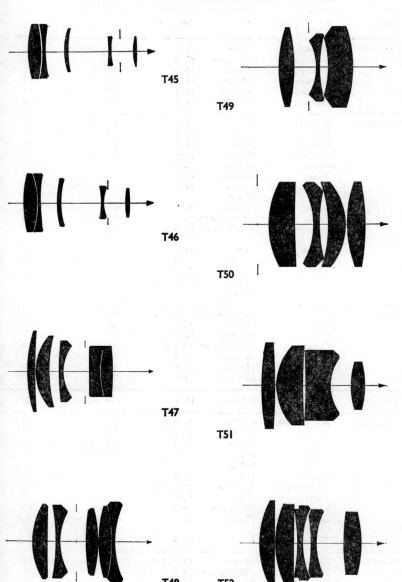

T45

T49

T46

T50

T47

T51

T48

T52

Maker	Name of Lens	Focus	Aperture	Field Covered	Diagram
Schacht	Travenar	50 mm.	f2·8	24 x 36 mm.	T4
	Travenar	85, 90 mm.	f2·8	28°	T12
	Travenar	85 mm.	f2·8	24 x 36 mm.	T5
	Travegar	100 mm.	f3·3	22°	T1
	Travenar	135 mm.	f3·5	18°	T5
	Travenon	135 mm.	f4·5	18°	T4
Schneider	Kinoplan	12·5 mm.	f2·7	8 mm. cine	T1
	Xenoplan	25 mm.	f1·9	9·6 x 12·8 mm.	T5
	Kino-Xenar	38 mm.	f2·8	8 mm. cine	T4
	Radionar	45 mm.	f2·8	24 x 36 mm.	T1
	Reomar	45 mm.	f2·8	24 x 36 mm.	T1
	Xenar	38 mm.	f2·8	24 x 24 mm.	T4
	Xenar	45 mm., 50 mm.	f2·8	24 x 36 mm.	T4
	Xenar	75 mm.	f3·5	60 x 60 mm.	T4
	Xenar	100–480 mm.	f3·5–4·7	60°–62°	T4
	Radionar	50–135 mm.	f2·9–4·5	24 x 36 mm. –90 x 120 mm.	T1
	Isogon	40 mm.	f4·5	24 x 36 mm.	T3
	Tele-Xenar	75 mm.	f2·8	9·6 x 12·8 mm.	T66
	Tele-Xenar	100 mm.	f2·8	9·6 x 12·8 mm.	T12
	Tele-Xenon	75, 90, 135 mm.	f3·5, 3·8	24 x 36 mm.	T12
Steinheil	Cassar	36–105 mm.	f2·8–6·3	52°	T11
	Quinon	50 mm.	f2	50°	T17
	Quinar	135 mm.	f2·8	18°	T8
	Culminon	150–210 mm.	f4, 4·5	55°	T4
	Cassaron	40 mm.	f3·5	56°	T1
	Culminar	135 mm.	f4·5	56°	T4
	Culminar	85 mm.	f2·8	28°	T16
Tomioka	Tominon-C	280 mm	f4·5	229 mm dia.	T7
T.T. & H.	Aviar II, IIIb	6–15 in.	f4·5, 6	52°	T3
	Adotal	80 mm.	f2·8	2¼ x 2¼ in.	T11
	Ivotal	2–3 in.	f1·4	8 & 16 mm. cine	T9
	Mytal	0·5, 0·7 in.	f2·5	8 & 16 mm. cine	T2
	Serital	1 in.	f1·9	8 & 16 mm. cine	T5
	Telekinic	2, 2·8 in.	f2·8, 3·5	8 & 16 mm. cine	T1
	Taytal	0·5 in.	f1·7	8 mm. cine	T5
	Kinetal	25–50 mm.	f1·8	16 mm. cine	T15
	Double Speed Panchro	75 mm.	f2	24 x 36 mm.	T15
	Tele-Panchro	6 in.	f2·8	24 x 36 mm.	T26
Voigtlander	Color-Skopar	50 mm.	f2·8, 3·5	24 x 36 mm.	T4
	Heliar	150–420 mm.	f4·5	45°–54°	T7
	Lanthar	50 mm.	f2·8	24 x 36 mm.	T1
	Color-Skopar	55–165 mm.	f3·5, 4·5	55°–60°	T4

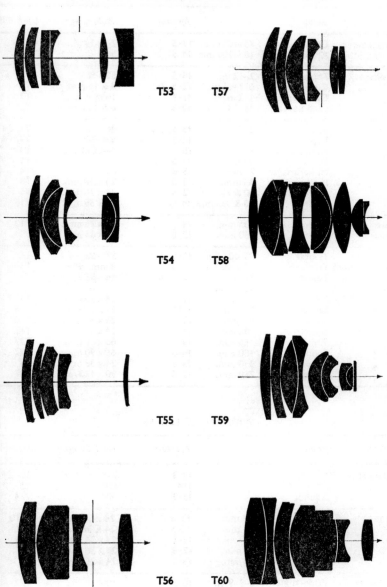

T53

T57

T54

T58

T55

T59

T56

T60

Maker	Name of Lens	Focus	Aperture	Field Covered	Diagram
Voigtlander —cont.	Color-Heliar	75–105 mm.	f3·5	2¼ x 2¼ in.	T7
	Apo-Lanthar	105–300 mm.	f4·5	55°	T7
Wollensak	Raptar	2–12 in.	f4·5	50°–56°	T4
	Cine Raptar	0·7–1½ in.	f2·5–3·5	8 & 16 mm. cine	T1
	Cine Raptar	1–2 in.	f1·9	16 mm. cine	T2
	Cine Raptar	1½–3 in.	f2·5	8 & 16 mm. cine	T5
Wray	Supar	2–7 in.	f3·5, 4·5	46°–52°	T1, T4
	Lustrar	5–⅜–15 in.	f4·5	52°–70°	T3, T4
	H. R. Lustrar	8 in.	f8	4–¾ x 6½ in.	T4
	Supar	2 in.	f3·5	46°	T5
	H. R. Lustrar	7–10 in.	f5·6	60°	T4
	Lustrar	35 mm.	f3·5	24 x 36 mm.	T4
	Unilux	50 & 75 mm.	f2·8	24 x 36 mm.	T5
	Lustrar	90 & 135 mm.	f4	24 x 36 mm.	T16
Zeiss (Jena)	Sonnar	135 mm.	f4	24 x 36 mm.	T12
	Sonnar	180 mm.	f2·8	24 x 36 mm.	T24
Carl Zeiss (Oberkochen)	Triotar	75–135 mm.	f3·5, 4	33°–60°	T1
	Triotar	10 mm.	f2·8	8 mm. cine	T1
	Tessar	37·5–300 mm.	f2·8–f6·3	44°–62°	T4
	Sonnar	50 mm.	f2	24 x 36 mm.	T17
	Sonnar	50 mm.	f1·5	24 x 36 mm.	T18
	Sonnar	85 mm.	f2	24 x 36 mm.	T18
	Sonnar	135 mm.	f4	24 x 36 mm.	T12
	Sonnar	150 mm.	f4	60 x 60 mm.	T27
	Sonnar	180 mm.	f4·8	65 x 90 mm.	T27
	Sonnar	250 mm.	f5·6	24 x 36 mm.	T5
	Sonnar	250 mm.	f5·6	90 x 120 mm.	T27

WIDE-ANGLE LENSES

Maker	Name of Lens	Focus	Aperture	Field Covered	Diagram
Berthiot	Angular	—	f3·3	72°	S5
	Perigraphe	—	f14	90°	S2
	Aquilor	—	f6·2	90°	W4
Canon	Canon*	19 mm.	f3·5	24 x 36 mm.	W10
	Canon*	25 mm.	f3·5	24 x 36 mm.	W11
	Canon	25 mm.	f3·5	24 x 36 mm.	W4
	Canon	28 mm.	f2·8	24 x 36 mm.	W6
	Canon	28 mm.	f3·5	24 x 36 mm.	S5
Dallmeyer	Wide-angle	2–⅜–9 in.	f6·5 *	100°	W2

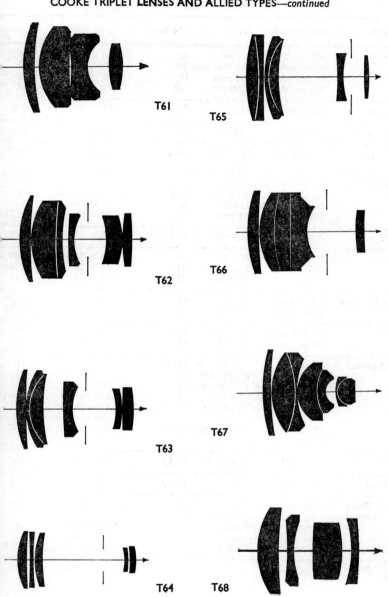

T61

T65

T62

T66

T63

T67

T64

T68

Maker	Name of Lens	Focus	Aperture	Field Covered	Diagram
Fuji	Fujinon-SW*	65 mm.	f8	56 × 84 mm.	W7
	Fujinon-A*	180, 240 mm.	f9	70°	S3
	Fujinon-A*	600 mm.	f9	70°	S3
	Fujinon-A*	1200 mm.	f24	70°	S3
Goerz	Rectagon	3 in.	f6‡	90°	W2
Komura	Komura	28 mm.	f3·5	24 × 36 mm.	W6
Kodak	Wide Field Ektar	5½–10 in.	f6·3	75°–80°	W2
Leitz	Super-Angulon	21 mm.	f3·4	24 × 36 mm.	W9
	Super-Angulon*	21 mm.	f3·4	24 × 36 mm.	W12
	Super-Angulon	21 mm.	f4	24 × 36 mm.	W9
	Elmarit*	28 mm.	f2·8	24 × 36 mm.	W13
Meyer	Aristostigmat	100–160 mm.	f6·3‡	85°	W2
Nikon	Nikkor	21 mm.	f4	24 × 36 mm.	W8
	Nikkor	25 mm.	f4	24 × 36 mm.	W4
	Nikkor	28 mm.	f3·5	24 × 36 mm.	S3
Rodenstock	Grandagon	58 mm.	f5·6	100°	W14
	Grandagon*	80 mm.	f5·6	90°	W14
Ross	W.A. Anst.	5½–10½ in.	f16	100°	W1
	W.A. Xpres	4–20 in.	f4	70°	S3
Schneider	Angulon	100–350 mm.	f5·6	70°	S3
	Angulon	65–210 mm.	f6·8	81°–85°	W3
	Super-Angulon	47–210 mm.	f8	100°	W7
	Super-Angulon	21 mm.	f4	24 × 36 mm.	W9
	Super-Angulon	65–210 mm.	f8	65 × 90 mm. –30 x 40 cm.	W7
	Super-Angulon*	47–90 mm.	f5·6	65 × 90 mm. –13 x 18 cm.	W8
T.T. & H.	Series VIIB	3¼–8–¾ in.	f6·5‡	90°–100°	W2
Wray	W.A. Anast.	3½ in.	f6·3‡	100°	W2
Carl Zeiss	Topogon	25 mm.	f4	24 × 36 mm.	W4
(Oberkochen)	Biogon	21–75 mm.	f4·5	90°	W5
	Biogon	35 mm.	f2·8	24 × 36 mm.	W17
Zeiss	Hologon*	15 mm.	f8	24 × 36 mm.	W15

‡For focusing only

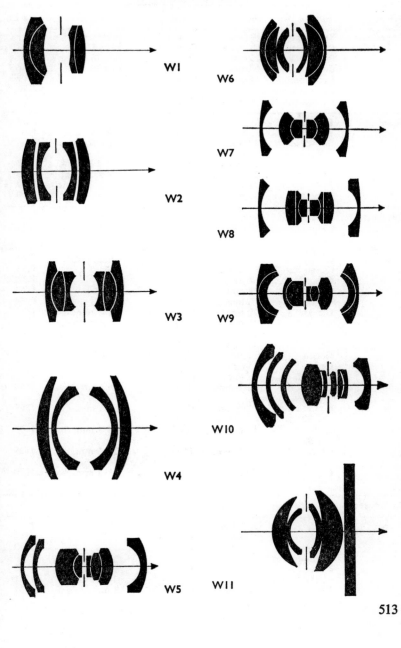

W1

W2

W3

W4

W5

W6

W7

W8

W9

W10

W11

INVERTED TELEPHOTO (RETRO-FOCUS) LENSES

Maker	Name of Lens	Focus	Aperture	Field Covered	Diagram
Angenieux	Retrofocus R21	10 mm.	f1·8	16 mm. cine	IT9
	Retrofocus	18·5, 24 mm.	f2·2	35 mm. cine	IT16
	Retrofocus	35 mm.	f2·5	24 x 36 mm.	IT8
	Retrofocus R11	28 mm.	f3·5	24 x 36 mm.	IT9
	Retrofocus R61	24 mm.	f3·5	24 x 36 mm.	IT19
	Retrofocus R61	15 mm.	f1·3	16 mm. cine	IT20
	Retrofocus R31	6·5 mm.	f1·8	8 mm. cine	IT9
Asahi	Takumar	35 mm.	f4	24 x 36 mm.	IT15
	Takumar	35 mm.	f2·3	24 x 36 mm.	IT8
	Fish-Eye Takumar*	17 mm.	f4	24 x 36 mm.	IT56
	Takumar*	20 mm.	f4·5	24 x 36 mm.	IT57
	Takumar*	24 mm.	f3·5	24 x 36 mm.	IT58
	Takumar*	28 mm.	f3·5	24 x 36 mm.	IT59
	Takumar*	35 mm.	f2	24 x 36 mm.	IT60
Berthiot	Cinor	6 mm.	f1·9	8 mm. cine	IT14
	Cinor	10 mm.	f1·9	9·5 & 16 mm. cine	IT14
Canon	Canon	6·5 mm.	f1·8	8 mm. cine	IT21
	Canon Fish-Eye	7·5 mm.	f5·6	180°	IT61
	Canon*	17 mm.	f4	104°	KT62
	Canon*	24 mm.	f2·8	83°	IT63
	Canon*	28 mm.	f3·5	75°	IT64
	Canon*	28 mm.	f3·5	24 x 36 mm.	IT71
	Canon*	35 mm.	f2·5	24 x 36 mm.	IT72
	Canon*	35 mm.	f3·5	64°	IT65
	Canon*	35 mm.	f2·8	63°	IT66
	Canon	35 mm.	f2·5	24 x 36 mm.	IT45
	Canon	35 mm.	f2	24 x 36 mm.	IT22
	Canon*	35 mm.	f2	62°	IT67
	Canon MR* x 33·6	12·7 mm.	f3·5	10·3 mm. dia.	IT68
	Canon MR* x 30	15·5 mm.	f3·5	13·2 mm. dia.	IT68
	Canon MR* x 30	17 mm.	f4	14·1 mm. dia.	IT68
	Canon MR* x 16	29·5 mm.	f4	26·5 mm. dia.	IT69
	Canon MR* x 20	40 mm.	f5	21·2 mm. dia.	IT70
Dallmeyer	Inverted Tele.	¼—1⅛ in.	f2·5–3·5	52°	IT1
Elgeet	Wide-angle	3·7 mm.	f1·5	165°	IT73
	Wide-angle	5 mm.	f1·5	120°	IT73
	Wide-angle	8 mm.	f1·5	80°	IT73
	Cine-Navitar	7·5 mm.	f1·5	8 mm. cine	IT29
	Cine-Navitar	7 mm.	f1·9	8 mm. cine	IT30
	Cine-Navitar	6·5 mm.	f2·5	8 mm. cine	IT31
	Cinematar	7 mm.	f2·7	8 mm. cine	IT31

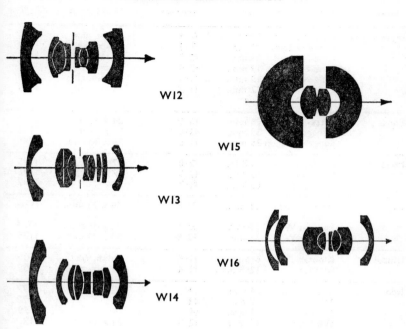

W12

W15

W13

W16

W14

INVERTED TELEPHOTO (RETROFOCUS) LENSES

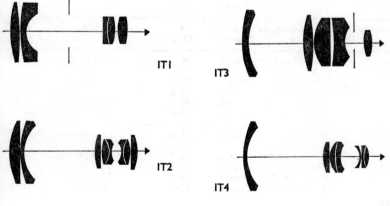

IT1

IT3

IT2

IT4

515

Maker	Name of Lens	Focus	Aperture	Field Covered	Diagram
Elgeet—*cont.*	Cine-Navitar	9 mm.	f1·9	8 mm. cine	IT32
	Cine-Navitar	13 mm.	f1·3	8 mm. cine	IT29
	Cine-Navitar	13 mm.	f2·5	16 mm. cine	IT8
	Cine-Navitar	13 mm.	f2·0	16 mm. cine	IT22
	Cine-Navitar	13 mm.	f1·5	16 mm. cine	IT30
	Golden Navitar	12 mm.	f1·2	16 mm. cine	IT43
Enna	Ultra-Lithagon	28 mm.	f3·5	24 x 36 mm.	IT40
	Lithagon	35 mm.	f2·8	24 x 36 mm.	IT41
	Super Lithagon	35 mm.	f1·5	24 x 36 mm.	IT41
Farrand	Farrogon	to 3 in.	f2·0	62°	IT45
	Farrogon	to 3 in.	f2·0	57°	IT46
	Farrogon	to 3 in.	f1·2	50°	IT47
Fuji	Fujinon Fish-Eye*	16 mm.	f2·8	24 x 36 mm.	IT76
	Fujinon-W*	28 mm.	f3·5	24 x 36 mm.	IT74
	Fujinon-W*	35 mm.	f2·8	24 x 36 mm.	IT75
Ichizuka	Kinotar	6·5 mm.	f1·4	8 mm. cine	IT39
	Kinotar	12·5 mm.	f1·4	16 mm. cine	IT39
Isco	Westragon	24 mm.	f4	82°	IT77
	Westromat	28 mm.	f4	74°	IT78
	Westron	28 mm.	f4	74°	IT79
	Westron	35 mm.	f2·8	24 x 36 mm.	IT3
Kinoptik	Super-Tegea*	1·9 mm.	f1·9	8·7 mm. dia.	—
	Tegea*	5·7 mm.	f1·8	16 mm. film	—
	Apochromat*	9 mm.	f1·5	16 mm. film	—
	Apochromat*	12·5 mm.	f2·5	Vidicon	—
Kodak	Cine Ektar	1 in.	f1·9	16 mm. cine	IT36
	Ektanar	35 mm.	f3·5	62°	IT37
Komura	Komura fisheye	32·4 mm.	f4	4 x 5 in.	IT128
	Komura	35 mm.	f2·5	24 x 36 mm.	IT44
Leitz	Super-Angulon R*	21 mm.	f4	24 x 36 mm.	IT80
	Elmarit-R*	28 mm.	f2·8	24 x 36 mm.	IT81
	Elmarit-R*	35 mm.	f2·8	24 x 36 mm.	IT82
	Summicron-R*	35 mm.	f2	24 x 36 mm.	IT83
	Elmarit-R	35 mm.	f2·8	24 x 36 mm.	IT46
Minolta	Fish-Eye Rokkor*	16 mm.	f2·8	24 x 36 mm.	IT84
	Rokkor-NL*	21 mm.	f2·8	24 x 36 mm.	IT85
	Rokkor-ST*	24 mm.	f2·8	24 x 36 mm.	IT86
	Rokkor-SG*	28 mm.	f3·5	24 x 36 mm.	IT87
	Rokkor-ST*	28 mm.	f2·5	24 x 36 mm.	IT88

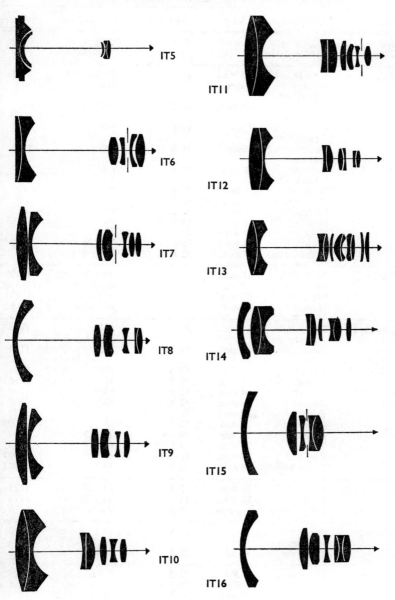

IT5

IT11

IT6

IT12

IT7

IT13

IT8

IT14

IT9

IT15

IT10

IT16

Maker	Name of Lens	Focus	Aperture	Field Covered	Diagram
Mintola	Rokkor-HG*	35 mm.	f2·8	24 x 36 in.	IT89
—cont.	Rokkor-HH*	35 mm.	f1·8	24 x 36 in.	IT90
Nikon	Cine Nikkor	6·5 mm.	f1·8	8 mm. cine	IT91
	Fish-Eye Nikkor*	6 mm.	f5·6	220°	—
	Fish-Eye Nikkor*	7·5 mm.	f5·6	180°	—
	Fish-Eye Nikkor*	8 mm.	f2·8	180°	—
	Fish-Eye Nikkor	8 mm.	f1·8	180°	IT92
	Fish-Eye Nikkor*	10 mm.	f5·6	180°	—
	Nikkor*	15 mm.	f5·6	110°	—
	Nikkor*	20 mm.	f3·5	94°	—
	Nikkor*	24 mm	f2·8	84°	—
	Nikkor*	28 mm.	f3·5	74°	—
	Nikkor*	28 mm.	f2	74°	—
	Nikkor-Auto	28 mm.	f3·5	24 x 36 mm.	IT38
	Nikkor-Auto	35 mm.	f2·8	24 x 36 mm.	IT4
Norita	Noritar*	17 mm.	f4	24 x 36 mm.	IT129
	Noritar*	40 mm.	f4	6 x 6 cm.	IT130
	Noritar*	55 mm.	f4	6 x 6 cm.	IT131
	Noritar*	70 mm.	f2·5	6 x 6 cm.	IT132
Olympus	Zuiko Fish-Eye*	8 mm.	f2·8	180°	IT93
	Zuiko Fish-Eye*	16 mm.	f3·5	180°	IT94
	Zuiko*	18 mm.	f3·5	100°	IT95
	Zuiko*	21 mm.	f3·5	92°	IT96
	Zuiko*	24 mm.	f2·8	83°	IT97
	Zuiko*	24 mm.	f2·8	83°	IT98
	Zuiko*	28 mm.	f2	75°	IT99
	Zuiko*	28 mm.	f2·5	75°	IT100
	E Zuiko	25 mm.	f4	18 x 24 mm.	IT3
	Zuiko*	35 mm.	f2	63°	IT101
	Zuiko*	35 mm.	f2·8	63°	IT102
	Zuiko Shift*	35 mm.	f2·8	84°	IT103
Rodenstock	Eurygon	30 mm.	f2·8	24 x 36 mm.	IT23
	Eurygon	35 mm.	f4	24 x 36 mm.	IT24
	Heligaron	6·5 mm.	f1·6	8 mm. cine	IT25
Schacht	Super-Travegon	35 mm.	f2·8	24 x 36 mm.	IT48
	Travegon	35 mm.	f3·5	24 x 36 mm.	IT48
Schneider	Cinegon	5·5 mm.	f1·8	8 mm. cine	IT28
	Cinegon	6·5 mm.	f1·9	8 mm. cine	IT11
	Cinegon	10 mm.	f1·8	16 mm. cine	IT28

518

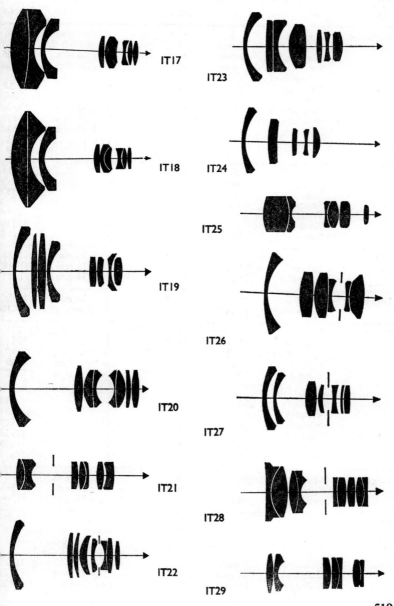

IT17

IT18

IT19

IT20

IT21

IT22

IT23

IT24

IT25

IT26

IT27

IT28

IT29

519

INVERTED TELEPHOTO (RETROFOCUS) LENSES—*continued*

Maker	Name of Lens	Focus	Aperture	Field Covered	Diagra
Schneider —*cont.*	Cinegon	11·5 mm.	f1·9	16 mm. cine	IT11
	Cinegon*	16 mm.	f1·4	9·6 x 12·8 mm.	IT10·
	Cinegon*	18 mm.	f1·8	18 x 24 mm.	IT10!
	Super-Angulon*	21 mm.	f4	24 x 36 mm.	IT10(
	Curtagon	28 mm.	f4	24 x 36 mm.	IT 27 or IT49
	Curtagon*	28 mm.	f4	24 x 36 mm.	IT78
	PA-Curtagon*	35 mm.	f4	24 x 36 mm.	IT107
	Curtagon*	35 mm.	f2·8	24 x 36 mm.	IT108
	Curtagon	35 mm.	f2·8	24 x 36 mm.	IT33 or IT49
Tamron	Tamron*	4·5 mm.	f2	101°	IT11
	Tamron*	6 mm.	f2	85°	IT11:
	Tamron*	8 mm.	f1·4	69°	IT11:
	Tamron*	8 mm.	f1·8	90°	IT11!
	Tamron*	9 mm.	f1·6	63°	IT11·
	Tamron*	9 mm.	f1·8	83°	IT11(
	Tamron*	12·5 mm.	f1·4	65°	IT117
Tokina	Tokina*	21 mm.	f2·8	24 x 36 mm.	IT118
	Tokina*	28 mm.	f2·8	24 x 36 mm.	IT119
	Tokina*	35 mm'	f2·8	24 x 36 mm.	IT41
Tomioka	Tominon*	21 mm.	f3·5	24 x 36 mm.	IT10(
	Tominon-M*	21 mm.	f3·0	10·2 mm. dia.	IT11(
T.T. & H.	Taytal	6·5 mm.	f1·75	8 mm. cine	IT17
	Ivotal	12·5 mm.	f1·4	8 mm. cine	IT3
	Speed Panchro	18, 25 mm.	f1·7–1·8	35 mm. cine	IT18
	Kinetal	9 mm.	f1·9	16 mm. cine	IT35
	Kinetal	12·5–17·5 mm.	f1·8	16 mm. cine	IT18
Vivitar	Vivitar*	20	f3·8	95°	IT13
	Vivitar*	21	f3·8	90°	IT13
	Vivitar*	24	f2·8	84°	IT13
	Vivitar*	28	f2·5	74°	IT13
	Vivitar*	28	f2·8	74°	IT13
	Vivitar*	35	f2·8	63°	IT8
Voigtlander	Skoparon	35 mm.	f3·5	24 x 36 mm.	IT15
	Skoparex	35 mm.	f3·4	24 x 36 mm.	IT8
	Skopagon	40 mm.	f2	24 x 36 mm.	IT50
Wollensak	Cine Raptar	6·5, 9 mm.	f2·5	8 mm. cine	IT10(
	Cine Raptar	6·5 mm.	f1·9	8 mm. cine	IT12
	Cine Raptar	12·5 mm.	f1·5	16 mm. cine	IT13
Zeiss	Distagon*	8 mm.	f2	75°	IT12
	Distagon*	15 mm.	f3·5	24 x 36 mm.	IT12
	F-Distagon*	16 mm.	f2·8	24 x 36 mm.	IT12

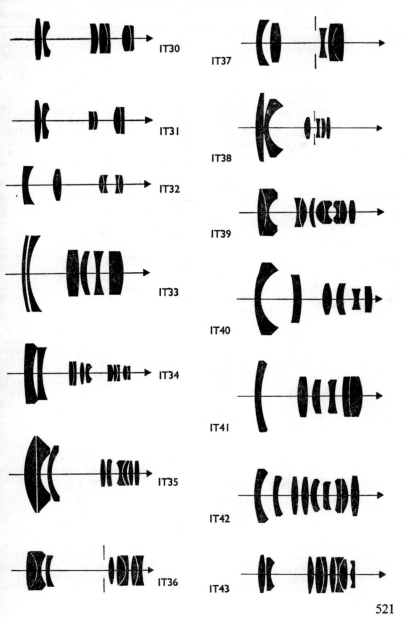

IT30

IT37

IT31

IT38

IT32

IT39

IT33

IT40

IT34

IT41

IT35

IT42

IT36

IT43

Maker	Name of Lens	Focus	Aperture	Field Covered	Diagram
Zeiss —cont.	Distagon*	18 mm.	f4	24 x 36 mm.	IT124
	Distagon	25 mm.	f2·8	24 x 36 mm.	IT54
	F-Distagon*	30 mm.	f3·5	24 x 36 mm.	IT126
	Flektogon	20 mm.	f4	24 x 36 mm.	IT55
	Flektogon	35 mm.	f2·8	24 x 36 mm.	IT4
	Distagon	35 mm.	f4	24 x 36 mm.	IT51
	Distagon*	35 mm.	f2	24 x 36 mm.	IT120
	Distagon HFT*	35 mm.	f1·4	24 x 36 mm.	IT123
	Distagon*	50 mm.	f4	6 x 6 cm.	IT53
	Distagon	55 mm.	f4	6 x 6 cm.	IT52
	Distagon*	60 mm.	f4	6 x 6 cm.	IT121
	Distagon	60 mm.	f4	6 x 6 cm.	IT53

TELEPHOTO LENSES

Maker	Name of Lens	Focus	Aperture	Field Covered	Diagram
Agfa	Color-Telinear	90 mm.	f4·0	24 x 36 mm.	T25
Agilux	Telephoto	160–300 mm.	f5·5	2¼ x 2¼ in.	TP1
	—	80 mm.	f5·5	24 x 36 mm.	TP1
Aldis	Projection	10–12 in.	f3·5, 4·2	8°–10°	TP7
Asahi	Takumar*	150, 200 mm.	f4	24 x 36 mm.	TP29
	Takumar	200 mm.	f3·5	24 x 36 mm.	TP16
	Takumar	300 mm.	f4	24 x 36 mm.	TP20
	Takumar*	300 mm.	f4	24 x 36 mm.	TP30
	Takumar*	300 mm.	f5·6	24 x 36 mm.	TP29
	Takumar*	400 mm.	f5·6	24 x 36 mm.	TP31
	Takumar*	500 mm.	f4·5	24 x 36 mm.	TP32
	Takumar*	1000 mm.	f8	24 x 36 mm.	TP31
Astro	Telastan*	2000 mm.	f10	9 x 12 cm.	TP34
	Apo-Telastan*	2000 mm.	f11	9 x 12 cm.	TP33
Berthiot	Tele Objectif	145 mm.	f4·5	16°	TP5
	Tele Cinor	—	f2·5	31°	TP8
Canon	Canon MR x 15*	95 mm.	f11	6 cm. dia.	TP35
	Canon	100 mm.	f3·5	24 x 36 mm.	TP6
	Canon*	135 mm.	f2·5	24 x 36 mm.	TP36
	Canon*	200 mm.	f4	24 x 36 mm.	TP37
	Canon	200 mm.	f3·5	24 x 36 mm.	TP13
	Canon*	300 mm.	f5·6	24 x 36 mm.	TP38
	Canon*	300 mm.	f5·6	24 x 36 mm.	TP39
	Canon	300 mm.	f4	24 x 36 cm.	TP6
	Canon	400 mm.	f4·5	24 x 36 mm.	TP6
	Canon*	500 mm.	f5·6	24 x 36 cm.	TP40

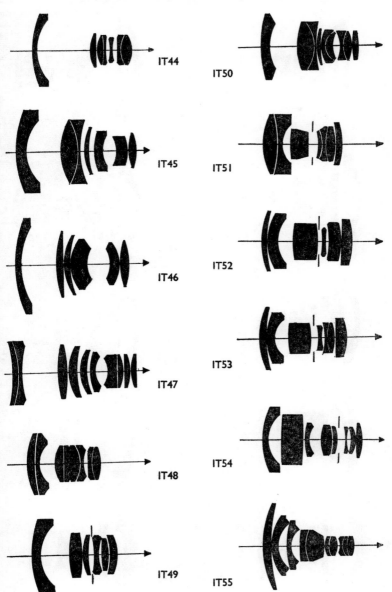

IT44

IT50

IT45

IT51

IT46

IT52

IT47

IT53

IT48

IT54

IT49

IT55

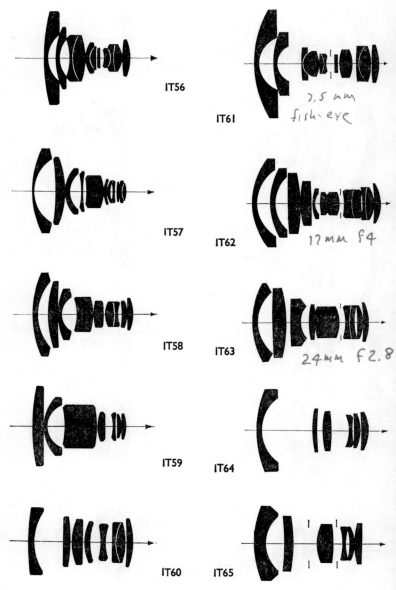

IT56

IT61

7,5 mm fish-eye

IT57

IT62

12 mm f4

IT58

IT63

24 mm f2.8

IT59

IT64

IT60

IT65

524

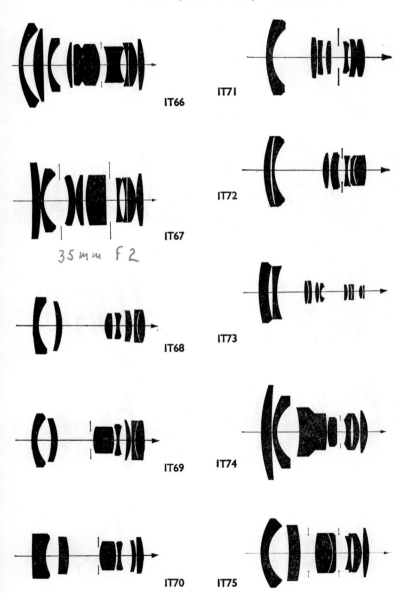

IT66

IT71

IT67

35mm f 2

IT72

IT68

IT73

IT69

IT74

IT70

IT75

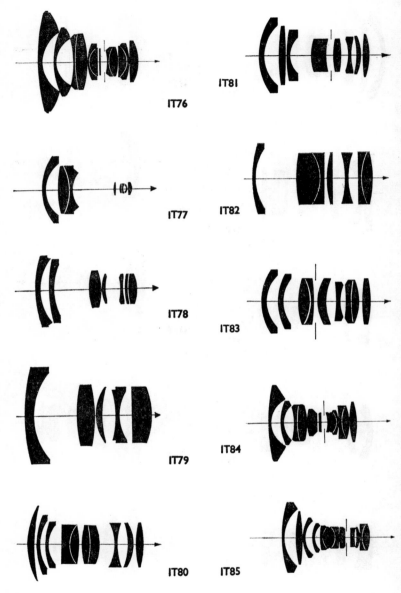

IT76

IT81

IT77

IT82

IT78

IT83

IT79

IT84

IT80

IT85

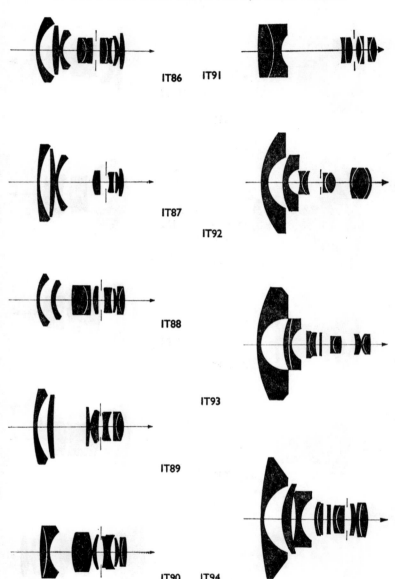

IT86 IT91

IT87

IT92

IT88

IT89

IT93

IT90 IT94

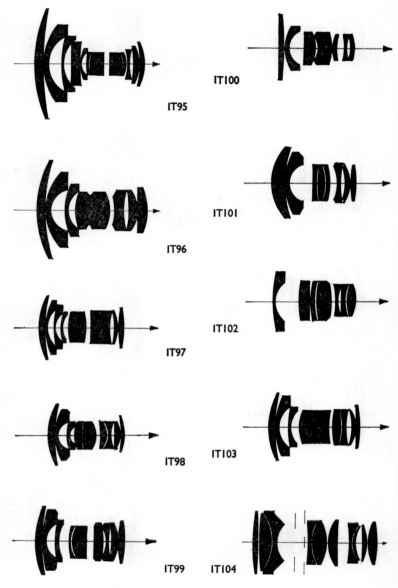

IT95

IT100

IT96

IT101

IT97

IT102

IT98

IT103

IT99

IT104

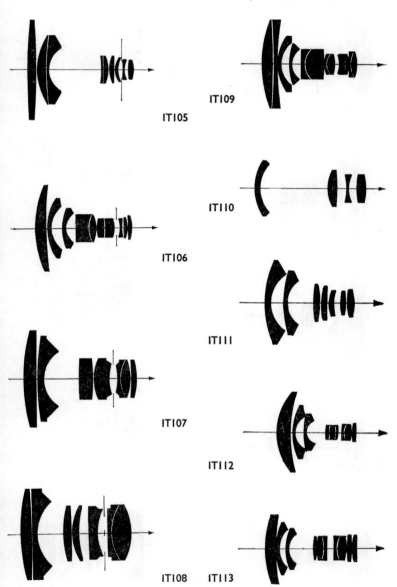

IT105

IT109

IT110

IT106

IT111

IT107

IT112

IT108 IT113

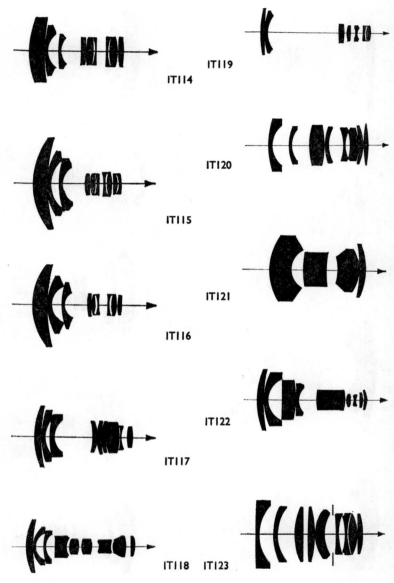

IT114

IT119

IT115

IT120

IT116

IT121

IT117

IT122

IT118 IT123

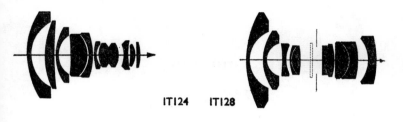

IT124 IT128

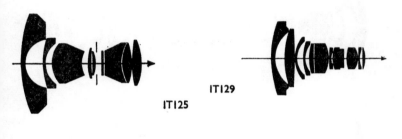

IT125 IT129

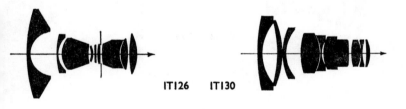

IT126 IT130

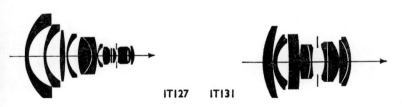

IT127 IT131

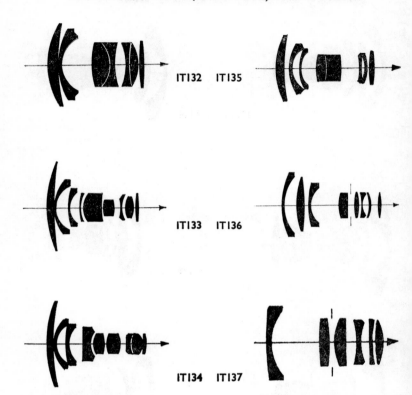

IT132 IT135

IT133 IT136

IT134 IT137

Maker	Name of Lens	Focus	Aperture	Field Covered	Diagram
Dallmeyer	Dallon	4–60 in.	f5·6–8	30°	TP1
	Adon	6–24 in.	f4·5	26°	TP1
	Cine Tele.	1½–12 in.	f3·5–5·6	16 mm. cine	TP1
Elgeet	Elgeet	152 mm.	f3·8	16 mm. cine	TP1
Enna	Tele-Ennalyt	135 mm.	f3·5	24 x 36 mm.	TP21
	Tele-Ennalyt	240–400 mm.	f4·5	24 x 36 mm.	TP23
Fuji	Fujinon-T*	180 mm.	f5·6	24 x 36 mm.	TP43
	Fujinon-T*	200 mm.	f4·5	24 x 36 mm.	TP41
	Fujinon*	400 mm.	f4·5	24 x 36 mm.	TP42
	Fujinon*	600 mm.	f5·6	24 x 36 mm.	TP42
	Fujinon*	1000 mm.	f8	24 x 36 mm.	TP23
Isco	Tele-Westanar	135 mm.	f3·5	24 x 36 mm.	TP28
Kilfitt	Tele-Kilar	300 mm.	f5·6	24 x 36 mm.	TP1
	Tele-Kilar	200 mm.	f2·8	24 x 36 mm.	T12
	Pan-Tele-Kilar	300 mm.	f4	24 x 36 mm.	TP1
	Tele-Kilar	500 mm.	f4·8	24 x 36 mm.	T5
Kodak	Ektanar	90 mm.	f4	27°	TP22
Komura	Komura	200 mm.	f4·5	24 x 36 mm.	TP1
	Komura	300 mm.	f5	24 x 36 mm.	TP1
	Komura	400 mm.	f6·3	24 x 36 mm.	TP1
Leitz	Tele-Elmarit*	90 mm.	f2·8	24 x 36 mm.	TP44
	Tele-Elmarit*	135 mm.	f4	24 x 36 mm.	TP45
	Elmarit*	135 mm.	f2·8	24 x 36 mm.	TP46
	Telyt	200 mm.	f4	24 x 36 mm.	TP16 or 25
	Telyt-R*	250 mm.	f4	24 x 36 mm.	TP47
	Telyt	280 mm.	f4·8	24 x 36 mm.	TP16 or 25
	Telyt	400 mm.	f5	24 x 36 mm.	TP16 or 25
Meyer	Telemegor	150–400 mm.	f5·5	12°–19°	TP1
Minolta	Tele-Rokkor QE	100 mm.	f3·5	24 x 36 mm.	TP12
	Tele-Rokkor QF	200–250 mm.	f3·5–4	24 x 36 mm.	TP24
	Tele-Rokkor TD	300–600 mm.	f4·5–5·6	24 x 36 mm.	TP22
	Tele Rokkor-HF*	300 mm.	f4·5	24 x 36 mm.	TP48
	Tele Rokkor-PE*	300 mm.	f4·5	24 x 36 mm.	TP49
Nikon	Nikkor	200 mm.	f4	24 x 36 mm.	TP14
	Nikkor	300 mm.	f4·5	24 x 36 mm.	TP25

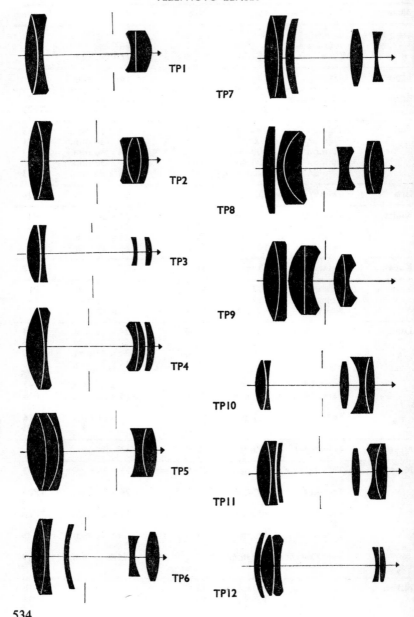

TP1

TP2

TP3

TP4

TP5

TP6

TP7

TP8

TP9

TP10

TP11

TP12

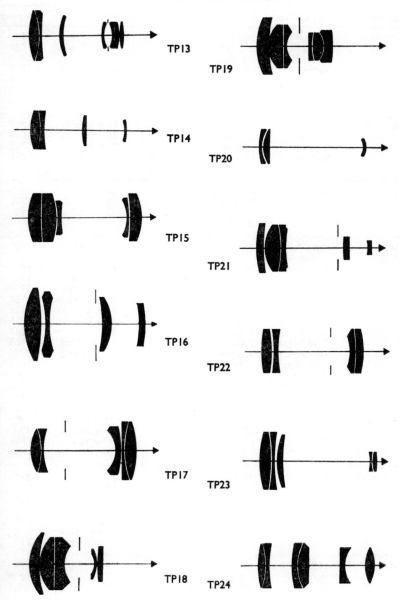

TP13

TP19

TP14

TP20

TP15

TP21

TP16

TP22

TP17

TP23

TP18 TP24

Maker	Name of Lens	Focus	Aperture	Field Covered	Diagram
Olympus	Zuiko*	200 mm.	f5	24 x 36 mm.	TP50
	Zuiko*	300 mm.	f4·5	24 x 36 mm.	TP51
	Zuiko*	300 mm.	f6·3	24 x 36 mm.	TP50
	Zuiko*	400 mm.	f4·5	24 x 36 mm.	TP52
	Zuiko*	400 mm.	f6·3	24 x 36 mm.	TP53
	Zuiko*	600 mm.	f6·5	24 x 36 mm.	TP52
	Zuiko*	1000 mm.	f11	24 x 36 mm.	TP23
Rodenstock	Rotelar	85–100 mm.	f4	24 x 36 mm.	TP15
	Rotelar	135 mm.	f4	24 x 36 mm.	TP12
	Rotelar	180 mm.	f4·5	24 x 36 mm.	TP15
	Rotelar	180–270 mm.	f4·5–f5·6	35°	TP15
Ross	Teleros	6¼–22 in.	f5·5	30°	TP2
	Teleros	9–25 in.	f6·3	19°	TP2
	Teleros	40 in., 50 in.	f8	15°	TP3
Schneider	Cine-Tele-Xenon	150 mm.	f4	16 mm. cine	TP21
	Tele-Xenar	75, 90 mm.	f3·5, 3·8	24 x 36 mm.	TP1
	Tele-Xenar	135–150 mm.	f4	24 x 36 mm.	TP21
	Tele-Xenar*	135 mm.	f3·5	24 x 36 mm.	TP54
	Tele-Xenar*	150 mm	f4	9·6 x 12·8 mm.	TP28
	Tele-Tenar	200 mm.	f4·8	24 x 36 mm.	TP26
	Tele-Arton	85 mm.	f4	24 x 36 mm.	TP18
	Tele-Arton	180–270 mm.	f5·5	35°	TP17
	Tele-Arton*	250 mm.	f5·6	9·5 x 12 cm.	TP55
	Tele-Arton*	360 mm.	f5·5	13 x 18 cm.	TP12
	Tele-Xenar	180–500 mm.	f4, 5·5	35°	TP1
	Tele-Xenar*	360 mm.	f5·5	13 x 18 cm.	TP1
	Tele-Xenar*	500 mm.	f8	18 x 24 cm.	TP3
	Tele-Xenar*	1000 mm.	f8	18 x 24 cm.	TP1
Tokina	Tokina*	300 mm.	f5·5	24 x 36 mm.	TP23
	Tokina*	400 mm.	f6·3	24 x 36 mm.	TP3
	Tokina*	600 mm.	f8	24 x 36 mm.	TP56
	Tokina*	800 mm.	f8	24 x 36 mm.	TP57
T.T. & H.	Series VIII	8½–36 in.	f5·6–6·3	30°	TP1
	Telekinic	3–6 in.	f3·5–4·5	16 mm. cine	TP1
	Tele-Panchro	8–16 in.	f4	24 x 36 & 35 mm. cine	TP12
	Tele-Panchro	22 in.	f5·6	24 x 36 & 35 mm. cine	TP3
	Kinetal	75–150 mm.	f2·5–f3·8	16 mm. cine	T11
Vivitar	Vivitar*	135 mm.	f2·8	18°	TP7
	Vivitar*	135 mm.	f3·5	18°	TP58
	Vivitar*	200 mm.	f3·5	12°	TP21

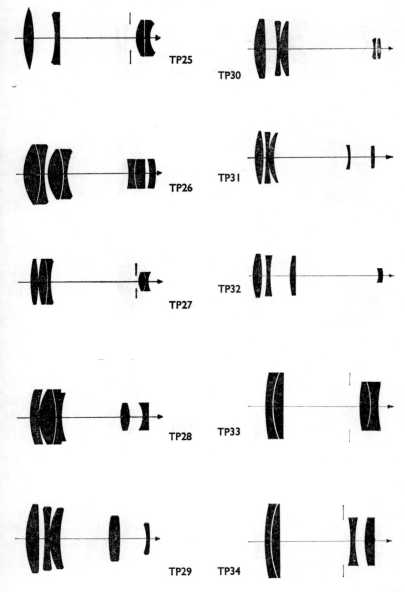

TP25

TP30

TP26

TP31

TP27

TP32

TP28

TP33

TP29

TP34

537

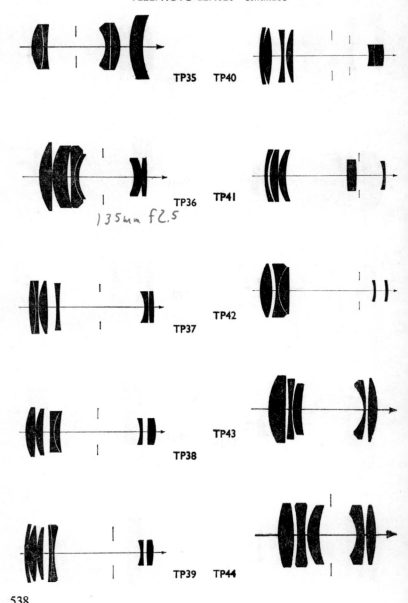

TP35 TP40

TP36 TP41

135mm f2.5

TP37 TP42

TP38 TP43

TP39 TP44

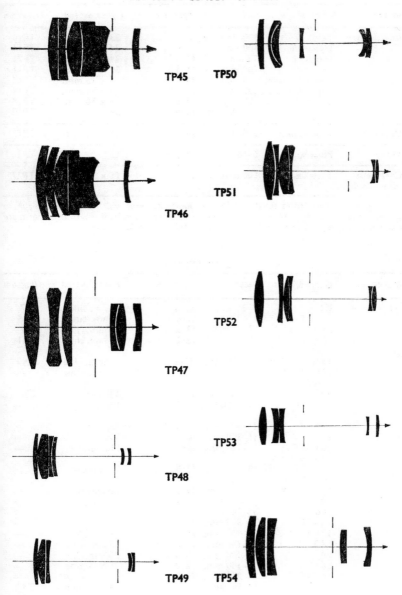

TP45 TP50

TP46

TP51

TP47

TP52

TP48

TP53

TP49 TP54

Maker	Name of Lens	Focus	Aperture	Field Covered	Diagram
Voigtlander	Telomar	100–360 mm.	f5·5	33°	TP10
	Dynaron	100 mm.	f4·5	24 x 36 mm.	TP11
	Dynarex	90 mm.	f3·4	24 x 36 mm.	TP23
	Dynarex	100 mm.	f4·8	24 x 36 mm.	TP11
	Super Dynarex	135 mm.	f4	24 x 36 mm.	TP14
	Super Dynarex	200 mm.	f4	24 x 36 mm.	TP14
	Super Dynaron	150 mm.	f4·5	24 x 36 mm.	TP14
	Telomer	180–450 mm.	f5·5	34°	TP10
Wollensak	Cine Raptar	3–6 in.	f4·5	16 mm. cine	TP1
Wray	Plustrar	6–18 in.	f4·5–6·3	27°	TP2
Carl Zeiss Oberkochen)	Tele-Tessar	500 mm.	f8	60 x 60 mm.	TP27

In many instances lenses for 8 and 16 mm. movie cameras which are called telephoto lenses are not actually of true telephoto form, but simply long focal length lenses of more conventional types. These are listed mostly in their appropriate table.

ZOOM LENSES

Maker	Name of Lens	Focus	Aperture	Field Covered	Diagram
Angenieux	K1	9–36 mm.	f1·8	8 mm. cine	Z7
	6 x 9·5, B*	9·5–57 mm.	f1·6	8 mm. cine	Z39
	L1, L2, L3	17–68 mm.	f2·2	16 mm. cine	Z6
	10 x 12 BMC, A AZO, BEK	12–120 mm.	f2·2	16 mm. cine	Z41
	15 x 14, E61*	14–210 mm.	f1·6	16 mm. cine	Z42
	20 x 12 BMC, AZO	12–240 mm.	f2·2	16 mm. cine	—
	LF5, LF6	20–80 mm.	f2·5	Vidicon	Z6
	L5RTR, L6RTR	12·5–50 mm.	f2·5	Vidicon	—
	10 x 15	15–150 mm.	f1·9, f2·8	Vidicon	—
	20 x 15 BMC	15–300 mm.	f6	Vidicon	—
	10 x 18 E(c) 10 x 18 H(B/W)	18–180 mm.	f2·2	Plumbicon	—
	10 x 18 F(B/W) 10 x 18 G(c)	18–180 mm.	f2·8	Plumbicon	—
	LB3	50–200 mm.	f3·0	Image Orthicon	—
	LB4	100–400 mm.	f5·3	,,	—
	LB5	35–140 mm.	f3·8	,,	—
	10 x 35	35–350 mm.	f3·8	,,	—
	12 x 68	68–800 mm.	f6·4	,,	—
	LA2	35–140 mm.	f3·5	35 mm. cine	—
	LA5	25–100 mm.	f3·5	35 mm. cine	—
	LB1	35–140 mm.	f2·2	35 mm. cine	—
	10 x 25	25–250 mm.	f3·2	35 mm. cine	—
	2 x 45*	45–90 mm.	f2·8	24 x 36 mm.	Z42

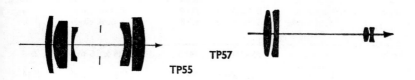

TP57

TP55

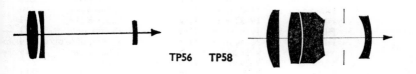

TP56 TP58

ZOOM LENSES

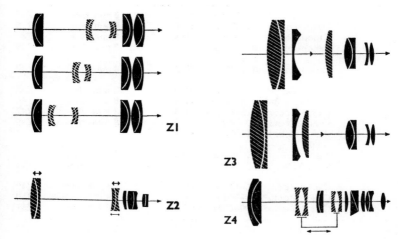

Z1

Z2

Z3

Z4

Maker	Name of Lens	Focus	Aperture	Field Covered	Diagram
Argus	Argus	8·5–35 mm.	f1·8	8 mm. cine	—
	with W.A. Attachment	6·5–26 mm.	f1·8	8 mm. cine	—
Asahi	Takumar-Zoom*	85–210 mm.	f4·5	24 x 36 mm.	Z43
	Takumar-Zoom*	135–600 mm.	f6·7	24 x 36 mm.	Z44
Astronar	Astronar	95–205 mm.	f6·3	24 x 36 mm.	—
Bell & Howell	Filmovara	15–25 mm.	f1·6	8 mm. proj.	Z10
	Filmovara	15–25 mm.	f1·2	8 mm. proj.	Z11
	Filmovara	17–27 mm.	f1·6	Super-8 proj.	Z10
	Filmovara	19–32 mm.	f1·2	Super-8 proj.	Z12
	Filmovara	1¾ in.–2¼ in.	f1·6	16 mm. proj.	Z13
	Filmovara	3¼–4½ in.	f3·5	35 mm. slide proj.	Z14
	Varamat	9–27 mm.	f1·8	8 mm. cine	Z15
	Varamat	9–29 mm.	f1·8	8 mm. cine	Z15
	Bell & Howell	9–36 mm.	f1·8	8 mm. cine	Z15
	Bell & Howell	11–35 mm.	f1·8	Super-8 cine	Z16
Berthiot	Pan-Cinor	9–36 mm.	f1·9	8 mm. cine	Z4
	Pan-Cinor 70	17·5–70 mm.	f2·4	16 mm. cine	Z4
	Pan-Cinor 85	17·5–85 mm.	f2	16 mm. cine	Z4
	Pan-Cinor 30	10–30 mm.	f2·8	8 mm. cine	Z3
Bolex	Paillard-Bolex Hi-Fi	12·5–25 mm.	f1·3	8 mm. proj.	—
	Paillard-Bolex Hi-Fi	17–28 mm.	f1·3	Super-8 proj.	—
Canon	Cine Canonet	10–25 mm.	f1·8	8 mm. cine	Z17
	Motor Zoom	10–40 mm.	f1·7	8 mm. cine	Z18
	Canon-Zoom	10–40 mm.	f1·4	8 mm. cine	Z8
	Canon-Zoom	8·5–42·5 mm.	f1·4	8 mm. cine	Z19
	Canon-Zoom	8·5–42·5 mm.	f1·2	8 mm. cine	Z20
	Canon Zoom*	7·5–60 mm.	f1·4	8 mm. cine	Z45
	Canon Zoom*	7·5–90 mm.	f1·8	8 mm. cine	Z46
	Canon Zoom*	9·5–47·5 mm.	f1·8	8 mm. cine	Z47
	Canon Zoom*	10–30 mm.	f1·8	8 mm. cine	Z48
	with telephoto unit	14–70 mm.	f1·4		
	P-8	15–25 mm.	f1·5	8 mm. proj.	—
	Canomatic Zoom	55–135 mm.	f3·5	24 x 36 mm.	Z21
	Canon Zoom*	55–135 mm.	f3·5	24 x 36 mm.	Z49
	Canon Zoom*	85–300 mm.	f5	24 x 36 mm.	Z50
	Canon Zoom*	100–200 mm.	f5·6	24 x 36 mm.	Z51
Couffin	Zoomalik	35–75 mm.	f2·8	24 x 36 mm.	Z22

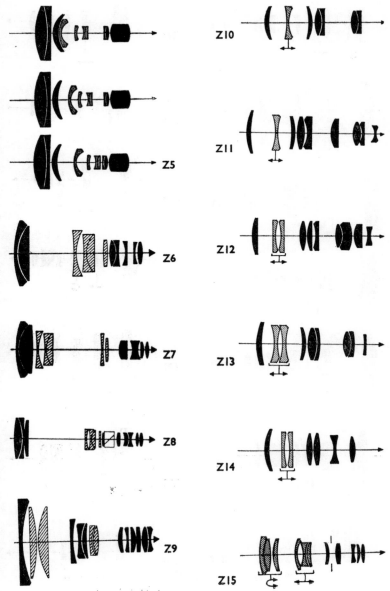

Z10

Z5

Z11

Z6

Z12

Z7

Z13

Z8

Z14

Z9

Z15

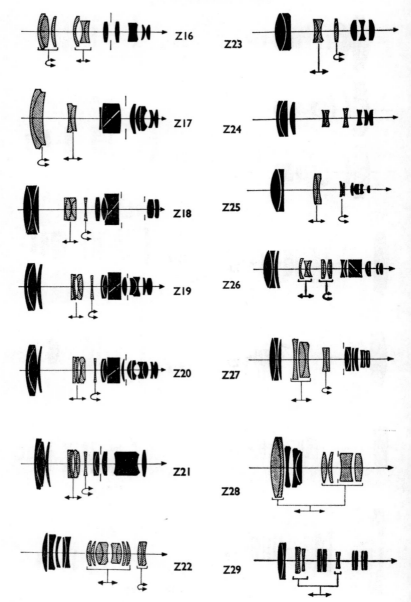

Z16

Z17

Z18

Z19

Z20

Z21

Z22

Z23

Z24

Z25

Z26

Z27

Z28

Z29

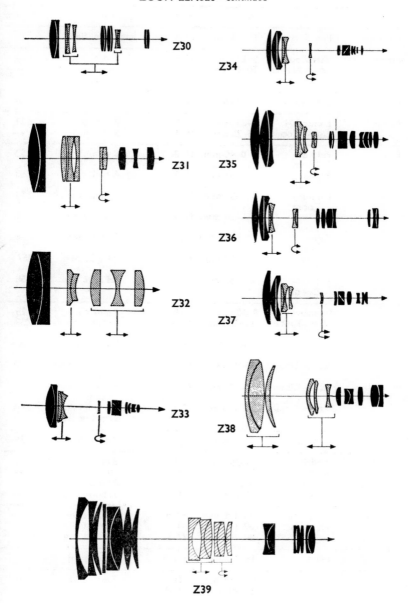

Z30

Z34

Z31

Z35

Z36

Z32

Z37

Z33

Z38

Z39

Maker	Name of Lens	Focus	Aperture	Field Covered	Diagram
Ednalite	Pro-Zoom	10–28 mm.	f2·4	8 mm. cine	Z23
Elgeet	Vari-Zoom	9–27 mm.	f1·8	8 mm. cine	—
	Zoom Navitar	20–80 mm.	f1·8	16 mm. & Vidicon	—
Elmo	Elmo Zoom	10–30 mm.	f1·8	8 mm. cine	—
Eumig	Eumig 504	8–25 mm.	f1·8	8 mm. cine	Z24
	Eupro-Zoom	15–25 mm.	f1·3	8 mm. proj.	—
Fuji	Fujinon-Zoom*	8·0–48 mm.	f1·8	8 mm. cine	Z52
	Fujinon-Zoom*	8·0–64 mm.	f1·8	8 mm. cine	Z53
	Fujinon-Zoom*	8·5–34 mm.	f1·8	8 mm. cine	Z54
	Fujinon-Zoom*	9·5–36 mm.	f1·9	8 mm. cine	Z55
	Fujinon-Zoom*	10·5–27·5 mm.	f1·8	8 mm. cine	Z56
	Fujinon-Zoom*	54–270 mm.	f4·5	24 x 36 mm.	Z57
	Fujinon-Zoom*	75–150 mm.	f4·5	24 x 36 mm.	Z58
Isco	Isconaron	9–30 mm.	f1·8	8 mm. cine	Z25
	Vario-Kiptar*	15–30 mm.	f1·3	8 mm. projection	Z59
	Vario Kiptar*	16·5–30 mm.	f1·3	8 mm. projection	Z59
	Vario-Kiptar*	18–30 mm.	f1·5	8 mm. projection	Z59
	Vario-Kiptar*	20–60 mm.	f1·8	16 mm. projection	—
	Vario-Projar*	70–120 mm.	f3·5	24 x 36 mm. projection	Z60
Kern	Vario-Switar	8–36 mm.	f1·9	8 mm. cine	Z26
Kodak	Kodak	15–25 mm.	f1·5	8 mm. proj.	—
	Kodak	20–32 mm.	f1·5	Super-8 mm.	—
	Kodak	9–27 mm.	f1·8	8 mm. cine	—
	Kodak	12–36 mm.	f1·8	Super-8 cine	—
Konica	Hexanon*	35–100 mm.	f2·8	24 x 36 mm.	—
	Hexanon*	60–135 mm.	f4	24 x 36 mm.	—
	Hexanon*	80–200 mm.	f7·5	24 x 36 mm.	—
Leitz	Leitz	15–25 mm.	f1·3	8 mm. proj.	—
Minolta	Rokkor	8·5–34 mm.	f1·4	8 mm. cine	—
	Rokkor	10–30 mm.	f1·8	8 mm. cine	—

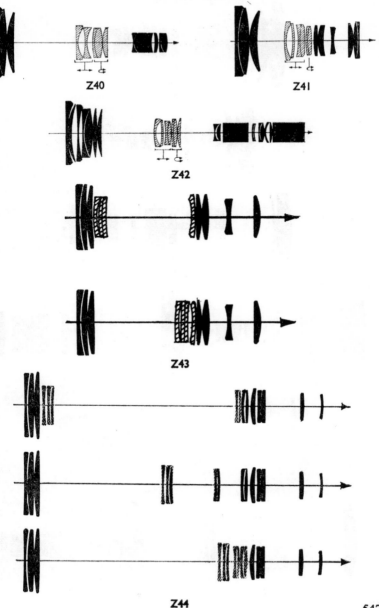

Z40

Z41

Z42

Z43

Z44

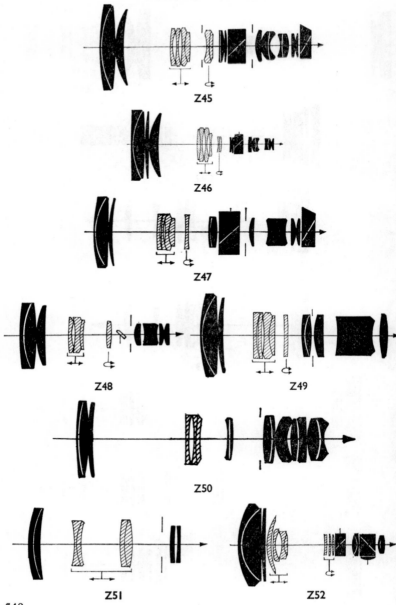

Z45

Z46

Z47

Z48 Z49

Z50

Z51 Z52

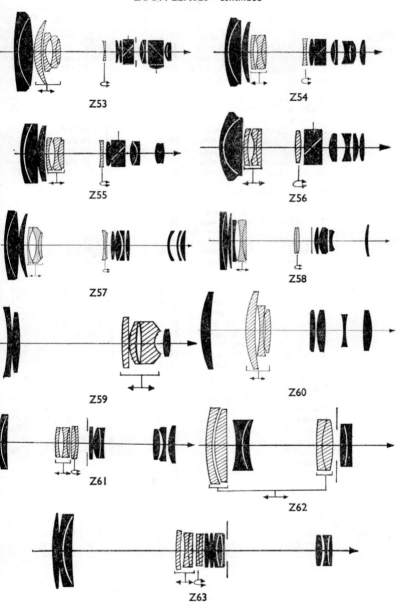

Z53

Z54

Z55

Z56

Z57

Z58

Z59

Z60

Z61

Z62

Z63

Maker	Name of Lens	Focus	Aperture	Field Covered	Diagram
Minolta	Rokkor	80–160 mm.	f3·5	24 x 36 mm.	Z27
—cont.	Zoom-Rokkor*	80–200 mm.	f4·5	24 x 36 mm.	Z61
	Zoom-Rokkor*	100–200 mm.	f5·6	24 x 36 mm.	Z62
	Zoom-Rokkor*	100–500 mm.	f8	24 x 36 mm.	Z63
	Rokkor	160–500 mm.	f8	24 x 36 mm.	—
Nikon	Nikkor-Zoom	8–32 mm.	f1·8	8 mm. cine	—
	Nikkorex 35 zoom	43–86 mm.	f3·5	24 x 36 mm.	Z28
	Nikkor-Zoom*	43–86 mm.	f3·5	24 x 36 mm.	—
	Nikkor-Zoom*	50–300 mm.	f4·5	24 x 36 mm.	—
	Nikkor-Zoom*	80–200 mm.	f4·5	24 x 36 mm.	—
	Nikkor-Zoom*	85–250 mm.	f4·5	24 x 36 mm.	—
	Auto-Nikkor	85–250 mm.	f4	24 x 36 mm.	Z29
	Auto-Nikkor	200–600 mm.	f9·5	24 x 36 mm.	Z30
	Nikkon-Zoom*	200–600 mm.	f9·5	24 x 36 mm.	—
Olympus	Zuiko Zoom	50–90 mm.	f3·5	18 x 24 mm.	Z31
	Zuiko-Zoom*	75–150 mm.	f4	24 × 36 mm.	Z64
Rokunar	Rokunar Zoom	55–90 mm.	f4	24 x 36 mm.	Z32
	Rokunar Zoom	95–205 mm.	f5·6	24 x 36 mm.	Z32
	Rokunar Zoom	200–400 mm.	f6·3	24 x 36 mm.	Z32
Schneider	Variogon	9–30 mm.	f1·8	8 mm. cine	Z33
	Variogon*	10–30 mm.	f1·8	8 mm. cine	Z70
	Variogon*	9–36 mm.	f1·8	8 mm. cine	Z71
	Variogon*	8–40 mm.	f1·8	8 mm. cine	Z66
	Variogon	10–40 mm.	f2·8	8 mm. cine	Z34
	Variogon	8–48 mm.	f1·8	8 mm. cine	Z37
	Variogon*	8–48 mm.	f1·8	8 mm. cine	Z65
	Variogon*	7–56 mm.	f1·8	8 mm. cine	Z67
	OptiVaron*	6–66 mm.	f1·8	8 mm. cine	Z65
	Variogon*	7–80 mm	f1·8	8 mm. cine	Z68
	Variogon	16–80 mm.	f2	16 mm. cine	Z35
	Variogon*	10–100 mm.	f2	16 mm. cine	Z69
	Variogon*	14–150 mm.	f1·7	9·6 x 12·8 mm.	Z72
	Variogon*	15–150 mm.	f2·8	9·6 x 12·8 mm.	Z73
	Variogon*	16–480 mm.	f1·7, 5·1	9·6 x 12·8 mm.	Z74
	Variogon*	17–170 mm.	f2	9·6 x 12·8 mm.	Z75
	Variogon*	18–90 mm.	f2	9·6 x 12·8 mm.	Z76
	Variogon*	18–200 mm.	f2·1	9·6 x 12·8 mm.	Z77
	Variogon*	20–600 mm.	f2·1-6·3	9·6 x 12·8 mm.	Z78
	Variogon*	25–125 mm.	f1·7	9·6 x 12·8 mm.	Z79
	Variogon*	45–100 mm.	f2·8	24 x 36 mm.	Z80
	Tele-Variogon*	80–240 mm.	f4	24 x 36 mm.	Z81
	Tele-Variogon	80–240 mm.	f4	24 x 36 mm.	Z36
Sopelem	SOM-Berthiot*	17–130 mm.	f2·6	9·6 x 12·8 mm.	—
	SOM-Berthiot*	17–85 mm.	f1·8	9·6 x 12·8 mm.	—
	SOM-Berthiot*	20–100 mm.	f2·1	9·6 x 12·8 mm.	—
	SOM-Berthiot*	24–180 mm.	f3·4	9·6 x 12·8 mm.	—
	SOM-Berthiot*	25–125 mm.	f2·6	9·6 x 12·8 mm.	—
	SOM-Berthiot*	40–200 mm.	f4·2	9·6 x 12·8 mm.	—
	SOM-Berthiot*	50–250 mm.	f5·2	9·6 x 12·8 mm.	—

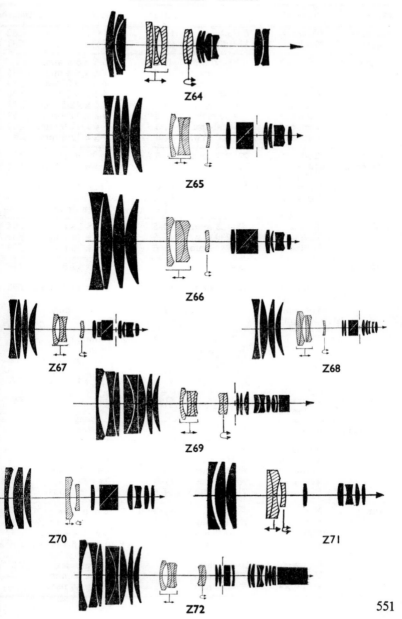

Z64

Z65

Z66

Z67

Z68

Z69

Z70

Z71

Z72

551

Maker	Name of Lens	Focus	Aperture	Field Covered	Diagram
Sopelem —cont.	Monital*	8–26 mm.	f1·6	74°	Z82
	Monital*	12–120 mm.	f3·3	74°	Z83
Tamron	Tamron*	12·5–50 mm.	f1·8	6·6 x 8·8 mm.	—
	Tamron*	14–70 mm.	f1·8	6·6 x 8·8 mm.	Z85
	Tamron*	16–64 mm.	f2	6·6 x 8·8 mm.	Z84
	Tamron*	12·5–80 mm.	f1·8	6·6 x 8·8 mm.	Z86
	Tamron*	18–108 mm.	f2·5	9·6 x 12·8 mm.	Z87
	Tamron*	20–80 mm.	f2·5	9·6 x 12·8 mm.	Z88
	Tamron*	15–150 nm.	f2·5	9·6 x 12·8 mm.	Z89
	Tamron*	25–100 mm.	f1·8	9·6 x 12·8 mm.	Z90
Taylor-Hobson	Studio-Varotal	22·5–80 mm.	f1·8	Vidicon	Z38
	Studio-Varotal	2¼ in.–8 in.	f4	Image Orthicon	Z38
	Varotal (I)	5 in.–25 in.	f5·6	Image Orthicon	—
	Varotal (III)	4 in.–20 in.	f4	Image Orthicon	—
		8 in.–40 in.	f8	Image Orthicon	—
Tokina	Tokina*	55–135 mm.	f3·5	24 x 36 mm.	Z91
	Tokina*	90–230 mm.	f4·5	24 x 36 mm.	Z92
	Tokina*	180–410 mm.	f5·6	24 x 36 mm.	Z93
Tomioka	Tominon Zoom*	18–90 mm.	f2	9·6 x 12·8 mm.	Z94
	Tominon Zoom*	18–150 mm.	f2	9·6 x 12·8 mm.	Z95
	Tominon Zoom*	45–153 mm.	f3·5	24 x 36 mm.	Z96
Vivitar	Vivitar*	7–70 mm.	f1·8	8 mm. cine	—
	Vivitar*	9–230 mm.	f1·8	8 mm. cine	—
	Vivitar*	55–135 mm.	f3.5	24 x 36 mm.	—
	Vivitar*	70–210 mm.	f3·5	24 x 36 mm.	—
	Vivitar*	85–205 mm.	f3·8	24 x 36 mm.	Z97
Voigtlander	Voigtlander-Zoomar	36–82 mm.	f2·8	24 x 36 mm.	Z9
Wollensak	Raptar	30–150 mm.	f2·7	Vidicon	—
Yashica	Yashinon	9–28 mm.	f1·8	8 mm. cine	—
	Yashinon	9–27 mm.	f1·8	8 mm. cine	—
	Yashinon*	45–135 mm.	f3·5	24 x 36 mm.	—
	Yashinon-R	90–190 mm.	f5·8	24 x 36 mm.	—
	Yashinon*	75–230 mm.	f4·5	24 x 36 mm.	—
Zeiss	Moviflex*	6–60 mm.	f2·8	8 mm. cine	—
	Vario-Sonnar*	7·5–30 mm.	f1·9	8 mm. cine	Z98
	Vario-Sonnar*	12·5–75 mm.	f2	8 mm. cine	Z99
	Vario-P-Sonnar*	15–25 mm.	f1·4	8 mm. projection	Z100
	Pentovar	30–120 mm.	f2	35 mm. cine	Z5
	Vario-Sonnar*	40–120 mm.	f2·8	24 x 36 mm.	—
	Vario-Sonnar*	85–250 mm.	f4	24 x 36 mm.	—

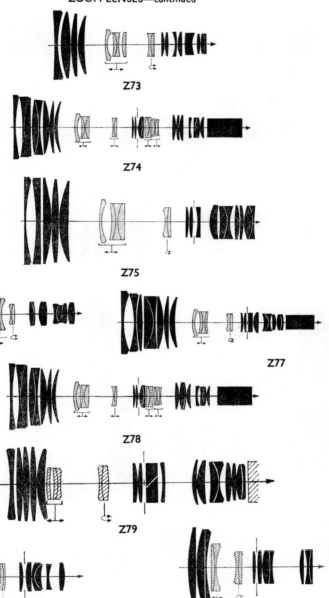

Z73

Z74

Z75

Z76

Z77

Z78

Z79

Z80

Z81

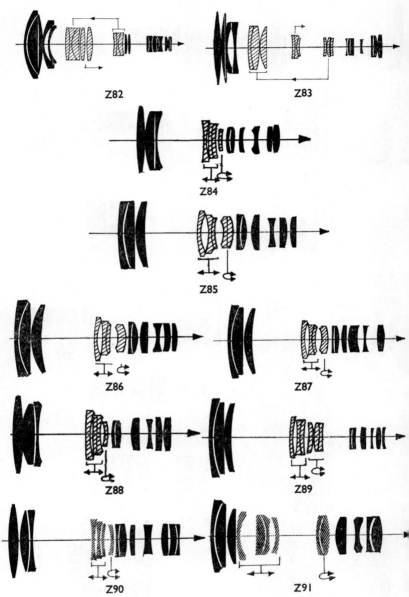

Z82

Z83

Z84

Z85

Z86

Z87

Z88

Z89

Z90

Z91

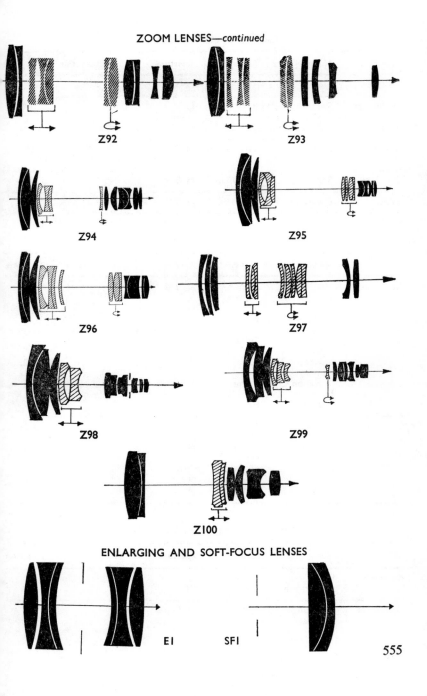

Z92

Z93

Z94

Z95

Z96

Z97

Z98

Z99

Z100

ENLARGING AND SOFT-FOCUS LENSES

E1 SF1

555

PORTRAIT AND SOFT-FOCUS LENSES

Maker	Name of Lens	Focus	Aperture	Field Covered	Diagram
Berthiot	Stellor	—	f3·5	40°	T1
Dallmeyer	Portrait Anast.	9–15 in.	f3·5	50°	T4
Kodak	Portrait Lens	12–16 in.	f4·5	48°	SF1
Rodenstock	Deep Field Imagon	120–480 mm.	f4·5–5·8	20°–40°	SF1
T.T. & H.	Series IIE	10½–20 in.	f4·5	44°–50°	T1
Wray	Portrait Anast.	8½–14 in.	f3·5	40°	T1

CONVERTIBLE LENSES

Maker	Name of Lens	Focus	Aperture	Field Covered	Diagram
Rodenstock	Heligon C	50 mm.	f2, 2·8		C1a, 1b, 1c
	Heligon C	35 mm.	f5·6		
	Heligon C	35 mm.	f4		
	Heligon C	80 mm.	f4		
Schneider	Xenon C Curtar	50 mm.	f2, 2·8		C2a, 2b, 2C
	Xenon C Curtar	35 mm.	f5·6		
	Xenon C Longar	35 mm.	f4		
	Xenon C	80 mm.	f4		
Zeiss	Tessar	50 mm.	f2·8		C3a, 3b, 3c, 3d
	Pro-Tessar	35 mm.	f4 or f3·2		
	Pro-Tessar	85 mm.	f4 or f3·2		
	Pro-Tessar	M1:1	—		
	Pantar	45 mm.	f2·8		C4a, 4b, 4c
	Pantar	30 mm.	f4		
	Pantar	75 mm.	f4		

ENLARGING AND PROCESS LENSES

Maker	Name of Lens	Focus	Aperture	Field Covered	Diagram
Berthiot	Flor	—	f2·8	45°	S5
	Apographe	—	f10	44°	E1
Dallmeyer	Enlarging Anast.	2–10 in.	f3·5–5·6	55°	T4
	High Resolution	1 in.	f8	50°	S5

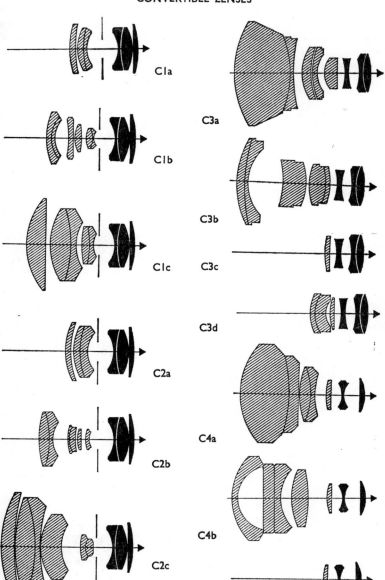

C1a

C1b

C1c

C2a

C2b

C2c

C3a

C3b

C3c

C3d

C4a

C4b

C4c

Maker	Name of Lens	Focus	Aperture	Field Covered	Diagram
Dallmeyer —*cont.*	High Resolution	2 in.	f8	46°	T4
Goerz	Artar Apo Process	4–70 in.	f9–16	44°	T3
	Gotar Process	8½–24 in.	f6·8–10	54°	T3
Kern	Apo-Repro	210–300 mm.	f6·6–9	53°	T3
Kodak	Enlarg. Ektanon	5½–10 in.	f4·5	44°	T4
	Enlarg. Ektar	2 & 3 in.	f4·5	44°	T7
	Microfile Ektar	2½ in.	f8	44°	T7
	Enlarg. Ektar	90 & 100 mm.	f4·5	48°	T3
	Ektar	8 & 10 in.	f8	40°	T3
	Copying Ektanon	13–21¼ in.	f10	48°	T3
Nikon	Micro-Nikkor	50 mm.	f3·5	46°	S15
	El-Nikkor	50 mm.	f2·8	46°	S29
	Apo-Nikkor	15–120 cm.	f9	46°	T4
	Apo-Nikkor	180 cm.	f14	46°	T4
Rodenstock	Ysaron	50–210 mm.	f4·5	55°	T4
	Apo-Ronar	150–600 mm.	f9	45°–50°	T3
	Apo-Ronar	800 mm.	f9	45°	T33
Ross	Resolux Enlarging	50–110 mm.	f3·5, 4	50°	T4
	Process Lens	9½–48 in.	f10–12·5	34°–37°	S3
	Ensar	105 mm.	f4·5	2½ × 3½ in.	T4
Schneider	Repro-Claron	55–610 mm.	f8, f9	46°	T3
	Componar	50–135 mm.	f4, f4·5	24 × 36 mm. —4 in. × 5 in.	T4
	Comparon	105–300 mm.	f4·5–f5·6	—	—
	Componon	28–300 mm.	f4–f5·6	24 × 36 mm. —8 in. × 10 in.	S3
Steinheil	Culminar	50–210 mm.	f4, 4·5	50°	T4
	Cassar	50–105 mm.	f3·5, 4·5	50°	T1
T.T. & H.	Ental	50–127 mm.	f3·5, 4·5	50°	T4
	Ental Series II	2–6 in.	f3·5–4·5	48°–54°	T16
	Ental Series II	7½–12½ in.	f5·6	54°	T7
	Copying Lens	4 in.	f2–4	35 mm. cine	S5 & T7
	Series IX	13–62 in.	f10–16	35°–45°	T3
	Apotal	9½–24 in.	f9	48°	T4
	Microfilm	20–50 mm.	f4	16 mm. cine	S5
	Radiography	8 in.	f1·4	5 × 5 in.	S5
Voigtlander	Apo Skopar	150–750 mm.	f8, f9	45°	T7

Maker	Name of Lens	Focus	Aperture	Field Covered	Diagram
Wollensak	Raptar	2–12 in.	f4·5	50°	T4
Wray	Apo Process	4–63 in.	f10–16	38°	T3
	W. A. Lustrar	12 in.	f10	50°	W2
Zeiss	Apo Tessar	140–900 mm.	f9	48°	T4

Metric Conversions

CONVERSION OF FEET TO METRES

Feet	Metres	Feet	Metres	Feet	Metres	Feet	Metres
2	·61	16	4·87	32	9·75	80	24·35
$2\frac{1}{2}$	·76	17	5·18	34	10·35	85	25·88
3	·91	18	5·48	36	10·96	90	27·40
4	1·22	19	5·79	38	11·56	95	28·90
5	1·52	20	6·09	40	12·16	100	30·43
6	1·83	21	6·39	42	12·78	110	33·48
7	2·13	22	6·70	44	13·38	120	36·52
8	2·44	23	7·01	46	14·00	130	39·56
9	2·74	24	7·31	48	14·60	140	42·60
10	3·04	25	7·61	50	15·22	150	45·64
11	3·35	26	7·92	55	16·73	160	48·70
12	3·65	27	8·22	60	18·26	170	51·72
13	3·96	28	8·52	65	19·77	180	54·76
14	4·26	29	8·83	70	21·30	190	57·80
15	4·57	30	9·13	75	22·83	200	60·84

CONVERSION OF DIOPTRES TO INCHES AND TO CENTIMETRES

Power [dioptres]	Focus [c.m.]	Focus [in.]	Power [dioptres]	Focus [cm.]	Focus [in.]	Power [dioptres]	Focus [cm.]	Focus [in.]
$\frac{1}{4}$	400	$157\frac{1}{8}$	$6\frac{1}{2}$	15·4	$6\frac{1}{16}$	$13\frac{1}{2}$	7·4	$2\frac{15}{16}$
$\frac{1}{2}$	200	$78\frac{3}{4}$	7	14·3	$5\frac{5}{8}$	14	7·1	$2\frac{13}{16}$
$\frac{3}{4}$	133·3	$52\frac{1}{2}$	$7\frac{1}{2}$	13·3	$5\frac{1}{4}$	$14\frac{1}{2}$	6·9	$2\frac{23}{32}$
1	100	$39\frac{3}{8}$	8	12·5	$4\frac{59}{64}$	15	6·7	$2\frac{5}{8}$
$1\frac{1}{2}$	66·6	$26\frac{1}{4}$	$8\frac{1}{2}$	11·7	$4\frac{5}{8}$	$15\frac{1}{2}$	6·45	$2\frac{35}{64}$
2	50	$19\frac{11}{16}$	9	11·1	$4\frac{3}{8}$	16	6·25	$2\frac{15}{32}$
$2\frac{1}{2}$	40	$15\frac{3}{4}$	$9\frac{1}{2}$	10·5	$4\frac{5}{32}$	$16\frac{1}{2}$	6·06	$2\frac{25}{64}$
3	33·3	$13\frac{1}{8}$	10	10	$3\frac{15}{16}$	17	5·88	$2\frac{5}{16}$
$3\frac{1}{2}$	28·6	$11\frac{1}{4}$	$10\frac{1}{4}$	9·5	$3\frac{3}{4}$	$17\frac{1}{2}$	5·72	$2\frac{1}{4}$
4	25	$9\frac{27}{32}$	11	9·1	$3\frac{9}{16}$	18	5·56	$2\frac{3}{16}$
$4\frac{1}{2}$	22·2	$8\frac{3}{4}$	$11\frac{1}{2}$	8·7	$3\frac{7}{16}$	$18\frac{1}{2}$	5·41	$2\frac{1}{8}$
5	20	$7\frac{7}{8}$	12	8·3	$3\frac{9}{32}$	19	5·27	$2\frac{1}{16}$
$5\frac{1}{2}$	18·2	$7\frac{5}{32}$	$12\frac{1}{2}$	8	$3\frac{6}{32}$	$19\frac{1}{2}$	5·13	$2\frac{1}{64}$
6	16·7	$6\frac{9}{16}$	13	7·7	$3\frac{1}{64}$	20	5	$1\frac{31}{32}$

DEPTH OF FIELD TABLES in METRES

DEPTH OF FIELD FOR LENSES OF 25 MM (1 in.) FOCAL LENGTH

In the table below each cell is given as **near limit – far limit** (in metres); the column heading is the distance focused upon (the middle figure of each original triplet).

Aperture	INF	10·00	9·00	8·00	7·00	6·00	5·00	4·00	3·50	3·00	2·50	2·00	1·50	1·00	0·75	0·50
f1·50	16·64–INF	6·25–25·00	5·84–19·57	5·41–15·38	4·93–12·07	4·41–9·37	3·85–7·14	3·23–5·26	2·89–4·43	2·54–3·66	2·17–2·94	1·79–2·27	1·38–1·65	0·94–1·06	0·72–0·79	0·49–0·52
f2·00	12·48–INF	5·56–50·00	5·23–32·14	4·88–22·22	4·49–15·91	4·05–11·54	3·57–8·33	3·03–5·88	2·73–4·86	2·42–3·95	2·08–3·13	1·72–2·38	1·34–1·70	0·93–1·09	0·71–0·80	0·48–0·52
f2·50	9·99–INF	5·00–INF	4·74–90·00	4·44–40·00	4·12–23·33	3·75–15·00	3·33–10·00	2·86–6·67	2·59–5·38	2·31–4·29	2·00–3·33	1·67–2·50	1·30–1·76	0·91–1·11	0·70–0·81	0·48–0·53
f3·00	8·33–INF	4·55–INF	4·33–INF	4·08–200·00	3·80–43·75	3·49–21·43	3·12–12·50	2·70–7·69	2·46–6·03	2·21–4·69	1·92–3·57	1·61–2·63	1·27–1·83	0·89–1·14	0·69–0·82	0·47–0·53
f3·50	7·14–INF	4·17–INF	3·98–INF	3·77–INF	3·54–350·00	3·26–37·50	2·94–16·67	2·56–9·09	2·35–6·86	2·11–5·17	1·85–3·85	1·56–2·78	1·24–1·90	0·88–1·16	0·68–0·84	0·47–0·54
f4·00	6·25–INF	3·85–INF	3·69–INF	3·51–INF	3·30–INF	3·06–150·00	2·78–25·00	2·44–11·11	2·24–7·95	2·03–5·77	1·79–4·17	1·52–2·94	1·21–1·97	0·86–1·19	0·67–0·85	0·46–0·54
f4·50	5·55–INF	3·57–INF	3·44–INF	3·28–INF	3·10–INF	2·88–INF	2·63–50·00	2·33–14·29	2·15–9·46	1·95–6·52	1·72–4·55	1·47–3·13	1·18–2·05	0·85–1·22	0·66–0·87	0·46–0·55
f5·60	4·46–INF	3·09–INF	2·98–INF	2·87–INF	2·73–INF	2·56–INF	2·36–INF	2·11–38·46	1·96–16·20	1·79–9·15	1·60–5·68	1·38–3·62	1·12–2·26	0·82–1·29	0·64–0·90	0·45–0·56
f6·30	3·97–INF	2·84–INF	2·75–INF	2·65–INF	2·53–INF	2·39–INF	2·21–INF	1·99–INF	1·86–29·66	1·71–12·30	1·53–6·76	1·33–4·03	1·09–2·41	0·80–1·34	0·63–0·92	0·44–0·57
f8·00	3·12–INF	2·38–INF	2·32–INF	2·25–INF	2·16–INF	2·05–INF	1·92–INF	1·75–INF	1·65–INF	1·53–75·00	1·39–12·50	1·22–5·56	1·01–2·89	0·76–1·47	0·60–0·99	0·43–0·60
f11·00	2·27–INF	1·85–INF	1·81–INF	1·77–INF	1·72–INF	1·65–INF	1·56–INF	1·45–INF	1·38–INF	1·29–INF	1·19–INF	1·06–16·67	0·90–4·41	0·69–1·79	0·56–1·12	0·41–0·64
f16·00	1·56–INF	1·35–INF	1·33–INF	1·31–INF	1·28–INF	1·24–INF	1·19–INF	1·12–INF	1·08–INF	1·03–INF	0·96–INF	0·88–INF	0·77–37·50	0·61–2·78	0·51–1·44	0·38–0·74
f22·00	1·14–INF	1·02–INF	1·01–INF	1·00–INF	0·98–INF	0·96–INF	0·93–INF	0·88–INF	0·86–INF	0·82–INF	0·78–INF	0·72–INF	0·65–INF	0·53–8·33	0·45–2·21	0·35–0·89

DEPTH OF FIELD FOR LENSES OF 28 mm (1⅛ in.) FOCAL LENGTH

Aperture	Limit	0·50	0·75	1·00	1·50	2·00	2·50	3·00	3·50	4·00	5·00	6·00	7·00	8·00	9·00	10·00	INF
f1·50	near	0·49	0·72	0·95	1·39	1·81	2·20	2·58	2·95	3·29	3·94	4·54	5·09	5·60	6·07	6·51	18·63
f1·50	far	0·51	0·78	1·06	1·63	2·24	2·89	3·57	4·31	5·09	6·83	8·84	11·20	14·00	17·38	21·54	INF
f2·00	near	0·48	0·71	0·93	1·35	1·75	2·12	2·47	2·80	3·11	3·68	4·20	4·67	5·09	5·48	5·83	13·98
f2·00	far	0·52	0·79	1·08	1·68	2·33	3·04	3·82	4·67	5·60	7·78	10·50	14·00	18·67	25·20	35·00	INF
f2·50	near	0·48	0·70	0·92	1·32	1·70	2·04	2·37	2·67	2·95	3·46	3·91	4·31	4·67	4·99	5·28	11·19
f2·50	far	0·52	0·80	1·10	1·73	2·43	3·22	4·10	5·09	6·22	9·03	12·92	18·67	28·00	45·82	93·33	INF
f3·00	near	0·47	0·69	0·90	1·29	1·65	1·97	2·27	2·55	2·80	3·26	3·65	4·00	4·31	4·58	4·83	9·32
f3·00	far	0·53	0·82	1·12	1·79	2·55	3·41	4·42	5·60	7·00	10·77	16·80	28·00	56·00	252·00	INF	INF
f3·50	near	0·47	0·69	0·89	1·26	1·60	1·90	2·18	2·43	2·67	3·08	3·43	3·73	4·00	4·24	4·44	7·99
f3·50	far	0·53	0·83	1·14	1·85	2·67	3·64	4·80	6·22	8·00	13·33	24·00	56·00	INF	INF	INF	INF
f4·00	near	0·47	0·68	0·88	1·24	1·56	1·84	2·10	2·33	2·55	2·92	3·23	3·50	3·73	3·94	4·12	7·00
f4·00	far	0·54	0·84	1·17	1·91	2·80	3·89	5·25	7·00	9·33	17·50	42·00	168·00	INF	INF	INF	INF
f4·50	near	0·46	0·67	0·86	1·21	1·51	1·78	2·02	2·24	2·43	2·77	3·05	3·29	3·50	3·68	3·84	6·22
f4·50	far	0·54	0·85	1·19	1·98	2·95	4·18	5·79	8·00	11·20	25·45	168·00	INF	INF	INF	INF	INF
f5·60	near	0·45	0·65	0·83	1·15	1·43	1·67	1·88	2·06	2·22	2·50	2·73	2·92	3·08	3·21	3·33	5·00
f5·60	far	0·56	0·88	1·25	2·14	3·33	5·00	7·50	11·67	20·00	INF	INF	INF	INF	INF	INF	INF
f6·30	near	0·45	0·64	0·82	1·12	1·38	1·60	1·79	1·96	2·11	2·35	2·55	2·72	2·86	2·98	3·08	4·44
f6·30	far	0·56	0·90	1·29	2·26	3·64	5·71	9·23	16·47	40·00	INF	INF	INF	INF	INF	INF	INF
f8·00	near	0·44	0·62	0·78	1·05	1·27	1·46	1·62	1·75	1·87	2·06	2·21	2·33	2·43	2·52	2·59	3·50
f8·00	far	0·58	0·95	1·40	2·62	4·67	8·75	21·00	INF	INF	INF	INF	INF	INF	INF	INF	INF
f11·00	near	0·42	0·58	0·72	0·94	1·12	1·26	1·38	1·47	1·56	1·69	1·79	1·87	1·93	1·98	2·03	2·54
f11·00	far	0·62	1·06	1·65	3·65	9·33	140·00	INF	INF	INF	INF	INF	INF	INF	INF	INF	INF
f16·00	near	0·39	0·52	0·64	0·81	0·93	1·03	1·11	1·17	1·22	1·30	1·35	1·40	1·44	1·47	1·49	1·75
f16·00	far	0·70	1·31	2·33	10·50	INF	INF	INF	INF	INF	INF	INF	INF	INF	INF	INF	INF
f22·00	near	0·36	0·47	0·56	0·69	0·78	0·84	0·89	0·93	0·97	1·01	1·05	1·08	1·10	1·12	1·13	1·27
f22·00	far	0·82	1·83	4·67	INF	INF	INF	INF	INF	INF	INF	INF	INF	INF	INF	INF	INF

DEPTH OF FIELD FOR LENSES OF 35 mm (1⅜ in.) FOCAL LENGTH

f-stop	0·50	0·75	1·00	1·50	2·00	2·50	3·00	3·50	4·00	5·00	6·00	7·00	8·00	9·00	10·00	INF
	0·49	0·73	0·96	1·41	1·84	2·26	2·66	3·04	3·41	4·12	4·77	5·38	5·96	6·49	7·00	23·28
f1·50	0·50	0·75	1·00	1·50	2·00	2·50	3·00	3·50	4·00	5·00	6·00	7·00	8·00	9·00	10·00	INF
	0·51	0·77	1·04	1·60	2·19	2·80	3·44	4·12	4·83	6·36	8·08	10·00	12·17	14·65	17·50	INF
	0·49	0·72	0·95	1·38	1·79	2·19	2·56	2·92	3·26	3·89	4·47	5·00	5·39	5·94	6·36	17·47
f2·00	0·50	0·75	1·00	1·50	2·00	2·50	3·00	3·50	4·00	5·00	6·00	7·00	8·00	9·00	10·00	INF
	0·51	0·78	1·06	1·64	2·26	2·92	3·62	4·38	5·19	7·00	9·13	11·67	14·74	18·53	23·33	INF
	0·48	0·71	0·93	1·35	1·75	2·12	2·47	2·80	3·11	3·68	4·20	4·67	5·09	5·48	5·83	13·98
f2·50	0·50	0·75	1·00	1·50	2·00	2·50	3·00	3·50	4·00	5·00	6·00	7·00	8·00	9·00	10·00	INF
	0·52	0·79	1·08	1·68	2·33	3·04	3·82	4·67	5·60	7·78	10·50	14·00	18·67	25·20	35·00	INF
	0·48	0·70	0·92	1·33	1·71	2·06	2·39	2·69	2·98	3·50	3·96	4·37	4·75	5·08	5·38	11·65
f3·00	0·50	0·75	1·00	1·50	2·00	2·50	3·00	3·50	4·00	5·00	6·00	7·00	8·00	9·00	10·00	INF
	0·52	0·80	1·09	1·72	2·41	3·18	4·04	5·00	6·09	8·75	12·35	17·50	25·45	39·38	70·00	INF
	0·48	0·70	0·91	1·30	1·67	2·00	2·31	2·59	2·86	3·33	3·75	4·12	4·44	4·74	5·00	9·99
f3·50	0·50	0·75	1·00	1·50	2·00	2·50	3·00	3·50	4·00	5·00	6·00	7·00	8·00	9·00	10·00	INF
	0·53	0·81	1·11	1·76	2·50	3·33	4·29	5·38	6·67	10·00	15·00	23·33	40·00	90·00	INF	INF
	0·47	0·69	0·90	1·28	1·63	1·94	2·23	2·50	2·75	3·18	3·56	3·89	4·18	4·44	4·67	8·74
f4·00	0·50	0·75	1·00	1·50	2·00	2·50	3·00	3·50	4·00	5·00	6·00	7·00	8·00	9·00	10·00	INF
	0·53	0·82	1·13	1·81	2·59	3·50	4·57	5·83	7·37	11·67	19·09	35·00	93·33	INF	INF	INF
	0·47	0·68	0·89	1·26	1·59	1·89	2·16	2·41	2·64	3·04	3·39	3·68	3·94	4·17	4·37	7·77
f4·50	0·50	0·75	1·00	1·50	2·00	2·50	3·00	3·50	4·00	5·00	6·00	7·00	8·00	9·00	10·00	INF
	0·53	0·83	1·15	1·86	2·69	3·68	4·88	6·36	8·24	14·00	26·25	70·00	INF	INF	INF	INF
	0·46	0·67	0·86	1·21	1·52	1·79	2·03	2·24	2·44	2·78	3·06	3·30	3·51	3·69	3·85	6·25
f5·60	0·50	0·75	1·00	1·50	2·00	2·50	3·00	3·50	4·00	5·00	6·00	7·00	8·00	9·00	10·00	INF
	0·54	0·85	1·19	1·97	2·94	4·17	5·77	7·95	11·11	25·00	150·00	INF	INF	INF	INF	INF
	0·46	0·66	0·85	1·18	1·47	1·72	1·95	2·15	2·33	2·63	2·88	3·10	3·28	3·44	3·57	5·55
f6·30	0·50	0·75	1·00	1·50	2·00	2·50	3·00	3·50	4·00	5·00	6·00	7·00	8·00	9·00	10·00	INF
	0·55	0·87	1·22	2·05	3·12	4·55	6·52	9·46	14·29	50·00	INF	INF	INF	INF	INF	INF
	0·45	0·64	0·81	1·12	1·37	1·59	1·78	1·94	2·09	2·33	2·53	2·69	2·83	2·94	3·04	4·37
f8·00	0·50	0·75	1·00	1·50	2·00	2·50	3·00	3·50	4·00	5·00	6·00	7·00	8·00	9·00	10·00	INF
	0·56	0·91	1·30	2·28	3·68	5·83	9·55	17·50	46·67	INF	INF	INF	INF	INF	INF	INF
	0·43	0·61	0·76	1·02	1·23	1·40	1·54	1·67	1·77	1·94	2·08	2·19	2·28	2·35	2·41	3·18
f11·00	0·50	0·75	1·00	1·50	2·00	2·50	3·00	3·50	4·00	5·00	6·00	7·00	8·00	9·00	10·00	INF
	0·59	0·98	1·46	2·84	5·38	11·67	52·50	INF	INF	INF	INF	INF	INF	INF	INF	INF
	0·41	0·56	0·69	0·89	1·04	1·17	1·27	1·35	1·41	1·52	1·60	1·67	1·72	1·76	1·79	2·19
f16·00	0·50	0·75	1·00	1·50	2·00	2·50	3·00	3·50	4·00	5·00	6·00	7·00	8·00	9·00	10·00	INF
	0·65	1·14	1·84	4·77	23·33	INF	INF	INF	INF	INF	INF	INF	INF	INF	INF	INF
	0·38	0·51	0·61	0·77	0·89	0·97	1·04	1·09	1·14	1·21	1·26	1·30	1·33	1·35	1·37	1·59
f22·00	0·50	0·75	1·00	1·50	2·00	2·50	3·00	3·50	4·00	5·00	6·00	7·00	8·00	9·00	10·00	INF
	0·73	1·42	2·69	26·25	INF	INF	INF	INF	INF	INF	INF	INF	INF	INF	INF	INF

DEPTH OF FIELD FOR LENSES OF 42·5 mm (1⅝ in.) FOCAL LENGTH

																
f1·50	0·49	0·73	0·97	1·42	1·87	2·30	2·71	3·12	3·51	4·25	4·95	5·61	6·24	6·83	7·39	28·25
	0·50	0·75	1·00	1·50	2·00	2·50	3·00	3·50	4·00	5·00	6·00	7·00	8·00	9·00	10·00	INF
	0·51	0·77	1·04	1·58	2·15	2·74	3·36	3·99	4·66	6·07	7·61	9·30	11·15	13·19	15·45	INF
f2·00	0·49	0·72	0·96	1·40	1·83	2·24	2·63	3·01	3·37	4·05	4·68	5·27	5·81	6·32	6·80	21·20
	0·50	0·75	1·00	1·50	2·00	2·50	3·00	3·50	4·00	5·00	6·00	7·00	8·00	9·00	10·00	INF
	0·51	0·78	1·05	1·61	2·21	2·83	3·49	4·19	4·93	6·54	8·36	10·44	12·83	15·61	18·89	INF
f2·50	0·49	0·72	0·94	1·38	1·79	2·18	2·55	2·90	3·24	3·86	4·43	4·96	5·44	5·88	6·30	16·97
	0·50	0·75	1·00	1·50	2·00	2·50	3·00	3·50	4·00	5·00	6·00	7·00	8·00	9·00	10·00	INF
	0·52	0·78	1·06	1·65	2·27	2·93	3·64	4·41	5·23	7·08	9·27	11·90	15·11	19·12	24·29	INF
f3·00	0·48	0·71	0·93	1·36	1·75	2·12	2·48	2·81	3·12	3·70	4·21	4·69	5·11	5·50	5·86	14·15
	0·50	0·75	1·00	1·50	2·00	2·50	3·00	3·50	4·00	5·00	6·00	7·00	8·00	9·00	10·00	INF
	0·52	0·79	1·08	1·68	2·33	3·04	3·81	4·65	5·57	7·73	10·41	13·84	18·38	24·68	34·00	INF
f3·50	0·48	0·71	0·92	1·34	1·72	2·07	2·41	2·72	3·01	3·54	4·02	4·44	4·82	5·17	5·48	12·13
	0·50	0·75	1·00	1·50	2·00	2·50	3·00	3·50	4·00	5·00	6·00	7·00	8·00	9·00	10·00	INF
	0·52	0·80	1·09	1·71	2·39	3·15	3·98	4·92	5·96	8·50	11·86	16·53	23·45	34·77	56·67	INF
f4·00	0·48	0·70	0·91	1·31	1·68	2·02	2·34	2·63	2·91	3·40	3·83	4·22	4·56	4·87	5·15	10·61
	0·50	0·75	1·00	1·50	2·00	2·50	3·00	3·50	4·00	5·00	6·00	7·00	8·00	9·00	10·00	INF
	0·52	0·81	1·10	1·75	2·46	3·27	4·18	5·22	6·42	9·44	13·78	20·52	32·38	58·85	170·00	INF
f4·50	0·47	0·69	0·90	1·29	1·65	1·98	2·28	2·55	2·81	3·27	3·67	4·02	4·33	4·61	4·86	9·44
	0·50	0·75	1·00	1·50	2·00	2·50	3·00	3·50	4·00	5·00	6·00	7·00	8·00	9·00	10·00	INF
	0·53	0·81	1·12	1·78	2·54	3·40	4·40	5·56	6·94	10·62	16·45	27·05	52·31	191·25	INF	INF
f5·60	0·47	0·68	0·88	1·25	1·58	1·88	2·15	2·40	2·62	3·01	3·35	3·64	3·89	4·12	4·31	7·58
	0·50	0·75	1·00	1·50	2·00	2·50	3·00	3·50	4·00	5·00	6·00	7·00	8·00	9·00	10·00	INF
	0·54	0·83	1·15	1·87	2·72	3·73	4·96	6·50	8·46	14·66	28·65	90·15	INF	INF	INF	INF
f6·30	0·47	0·67	0·87	1·23	1·54	1·82	2·08	2·30	2·51	2·87	3·18	3·44	3·66	3·86	4·03	6·74
	0·50	0·75	1·00	1·50	2·00	2·50	3·00	3·50	4·00	5·00	6·00	7·00	8·00	9·00	10·00	INF
	0·54	0·84	1·17	1·93	2·84	3·97	5·40	7·27	9·83	19·32	54·26	INF	INF	INF	INF	INF
f8·00	0·46	0·66	0·84	1·17	1·45	1·70	1·92	2·11	2·28	2·58	2·82	3·02	3·19	3·34	3·47	5·31
	0·50	0·75	1·00	1·50	2·00	2·50	3·00	3·50	4·00	5·00	6·00	7·00	8·00	9·00	10·00	INF
	0·55	0·87	1·23	2·09	3·21	4·72	6·89	10·26	16·19	85·00	INF	INF	INF	INF	INF	INF
f11·00	0·44	0·63	0·79	1·08	1·32	1·52	1·69	1·84	1·97	2·18	2·35	2·49	2·61	2·70	2·79	3·86
	0·50	0·75	1·00	1·50	2·00	2·50	3·00	3·50	4·00	5·00	6·00	7·00	8·00	9·00	10·00	INF
	0·57	0·93	1·35	2·45	4·15	7·08	13·42	37·19	INF	INF	INF	INF	INF	INF	INF	INF
f16·00	0·42	0·58	0·73	0·96	1·14	1·29	1·41	1·51	1·60	1·73	1·84	1·93	1·99	2·05	2·10	2·66
	0·50	0·75	1·00	1·50	2·00	2·50	3·00	3·50	4·00	5·00	6·00	7·00	8·00	9·00	10·00	INF
	0·62	1·05	1·60	3·45	8·10	42·50	INF	INF	INF	INF	INF	INF	INF	INF	INF	INF
f22·00	0·40	0·54	0·66	0·84	0·98	1·09	1·18	1·24	1·30	1·39	1·46	1·51	1·56	1·59	1·62	1·93
	0·50	0·75	1·00	1·50	2·00	2·50	3·00	3·50	4·00	5·00	6·00	7·00	8·00	9·00	10·00	INF
	0·67	1·23	2·07	6·71	INF	INF	INF	INF	INF	INF	INF	INF	INF	INF	INF	INF

DEPTH OF FIELD FOR LENSES OF 50 mm (2 in.) FOCAL LENGTH

f-stop		0·50	0·75	1·00	1·50	2·00	2·50	3·00	3·50	4·00	5·00	6·00	7·00	8·00	9·00	10·00	INF
f1·50	near	0·49	0·73	0·97	1·44	1·89	2·33	2·75	3·17	3·57	4·35	5·08	5·79	6·45	7·09	7·69	33·22
	set	0·50	0·75	1·00	1·50	2·00	2·50	3·00	3·50	4·00	5·00	6·00	7·00	8·00	9·00	10·00	INF
	far	0·51	0·77	1·03	1·57	2·13	2·70	3·30	3·91	4·55	5·88	7·32	8·86	10·53	12·33	14·29	INF
f2·00	near	0·49	0·73	0·96	1·42	1·85	2·27	2·68	3·07	3·45	4·17	4·85	5·47	6·06	6·62	7·14	24·94
	set	0·50	0·75	1·00	1·50	2·00	2·50	3·00	3·50	4·00	5·00	6·00	7·00	8·00	9·00	10·00	INF
	far	0·51	0·77	1·04	1·60	2·17	2·78	3·41	4·07	4·76	6·25	7·89	9·72	11·76	14·06	16·67	INF
f2·50	near	0·49	0·72	0·95	1·40	1·82	2·22	2·61	2·98	3·33	4·00	4·62	5·19	5·71	6·21	6·67	19·96
	set	0·50	0·75	1·00	1·50	2·00	2·50	3·00	3·50	4·00	5·00	6·00	7·00	8·00	9·00	10·00	INF
	far	0·51	0·78	1·05	1·62	2·22	2·86	3·53	4·24	5·00	6·67	8·57	10·77	13·33	16·36	20·00	INF
f3·00	near	0·49	0·72	0·94	1·38	1·79	2·17	2·54	2·89	3·23	3·85	4·41	4·93	5·41	5·84	6·25	16·64
	set	0·50	0·75	1·00	1·50	2·00	2·50	3·00	3·50	4·00	5·00	6·00	7·00	8·00	9·00	10·00	INF
	far	0·52	0·79	1·06	1·65	2·27	2·94	3·66	4·43	5·26	7·14	9·37	12·07	15·38	19·57	25·00	INF
f3·50	near	0·48	0·71	0·93	1·36	1·75	2·13	2·48	2·81	3·12	3·70	4·23	4·70	5·13	5·52	5·88	14·27
	set	0·50	0·75	1·00	1·50	2·00	2·50	3·00	3·50	4·00	5·00	6·00	7·00	8·00	9·00	10·00	INF
	far	0·52	0·79	1·08	1·68	2·33	3·03	3·80	4·64	5·56	7·69	10·34	13·73	18·18	24·32	33·33	INF
f4·00	near	0·48	0·71	0·93	1·34	1·72	2·08	2·42	2·73	3·03	3·57	4·05	4·49	4·88	5·23	5·56	12·48
	set	0·50	0·75	1·00	1·50	2·00	2·50	3·00	3·50	4·00	5·00	6·00	7·00	8·00	9·00	10·00	INF
	far	0·52	0·80	1·09	1·70	2·38	3·13	3·95	4·86	5·88	8·33	11·54	15·91	22·22	32·14	50·00	INF
f4·50	near	0·48	0·70	0·92	1·32	1·69	2·04	2·36	2·66	2·94	3·45	3·90	4·29	4·65	4·97	5·26	11·10
	set	0·50	0·75	1·00	1·50	2·00	2·50	3·00	3·50	4·00	5·00	6·00	7·00	8·00	9·00	10·00	INF
	far	0·52	0·80	1·10	1·73	2·44	3·23	4·11	5·11	6·25	9·09	13·04	18·92	28·57	47·37	100·00	INF
f5·60	near	0·47	0·69	0·90	1·28	1·63	1·95	2·25	2·51	2·76	3·21	3·59	3·92	4·22	4·48	4·72	8·92
	set	0·50	0·75	1·00	1·50	2·00	2·50	3·00	3·50	4·00	5·00	6·00	7·00	8·00	9·00	10·00	INF
	far	0·53	0·82	1·13	1·80	2·58	3·47	4·52	5·76	7·25	11·36	18·29	32·41	76·92	INF	INF	INF
f6·30	near	0·47	0·69	0·89	1·26	1·60	1·90	2·18	2·43	2·66	3·07	3·42	3·72	3·98	4·22	4·42	7·93
	set	0·50	0·75	1·00	1·50	2·00	2·50	3·00	3·50	4·00	5·00	6·00	7·00	8·00	9·00	10·00	INF
	far	0·53	0·83	1·14	1·85	2·67	3·65	4·82	6·26	8·06	13·51	24·59	59·32	INF	INF	INF	INF
f8·00	near	0·46	0·67	0·86	1·21	1·52	1·79	2·03	2·24	2·44	2·78	3·06	3·30	3·51	3·69	3·85	6·25
	set	0·50	0·75	1·00	1·50	2·00	2·50	3·00	3·50	4·00	5·00	6·00	7·00	8·00	9·00	10·00	INF
	far	0·54	0·85	1·19	1·97	2·94	4·17	5·77	7·95	11·11	25·00	150·00	INF	INF	INF	INF	INF
f11·00	near	0·45	0·64	0·82	1·13	1·39	1·61	1·81	1·98	2·13	2·38	2·59	2·76	2·90	3·02	3·12	4·54
	set	0·50	0·75	1·00	1·50	2·00	2·50	3·00	3·50	4·00	5·00	6·00	7·00	8·00	9·00	10·00	INF
	far	0·56	0·90	1·28	2·24	3·57	5·56	8·82	15·22	33·33	INF	INF	INF	INF	INF	INF	INF
f16·00	near	0·43	0·60	0·76	1·01	1·22	1·39	1·53	1·65	1·75	1·92	2·05	2·16	2·25	2·32	2·38	3·12
	set	0·50	0·75	1·00	1·50	2·00	2·50	3·00	3·50	4·00	5·00	6·00	7·00	8·00	9·00	10·00	INF
	far	0·60	0·99	1·47	2·88	5·56	12·50	75·00	INF	INF	INF	INF	INF	INF	INF	INF	INF
f22·00	near	0·41	0·56	0·69	0·90	1·06	1·19	1·29	1·38	1·45	1·56	1·65	1·72	1·77	1·81	1·85	2·27
	set	0·50	0·75	1·00	1·50	2·00	2·50	3·00	3·50	4·00	5·00	6·00	7·00	8·00	9·00	10·00	INF
	far	0·64	1·12	1·79	4·41	16·67	INF	INF	INF	INF	INF	INF	INF	INF	INF	INF	INF

DEPTH OF FIELD FOR LENSES OF 62.5 mm (2¼ in.) FOCAL LENGTH

Each cell lists the near limit, the focus setting (bold in the original), and the far limit of the depth of field.

																
f1·50	0·74 0·75 0·76	0·98 1·00 1·02	1·45 1·50 1·56	1·91 2·00 2·10	2·36 2·50 2·66	2·80 3·00 3·23	3·23 3·50 3·82	3·65 4·00 4·42	4·46 5·00 5·68	5·24 6·00 7·01	5·99 7·00 8·41	6·71 8·00 9·90	7·40 9·00 11·48	8·06 10·00 13·16	9·62 12·50 17·86	41·49 INF INF
f2·00	0·73 0·75 0·77	0·97 1·00 1·03	1·43 1·50 1·58	1·88 2·00 2·14	2·31 2·50 2·72	2·74 3·00 3·32	3·15 3·50 3·94	3·55 4·00 4·59	4·31 5·00 5·95	5·03 6·00 7·43	5·72 7·00 9·02	6·37 8·00 10·75	6·99 9·00 12·64	7·58 10·00 14·71	8·93 12·50 20·83	31·15 INF INF
f2·50	0·73 0·75 0·77	0·96 1·00 1·04	1·42 1·50 1·60	1·85 2·00 2·17	2·27 2·50 2·78	2·68 3·00 3·41	3·07 3·50 4·07	3·45 4·00 4·76	4·17 5·00 6·25	4·84 6·00 7·89	5·47 7·00 9·72	6·06 8·00 11·76	6·62 9·00 14·06	7·14 10·00 16·67	8·33 12·50 25·00	24·94 INF INF
f3·00	0·72 0·75 0·78	0·95 1·00 1·05	1·40 1·50 1·62	1·82 2·00 2·21	2·23 2·50 2·84	2·62 3·00 3·50	3·00 3·50 4·21	3·36 4·00 4·95	4·03 5·00 6·58	4·66 6·00 8·43	5·24 7·00 10·54	5·78 8·00 12·99	6·28 9·00 15·85	6·76 10·00 19·23	7·81 12·50 31·25	20·79 'INF INF
f3·50	0·72 0·75 0·78	0·95 1·00 1·06	1·38 1·50 1·64	1·80 2·00 2·25	2·19 2·50 2·91	2·57 3·00 3·61	2·93 3·50 4·35	3·27 4·00 5·15	3·91 5·00 6·94	4·49 6·00 9·04	5·03 7·00 11·51	5·52 8·00 14·49	5·98 9·00 18·15	6·41 10·00 22·73	7·35 12·50 41·67	17·83 INF INF
f4·00	0·72 0·75 0·79	0·94 1·00 1·07	1·37 1·50 1·66	1·77 2·00 2·29	2·16 2·50 2·98	2·52 3·00 3·71	2·86 3·50 4·51	3·18 4·00 5·38	3·79 5·00 7·35	4·34 6·00 9·74	4·83 7·00 12·68	5·29 8·00 16·39	5·71 9·00 21·23	6·10 10·00 27·78	6·94 12·50 62·50	15·60 INF INF
f4·50	0·71 0·75 0·79	0·93 1·00 1·08	1·35 1·50 1·68	1·75 2·00 2·34	2·12 2·50 3·05	2·47 3·00 3·83	2·80 3·50 4·68	3·11 4·00 5·62	3·68 5·00 7·81	4·19 6·00 10·56	4·65 7·00 14·11	5·08 8·00 18·87	5·46 9·00 25·57	5·81 10·00 35·71	6·58 12·00 125·00	13·87 INF INF
f5·60	0·70 0·75 0·80	0·92 1·00 1·10	1·32 1·50 1·73	1·70 2·00 2·44	2·04 2·50 3·22	2·36 3·00 4·10	2·66 3·50 5·10	2·94 4·00 6·23	3·45 5·00 9·06	3·90 6·00 12·98	4·30 7·00 18·78	4·66 8·00 28·25	4·98 9·00 46·49	5·27 10·00 96·15	5·90 12·50 INF	11·15 INF INF
f6·30	0·70 0·75 0·81	0·91 1·00 1·11	1·30 1·50 1·77	1·66 2·00 2·51	2·00 2·50 3·34	2·30 3·00 4·30	2·59 3·50 5·41	2·85 4·00 6·70	3·32 5·00 10·08	3·74 6·00 15·18	4·10 7·00 23·78	4·43 8·00 41·32	4·72 9·00 96·98	4·98 10·00 INF	5·53 12·50 INF	9·91 INF INF
f8·00	0·68 0·75 0·83	0·89 1·00 1·15	1·26 1·50 1·86	1·59 2·00 2·69	1·89 2·50 3·68	2·17 3·00 4·87	2·42 3·50 6·34	2·65 4·00 8·20	3·05 5·00 13·89	3·39 6·00 25·86	3·69 7·00 67·31	3·95 8·00 INF	4·18 9·00 INF	4·39 10·00 INF	4·81 12·50 INF	7·81 INF INF
f11·00	0·66 0·75 0·86	0·85 1·00 1·21	1·19 1·50 2·04	1·48 2·00 3·09	1·74 2·50 4·46	1·96 3·00 6·36	2·17 3·50 9·11	2·35 4·00 13·61	2·66 5·00 41·67	2·92 6·00 INF	3·14 7·00 INF	3·32 8·00 INF	3·48 9·00 INF	3·62 10·00 INF	3·91 12·50 INF	5·68 INF INF
f16·00	0·63 0·75 0·93	0·80 1·00 1·34	1·08 1·50 2·44	1·32 2·00 4·10	1·52 2·50 6·94	1·70 3·00 12·93	1·85 3·50 33·65	1·98 4·00 INF	2·19 5·00 INF	2·37 6·00 INF	2·51 7·00 INF	2·62 8·00 INF	2·72 9·00 INF	2·98 10·00 INF	2·98 12·50 INF	3·0 INF INF
f22·00	0·59 0·75 1·02	0·74 1·00 1·54	0·98 1·50 3·18	1·17 2·00 6·76	1·33 2·50 20·83	1·46 3·00 INF	1·57 3·50 INF	1·66 4·00 INF	1·81 5·00 INF	1·93 6·00 INF	2·02 7·00 INF	2·10 8·00 INF	2·16 9·00 INF	2·21 10·00 INF	2·31 12·50 INF	2·84 INF INF

DEPTH OF FIELD FOR LENSES OF 75 mm (3 in.) FOCAL LENGTH

	0·75	1·00	1·50	2·00	2·50	3·00	3·50	4·00	5·00	6·00	7·00	8·00	9·00	10·00	12·50	INF
f1·50 near	0·74	0·98	1·46	1·92	2·38	2·83	3·27	3·70	4·55	5·36	6·14	6·90	7·63	8·33	10·00	49·75
f1·50 set	0·75	1·00	1·50	2·00	2·50	3·00	3·50	4·00	5·00	6·00	7·00	8·00	9·00	10·00	12·50	INF
f1·50 far	0·76	1·02	1·55	2·08	2·63	3·19	3·76	4·35	5·56	6·82	8·14	9·52	10·98	12·50	16·67	INF
f2·00 near	0·74	0·97	1·44	1·90	2·34	2·78	3·20	3·61	4·41	5·17	5·90	6·59	7·26	7·89	9·38	37·36
f2·00 set	0·75	1·00	1·50	2·00	2·50	3·00	3·50	4·00	5·00	6·00	7·00	8·00	9·00	10·00	12·50	INF
f2·00 far	0·77	1·03	1·56	2·11	2·68	3·26	3·86	4·48	5·77	7·14	8·61	10·17	11·84	13·64	18·75	INF
f2·50 near	0·73	0·97	1·43	1·88	2·31	2·73	3·13	3·53	4·29	5·00	5·68	6·32	6·92	7·50	8·82	29·91
f2·50 set	0·75	1·00	1·50	2·00	2·50	3·00	3·50	4·00	5·00	6·00	7·00	8·00	9·00	10·00	12·50	INF
f2·50 far	0·77	1·03	1·58	2·14	2·73	3·33	3·96	4·62	6·00	7·50	9·13	10·91	12·86	15·00	21·43	INF
f3·00 near	0·73	0·96	1·42	1·85	2·27	2·68	3·07	3·45	4·17	4·84	5·47	6·06	6·62	7·14	8·33	24·94
f3·00 set	0·75	1·00	1·50	2·00	2·50	3·00	3·50	4·00	5·00	6·00	7·00	8·00	9·00	10·00	12·50	INF
f3·00 far	0·77	1·04	1·60	2·17	2·78	3·41	4·07	4·76	6·25	7·89	9·72	11·76	14·06	16·67	25·00	INF
f3·50 near	0·72	0·96	1·40	1·83	2·24	2·63	3·01	3·37	4·05	4·69	5·28	5·83	6·34	6·82	7·89	21·38
f3·50 set	0·75	1·00	1·50	2·00	2·50	3·00	3·50	4·00	5·00	6·00	7·00	8·00	9·00	10·00	12·50	INF
f3·50 far	0·78	1·05	1·61	2·21	2·83	3·49	4·18	4·92	6·62	8·33	10·40	12·77	15·52	18·75	30·00	INF
f4·00 near	0·72	0·95	1·39	1·81	2·21	2·59	2·95	3·30	3·95	4·55	5·10	5·61	6·08	6·52	7·50	18·71
f4·00 set	0·75	1·00	1·50	2·00	2·50	3·00	3·50	4·00	5·00	6·00	7·00	8·00	9·00	10·00	12·50	INF
f4·00 far	0·78	1·06	1·63	2·24	2·88	3·57	4·30	5·08	6·82	8·82	11·17	13·95	17·31	21·43	37·50	INF
f4·50 near	0·72	0·94	1·38	1·79	2·17	2·54	2·89	3·23	3·85	4·41	4·93	5·41	5·84	6·25	7·14	16·64
f4·50 set	0·75	1·00	1·50	2·00	2·50	3·00	3·50	4·00	5·00	6·00	7·00	8·00	9·00	10·00	12·50	INF
f4·50 far	0·79	1·06	1·65	2·27	2·94	3·66	4·43	5·26	7·14	9·37	12·07	15·38	19·57	25·00	50·00	INF
f5·60 near	0·71	0·93	1·35	1·74	2·11	2·45	2·77	3·08	3·64	4·14	4·60	5·01	5·38	5·73	6·47	13·37
f5·60 set	0·75	1·00	1·50	2·00	2·50	3·00	3·50	4·00	5·00	6·00	7·00	8·00	9·00	10·00	12·50	INF
f5·60 far	0·79	1·08	1·69	2·35	3·07	3·87	4·74	5·70	7·98	10·87	14·66	19·87	27·44	39·47	187·50	INF
f6·30 near	0·71	0·92	1·33	1·71	2·07	2·40	2·70	2·99	3·52	3·99	4·41	4·78	5·13	5·43	6·10	11·89
f6·30 set	0·75	1·00	1·50	2·00	2·50	3·00	3·50	4·00	5·00	6·00	7·00	8·00	9·00	10·00	12·50	INF
f6·30 far	0·80	1·09	1·72	2·40	3·16	4·01	4·96	6·02	8·62	12·10	16·99	24·39	36·89	62·50	INF	INF
f8·00 near	0·69	0·90	1·29	1·65	1·97	2·27	2·55	2·80	3·26	3·66	4·01	4·32	4·59	4·84	5·36	9·37
f8·00 set	0·75	1·00	1·50	2·00	2·50	3·00	3·50	4·00	5·00	6·00	7·00	8·00	9·00	10·00	12·50	INF
f8·00 far	0·82	1·12	1·79	2·54	3·41	4·41	5·58	6·98	10·71	16·67	27·63	54·55	225·00	INF	INF	INF
f11·00 near	0·68	0·87	1·23	1·55	1·83	2·08	2·31	2·52	2·88	3·19	3·45	3·68	3·88	4·05	4·41	6·81
f11·00 set	0·75	1·00	1·50	2·00	2·50	3·00	3·50	4·00	5·00	6·00	7·00	8·00	9·00	10·00	12·50	INF
f11·00 far	0·84	1·17	1·92	2·83	3·95	5·36	7·19	9·68	18·75	50·00	INF	INF	INF	INF	INF	INF
f16·00 near	0·65	0·82	1·14	1·40	1·63	1·83	2·00	2·16	2·42	2·63	2·81	2·96	3·08	3·19	3·41	4·69
f16·00 set	0·75	1·00	1·50	2·00	2·50	3·00	3·50	4·00	5·00	6·00	7·00	8·00	9·00	10·00	12·50	INF
f16·00 far	0·89	1·27	2·21	3·49	5·35	8·33	13·82	27·27	INF	INF	INF	INF	INF	INF	INF	INF
f22·00 near	0·61	0·77	1·04	1·26	1·44	1·60	1·73	1·84	2·03	2·17	2·29	2·39	2·47	2·54	2·68	3·41
f22·00 set	0·75	1·00	1·50	2·00	2·50	3·00	3·50	4·00	5·00	6·00	7·00	8·00	9·00	10·00	12·50	INF
f22·00 far	0·96	1·42	2·68	4·84	9·37	25·00	INF	INF	INF	INF	INF	INF	INF	INF	INF	INF

DEPTH OF FIELD FOR LENSES OF 87·5 mm (3½ in.) FOCAL LENGTH

In each aperture block the three rows are: near limit (top), distance focused (middle), far limit (bottom). Values in metres; INF = infinity.

															
f2·00	0·98	1·91	2·36	2·81	3·24	3·66	4·49	5·28	6·03	6·76	7·46	8·14	9·72	11·17	43·56
	1·00	2·00	2·50	3·00	3·50	4·00	5·00	6·00	7·00	8·00	9·00	10·00	12·50	15·00	INF
	1·02	2·10	2·65	3·22	3·80	4·40	5·65	6·95	8·33	9·79	11·33	12·96	17·50	22·83	INF
f2·50	0·97	1·89	2·33	2·76	3·18	3·59	4·38	5·12	5·83	6·51	7·16	7·78	9·21	10·50	34·88
	1·00	2·00	2·50	3·00	3·50	4·00	5·00	6·00	7·00	8·00	9·00	10·00	12·50	15·00	INF
	1·03	2·12	2·69	3·28	3·89	4·52	5·83	7·24	8·75	10·37	12·12	14·00	19·44	26·25	INF
f3·00	0·97	1·87	2·30	2·72	3·12	3·52	4·27	4·98	5·65	6·28	6·88	7·45	8·75	9·91	29·08
	1·00	2·00	2·50	3·00	3·50	4·00	5·00	6·00	7·00	8·00	9·00	10·00	12·50	15·00	INF
	1·04	2·15	2·73	3·34	3·98	4·64	6·03	7·55	9·21	11·02	13·02	15·22	21·87	30·88	INF
f3·50	0·96	1·85	2·27	2·68	3·07	3·45	4·17	4·84	5·47	6·06	6·62	7·14	8·33	9·38	24·94
	1·00	2·00	2·50	3·00	3·50	4·00	5·00	6·00	7·00	8·00	9·00	10·00	12·50	15·00	INF
	1·04	2·17	2·78	3·41	4·07	4·76	6·25	7·89	9·72	11·76	14·06	16·67	25·00	37·50	INF
f4·00	0·96	1·83	2·24	2·64	3·02	3·38	4·07	4·71	5·30	5·86	6·38	6·86	7·95	8·90	21·83
	1·00	2·00	2·50	3·00	3·50	4·00	5·00	6·00	7·00	8·00	9·00	10·00	12·50	15·00	INF
	1·05	2·20	2·82	3·48	4·17	4·90	6·48	8·27	10·29	12·61	15·29	18·42	29·17	47·73	INF
f4·50	0·95	1·81	2·22	2·60	2·97	3·32	3·98	4·59	5·15	5·67	6·16	6·60	7·61	8·47	19·41
	1·00	2·00	2·50	3·00	3·50	4·00	5·00	6·00	7·00	8·00	9·00	10·00	12·50	15·00	INF
	1·05	2·23	2·87	3·55	4·27	5·04	6·73	8·68	10·94	13·59	16·76	20·59	35·00	65·62	INF
f5·60	0·94	1·77	2·16	2·52	2·86	3·18	3·79	4·34	4·83	5·29	5·71	6·10	6·94	7·65	15·60
	1·00	2·00	2·50	3·00	3·50	4·00	5·00	6·00	7·00	8·00	9·00	10·00	12·50	15·00	INF
	1·07	2·29	2·98	3·71	4·51	5·38	7·35	9·74	12·68	16·39	21·23	27·78	62·50	375·00	INF
f6·30	0·93	1·75	2·12	2·47	2·80	3·11	3·68	4·19	4·65	5·08	5·46	5·81	6·58	7·21	13·87
	1·00	2·00	2·50	3·00	3·50	4·00	5·00	6·00	7·00	8·00	9·00	10·00	12·50	15·00	INF
	1·08	2·34	3·05	3·83	4·68	5·62	7·81	10·56	14·11	18·87	25·57	36·71	125·00	INF	INF
f8·00	0·92	1·69	2·03	2·35	2·65	2·93	3·43	3·87	4·27	4·62	4·94	5·22	5·83	6·33	10·93
	1·00	2·00	2·50	3·00	3·50	4·00	5·00	6·00	7·00	8·00	9·00	10·00	12·50	15·00	INF
	1·10	2·45	3·24	4·13	5·15	6·31	9·21	13·29	19·44	29·79	50·81	116·67	INF	INF	INF
f11·00	0·89	1·60	1·90	2·18	2·43	2·66	3·07	3·42	3·72	3·99	4·22	4·43	4·86	5·20	7·95
	1·00	2·00	2·50	3·00	3·50	4·00	5·00	6·00	7·00	8·00	9·00	10·00	12·50	15·00	INF
	1·14	2·67	3·65	4·82	6·25	8·05	13·46	24·42	58·33	INF	INF	INF	INF	INF	INF
f16·00	0·85	1·46	1·72	1·94	2·13	2·31	2·61	2·86	3·07	3·25	3·40	3·54	3·80	4·01	5·47
	1·00	2·00	2·50	3·00	3·50	4·00	5·00	6·00	7·00	8·00	9·00	10·00	12·50	15·00	INF
	1·22	3·15	4·61	6·65	9·72	14·89	58·33	INF	INF	INF	INF	INF	INF	INF	INF
f22·00	0·80	1·33	1·54	1·71	1·86	1·99	2·22	2·39	2·54	2·66	2·76	2·85	3·02	3·14	3·98
	1·00	2·00	2·50	3·00	3·50	4·00	5·00	6·00	7·00	8·00	9·00	10·00	12·50	15·00	INF
	1·34	4·02	6·73	12·21	29·17	INF	INF	INF	INF	INF	INF	INF	INF	INF	INF
f32·00	0·73	1·16	1·31	1·43	1·54	1·62	1·77	1·88	1·97	2·04	2·10	2·15	2·24	2·31	2·73
	1·00	2·00	2·50	3·00	3·50	4·00	5·00	6·00	7·00	8·00	9·00	10·00	12·50	15·00	INF
	1·58	7·45	29·17	INF	INF	INF	INF	INF	INF	INF	INF	INF	INF	INF	INF

DEPTH OF FIELD FOR LENSES OF 100 mm (4 in.) FOCAL LENGTH

Each cell gives the near and far limits of sharp focus (near – far) for the focus setting shown in the column heading (bold). Values as printed; INF = infinity.

f/	1·00	1·50	2·00	2·50	3·00	3·50	4·00	5·00	6·00	7·00	8·00	9·00	10·00	12·50	15·00	INF
f2·00	0·98–1·02	1·46–1·55	1·92–2·08	2·38–2·63	2·83–3·19	3·27–3·76	3·70–4·35	4·55–5·56	5·36–6·82	6·14–8·14	6·90–9·52	7·63–10·98	8·33–12·50	10·00–16·67	11·54–21·43	49·75–INF
f2·50	0·98–1·03	1·45–1·56	1·90–2·11	2·35–2·67	2·79–3·24	3·22–3·84	3·64–4·44	4·44–5·71	5·22–7·06	5·96–8·48	6·67–10·00	7·35–11·61	8·00–13·33	9·52–18·18	10·91–24·00	39·84–INF
f3·00	0·97–1·03	1·44–1·57	1·89–2·13	2·33–2·70	2·75–3·30	3·17–3·91	3·57–4·55	4·35–5·88	5·08–7·32	5·79–8·86	6·45–10·53	7·09–12·33	7·69–14·29	9·09–20·00	10·34–27·27	33·22–INF
f3·50	0·97–1·04	1·43–1·58	1·87–2·15	2·30–2·74	2·71–3·35	3·12–3·99	3·51–4·65	4·26–6·06	4·96–7·59	5·62–9·21	6·25–11·11	6·84–13·14	7·41–15·38	8·70–22·22	9·84–31·58	28·49–INF
f4·00	0·96–1·04	1·42–1·60	1·85–2·17	2·27–2·78	2·68–3·41	3·07–4·07	3·45–4·76	4·17–6·25	4·84–7·89	5·37–9·72	6·06–11·76	6·62–14·06	7·14–16·67	8·33–25·00	9·38–36·50	24·94–INF
f4·50	0·96–1·05	1·41–1·61	1·83–2·20	2·25–2·82	2·64–3·47	3·02–4·15	3·39–4·88	4·08–6·45	4·72–8·22	5·32–10·22	5·88–12·50	6·41–15·13	6·90–18·18	8·00–28·57	8·96–46·15	22·17–INF
f5·60	0·95–1·06	1·38–1·64	1·80–2·25	2·19–2·91	2·57–3·61	2·93–4·35	3·27–5·15	3·91–6·94	4·49–9·04	5·03–11·51	5·51–14·49	5·98–18·15	6·41–22·73	7·35–41·67	8·15–93·75	17·83–INF
f6·30	0·94–1·07	1·37–1·66	1·78–2·29	2·16–2·97	2·52–3·70	2·87–4·49	3·19–5·35	3·80–7·30	4·35–9·65	4·86–12·52	5·32–16·13	5·74–20·79	6·13–27·03	6·99–58·82	7·71–272·73	15·85–INF
f8·00	0·93–1·09	1·34–1·70	1·72–2·38	2·08–3·13	2·42–3·95	2·73–4·86	3·03–5·88	3·57–8·33	4·05–11·54	4·49–15·91	4·88–22·22	5·23–32·14	5·56–50·00	6·25–INF	6·82–INF	12·48–INF
f11·00	0·90–1·12	1·29–1·80	1·64–2·56	1·96–3·45	2·26–4·48	2·53–5·69	2·78–7·14	3·23–11·11	3·61–17·65	3·95–30·43	4·26–66·67	4·52–900·00	4·76–INF	5·26–INF	5·66–INF	9·08–INF
f16·00	0·86–1·19	1·21–1·97	1·52–2·94	1·79–4·17	2·03–5·77	2·24–7·95	2·44–11·11	2·78–25·00	3·06–150·00	3·30–INF	3·51–INF	3·69–INF	3·85–INF	4·17–INF	4·41–INF	6·25–INF
f22·00	0·82–1·28	1·13–2·24	1·39–3·57	1·61–5·56	1·81–8·82	1·98–15·22	2·13–33·33	2·38–INF	2·59–INF	2·76–INF	2·90–INF	3·02–INF	3·12–INF	3·33–INF	3·49–INF	4·54–INF
f32·00	0·76–1·47	1·01–2·88	1·22–5·56	1·39–12·50	1·53–75·00	1·65–INF	1·75–INF	1·92–INF	2·05–INF	2·16–INF	2·25–INF	2·32–INF	2·38–INF	2·50–INF	2·69–INF	3·12–INF

DEPTH OF FIELD FOR LENSES OF 112·5 mm (4½ in.) FOCAL LENGTH

Each cell shows near limit – far limit (in the same units); the column heading is the distance focused on.

f/	1·00	1·50	2·00	2·50	3·00	3·50	4·00	5·00	6·00	7·00	8·00	9·00	10·00	12·50	15·00	INF
f2·00	0·98–1·02	1·46–1·54	1·93–2·07	2·39–2·62	2·85–3·17	3·29–3·73	3·73–4·31	4·59–5·49	5·42–6·72	6·23–7·99	7·00–9·33	7·76–10·71	8·49–12·16	10·23–16·07	11·84–20·45	55·94–INF
f2·50	0·98–1·02	1·45–1·55	1·91–2·09	2·37–2·65	2·81–3·21	3·25–3·80	3·67–4·39	4·50–5·63	5·29–6·92	6·06–8·29	6·79–9·73	7·50–11·25	8·18–12·86	9·78–17·31	11·25–22·50	44·80–INF
f3·00	0·97–1·03	1·44–1·56	1·90–2·11	2·34–2·68	2·78–3·26	3·20–3·86	3·61–4·48	4·41–5·77	5·17–7·14	5·90–8·61	6·59–10·17	7·26–11·84	7·89–13·64	9·38–18·75	10·71–25·00	37·36–INF
f3·50	0·97–1·03	1·43–1·57	1·88–2·13	2·32–2·71	2·74–3·31	3·16–3·93	3·56–4·57	4·33–5·92	5·06–7·38	5·75–8·95	6·41–10·65	7·03–12·50	7·63–14·52	9·00–20·45	10·23–28·12	32·04–INF
f4·00	0·97–1·04	1·42–1·58	1·87–2·15	2·30–2·74	2·71–3·36	3·11–4·00	3·50–4·66	4·25–6·08	4·95–7·63	5·60–9·32	6·23–11·18	6·82–13·24	7·38–15·52	8·65–22·50	9·78–32·14	28·05–INF
f4·50	0·96–1·04	1·42–1·60	1·85–2·17	2·27–2·78	2·68–3·41	3·07–4·07	3·45–4·76	4·17–6·25	4·84–7·89	5·47–9·72	6·06–11·76	6·62–14·06	7·14–16·67	8·33–25·00	9·38–37·50	24·94–INF
f5·60	0·95–1·05	1·40–1·62	1·82–2·22	2·22–2·86	2·61–3·53	2·98–4·24	3·34–4·99	4·00–6·66	4·62–8·56	5·19–10·74	5·72–13·29	6·22–16·30	6·68–19·91	7·71–33·09	8·59–59·21	20·05–INF
f6·30	0·95–1·06	1·38–1·64	1·80–2·25	2·19–2·91	2·57–3·61	2·93–4·35	3·27–5·15	3·91–6·94	4·49–9·04	5·03–11·51	5·52–14·49	5·98–18·16	6·41–22·73	7·35–41·67	8·15–93·75	17·83–INF
f8·00	0·93–1·08	1·36–1·68	1·75–2·33	2·12–3·04	2·47–3·81	2·80–4·66	3·11–5·59	3·69–7·76	4·21–10·47	4·67–13·94	5·10–18·56	5·49–25·00	5·84–34·62	6·62–112·50	7·26–INF	14·04–INF
f11·00	0·91–1·11	1·31–1·76	1·67–2·49	2·01–3·31	2·32–4·25	2·61–5·32	2·88–6·57	3·36–9·78	3·78–14·52	4·16–22·18	4·49–36·73	4·79–75·00	5·06–450·00	5·62–INF	6·08–INF	10·22–INF
f16·00	0·88–1·17	1·24–1·91	1·56–2·80	1·84–3·88	2·10–5·23	2·34–6·97	2·55–9·28	2·92–17·31	3·24–40·91	3·51–INF	3·74–INF	3·95–INF	4·13–INF	4·50–INF	4·79–INF	7·03–INF
f22·00	0·84–1·24	1·16–2·12	1·44–3·28	1·68–4·89	1·89–7·26	2·08–11·09	2·24–18·37	2·53–225·00	2·76–INF	2·95–INF	3·12–INF	3·26–INF	3·38–INF	3·63–INF	3·81–INF	5·11–INF
f32·00	0·68–1·40	1·05–2·62	1·27–4·64	1·46–8·65	1·62–20·45	1·75–787·50	1·87–INF	2·06–INF	2·22–INF	2·34–INF	2·44–INF	2·53–INF	2·60–INF	2·74–INF	2·85–INF	3·51–INF

DEPTH OF FIELD FOR LENSES OF 125 mm (5 in.) FOCAL LENGTH

The table below gives, for each aperture (left column), three values per focus setting: the near limit of sharp focus, the focus distance (middle value), and the far limit of sharp focus. The focus distances (middle row, constant for every aperture) are: 1·50, 2·00, 2·50, 3·00, 3·50, 4·00, 5·00, 6·00, 7·00, 8·00, 9·00, 10·00, 12·50, 15·00, 20·00, INF.

																
f2·00	1·46	1·94	2·40	2·86	3·31	3·76	4·63	5·47	6·29	7·09	7·87	8·62	10·42	12·10	15·15	62·11
	1·50	2·00	2·50	3·00	3·50	4·00	5·00	6·00	7·00	8·00	9·00	10·00	12·50	15·00	20·00	INF
	1·54	2·07	2·60	3·15	3·71	4·27	5·43	6·64	7·88	9·17	10·51	11·90	15·63	19·74	29·41	INF
f2·50	1·46	1·92	2·38	2·83	3·27	3·70	4·55	5·36	6·14	6·90	7·63	8·33	10·00	11·54	14·29	49·75
	1·50	2·00	2·50	3·00	3·50	4·00	5·00	6·00	7·00	8·00	9·00	10·00	12·50	15·00	20·00	INF
	1·55	2·08	2·63	3·19	3·76	4·35	5·56	6·82	8·14	9·52	10·98	12·50	16·67	21·43	33·33	INF
f3·00	1·45	1·91	2·36	2·80	3·23	3·65	4·46	5·24	5·99	6·71	7·40	8·06	9·62	11·03	13·51	41·49
	1·50	2·00	2·50	3·00	3·50	4·00	5·00	6·00	7·00	8·00	9·00	10·00	12·50	15·00	20·00	INF
	1·56	2·10	2·66	3·23	3·82	4·42	5·68	7·01	8·41	9·90	11·48	13·16	17·86	23·44	38·46	INF
f3·50	1·44	1·89	2·34	2·77	3·19	3·60	4·39	5·14	5·85	6·54	7·19	7·81	9·26	10·56	12·82	35·59
	1·50	2·00	2·50	3·00	3·50	4·00	5·00	6·00	7·00	8·00	9·00	10·00	12·50	15·00	20·00	INF
	1·57	2·12	2·69	3·28	3·88	4·50	5·81	7·21	8·71	10·31	12·03	13·89	19·23	25·86	45·45	INF
f4·00	1·43	1·88	2·31	2·74	3·15	3·55	4·31	5·03	5·72	6·37	6·99	7·58	8·93	10·14	12·20	31·15
	1·50	2·00	2·50	3·00	3·50	4·00	5·00	6·00	7·00	8·00	9·00	10·00	12·50	15·00	20·00	INF
	1·58	2·14	2·72	3·32	3·94	4·59	5·95	7·43	9·02	10·75	12·64	14·71	20·83	28·85	55·56	INF
f4·50	1·42	1·87	2·29	2·71	3·11	3·50	4·24	4·93	5·59	6·21	6·80	7·35	8·62	9·74	11·63	27·70
	1·50	2·00	2·50	3·00	3·50	4·00	5·00	6·00	7·00	8·00	9·00	10·00	12·50	15·00	20·00	INF
	1·59	2·16	2·75	3·36	4·00	4·67	6·10	7·65	9·36	11·24	13·31	15·62	22·73	32·61	71·43	INF
f5·60	1·41	1·86	2·25	2·64	3·03	3·39	4·08	4·73	5·33	5·91	6·41	6·90	8·01	8·97	10·55	22·27
	1·50	2·00	2·50	3·00	3·50	4·00	5·00	6·00	7·00	8·00	9·00	10·00	12·50	15·00	20·00	INF
	1·61	2·20	2·82	3·47	4·15	4·87	6·44	8·21	10·20	12·47	15·08	18·12	28·41	45·73	192·31	INF
f6·30	1·39	1·82	2·22	2·61	2·98	3·33	3·99	4·61	5·17	5·71	6·19	6·65	7·67	8·54	9·96	19·80
	1·50	2·00	2·50	3·00	3·50	4·00	5·00	6·00	7·00	8·00	9·00	10·00	12·50	15·00	20·00	INF
	1·62	2·22	2·86	3·53	4·25	5·01	6·68	8·60	10·82	13·40	16·47	20·16	33·78	61·48	INF	INF
f8·00	1·37	1·77	2·16	2·52	2·86	3·18	3·79	4·34	4·83	5·29	5·71	6·10	6·94	7·65	8·07	15·60
	1·50	2·00	2·50	3·00	3·50	4·00	5·00	6·00	7·00	8·00	9·00	10·00	12·50	15·00	20·00	INF
	1·66	2·29	2·98	3·71	4·51	5·38	7·35	9·74	12·68	16·39	21·23	27·78	62·50	375·00	INF	INF
f11·00	1·33	1·70	2·05	2·37	2·68	2·96	3·47	3·93	4·33	4·69	5·02	5·32	5·95	6·47	7·25	11·35
	1·50	2·00	2·50	3·00	3·50	4·00	5·00	6·00	7·00	8·00	9·00	10·00	12·50	15·00	20·00	INF
	1·73	2·43	3·21	4·08	5·06	6·17	8·93	12·71	18·23	27·03	43·27	83·33	INF	INF	INF	INF
f16·00	1·26	1·59	1·89	2·17	2·42	2·65	3·05	3·39	3·69	3·95	4·18	4·39	4·81	5·14	5·62	7·81
	1·50	2·00	2·50	3·00	3·50	4·00	5·00	6·00	7·00	8·00	9·00	10·00	12·50	15·00	20·00	INF
	1·86	2·69	3·68	4·87	6·34	8·20	13·89	25·86	67·31	INF	INF	INF	INF	INF	INF	INF
f22·00	1·19	1·48	1·74	1·96	2·17	2·35	2·66	2·92	3·14	3·32	3·48	3·62	3·91	4·12	4·42	5·68
	1·50	2·00	2·50	3·00	3·50	4·00	5·00	6·00	7·00	8·00	9·00	10·00	12·50	15·00	20·00	INF
	2·04	3·09	4·46	6·36	9·11	13·51	41·67	INF	INF	INF	INF	INF	INF	INF	INF	INF
f32·00	1·08	1·32	1·52	1·70	1·85	1·98	2·19	2·37	2·51	2·62	2·72	2·81	2·98	3·10	3·27	3·90
	1·50	2·00	2·50	3·00	3·50	4·00	5·00	6·00	7·00	8·00	9·00	10·00	12·50	15·00	20·00	INF
	2·44	4·10	6·94	12·93	33·65	INF	INF	INF	INF	INF	INF	INF	INF	INF	INF	INF

DEPTH OF FIELD FOR LENSES OF 137·5 mm (5½ in.) FOCAL LENGTH

Aperture	1·50	2·00	2·50	3·00	3·50	4·00	5·00	6·00	7·00	8·00	9·00	10·00	12·50	15·00	20·00	INF
f2·00	1·47	1·94	2·41	2·87	3·33	3·78	4·66	5·52	6·35	7·17	7·96	8·73	10·58	12·31	15·49	68·28
	1·50	2·00	2·50	3·00	3·50	4·00	5·00	6·00	7·00	8·00	9·00	10·00	12·50	15·00	20·00	INF
	1·53	2·06	2·59	3·14	3·69	4·25	5·39	6·57	7·79	9·05	10·36	11·70	15·28	19·19	28·21	INF
f2·50	1·46	1·93	2·39	2·84	3·29	3·73	4·58	5·41	6·21	6·98	7·72	8·46	10·19	11·79	14·67	54·70
	1·50	2·00	2·50	3·00	3·50	4·00	5·00	6·00	7·00	8·00	9·00	10·00	12·50	15·00	20·00	INF
	1·54	2·08	2·62	3·17	3·74	4·31	5·50	6·73	8·02	9·36	10·76	12·22	16·18	20·62	31·43	INF
f3·00	1·45	1·92	2·37	2·82	3·25	3·68	4·51	5·31	6·07	6·81	7·52	8·21	9·82	11·30	13·92	45·62
	1·50	2·00	2·50	3·00	3·50	4·00	5·00	6·00	7·00	8·00	9·00	10·00	12·50	15·00	20·00	INF
	1·55	2·09	2·64	3·21	3·79	4·38	5·61	6·90	8·26	9·69	11·20	12·79	17·19	22·30	35·48	INF
f3·50	1·44	1·90	2·35	2·79	3·21	3·63	4·44	5·21	5·94	6·65	7·32	7·97	9·48	10·86	13·25	39·13
	1·50	2·00	2·50	3·00	3·50	4·00	5·00	6·00	7·00	8·00	9·00	10·00	12·50	15·00	20·00	INF
	1·56	2·11	2·67	3·25	3·84	4·45	5·73	7·08	8·52	10·05	11·67	13·41	18·33	24·26	40·74	INF
f4·00	1·44	1·89	2·33	2·76	3·18	3·58	4·37	5·11	5·82	6·49	7·13	7·75	9·17	10·44	12·64	34·26
	1·50	2·00	2·50	3·00	3·50	4·00	5·00	6·00	7·00	8·00	9·00	10·00	12·50	15·00	20·00	INF
	1·57	2·12	2·70	3·29	3·90	4·52	5·85	7·27	8·79	10·43	12·19	14·10	19·64	26·61	47·83	INF
f4·50	1·43	1·88	2·31	2·73	3·14	3·54	4·30	5·02	5·70	6·34	6·95	7·53	8·87	10·06	12·09	30·46
	1·50	2·00	2·50	3·00	3·50	4·00	5·00	6·00	7·00	8·00	9·00	10·00	12·50	15·00	20·00	INF
	1·58	2·14	2·72	3·33	3·95	4·60	5·98	7·47	9·08	10·84	12·76	14·86	21·15	29·46	57·89	INF
f5·60	1·41	1·85	2·27	2·67	3·06	3·44	4·15	4·82	5·45	6·03	6·59	7·11	8·28	9·31	11·02	24·49
	1·50	2·00	2·50	3·00	3·50	4·00	5·00	6·00	7·00	8·00	9·00	10·00	12·50	15·00	20·00	INF
	1·60	2·18	2·78	3·42	4·08	4·78	6·28	7·94	9·79	11·87	14·21	16·87	25·46	38·55	107·84	INF
f6·30	1·40	1·83	2·24	2·64	3·02	3·38	4·07	4·71	5·30	5·85	6·37	6·86	7·95	9·89	10·44	21·78
	1·50	2·00	2·50	3·00	3·50	4·00	5·00	6·00	7·00	8·00	9·00	10·00	12·50	15·00	20·00	INF
	1·61	2·20	2·82	3·48	4·17	4·90	6·49	8·27	10·31	12·63	15·32	18·46	29·26	47·97	239·13	INF
f8·00	1·38	1·79	2·18	2·55	2·91	3·24	3·87	4·45	4·97	5·46	5·91	6·32	7·24	8·01	9·24	17·16
	1·50	2·00	2·50	3·00	3·50	4·00	5·00	6·00	7·00	8·00	9·00	10·00	12·50	15·00	20·00	INF
	1·70	2·38	3·13	3·95	4·86	5·88	8·33	11·54	15·91	22·22	32·14	50·00	INF	INF	INF	INF
f16·00	1·28	1·62	1·94	2·22	2·49	2·73	3·16	3·53	3·86	4·14	4·40	4·62	5·09	5·46	6·01	8·59
	1·50	2·00	2·50	3·00	3·50	4·00	5·00	6·00	7·00	8·00	9·00	10·00	12·50	15·00	20·00	INF
	1·82	2·61	3·53	4·61	5·90	7·48	11·96	19·88	37·75	115·79	INF	INF	INF	INF	INF	INF
f22·00	1·21	1·52	1·79	2·03	2·24	2·44	2·78	3·06	3·30	3·51	3·69	3·85	4·17	4·41	4·76	6·25
	1·50	2·00	2·50	3·00	3·50	4·00	5·00	6·00	7·00	8·00	9·00	10·00	12·50	15·00	20·00	INF
	1·97	2·94	4·17	5·77	7·95	11·11	25·00	150·00	INF	INF	INF	INF	INF	INF	INF	INF
f32·00	1·11	1·36	1·58	1·77	1·93	2·07	2·31	2·50	2·66	2·80	2·91	3·01	3·20	3·34	3·54	4·30
	1·50	2·00	2·50	3·00	3·50	4·00	5·00	6·00	7·00	8·00	9·00	10·00	12·50	15·00	20·00	INF
	2·30	3·74	5·98	9·94	18·87	57·89	INF	INF	INF	INF	INF	INF	INF	INF	INF	INF

DEPTH OF FIELD FOR LENSES OF 150 mm (6 in.) FOCAL LENGTH

For each aperture the three lines give: near limit / distance focused on / far limit.

Aperture	1·50	2·00	2·50	3·00	3·50	4·00	5·00	6·00	7·00	8·00	9·00	10·00	12·50	15·00	20·00	INF
f2·00	1·47	1·95	2·42	2·88	3·34	3·80	4·69	5·56	6·40	7·23	8·04	8·82	10·71	12·50	15·79	74·44
	1·50	2·00	2·50	3·00	3·50	4·00	5·00	6·00	7·00	8·00	9·00	10·00	12·50	15·00	20·00	INF
	1·53	2·05	2·59	3·13	3·67	4·23	5·36	6·52	7·72	8·96	10·23	11·54	15·00	18·75	27·27	INF
f2·50	1·46	1·94	2·40	2·86	3·31	3·75	4·62	5·45	6·27	7·06	7·83	8·57	10·34	12·00	15·00	59·64
	1·50	2·00	2·50	3·00	3·50	4·00	5·00	6·00	7·00	8·00	9·00	10·00	12·50	15·00	20·00	INF
	1·54	2·07	2·61	3·16	3·72	4·29	5·45	6·67	7·92	9·23	10·59	12·00	15·79	20·00	30·00	INF
f3·00	1·46	1·92	2·38	2·83	3·27	3·70	4·55	5·36	6·14	6·90	7·63	8·33	10·00	11·54	14·29	49·75
	1·50	2·00	2·50	3·00	3·50	4·00	5·00	6·00	7·00	8·00	9·00	10·00	12·50	15·00	20·00	INF
	1·55	2·08	2·63	3·19	3·76	4·35	5·56	6·82	8·14	9·52	10·98	12·50	16·67	21·34	33·33	INF
f3·50	1·45	1·91	2·36	2·80	3·24	3·66	4·48	5·26	6·02	6·74	7·44	8·11	9·68	11·11	13·64	42·67
	1·50	2·00	2·50	3·00	3·50	4·00	5·00	6·00	7·00	8·00	9·00	10·00	12·50	15·00	20·00	INF
	1·55	2·10	2·65	3·23	3·81	4·41	5·66	6·98	8·37	9·84	11·39	13·04	17·65	23·08	37·50	INF
f4·00	1·44	1·90	2·34	2·78	3·20	3·61	4·41	5·17	5·90	6·59	7·26	7·89	9·38	10·71	13·04	37·36
	1·50	2·00	2·50	3·00	3·50	4·00	5·00	6·00	7·00	8·00	9·00	10·00	12·50	15·00	20·00	INF
	1·56	2·11	2·68	3·26	3·86	4·48	5·77	7·14	8·61	10·17	11·84	13·64	18·75	25·00	42·86	INF
f4·50	1·44	1·89	2·33	2·75	3·17	3·57	4·35	5·08	5·79	6·45	7·09	7·69	9·09	10·34	12·50	33·22
	1·50	2·00	2·50	3·00	3·50	4·00	5·00	6·00	7·00	8·00	9·00	10·00	12·50	15·00	20·00	INF
	1·57	2·13	2·70	3·30	3·91	4·55	5·88	7·32	8·86	10·53	12·33	14·29	20·00	27·27	50·00	INF
f5·60	1·42	1·86	2·29	2·70	3·10	3·48	4·21	4·90	5·55	6·16	6·74	7·28	8·52	9·62	11·45	26·71
	1·50	2·00	2·50	3·00	3·50	4·00	5·00	6·00	7·00	8·00	9·00	10·00	12·50	15·00	20·00	INF
	1·59	2·16	2·76	3·38	4·03	4·76	6·15	7·73	9·58	11·41	13·55	15·96	23·44	34·09	78·95	INF
f6·30	1·41	1·85	2·26	2·66	3·05	3·42	4·13	4·79	5·41	5·99	6·53	7·04	8·20	9·20	10·87	23·75
	1·50	2·00	2·50	3·00	3·50	4·00	5·00	6·00	7·00	8·00	9·00	10·00	12·50	15·00	20·00	INF
	1·60	2·18	2·79	3·43	4·10	4·81	6·33	8·02	9·92	12·05	14·47	17·24	26·62	40·54	125·00	INF
f8·00	1·39	1·81	2·21	2·59	2·95	3·30	3·95	4·55	5·10	5·61	6·08	6·52	7·50	8·33	9·68	18·71
	1·50	2·00	2·50	3·00	3·50	4·00	5·00	6·00	7·00	8·00	9·00	10·00	12·50	15·00	20·00	INF
	1·63	2·24	2·88	3·57	4·30	5·08	6·82	8·82	11·17	13·95	17·31	21·43	37·50	75·00	INF	INF
f11·00	1·35	1·74	2·11	2·46	2·79	3·09	3·66	4·17	4·63	5·04	5·42	5·77	6·52	7·14	8·11	13·62
	1·50	2·00	2·50	3·00	3·50	4·00	5·00	6·00	7·00	8·00	9·00	10·00	12·50	15·00	20·00	INF
	1·69	2·34	3·06	3·85	4·71	5·66	7·89	10·71	14·38	19·35	26·47	37·50	150·00	INF	INF	INF
f16·00	1·29	1·65	1·97	2·27	2·55	2·80	3·26	3·66	4·01	4·32	4·59	4·84	5·36	5·77	6·38	9·37
	1·50	2·00	2·50	3·00	3·50	4·00	5·00	6·00	7·00	8·00	9·00	10·00	12·50	15·00	20·00	INF
	1·79	2·54	3·41	4·41	5·59	6·98	10·71	16·67	27·63	54·55	225·00	INF	INF	INF	INF	INF
f22·00	1·23	1·55	1·83	2·08	2·31	2·52	2·88	3·19	3·45	3·68	3·88	4·05	4·41	4·69	5·08	6·81
	1·50	2·00	2·50	3·00	3·50	4·00	5·00	6·00	7·00	8·00	9·00	10·00	12·50	15·00	20·00	INF
	1·92	2·83	3·95	5·36	7·19	9·68	18·75	50·00	INF	INF	INF	INF	INF	INF	INF	INF
f32·00	1·14	1·40	1·63	1·83	2·00	2·16	2·42	2·63	2·81	2·96	3·08	3·19	3·41	3·57	3·80	4·69
	1·50	2·00	2·50	3·00	3·50	4·00	5·00	6·00	7·00	8·00	9·00	10·00	12·50	15·00	20·00	INF
	2·21	3·49	5·36	8·33	13·82	27·27	INF	INF	INF	INF	INF	INF	INF	INF	INF	INF

DEPTH OF FIELD FOR LENSES OF 175 mm (7 in.) FOCAL LENGTH

Each cell shows near limit / far limit; the column headings are the focused (subject) distances. Distances in feet.

f	2·50	3·00	3·50	4·00	5·00	6·00	7·00	8·00	9·00	10·00	12·50	15·00	20·00	25·00	30·00	INF
f2·00	2·43/2·57	2·90/3·11	3·37/3·65	3·83/4·19	4·73/5·30	5·61/6·44	6·48/7·61	7·33/8·81	8·16/10·03	8·97/11·29	10·94/14·58	12·80/18·10	16·28/25·93	19·44/35·00	22·34/45·65	86·74/INF
f2·50	2·41/2·59	2·88/3·13	3·33/3·68	3·78/4·24	4·67/5·38	5·53/6·56	6·36/7·78	7·18/9·03	7·97/10·33	8·75/11·67	10·61/15·22	12·35/19·09	15·56/28·00	18·42/38·89	21·00/52·50	69·51/INF
f3·00	2·40/2·61	2·85/3·16	3·30/3·72	3·74/4·29	4·61/5·47	5·44/6·69	6·25/7·95	7·04/9·27	7·80/10·64	8·54/12·07	10·29/15·91	11·93/20·19	14·89/30·43	17·50/43·75	19·81/61·76	58·00/INF
f3·50	2·38/2·63	2·83/3·19	3·27/3·76	3·70/4·35	4·55/5·56	5·36/6·82	6·14/8·14	6·90/9·52	7·63/10·98	8·33/12·50	10·00/16·67	11·54/21·43	14·29/33·33	16·67/50·00	18·75/75·00	49·75/INF
f4·00	2·36/2·65	2·81/3·22	3·24/3·80	3·66/4·40	4·49/5·65	5·28/6·95	6·03/8·33	6·76/9·79	7·46/11·33	8·14/12·96	9·72/17·50	11·17/22·83	13·73/36·84	15·91/58·33	17·80/95·45	43·56/INF
f4·50	2·35/2·67	2·79/3·25	3·21/3·85	3·63/4·46	4·43/5·74	5·20/7·09	5·93/8·54	6·64/10·07	7·35/11·71	7·93/13·46	9·46/18·42	10·82/24·42	13·21/41·18	15·22/70·00	16·94/131·25	38·74/INF
f5·60	2·31/2·72	2·74/3·32	3·15/3·94	3·55/4·59	4·31/5·95	5·03/7·43	5·72/9·02	6·37/10·75	6·99/12·64	7·58/14·71	8·93/20·83	10·14/28·85	12·20/55·56	13·89/125·00	15·31/750·00	31·15/INF
f6·30	2·29/2·75	2·71/3·36	3·11/4·00	3·50/4·67	4·24/6·10	4·93/7·65	5·59/9·36	6·21/11·24	6·80/13·31	7·35/15·62	8·62/22·73	9·74/32·61	11·63/71·43	13·16/250·00	14·42/INF	27·70/INF
f8·00	2·24/2·82	2·64/3·48	3·02/4·17	3·38/4·90	4·07/6·48	4·71/8·27	5·30/10·29	5·86/12·61	6·38/15·29	6·86/18·42	7·95/29·17	8·90/47·73	10·45/233·33	11·67/INF	12·65/INF	21·83/INF
f11·00	2·16/2·97	2·52/3·70	2·87/4·49	3·20/5·34	3·80/7·29	4·36/9·63	4·86/12·50	5·32/16·09	5·75/20·72	6·14/26·92	7·00/58·33	7·72/262·00	8·86/INF	9·72/INF	10·40/INF	15·98/INF
f16·00	2·03/3·24	2·35/4·13	2·65/5·15	2·93/6·31	3·43/9·21	3·87/13·29	4·27/19·44	4·62/29·79	4·94/50·81	5·22/116·67	5·83/INF	6·33/INF	7·07/INF	7·61/INF	8·02/INF	10·93/INF
f22·00	1·90/3·65	2·18/4·82	2·43/6·25	2·66/8·05	3·07/13·46	3·42/24·42	3·72/58·33	3·99/INF	4·22/INF	4·43/INF	4·86/INF	5·20/INF	5·69/INF	6·03/INF	6·29/INF	7·95/INF
f32·00	1·72/4·61	1·94/6·65	2·13/9·72	2·31/14·89	2·61/58·33	2·86/INF	3·07/INF	3·25/INF	3·40/INF	3·54/INF	3·80/INF	4·01/INF	4·29/INF	4·49/INF	4·63/INF	5·47/INF

DEPTH OF FIELD FOR LENSES OF 200 mm (8 in.) FOCAL LENGTH

f/No.		3·00	3·50	4·00	5·00	6·00	7·00	8·00	9·00	10·00	12·50	15·00	20·00	25·00	30·00	50·00	INF
f2·00	near	2·91	3·38	3·85	4·76	5·66	6·54	7·41	8·26	9·09	11·11	13·04	16·67	20·00	23·08	33·33	99·01
	set	**3·00**	**3·50**	**4·00**	**5·00**	**6·00**	**7·00**	**8·00**	**9·00**	**10·00**	**12·50**	**15·00**	**20·00**	**25·00**	**30·00**	**50·00**	**INF**
	far	3·09	3·63	4·17	5·26	6·38	7·53	8·70	9·89	11·11	14·29	17·65	25·00	33·33	42·86	100·00	INF
f2·50	near	2·89	3·35	3·81	4·71	5·58	6·44	7·27	8·09	8·89	10·81	12·63	16·00	19·05	21·82	30·77	79·37
	set	**3·00**	**3·50**	**4·00**	**5·00**	**6·00**	**7·00**	**8·00**	**9·00**	**10·00**	**12·50**	**15·00**	**20·00**	**25·00**	**30·00**	**50·00**	**INF**
	far	3·12	3·66	4·21	5·33	6·49	7·67	8·89	10·14	11·43	14·81	18·46	26·67	36·36	48·00	133·3	INF
f3·00	near	2·87	3·33	3·77	4·65	5·50	6·33	7·14	7·93	8·70	10·53	12·24	15·38	18·18	20·69	28·57	66·23
	set	**3·00**	**3·50**	**4·00**	**5·00**	**6·00**	**7·00**	**8·00**	**9·00**	**10·00**	**12·50**	**15·00**	**20·00**	**25·00**	**30·00**	**50·00**	**INF**
	far	3·14	3·69	4·26	5·41	6·59	7·82	9·09	10·40	11·76	15·38	19·35	28·57	40·00	54·55	200·00	INF
f3·50	near	2·85	3·30	3·74	4·60	5·43	6·24	7·02	7·78	8·51	10·26	11·88	14·81	17·39	19·67	26·67	56·82
	set	**3·00**	**3·50**	**4·00**	**5·00**	**6·00**	**7·00**	**8·00**	**9·00**	**10·00**	**12·50**	**15·00**	**20·00**	**25·00**	**30·00**	**50·00**	**INF**
	far	3·17	3·73	4·30	5·48	6·70	7·98	9·30	10·68	12·12	16·00	20·34	30·77	44·44	63·16	400·00	INF
f4·00	near	2·83	3·27	3·70	4·55	5·36	6·14	6·90	7·63	8·33	10·00	11·54	14·29	16·67	18·75	25·00	49·75
	set	**3·00**	**3·50**	**4·00**	**5·00**	**6·00**	**7·00**	**8·00**	**9·00**	**10·00**	**12·50**	**15·00**	**20·00**	**25·00**	**30·00**	**50·00**	**INF**
	far	3·19	3·76	4·35	5·56	6·82	8·14	9·52	10·98	12·50	16·67	21·43	33·33	50·00	75·00	INF	INF
f4·50	near	2·81	3·24	3·67	4·49	5·29	6·05	6·78	7·48	8·16	9·76	11·21	13·79	16·00	17·91	23·53	44·25
	set	**3·00**	**3·50**	**4·00**	**5·00**	**6·00**	**7·00**	**8·00**	**9·00**	**10·00**	**12·50**	**15·00**	**20·00**	**25·00**	**30·00**	**50·00**	**INF**
	far	3·22	3·80	4·40	5·63	6·94	8·31	9·76	11·29	12·90	17·39	22·64	36·36	57·14	92·31	INF	INF
f5·60	near	2·77	3·19	3·60	4·39	5·14	5·85	6·54	7·19	7·81	9·26	10·56	12·82	14·71	16·30	20·83	35·59
	set	**3·00**	**3·50**	**4·00**	**5·00**	**6·00**	**7·00**	**8·00**	**9·00**	**10·00**	**12·50**	**15·00**	**20·00**	**25·00**	**30·00**	**50·00**	**INF**
	far	3·28	3·88	4·50	5·81	7·21	8·71	10·31	12·03	13·89	19·23	25·86	45·45	83·33	187·50	INF	INF
f6·30	near	2·74	3·15	3·55	4·32	5·05	5·74	6·39	7·01	7·60	8·97	10·19	12·27	13·99	15·42	19·42	31·65
	set	**3·00**	**3·50**	**4·00**	**5·00**	**6·00**	**7·00**	**8·00**	**9·00**	**10·00**	**12·50**	**15·00**	**20·00**	**25·00**	**30·00**	**50·00**	**INF**
	far	3·31	3·93	4·58	5·93	7·40	8·98	10·70	12·56	14·60	20·62	28·44	54·05	117·65	545·45	INF	INF
f8·00	near	2·68	3·07	3·45	4·17	4·84	5·47	6·06	6·62	7·14	8·33	9·38	11·11	12·50	13·64	16·67	24·94
	set	**3·00**	**3·50**	**4·00**	**5·00**	**6·00**	**7·00**	**8·00**	**9·00**	**10·00**	**12·50**	**15·00**	**20·00**	**25·00**	**30·00**	**50·00**	**INF**
	far	3·41	4·07	4·76	6·25	7·89	9·72	11·76	14·06	16·67	25·00	37·50	100·00	INF	INF	INF	INF
f11·00	near	2·58	2·94	3·28	3·92	4·51	5·05	5·56	6·02	6·45	7·41	8·22	9·52	10·53	11·32	13·33	18·15
	set	**3·00**	**3·50**	**4·00**	**5·00**	**6·00**	**7·00**	**8·00**	**9·00**	**10·00**	**12·50**	**15·00**	**20·00**	**25·00**	**30·00**	**50·00**	**INF**
	far	3·59	4·33	5·13	6·90	8·96	11·38	14·29	17·82	22·22	40·00	85·71	INF	INF	INF	INF	INF
f16·00	near	2·42	2·73	3·03	3·57	4·05	4·49	4·88	5·23	5·56	6·25	6·82	7·69	8·33	8·82	10·00	12·48
	set	**3·00**	**3·50**	**4·00**	**5·00**	**6·00**	**7·00**	**8·00**	**9·00**	**10·00**	**12·50**	**15·00**	**20·00**	**25·00**	**30·00**	**50·00**	**INF**
	far	3·95	4·86	5·88	8·33	11·54	15·91	22·22	32·14	50·00	INF	INF	INF	INF	INF	INF	INF
f22·00	near	2·26	2·53	2·78	3·23	3·61	3·95	4·26	4·52	4·76	5·26	5·69	6·25	6·67	6·98	7·69	9·08
	set	**3·00**	**3·50**	**4·00**	**5·00**	**6·00**	**7·00**	**8·00**	**9·00**	**10·00**	**12·50**	**15·00**	**20·00**	**25·00**	**30·00**	**50·00**	**INF**
	far	4·48	5·69	7·14	11·11	17·65	30·43	66·67	900·00	INF	INF	INF	INF	INF	INF	INF	INF
f32·00	near	2·03	2·24	2·44	2·78	3·06	3·30	3·51	3·69	3·85	4·17	4·41	4·76	5·00	5·17	5·56	6·25
	set	**3·00**	**3·50**	**4·00**	**5·00**	**6·00**	**7·00**	**8·00**	**9·00**	**10·00**	**12·50**	**15·00**	**20·00**	**25·00**	**30·00**	**50·00**	**INF**
	far	5·77	7·95	11·11	25·00	150·00	INF	INF	INF	INF	INF	INF	INF	INF	INF	INF	INF

DEPTH OF FIELD FOR LENSES OF 250 mm (10 in.) FOCAL LENGTH

The central "focus" value in each aperture block is the focus distance (header row below); the upper and lower values of each block are the near and far limits of the depth of field.

Aperture	Limit	3·00	3·50	4·00	5·00	6·00	7·00	8·00	9·00	10·00	12·50	15·00	20·00	25·00	30·00	50·00	INF
f2·00	near	2·93	3·40	3·88	4·81	5·73	6·63	7·52	8·40	9·26	11·36	13·39	17·24	20·83	24·19	35·71	123·46
	far	3·07	3·60	4·13	5·21	6·30	7·42	8·55	9·70	10·87	13·89	17·05	23·81	31·25	39·47	83·33	INF
f2·50	near	2·91	3·38	3·85	4·76	5·66	6·54	7·41	8·26	9·09	11·11	13·04	16·67	20·00	23·08	33·33	99·01
	far	3·09	3·63	4·17	5·26	6·38	7·53	8·70	9·89	11·11	14·29	17·65	25·00	33·33	42·86	100·00	INF
f3·00	near	2·90	3·36	3·82	4·72	5·60	6·46	7·30	8·12	8·93	10·87	12·71	16·13	19·23	22·06	31·25	82·64
	far	3·11	3·65	4·20	5·32	6·47	7·64	8·85	10·09	11·36	14·71	18·29	26·32	35·71	46·87	125·00	INF
f3·50	near	2·88	3·34	3·79	4·67	5·54	6·38	7·19	7·99	8·77	10·64	12·40	15·62	18·52	21·13	29·41	70·92
	far	3·13	3·68	4·24	5·38	6·55	7·76	9·01	10·30	11·63	15·15	18·99	27·78	38·46	51·72	166·67	INF
f4·00	near	2·86	3·31	3·76	4·63	5·47	6·29	7·09	7·87	8·62	10·42	12·10	15·15	17·86	20·27	27·78	62·11
	far	3·15	3·71	4·27	5·43	6·64	7·88	9·17	10·51	11·90	15·63	19·74	29·41	41·67	57·69	250·00	INF
f4·50	near	2·85	3·29	3·73	4·59	5·42	6·22	6·99	7·75	8·47	10·20	11·81	14·71	17·24	19·48	26·32	54·25
	far	3·17	3·74	4·31	5·49	6·73	8·01	9·35	10·74	12·20	16·13	20·55	31·25	45·45	65·22	500·00	INF
f5·60	near	2·81	3·25	3·67	4·50	5·29	6·05	6·78	7·49	8·17	9·77	11·23	13·81	16·03	17·94	23·58	44·44
	far	3·22	3·80	4·39	5·63	6·93	8·30	9·75	11·27	12·89	17·36	22·59	36·23	56·82	91·46	INF	INF
f6·30	near	2·79	3·22	3·63	4·44	5·21	5·95	6·66	7·34	7·99	9·51	10·89	13·30	15·34	17·08	22·12	39·53
	far	3·25	3·84	4·45	5·72	7·07	8·50	10·02	11·64	13·37	18·25	24·12	40·32	67·57	122·95	INF	INF
f8·00	near	2·74	3·15	3·55	4·31	5·03	5·72	6·37	6·99	7·58	8·93	10·14	12·20	13·89	15·31	19·23	31·15
	far	3·32	3·94	4·59	5·95	7·43	9·02	10·75	12·64	14·71	20·83	28·85	55·56	125·00	750·00	INF	INF
f11·00	near	2·65	3·03	3·40	4·10	4·75	5·35	5·92	6·45	6·94	8·06	9·04	10·64	11·90	12·93	15·62	27·68
	far	3·46	4·14	4·85	6·41	8·15	10·12	12·35	14·90	17·86	27·78	44·12	166·67	INF	INF	INF	INF
f16·00	near	2·52	2·86	3·18	3·79	4·34	4·83	5·29	5·71	6·10	6·94	7·65	8·77	9·62	10·27	11·90	15·60
	far	3·71	4·51	5·38	7·35	9·74	12·68	16·39	21·23	27·78	62·50	375·00	INF	INF	INF	INF	INF
f22·00	near	2·37	2·68	2·96	3·47	3·93	4·33	4·69	5·02	5·32	5·95	6·47	7·25	7·81	8·24	9·26	11·35
	far	4·08	5·06	6·17	8·93	12·71	18·23	27·03	43·27	83·33	INF	INF	INF	INF	INF	INF	INF
f32·00	near	2·17	2·42	2·65	3·05	3·39	3·69	3·95	4·18	4·39	4·81	5·14	5·62	5·95	6·20	6·76	7·81
	far	4·87	6·34	8·20	13·89	25·86	67·31	INF	INF	INF	INF	INF	INF	INF	INF	INF	INF

Bibliography

For the reader who wishes to extend his knowledge of optics, particularly of photographic optics, the following books may be recommended.
This list is necessarily incomplete, and for a more complete bibliography of optical literature reference may be made to *A System of Optical Design* by the present author.

1. At a level of treatment comparable with the present book:

 LENSES IN PHOTOGRAPHY. *Rudolf Kingslake*. Garden City Books. New York. (1951).

 PHOTOGRAPHIC LENSES. *C. B. Neblette*. Fountain Press. London. (1965).

 THE PHOTOGRAPHIC LENS. *H. M. Brandt*. Focal Press, London. (1968).
 (This gives a very full listing of Lens types).

 ENGINEERING OPTICS. *K. J. Habell & A. Cox*. Pitman. London. (1953).
 (This is mainly concerned with the application of optics to the problems of engineering measurements).

 PHYSICAL OPTICS IN PHOTOGRAPHY. *G. Franke*. Focal Press. London. (1966).
 (This covers much of the ground of the present book, but the treatment in some areas is more detailed).

2. An excellent account of elementary optical theory is given in

 GEOMETRICAL OPTICS. *W. T. Welford*. North-Holland. Amsterdam. (1962).

 GEOMETRICAL AND PHYSICAL OPTICS. *R. S. Longhurst*. Longmans. London. (1957).

3. For a somewhat more advanced treatment reference may be made to

LIGHT. *R. W. Ditchburn.* Interscience Publishers. New York. (1953).

APPLIED OPTICS AND OPTICAL ENGINEERING. Edited by *R. Kingslake* (5 vols.). Academic Press. London. (1965).

4. Probably the best treatment of Spatial Frequency Analysis, for those with the necessary mathematical background is

FOURIER METHODS IN OPTICAL IMAGE EVALUATION. *E. H. Linfoot.* Focal Press. London. (1964).

5. More advanced and more specialised books are:

APPLIED OPTICS AND OPTICAL DESIGN. *A. E. Conrady.* Parts 1 and 2. Dover Publications. New York. (1960).

(For many years this was the bible of English-speaking optical designers, and although it is now somewhat outmoded by the computer-oriented systems of design, its use of only elementary mathematics makes it attractive to a wide public).

RECENT ADVANCES IN OPTICS. *E. H. Linfoot.* Oxford University Press. (1955).

OPTICAL ABERRATION COEFFICIENTS. *H. A. Buchdahl.* Oxford University Press. (1954).

WAVE THEORY OF ABERRATIONS. *H. H. Hopkins.* Oxford University Press. (1950).

MODERN GEOMETRICAL OPTICS. *Max Herzberger.* Interscience Publishers. New York. (1958).

GRUNDLAGEN DER OPTIK. Edited by *S. Flügge.* Springer. Berlin. (1956).

DAS PHOTOGRAPHISCHE OBJEKTIV. *J. Flügge.* Springer. Vienna. (1955).

A SYSTEM OF OPTICAL DESIGN. *A. Cox.* Focal Press. London. (1964).

6. Topics of specialised kinds, which have an indirect bearing on photographic optics, are well treated in the following:

MEASUREMENT OF OPTICAL RADIATIONS. *G. Bauer* Focal Press. London. (1965).

FIBRE OPTICS. *N. S. Kapany.* Academic Press. New York. (1966)

FIBRE OPTICS AND ITS APPLICATIONS. *R. Tiedeken.* Focal Press, London. (1972)

THIN FILMS IN OPTICS. *H. Anders.* Focal Press, London (1967)

Glossary

ABERRATION. A fault in the performance of a lens because of which the rays of light are not brought to an exact point focus. The various types of aberration are discussed in the text. (See p. 98.)

ACHROMAT. A lens which is so designed that it will bring light of two colours to the same focus. Such a lens is *achromatised*, or is an *achromatic* lens. (See p. 132.)

ACUTANCE. The measure of a lens performance, or of picture quality, in terms of the sharpness of the transition across the boundary between the images of light and dark areas. (See p. 162.)

AFOCAL ATTACHMENT. An optical unit which is mounted in front of a camera lens, so that the combination will have a longer or shorter focal length than the camera lens alone. (See p. 290.)

ALATE ABERRATION. A form of image error or aberration which shows up as a winged or bow-tie shaped light patch. (See p. 123.)

ALBADA FINDER. A viewfinder in which images of lines defining the picture area seemed to be projected onto the scene. As a rule a greater extent of the scene is visible than that part which will be recorded on the film. (See p. 325.)

ANAMORPHIC SYSTEM. An optical system which utilises prisms or cylindrical surfaces in order to produce a picture which is compressed or expanded in one direction. (See p. 308.)

ANASTIGMAT. Originally this term meant a lens which claimed to bring light rays to point images over a reasonable image field or area. It now means a lens embodying a number of glass elements, so that it has a low *Petzval sum* and covers quite a large field, but is not of a specialised form such as a *telephoto lens* or a *retrofocus* lens. (See p. 240.)

ANGLE OF VIEW. The greatest angle between two rays going through the lens which will encounter the plate or film,

or which will reach an area on these where the quality of picture definition is acceptable. (See p. 48.)

ANGULAR FIELD. The same as ANGLE OF VIEW.

APOCHROMAT. A lens in which light of three colours is brought to a common focus. Frequently used in process work. (See p. 136.)

ASPHERIC SURFACE. A surface of revolution in which the radius of curvature varies smoothly over a range of values according to the distance of a point on the surface from the axis of revolution. (See p. 307.)

ASTIGMATISM. A lens suffers from *astigmatism* when the light rays which emerge from it, and which originate from an object point, form two short bars of light at right angles to each other, with a small separation between them. One is the *sagittal* or *radial image*, the other is the *tangential image*. (See p. 116.)

AXIAL COLOUR. A lens suffers from *Axial Colour* when the images formed by light of different colours vary in their distance from the lens, measured along the lens axis. (See p. 136.)

AXIS. The centres of the spherical surfaces bounding the glass elements in a well-made lens lie on a straight line, the *axis* of the lens. The lens is symmetrical about its axis. (See p. 16.)

BACK FOCUS. The distance from the rearmost glass surface of a lens to the focusing screen or sensitive film when a distant object is in focus on the latter. (See p. 34.)

BARREL DISTORTION. A lens suffers from *barrel distortion* when the images of straight lines are curved lines which are concave to the centre of the plate or film. (See p. 124.)

BLOOMING. The same as SURFACE COATING.

BOW-TIE ABERRATION. See ALATE ABERRATION.

CENTRE OF FIELD. The point where the *axis* of the lens cuts the image plane. (See p. 107.)

CENTRAL DEFINITION. The quality of the lens definition or picture quality in the centre of the field. It depends only on the *spherical aberration* and *axial chromatic aberration.* (See p. 107.)

CHROMATIC ABERRATIONS. These are faults in the performance of a lens which arise because light of different colours is bent to varying extents by the same piece of

581

glass. They are subdivided into *axial* and *lateral chromatic aberrations*. (See p. 103.)

COHERENT LIGHT. A pattern of light in which there is a sustained relationship between light which comes through different points on the microfilm format. (See p. 420)

COLLIMATED SPACE. A region in which the rays of light from an object point form a parallel bundle of rays. (See p. 426)

COMA. A fault in lens performance which results in an unsymmetrical light patch, flaring away like the tail of a comet. (See p. 112.)

COMPOUND LENS. A lens which consists of two or more glass elements which are joined together with a transparent cement such as Canada Balsam, or a synthetic cement. (See p. 16.)

CONDENSER. A lens or lens system which is concerned mainly with the even distribution of light in a projected image, and not with the quality of an image. (See p. 364.)

CONVERGENCE OF PERPENDICULARS. When a photograph is taken with the camera pointing upwards the parallel edges of buildings are reproduced in such a fashion that they appear to be converging towards one another. (See p. 368.)

CONVERGING LENS. A lens which causes previously diverging rays of light to converge so that they meet in a point, or which increases the degree of convergence of already converging light rays. (See p. 32.)

CONVERTIBLE LENS. A complex lens whose component parts may be used separately or in combination in order to provide lenses of different focal lengths. (See p. 286.)

CORRECTION OF DISTORTION. The convergence of perpendiculars may be remedied when an enlargement is made by using a sloping enlarging board, with or without a sloping negative, provided that suitable precautions are taken. (See p. 368.)

COVERING POWER. The area of a plate or film over which the lens will give an image of reasonable quality, or the region of object space which is recorded on this area of a plate or film. (See p. 48.)

CRITICAL ANGLE. The angle of incidence beyond which a ray inside a prism is trapped within the prism. (See p. 424)

DECENTRATION. A lens suffers from *decentration* when one or more of the centres of the spherical surfaces which

582

bound the glass elements in the lens do not lie on the lens axis. (See p. 147.)

DECENTRATION ABERRATIONS. The aberrations which are introduced into an optical system when one or more of the lens surfaces in the system are decentred. (See p. 147.)

DEFINITION. The quality of the image which is produced by a lens. A major problem in optics is to obtain a satisfactory method of measuring definition. (See p. 64.)

DELTA PRISM. (See Rotation Prism).

DEPTH OF FIELD. The region in front of and behind the focused distance within which object points still produce an image of a required standard of sharpness. It is also the tolerance in object to lens distances. (See p. 64.)

DEPTH OF FOCUS. The permissible film movement, or tolerance in lens to film distances, within which the sharpness of the image of an object point is up to a required standard. (See p. 20.)

DIFFRACTION. Light has a certain tendency to spread into the shadow of an object, or to spread away from a point image. This is due to the *diffraction* of light. In many cases it is not appreciable. (See p. 128.)

DISPERSION. The *dispersion* of glass is its property of bending light rays of different colours to different extents. It is measured by the *Abbe number*. (See p. 100.)

DISTORTION. A lens suffering from distortion reproduces straight lines in the object space as curved lines on the plate or film. See also *Barrel Distortion* and *Pincushion Distortion*. (See p. 123.)

DIVERGING LENS. A lens which increases the divergence of a group of already diverging light rays, or which causes a group of parallel rays to become divergent. (See p. 32.)

DOVE PRISM. (See Rotation Prism).

EDGE GRADIENT. Because of aberrations and diffraction the boundary separating the images of light and dark areas is not sharp. There is a gradual transition from light to dark and this is measured by the rate at which the image brightness changes. This is the *edge gradient*. (See p. 158.)

E.K. DEFINITION. An attempt has been made to specify picture quality in terms of both the *resolving power* and the *acutance* of an optical system. This has resulted in a

formula developed by the workers at the *Eastman Kodak Company*. (See p. 164.)

ENLARGING LENS. A lens which is specifically designed to give its best performance under the conditions which are met with in making enlargements. (See p. 142.)

EQUIVALENT FOCUS. This is the same as FOCAL LENGTH.

FIELD. The region of space which is recorded by a lens. It is also used to denote the part of the space which does not lie on the lens axis. According to this usage any point which does not lie on the lens axis is *in the field* of the lens. Correspondingly the image of a point in the field of a lens lies away from the exact centre of the sensitive plate or film. (See p. 107.)

FIELD CURVATURE. When there is *field curvature* in a lens, the images of points in the lens field at a given distance from the lens, instead of being imaged on a plane surface, are imaged on a curved surface and the plate or film needs to be bent to fit this surface in order to get the best definition. The *field curvature* depends on the *Petzval sum*. (See p. 116.)

FLARE. The distribution of extraneous light on the plate or film which is due to light that has been reflected at two air-glass surfaces in the lens, when this light produces a more or less even illumination. (See p. 214.)

f-NUMBER. A number measuring the light passing power of a lens, which is obtained by dividing the focal length of the lens by the diameter of the axial beam of light which goes through the lens. The smaller the *f*-number the more light is passed by the lens. A halving of the *f*-number represents an increase in the light gathering power of the lens by a factor of four. (See p. 20).

FOCAL LENGTH. This is the distance from a *nodal point* to a *focal point* of a lens. It determines the scale of reproduction of images. (See p. 28.)

FOCAL PLANE. A plane at right angles to the lens axis through the *focal point*. Infinitely distant objects form images which lie in this plane. (See p. 28.)

FOCAL POINT. The position of the *focus* when the rays of light entering or leaving the lens are a parallel bundle which is also parallel to the lens axis. The *focus* corresponding to an infinitely distant point on the lens axis. (See p. 18.)

FOCUS. The point where the rays of light radiating from a luminous object point, and bent by the refracting surfaces in a lens, meet again. Alternatively it is the position where such light rays come to their most compact form, as judged by the size of the illuminated area which they produce on a focusing screen or on a sensitive plate or film. Ideally this light patch is an exact point. (See p. 16.)

FOCUSING. The adjustment of a lens relative to a screen or to the surface of a plate or film so that the *focus* of any given point or group of points lies on it. (See p. 20.)

FOCUSING SCALE. A scale which is mounted on the camera so that the focusing of the lens may be carried out without the use of a focusing screen. (See p. 228.)

FOCUSING SCREEN. A ground glass screen placed in the camera in the position occupied by the surface of the sensitive plate or film, so that by inspection of the image formed upon it the focusing of the lens may be carried out. When the image is at its best on the ground glass screen then it is also at its best on the sensitive plate or film. (See p. 315.)

FOOT-CANDLE. A unit of screen illumination. (See p. 434)

FOOT-LAMBERT. A unit of screen brightness. A *Lambertian* surface with one *foot-candle* of illumination has a brightness of one *foot-lambert*. (See p. 434.)

FREQUENCY RESPONSE. See M.T.F. and O.T.F.

FRESNEL LENS. A lens constructed as a series of concentric rings, each one being a section of a normal lens. Thus producing the effect of the normal lens, without the thickness. It may be a thin sheet of plastic with a series of concentric grooves with flanks of specified angles. (See p. 436.)

GHOST IMAGE. An image which is formed by light rays which have been reflected at two air-glass surfaces inside the lens, and which lies near the image which is formed by the lens in the normal way. (See p. 214.)

HALF-SPEED PRISM. (See Rotation Prism).

HOT MIRROR. A glass plate coated with a number of thin layers of various transparent materials in such a way that it transmits visible light but reflects infra-red energy. (See p. 433.)

IMAGE. The pattern of light and shade which is formed on a

585

screen placed behind a lens from which we may recognize what were the objects which gave rise to this particular pattern. (See p. 16.)

IMAGE POINT. The same as FOCUS.

IMAGE SYNTHESIS. A technique of predicting what the quality of an image will be by using *Spot Diagrams* which are obtained by tracing rays through a lens with an electronic computer. (See p. 192.)

IMAGE WANDER. When a lens has *decentration* within it then the image which it gives moves around as the lens is rotated about its own axis. (See p. 148.)

INVERTED TELEPHOTO. A lens consisting of a diverging group of lens elements followed by a converging group, so that the back focus of the complete system is greater than the focal length of the complete system. (See p. 268.)

LAMBERTIAN SURFACE. A surface which appears equally bright from all viewing aspects. (See p. 432.)

LENS. A term which is used elastically to mean either a single piece of glass with polished surfaces, or a unit which comprises a number of such pieces of glass mounted together, so that they are capable of bending light rays. (See p. 16.)

LENS CENTRING. The adjustment of the elements which make up a complete lens so that the centres of all the polished spherical surfaces of these elements lie on a straight line. (See p. 147.)

LIGHT. The link between an object which is seen and the viewing eye which sees the object. It is a form of energy which travels along straight lines from an object point to the eye, or from an object point to a lens. (See p. 15.)

LIGHT RAY. The path along which the light energy travels from a luminous point to an observer's eye or to a camera lens. (See p. 15.)

MENISCUS LENS. A lens which has one of its air-to-glass surfaces convex and the other concave. A *meniscus lens* may be either positive or negative. (See p. 233.)

MICROFICHE. A sheet of film containing an array of reduced images of original documents. Usually prepared by a *micro-publishing* company. (See p. 404).

MICROGRAPHICS. The art or science of storing or presenting visual information which has been reduced to a con-

densed form, using some type of photo sensitive material. (See p. 404.)

M.T.F. If the ability of a lens to record picture quality is assessed in terms of the brightness variation in a pure spatial pattern, without reference to any phase shift, we have the *M.T.F.* (modulation transfer function) of the lens. See also O.T.F. (See p. 174.)

NODAL POINTS. These are two points on the lens axis so that a ray of light which enters the lens aiming at the forward nodal point, emerges from the lens aiming away from the second nodal point and parallel to its ingoing direction. (See p. 28.)

NODAL SLIDE. A device which makes use of the properties of the *nodal points* of a lens in order to measure the *focal length* of the lens. (See p. 35.)

O.T.F. This is a set of numbers which specifies how a lens will perform by indicating how basic patterns of light and shade will be reproduced in the image plane. It comprises two parts, a statement of the brightness which is reproduced by means of an M.T.F., and a statement of a *phase shift*. (See p. 174.)

OBLIQUE SPHERICAL ABERRATION. An aberration which yields a symmetrical light patch at points which do not lie on the lens axis. It increases in size very rapidly as the image points move away from the centre of the field. (See p. 122.)

PANORAMIC CAMERA. A camera in which a large field of view is covered by means of a lens which rotates about its rear nodal point. (See p. 46.)

PARALLAX ERROR. The error introduced because the viewfinder on a camera sees the scene to be recorded from a viewpoint which is slightly different to that of the camera lens, and so the area seen in the viewfinder is not exactly that which will be recorded on the sensitive plate or film. (See p. 321.)

PÉCHAN PRISM. (See Rotation Prism).

PERFECT LENS. A perfect lens is defined as one which would reproduce every object point as an exact image point, and which would reproduce every straight line in the object space as a straight line in image space. (See p. 27.)

PERSPECTIVE. The *perspective* of a group of objects is their

relative grouping and sizes as they appear to the eye or camera viewing them. (See p. 41.)

PETZVAL LENS. A lens consisting of two widely separated groups of lens elements, each group having positive power and being substantially achromatic. Such a lens is very popular for projection work. (See p. 234.)

PETZVAL SUM. An important number which depends only on the refractive indices and on the surface radii of the glasses which are used in a complex lens, and which determines the *curvature of field*. The greater the *Petzval sum* the more curved is the field. (See p. 118.)

PHASE HOLOGRAM. A hologram from which the silver has been removed by bleaching to produce a brighter image. The information is retrieved as phase differences in light passing through the hologram. (See p. 442.)

PINCUSHION DISTORTION. A lens suffers from pincushion distortion when the images of straight lines in the objects which are photographed are reproduced as curved lines that are convex towards the centre of the plate or film. (See p. 124.)

PLANETARY CAMERA. A camera in which microfilm records are made by standard picture taking methods. (See p. 412.)

POLARISED LIGHT. With a *polarising filter* the light which is transmitted through it is *polarised* and has the following property: if two polarising filters are *parallel* then the light which is transmitted by the first is also transmitted unchanged by the second; if the second filter is turned through a right angle, so that the filters are *crossed* the light which is transmitted by the first filter is completely extinguished by the second. (See p. 354.)

PRINCIPAL PLANES. These are planes that are perpendicular to the axis of the lens, and which go through the *nodal points* of the lens. They have the property that if a light ray enters the lens aiming at a certain point in the first principal plane, then it emerges from the lens aiming away from a point in the second principal plane, and the two points in question are at equal distances from the lens axis. (See p. 30.)

RANGEFINDER. A device for measuring the distance of an object which is to be photographed. As a rule a rangefinder is coupled to the focusing action of a lens so that when the object distance is measured the lens is auto-

588

matically set to give a sharp image of that object. (See p. 322.)

REFRACTIVE INDEX. A number which measures the power of glass to bend light rays. The greater the refractive index the more a ray of light is bent when it goes from air into the glass. (See p. 100.)

RESOLUTION CHART. A set of patterns which may be photographed in order to determine the *resolving power* of a lens. (See p. 152.)

RESOLVING POWER. The power of a lens to produce images of closely spaced lines or points in such a fashion that the individual identities of the images may be recognised. The *resolving power* of a photographic lens is usually specified in *lines/mm*. (See p. 151.)

RETRO-FOCUS LENS. This is the same as an *inverted telephoto* lens.

RISING FRONT. An adjustment in some types of camera which permits the lens axis to be raised bodily upwards. By means of this adjustment it is possible to photograph parts of a scene which would otherwise require the whole camera to be tilted upwards. (See p. 44.)

ROTARY CAMERA. A camera in which a microfilm record is made while the document and the film are in synchronised motion. Exposure is through a narrow slit. (See p. 412.)

ROTATION PRISM. A prism which provides reflection within the glass at an odd number of surfaces and thus provides for image rotation at twice the speed of rotation of the prism. (See p. 424.)

SCHMIDT PRISM. (See Rotation Prism).

SCINTILLATION. The appearance of localised bright points of light on a viewing screen. (See p. 438.)

SCREEN GAIN. The apparent brightness of a screen as compared with that of a Lambertian surface when both receive the same amount of light. (See p. 434.)

SECONDARY SPECTRUM. Although it is possible to bring light of two colours to a common focus, it is not usually possible to bring light of all colours to that common focus. The residual spreading out of colour images is known as secondary spectrum. (See p. 134.)

SPECTRUM. The coloured patch of light, which is red at one end and which shades off through orange, yellow, green and blue to violet, that is produced when a beam of white

589

light is bent by a prism before the light falls on a viewing screen. (See p. 24.)

SPECTRUM LINE. The colour of light may be specified by relating it to pure colours. When light of a pure colour traverses a prism it does not produce a spectrum, but instead it produces only a single line on a viewing screen. This is a *spectrum line*. (See p. 133.)

SPHERICAL ABERRATION. The defect in the performance of a lens which results in the lens producing a disc of light as the image of an object point on the lens axis. This disc has a certain minimum size which cannot be reduced by focusing the lens, but which may be reduced by stopping down the lens. (See p. 107.)

SPHERO-CHROMATISM. The spherical aberration in a lens will normally vary with the colour of light which is traversing the lens. This is due to *sphero-chromatism*. (See p. 136.)

SPOT DIAGRAM. By tracing a large number of rays through a lens, and by noting where each ray encounters an image plane, we obtain a *spot diagram*. Each spot records the point of intersection of a ray with the image plane. (See p. 126.)

STEREOSCOPIC EFFECT. The two eyes of a normal observer see the same scene from slightly different viewpoints, and consequently two slightly different impressions of the scene are transmitted to the brain. The mental fusion of these two impressions to give a sensation of depth and relief is the *stereoscopic effect*. (See p. 358.)

SUPPLEMENTARY LENS. A lens, usually comprising a single piece of glass or at the most two cemented pieces of glass, which when used with a camera lens may shorten its focal length so that close-ups can be taken. (See p. 55.)

SURFACE COATING. This is also known as *blooming* or as surface treatment. It comprises the production of a thin film on the surface of glass of a suitably adjusted refractive index and thickness, so that the reflection of light from the glass surface is reduced to a minimum. This improves image brightness and contrast and helps to eliminate *ghost images* and *flare*. (See p. 215.)

TELEPHOTO LENS. A lens which consists of a positive group of lenses followed by a negative group, so that the back focus of the lens is only a fraction, normally about one-

half or one-third, of the equivalent focal length of the lens. (See p. 272.)

TELEPHOTO RATIO. The ratio of the distance from the front of a telephoto lens to the focal plane, to the equivalent focal length of the lens. (See p. 272.)

T-STOP. When there is a significant loss of light in a lens, either because of reflection of light at the air-to-glass surfaces in the lens, or because of absorption of light in the glass itself, the light gathering power of the lens may be expressed by means of a *T-Stop*. (See p. 222.)

ULTRA-FICHE. A microfiche in which a high degree of reduction, up to $150\times$, is used. (See p. 412.)

VIEWFINDER. A device which is mounted on the camera so that the user may ascertain what part of a scene will be recorded on the sensitive plate or film. (See p. 322.)

VIGNETTING. The lower intensity of illumination produced by a lens at the corner of the plate or film, compared with the illumination in the centre of the field, due to the obstruction of light rays by the edges of the glass elements used in the lens, is known as *vignetting*. (See p. 211.)

WAVELENGTH OF LIGHT. There is a repeated pattern of electric and magnetic forces along the path of a light ray. The unit of pattern in this repeated sequence is the *wavelength* of the light. (See p. 24.)

ZOOM LENS. A lens in which the focal length is varied, while the image position remains unchanged, so that the size of any part of the picture is changed while the picture itself stays in sharp focus. (See p. 242.)

Index

592

594